POETS ON PAINTINGS

POETS ON PAINTINGS

A Bibliography

Robert D. Denham

McFarland & Company, Inc., Publishers
Jefferson, North Carolina, and London

LIBRARY OF CONGRESS CATALOGUING-IN-PUBLICATION DATA

Denham, Robert D.
Poets on paintings : a bibliography / Robert D. Denham.
p. cm.
Includes bibliographical references and index.

ISBN 978-0-7864-4725-1
softcover : 50# alkaline paper ∞

1. Painting — Poetry — Bibliography.
2. Painters — Poetry — Bibliography.
3. Ekphrasis — Bibliography.
4. Painting in literature — Bibliography.
5. Art in literature — Bibliography.
I. Title.
Z6514.A77D46 [PN53] 2010 016.80881'9357 — dc22 2010000219

British Library cataloguing data are available

On the cover: A version of the lost original by Pieter Bruegel the Elder,
Landscape with the Fall of Icarus, oil on canvas, 29" × 44", 1558
(Musées Royaux des Beaux-Arts de Belgique, Brussels)

Manufactured in the United States of America

*McFarland & Company, Inc., Publishers
Box 611, Jefferson, North Carolina 28640
www.mcfarlandpub.com*

For Rachel

Contents

Preface

Painting is mute poetry, and poetry a speaking picture.
— Simonides of Ceos (ca. 556–467 B.C.)

In 1980 John Dixon Hunt wrote that "the incidence of poems on paintings, especially in the twentieth century, is quite astonishing."* When I began preparing to teach a course on "Poems on Paintings" at Roanoke College during May 2003, I was not aware of the scope of ekphrastic practice. But I soon began to share the astonishment that Hunt had registered twenty-three years earlier, and I have discovered in the meantime that the number of poems written about paintings (and painters), as well as theoretical studies of ekphrasis, continues to multiply at an exponential rate. The present bibliography contains an inventory of both. Part One is a record of *ekphrasis* in its narrower sense — a poetic description or other verbal engagement with paintings and painters. Although Part One includes poems about occasional mosaics, tapestries, and graphic arts (drawings, sketches, wood cuts, wood engravings, etchings), it excludes poems on sculptures, photographs, films, music, installations, and other art forms. Users can readily locate the names of poets from the alphabetical list in section 6; the index provides similar access to the names of painters. Part Two is a record of the secondary literature, both theoretical and practical, on *ekphrasis*, defined in its broadest sense — literary (including prose *ekphrases*), sculptural, musical, photographic, filmic, and mixed media forms. It generally excludes studies of other related tropes that point to the relationship between poetry and painting, such as *enargia* (figures aimed at vivid description) and *ut pictura poesis* (as is painting so is poetry).

Sections 1 through 4 of Part One are devoted to book collections — eighty-eight altogether. These are in four categories:

1. Fifteen anthologies of poems on paintings from the collections of particular museums. These volumes include the paintings alongside the poems. The titles of the paintings are noted in square brackets following the name of the poet and the title of the poem.
2. Thirteen other collections. When these anthologies include both the poem and the painting, that information is noted following the bibliographic data for the collection.
3. Books devoted to the works of a single painter. These twenty-nine volumes are arranged alphabetically by the painter's surname.
4. Thirty-one volumes on multiple paintings and painters, each by a single poet.

*Quoted in Edna Longley, "No More Poems about Paintings?" *The Living Stream: Literature and Revisionism in Ireland* (Newcastle-Upon-Tyne: Bloodaxe 1994), 227.

Section 6 of Part One is an extensive list of poets and their individual poems on paintings (and painters)—some 2500 works. These are organized alphabetically by the poet's surname, followed by the titles of the poems. When the painter and painting are not obvious from the poem's title, this information is provided on the second line of each entry. The final line contains the bibliographic data for the source of the poem. Sometimes the source is only a URL on the World Wide Web, and while URLs frequently disappear into the ether of cyberspace, those provided were active in 2007 and 2008. If the painting is unidentified or unidentifiable, this information is noted, and if the focus is on the painter rather than a specific painting, only the painter's name is given on the second line of the entry. Although the list includes several poems on imaginary paintings, I have generally excluded works in this category—what John Hollander calls "notional ekphrasis." The entries in section 6 have numerous cross-references to the items in sections 1–4, as in "Levin (3J, above), 50" or "see 4Zd." These references direct the user to the complete bibliographical information of the source.

I have also excluded from section 6 poems from the Chinese tradition, which contains a rich and extensive body of work written in response to paintings from the T'ang dynasty on. T'ao Ch'ien's *Classic of Mountains and Sea*, for example, is a poem on an unidentified illustration. The sequence of painting followed by a poetic response is apparent also in Tu Fu's *Three Poems on Viewing a Landscape Painted by the Adjutant at the Request of His Brother Li Ku* and in his *On Seeing a Painting of Horses by General Ts'ao Pa at Secretary Wei Feng's House*. Yang Wei-chen (1296–1370) wrote numerous poems on paintings. But commonly the Chinese practice was to reverse this process, illustrating poems with paintings or otherwise decorating the calligraphy, the poet and the painter often being the same person. This composite art, as found in, say, Tao-Chi's *Album of Landscape and Flowers*, has its Western parallel in William Blake's engraved poems. I have not included such hybrid forms in the list in section 6, nor have I included any of the numerous paintings on poems (reverse ekphrasis), such as Charles Demuth's *Figure Five in Gold*, a painting inspired by William Carlos Williams's *The Great Figure*. I have excluded as well the relatively frequent efforts by curators simply to link a poem with a painting, as in the King County, Washington project, *Paint Me a Poem: A Canvas of Words* (Seattle: King County Public Art Program, 1999). Finally, I have excluded collaborative projects, such as Bob Pereleman and Francie Shaw's *Playing Bodies*, Archie Rand and John Yau's *100 More Jokes from the Book of the Dead*, and scores of other joint ventures, some quite complex. One of the more interesting of such projects was "Interwoven Illuminations," held at the Taos Fall Art Festival in 2008, in which a painting by Bill Rane was sent to a poet, who wrote a poem in reaction to it; then that poem (presented anonymously) was sent to another artist, who created another painting in reaction to the poem; then that painting (presented anonymously) was sent to yet another poet, and so on. Eleven poets and eleven painters participated in the project.

It is, of course, impossible to compile an exhaustive list: practically every third book of poems that crosses my desk has one or more ekphrastic poems, and they appear with regularity on internet web sites. Similarly, items in the secondary literature continue to appear at a steady rate. The bibliography is, therefore, preliminary, making no claims to completeness, and in time will naturally need to be supplemented. Of the several dozen items that came to my attention after the book was typeset, three, which would have otherwise been recorded in section 3 of part 1, are worthy of special note: *Light Lines* (DiVerse: Sydney, Australia, 2009);

Ernest Farrés, *Edward Hopper*, trans. Lawrence Venuti (St. Paul, MN: Graywolf Press, 2009; Manchester, UK: Carcanet, 2010; and Randall R. Freisinger, *Nostalgia's Thread: Ten Poems on Norman Rockwell's Paintings* (Tuscon, AZ: Hol Art Books, 2009).

Users who want to locate particular poets can find their names in the alphabetical list of section 6. The names of painters, along with the titles of their paintings, can be found in the index, where the page numbers reveal the scope of poetic responses to individual painters and paintings. Pieter Brueghel's *Landscape with the Fall of Icarus*, for example, has been the subject of at least sixty-three poems. Among American paintings, Edward Hopper's *Nighthawks* has been a favorite, inspiring more than thirty-seven poems. If more than one instance of a painting or painter appears on a single page, that number is indicated in parentheses following the page reference. In the titles of both poems and paintings I have made no effort to force a consistency in the spellings of such names as "Breughel," "Brueghel," "Bruegel" and the like. Occasionally, page references are missing from the entries in section 6, which means that I have not been able to check the book or journal where the poem appears, relying instead on the reference from an index, database, or other citation. Part Two is followed by an index of the personal names that appear in the titles of the secondary literature.

Like most critical terms, "ekphrasis" is multivalent. It derives from the Greek *ek* (out) and *phrazein* (to tell or declare). In its most general sense, it means a verbal representation of something visual. In Classical times the context for *ekphrasis* was primarily oral. Teachers of rhetoric devised exercises for young students to compose an ekphrastic passage. Such a passage, according to the Greek rhetoricians who first used the term in the second century A.D., was "a vivid description intended to bring the subject before the mind's eye of the listener" (*Grove Dictionary of Art*). This broad definition still obtains in accounts of *ekphrasis* as an extended literary description, though in general the term today has a more restricted use, most frequently referring to poems about paintings. The history of the term and the continuing discussion about its various meanings can naturally be found in the secondary literature (part 2).

Studies about ekphrasis worthy of special mention are the books by Andrew Sprague Becker, Emilie Bergmann, Gottfried Boehm and Helmut Pfotenhauer, Claus Clüver, Frederick Alfred de Armas, Jaś Elsner, Amy Golahny, James Heffernan, John Hollander, Mario Klarer, Murray Krieger, Elizabeth Loizeaux, W.J.T. Mitchell, Margaret Persin, Michael Putnam, Michael Riffaterre, Valerie Robillard and Els Jongeneel, Grant F. Scott, Hans Peter Wagner, and Haiko Wandhof. Ryan Welsh's "Ekphrasis" is a brief but illuminating discussion of the changing meaning of the term.

The catalogue in Part One, section 6, is indebted to two lists compiled more than thirty years ago by Eugene L. Hussleston and Douglas A. Noverr, "American Poems on Painting" (144 items) and "American Poems on Painters (135 items)" (*The Relationship of Painting and Literature: A Guide to Information Sources* [Detroit, MI: Gale Research Company, 1978]). I am indebted as well to Beverly Whittaker Long and Timothy Scott Cage's "Contemporary American Ekphrastic Poetry: A Selected Bibliography" (*Text and Performance Quarterly* 9 [1989]: 286–97), which catalogues 106 ekphrastic poems. I owe a special debt to Carol Frith who kindly provided me with tables of contents for out-of-print issues of the journal *Ekphrasis*, which she and Laverne Frith edit. I have also benefited from the research of Therese Broderick, who for some months ran a blog called "Ekphrasis: Poetry Inspired by Art" (now

inactive). Broderick, herself a poet, has generously supplied me with scores of ekphrastic poems that had escaped my notice. I express my thanks to her and to others who have provided me with information of one kind or another: Vincent Anthony, Suzanne Bruce, Carol Ann Davis, Barbara Fischer, Willow Fox, Grace Marie Grafton, Jonathan Holden, Chloë Honum, Chris Killen, Pat King, Leslie Koppenhaver, Mary Leader, Ricardo Pau-Llosa, Dan Masterson, Eric Pankey, Norma Richardson, Carla Taban, Guy Terrell, Gregory Vincent St. Thomasino, Anna Ustarbowska, Tom von Meyenfeldt, Rosanna Warren, and Martin Willitts, Jr. The interlibrary loan department of the Washington County Library in Abingdon, Virginia, deserves special thanks for its generous and efficient assistance.

PART ONE

*Poems on Paintings
and Painters*

1. Anthologies from Museum Collections

Arranged chronologically

1A. Dianne Perry Vanderlip. *Poets & Painters.* Denver, CO: Denver Art Museum, 1979. In organizing a 1979–1980 exhibition, Vanderlip "asked twelve poets whose work reflects a serious involvement with the visual arts to select for inclusion painters to whom they felt a special affinity. Additionally, the poets agreed to write, in whatever form they chose, a piece about the artist they selected." Color and black-and-white reproductions accompany the poems. Those who chose to write poems about painters and paintings:

Bill Berkson, *On Four Hearts* [Lynn O'Hare, *Blind*, 1979]

Bill Berkson, *Source* [Philip Guston, *Midnight Pass Road*, 1975]

John Cage, Untitled [Jasper Johns, Study for *Skin with O'Hara Poem*, 1963–65]

John Cage, Untitled [Robert Rauschenberg, *Half a Grandstand (Spread)*, 1978]

Barbara Guest, *Latitudes (The Art of Fay Lansner)* [Fay Lansner, *Women in Space*, panel III, 1978–79]

Barbara Guest, *Blue Endings* [Robert Fabian, Untitled, 1979]

James Schuyler, *Anne Dunn Drawing* [Anne Dunn, *Manhattan*, 1974]

James Schuyler, *Looking Forward to See Jane Real Soon* [Jane Freilicher, *The Gardeners*, 1977–78]

John Perreault, *I (for Sylvia Sleigh)* [Sylvia Sleigh, *A.I.R. Group Portrait*, 1978]

John Perreault, *II (for Ira Joel Haber)* [Ira Joel Haber, *My Landscape Grows Older When I'm Not with You*, 1974]

Carter Ratcliff, *Mr. Minotaur Builds a Labyrinth* [Rafael Ferrer, *A-af*, 1979]

Carter Ratcliff, *To Light* [Willem de Kooning, *Untitled XXII*, 1977]

Ann Waldman, *Gut Convinced* [Yvonne Jacquette, *Irving Place Intersection*, 1975–76]

Ann Waldman, *Love of His Art* [Joe Brainard, Untitled, 1978]

Peter Frank, *The Orgasm of Reason* [Ted Stamm, *Dodger-44*, 1978–79]

Peter Frank, *Parergon: Deadline City* [Tobi Zausner, *The Poet Drinks*, 1978–79]

1B. Pat Adams, ed. *With a Poet's Eye: A Tate Gallery Anthology.* London: Tate Gallery, 1986. Exploring works in the Tate Gallery through fifty poems by contemporary poets, this book is arranged as a chronological tour from the sixteenth century to the present. The poems and paintings (reproduced in color) are:

Judith Kazantis, *The Saltonstall Family* [David des Granges, *The Saltonstall Family*]

John Heath-Stubbs, *Homage to George Stubbs* [George Stubbs, *Horse Attacked by a Lion*]

Gerda Mayer, *Sir Brooke Boothby* [Joseph Wright of Derby, *Sir Brooke Boothby*]

Peter Schupam, *Henry Fuseli: "Titania and Bottom"* [Henry Fuseli, *Titania and Bottom*]

D.J. Enright, *God Creating Adam* [William Blake, *Elohim Creating Adam*]

Roy Fisher, *The Elohim* [William Blake, *Elohim Creating Adam*]

Colin Archer, *Nebuchadnezzar* [William Blake, *Nebuchadnezzar*]

Charles Causley, *Samuel Palmer's "Coming from Evening Church"*

John Wain, *The Shipwreck* [J.M.W. Turner, *The Shipwreck*]

Patricia Beer, *Yacht Approaching the Coast* [J.M.W. Turner, *Yacht Approaching the Coast*]

Vernon Scannell, *The Long and Lovely Summers* [John Crome, *The Poringland Oak* and J.M.W. Turner, *The Thames Near Walton Bridges*]

John Mole, *An Amateur Watercolourist to Thomas Girtin* [Thomas Girtin, *The White House*]

Kevin Crossley-Holland, *In "The Garden Tent"* [Thomas Churchyard, *The Garden Tent*]

David Wright, *James Ward's "Gordale Scar"*

Amryl Johnson, *The Deluge* [Francis Danby, *The Deluge*]

Alan Brownjohn, *The Boyhood of Raleigh* [J.E. Millais, *The Boyhood of Raleigh*]

Roger McGough, *The Boyhood of Raleigh* [J.E. Millais, *The Boyhood of Raleigh*]

U.A. Fanthorpe, *The Doctor* [Luke Fildes, *The Doctor*]

Michael Hulse, *Carnation, Lily, Lily, Rose* [John Singer Sargent, *Carnation, Lily, Lily, Rose*]

Gareth Owen, *Siesta* [John Frederick Lewis, *The Siesta*]

Sylvia Kantaris, *Thank Heaven for Little Girls* [Thomas Gotch, *Alleluia*]

John Loveday, *The Bowl of Milk* [Pierre Bonnard, *The Bowl of Milk*]

Jenny Joseph, *A Chair in My House: After Gwen John* [Gwen John, *A Lady Reading*]

Elizabeth Bartlett, *Millbank* [Gwen John, *Young Woman Holding a Black Cat*]

Dannie Abse, *The Merry-go-Round at Night* [Mark Gertler, *The Merry-go-Round*]

Emily Mitchell, *A Place* [Spencer Gore, *Letchworth*]

Jeremy Hooker, *Edvard Munch: "The Sick Child"*

Charles Tomlinson, *The Miracle of the Bottle and the Fishes* [Georges Braque, *Bottle and Fishes*]

George Szirtes, *The Green Mare's Advice to the Cows* [Marc Chagall, *The Green Mare*]

Paul Muldoon, *Paul Klee: "They're Biting"* [Paul Klee, *They're Biting (Sie beissen an)*]

Wendy Cope, *The Uncertainty of the Poet* [Giorgio de Chirico, *The Uncertainty of the Poet*]

Sarah Jane Ratherman, *Telephone to Nowhere* [Salvador Dali, *Mountain Lake*]

George MacKay Brown, *Henry Moore: "Woman Seated in the Underground"*

Carol Ann Duffy, *Woman Seated in the Underground, 1941* [Henry Moore, *Woman Seated in the Underground*]

David Gascoyne, *Entrance to a Lane* [Graham Sutherland, *Entrance to a Lane*]

Jeremy Reed, *Summer: Young September's Corn Field* [Alan Reynolds, *Summer: Young September's Corn Field*]

James Berry, *The Arrest— on Seeing Matisse's Painting "The Snail"*

Gillian Clarke, *The Rothko Room*

Peter Redgrove, *Into the Rothko Installation*

Michael Hamburger, *A Painter Painted* [Lucien Freud, *Portrait of Francis Bacon*]

Anne Stevenson, *Poems after Francis Bacon* [Francis Bacon, *Three Figures and a Portrait* and *Seated Figure*]

Blake Morrison, *Teeth* [Francis Bacon, *Seated Figure*]

Edward Lucie-Smith, *Five Morsels in the Form of Pears* [William Scott, *Pears*]

Vicki Feaver, *Oi yoi yoi* [Roger Hilton, *Oi yoi yoi*]

Richard Burns, *Awakening* [Frances Richards, *Les Illuminations*]

Edward Morgan, *The Bench* [Tom Phillips, *Benches*]

David Roger, *Percy* [David Hockney, *Mr and Mrs Clark and Percy*]

Connie Bensley, *The Badminton Game* [David Inshaw, *The Badminton Game*]

John James, *Lines for Richard Long* [Richard Long, *Slate Circle*]

David Frommer, *Swinging Man* [Bruce McLean, *Construction of the Grey Flag*]

1C. Paul Durcan. *Crazy about Women*. Dublin: National Gallery of Ireland, 1991. Durcan was invited by the National Gallery of Ireland to create a book of poems out of his experience of the collection. Color reproductions accompany the poems.

St Galganus [Andrea di Bartolo, *St. Galganus*]

The Crucifixion [Giovanni di Paolo, *The Crucifixion*]

The Holy Family with St John [Francesco Granacci, *The Holy Family with St John*]

The Separation of the Apostles [Styrian School, *The Separation of the Apostles*]

Christ Bidding Farewell to His Mother [Gerard David, *Christ Bidding Farewell to His Mother*]

Katherina Knoblach [Conrad Faber, *Katherina Knoblach*]

Portrait of a Man Aged Twenty-Eight [Georg Pencz, *Portrait of a Man Aged Twenty-Eight*]

Man with Two Daughters [Giambattista Moroni, *Man with Two Daughters*]

Cain and Abel [Circle of Riminaldi, *Cain and Abel*]

Interior with Figures [Nicolas de Gyselaer, *Interior with Figures*]

Acis and Galatea [Nicholas Poussin, *Acis and Galatea*]

The Veneration of the Eucharist [Jacob Jordaens, *The Veneration of the Eucharist*]

Kitchen Maid with the Supper at Emmaus [Diego Velázquez, *Kitchen Maid with the Supper at Emmaus*]

Saint Cecilia [Jacopo Vignali, *Saint Cecilia*]

The Levite and His Concubine at Gibeah [Jan Victors, *The Levite and His Concubine at Gibeah*]

The Sleeping Shepherdess [Jan Baptist Weenix, *The Sleeping Shepherdess*]

The Riding School [Karel Dujardin, *The Riding School*]

Lady Mary Wortley Montagu [Charles Jervas, *Lady Mary Wortley Montagu*]

The Dilettanti [Cornelius Troost, *The Dilettanti*]

Bishop Robert Clayton and His Wife Katherine [James Latham, *Bishop Robert Clayton and His Wife Katherine*]

Joseph Leeson [Pompeo Batoni, *Joseph Leeson*]

An Interior with Members of a Family [Philip Hussey, *An Interior with Members of a Family*]

The Earl of Bellamont [Sir Joshua Reynolds, *The Earl of Bellamont*]

Mrs Congreve with Her Children [Philip Reinagle, *Mrs Congreve with Her Children*]

Bishop of Derry with His Granddaughter [Hugh Douglas Hamilton, *Bishop of Derry with His Granddaughter*]

Sir John and Lady Clerk of Penicuik [Henry Raeburn, *Sir John and Lady Clerk of Penicuik*]

Thomas Moore in His Study at Sloperton Cottage [English School, 19th century, *Thomas Moore in His Study at Sloperton Cottage*]

Bathers Surprised [William Mulready, *Bathers Surprised*]

Demosthenes on the Seashore [Eugène Delacroix, *Demosthenes on the Seashore*]

Marguerite in Church [James Tissot, *Marguerite in Church*]

The Meeting on the Turret Stairs [Frederic William Burton, *The Meeting on the Turret Stairs*]

A Group of Cavalry in the Snow [Ernest Meissonier, *A Group of Cavalry in the Snow*]

Boy Eating Cherries [Pierre Bonnard, *Boy Eating Cherries*]

A Man Seated on a Sofa [Edouard Vuillard, *A Man Seated on a Sofa*]

Dawn, Connemara [Paul Henry, *Dawn, Connemara*]

Supper Time [Patrick Tuohy, *Supper Time*]

Self-Portrait in the Artist's Studio [Moyra Barry, *Self-Portrait in the Artist's Studio*]

Man Walking the Stairs [Chaim Soutine, *Man Walking the Stairs*]

A Portrait of the Artist's Wife [William Leech, *A Portrait of the Artist's Wife*]

A Self-Portrait [William Leech, *A Self-Portrait*]

Draughts [Jack B. Yeats, *Draughts*]

In The Tram [Jack B. Yeats, *In the Tram*]

Flower Girl, Dublin [Jack B. Yeats, *Flower Girl, Dublin*]

No Flowers [Jack B. Yeats, *No Flowers*]

The Cavalier's Farewell to His Steed [Jack B. Yeats, *The Cavalier's Farewell to His Steed*]

Grief [Jack B. Yeats, *Grief*]

1D. Edward Hirsch, ed. *Transforming Vision: Writers on Art.* Boston: Little, Brown, 1994. A collection of poems, short fiction, and essays inspired by works at the Art Institute of Chicago. The poems — and their paintings (reproduced in color):

Robert Hayden, *Monet's "Water Lilies"*

Delmore Schwartz, *Seurat's Sunday Afternoon along the Seine* [Georges Seurat, *A Sunday on La Grande Jatte*]

Richard Howard, *Henri Fantin-Latour "Un coin de table" (1873)*

Jon Stallworthy, *Toulouse Lautrec at the Moulin Rouge*

Adam Zagajewski, *Edgar Degas: "The Millinery Shop"*

Cynthia Macdonald, *Mary Cassatt's "Twelve Hours in the Pleasure Quarter"* [Mary Cassatt, *Woman Bathing*, 1891]

Patricia Hampl, *Woman before an Aquarium* [Henri Matisse, *Woman before an Aquarium*, 1921]

Joyce Carol Oates, *Edward Hopper's "Nighthawks"*

Wallace Stevens, *The Man with the Blue Guitar* (excerpts) [Pablo Picasso, *The Old Guitarist*]

Rita Dove, *There Came a Soul* [Ivan Albright, *Into the World There Came a Soul Called Ida*]

John Hollander, *Charles Sheeler's "The Artist Looks at Nature"*

Gerald Stern, *The Jew and the Rooster Are One* [Chaim Soutine, *Dead Fowl*]

C.K. Williams, *Interrogation II: After the Painting by Leon Golub*

Stanley Kunitz, *The Sea, That Has No Ending* [Philip Guston, *Green Sea*]

Mark Strand, *The Philosopher's Conquest* [Giorgio de Chirico, *The Philosopher's Conquest*]

Philip Levine, *A Glass of Sea Water or a Pinch of Salt* [Lionel Feininger, *Carnival in Arcueil*]

Charles Wright, *Summer Storm* [Piet Mondrian, *Composition — Gray Red*]

Li-Young Lee, *The Father's House* [Li-Lin Lee, *Corban Ephphatha I*]

Miroslav Holub, *The Earliest Angels* [Paul Klee, *Strange Glance*]

Jorie Graham, *The Field* [Anselm Kiefer, *The Order of the Angels*]

Ellen Bryant Voigt, *Wormwood: The Penitents* [Georgia O'Keeffe, *Black Cross*]

1E. *Wisconsin Poets at the Elvehjem Museum of Art.* Foreword by Russell Panczenko. Elvehjem Museum of Art, University of Wisconsin–Madison, 1995. Twenty-six poets used art in the galleries of the Elvehjem Museum of Art as their inspiration. Each painting, reproduced in color, is shown on a page facing the poem.

Mary Gallagher Price, *The Mourning Madonna* [Andrea Vanni, *The Mourning Madonna*]

Elaine Cavanaugh, *Pietà* [Colijn de Coter, *Bernatsky Triptych: The Lamentation*]

Phyllis Reisdorf, *A Musical Company* [Anthonie Palamedesz, *The Musical Company*]

Mary Louise Frary, *Introductory Comments by Sir Thomas Butler of Offrey* [Peter Lely, *Thomas Butler, Earl of Ossory, First Duke of Ormonde*]

Margaret Rozga, *Sleeping Country Girl* [Giuseppe Angeli, *Sleeping Country Girl*]

Jo Bartels Alderson, *To Gilbert Stuart from His Subject* [Gilbert Stuart, *Mrs. Aaron Davis*]

Kay Saunders, *Seated Boy with a Portfolio* [François Bonvin, *Seated Boy with a Portfolio*]

Karen Updike, *Still Life with Watermelon* [Severin Roesen, *Still Life with Watermelon*]

Josephine M. Zell, *Orpheus Greeting the Dawn* [Jean-Baptiste-Camille Corot, *Orpheus Greeting the Dawn*]

Pat Kardas, *Little Girl with Basket of Apples* [Adolphe-William Bouguereau, *Little Girl with Basket of Apples*]

Sue Silvermarie, *The Moment before Speaking* [Alma Erdmann, *At the Fortune Tellers*]

Charlotte A. Cote, *Young Woman in Black* [Homer Boss, *Young Woman in Black*]

Helen Fahrbach, *To the Children Dancing on the Strand* [George William Russell, *Children Dancing on the Strand*]

Cate Riedl, *Talking Back to the Portrait Hanging on the Wall* [Grant Wood, *Portrait of Nan*]

Judith Strasser, *Red Army in the Don Basin* [Pavel Sokolov-Skalya, *Red Army in the Don Basin*]

Iefke Goldberger, *Demon of Shipwrecks* [Eugene Brands, *Demon of Shipwrecks*]

Richard A. Loescher, *My Handkerchief* [Antonio Tapies, *Cracked White*]

Dale Kushner, *Landscape with Heart: Hans Hoffman in Manhattan* [Hans Hofmann, *August Light*]

Steve Timm, *Face* [Jack Tworkov, *Barrier Series No. 4*]

Eve Larkin, *Migration of Butterflies by Moonlight* [Charles Burchfield, *Migration of Butterflies by Moonlight*]

Kelly Cherry, *Rothko* [Mark Rothko, *Untitled, 1968*]

Andrea Musher, *This Painting Can't Be Reproduced* [Helen Frankenthaler, *Pistachio*]

Jennifer Vaughan Jones, *Al Held's American "Bruges III"* [Al Held, *Bruges III*]

Phyllis Wax, *Southwest Pietà* [Luis Jiminez, *Southwest Pietà*]

C.J. Muchhala, *Artistic License* [Bernar Venet, *Undetermined Line*]

Rusty Russell, *Pico Escondido* [Michael C. McMillen, *Pico Escondido*]

1F. Richard Tillinghast, ed. *A Visit to the Gallery.* Ann Arbor: University of Michigan Press, 1997. Thirty poets and fiction writers were invited to visit the University of Michigan Museum of Art on the occasion of its fiftieth anniversary to pick a work of art that appealed to them, and then to write a poem or prose piece in response. The poems and the paintings (reproduced in color):

Conrad Hilberry, *Egon Schiele: Portrait of Franz Hauer*

Alyson Hagy, *The Nymph of the Lo River* [Fei Tan-Hsü, *The Nymph of the Lo River*]

Thomas Lynch, *Still Life in Milford* [Lester Johnson, *Still Life in Milford*]

Molly Peacock, *Girl and Friends View Naked Goddess* [Pier Celestino Gilardi, *A Visit to the Gallery*]

Thylias Moss, *Picturing the Good Brown Life in John Phillip's The Highlander's Home (Sunshine in the Cottage)* [John Philip, *The Highlander's Home*]

Michael Loncar, *picasso shag* [Pablo Picasso, *Two Girls Reading*]

Charles Baxter, *A Disappearance* [James McNeill Whistler, *Sea and Rain*]

J. Allyn Rosser, *Sea and Rain* [James McNeill Whistler, *Sea and Rain*]

Susan Jane Gilman, *The Dead Sea from Masada, 1987* [Edward Lear, *The Dead Sea, from Masada*]

Robert VanderMolen, *Diebenkorn's Ocean Park No. 52* [Richard Diebenkorn, *Ocean Park No. 52*]

Diane Wakoski, *Night City* [Milton Avery, *Hammock Reader*]

Ken Mikolowski, *You Are What You Art* [Franz Kline, *To Win*]

Debra Allbery, *Figure/Ground* [Franz Kline, *To Win*]

Linda Gregerson, *Bleedthrough* [Helen Frankenthaler, *Sunset Corner*]

Alice Fulton, *Close* [Joan Mitchell, *White Territory*]

Robert Pinsky, *On "Eve Tempted by the Serpent" by Defendente Ferrari, and In Memory of Congresswoman Barbara Jordan of Texas* [Attributed to Defendente Ferrari, *Eve Tempted by the Serpent*]

Keith Taylor, *On the Easy Life of Saints* [Joos van Cleve, *Saint John the Evangelist on Patmos*]

Danny Rendleman, *Poem* [Philippe de Champaigne, *Christ Healing the Deaf-Mute*]

Jonis Agee, *In The Family Hour* [Jules Olitski, *Absolom Passage—18*]

Josie Kearns, *Joseph Interpreting the Dreams of Pharoah's Servants* [Nöel Hallé, *Joseph Interpreting the Dreams of Pharoah's Servants*]

Mary O'Malley, *The Annunciation* [Juan de Valdés Leal, *Annunciation*]

Tish O'Dowd, *"I wish I were a girl again, half savage and hardy, and free..."* [Camille Pissarro, *Young Girl Knitting*]

Nicholas Delbanco, *Dancer from the Dance* [Max Beckman, *Begin the Beguine*]

1G. Huston Paschal, ed. *The Store of Joys: Writers Celebrate the North Carolina Museum of Art's Fiftieth Anniversary.* Winston-Salem, NC: North Carolina Museum of Art in association with John H. Blair, Publisher, 1997. Forty-five contributors were commissioned to respond to paintings and other works of art in the North Carolina Museum of Art in Raleigh. Sixteen responded with poems, accompanied by color reproductions of the paintings.

David Brendan Hopes, *Gerard Seghers: "The Denial of St. Peter"*

Julie Suk, *St. Matthew and the Angel* [William Drost, *St. Matthew and the Angel*]

Charles, Edward Eaton, *A Story of Response* [Jean-Baptiste Oudry, *Swan Attacked by a Dog*]

Robert Watson, *Distances* [Pierre-Jacques Volaire, *The Eruption of Mt. Vesuvius*]

Eleanor Ross Taylor, *Indigo Mundi* [David Wilkie, *Christopher Columbus in the Convent of La Rábida Explaining His Intended Voyage*]

James Applewhite, *On Winslow Homer's "Weaning the Calf"*

Kathryn Stripling Byer, *June Pastoral* [Willard Leroy Metcalf, *June Pastoral*]

Romulus Linney, *To an Artist's Daughter* [William Merritt Chase, *The Artist's Daughter, Alice*]

R.S. Gwynn, *The Garden Parasol* [Frederick Carl Frieseke, *The Garden Parasol*]

Peter Makuck, *Wyeth's Winter* [Andrew Wyeth, *Winter 1946*]

Deborah Pope, *Plain Spoken* [Georgia O'Keeffe, *Cebolla Church*]

Ann Deagon, *George the Knife Does Windows* and *Iron Ann Sees Red* [George Bireline, *L-1962*]

William Harmon, *Riddle* [Richard Diebenkorn, *Berkeley No. 8*]

Michael McFee, *The Gospel According to Minnie Evans* [Minnie Evans, *The Eye of God*]

Fred Chappell, *The Phantom Pattern: A Pantoum* [Frank Stella, *Raqqa II*]

Gibbons Ruark, *Swamp Mallows* [Ben Berns, *Swamp Mallows*]

Betty Adcock, *Untitled Triptych* [Anselm Kiefer, *Untitled Triptych*] [also in Adcock's *Intervale* (Baton Rouge: Louisiana State University Press, 2001), 46–8]

1H. John Hollander and Joanna Weber, eds. *Words for Images: A Gallery of Poems.* New Haven, CT: Yale University Press, 2001. Twenty-two Yale alumni poets write on twentieth-century paintings, sculptures, photographs. The poets and the paintings (reproduced in color):

Stephen Cushman, *The Plowmen* [Käthe Kollwitz, *The Ploughmen*, 1906]

John Burt, *The Principle of Flickering* [Kasimir Malevich, *The Knifegrinder*, 1912–13]

Rachel Wetzsteon, *Spring (The Procession)* [Joseph Stella, *Spring (The Procession)*, 1914–16]

Jonathan Aaron, *Kurt Schwitter's Real Name* [Kurt Schwitter, *Merz, 19*, 1920]

Martha Hollander, *The Phantom Cart by Salvador Dali, 1933*

Rosanna Warren, *Bonnard* [Pierre Bonnard, *Interior at Le Cannet*, 1938]

David R. Slavitt, *Jackson Pollock's 13A: Arabesque* [*Number 13A: Arabesque*, 1948]

John Hollander, *Rooms by the Sea* [Edward Hopper, *Rooms by the Sea*, 1951]

Stephen Sandy, *Serial* [Mark Rothko, *Untitled*, 1934]

Elizabeth Alexander, *Islands Number Four* [Agnes Martin, *Islands No. 4*, ca. 1961]

Stephen Burt, *Franz Kline: Ravenna*

Rika Lesser, *Opposite Corners* [Sylvia Plimack Mangold, *Opposite Corners*, 1973]

1I. Grant Holcomb, ed. *Voices in the Gallery: Writers on Art.* Rochester, NY: University of Rochester Press, [2001]. This volume collects the work of forty writers who were asked to select a work of art from the Rochester Memorial Art Gallery and respond with a poem, short story, or essay. The poems and paintings (which are reproduced in color) are:

Kath M. Anderson, *As Could the Sea* [Milton Avery, *Haircut by the Sea*]

Todd Beers, *Ralph Blakelock's "Landscape with Trees"*

Marvin Bell, *Paul Klee Tells His Story to the Children* [Paul Klee, *Fairy Tales*]

Bruce Bennett, *Perspectives: A Triptych* [Ralston Crawford, *Whitestone Bridge*; Edwin Dickinson, *Snow on Quai, Sanary*; and Wayne Thiebaud, *River Pond*]

Charles Bernstein, *Slap Me Five, Cleo, Mark's History* [Bernard Duvivier, *Cleopatra Captured by Roman Soldiers*]

Kate Braverman, *Bar Scene* [Douglas Warner Gorsline, *Bar Scene*]

Joseph Bruchac, *Paddling at Dusk* [Winslow Homer, *Paddling at Dusk*]

Hayden Carruth, *William H. Macdowell* [Thomas Eakins, *William H. Macdowell*]

Robert Creeley, *As If* [Edouard Vuillard, *Portrait of Lugné Poë*]

Cornelius Eady, *Jacob Lawrence: Summer Street Scene* [Lawrence, *Summer Street Scene in Harlem*]

Anthony Hecht, *The Road to Damascus* [Francesco Ubertini, *The Conversion of St. Paul*]

Susan Howe, *Late afternoon fog* [Winslow Homer, *The Artist's Studio in an Afternoon Fog*]

M.J. Iuppa, *Mother's Dream* [Fairfield Porter, *The Beginning of the Fields*]

Bruce A. Jacobs, *The Jefferson Brothers Go Out for Mackerel* [Roy De Forest, *The Dipolar Girls Take a Voyage on the St. Lawrence*]

Barbara Jordan, *Carnal Knowledge* [Jan Davidszoon De Heem, *Still Life*]

Judith Kitchen, *Springtime in the Pool* [Charles Ephriam Burchfield, *Springtime in the Pool*]

Jim LaVilla-Havelin, *A Showery Day, Lake George* [John Frederick Kensett, *A Showery Day, Lake George*]

Eleanor A. McQuilkin, *Sullivan Street* [Everett Shinn, *Sullivan Street*]

Rennie McQuilkin, *Noon at the Gallery* [Gustave Courbet, *The Stonebreaker*]

Joan Murray, *Interlude* [John Koch, *Interlude*]

Anthony Piccione, *Entering Genesee Gorge* [Thomas Cole, *Genesee Scenery*]

Jarold Ramsey, *Running West* [Asher Brown Durand, *Genesee Oaks*]

Stan Sanvel Rubin, *Blue Shutters* [Edwin Dickinson, *Snow on Quai, Sanary*]

Joanna Scott, *Rachel Ruysch Looks Back* [Rachel Ruysch, *Floral Still Life*]

Deborah Tall, *The Artist's Studio in an Afternoon Fog* [Winslow Homer, *The Artist's Studio in an Afternoon Fog*]

Lewis Turco, *James Henry Beard: The Night before the Battle, 1965*

Kathleen Wakefield, *Resting Rock* [Walter Murch, *Resting Rock*]

Tom Ward, *American Fragment* [Nancy S. Graves, *Fragment*]

David Weiss, *A Sin of Commission* [John Henry Twachtman, *The White Bridge*]

1J. Angela Reid and Adrian Rice, eds. *A Conversation Piece: Poetry and Art.* Newry: National Museums and Galleries of Northern Ireland/Abbey Press, 2002. Poets' responses to an exhibition at the Ulster Museum. The poems and paintings (reproduced in color):

Tom Paulin, *On* [Jack Butler Yeats, *Through the Silent Lands*]

Gabriel Fitzmaurice, *The Solitary Digger* [Paul Henry, *The Potato Digger*]

Paula Meehan, *Quitting the Bars* [Hector McDonnell, *Bewley's Restaurant II*]

Dennis O'Driscoll, *Variations on Yellow* [Patrick Scott, *Yellow Device*]

Julie O'Callaghan, *The Road to the West* [John Luke, *The Road to the West*]

Michael Longley, *Yellow Bungalow* [Gerard Dillon, *Yellow Bungalow*]

Enda Wyley, *Painter at Work* [Roderic O'Conor, *View of Pont Aven*]

Anthony Cronin, *Riveters* [William Cronin, *Riveting*]

Joan Newmann, *Give Me to Drink* [Colin Middleton, *Give Me to Drink*]

Theo Dorgan, *James Joyce on Inishere* [Sean Keating, *Slan Leat a Athair/Goodbye, Father*]

Sinéad Morrissey, *Eileen* [Sir John Lavery, *Eileen, Her First Communion*]

Carol Rumens, *Nadir* [Tony O'Malley, *Farm in Winter*]

Paul Muldoon, *Mr. and Mrs. Stanley Joscelyne: The Second Marriage* [Anthony Green, *Mr. and Mrs. Stanley Joscelyne: The Second Marriage*]

Ruth Padel, *Ruins of Holy Island on Lough Derg* [Bartholomew Colles Watkins, *Ecclesiastical Ruins on Inniscaltra*]

Cathal Ó Searcaigh, *Transfigured*, trans. Frank Sewell [Hans Iten, *Five Trees by a River*]

Katie Donovan, *The Turning* [George William 'Æ' Russell, *Eventide*]

Seamus Heaney, *The Guttural Muse* [Barrie Cooke, *Big Tench Lake*]

Martin Mooney, *The Ginger Jar* [Louis le Brocquy, *Girl in White*]

Conor O'Callaghan, *Inside* [Robert Ballagh, *Inside No. 3*]

Vona Groarke, *En Plein Air* [Roderic O'Conor, *Field of Corn, Pont Aven*]

John Montague, *The Yachtsman's Jacket* [Edward McGuire, *John Montague*]

Brian Keenan, *Requiem* [Gerard Dillon, *Children Playing on Lagan*]

Chris Agee, *The Ivy Room* [Tony O'Malley, *Ghost of a Place*]

John Brown, *Where Uncle When* [A. Romilly Fedden, *The Fun of the Fair*]

Nathalie F. Anderson, *Daylight Raid from My Studio Window, 7 July 1917* [Sir John Lavery, *Daylight Raid from My Studio Window, 7 July 1917*]

Peter Sirr, *Passion Bed* [Dorothy Cross, *Passion Bed*]

Adrian Rice, *The Mason's Tongue* [Colin Middleton, *Head*]

Mark Roper, *The Watcher* [George William 'Æ' Russell, *The Watcher*]

Edward Denniston, *Killary Harbour View* [Paul Henry, *Dawn, Killary Harbour*]

Ian Duhig, *Watercolour* [Sampson Towgood Roch(e), *Rustics Dancing outside an Inn*]

Molly Freeman, *Tired Child* [Louis le Brocquy, *Tired Child*]

Ruth Carr, *The Three Dancers* [John Luke, *The Three Dancers*]

Frank Delaney, *Dream of the Moth* [Colin Middleton, *Dream of the Moth*]

Bernard O'Donoghue, *The Potato Gatherers* [George William 'Æ' Russell, *The Potato Gatherers*]

Derek Mahon, *Shapes and Shadows* [William Scott, *Shapes and Shadows*]

Medbh McGuckian, *Hazel Lavery: The Green Coat* [Sir John Lavery, *The Green Coat*]

Jean Bleakney, *Village by the Sea* [Norah McGuinness, *Village by the Sea*]

Brendan Kennelly, *Designing Friday* [Edward Burra, *Dublin Street Scene No. 1*]

John Boland, *Boon Companions* [Harry Kernoff, *Boon Companions*]

Peter Fallon, *A Thanksgiving* [William John Hennessy, *Fête Day in a Cider Orchard, Normandy*]

Leon McAuley, *Negative (4)* [Mark Francis, *Negative (4)*]

Mel McMahon, *Huck Finn* [Aloysius O'Kelly, *Huckleberry Finn*]

Rand Brandes, *Jimbo Blue* [Basil Blackshaw, *The Barn (Blue II)*]

Gerald Dawe, *The Fox* [John Luke, *The Fox*]

David Wheatley, *Gone* [James Arthur O'Connor, *Scene in Co. Wicklow*]

Frank Ormsby, *Lagan, Annadale* [Colin Middleton, *Lagan: Annadale, October*]

Kerry Hardie, *Spaced Shapes in a Space of Sand* [William Scott, *Egypt Series No. 3*]

Eilean Ni Chuilleanain, *Apocalyptic* [Jack Butler Yeats, *The End of the World*]

Matthew Sweeney, *Lost* [Daniel O'Neill, *Three Friends*]

Kevin Smith, *Wish You Were Here* [Gerard Dillon, *Self-contained Flat*]

Brendan Kennelly, *Herself and Himself* [Edward Burra, *Dublin Street Scene No. 1*]

1K. Grace Nichols, ed. *Paint Me a Poem: New Poems Inspired by Art in Tate.* London: A & C Black, 2004. Responses to paintings and sculpture in the Tate Gallery, London, by Grace Nichols and school-children (identified by their first names). The poems on paintings (reproduced in color) are:

Grace Nichols, *The Snail* [Henri Matisse, *The Snail*]

Reception Class, St. Gabriel's Church of England, *The Snail* [Henri Matisse, *The Snail*]

Grace Nichols, *The Queen Who Reigned Supreme* [Nicholas Hilliard, *Elizabeth I* (The Phoenix Portrait)]

Grace Nichols, *Elizabth I* [Nicholas Hilliard, *Elizabeth I* (The Phoenix Portrait)]

Grace Nichols, *Dora Maar (Picasso's Weeping Woman)* [Pablo Picasso, *Weeping Woman*]

Nasmin, Foreda, Roison, and Shahana (Shapla School), *Weeping Woman* [Pablo Picasso, *Weeping Woman*]

Grace Nichols, *Marilyn* [Andy Warhol, *Marilyn Diptych*]

Grace Nichols, *Proserpine Thinks about Her Mother* [Dante Gabriel Rossetti, *Proserpine*]

Shahana and Roisin [sic] (Shapla School), *Proserpine* [Dante Gabriel Rossetti, *Proserpine*]

Grace Nichols, *Ophelia* [Sir John Everett Millais, *Ophelia*]

Mathew (Latorn Junior School), *The Lady of Shalott* [John William Waterhouse, *The Lady of Shalott*]

Grace Nichols, *Goodbye Shalott* [John William Waterhouse, *The Lady of Shalott*]

Grace Nichols, *The Gardener* [Paul Cézanne, *The Gardener Vallier*]

Grace Nichols, *The Three Dancers* [Pablo Picasso, *The Three Dancers*]

Gail (Gloucester Primary), *Lady Anne* [Philip Mercier, *The Schutz Family and Friends on a Terrace*]

Grace Nichols, *Just Married* [Philip Mercier, *The Schutz Family and Friends on a Terrace*]

Grace Nichols, *Last Day in the Old Home* [Robert Braithwaite Martineau, *Last Day in the Old Home*]

Sam Leo (Marion Richardson Primary), *Wondering WHY?* [Robert Braithwaite Martineau, *Last Day in the Old Home*]

Grace Nichols, *Learning to Swim* [Michael Andrews, *Melanie and Me Swimming*]

Jaton (Vicarage Primary School), *Melanie and Me Swimming* [Michael Andrews, *Melanie and Me Swimming*]

Grace Nichols, *Turner to His Critic* [J.M.W. Turner, *Snow Storm — Steamboat off a Harbour's Mouth*]

Grace Nichols, *Waterfall* [Ashile Gorky, *Waterfall*]

Neneh (Gloucester Primary), *Magic Waterfall* [Ashile Gorky, *Waterfall*]

Grace Nichols, *Women and Bird in the Moonlight* [Joan Miró, *Women and Bird in the Moonlight*]

Grace Nichols, *The Dance* [Paula Rego, *The Dance*]

1L. Justine Rowden. *Paint Me a Poem.* Honesdale, PA: Wordsong, 2005. Poems inspired by paintings (reproduced in color) at the National Gallery of Art, Washington, DC.

Ziggedy, Zaggedy [Sam Francis, *Speck*]

With My Father [Auguste Renoir, *Madame Henriot*]

Dancin' [Joseph Decker, *Green Plums*]

Faster, Faster, Faster [Anonymous, *General Washington on a White Charger*]

Noisy Night at Sea [J.M.W. Turner, *Keelmen Heaving in Coals by Moonlight*]

Moving White Fluffs [Alfred Sisley, *Meadow*]

Whoosh! [Mark Rothko, *Untitled*, 1967]

Oh So Perfect [Édouard Vuillard, *The Visit*]

So Close [André Derain, *Flowers in a Vase*]

It's All Hidden [Francisco Goya, *Bartolomé Sureda y Miserol*]

Purple in My Path [André Derain, *Mountains at Collioure*]

Twirling [Leonardo da Vinci, *Ginerva de'Benci*]

Blue [Henri Matisse, *Woman with Amphora and Pomegranates*]

Don't I Know You [Anonymous, *Cat and Kittens*]

1M. Peter Steele. *The Whispering Gallery.* South Yarra, Victoria, Australia: Macmillan Art Publishing, 2006. Fifty-five poems, each prompted by a work of art drawn from the collection of the National Gallery of Victoria, Australia. The poems on paintings are:

Barber [John Brack, *The Barber's Shop*]

Boat [Charles Blackman, *Boat*]

Building [Jan Senbergs, *Altered Parliament House*]

Canaletto [Canaletto, *Bacino di S. Marco, from Piazzetta*]

Carcass [Sidney Nolan, *Carcass*]

Cello [Pietro Longhi, *Luigi Boccerini*]

Cranach [Lucas Cranach, *Philipp Melanchthon*]

Dancers [Peter Purves Smith, *The Pond, Paris*]

Finding of Moses [Sebastiano Ricci(?), *The Finding of Moses*]

Fitzroy Autumn [John Mather, *Fitzroy Gardens, Autumn*]

Genius Loci [Robert Clinch, *The Source*]

Golden City: Rome from the Janiculum [Samuel Palmer, *The Golden City: Rome from the Janiculum*]

Haydon [Benjamin Robert Haydon, *Marcus Curtius*]

Illuminator [Maître Francois, *The Flight into Egypt*]

In Memory of Anthony Hecht [John Perceval, *Ocean Beach, Sorrento*]

In Praise of Dialectics [René Magritte, *In Praise of Dialectics*]

Italy [Rosslynd Piggott, *Italy*]

Lake Nemi [Joseph Wright of Derby, *Lake Nemi*]

Magi [Giovanni Toscani, *The Adoration of the Magi*]

Miracle [unknown Flemish artist, *The Miracle of the Loaves and Fishes*]

Moses [Nicolas Poussin, *The Crossing of the Red Sea*]

Oak [Meindert Hobbema, *The Old Oak*]

October [Jules Bastien-Lepage, *October*]

The Old Adam [Adrian Feint, *The Illawarra Flame Tree*]

Originals [William Blake, *Dante Running from the Three Beasts*]

Parade [Fernand Léger, *Grand Parade with Red Background*]

Piranesi: Finale [Giovanni Battista Piranesi, *The Round Tower*]

Pond [Edward Haytley, *The Brockman Family and Friends at Beachborough Manor: Temple Pond with Temple in the Distance*]

Quixote Reading [Honoré Daumier, *Don Quixote Reading*]

Ramsay [Allan Ramsay, *Richard Grenville, 2nd Earl Temple*]

Rembrandt [Rembrandt van Rijn, *Two Old Men Disputing*]

Sergeant [George Lambert, *A Sergeant of the Light Horse in Palestine*]

Sirens [John Waterhouse, *Ulysses and the Siren*]

Solo [Jeffrey Smart, *Cahill Expressway*]

St. Jerome in His Study [Albrecht Dürer, *St. Jerome in His Study*]

Still Life [Bernard Buffet, *Owl*]

Tailor [Thomas Rowlandson, *A Little Bigger*]

The Bridge [Grace Cossington Smith, *The Bridge In-curve*]

The Two [Jean Lurcat, *Adam before Creation*]

Trees [Fred Williams, *Echuca Landscape*]

Trees in Quarry [Godfrey Miller, *Trees in Quarry*]

Waterhole [Arthur Boyd, *The Waterhole*]

Wheat [John Linnell, *Wheat*]

Wood in Snow [Peter Booth, *Winter*]

1N. Katie Geha and Travis Nichols. *Poets on Painters.* Wichita, KS: Ulrich Museum of Art, Wichita State University, 2007. Twenty poems written in response to an exhibition at the Ulrich Museum of Art, 22 April–5 August, 2007. The paintings are reproduced in color.

Eric Baus, *A red dress* [Mequitta Ahuja, *Tsunami Generation*]

Laura Solomon, *the dream is often of a nest* [Abel Auer, *Untitled*]

Paul Killebrew, *I Lack a Certain Presence of Mind* [Jules de Balincourt, *The Watchtower*]

Hoa Nguyen, *I Said Apprenend To Seize* [Nina Bovasso, *Silver-Roofed Structure*]

Sawako Nakayasu, *In the Form of* [Echo Eggebrecht, *Barnswallow*]

Aimee Kelley, *A Final Sonnet: Romeo and Juliet (Yellow Couple)* [James Benjamin Franklin, *Untitled*]

Noah Eli Gordon, *Color System* [Joanne Greenbaum, *Color System*]

Nick Moudry, *The proper perspective* [Mark Grotjahn, *Untitled (Black Butterfly Pink MG03)*]

Kary Wayson, *Intimacy vs. Autonomy* [Angelina Gualdoni, *Reflecting Skin 2*]

Kristin Prevallet, *Asteroid* [Laura Owens, *Untitled*]

John Olson, *Patch Work* [Christopher Patch, *Reading Room*]

Sueyeun Juliette Lee, *Down the mountain (an afternoon appearance of man and mystery)* [Lamar Peterson, *Untitled*]

Joshua Marie Wilkinson, *City, Phantom, Quays* [Sam Prekop, *Committees*]

Jeff Clark, *Against* [Monique Prieto, *Tide*]

Sara Veglahn, *Reading Lady* [Christopher Ruckhäberle, *Reading Lady*]

Corina Copp, *Pale Tomato (Illume)* [Anna Schachte, *Tunnel of Love*]

Dorothea Lasky, *Go On There, Boy* [Dana Schutz, *Missing Link Finds Superman*]

Juliana Leslie, *The Life of Marginal Fauna* [Sandra Scolnik, *Self-Portrait, Undeveloped*]

Monica Fambrough, *Don't you think salt is pretty?* [Amy Sillman, *Untitled*]

Brad Flis, *Customs* [Whiting Tennis, *Bovine*]

1O. Karen O. Janovy, curator. *Nebraska Poets on Sheldon Painters: A Selection of Poems from the Contest, 2008* (Lincoln, NB: Sheldon Museum of Art, University of Nebraska–Lincoln), 2008. Nebraskan

poets of all ages were asked to respond to paintings in the Sheldon Museum's permanent collection with an original poem. The collection is available in a pdf file at http://sheldonartgallery.org/photos/graphics/2573wsheldonmuseum.pdf

James Rehwaldt-Alexander, Untitled [Max Weber, *Night*]

Monica Claesson, *Untold Voyage* [Jacob Lawrence, *Paper Boats*]

Kelly Weber, *Cold Breath* [Robert Henri, *Woods Interior*]

Rebekah Banks, *In Window, from Within* [Georgia O'Keeffe, *New York, Night*]

Carmen Claesson, *Seagull Boats* [John H. Thwachtman, *Bark and Schooner*]

Aubrey Thompson, *Perspective* [Lilian Westcott Hale, *The Convalescent*]

Ryan McManaman, *A Mountainous Morning in the Forest* [Marsden Hartley, *Painting Number One, 1913*]

Leah Grace Adams, *Little Space* [Edward Hopper, *Room in New York*]

Erin Carey, *All Strung Out* [Frank Tuchfarber, *The Old Violin*]

Sarah Voss, *Woman Scrubbing* [Elizabeth Terrell, *Woman Scrubbing*]

Cassie Failor, Untitled [Robert Henri, *Woods Interior*]

A. Lauren Higgins, *Opening* [Mark Rothko, *Yellow Band*]

Erica Bartz, *Opulence* [Frank Duveneck, *Laughing Boy*]

Bethany Thornton, *Fetching Jumanah* [Henry Ossawa Tanner, *Horse of the Khedive-Egypt*]

Camille Harrah, *This Was the Most Interesting Painting I Could Find* [Frank Tuchfarber, *The Old Violin*]

Christine Hope Starr, *A Sadness* [Mark Rothko, *Yellow Band*]

Derek Wallin, *A Hunter's Night* [Albert Pinkham Ryder, *Hunter's Rest*]

Luta Menard, Untitled [Albert Bierstadt, *River Landscape*]

Richard David Wyatt, *The City* [Hans Hofmann, *The City*]

1Q. John Yau, ed. *New Smoke: An Anthology of Poetry Inspired by Neo Rauch Paintings.* Introduction by John Yau. New York: Off the Park Press, 2009. This anthology contains work by a group of poets who wrote in response to Neo Rauch's "para" paintings while on exhibit at the Metropolitan Museum of Art in New York. The poets: Gale Batchelder, Susan Berger-Jones, Judson Evans, Vivian Eyre, Eileen B. Hennessy, Boni Joi, Ronna Lebo, Catherine Shainberg, and Marian Brown St. Onge.

See also *Ekphrasis: Writing on the Collection.* An online exhibit, 5 March–22 April 2007, of eight paintings in the permanent collection of the Purdue University Galleries: Guillermo Meza, *Polyphemus*; José Chavez Morado, *Woman Polishing a Stone Slab*; Leonard Koscianski, *Fire Eaters*; Robert Browning Reed, *Wabash River VI*; Fernand Léger, *La Vielle*; Juli Haas, *Dreamer*; Margaret Van Patten, *Chaos Standing Still*; and Jess Hobby, *Brown County Autumn Landscape.* Writers of all ages were invited to respond creatively to these paintings. Their poems, some by schoolchildren, can be found at the website: http://www2.itap.purdue.edu/galleries/ekphrasis/

A number of museums sponsor programs that bring together artists and poets, including the Art Institute of Chicago, Detroit Institute of Art, Fine Arts Museum of San Francisco ("Poets in the Gallery" program), Reynolda House, Museum of American Art (Winston-Salem, NC), Santa Barbara Museum of Art (which sponsors "Poetry Month"), and various museums in Houston, TX, in connection with the Writers in the Schools program. For an account of these programs, see Kathy Walsh-Piper, "Writing Programs in Art Museums," in Tonya Foster and Kristin Prevallet, eds., *Third Mind: Creative Writing Through Visual Art* (New York: Teachers and Writers Collaborative, 2002), 200–7. A group of organizations in Hickory, NC, sponsors an annual ekphrasis event. In March 2009 The Castlemaine Art Gallery (Australia), sponsored Artlines, a gallery tour in which four prize-winning poets — Sheryl Persson, Ross Gillett, E.A. Gleeson and Ross Donlon — led their audience on a walk around the gallery, stopping to read their poems next to the artworks that inspired them. The poems were displayed alongside the related works of art.

The following four volumes, all out of print, came from poetic responses to the collections of the Fine Arts Museum of San Francisco:

Genny Lim, ed. *Eyes of the World: An Anthology of Poems.* San Francisco: Fine Arts Museum of San Francisco, 1992.

Genny Lim, ed. *Through Our Voices: An Anthology.* San Francisco: Fine Arts Museum of San Francisco, 1990.

Genny Lim, ed. *Unsilenced Voices: An Anthology.* San Francisco: Fine Arts Museum of San Francisco, 1991.

Genny Lim and Jeanine Jeffries, eds. *Sunlight and Shadows: An Anthology of Poems.* San Francisco: Fine Arts Museum of San Francisco, 1993.

A collection of poems written by school children from art works in the Fine Arts Museum of San Francisco and elsewhere are reproduced in

(1) *A Gallery of Poems: An Anthology of Poems by Students*, ed., Devorah Major (San Francisco: San Francisco Fine Arts Museums, 2003), available on line at http://74.125.113.132/search?q=cache: T5NlB6G8h24J:www.famsf.org/files/education/01-02PoetsBookw-cover.pdf+%22Devorah+ Major%22+%22a+gallery+of+poems%22&hl=en &ct=clnk&cd=1&gl=us

(2) *Who Has Looked in Your Mirror*, eds., Devorah Major and Jorge Argueta (San Francisco: San Francisco Fine Arts Museums, 1994). The latter is available online at http://www.famsf.org/fam/education/publications/poets93-94/index.html

The online journal *Northography* has joined with the Minneapolis Institute of Arts for an ekphrasis initiative, inviting poets to respond to works in the Institute's collection. See http://www.northography.com/mia.php.

In April 2009 two bloggers, Amy and Lavelle, invited readers to respond poetically to works of art from the Portland Museum of Art. They encouraged readers to visit the museum, and they posted images from the museum each week. See http://museumpoetry.blogspot.com/

2. Other Anthologies

Arranged chronologically

2A. D.G. Kehl. *Poetry and the Visual Arts.* Belmont, CA: Wadsworth Publishing Co., 1975. Juxtaposes poems with their visual-art companions (reproduced in black-and-white), including some poems not written specifically about their companion pieces. The ekphrastic pairs are:

W.D. Snodgrass, *The Red Studio* [Henri Matisse, *The Red Studio*]

Walter Pater, *Mona Lisa* [Leonardo da Vinci, *Mona Lisa*]

William Carlos Williams, *Portrait of a Lady* [Jean-Honore Fragonard, *The Swing*]

Marianne Moore, *Leonardo da Vinci's* [Leonardo da Vinci, *St. Jerome Healing the Lion*]

Morris Bishop, *Rubens' "La Petite Pelisse"* [Peter Paul Rubens, *La Petite Pelisse*]

W.H. Auden, *Musée des Beaux Arts* [Pieter Brueghel the Elder, *Landscape with the Fall of Icarus*]

Joseph Langland, *Fall of Icarus: Brueghel* [Pieter Brueghel, *Landscape with the Fall of Icarus*]

Paul Engle, *Venus and the Lute Player* [Titian, *Venus and the Lute Player*]

Hy Sobiloff, *Communion* [Pablo Picasso, *The Blind Man's Meal*]

Paul Engle, *Blind Man* [Pablo Picasso, *The Blind Man's Meal*]

Randall Jarrell, *The Knight, Death, and the Devil* [Albrecht Dürer, *The Knight, Death, and the Devil*]

Ann Stanford, *Edward Hicks's "The Peaceable Kingdom"*

John Malcolm Brinnin, *Le Creazione degli Animali* [Tintoretto, *The Creation of the Animals*]

Howard Moss, *"Around the Fish": After Paul Klee* [Paul Klee, *Around the Fish*]

W.D. Snodgrass, Manet: *"The Execution of the Emperor Maximilian"*

Anne Sexton, *The Starry Night* [Vincent Van Gogh, *The Starry Night*]

W.D. Snodgrass, *Van Gogh: "The Starry Night"*

Adrienne Rich, *Mourning Picture* [Edwin Romanzo Elmer, *Mourning Picture*]

Donald Finkel, *"The Dream": Rousseau* [Henri Rousseau, *The Dream*]

Deborah Austin, *La Rêve de Yadwigi (Henri Rousseau, 1910)* [Henri Rousseau, *The Dream*]

X.J. Kennedy, *Nude Descending a Staircase* [Marcel Duchamp, *Nude Descending a Staircase*]

George Garrett, *David* [Caravaggio, *David with the Head of Goliath*]

David Ray, *A Midnight Diner by Edward Hopper* [Edward Hopper, *Nighthawks*]

Samuel Yellen, *Nighthawks* [Edward Hopper, *Nighthawks*]

Sylvia Plath, *Two Views of a Cadaver Room* [Pieter Brueghel the Elder, *Triumph of Death*]

N. Scott Momaday, *Before an Old Painting of the Crucifixion* [Anon., painting of the Crucifixion, Mission Carmel]

2B. Gisbert Kranz, ed. *Gedichte auf Bilder: Anthologie und Galerie.* München: Deutscher Taschenbuch Verlag, 1976. Black and white reproductions of numerous sculptures and paintings alongside the poetic responses they generated. The poems on paintings and painters are:

Bernt von Heiseler, *Zu einem Bild von Hieronymus Bosch*

Jan Czerski-Brant, *Boschs Antonius* [Hieronymus Bosch, *Versuchung des hl. Antonius* (*The Temptation of St. Anthony*)]

Paul Wiens, *Stoffwechsel: Hieronymus Bosch*

Dominicus Lamponius, *Hieronymo Boschio Pictori* [German trans., *An der Maler Hieronymus Bosch*]

Albert Verwey, *Breughels Icarus* [Pieter Brueghel the Elder, *Landscape with the Fall of Icarus*]

Wystan Hugh Auden, *Musée des Beaux Arts* [Pieter Brueghel the Elder, *Landscape with the Fall of Icarus*]

Ronald Bottrall, *Icarus* [Pieter Brueghel the Elder, *Landscape with the Fall of Icarus*]

Michael Hamburger, *Lines on Breughel's Icarus* [Pieter Brueghel the Elder, *Landscape with the Fall of Icarus*]

Raïssa Maritain, *La Chute d'Icare (D'apres Breughel)* [Pieter Brueghel the Elder, *Landscape with the Fall of Icarus*]

Friedrich Bischoff, *Der Sturz des Ikarus (nach dem Gemälde von Pieter Breughel d. Ä.)* [Pieter Brueghel the Elder, *Landscape with the Fall of Icarus*]

Alexander Fhares, *Ikarus* [Pieter Brueghel the Elder, *Landscape with the Fall of Icarus*]

Calistrat Costin, *Breughel* [Pieter Brueghel the Elder, *Landscape with the Fall of Icarus*]

Rudolf Otto Wiemer, *Pieter Brueghel: Heimkehr der Herde* [Pieter Brueghel the Elder, *The Return of the Herd*]

Heinz Piontek, *Bruegelscher Oktober* [Pieter Brueghel the Elder, *The Return of the Herd*]

Rudolf Otto Wiemer, *Pieter Bruegel: Jäger in Schnee* [Pieter Brueghel the Elder, *The Hunters in the Snow*]

Sarah Kirsch, *Breughel-Bild* [Pieter Brueghel the Elder, *The Hunters in the Snow*]

Walter de la Mare, *Brueghel's Winter* [Pieter Brueghel the Elder, *The Hunters in the Snow*]

Josef Weinheber, *Die Blinden (Nach dem gleichnamigen Bilde von Pieter Brueghel d. Ä.)* [Pieter Brueghel the Elder, *The Parable of the Blind*]

Erich Lotz, *Breughel: Die Parabel von den Blinden* [Pieter Brueghel the Elder, *The Parable of the Blind*]

Walter Bauer, *Brueghel: Die Blinden* [Pieter Brueghel the Elder, *The Parable of the Blind*]

Carlo Carduna, *Breughels Blinde* [Pieter Brueghel the Elder, *The Parable of the Blind*]

Rafael Alberti, *Botticelli* [Sandro Botticelli, *The Birth of Venus*]

Herbert Budek, *Aphrodite* [Sandro Botticelli, *The Birth of Venus*]

Manuel Machado, *Sandro Botticelli: Der Frühling* [German trans. from the Spanish of *Sandro Botticelli (La Primavera)*]

Alex Gutteling, *Botticelli: Primavera* [Sandro Botticelli, *La Primavera*]

Dante Gabriel Rossetti, *For Spring by Sandro Botticelli* [Sandro Botticelli, *La Primavera*]

Bo Setterlind, *Auf Botticellis "Frühling"* [Sandro Botticelli, *La Primavera*]

Johannes Hübner, *San Girolamo von Carpaccio* [Vittore Carpaccio, *St. Jerome Leads the Lion to the Monastery*]

Edward Dowden, *Mona Lisa* [Leonardo da Vinci, *Mona Lisa*]

Walter Horatio Pater, *Mona Lisa* [Leonardo da Vinci, *Mona Lisa*]

Michael Field, *La Gioconda, by Leonardo da Vinci* [Leonardo da Vinci, *Mona Lisa*]

Jaroslav Vrchlický, *Mona Lisa* [Leonardo da Vinci, *Mona Lisa*]

Manuel Machado, *Die Gionconda*, German trans. from the Spanish [Leonardo da Vinci, *Mona Lisa*]

Gustav Fröding, *Mona Lisa* [Leonardo da Vinci, *Mona Lisa*]

Hermann Claudius, *Mona Lisa* [Leonardo da Vinci, *Mona Lisa*]

Thomas McGreevy, *Gioconda* [Leonardo da Vinci, *Mona Lisa*]

Cor Klinkenbijl, *Mona Lisa* [Leonardo da Vinci, *Mona Lisa*]

Zbigniew Herbert, *Mona Lisa* [Leonardo da Vinci, *Mona Lisa*]

Kurt Tucholsky, *Der Lächeln der Mona Lisa* [Leonardo da Vinci, *Mona Lisa*]

Birthe Arnback, *Mona Lisa* [Leonardo da Vinci, *Mona Lisa*]

Thorkild Bjørnvig, *Mona Lisa* [Leonardo da Vinci, *Mona Lisa*]

Jess Ørnsbo, *Mona Lisa* [Leonardo da Vinci, *Mona Lisa*]

Peter Spaan, *Da Vinci. La Gioconda* [Leonardo da Vinci, *Mona Lisa*]

Bruno Stephan Scherer, *Die Frau. Leonardo da Vinci: Mona Lisa* [Leonardo da Vinci, *Mona Lisa*]

Dante Gabriel Rossetti, *For a Venetian Pastoral by Giorgione* [*Concert Champêtre* or *Concert in the Open Air*, once ascribed to Giorgione but now thought to be by Titian]

Adolf Friedrich von Schack, *Ein Bild Giorgione* [*Concert Champêtre* or *Concert in the Open Air*, once ascribed to Giorgione but now thought to be by Titian]

Beat Brechbühl, *Giorgione: Das ländische Konzert* [*Concert Champêtre* or *Concert in the Open Air*, once ascribed to Giorgione but now thought to be by Titian]

Ronald Bottrall, *Galatea* [Raphael, *Triumph of Galatea*]

Gregorio Comanini, *Vertumnus* [Giuseppe Arcimboldi (Arcimboldo), *Rudolf II as Vertumnus*]

Kris Tanzberg, *bildnis rudolfs des zweiten* [Giuseppe Arcimboldi (Arcimboldo), *Rudolf II as Vertumnus*]

Hortensio Félix Paravicino y Arteaga, [*Auf das Portrait, das Greco vom ihm malte*] [El Greco, *Portrait of Fray Felix Hortensio Paravicino*]

Luis de Góngora y Argote, *inschrift für das Grab Dominico Grecos* [El Greco, *Portrait of Fray Felix Hortensio Paravicino*]

Franz Freiherr von Gaudy, *Die väterliche Ermahnung* [Gerard Terborch, *Die väterliche Ermahnung (The Fatherly Admonition)*]

Marcel Proust, *Antoine van Dyck* [Anton van Dyck, *Portrait of James Stuart, Duke of Lennox and Richmond*]

Manuel Machado, *Rembrandt, Die anatomische Vorlesung* [Rembrandt van Rijn, *The Anatomy Lesson*]

Stefan George, *König und Harfner* [Rembrandt van Rijn, *David spielt die Harfe vor Saul* (*David Playing the Harp before Saul*)]

Rainer Maria Rilke, *David singt vor Saul* [Rembrandt van Rijn, *David spielt die Harfe vor Saul* (*David Playing the Harp before Saul*)]

Herman Claudius, *Rembrandt, Gemälde im Haag* [Rembrandt van Rijn, *David spielt die Harfe vor Saul* (*David Playing the Harp before Saul*)]

Sophus Michaelis, *David spielt vor Saul* [Rembrandt van Rijn, *David spielt die Harfe vor Saul* (*David Playing the Harp before Saul*)]

Marcel Proust, *Albert Cuyp* [Albert Cuyp, *Der Ausritt* (*The Ride*)]

Théophile Gautier, *Sur le Prométhée du Musée da Madrid* [José de Ribera, *Tityos*]

James Kirkup, *A Picture by Claude* [Claude Lorrain, an amalgam from Lorrain's pictures in the National Gallery (London)]

Pierre-Jean Jouve, *Psyché Abandonnée Devant le Chateau d'Eros* [Claude Lorrain, *Landscape with Psyche outside the Palace of Cupid*]

Erik Knudsen, *Ordnung der Welt* [Francisco Goya, *The Third of May, 1808: The Execution of the Defenders of Madrid*]

Manuel Machado, *Goya, Die Erschießung der Aufständischen* [Francisco Goya, *The Third of May, 1808: The Execution of the Defenders of Madrid*]

Walter Bauer, ["Der zweite Mai"] [Francisco Goya, *The Third of May, 1808: The Execution of the Defenders of Madrid*]

James Elroy Flecker, *On Turner's Polyphenus* [J.M.W. Turner, *Ulysses Deriding Polyphemus*]

Johannes Bobrowski, *An Runge* [Philipp Otto Runge, *Self Portrait*]

Dagmar Nick, *Der Hafen von Greifswald* [Caspar David Friedrich, *Greifswalder Hafen* (*Greifswald Harbor*)]

Theodor Körner, *Friedrichs Totenlandschaft* [Caspar David Friedrich, *Abbey in Eishwald*]

René Char, *Courbet: Les Casseurs de Cailloux* [Gustave Courbet, *The Stonebreakers*]

Algernon Charles Swinburne, *A Landscape by Courbet* [Gustave Courbet, Unidentified painting]

Anna Pogonowska, *Vincent Van Gogh* [Vincent Van Gogh, *Crows over Cornfield* and other Van Gogh paintings]

Paul Celan, *Unter ein Bild von Vincent Van Gogh* [Vincent Van Gogh, *Crows over Cornfield*]

Albrecht Goes, *Landschaft der Selle* [Vincent Van Gogh, *Crows over Cornfield*]

D.M. Frank, *Sommer in Auvers* [Vincent Van Gogh, *Crows over Cornfield*]

Rudolf Peyer, *Kornfeld mit Raben: Dem Lezten Bild Van Goghs* [Vincent Van Gogh, *Crows over Cornfield*]

Margot Scharpenberg, *Munch* [Edvard Munch, *The Scream*]

Kris Tanzberg, *Ensors Masken* [James Ensor, *The Strange Masks*]

Antonio Ribeiro, *Jawlenskys letzte Bilder* [Alexej Jawlensky, *Meditationen*]

Lothar Klünner, *Femme au Corsage bleu* [Pablo Picasso, *Woman with Hat Seated in an Armchair*]

Friedrich Rasche, *Picasso-Mensch* [Pablo Picasso, portraits]

Jean Cocteau, *La Jeune Femme* and *Das Mädchen* [Pablo Picasso, paintings of girls]

Sarah Kirsch, *Chagall in Witebsk* [Marc Chagall, *The Revolution*]

Kurt Bartsch, *Die Revolutionsfeier* [Marc Chagall, *The Revolution*]

Paul Éluard, Paul, *Á Marc Chagall* [images from Chagall's paintings, some of which are on the right-hand side of *The Revolution*]

Kris Tanzberg, *Aufstand des Viadukts* [Paul Klee, *Revolution of the Viaducts*]

Peter Jokostra, *Unter einem Bilde Mirós* [Joan Miró, *People and Dog under Sun*]

Kurt Marti, *joan miró*

Wieland Schmied, *Erfahrungen mit Josef Albers*

Beat Brechbühl, *Salvador Dali: Die brennende Giraffe* [Salvador Dali, *Giraffe on Fire*]

Antonio Ribeiro, *Max Ernst* [Max Ernst, *The Last Forest*] (trans. into German by Kris Tanzberg)

2C. Emilie Buchwald and Ruth Roston, eds. *The Poet Dreaming in the Artist's House: Contemporary Poems about the Visual Arts.* Minneapolis: Milkweed Editions, 1984. An ekphrastic anthology that includes, among other things, these poems on painters and paintings:

Olga Cabral, *Picasso's Women* [Pablo Picasso, images of women from numerous paintings]

Anne Cherner, *To Mark Rothko of "Untitled (Blue, Green)," 1969*

Anne Cherner, *To Morris Louis of the "Blue Veil" 1958–9*

Anne Cherner, *To Helen Frankenthaler of "Circe," 1974*

Norbert Krapf, *Dürer's Piece of Turf* [Albrecht Dürer, *The Large Turf*]

Erika Mumford, *Woman Painter of Mithila* [Mithila (Bihar) wall decoration]

Frank Graziano, *The Potato Eaters* [Vincent Van Gogh, *The Potato Eaters*]

Edward Hirsch, *Matisse*

Tony Quagliano, *The Edward Hopper Retrospective* [Edward Hopper, *Four-Lane Road*]

Ruth Good, *Mountains and Other Outdoor Things* [paintings of Harvey Dinnerstein]

Edward Tick, *Kandinsky: "Improvisation No. 27"* [Wassily Kandinsky, *Improvisation No. 27 (Garden of Love)*]

Nick Johnson, *The Sleeping Gypsy* [Henri Rousseau, *The Sleeping Gypsy*]

Phyllis Janik, *Sleeping Peasants* [Pablo Picasso, *Sleeping Peasants*]

Constance Egemo, *The Great Wave off Kanagwa* [Katsushika Hokusai, *The Great Wave at Kamagawa*]

Olga Cabral, *Hokusai's Wave* [Katsushika Hokusai, *The Great Wave at Kamagawa*]

Maria Puziss, *Following Van Gogh (Avignon,1982)* [Vincent Van Gogh]

Judith Berke, *The Red Room* [Henri Matisse, *The Red Room (Harmony in Red)*]

Ruth Roston, *Two Windows by Magritte* [René Magritte, *The Postcard* and *The Golden Legend*]

Robin Magonan, *Pastoral* [Aristodemos Kaldis]

John Minczeski, *Another Sunset* [Alvaro Cardona-Hine]

Renee Wenger, *After Chagall* [Marc Chagall]

John Logan, *Three Poems on Morris Graves' Paintings* [Morris Graves, *Bird on a Rock*, *Spirit Bird*, and *Moor Swan*]

Norbert Krapf, *Rural Lines after Breughel* [Pieter Brueghel the Elder, *Hunters in the Snow*, *Harvesting Wheat* (*The Corn Harvest*), and *Gloomy Day*]

Ira Sadoff, *Nighthawks* [Edward Hopper, *Nighthawks*]

Ira Sadoff, *Seurat* [Georges Seurat, *Sunday Afternoon on the Island of La Grande Jatte*]

Joan Colby, *The Magician* [Marc Chagall, *The Magician*]

Joan Colby, *Equestrienne* [Marc Chagall, *The Equestrienne*]

Alice Fulton, *The Magistrate's Escape* [René Magritte, *La Golconde*]

Katha Pollitt, *Woman Asleep on a Banana Leaf* [from a Chinese painting]

Alice R. Friman, *Leda and the Swan* [Tintoretto, *Leda and the Swan*]

Roger Blakely, *Winslow Homer, Prisoners from the Front* [Winslow Homer, *Prisoners from the Front*]

Alvaro Cardona-Hine, *Geo-Politics* [Sebastiano del Piombo, *Cardinal Bandinello Saudi, His Secretary and Two Geographers*]

Criss E. Cannady, *In the Sitting Room of the Opera* [after a sketch by Edgar Degas]

Criss E. Cannady, *Sunlight in a Cafeteria* [Edward Hopper, *Sunlight in a Cafeteria*]

Olga Cabral, *Mother and Sister of the Artist* [Édouard Vuillard, *Mother and Sister of the Artist*]

Deborah Keenan, *Folds of a White Dress/Shaft of Light* [Peter Paul Rubens, *The Annunciation*]

Claude Clayton Smith, *The Kiss* [Edvard Munch, *The Kiss*]

Margot Kriel, *The Annunciation* [Leonardo da Vinci, *The Annunciation*]

Susan Donnelly, *Rilke Speaks of Angels* [unnamed painting by Lucas van Leyden]

John Minczeski, *Renaissance/a Triptych* [unnamed paintings of the Annunciation and Leda]

Denise Levertov, *The Postcards: A Triptych* [paintings of a Minoan Snake Goddess, Jean-Siméon Chardin's *Still Life with Plums*, and Mohammedan angels]

2D. Dannie and Joan Abse, eds. *Voices in the Gallery.* London: The Tate Gallery, 1986. Fifty-nine poems printed alongside color reproductions of the paintings they respond to. The book includes a section of "Correspondences," not catalogued below, where poet and painter dwell on similar themes.

W.H. Auden, *Musée des Beaux Arts* [Pieter Brueghel the Elder, *Landscape with the Fall of Icarus*]

Martyn Crucefix, *At the National Gallery* [Gerrit Honthorst, *Christ before the High Priest*]

Linda Pastan, *Fresco* [Masaccio, *The Expulsion from the Garden of Eden*]

U.A. Fanthorpe, *Not My Best Side* [Paolo Uccello, *St. George and the Dragon*]

Jon Manchip White, *The Rout of San Romano* [Paolo Uccello, *Rout of San Romano*]

Anne Ridler, *Backgrounds to Italian Paintings: 15th Century* [Piero della Francesca, *Triumph of Montefeltro*]

Ezra Pound, *The Picture* and *Of Jacopo del Sellaio* [Jacopo del Sellaio, *Venus Reclining*]

F.T. Prince, *Soldiers Bathing* [Michelangelo, *Battle of Cascina Cartoon*]

R.S. Thomas, *Threshold* [Michelangelo, *Creation of Adam*]

William Carlos Williams, *The Dance* [Pieter Brueghel the Elder, *Peasant Dance*]

Peter Porter, *Looking at a Melozzo da Forli* [Melozzo da Forli, *Annunciation*]

Thom Gunn, *In Santa Maria del Popola* [Caravaggio, *Conversion of St. Paul*]

Edward Lucie-Smith, *Rubens to Hélène Fourment* [Peter Paul Rubens, *La Pélisse*]

Theodore Weiss, *Ten Little Rembrandts* [Rembrandt van Rijn, *Scholar in His Study*, et al.]

Earle Birney, *El Greco: Espolio* [El Greco, *The Disrobing of Christ*]

Seamus Heaney, *Summer 1969* [Francisco Goya, *Panic*]

Stevie Smith, *Spanish School* [El Greco, Ribera, et al.]

Edward Lucie-Smith, *On Looking at Stubbs's "Anatomy of the Horse"* [George Stubbs, *Anatomy of the Horse*]

Daniel Hoffman, *Brotherly Love* [Benjamin West, *Penn's Treaty with the Indians*]

Gerda Mayer, *Sir Brooke Boothby* [Joseph Wright of Derby, *Sir Brooke Boothby*]

Jonathan Price, *"Experiment with an Air Pump" by Joseph Wright of Derby*

James Aitchison, *Uncertain Grace* [Sir Henry Raeburn, *Rev. Robert Walker Skating on Duddingstone Loch*]

D.J. Enright, *God Creating Adam* [William Blake, *Elohim Creating Adam*]

John Wain, *J.M.W. Turner: "The Shipwreck"*

B.C. Leale, *Sketch by Constable* [John Constable, *Willy Lott's House near Flatford Mill*]

James Harpur, *A Reproduction of Constable's "Salisbury Cathedral" in a Room on a Greek Island* [John Constable, *Salisbury Cathedral from the Bishop's Grounds*]

John Ash, *Peter Boy: Portrait of a Painting* [Henry Wallis, *Chatterton*]

John Ormond, *Certain Questions for Monsieur Renoir* [Auguste Renoir, *La Parisienne*]

D.J. Enright, *Home and Colonial* [Henri Rousseau, *Tropical Storm with a Tiger*]

Richard Wilbur, *Museum Piece* [Edgar Degas, *Two Dancers on the Stage*]

Robert Fagles, *Portrait of the Artist's Mother* [Vincent Van Gogh, *Portrait of the Artist's Mother*]

John Stallworthy, *Toulouse Lautrec at the Moulin Rouge* [Henri de Toulouse-Lautrec, *At the Moulin Rouge*]

Delmore Schwartz, *Seurat's Sunday Afternoon along the Seine* [George Seurat, *Sunday Afternoon on the "Ile de la Grande Jatte"*]

Lawrence Ferlinghetti, *Short Story on a Painting of Gustav Klimt* [Klimt, *The Kiss*]

Wallace Stevens, *The Man with the Blue Guitar* [Pablo Picasso, *The Old Guitarist*]

Tony Curtis, *Spring Fed* [Andrew Wyeth, *Spring Fed*]

Derek Mahon, *Girls on the Bridge* [Edvard Munch, *Girls on the Bridge*]

Irving Feldman, *Who Is Dora? What Is She?* [Pablo Picasso, *Dora Maar Seated*]

X.J. Kennedy, *Nude Descending a Staircase* [Marcel Duchamp, *Nude Descending a Staircase*]

Carol Ann Duffy, *Standing Female Nude* [Georges Braque, *Bather*]

Vicki Feaver, *Oi yoi yoi (to Roger Hilton about his painting in the Tate)* [Roger Hilton, *Oi yoi yoi*]

Michael Longley, *Man Lying on a Wall* [L.S. Lowry, *Man Lying on a Wall*]

Michael Hamburger, *A Painter Painted* [Lucien Freud, *Francis Bacon*]

Thomas Blackburn, *Francis Bacon* [Francis Bacon, *Study for Portrait on Folding Bed*]

Anna Adams, *Totes Meer — by Paul Nash, 1940–41* [Paul Nash, *Totes Meer (Dead Sea)*]

Gillian Clarke, *The Rothko Room* [Mark Rothko, *Red on Maroon* and other paintings]

W.S. Graham, *The Thermal Stair* [Peter Lanyon, *Thermal*]

Anthony Cronin, *Lines for a Painter* [Patrick Swift, *Tree in Camden Town*]

W.H. Davies, *The Bird of Paradise* [W.R. Sickert, *The Blackbird of Paradise*]

2E. Michael and Peter Benton. *Double Vision: Reading Paintings, Reading Poems, Reading Paintings*. London: Hodder & Stoughton, in association with The Tate Gallery, 1990. A collection of paired poems and paintings. In some, the poem and painter are the same (e.g., William Blake) and in a few, the painting is an illustrations of the poems. Most pairings, however, are the poetic responses to particular paintings, reproduced in color. These pairs are:

John Mole, *Entr'acte* [Pierre-Auguste Renoir, *The Box (La Loge)*]

Michael Longley, *Man Lying on a Wall* [L.S. Lowry, *Man Lying on a Wall*]

Paul Muldoon, *Paul Klee: "They're Biting"*

Grevel Lindrop, from *Vignettes: Poems for Twenty-One Wood Engravings by Thomas Bewick* [Thomas Bewick, *Roadmender*]

Roger McGough, *The Boyhood of Raleigh* [John Everett Millais, *The Boyhood of Raleigh*]

Anna Adams, *Jean Arnolfini and His Wife* [Jan Van Eyck, *The Arnolfini Marriage*]

Lawrence Ferlinghetti, *Short Story on a Painting of Gustav Klimt* [Gustav Klimt, *The Kiss*]

Garth Owen, *Siesta* [John Frederick Lewis, *The Siesta*]

Martyn Crucefix, *George and the Dragon* [Paolo Uccello, *St. George and the Dragon*]

U.A. Fanthorpe, *Not My Best Side* [Paolo Uccello, *St. George and the Dragon*]

Connie Rosen, *Andromeda* [Edward Burne-Jones, *The Rescue of Andromeda*]

Sylvia Kantaris, *Thank Heaven for Little Girls* [Thomas Gotch, *Alleluia*]

B.C. Leale, *Van Gogh, July 1890* [Vincent Van Gogh, *Wheatfield under Threatening Skies with Crows (Cornfield with Crows)*]

James O. Taylor, *Van Gogh, Cornfield with Crows*

Francis Barker, *Just Passing* [Vincent Van Gogh, *Cornfield with Crows*]

Colin Rowbotham, *The Artist, Arles 1890* [Vincent Van Gogh, *Cornfield with Crows*]

Phoebe Hesketh, *Vincent* [Vincent Van Gogh, *Cornfield with Crows* and *Landscape with Cypresses Near Arles*]

Phoebe Hesketh, *Letter to Vincent* [Vincent Van Gogh]

Anne Sexton, *Starry Night* [Vincent Van Gogh, *Starry Night*]

Charles Causley, *Samuel Palmer's "Coming from Evening Church"*

B.C. Leale, *Sketch by Constable* [John Constable, *Willy Lott's House Near Flatford Mill*]

U.A. Fanthorpe, *La Débâcle. Temps Gris* [Claude Monet, *Break-up of the Ice Near Lavacourt*]

John Ash, *Poor Boy: Portrait of a Painting* [Henry Wallis, *Chatterton*]

William Carlos Williams, *Children's Games* [Pieter Brueghel the Elder, *Children's Games*]

William Carlos Williams, *The Dance* [Pieter Brueghel the Elder, *Peasant Dance*]

Sylvia Plath, *In Brueghel's Panorama* [Pieter Brueghel the Elder, *The Triumph of Death*]

William Carlos Williams, *Landscape with the Fall of Icarus* [Pieter Brueghel the Elder, *Landscape with the Fall of Icarus*]

Joseph Langland, *Fall of Icarus: Brueghel* [Pieter Brueghel the Elder, *Landscape with the Fall of Icarus*]

W.H. Auden, *Musée des Beaux Arts* [Pieter Brueghel the Elder, *Landscape with the Fall of Icarus*]

Derek Mahon, *Girls on the Bridge* [Edvard Munch, *Girls on the Bridge*]

B.C. Leale, *The Scream* [Edvard Munch, *The Scream*]

Julie O'Callaghan, *Nighthawks* [Edward Hopper, *Nighthawks*]

Julie O'Callaghan, *Automat* [Edward Hopper, *Automat*]

Seamus Heaney, *Summer 1969* [Francisco Goya, *The Third of May 1808*, *Panic*, and *Two Strangers*]

Jenny Joseph, *A Chair in My House: After Gwen John* [Gwen John, *A Lady Reading*]

2F. Anton Korteweg and Annemarie Vels Heijn, ed. *Een engel zingend achter een pilaar: Gedichten over schilderijen = An Angel Singing behind a Pillar: Poems on Paintings*. The Hague, Sdu Uitgeverij, 1992. Contains more than one hundred twentieth-century poems inspired by the Dutch and Flemish masters of the fifteenth through the seventeenth centuries. Color reproductions are repeated in black-and-white.

Bertus Aafjes, *Altaarstuk naar Jan van Eyck* [Adam and Eve from the van Eyck altarpiece]

Bertus Aafjes, *Meester Frans* [Franz Hals, *The Governors of the Old Men's Almhouse at Haarlem*]

Bertus Aafjes, *Portret van Titus in het Louvre* [Rembrandt van Rijn, *Portrait of Titus*]

Bertus Aafjes, *Het Joodse Bruidje* [Rembrandt van Rijn, *Portrait of Isaac and Rebecca (The Jewish Bride)*]

Marc van Alstein, *Breugel, de jagers in de sneeuw* [Pieter Brueghel the Elder, *Hunters in the Snow*]

Robert Anker, *Landschap met de val van Icarus* [Pieter Brueghel the Elder, *Landscape with the Fall of Icarus*]

Robert Anker, *De thuiskomst van de jagers* [Pieter Brueghel the Elder, *Hunters in the Snow*]

Theo van Baaren, *De zwerver* [Hieronymus Bosch, *The Prodigal Son*]

Frans Babylon, *Rembrandt* [Rembrandt van Rijn, *Self-Portrait* 1667)]

Dirk van Bastelaere, *Jan van Eyck, de Arnolfini-bruiloft (1434)* [Jan van Eyck, *Arnolfini Wedding Portrait*]

Frans Bastiaanse, *Rembrandt spreekt:* [Rembrandt van Rijn, *Self-Portrait (1668)*]

J. Bernlef, *Riviergezicht met roeiboot* [Jan van Goyen, *View of the River*]

J. Bernlef, *Een ontmoeting met Pieter Saenredam* [Pieter Saenredam, *The St. Bavo Church in Haarlem*]

Rein Bloem, *Bosch* [Hieronymus Bosch, *The Conjuror*]

P.C. Boutens, *Meisje met dood vogeltje* [South Netherlands School, *Girl with a Dead Bird*]

P.C. Boutens, *Jonge Titus* [Rembrandt van Rijn, *Titus at His Desk*]

P.C. Boutens, *Zelfportret. Het atelier van Vermeer van Delft in de verzameling Czernin* [Johannes Vermeer, *Allegory of Painting (Het schildersatelier)*]

Lenze L. Bouwers, *"hun viermaster, bonkig schip van geweld"* [Hendrick Vroom, *De Amsterdamse viermaster "De Hollandse Tuyn" en andere schepen*]

Lenze L. Bouwers, *"jij bent m'bruidegom, ik ben je bruid"* [Rembrandt van Rijn, *Portrait of Isaac and Rebecca (The Jewish Bride)*]

Lenze L. Bouwers, *"koortsoogjes van dit lieve, bleke kind"* [Gabriël Metsy, *The Sick Child*]

Lenze L. Bouwers, *"rood, wit, blauw, geel: Een Meyd die melk uytgiet"* [Johannes Vermeer, *The Milkmaid*]

Lenze L. Bouwers, *"die kleine jongen op dat schilderij"* [Adriaen Backer, *Regentesses of the Civic Orphanage in Amsterdam*]

Gerard den Brabander, *De anatomische les* [Rembrandt van Rijn, *The Anatomy Lesson of Dr. Joan Deyman* and *The Anatomy Lesson of Dr. Nicolaes Tulp*]

Henri Bruning, *Claudius Civilis* [Rembrandt van Rijn, *The Conspiracy of Claudius Civilis*]

Dirk Christiaens, *Dulle Griet* [Pieter Brueghel the Elder, *Mad Meg*]

Hugo Claus, *Visio Tondalis* [Hieronymus Bosch, *The Vision of Tondalus*]

Hugo Claus, *In het museum van Chicago* [Joachim Patinier, *Saint Hieronymus*]

Hugo Claus, *Het land (Egyptisch)* [Pieter Brueghel the Elder, *The Numbering at Bethlehem* and *The Massacre of the Innocents*]

Hugo Claus, *Rembrandt van Rijn* [*Sophonisba Receiving the Poisoned Cup* and *Rembrandt and Saskia*]

Pierre H. Dubois, *Meisjesportret* [Petrus Christus, *A Young Lady*]

Pierre H. Dubois, *Rembrandt* [Rembrandt van Rijn, *Self-Portrait* (1669)]

Jan Eijkelboom, *Pieter de Roovere als ambachtsheer van Hardinxveld* [Aelbert Cuyp, *Portrait of Pieter de Roovere as Lord of the Manor of Hardinxveld*]

Remco Ekkers, "*Gewandeld in het landschap*" [Paulus Potter, *The Young Steer*]

J.A. Emmens, *Meesterwerk* [Rembrandt van Rijn, *David Playing the Harp before Saul*]

Jan Engelman, *Lezende Titus* [Rembrandt van Rijn, *Titus Reading*]

Eddy Evenhuis, *Rembrandt en Saskia* [Rembrandt van Rijn, *The Prodigal Son in the Tavern (Rembrandt and Saskia)*]

Hans Faverey, "*De boom als larix*" (uit de reeks "*Hommage à Hercules Seghers*") [Hercules Seghers, various drawings]

Hans Faverey, *Adriaen Coorte* [Adriaen Coorte, *Exotic Birds, Three Medlars with a Butterfly, Still Life with Hopvogel, Still Life with Shells, Still Life with Strawberries in a Wan Li-kom*]

Koos Geerds, "*Winterlandschap van Hendrick Avercamp*" [Hendrick Avercamp, *Skating Scene Near a City*]

Ida G.M. Gerhardt, *Het weerzien* [Salamon van Ruysdael, *Ferry on a River*]

Ida G.M. Gerhardt, *Christus als hovenier* [Rembrandt van Rijn, *Christ Appearing to Mary Magdalene*]

Ida G.M. Gerhardt, *Confrontatie* [Jan Asselijn, *The Threatened Swan*]

Habakuk II de Balker, *Roggeveld geschilderd door Breughel* [Pieter Brueghel the Elder, *The Corn Harvest*]

Habakuk II de Balker, *Het landschap met de sparretak (Hercules Seghers)* [Hercules Seghers, *Landschap met sparretak*]

Jacques Hamelink, *Hercules Seghers* [Hercules Seghers, *Rocky Landscape with Stroller*]

Pé Hawinkels, "*De bruiloft van Kana*" [Hieronymus Bosch, *The Marriage Feast at Cana*]

Pé Hawinkels, "*De thuiskomst van de jagers*" [Pieter Brueghel the Elder, *Hunters in the Snow*]

Pé Hawinkels, "*De korenoogst*" [Pieter Brueghel the Elder, *The Corn Harvest*]

F.W. van Heerikhuizen, *Het Meisje op Vermeer's Ate-lier* [Johannes Vermeer, *Allegory of Painting (Het schildersatelier)*]

Judith Herzberg, *De boer* [Pieter Brueghel the Elder, *Landscape with the Fall of Icarus*]

Judith Herzberg, *De zeeman* [Pieter Brueghel the Elder, *Landscape with the Fall of Icarus*]

Judith Herzberg, *De visser* [Pieter Brueghel the Elder, *Landscape with the Fall of Icarus*]

C.O. Jellema, *Fyt fecit* [Jan Fyt, *Still Life with Hare, Fruit, and Parrot*]

C.O. Jellema, *De kettinghond* [Paulus Potter, *Dog on a Chain*]

C.O. Jellema, *Van Hoogstraten. Zelfportret* [Samuel van Hoogstraten, *Self-Portrait*]

C.O. Jellema, *Reflecties op Ruysdael* [Jacob van Ruisdael, *View of Haarlem with the Bleaching Fields, Country House in a Park, An Oak beside a Fen, Deer Hunt in a Swampy Forest, The Jewish Cemetery, Bentheim Castle*, and *The Ray of Sunlight*]

Martien J.G. de Jong, *Capodimonte* [Pieter Brueghel the Elder, *The Parable of the Blind*]

Roland Jooris, *Breughel* [Pieter Brueghel the Elder, *Hunters in the Snow*]

Jan Kal, *De val van Icarus* [Pieter Brueghel the Elder, *Landscape with the Fall of Icarus*]

Pierre Kemp, *Het Rood van't Joodse Bruidje* [Rembrandt van Rijn, *Portrait of Isaac and Rebecca (The Jewish Bride)*]

Rutger Kopland, "*Winter van Breughel, de heuvel met de jagers*" [Pieter Brueghel the Elder, *Hunters in the Snow*]

Wiel Kusters, *Bruegel: Dulle Griet* [Pieter Brueghel the Elder, *Mad Meg*]

Ed Leeflang, *Als Paulus* [Rembrandt van Rijn, *Self-Portrait as the Apostle Paul*]

Ed Leeflang, *Adriaen Coorte* [Adriaen Coorte, *Still Life with Asparagus, Gooseberries, and Strawberries*]

Sipko Melissen, *A 123* [Jan Van Goyen, *Landscape with Two Oaks*]

Sipko Melissen, *Gezicht over de Amstel* [Rembrandt van Rijn, *View over the Amstel*]

Sipko Melissen, *Gezicht op Sloten* [Rembrandt van Rijn, *View of Sloten*]

Sipko Melissen, *Pieter de Hooch* [Pieter de Hooch, *A Courtyard in Delft: A Woman Spinning (Twee vrouwen op een binnenplaats)*]

Willem de Mérode, *Madonna van Quinten Metsijs* [Quinten Massijs, *The Virgin at Prayer*]

Willem de Mérode, *Dullaert* [Philips Koninck, *Portrait of Heiman Dullaert*]

J.J.A. Mooij, *De watermolen* [Meindert Hobbema, *A Watermill*]

Huub Oosterhuis, *Val van Icarus* [Pieter Brueghel the Elder, *Landscape with the Fall of Icarus*]

Drs. P [pseudonym for H.H. Polzer], *Het melkmeisje* [Johannes Vermeer, *The Milkmaid*]

E. du Perron, *Adriana de Buuck* and *Reprise (na 6 jaar)* [Pieter Pourbus, *Portrait of Jacquemijne Buuck*]

A. Roland Holst, *De prins weergekeerd* [Anthonie Mor van Dashorst, *Portrait of William of Orange*]

J.W. Schulte Nordholt, *Marchesa Balbi* [Anthony van Dyck, *Portrait of Marchesa Balbi*]

J.W. Schulte Nordholt, *Rembrandt* [Rembrandt van Rijn, *Hendrickje in Bed*]

J.W. Schulte Nordholt, *Bathseba* [Rembrandt van Rijn, *Bathsheba Reading King David's Letter*]

Willy Spillebeen, "*Geen ploeg staat stil*" [Pieter Brueghel the Elder, *Landscape with the Fall of Icarus*]

Erik Spinoy, *De jagers in de sneeuw* [Pieter Brueghel the Elder, *Hunters in the Snow*]

F.C. Terborgh, *Vaart over den Styx* [Joachim Patinier, *Landscape with Charon Crossing the Styx*]

Willem van Toorn, *Vermeer: Gezicht op Delft* [Johannes Vermeer, *View of Delft*]

Ferdinand Vercnocke, *Bij Rembrandts "Man met de helm"* [Disciple of Rembrandt van Rijn, *Man with the Golden Helmet*]

Albert Verwey, *Breughels Ikarus* [Pieter Brueghel the Elder, *Landscape with the Fall of Icarus*]

Albert Verwey, *Rembrandt* [Rembrandt van Rijn, *Portrait of a Family with Three Children*]

Albert Verwey, *Delfse Vermeer, ziende naar Delft zoals hij het zal schilderen* [Johannes Vermeer, *View of Delft*]

Albert Verwey, *Op een afbeelding van Vermeer's vrouweportret* [Johannes Vermeer, *Girl with a Pearl Earring*]

Simon Vestdijk, *Vrouwenportret* [Maerten van Heemskerck, *Portrait of a Woman*]

Simon Vestdijk, *Blinden* [Pieter Brueghel the Elder, *The Parable of the Blind*]

Simon Vestdijk, *Laatste oordeel* [Peter Paul Rubens, *The Last Judgment*]

Simon Vestdijk, *De boer en de sater* [Jacob Jordaens, *Satyr and Peasant*]

Simon Vestdijk, *Rembrandt en Saskia* [Rembrandt van Rijn, *Rembrandt and Saskia*]

Simon Vestdijk, *De oprichting van het kruis* [Rembrandt van Rijn, *The Raising of the Cross*]

Simon Vestdijk, *Bathseba bij het toilet* [Rembrandt van Rijn, *Bathsheba Reading King David's Letter*]

Simon Vestdijk, *Lezende Titus* [Rembrandt van Rijn, *Titus Reading*]

Simon Vestdijk, *Saul en David* [Rembrandt van Rijn, *David Playing the Harp before Saul*]

Simon Vestdijk, *De miskende Phoenix* [Rembrandt van Rijn, *Phoenix*]

Simon Vestdijk, *Zelfportret* [Rembrandt van Rijn, *Self-Portrait* (1668)]

Simon Vestdijk, *Hetjoodse bruidje* [Rembrandt van Rijn, *Portrait of Isaac and Rebecca* (*The Jewish Bride*)]

Rien Vroegindeweij, *Straat* [Meindert Hobbema, *The Avenue at Middelharnis*]

Anton van Wilderode, *Passie volgens Rubens*
 Boom en braamstruik [Peter Paul Rubens, *Tree and Blackberry Bush*]
 Kroning Christi [Peter Paul Rubens, *The Derision of Christ*]
 De Kruisdraging [Peter Paul Rubens, *The Bearing of the Cross*]
 De oprichting van het kruis [Peter Paul Rubens, *The Elevation of the Cross*]
 De Kruisiging [Peter Paul Rubens, *The Crucifixion*]
 De lanssteek [Peter Paul Rubens, *Christ on the Cross* or *The Lance Cross*]
 De kruisafneming [Peter Paul Rubens, *The Descent from the Cross*]
 Bewening Christi [Peter Paul Rubens, *The Lamentation of Christ* (1601) and *The Lamentation of Christ by John the Evangelist and the Holy Women* (1614)]

Anton van Wilderode, *Kopie naar Rubens* [pencil drawing after Rubens of the *Lamentation of Christ*]

2G. Michael Benton and Peter Benton. *Painting with Words*. London: Hodder & Stoughton, 1995. A companion volume to the Bentons' *Double Vision* (2E). Poems inspired by paintings (reproducerd in color) and paintings inspired by poems are shown side by side. The former are:

Anna Adams, *Boulogne Sands* [Philip Wilson Steer, *Boulogne Sands*]

John Loveday, *The Bowl of Milk* [Pierre Bonnard, *The Bowl of Milk*]

Julie O'Callaghan, *Dancer* [Edgar Degas, *Ballet Rehearsal* and *Dancer Tying Her Shoe Ribbon*]

Julie O'Callaghan, *Spring* [Giuseppe Arcimbolo, *Spring*]

Julie O'Callaghan, *Winter* [Giuseppe Arcimbolo, *Winter*]

Valerie Bird, *Looking Back* [L.S. Lowry, *A Fight*]

Valerie Bird, *Faux Pas* [Atkinson Grimshaw, *Liverpool Docks by Midnight*]

Alfred Noyes, *The Highwayman* [Charles Keeping, "*The Highwayman*" illustrations]

Nick Dunning, *From a Picture by Bridget Riley* [Bridget Riley, *Study for Cataract, 1967*]

Peter Benton, *Waterfall* [M.C. Escher, *Waterfall*]

R.S. Thomas, *Father and Child: Ben Shahn* [Ben Shahn, *Father and Child*]

Connie Bensley, *The Badminton Game* [David Inshaw, *The Badminton Game*]

Heather Harvey, *The Badminton Game* [David Inshaw, *The Badminton Game*]

Wendy Cope, *The Uncertainty of the Poet* [Giorgio de Chirico, *The Uncertainty of the Poet*]

Hannah Holland, *The Paintbrush* [Giorgio de Chirico, *The Uncertainty of the Poet*]

Moniza Alvi, *I Would Like to be a Dot in a Painting by Miro* [Joan Miró, *Mural, March 20, 1961*]

R.S. Thomas, *Woman Combing* [Edgar Degas, *Woman Combing Her Hair*]

Peter Benton, *To My Daughter* [Jan Vermeer, *Head of a Girl*]

Sylvia Kantaris, *Gwen John's Cat* [Gwen John, *Young Woman Holding a Black Cat*]

Michael Benton, *Suzon* [Édouard Manet, *A Bar at the Folies-Bergère*]

Michael Benton, *In Limbo* [Édouard Manet, *A Bar at the Folies-Bergère*]

Carole Satyamurti, *The Balcony: After Manet* [Édouard Manet, *The Balcony*]

Peter Benton, *Alice at 70* [Sir John Everett Millais, *Autumn Leaves*]

R.S. Thomas, *Veneziano: The Annunciation* [Domenico Veneziano, *The Annunciation*]

Carol Ann Duffy, *The Virgin Punishing the Infant* [Max Ernst, *The Blessed Virgin Chastises the Infant Jesus before Three Witnesses*]

William Carloes Williams, *The Hunters in the Snow* [Pieter Brueghel the Elder, *The Return of the Hunters*]

John Berryman, *Winter Landscape,* [Pieter Brueghel the Elder, *The Return of the Hunters*]

Anne Stevenson, *Brueghel's Snow* [Pieter Brueghel the Elder, *The Return of the Hunters*]

2H. Michael Benton and Peter Benton. *Picture Poems.* London: Hodder & Stoughton, 1995. Each of the poems in this children's collection was written in response to a famous painting, reproduced in color.

Alan Brownjohn, *The Twins* [British School, 17th Century, *The Cholmondeley Sisters*]

Beverley Nadoo, *Big Woman's Talk* [Sonia Boyce, *Big Woman's Talk*]

Olusola Oyeleye, *Big Woman's Talk* [Sonia Boyce, *Big Woman's Talk*]

Garth Owen, *Icarus by Mobile* [Pieter Brueghel the Elder, *Landscape with the Fall of Icarus*]

Dannie Abse, *Brueghel in Naples* [Pieter Brueghel the Elder, *Landscape with the Fall of Icarus*]

Heather Harvey, *Narcissus — a sonnet* [Salvador Dali, *Metamorphosis of Narcissus*]

Moniza Alvi, *Only Dali, or the Gods* [Salvador Dali, *Metamorphosis of Narcissus*]

James Berry, *"Fin d'Arabesque" by Edgar Degas*

Heather Harvey, *Fin d'Arabesque* [Edgar Degas, *Fin d'Arabesque*]

U.A. Fanthorpe, *Look, no hands* [Edgar Degas, *Lola at the Fernando Circus*]

U.A. Fanthorpe, *Woman Ironing* [Edgar Degas, *La Repasseuse (Woman Ironing)*]

Heather Harvey, *Drawing Hands — a Pantoum* [M.C. Escher, *Drawing Hands*]

Colin Rowbotham, *Vace/Faces* [Anon., *Vase/Faces*]

Vicki Feaver, *The Avenue* [Meindert Hobbema, *The Avenue at Middelharnis*]

Anna Adams, *Perspective is Bunk* [Meindert Hobbema, *The Avenue at Middelharnis*]

Anna Adams, *The Mysteries of Perspective* [Meindert Hobbema, *The Avenue at Middelharnis*]

Valerie Bird, *Captive Flesh* [William Hogarth, *The Graham Children*]

Gillian Clarke, *The Artist's Room* [Gwen John, *A Corner of the Artist's Room, Paris*]

James Berry, *A Corner of the Artist's Room, Paris* [Gwen John, *A Corner of the Artist's Room, Paris*]

Moniza Alvi, *Swinging* [Wassily Kandinsky, *Swinging*]

Heather Harvey, *A Round — with Colours* [Wassily Kandinsky, *Swinging*]

Heather Harvey, *Time Transfixed* [René Magritte, *Time Transfixed*]

Carol Ann Duffy, *"Time Transfixed" by René Magritte*

Carol Satyamurti, *Leaving Present* [René Magritte, *Time Transfixed*]

Peter Benton, *Time — Gentle Men* [René Magritte, *Golconda*]

Phoebe Hesketh, *Printemps* [Claude Monet, *Spring Landscape*]

Gregory Harrison, *Child with Dove* [Pablo Picasso, *Child With Dove*]

Valerie Bird, *The Three Musicians* [Pablo Picasso, *The Three Musicians*]

John Mole, *Olé* [Pablo Picasso, *The Three Musicians*]

Anna Adams, *To Titus, Rembrandt's Son* [Rembrandt van Rijn, *Portrait of Titus*]

Charles Causley, *Stanley Spencer's "A Village in Heaven"*

Peggy Poole, *Polishing Pans* [Marianne Stokes, *Polishing Pans*]

Michael Benton, *Alfred Wallace Day-Dreams in the Bath* [Alfred Wallace, *Penzance Harbour*]

Wes Magee, *The Harbour Wall* [Alfred Wallace, *Penzance Harbour*]

Peter Benton, *Perspectives* [Paolo Uccello, *A Hunt in a Forest*]

Carole Satyamurti, *Best Friends* [James Abbott McNeill Whistler, *Miss Cicely Alexander: Harmony in Gray and Green*]

Heather Harvey, *Miss Cicely Alexander* [James Abbott McNeill Whistler, *Miss Cicely Alexander: Harmony in Gray and Green*]

Sylvia Kantaris, *Growing Pains* [James Abbott McNeill Whistler, *Miss Cicely Alexander: Harmony in Gray and Green*]

Anna Adams, *"Prince Baltasar Carlos in Silver,"* by Velasquez, and *"Miss Cicely Alexander,"* by Whistler

Michael Benton, *Experiment with an Air Pump* [Joseph Wright of Derby, *An Experiment on a Bird in the Air Pump*]

2I. John Hollander. *The Gazer's Spirit: Poems Speaking to Silent Works of Art.* Chicago: University of Chicago Press, 1995. Contains more than fifty poems side by side with works of art, along with Hollander's commentaries. The poem on paintings:

Pietro Aretino, *Sonnet* [Titian, *Portrait of Francesco Maria della Rovere, Duke of Urbino*]

Allen Tate, *Sonnet* [William Lescaze, *Portrait of Hart Crane*]

Richard Howard, *Nadar* [Adrien Tournachon, *Portrait of Nadar*]

Ben Jonson, *The Mind of the Frontispiece to a Book* [Renold Elstrack, *Engraved Title Page of Sir Walter Ralegh's History of the World*]

Richard Lovelace, *To My Worthy Friend Mr. Peter Lilly* [Sir Peter Lely, *Charles I and the Duke of York*]

William Wordsworth, *Elegiac Stanzas* [Sir George Beaumont, *Piel Castle in a Storm*]

Washington Allston, *On the Group of the Three Angels Before the Tent of Abraham, by Rafaelle, in the Vatican* [Raphael, *Abraham and the Angels*]

Percy Bysshe Shelley, *On the Medusa of Leonardo da Vinci in the Florentine Gallery* [Anon., *The Head of Medusa* (no longer attributed to Leonardo)]

Joseph Rodman Drake, *The National Painting* [John Trumbull, *The Declaration of Independence*]

Dante Gabriel Rossetti, *For Our Lady of the Rocks* [Leonardo da Vinci, *Virgin of the Rocks*]

Dante Gabriel Rossetti, *For a Venetian Pastoral* [Titian, *Concert Champêtre*]

Ford Madox Brown, *The Last of England* [Ford Madox Brown, *The Last of England*]

Charles Baudelaire, *Gypsies on the Move* [Jacques Callot, *Les Bohémiens*]

Algernon Charles Swinburne, *Before the Mirror* [J.A.M. Whistler, *Symphony in White no. 1: The Little White Girl*]

Herman Melville, *The Temeraire* [J.M.W. Turner, *The Fighting Téméraire*]

James Thomson (B.V.), From *The City of Dreadful Night* [Albrecht Dürer, *Melencolia*]

Dante Gabriel Rossetti, *For Spring, by Sandro Botticelli* [Sandro Botticelli, *Primavera*]

Walt Whitman, *Death's Valley* [George Inness, *The Valley of the Shadow of Death*]

Edwin Markham, *The Man with the Hoe* [J.B. Millet, *L'Homme à la houe*]

Edith Wharton, *Mona Lisa* [Leonardo da Vinci, *Mona Lisa*]

Robert Bridges, from *The Testament of Beauty*, Book III [Titian, *Sacred and Profane Love*]

Walter de la Mare, *Brueghel's Winter* [Pieter Brueghel the Elder, *The Hunters in the Snow*]

W H. Auden, *Musée des Beaux Arts* [Pieter Brueghel the Elder, *Landscape with the Fall of Icarus*]

Randall Jarrell, *The Knight, Death, and the Devil* [Albrecht Dürer, *The Knight, Death, and the Devil*]

Anthony Hecht, *At the Frick* [Giovanni Bellini, *St. Francis in Ecstasy*]

Robert Conquest, *The Rokeby Venus* [Velázquez, *The Rokeby Venus*]

W.S. Merwin, *Voyage to Labrador* [Alfred Wallis, *Voyage to Labrador*]

Donald Hall, *The Scream* [Edvard Munch, *The Scream*]

Irving Feldman, *"Se Aprovechan"* [Francisco Jose Goya y Lucientes, *Caprichos*, no. 16]

Marianne Moore, *Charity Overcoming Envy* [Anon., *Tapestry*, 15th century]

W. D. Snodgrass, *Matisse: "The Red Studio"* [Henri Matisse, *The Red Studio*]

Daryl Hine, *Untitled* [Roger van der Weyden, *Calvary*]

Richard Howard, *Giovanni da Fiesole on the Sublime, or Fra Angelico's "Last Judgment"* [Fra Angelico, *Last Judgment*]

J.D. McClatchy, *A Capriccio of Roman Ruins and Sculpture with Figures* [Giovanni Paolo Panini, *Capriccio of Roman Ruins and Sculpture with Figures*]

David Ferry, *Cythera* [Jean-Antoine Watteau, *Le Pélerinage a l'isle de Cythère*]

Vicki Hearne, *Gauguin's White Horse* [Paul Gauguin, *Le Cheval blanc*]

Rosanna Warren, *Renoir* [Pierre-Auguste Renoir, *Luncheon of the Boating Party*]

Rachel Hadas, *Mars and Venus* [Sandro Botticelli, *Mars and Venus*]

John Hollander, *Effet de Neige* [Claude Monet, *Le Route de la ferme St.-Siméon*]

2J. Jan Greenberg, ed. *Heart to Heart: New Poems Inspired by Twentieth-Century American Art.* New York: Abrams, 2001. Commissioned works by American poets on twentieth-century American art. Color reproductions.

Dave Etter, *Down by the Riverside* [Thomas Hart Benton, *Down by the Riverside*]

William Jay Smith, *Woman at the Piano* [Elie Nadelman, *Woman at the Piano*]

Deborah Chandra, *The Peacock* [Joseph Stella, *The Peacock*]

Carol Boston Weatherford, *The Brown Bomber*

[William H. Johnson, *Joe Louis and Unidentified Boxer*]

Jacinto Jesús Cardona, *Bato Con Khakis* [César A. Martinez, *Bato Con Khakis*]

Dan Masterson, *Early Sunday Morning* [Edward Hopper, *Early Sunday Morning*]

Siv Cedering, *Sit a While* [Romare Bearden, *Black Manhattan*]

X.J. Kennedy, *Stuart Davis: Premier, 1957* [Stuart Davis, *Premier, 1957*]

Gary Gildner, *A Word* [Arthur Dove, *That Red One*]

Ron Koertge, *Ringside* [George Bellows, *Stag at Sharkey's*]

Angela Johnson, *From Above* [Faith Ringgold, *Tar Beach*]

David Mura, *Fresh from the Island Angel* [Pacita Abad, *How Mali Lost Her Accent*]

David Harrision, *It's Me* [Andy Warhol, *Marilyn Diptych*]

Peter Neumeyer, *America Talks* [Jacob Lawrence, *Barber Shop*]

Joy Harjo, *Naming, Or, There is no such things as an Indian* [Jaune Quick-to-See Smith, *Indian, Indio, Indigenous*]

Laura Kasischke, *Red Hills and Bones* [Georgia O'Keeffe, *Red Hills and Bones*]

Brenda Seabrooke, *On a Windy Wash Day Morn* [Grandma Moses, *Wash Day*]

Jane Yolen, *Grant Wood: American Gothic* [Grant Wood, *American Gothic*]

Constance Levy, *Madinat as Salam* [Frank Stella, *Madinat as Salam III*]

Kristine O'Connell George, *Pantoum for These Eyes* [Kiki Smith, *Untitled (Fluttering Eyes)*]

Marvin Bell, *Big French Bread* [Red Grooms, *French Bread*]

Janine Pommy Vega, *The Poppy of Georgia O'Keeffe* [Georgia O'Keeffe, *Poppy*]

Jan Greenberg, *Diamante for Chuck* [Chuck Close, *Self-Portrait*]

J. Patrick Lewis, *Map* [Jasper Johns, *Map*]

Bobbi Katz, *Lessons from a Painting by Rothko* [Mark Rothko, *Untitled*, 1960]

Deborah Pope, *On Lichtenstein's "Bananas and Grapefruit"* [Roy Lichtenstein, *Bananas and Grapefruit #3*]

Stephen Corey, *The Painting Comes Home* [Charles Burchfield, *Six O'Clock*]

Warren Woessner, *River Song* [Joseph Stella, *Brooklyn Bridge: Variation on an Old Theme*]

Jane O. Wayne, *Girl Writing* [Milton Avery, *Girl Writing*]

Sandy Asher, *Pas des Trois* [Jackson Pollock, *Number 27*]

David Clewell, *Man Ray Stares into the Future of Jazz: 1919* [Man Ray, *Jazz*]

Donald Finkel, *More Light* [Edward Hopper, *Nighthawks*]

Hettie Jones, *Ladies and Gentlemen, Step Right Up, The Drawer is Open!* [Elizabeth Murray, *Open Drawer*]

Naomi Shihab Nye, *The World, Starring You* [Florine Stettheimer, *The Cathedrals of Broadway*]

2K. Vladimir Martinovski, ed. *Ut Pictura Poesis: Poetry in Dialogue with the Plastic Arts: A Thematic Selection of Contemporary Macedonian Poetry.* Trans. Zoran Ancíevski. [Struga, Macedonia]: Struga Poetry Evenings, 2006. Contains 130 poems on the dialogue between contemporary Macedonian poetry and the plastic arts. The volume includes poems on sculptures, frescoes, paintings, various representations of the St. George myth, and artists. The poems on paintings and painters:

Blazíe Koneski, *A Visit to a Museum* [Claude Monet, *Red Lines*, Pablo Picasso, *Guernica*]

Slavko Janevski, *The Sower* [El Greco, *The Parable of the Sower*]

Slavko Janevski, *A Procession in Yellow* [Vincent Van Gogh, *The Sunflowers*]

Slavko Janevski, *Customs Office* [Henri Rousseau]

Slavko Janevski, *Flamenco* [Pablo Picasso]

Slavko Janevski, *Wedding* [Marc Chagall]

Slavko Janevski, *Flocks* [Joan Miró]

Vlada Uroševiḱ, *Hieronymus Bosch*

Vlada Uroševiḱ, *Pieter Bruegel*

Vlada Uroševiḱ, *Vincent van Gogh*

Vlada Uroševiḱ, *Marc Chagall*

Vlada Uroševiḱ, *Hieronymus Bosch: "The Garden of Earthly Delights"*

Ante Popovski, *The Yellow Christ* [Paul Gauguin, *The Yellow Christ*]

Radovan Pavlovski, *The Hymn of the Colours* [Vincent Van Gogh]

Radovan Pavlovski, *A Cornfield with Ravens* [Vincent Van Gogh, *Wheat Field with Ravens*]

Katica Kúlavkova, *The Holy Family* [Visions from the paintings of the Italian masters from the seventeenth century]

Vera Čejkovska, *Bosch*

Vera Čejkovska, *The Garden of Earthly Delights* [Hieronymus Bosch, *The Garden of Earthly Delights*]

Nehas Sopaj, *(The Flying Dutchman)*

Petko Dabeski, *The Words of the Etching and the Pelerine*

Svetlana Hristova-Jociḱ, *The Fire and the Square* [Albrecht Dürer, magic square in *Melancholia*]

Nuhi Vinca, *Standing before the Painting "Cradle" by K K*

Razme Kumbaroski, *The Magic Seeker* [Max Ernst]

Vele Smilevski, *Kandinsky's Advice* [Wassily Kandinsky]

Vele Smilevski, *The Anti-Portrait Poem* [René Magritte, *Edward James in Front of "On the Threshold of Liberty"*]

Ivan Dźieparoski, *A Knight, Death and the Devil* [Albrecht Dürer, *Knight, Death, and the Devil*]

Ivan Dźieparoski, *A Starry Night* [Vincent Van Gogh, *Starry Night*]

Ivan Dźieparoski, *The Red Concert* [Raoul Dufy, *Red Concert*]

Bratislav Taškovski, *Having My Photo Taken in front of a Painting by Van Gogh*

Bratislav Taškovski, *The Matador* [Picasso]

Ivica Anteski, *Bright Balls* [Vincent Van Gogh, *Starry Night*]

Nuhi Vinca, * * * [Leonardo Da Vinci, *Mona Lisa*]

Sadije Haliti, *Mona Lisa* [Leonardo Da Vinci, *Mona Lisa*]

Jusuf Sulejman, *On the Wharf of Cubism*

Petre M. Andreevski, *The Handsome Goat* [Dimitar Manev, *Woman and Goat*]

Petre Bakevski, *Between Illusion and Reality—the Lake of Vangel Naumovski* [Vangel Naumovski]

Risto Vasilevski, *The Sight, the Beginning* [Gligor Čemerski, *Waking of the Stone*]

Slave Ġorġo Dimoski, *Blue and Dark* [Vangel Naumovski, *Polar Galaxy*]

Bogomil Ġuzel, *Homer* [Vlado Georgievski, watercolor]

Slavko Janevski, *The Clown* [Spase Kunoski]

Eftim Kletnikov, *The Prayer at the Mount of Olives* [Vladimir Georgievski, *The Prayer at the Mount of Olives*]

Blazíe Koneski, *Guté's Burial* [unidentified painter and painting]

Vahit Nasufi, *What Do You Say Omer Kaleshi* [Omer Kaleshi]

Radije Hoxha-Dija, *The Drama of Omer Kaleshi* [Omer Kaleshi]

Trajan Petrovski, *The Old Olive Tree* [Vasko Taškovski]

Mihail Rendžov, *Dandelion* [Tanas Lulovski]

Abdulazis Islami, *Lily of the Valley* [Bajram Salihu]

Numan Limani, *A Belated Question* [Gouri Madhit]

Gane Todorovski, *The Rebellion of Colours* [Petar Mazev]

Todor Čalovski, *Explosion of Colours* [Gligor Čemerski]

Aco Šopov, *Beauty* [Lazar Lićenovski]

2L. Charlotte Maurisson and Agnès Verlet. *Écrire sur la peinture: anthologie: dossier par Charlotte Maurisson; Lecture d'image par Agnès Verlet*. Paris: Gallimard, 2006. A collection of forty-six poetic and prose ekphrases by French writers, accompanied by extensive critical apparatus. The poems:

Pierre de Ronsard, *Ode XXIX* [Unidentified painting of "des amours de Vénus et de Mars"]

Charles Perrault, *La Peinture* [Charles le Brun]

Georges de Scudéry, *La naissance de Vénus* [tableau on the birth of Venus attributed to Paolo Véronese]

Charles Baudelaire, *Salon de 1855* [Eugène Delacroix, *Sur la Chasse aux lions*]

Charles Baudelaire, *"Les Phares"* from *Les Fleurs du Mal* [Rubens, da Vinci, Rembrandt, Michelangelo, Watteau, Goya, Delacroix]

Charles Baudelaire, *"Bohémiens en voyage"* from *Les Fleurs du Mal* [Jacques Callot, *Les Bohémiens en marche*]

José-Maria de Heredia, *Le Tepidarium* [Théodore Chassériau, *Le Tepidarium*]

André Breton, *André Derain*

Paul Eluard, *Max Ernst* and *Georges Braque*

Louis Aragon, *Discours pour les grands jours d'un jeune home appelé Pablo Picasso* [Pablo Picasso, *Guernica*]

Bonnefoy, Yves, *Sur une Pietà de Tintoret* [Jacopo Robusti Tintoretto, *Pietà*]

2M. Jan Greenberg, ed. *Side by Side: New Poems Inspired by Art from Around the World*. New York: Harry N. Abrams, 2008. An anthology of thirty poems, juxtaposed to the works of art (in color) that are their subjects. The twenty-two on paintings are:

Lam Thi My Da, *The Color of Phai Street* [Bùi Xuân Phái, *Small Street*]

Maria Teresa Andruetto, *The Pears* [Pablo Picasso, *Dish of Pears*]

Yusuf Eradam, *Two Leaves in Snow* [Reha Yalnizcik, *Two Leaves in Snow*]

Renée Ferrer, *Gallop* [Malola (Maria Gloria Echauri), *Tornado*]

Gunnar Harding, *The Doppelgangers* [Dante Gabriel Rossetti, *How They Met Themselves*]

Carmen T. Bernier-Grand, *Quetzalcoatl* [Diego Rivera, *Pan American Unity*]

Karma Ura, *The Ballad of Pemi Tshewang Tashi* (excerpt) [Karma Ura, *Wangdue Dzongan*]

Lorraine Marwood, *Ned Kelly* [Sidney Nolan, *Ned Kelly*]

Luis Martínez de Merlo, *Portrait of Prince Baltasar Carlos de Caza* [Diego Velázquez, *Portrait of Prince Baltasar Carlos de Caza*]

Wafaa S. Jdeed, *Forest* [Wafaa S. Jdeed, *Forest*]

Gunter Künert, *The Scream* [Edvard Munch, *The Scream*]

Anne Provoost, *Memling's Sibÿlle Sambetha* [Hans Memling, *Portrait of a Young Woman*]

Grace Nichols, *Turner to His Critic* [J.M.W. Turner, *Snow Storm—Steamboat off a Harbour's Mouth*]

Rina Ferrarelli, *Portrait of a Young Man* [Sandro Botticelli, *Portrait of a Young Man*]

Carol Malyon, *To Prince Edward Island* [Alex Colville, *To Prince Edward Island*]

Lo Ch'ing, *Cat Heaven* [Lo Ch'ing, *Cat Heaven*]

Janeen Brian, *It's a Dog-Dust Day* [Tom Roberts, *A Break Away*]

Ernest Farrés, *Cape Cod Evening* [Edward Hopper, *Cape Cod Evening*]

Cristina Peri Rossi, *Babel* [Pieter Brueghel the Elder, *The Tower of Babel*]

James Sacré, *Woman in Blue* [Henri Matisse, *Woman in Blue*]

Naoko Nishimoto, *On Dawn* [Ei-Kyu, *Dawn*]

Nimah Ismail Nawab, *The Vision* [Shahzia Sikander, *The Illustrated Page Series*]

Ekphrasis 2007–2008, a collection of poems in response to art by students at Forest Park High School, is available at http://www.lulu.com/content/2078508

3. Volumes on Individual Painters

Arranged alphabetically by painter's surname

Balthus (Balthazar Klossowski de Rola)

3A. Stephen Dobyns, *The Balthus Poems*. New York: Atheneum, 1982. Each of the thirty-two poems takes its title from a painting by Balthus.

The Street	Landscape at Champrovent
The Greedy Child	The Mountain
The Card Game	The Golden Days
The Living Room	The Turkish Room
The Room	Dream
Nude Resting	The Triangular Field
Getting Up	The White Skirt
The Children	Landscape with Oxen
The Moth	Gotteron Landscape
Patience	Katia Reading
Nude in Profile	Larchant
The Guitar Lesson	The Fortune Teller
Boy with Pigeons	The Window
The Cherry Tree	Japanese Girl with Red Table
Girl in White	Farmyard at Chassy
The Room	The Passage

Edward Boccia

3B. Jennifer Bosveld, *The Magic Fish: Poems on an Edward Boccia Sketchbook*. Johnstown, OH: Pudding House Publications, 2002. Sixty-four poems on one oil painting and sixty-three sketches by Boccia:

The Magic Fish (oil)	Pensive Animal
The Good Catch	Thinking about a Ride
The Arrival of God	Man Radiating Light
Dinner for Three	He Has Been Called
Trees of a Pear	We Must Communicate
Manfred and Alma	Foot untitled
Battle at Sea	Lovers II
Lovers	He Remembers
The Luminous Fish	Husband and Wife
Bowl of No Fruit	Vision in the Pensione
Narcissus of Another Color	France
Totem	He Bears Adversity
One inside of One	Yesterday's Pleasure
Horse Sense	Venus Unfinished

The Wheels that Should Have Given Him Comfort	He Is Always Near
One Life Is Not Enough	Piled Up
Vision over Peconic	Bert
Room with a Chair	Two Plus Two
Jane	After Thought
Three in One	Portrait of Venus #2
A Poet Reading	Portrait of a Intruder
Seeing through It All	Remnants of Guilt
Awareness	Two Venetians
Blessings	Ancient Travelers on the Canguro Bruno
A Man Making Love	Rider in/DRA
A Greek in Kiffissia	Man with a Vision
Poet Asleep in a Boat	Sky-Man
Her Toys	Man Meditating
Caught Sneaking In	Law of Life
Strangers	Mosaic Man
Bird/Tree untitled	Miracle outside the Window
Conversation	
Portrait of a Friend	

Carroll Cloar

3C. Dabney Stuart. *Second Sight: Poems for Paintings by Carroll Cloar*. Columbia: University of Missouri Press, 1997. The poems bear the same titles as those of the paintings, which accompany the poems:

Group of Myselves	The Thicket Revisited
Alien Child	The Clearing
The Appleknocker	Where the Southern Cross the Yellow Dog
The Grandparents	The Thicket in Autumn
Charlie Mae Practicing for the Baptism	The Lightning that Struck Rufo Barcliff
Sunday at the Lake	The Tea Party
My Father Was Big as a Tree	The Maidenhair Tree
Dreampt	Panther Bourne
Self Encounter	Sun Sinking into River
Watchers	Feeding
Joe Goodbody's Ordeal	Reelfoot
The Wild Geese	Kudzu
Charlie Mae and the Panther	Boaters Observed
	Couple at Reelfoot

Night Landscape *The River at*
After Rain *Montgomery*

Henry Darger

3D. John Ashbery, *Girls on the Run*. New York: Farrar, Straus and Giroux, 1999. A volume based loosely on the life works of "outsider" artist Henry Darger.

John Digby

3E. Tony Curtis. *The Arches*. Bridgend, Wales: Seren, Poetry Wales Press, 1998. Contains twenty-five surreal collages by Digby, each accompanied by an untitled poem by Curtis.

Thomas Eakins

3F. Philip Dacey. *The Mystery of Max Schmitt: Poems on the Life and Work of Thomas Eakins.* Cincinnati, OH: Turning Point, 2004.

Found Sonnet: Thomas Eakins on Painting
Thomas Eakins: The Badlands
The Anatomy of Horses: Homage to Thomas Eakins
Models
In Camden
Thomas Eakins' "The Gross Clinic" (1875)
Thomas Eakins: "The Crucifixion"
The Swimming Hole
The Mystery of Max Schmitt
With Susan
The Students
Thomas Eakins' "The Agnew Clinic" [appeared also in *Ekphrasis* 2 (Fall–Winter 2000): 22–3]
Two Victorian Portraits Mary Adeline Williams Frank Hamilton Cushing [appeared also in *Ekphrasis* 3, no. 2 (Fall–Winter 2003): 23–4]
Thomas Eakins' "Between Rounds"
Thomas Eakins: Painting President Rutherford B. Hayes
Seven Hands: From the Paintings of Thomas Eakins
Eakins Up-to-Date
Elegiac
"Reflections On Water": The Lost Lecture of Thomas Eakins
Coda: Painting Eakins

M.C. Escher

3G. Catherine A. Callaghan. *Other Worlds: Poems on Prints by M.C. Escher*. Johnstown, OH: Pudding House Publications, 1999. Poems on the following prints of Escher.

Drawing Hands *The Sixth Day of*
Other World Eye *Creation*

Magic Mirror *Bond of Union*
Rind *Tower of Babel*
Belvedere *Mummified Priests in*
Reptiles *Gangi, Sicily*
Dusk *Dream (Mantis religiosa)*
Puddle *Procession in Crypt*
Cubic Space Division *Castle in the Air*
Ascending and *House of Stairs*
Descending *Doric Columns*
Day and Night *Relativity*
Still Life with Reflecting *Dragon*
Sphere *Snakes*
Ghost *M.C. Escher (Self-*
Witch *Portrait)*

Morris Graves

3H. Tim McNulty. *Reflected Light: Poems on Paintings of Morris Graves* [Berkeley]: Tangram, 1990. Poems on the following Graves's paintings:

Varied Thrush Calling in Autumn [painting in *Morris Graves: Vision of the Inner Eye* (New York: Braziller, 1983), plate 34]
Resilient Young Pine, 1944 [painting in *Morris Graves*, ibid., plate 66]
Joyous Young Pine [*Joyous Young Pine* series, 1944]
Shore Birds Submerged in Moonlight, 1940 [painting in *Morris Graves*, ibid., plate 18]
Each Time You Carry Me This Way, 1953 [painting in *Morris Graves*, ibid., plate 99]
Hibernation I, 1954 [painting in *Morris Graves*, ibid., plate 76]
Hibernation II, 1954 [painting in *Morris Graves*, ibid., plate 112]
Hibernation III, 1954 [painting in *Morris Graves*, ibid., plate 113]

Stephen Hannock

3I. *Texts with Vistas: Words Inspired by Paintings of Stephen Hannock*. Compiled by Therese L. Broderick. Albany, NY: n.p., 2007. Two chapbooks (Parts One and Two) of writing inspired by an exhibit of Hannock's paintings at the Albany Institute of History and Art, June-September 2007. The poems:

Part One
Mary McCarthy, *Untitled* [various images from Hannock's paintings]
Alan Catlin, *Squid Boats on the Gulf of Slam* [Hannock, *Squid Boats on the Gulf of Slam*]
Alan Catlin, *After the Deluge, Red Maple (For Laurie, Sadly Listening)* [Hannock, *After the Deluge, Red Maple of Peace, for Laurie, Sadly Listening*]
Barbara Backus, *The City* [Hannock, *American City with Restored Park*]

Therese L. Broderick, *Oxbow* [Hannock, *The Oxbow, After Church, After Cole, Flooded*]

Pamela Marvin, *Oxbow Portrait after Church and Cole* [Hannock, *The Oxbow, After Church, After Cole, Flooded*]

Mary McCarthy, *Judy Meets Stephen* [Hannock, *Portrait of the Artist with Oscar and Skin Cancer*]

Pamela Marvin, *Portrait of the Artist and Oscar* [Hannock, *Portrait of the Artist with Oscar and Skin Cancer*]

Alan Catlin, *Self-Portrait of the Artist Working in the Dark* [Hannock, *Portrait of the Artist Painting in the Dark*]

Marilyn Zembo Day, *Poet Views Stephen Hannock Painting* [Hannock, *Artist after We Lost, and Holmes Got Away*]

Mimi Moriarty, *Letter to Stephen Hannock*

Part Two

Beatrice R. Cohen, *The First Lady of the World* [Hannock, *Nocturne for the River Keeper, Green Light*]

Edward Hopper

3J. Gail Levin. *The Poetry of Solitude: A Tribute to Edward Hopper.* New York: Universe Publishing, 1995. Twenty-six poets repond to Hopper's paintings, which are reproduced in color. Hopper's titles are in square brackets.

Diane Bonds, *The Life of the Body* [*People in the Sun*]

Marianne Boruch, *Light* [*Summer Evening*]

William Carpenter, *Evening Wind* [*Evening Wind*] and *Night Shadows* [*Night Shadows*]

Ann Babson Carter, *Cobb's Barns* [*Cobb's Barns*]

Simon Cutts, From *Pianostool Footnotes* [*Sun in an Empty Room*]

Stephen Dunn, *Impediment* [*Eleven A.M.*]

W.R. Elton, *Hopper: In the Café* [*Chop Suey*]

Debra Greger, *The Man on the Bed* [*Excursion into Philosophy*]

Edward Hirsch, *Edward Hopper and the House by the Railroad (1925)* [*House by the Railroad*]

John Hollander, *Edward Hopper's Seven A.M. (1948)* [*Seven A.M.*] and *Sunday A.M. Not in Manhattan* [*Early Sunday Morning*]

Larry Levis, Edward Hopper, *"Hotel Room,"* 1931

Susan Ludvigson, *Inventing My Parents* [*Nighthawks*]

Robert Mezey, *Evening Wind* [*Evening Wind*]

Lisel Mueller, *A Nude by Edward Hopper* [*Girlie Show*] and *American Literature* [*Sun in an Empty Room*]

Joyce Carol Oates, *Edward Hopper, Nighthawks*

Tony Quagliano, *Edward Hopper's "Lighthouse at Two Lights"* [*Captain Upton's House*] and *The Edward Hopper Retrospective* [*Four Lane Road*]

Lawrence Raab, *After Edward Hopper* [*Moonlight Interior*]

David Ray, *A Midnight Diner by Edward Hopper* [*Nighthawks*] and *Automat* [*Automat*]

Anthony Rudolf, *Edward Hopper* [*Dauphinée House*]

Ira Sadoff, *Hopper's "Nighthawks" (1942)* and *February: Pemaquid Point* [*Pemaquid Light*]

Grace Schulman, *American Solitude* [*Study of Portrait of Orleans*]

Sue Standing, *Hopper's Women* [*House by the Railroad*; *East Side Interior*; and *Nighthawks*]

John Stone, *Early Sunday Morning* [*Early Sunday Morning*]

John Updike, *Two Hoppers* [*Girl at a Sewing Machine* and *Hotel Room*]

Sidney Wade, *Gas* [*Gas*]

Alan Williamson, *The Light's Reading: Meditations on Edward Hopper* [*Two Comedians*]

Edward Hopper

3Ja. Deborah Lyons and Adam D. Weinberg. *Edward Hopper and the American Imagination.* New York: Norton, 1995. The engagement with Hopper's art by thirteen creative writers, along with fifty-nine of Hopper's paintings and an essay by Gail Levin. The poets:

Galway Kinnell, *Hitchhiker*

Ann Lauterbach, *Edward Hopper's Way* [images from various of Hopper's paintings]

Thom Gunn, *Phaedra in the Farm House*

Tess Gallagher, *From Moss-Light to Hopper with Love*

John Hollander, *Sun in an Empty Room* [*Sun in an Empty Room*]

Frida Kahlo

3K. Linda Frank. *Kahlo: The World Split Open.* Ottawa: Buschek, 2008. A fictional account of Kahlo's life as seen through her paintings.

3Ka. Keith Garebian. *Frida: Paint Me as a Volcano/Frida: Un Volcan de Souffrance.* Ottawa: Buschek Books, 2004. A poetic biography of Kahlo as told by Garebian's Frida.

DeLoss McGraw

3L. W.D. Snodgrass. *Make-Believes: Verses and Visions.* West Eaton, NY: Etonbrook Editions, 2004. Forty-seven poems by Snodgrass on paintings and constructions by McGraw — two longtime collaborators on the Death of Cock Robin poems and paintings, one of which is entitled *W.D. Meets Mr. Evil While Removing the Record of Bartok and Replacing It with a Recent Recording by the Everly Brothers in Order to Create a Mood Conducive to Searching for Cock Robin.* The Cock Robin poems are in Snodgrass's *Selected Poems 1957–1987* (New York: Soho, 1987), 211–40.

Janet Manalo

3M. Suzanne Bruce [poet] and Janet Manalo [artist]. *Voices beyond the Canvas: Ekphrastic Expression: Poetry Inspired by Art.* Collierville, TN: Instant Publisher, 2007. The titles of Manalo's paintings are in square brackets.

Strength [Patwin's Grove]
October's Carpet [October's Carpet]
Drowning [Drowning]
Beyond Belonging [Moro Bay]
Elusive Connections [Elusive Dreams]
Woven Puzzle [Woven Elements; Woven Earth, Woven Water, Woven Fire, and Woven Wind]
Bird of Paradise [Hidden Garden]
Spring Recital [Spring Recital]
Musical Reaction [Chemistry of Music]
Invisible [Limitations]
Affirmation [Still Love You]
Winter Rose [The Rose]
Sky Ribbon [Sky Ribbon]
Pearls of Wisdom [Pearls of Wisdom]
Toy Box [Faded Memories]
Release [Warrior I]
Metamorphosis [Backbend Asana]
Meditation [Meditation]
Magic of Chocolate [Homage to Chocolate]
Endless loop ... [Happy Hour]
Mural Dancer [Mural Dancer]
Cosmo's Voice [Flights of Fantasy]

Henri Matisse

3N. Christopher Pilling. *In the Pink: Poems on Paintings by Matisse.* Bradford, West Yorkshire: Red Beck Press, 1999. The titles of Matisse's painting are in square brackets.

You and You, in the Pink [Fenêtre ouverte à Collioure]
In a Corner [Coin d'atelier]
French Window [Porte-fenêtre à Collioure]
Greta Moll [Greta Moll]
What To Believe [Nature morte aux oranges]
The Pink Tablecloth [La nappe rose]
What Greta Can Do [Portrait de Greta Prozor]
Chair & Dancer [Danseuse fond noir fauteuil rocaille]
Instead of an Annunciation [La conversation]
The Red Studio [L'atelier rouge]
Nude in 21States [Rose nude]
Cross-legged & Cross [Hindu pose]
The Piano Lesson [La leçon de piano]
In the Aquarium [Le Nageusse dans l'aquarium]
On the Carpet [Sleeping Nude]
Purely a Matter of Taste [Sculpture et vase de lierre]
Tzigane a slice of pineapple
Half-hidden in "The Joy of Living" [Study for Le Bonheur de vivre]
Creole Dancer/Cut Flowers [Danseuse Créole]
Splashing Out! [La chapelle du Rosaire à Vence]
It's All in the Game [Les joueurs de boules]

Red-headed Nude [Nu dans la forêt]
Stanza [Femme au chat]
The Sandman [La rêve]
Are You Sitting Comfortably? [L'étang de Trivaux]
Guitar Solo [La tristesse du roi]
Icarus [Icare]
Zorah in Yellow [Zorah en jaune]
O for Oysters [Nature morte aux huîtres]
Into the Blue [Nature morte aux oranges]

Claude Monet

3O. James R. Scrimgeour. *Monet in the Twentieth Century.* Columbus, OH: Pudding House Publications, 2002.

Waterloo Bridge: Sunlight Effect, 1903
Houses of Parliament, Seagulls, 1904
Houses of Parliament: Sunset, 1904
Water Littlies, 1908
Waterlilies, 1907
The Grand Canal, 1908
Waterlilies, 1914–17
The Water Lily Pond at Giverney: 1917
The Japanese Bridge, c 1919–24
Weeping Willow: 1918
The Path Under Rose Arches
The House Seen from the Rose Garden: 1922–24
Panel: The Water Lily Pond, Evening, 1920–26

Georgia O'Keeffe

3P. Alan Catlin. *O'Keeffe Equivalents: A Collection of Poems.* Produced in Cooperation with Origami Condom website, 2007. http://www.origamicondom.org/Chapbooks/ACatlin.01.pdf

O'Keeffe Equivalents [art work by Pat Johansen]
Georgia O'Keeffe in Glen Canyon [Todd Webb, A Study in Black and White]
Georgia O'Keeffe's Pelvis IV, 1944
Georgia O'Keeffe's Winter Road 1, 1963
Georgia O'Keeffe's Hands
Georgia O'Keeffe's Equivalents
Georgia O'Keeffe and Eastborn Smith in Twilight Canyon [Todd Webb, Lake Powell, Utah, 1964]
Recuerdos
Georgia O'Keeffe's Studio by Todd Webb
Alfred Stieglitz, Georgia O'Keeffe: Portrait Show at "291"
Georgia O'Keeffe's Desert Dreamscape #1
Georgia O'Keeffe's Desert Dreamscape #2
Georgia O'Keeffe's Desert Dreamscape #3
Georgia O'Keeffe's Desert Dreamscape #4
Georgia O'Keeffe's Black Abstraction
Georgia O'Keeffe's Slightly Open Clam Shell, 1926
Georgia O'Keeffe's Special No. 35, 1915
Georgia O'Keeffe's Ram's Head, White Hollyhock Hills, New Mexico, 1935

Georgia O'Keeffe's Green Yellow and Orange, 1960
Dreaming Georgia O
Georgia O'Keeffe on Block Island
Georgia O'Keeffe's Dream Garden
Georgia O'Keeffe's Blue and Green Music, 1919
Georgia O'Keeffe's From the Lake #1, 1924
Georgia O'Keeffe's Pink and Blue #1, 1919
O'Keeffe Requirements
Georgia O'Keeffe's Day with Juan
Georgia O'Keeffe at 30,000 feet
Todd Webb's O'Keeffe Walking in the White Place, 1955
Eliot Porter's Georgia O'Keeffe and Head of O'Keeffe
 [Mary Callery, *Ghost Ranch, New Mexico 1945*]

Camille Pissarro

3Q. Derek Walcott, *Tiepolo's Hound*. New York: Farrar, Strauss and Giroux, 2000. The ekphrases center not simply on the narrative of Pissarro but also on the narrator's quest to find a once seen painting by Paolo Veronese or Giambattista Tiepolo.

Francine Schrock

3R. *Ekphrasis: Abstract Paintings by Francine Schrock, Poems by Annie Seikonia*. Blurb, 2009.

Dorothea Tanning

3S. James Merrill, Tanning, Dorothea, et al. *Another Language of Flowers*. New York: Braziller, 1998. Twelve poems on Tanning's paintings of imaginary flowers, all but the first named by the poet:

James Merrill, *Merrillium trovatum* [from Merrill's *Declaration Day*]
Harry Matthews, *Agripedium vorax Saccherii (Clog Herb)*
Rosanna Warren, *Siderium exaltatum (Starry Venusweed)*
Debora Greger, *Zephirium apochripholiae (Windwort)*
Adrienne Rich, *Pictor mysteriosa (Burnt Umbrage)*
Anthony Hecht, *Asclepius formidabilis (Griefbane)*
Richard Howard, *Cyanea barbellata (Dalliance)*
J.D. McClatchy, *Nephaster cyaneus (Cloudstar)*
W.S. Merwin, *Crepuscula glacialis (var., Flos cuculi)*
John Ashbery, *Victrola floribunda*
Stephen Yenser, *Flagrantis speculum veneris (Loveknot)*
Brenda Shaughnessy, *Convolotus alchemilia (Quietwillow window)*

Très Riches Heures of the Duke of Berry

3T. Cole Swensen. *Such Rich Hour*. Iowa City: University of Iowa Press, 2001. Poems based on the calendar illuminations from the *Très Riches Heures du Duc de Berry*.

J.M.W. Turner

3U. Alan Catlin. *Our Lady of the Shipwrecks*. Georgetown, KY: Finishing Line Press, 2006. Twenty poems inspired by the painting of J.M.W. Turner:

Our Lady of Ship-wrecks
Unfinished Dawn
Castle Keep
The Wreck of a Merchant Ship
Celebration Off Shore, at Sea
Steam Locomotive Before the Deluge
The Passenger Steamer, Esmeralda, Nearing the Harbor Venice
Thunderstorm with Fire-works
Still Life with Snowstorm
Unfinished Engagement at Sea
Stonehenge, date unknown
The Shore at Folkestone, Twilight 1845
Death as Pale Horse
Norham Castle, Sunrise 1797–8
Turner's Death Mask 1852
High Noon
Venice Dawn
Whaler 'round "The Horn"
Old Sarum
The Burning of the Houses of Lords and Commons

J.M.W. Turner

3Ua. David Dabydeen, *Turner*. Leeds, UK: Peepal Tree Press, 2002. A 600-verse poem inspired by Turner's *Slave Traders Ditching the Dead and the Dying with Hurricane Approaching*

Vincent Van Gogh

3V. Peter Cooley. *Van Gogh Notebook*. Pittsburgh: Carnegie-Mellon University Press, 1987. Poems on fifty-five of Van Gogh's paintings:

The Loom
The Potato Eaters
Still Life with Open Bible
A Wheat Field
Still Life, Hat and Pipe
Self-Portrait in Front of an Easel
The Woman at Café Tambourin
Self-Portrait with Soft Felt Hat
Montmartre
The Orchard
Orchard with Peach Blossom
Harvest Landscape: Blue Cart
The Sower
The Zouave

The Drawbridge [also published in *Ekphrasis* 1, no. 6 (Fall–Winter 1999): 52]
Orchard Bordered by Cypresses
Fishing Boats on the Beach at Saintes-Maries
Old Peasant (Patience Escalier)
The Postman Roulin
Sunflowers
Night Café
Public Garden at Arles
Pavement Café at Night
Pavement Café at Night
Self-Portrait [also published in *Ekphrasis* 1, no. 6 (Fall–Winter 1999): 25]
Public Garden with Weeping Tree: Poet's Garden
Iron Bridge at Trinquetaille
Tarascon Diligence
The Bedroom at Arles
Portrait of Armand Roulin
L'Arlesienne: Madame Ginoux
Le Mousmé
The Chair and the Pipe
Gauguin's Chair
Augustine Roulin: La Berceuse
Garden at the Hospital at Arles
Irises [also published in *Ekphrasis* 1, no. 6 (Fall–Winter 1999): 42]
Meadow and Butterflies
Road with Men Walking, Carriage, Cypress, Star and Crescent Moon
The Enclosed Field
The Starry Night [also published in *Ekphrasis* 2, no. 1 (Spring–Summer 2000): 52]
Pietà
Pine Trees
Olive Orchard
The Road Menders
Passage at the Asylum
Landscape with Ploughed Fields
The Last Self-Portrait
Portrait of Dr. Gachet
Undergrowth with Two Figures
Peasant Girl
Stairway at Auvers
Olive Trees in a Mountain Landscape [also published in *Ekphrasis* 2, no. 1 (Spring–Summer 2000): 6]
Self-Portrait as Van Gogh
Wheatfields Under a Threatening Sky with Crows

Vincent Van Gogh

3Va. Xue Di, *Flames (Poems Dedicated to Vincent Van Gogh).* Trans. Wang Ping, Iona Crook, and Keith Waldrop. Kent, WA: Paradigm Press, 1995.

Road [*Road with Cypresses*, 1890]
The Buring Silk Veil [*Wheatfield with Cypresses*, 1889]

Sower [*Sower with Setting Sun*, 1888]
The Gleaner [*Peasant Woman Stooping*, 1885]
Poppy Fields [*Field with Poppies*, 1890]
The Field Covered with Crows [*Wheat Field with Crows*, 1890]
Church [*The Church at Auvers*, 1890]
Injured Portrait [*Self-Portrait with Bandaged Ear and Pipe*, 1889]
White Chinese Roses [*White Roses*, 1888]
Drawbridge [*The Langlois Bridge*, 1888]
Scene [*The Plain with Farm Near Auvers*, 1890]
Sunflower [*Sunflowers*, 1888]
Tonight [*Starry Night over the Rhône*, 1888]
Starry Night [*Starry Night*, 1889]
Portrait [*Self-Portrait*, 1889]
Blues [*The Night Café*, 1888]

3Vb. Robert Fagles. *I, Vincent: Poems from the Pictures of Van Gogh.* Princeton, NJ: Princeton University Press, 1978.

Miners' Wives Carrying Sacks of Coal
Carpenter's Workshop, Seen from the Artist's Window
Sien's Daughter: Profile
The Paddemoes, Jewish Quarter
The Forge
Weaver with Loom
The Potato-Eaters
Dancing Hall
Portrait of a Woman: Bust, Left Profile
Woman Sitting in the Café du Tambourin
Fishing in Spring, Probably near the Pont Levallois
View from Montmarte Near the Upper Mill
Père Tanguy the Paint-Grinder
Self-Portrait in Front of the Easel
The Coaches of Tarascon
Bedroom in Arles
Sunflowers
Self-Portrait: A Mon Ami Paul G[auguin]
Harvest
Boats on the Beach at Saintes-Maries
Vincent's Chair with His Pipe
The Postman Roulin
Portrait of the Artist's Mother [also in Abse (2D, above), 99]
Old Shepherd in Provence
The Rhone River at Night
Woman of Arles
A Bugler of the Zouave Regiment
The Night Cafe
Self-Portrait with Bandaged Ear and Pipe
A Passage at St. Paul's Hospital
Wheat Field behind St. Paul's Hospital at Fall of Day with a Reaper
The Cypress
The Starry Night
Self-Portrait

Olive Trees
The Road Menders
Branch of an Almond Tree in Blossom
Reaper under a Rising Sun
Portrait of Dr. Gachet
Pietà (after Delacroix)
Crows over the Wheat Field
The Church at Auvers

Diego Velázquez

3W. Miguel de Unamuno. *The Velázquez Christ.* Lanham, MD: University Press of America, 2002. Also published as *The Christ of Velázquez.* Baltimore, MD: Johns Hopkins University Press, 1951. Velázquez's masterpiece *Christ on the Cross* (1632) is the central theme of this detailed meditation, a book-length poem.

Jan Vermeer

3X. Marilyn Chandler McEntyre. *In Quiet Light: Poems on Vermeer's Women.* Grand Rapids, MI: Eerdmans, 2000. Twenty poems — "experiments in contemplation" — alongside Vermeer's paintings that inspired them. Except for the first and last, the titles of the poems are the titles of the paintings.

Artists at Work [Allegory of Painting, detail]
Little Street
The Lacemaker
The Milkmaid
Girl with a Pearl Earring
Woman in Blue
Woman Writing a Letter
Young Woman with a Water Pitcher
A Girl Asleep
Portrait of a Young Woman
Woman with a Lute
Lady Writing a Letter with Her Maid
Officer and Laughing Girl
Girl Reading a Letter at an Open Window
Mistress and Maid
Allegory of Painting
The Girl with a Red Hat
Woman with a Pearl Necklace
Woman Holding a Balance
Life Drawing: Advanced Beginners [Allegory of Painting, detail, and Lady Writing a Letter with Her Maid, detail]

Jan Vermeer

3Xa. Graham Burchell. *Vermeer's Corner: Poetry for the Art of Johannes Vermeer (1632–1675).* Kanona, NY: Foothills Publishing, 2008.

In the House of Martha and Mary [Christ in the House of Martha and Mary]
Elegy for the Victims of Delft [Diana and Her Companions]
The Procuress [The Procuress]
Acedia [Girl Asleep at a Table]
Seduction and Wine [Officer and a Laughing Girl]
Girl Reading a Letter at an Open Window [Girl Reading a Letter at an Open Window]
Milkmaid [The Milkmaid]
Mussels on Rocks [Street in Delft]
View of Delft [View of Delft]
The Glass of Wine [The Glass of Wine]
The Girl with the Wine Glass [The Girl with the Wine Glass]
Interrupted [Girl Interrupted at Her Music]
The Music Lesson [The Music Lesson]
Ménage-A-Trois [The Concert]
Woman in Blue [Woman in Blue Reading a Letter]
Judgment Day [Woman Holding a Balance]
Woman with a Pearl Necklace [Woman with a Pearl Necklace]
In 1944 [Woman with a Lute]
Inside and Out [Young Woman with a Water Jug]
Lady Writing a Letter [Lady Writing a Letter]
Girl with a Red Hat [Girl with a Red Hat]
Girl with a Flute [Girl with a Flute]
Mystery [The Girl with a Pearl Earring]
Head of a Girl — A Pearl [Head of a Girl]
The Art of Painting [The Art of Painting]
Allegory of the Faith [Allegory of the Faith]
The Astronomer [The Astronomer]
The Geographer [The Geographer]
Mistress and Maid [Mistress and Maid]
Sonnet [The Love Letter]
Pillar and Bell [Lady Writing a Letter with Her Maid]
The Guitar Player [The Guitar Player]
The Lacemaker [The Lacemaker]
No Mystery [Lady Standing in a Virginal]
Finale [Lady Seated at a Virginal]

4. Volumes by a Single Poet on Multiple Paintings

Chronological by date of publication

4A. Michael Field [pen name of Katherine Harris Bradley and Edith Cooper, also known as Arran and Isla Leigh]. *Bellerophôn*. London: C. Kegan Paul and Co., 1881. A series of poems on Renaissance paintings:

Jean-Antoine Watteau, *L'Indifférent* (*The Casual Lover*)

Antonio da Correggio, *Venus, Mercury and Cupid* (*The School of Love*)

Leonardo da Vinci, *Drawing of Roses and Violets*

Leonardo da Vinci, *La Gioconda* (*Mona Lisa*)

Antonio da Correggio, *The Faun's Punishment*

Sandro Botticelli, *The Birth of Venus*

Antonio da Correggio, *Antiope* (*Jupiter and Antiope*)

Benozzo Gozzoli, *Treading the Press*

Sandro Botticelli, *Spring*

Bartolommeo Veneto, *A Portrait* (*Portrait of a Woman*)

Bartolommeo Veneto, *Saint Katherine of Alexandria*

Antonio da Correggio, *St. Sebastian*

Fiorenzo di Lorenzo, *Madonna with Saints*

Tintoretto, *The Rescue*

Sandro Botticelli, *Venus and Mars*

Piero di Cosimo, *The Death of Procris*

Cosimo Yura, *St. Jerome in the Desert*

Unknown artist, *Mettus Curtius*

Jean-Antoine Watteau, *Fête champêtre*

Giorgione, *A Shepherd-Boy*

Antonello da Messima, *Saint Sebastian*

Timoteo Viti, *The Madalen*

Sodoma, *A Pen-drawing of Leda*

Tintoretto, *Marriage of Bacchus and Ariadne*

Sandro Botticelli, *Spring* [figure of Venus]

Perugino, *Apollo and Marsyas*

Giovanni Bellini, *The Blood of the Redeemer*

Giorgione, *The Sleeping Venus*

Carlo Crivelli, *A Pietà*

Lorenzo di Credi, *The Virgin, Child and St. John*

Jean-Antoine Watteau, *L'Embarquement pour Cythère*

4B. R.S. Thomas. *Between Here and Now*. London: Macmillan, 1981. This volume includes thirty-three poems on paintings that Thomas calls "Impressions":

Monet, *Lady with a Parasol*

Jongkind, *The Beach at Sainte-Adresse*

Monet, *The Bas-Bréau Road*

Bazille, *Family Reunion*

Degas, *Portrait of a Young Woman*

Monet, *Portrait of Madame Gaudibert*

Degas, *Mademoiselle Dihau at the Piano*

Degas, *The Musicians in the Orchestra*

Cézanne, *The Repentant Magdalen*

Manet, *The Balcony*

Pissarro, *The Louveciennes Road*

Cézanne, *Dr Gachet's House*

Degas, *The Dancing Class*

Monet, *The Gare Saint-Lazare*

Pissarro, *Kitchen Garden, Trees in Blossom*

Degas, *Absinthe*

Pissarro, *Landscape at Chaponval*

Renoir, *Muslim Festival at Algiers*

Cézanne, *The Bridge at Maincy*

Cézanne, *The Card Players*

Degas, *Women Ironing*

Cassatt, *Young Woman Sewing*

Gauguin, *Breton Landscape, the Mill*

Gauguin, *The Alyscamps at Arles*

Gauguin, *La Belle Angèle*

Van Gogh, *Portrait of Dr Gachet*

Toulouse-Laturec, *Jane Avril Dancing*

Toulouse-Lautrec, *Justine Dieuhl*

Gauguin, *Breton Village in the Snow*

Monet, *Rouen Cathedral, Full Sunshine*

Rousseau, *The Snake Charmer*

Renoir, *The Bathers*

4C. Helen Pinkerton, "*The Harvesters*" *and Other Poems on Works of Art*. Florence, KY: Robert L. Barth, 1984. These poems also appear in Pinkerton's *Taken in Faith*. Athens, OH: Swallow Press, 2002. 97–118.

On Brueghel the Elder's "The Harvesters" in the Metropolitan Museum

On Leonard Baskin's Etching "Benevolent Angel"
On Rembrandt's Self-Portrait (1658) in the Frick Museum
On an Attic Red-Figured Klyix Depicting Oedipus and the Sphinx (470 B.C.) by the "Oedipus Painter" in the Vatican Collections
On G.B. Tiepolo's Etching "Adoration of the Magi" (1753) in the Stanford Museum
On Dürer's Etching of Pilate Washing His Hands (1512)
On Blakelock's "Moonlit Landscape" in the Deyoung Museum
On Winslow Homer's "The Gale" in the Worcester Museum
On Fitz Hugh Lane's "Ships and the Approaching Storm, Camden, Maine, 1860" in the Deyoung Museum
On Goya's "Duel with Cudgels" (ca. 1820), A "Black Painting" in the Prado

4D. R.S. Thomas, *Ingrowing Thoughts*. London: Orion, 2000, 1985.

Guernica. Pablo Picasso
Portrait of a Girl in a Yellow Dress. Henri Matisse
Father and Child. Ben Shahn
Portrait of Madame Renou. André Derain
The Maid of Honour. Chaim Soutine
Still Life. Carl Hofer
L'Abbaye de Chartre. André Bauchant
Lilac above the River. Marc Chagall
The Meeting. Gustav de Smet
The Good Inn. Frits van den Berghe
The Child's Brain. Giorgio di Chirico
The Oracle. Giorgio di Chirico
The Red Model. Rene Magritte
Encounter in the Afternoon. Paul Nash
Drawing. Salvador Dali
Composition. John Selby Bigge
La Nuit Vénitienne. Paul Éluard
Two Children Menaced by a Nightingale. Max Ernst
On the Threshold of Liberty. René Magritte
Captain Cook's Last Voyage. Roland Penrose
Drawing by a Child. Diana Brinton Lee

4E. J.J.A. Mooij. *De ruimte van tijd = The Space of the Time*. Amsterdam: Bert Bakker, 1991. Twenty-six sonnets in five sections:

De Staalmeesters [Rembrandt van Rijn, *Syndics of the Amsterdam Draper's Guild*]. Five sonnets:
 De opdrachtgever
 Schijn en weerschijn
 Meester en knecht
 Het rode kleed
 Naleven
Gezichten op "Gezicht op Delft" [Jan Vermeer, *View of Delft*]

Portret van kardinaal Bibbiena [Raphael, *Portrait of Cardinal Bernardo Dovizi Bibbiena*]
Hendrik VIII [Hans Holbein, *Henry VIII*]
Stilleven met citroen [Willem Kalf, *Still Life with Lemon*]
Rivierlandschap met ruiters [Albert Cuyp, *Landscape with River and Horsemen*]
De watermolen [Meindert Hobbema, *The Watermill*]
Salisbury Cathedral from the Bishop's Grounds [John Constable]
Twee eenden neerstrijkend bij een vijver [Willem Maris, *Two Ducks Alighting on a Pool*]
Vijver met waterelies [Claude Monet, *Corner of a Pond with Water Lilies*]
Dans le parc de chateau noir [Paul Cézanne, *In the Park of the Chateau Noir*]
De blauwe en de rode paarden [Franz Marc, paintings of blue and red horses]
Chamonix: Mont Blanc [Oskar Kokoschka, *Chamoix: Mont Blanc*]
Stilleven van Braque [Georges Braque, untitled still life, Peggy Guggenheim collection, Venice]
Het Duet [Georges Braque, *Le Duo*]
Stilleven van Morandi [Giorgio Morandi, *Natura mortas, 1953/55*]
De sneeuwuil [Karel Purkyně, *The Snowy Owl*]

4F. Douglas McClelland. *The White Gallery*. Santa Cruz, CA: Many Names Press, 1993. Poems entitled:

Max Beckman	Henri Matisse
Pierre Bonnard	Giorgio Morandi
Paul Cézanne	Alice Neel
Marcel Duchamp	Isamu Noguchi
Philip Guston	Georgia O'Keeffe
Marsden Hartley	Jose Clemente Orozco
Vassily Kandinsky	Pablo Picasso
Paul Klee	Jackson Pollock
René Magritte	Egon Schiele

4G. Christopher Buckley. *Still Light: Twelve Poems on Paintings*. Columbia, MO: Sutton Hoo Press, 1994.

A Short History of Light [Leonardo Da Vinci, Filippo Brunelleschi, Jan Van Eyck's *Wedding Portrait*]
Corot at Chartres [Jean Baptiste-Camille Corot, *La Cathedral de Chartres*]
Corot at Mantes-la-jolie [Jean Baptiste-Camille Corot, *Le Pont de Mantes*]
Interior with Violin [Henri Matisse, *Interior with Violin*]
The Moroccans [Henri Matisse, *The Moroccans*]
Still Life with Grenadines [Henri Matisse]
O'Keeffe's "Spring, 1948"

O'Keeffe's "Pelvis IV" (Oval with Moon)
O'Keeffe's "The Beyond" (Last Unfinished Painting)
Two from Monet [Claude Monet, *Sunday at Argenteuil, 1872* and *Pond at Montgernon, 1876*]
Vermeer's "View of Delft"

4H. Alice Heard Williams. *Hey, Madame Matisse: A Collection of Poems about Paintings.* Lynchburg, VA: Warwick House Publishing, 1997.

Hey, Madame Matisse [Henri Matisse, *Red Madras Headdress*]
Les Fauves
The Moorish Screen by Henri Matisse, 1921
Russian Dancers by Edgar Degas
Still Life with Puppies by Paul Gauguin, 1888
The Port of Colloiure by Andre Derain
The Idlers by Maurice Pendergast (1859–1924)
Monsieur Degas and the Laundress
The White Girl [James McNeill Whistler, *Symphony in White, No. 1: The White Girl*]
The Geographer [Jan Vermeer, *The Geographer*]
Thoughts of Camille Monet [Claude Monet, *On the Seine at Bennecourt*]
The Palm by Pierre Bonnard
Cézanne and the Cours Mirabeau
Vincent's Song, a Pantoum [Van Gogh]
Thoughts of Whistler's Mother
Vermeer Magic: The Kitchen Maid by Johannes Vermeer
Claude Monet at the Art Institute
At the Seaside by Edgar Degas, 1876
Moret-sur-Loing by Ernest Lawson, 1895
Girl in a Blue Turban by Johannes Vermeer
Renoir Painting, in the Forest of Fontainbleau
Children on the Beach by Mary Cassatt, 1884
The Magdalene at the Mirror by Georges de La Tour
The Gleaners by Jean François Millet
The Ermine Portrait of Elizabeth I, Hatfield House [Nicholas Hilliard]
Rembrandt [Hundred Guilder Print]
Woman in a Striped Dress: A Painting by Edouard Vuillard, 1895
Piero's Women: The Baptism by Pierro della Francesca
Sunday Afternoon at the Grande Jatte [Georges Seurat]
Les Dindons (The Turkeys), 1877, by Claude Monet
The Shrimp Girl by William Hogarth
The Dancer by Auguste Renoir
The Battle of San Romano by Paolo Uccello, c. 1445
The Harvesters by Peter Brueghel
Les Demoiselles D'Avignon by Pablo Picasso
Mont St. Victoire by Paul Cézanne, 1886–88
Le Dejuner sur l'Herbe, circa 1865 by Claude Monet
The Shepherdess (La Bergere) by Camille Pissarro
Impressionism's Lost Worlds [lost paintings of Renoir, Monet]
Little Breton Girls Dancing by Paul Gauguin

4I. Joseph Stanton. *Imaginary Museum: Poems on Art.* St. Louis, MO: Time Being Books, 1999. Ekphrases about a series of works of art, including movies, Japanese Noh plays, and tales. The poems on paintings:

Giorgione's "The Tempest"
Vermeer's "A Woman Weighing Gold" [Jan Vermeer]
Watteau's "Italian Comedians" [Jean-Antoine Watteau]
Delacroix's "Jacob Wrestling with the Angel" [Eugène Delacroix]
Daumier's "The Third-Class Carriage" [Honoré Daumier]
Rossetti's "Paolo and Francesca" [Dante Gabriel Rossetti]
Heade's "Thunderstorm on Narragansett Bay" [Martin Johnson Heade]
Pissarro's "View of the Port of Rouen" [Camille Pissarro]
Rousseau's "Sleeping Gypsy [Henri Rousseau]
Seurat's "Evening at Honfleur" [Georges Seurat]
The Hour of Cézanne [Paul Cézanne]
Matisse Replies to Snodgrass: A Poem about a Poem about a Painting [Henri Matisse, *The Red Studio*]
Magritte Variations [René Magritte]
Feher's "The Anchor Takes Command" [Joseph Feher]
Ma Yuen's "Walk on a Mountain Path" [Ma Yuen (Yuan), *A Walk on the Mountain Path in Spring*]
The Dark Day: March [Pieter Brueghel the Elder]
The Harvesters: August [Pieter Brueghel the Elder]
The Return of the Herd: October [Pieter Brueghel the Elder]
The Hunters in the Snow: January [Pieter Brueghel the Elder]
The Triumph of Death [Pieter Brueghel the Elder]
The Tower of Babel [Pieter Brueghel the Elder]
The Book [Harris Burdick]
The Floor [Harris Burdick]
The Child Descends the Stair [Harris Burdick]
The Walls [Harris Burdick]
Ahead [Harris Burdick]
Approaching a City [Edward Hopper]
New York Corner [Edward Hopper]
New York Movie [Edward Hopper]
Drugstore [Edward Hopper]
Nighthawks [Edward Hopper]
Room in Brooklyn [Edward Hopper]
Office in a Small City [Edward Hopper]
Rooms by the Sea [Edward Hopper]
The Lee Shore [Edward Hopper]
House at Dusk [Edward Hopper]
Shakespeare at Dusk [Edward Hopper]
Sun in an Empty Room [Edward Hopper]
Road and Trees [Edward Hopper]
Rooms for Tourists [Edward Hopper]

Gas [Edward Hopper]
Cape Cod Evening [Edward Hopper]
Solitude [Edward Hopper]
High Road [Edward Hopper]

4J. Rafael Alberti. *To Painting: Poems.* Trans. Carolyn L. Tipton. Evanston, IL: Northwestern University Press, 1999. Alberti's book contains three kinds of poems: poems to colors, poems to instruments of painting, and poems to painters. Those to painters are:

Giotto [frescoes]
Botticelli [Sandro Botticelli, *Birth of Venus* and *Primavera*]
Raphael [paintings on the walls of the Vatican Palace]
Titian [*Venus and Adonis, Danaë, Bacchanal,* and other of Titian's *poesies*]
Tintoretto [*Christ at the Sea of Galilee, Saint Mark Saving a Saracen, Battle between the Christians and the Moors,* et al.]
Veronese [Paolo Veronese, *Allegory of Spring, Wedding of Cana, Christ in the House of Levi,* et al.]
Bosch [Hieronymus Bosch, *Garden of Earthly Delights*]
Dürer [Albrecht Dürer, *The Knight, Death, and the Devil, Melencolia I,* et al.]
Rubens [Peter Paul Rubens, *St. George and the Dragon, Flood Landscape with Philemon and Baucis, Storm Landscape, Shipwreck,* et al.]
Pedro Berruguete [*Apparition of the Virgin,* et al.]
Zubarán [Francisco de Zubarán, *The Vision of St. Peter Nolasco, The Miracle of St. Hugo,* et al.]
Velázquez [Diego Velázquez, *Prince Balthasar Carlos in Hunting Dress with Two Dogs, The Lances, The Drunkards, The Toilet of Venus,* et al.]
Valdés Leal [*Postrimerías: Finis Gloriae Mundi* and *Postrimerías: In Ictu Oculi*]
Goya [Francisco Goya, *Saturn Devouring His Children, The Family of Charles IV, The Third of May, 1808,* et al.]
Delacroix [Eugène Delacroix, *The Battle of Taillebourg, Tam O'Shanter,* et al.]
Cézanne [Paul Cézanne, still life and landscape images]
Renoir [Auguste Renoir, *Children on the Seashore, Dancing at the Moulin de la Galette, The Music Lesson,* et al.]
Van Gogh [Vincent Van Gogh, *Starry Night,* et al.]
Picasso [Pablo Picasso, *Woman Ironing, Guernica,* and numerous other paintings]

4K. Robert Kirschten. *Nighthawks and Irises: Poems about Paintings.* Lewiston, NY: Edward Mellen Press, 2000. Poems entitled.

Edward Hopper's Painting "Nighthawks," 1942
Edward Hopper's Painting "Gas," 1940

Edward Hopper's Painting "Lighthouse at Two Lights," 1929
Edward Hopper's Watercolor "Methodist Church, Provincetown," 1930
Vincent Van Gogh's "Irises," 1890
Jonathan Green's Painting "White Breeze," 1995
Mary Cassatt's Painting "The Letter," 1891
William Merritt Chase's Painting "At the Seaside," c. 1892
Paul Cezanne's "Still Life with Apples" 1895-1900
Claude Monet's "Landscape near Zaandam" 1872
Claude Monet's "Morning on the Seine near Giverny," 1897
Claude Monet's "La Pie (The Magpie)," 1869
Georges de la Tour's Painting "Christ in the Carpenter's Shop," c. 1640
Sebastien Stoskopff's "Still Life of Glasses in a Basket," 1644
Pierre Dupuy's Painting "Basket of Grapes," c. 1650
Pierre Patel (the Elder): "Landscape with Ruins," c. 1763
Francois Daubigny's "The Barges," 1865
Georgia O'Keeffe's Painting "Music—Pink and Blue, II," 1919
Édouard Manet's "The Artist's Garden, Versailles," 1881
Jean Baptiste-Camille Corot's "La Dame en Bleu," 1874
Edgar Degas' "Ecole de Danse," 1873
Edgar Degas' "Dancers in Pink"
Henri Matisse's "The Dinner Table" (Harmony in Red) 1908
Marc Chagall's "Bouquet and Red Circus," 1960
Marc Chagall's "Fiancée with Bouquet," 1977
Marc Chagall's "Bouquet with Flying Lovers," 1934–47
Thomas Hart Benton's "Persephone," 1939
Thomas Hart Benton's "Butterfly Chaser," 1951
Pre-Raphaelite Swans [unidentified painter and painting]
Alberta McCloskey's Painting, "Still Life, Oranges with Vase," 1889
Francisco Goya's Painting "The Bewitched" (Priest Pouring Oil on the Devil's Lamp), 1798
Francisco Goya's Painting "Witches' Sabbath," 1798
Fra Angelico's "The Archangel Gabriel Annunciate," c. 1430
Anna Gellenbeck's Painting "Richardson Highway, Alaska," 1944
Four Screens and Handscrolls:
 River Landscape in Mist with Geese and Flocking Crows [Chao Ling-jan, Chinese handscroll, ca. 1070–1100
 Autumn Grasses [Japanese six-panel screen, mid-seventeenth century]
 Swallows and Apricot Blossoms [Chinese hanging scroll, Ming Dynasty]

Poppies [Japanese painting on gold paper, mid-seventeenth century]

Thalia, suggested by Jean-Baptiste Regnault's painting "The Three Graces"

Harriet Foster Beecher's Painting, "A Camp on the Tide Flats," 1897

Clarisse Madelene Laurent's Painting, "Eggs," 1892

Emma Richard Cherry's Painting, "Sweet Peas," 1894

Marion Canfield Smith's Painting, "A Corn Field," 1920

4L.　Lynne Knight. *Snow Effects: Poems on "Impressionists in Winter,"* with French translations by Nicole Courtet Concord, CA: Small Poetry Press, 2000. A cycle of poems on fifteen paintings from the 1998–99 exhibition "Impressionists in Winter," shown in Washington, DC, and San Francisco.

Body That I Bring to You in Winter [Alfred Sisley, *Snow Effect at Argenteuil*]

The Snow Bride [Alfred Sisley, *Snow at Louveciennes*]

Bodies like Deeper Beds [Gustave Caillebotte, *View of Rooftops (Snow) (1878)*]

Horse Shadowing Two Bodies [Camille Pissarro, *Road, Winter Sun and Snow*]

Body Bent on More [Alfred Sisley, *Snow at Louveciennes*]

Bodies in Black and White [August Renoir, *Skaters in the Bois de Boulogne*]

Body in Remembrance [Claude Monet, *The Magpie*]

Body in a Dream of Arms [Camille Pissarro, *Snow at Louveciennes*]

Standing in a Dream of Body [Paul Gauguin, *The Seine at the Pont d'Iena—Snowy Weather*]

Body in a Dream of Spring [Claude Monet, *View of Argenteuil, Snow*]

Bodies in a Ghostly Reach [Claude Monet, *A Cart on the Snowy Road at Honfleur*]

Mme Monet, Reflecting [Claude Monet, *The Red Kerchief: Portrait of Mrs. Monet*]

Body of Desire [Claude Monet, *Boulevard des Capucines*]

Body in Late Meditation [Claude Monet, *Sunset on the Seine in Winter*]

Body as a River Passing into Shadow [Claude Monet, *Morning Haze*]

4M.　Marc Elihu Hofstadter. *Visions: Paintings Seen through the Optic of Poetry*. Oakland, CA: Scarlet Tanager Books, 2001. One-hundred-ten poems on paintings by Jackson Pollock, Mark Rothko, Chang Dai-Chen, and fourteen California Impressionists.

Pollock, Jackson

Alchemy
Autumn Rhythm: Number
Blue Poles: Number 11

Lucifer
Number 1
Number 1A
Number 2
Number 3
Number 7
Number 13A, 1948: Arabesque
Number 32
One: Number 31
Out of the Web: Number 7
Summertime: Number 9A
White Cockatoo: Number 24A

Rothko Mark

Black Over Reds (Black on Red), 1957
Blue and Gray, 1962
Lavender and Mulberry, 1959
No. 1 (Royal Red and Blue) (Untitled), 1954
No. 1 (White and Red), 1962
No. 2/No. 7/No. 20, 1951
No. 2/No. 101, 1961
No. 2 (Untitled), 1963
No. 3 (Bright Blue, Brown, Dark Blue on Wine), 1962
No. 3/No. 13 (Magenta, Black, Green on Orange), 1949
No. 7, 1951
No. 7, 1960
No. 8, 1964 (Weiss TOO)
No. 8 (Multiform), 1949
No. 10, 1950
No. 10, 1952
No. 10, 1958
No. 13 (White, Red on Yellow), 1958
No. 14, 1960
No. 18, 1951
No. 19, 1949
No. 25 (Red, Gray, White on Yellow), 1951
No. 46 (Black, Ochre, Red Over Red), 1957
No. 61 (Rust and Blue) (Brown, Blue, Brown on Blue), 1953
Untitled, 1947 (Anfam 359)
Untitled, 1948 (Anfam 370)
Untitled, 1949 (Weiss 42)
Untitled, 1949 (Anfam 425)
Untitled, 1959 (Weiss 81)
Untitled, 1963 (Anfam 743)
Untitled, 1964 (Weiss 97)
Untitled, 1968 (Anfam 812)
Untitled, 1968 (Weiss 105)
Untitled, 1968 (Weiss 106)
Untitled, 1969 (Weiss 107)
Untitled, 1969 (Weiss 108)
Untitled, 1969 (Weiss 109)
Untitled, 1969 (Weiss 110)
Untitled, 1969 (Weiss 111)
Untitled, 1970 (Anfam 834)

Untitled (Black on Gray), 1969 (Anfam 825)
Untitled (Black on Gray), 1969–70 (Anfam 830)
Untitled (Blue, Green and Brown), 1952
Untitled (Blue, Yellow, Green on Red), 1954
Untitled (Purple, White and Red), 1953

California Impressionists

Benjamin Brown, *The Joyous Garden*
Alson S. Clark, *The Weekend, Mission Beach*
Paul Dougherty, *The Twisted Ledge*
Arthur Hill Gilbert, *Land of Gray Dunes, Monterey*
William F. Jackson, *Radiant Valley*
Alfred Mitchell, *In Morning Light*
Alfred Mitchell, *Sunset Glow, California*
Bruce Nelson, *The Summer Sea*
Edgar Payne, *The Sierra Divide*
Charles Reiffel, *Summer*
William Ritschel, *Purple Tide*
Guy Rose, *Incoming Tide*
Guy Rose, *Laguna Eucalyptus*
Guy Rose, *Mist Over Point Lobos*
Marion Kavanagh Wachtel, *Landscape with Oak Trees*
William Wendt, *I Lifted Mine Eyes Unto the Hills*
William Wendt, *The Silent Summer Sea*
William Wendt, *There Is No Solitude, Even in Nature*
Theodore Wores, *A Hillside in Saratoga*
Theodore Wores, *A Saratoga Road*

Chang Dai-chien

Autumn Mountains in Twilight
Clouded Village
Finger Painting: Splashed Ink on Fiberglass
Landscape
Manchurian Mountains
Panorama of Mount Lu
Red Hills Overshadowed by Snow
Spring Clouds
Summer on California Mountain
Temple in the Mountains

O'Keeffe, Georgia

Brown and Tan Leaves
Dark and Lavender Leaf
From a Shell
In the Patio #1
It Was Yellow and Pink II
Lawrence Tree, The
Leaf Motif #2
Morning Glory with Black, No. 3
Oriental Poppies
Pelvis Series, Red with Yellow
Pelvis with Blue (Pelvis I)
Pelvis with Pedernal
Petunia II
Summer Days
Winter Road I

Untitled (Violet, Black, Orange on Gray), 1953
Untitled (White, Blacks, Grays on Maroon), 1963
White Center (Yellow, Pink and Lavender on Rose), 1950
White, Orange and Yellow, 1953
Yellow and Blue (Yellow, Blue on Orange), 1955

4N. Grace Marie Grafton. *Visiting Sisters.* Berkeley, CA: Coracle Books, 2001. Forty-eight poems inspired by the artwork of various contemporary women artists.

Poppies placed in a goblet for the sake of the artist [Lucia K. Mathews, *California Poppies in a Tall Goblet*]
The Womb [Diane Darrow, *Womb Wonder*]
Here is Paradise [Judy Molyneux, *Leaving Bolinas*]
Threshold [Rose Ann Janzen, *When Crows Get in Your Eyes*]
In the hall [Louise Jarmilowicz, *In the Hall with the Fish*]
Taking it further [Polly Kraft, *White Bowl with Red Delicious*]
Gold trees [Patricia Friend, *44th St Hill*]
No longer unclear [Jane Wilson, *Moon and Tide*]
The Visit [Marianne Kolb, *Woman with Aspersorium #2*]
Viewing Earth [Meinrad Craighead, *Maat Moon*]
Copper Woman [Susan Seddon Boulet, *Copper Woman*]
Why is this woman important? [Marianne Kolb, *The Auditor #2*]
Woman [Elly Simmons, *Woman Series #1*]
An American woman, dressed to kill [Leah Kosh, *Entre Nous #14*]
The Woman with an owl on her head [Leah Kosh, *Bird Communication II*]
Human accomplishment [Millicent Tompkins, *Mt. Tamalpais Angel*]
Still Life [Millicent Tompkins, *... Cupids, Still Life ...*]
The honorable warning [J.A. Durham, *Spectrum Variations*]
Woman and her white shadow [Selina Trieff, *Two Women in Red*]
Back through the calendar [Melissa Wood, *House of Rain*]
Mountains near the eyes [Nicole Dextras, *Offering*]
Placed in the altar's hollow [Beverly Pepper, *San Martin Altar*]
The two muses discovered at the edge of the race track [Selina Trieff, *Two Figures and the Dog*]
Creating a self [Deborah Deichler, *The Chocolate Thief*]
Self-portraits [Harriette Estelle Berman, *The Deceiver and the Deceived*]
Remembering how to [Joyce Stolaroff, *Woman with Mexican Hat*]

Coming to a new country [Carol Mothner, *Melanzanic*]

Red dog [Candace Compton, *Self-Portrait with Guardian Angel*]

The Tiller [Lee Lawson, *The Tiller*]

To get it precisely [Deborah Deichler, *Tomatoes with salt ...*]

Spring equinox [Julie L. Kahn, *Closer*]

Memory strokes the back of the hand [Candace Jans, *Terrace Still Life*]

Her self-portrait [Patty La Duke, *Memories of the Bitter Past*]

Paint the porch white [Evelyn Wander, *Hummingbird's Desire*]

Still time [Greta Barrier, *Fall Delights*]

Formal black and gold [Barbara Rogers, *Tropical Debris 7*]

Building the world [Donna Bittner, *The Crowd*]

Balance? [Joan Fugazi, *Doe Bay*]

Blown glass [Julie Kahn, *Her Cure*]

The sturdiness of the world [Wanda Reis, *Untitled*]

To be in love in that particular [Pascaline, *Romeo and Juliette*]

To be healed [Kayoko Bird, *Yellow Datura*]

Lightshift [Carol Riley, *Lightshaft*]

Worship [Jane Wilson, *Sunday: Towd Pt.*]

Simple Art [Carol Anthony, *Tulip*]

Telling the story [Susan Marie Dopp, *Mi Caratilla*]

The Barn [Pamela Marron, *Leach Farm*]

The Dragon and The Phoenix [Julie Bomberger, *The Final Romance*]

4O. Peter Steele: *Plenty: Art into Poetry.* Melbourne : Macmillan Art Publishing, 2003. Fifty-two poems inspired by art works, reproduced in color, from all over the world. Those on paintings are:

A Chardin [Jean Siméon Chardin, *The White Tablecloth*]

A Fine Time [Petrus Christus, *A Goldsmith in His Shop*]

A Good Friday [Carlo Crivelli, *The Annunciation with Saint Emidius*]

A Haystack [William Delafield Cook, *A Haystack*]

A Resurrection [Don Niccolò Rosselli, *The Resurrection, Easter Day* (illumination)]

Apple [Hans Memling, *Diptych of the Virgin and Child and Maarten Nieuwenhove*]

April 25 [George W. Lambert, *Anzac, the Landing 1915*]

Beginnings [Giovanni di Paolo, *The Creation and Expulsion of Adam and Eve from Paradise*]

Building the Horse [Giovanni Domenico Tiepolo, *The Building of the Trojan Horse*]

Cat on a Balustrade: Summer [Théophile A. Steinien, *Cat on a Balustrade: Summer*]

Cherry from Window [Tosa Mitsuoki, *Flowering Cherry with Poem Slips*]

Cleopatra's Feast with Attendant Lord [Giovanni Battista Tiepolo, *The Banquet of Cleopatra*]

Dreaming the Bridge [Claude Monet, *Bridge over a Pool of Water Lilies*]

Gardener [Lavinia Fontana, *Noli me Tangere*]

Geographer [Jan Vermeer, *The Geographer*]

Innkeeper at Emmaus [Caravaggio, *The Supper at Emmaus*]

Johnson [James Barry, *Samuel Johnson*]

Law [Leonard French, *The Trial*]

Light [Honoré Daumier, *Don Quixote and Sancho Panza*]

Mannix [Clifton E. Pugh, *Portrait of Daniel Mannix*]

Matinée on Friday [Eric Smith, *Head of Christ*]

Orpheus [Rolandt Savery, *Orpheus*]

Plenty [Francisco de Zurbarán, *A Cup of Water and a Rose on a Silver Plate*]

Quince, Cabbage, Melon, Cucumber [Juan Sánchez Cotán, *Quince, Cabbage, Melon, and Cucumber*]

Rounds [Diego Velázquez, *An Old Woman Cooking Eggs*]

Sailor [The Bedford Hours, *The Building of Noah's Ark*]

Sixty [Hugo van der Goes, *Portinari Triptych, Central Panel: Nativity Scene with Adoration of the Shepherds*]

Swift [Charles Jervas, *Jonathan Swift*]

The Concert [Lorenzo Costa, *A Concert*]

The Dice Players [Georges de la Tours, *The Dice Players*]

The Handing Over [Caravaggio, *The Taking of Christ*]

The Resurrection, Cookham [Sir Stanley Spencer, *The Resurrection, Cookham*]

The Return [Pintorcchio (Bernardino di Betto), *Penelope with the Suitors*]

The Sleeping Fool [Cecil Collins, *The Sleeping Fool*]

Waiting for the Revolution [Jan van Eyck, *The Annunciation*]

4P. Mary Jo Bang, *The Eye Like a Strange Balloon.* New York: Grove Press, 2004. Thirty-eight poems rooted in paintings, film, video, photographs, and collage. "In the ekphrastic poems I am taking an existing work of art and rewriting over it. I'm imposing a new narrative on it, one that is partially suggested by the artwork itself and partially by something that comes from within." The poems that "rewrite" paintings:

Rock and Roll Is Dead, The Novel Is Dead, God Is Dead, Painting Is Dead [Bruce Pearson, *Rock and Roll Is Dead, The Novel Is Dead, God Is Dead, Painting Is Dead*]

Tact [Neo Rauch, *Takt*]

Three Trees [Michael Van Hook, *Three Trees*]

How Did the Monkeys Get into My Work? (Or Table Turning) [Sigmar Polke, illustration no. 3]

The Three Lies of Painting [Sigmar Polke, *Die drei Lü der Malerei*]

Rococo [Sigmar Polke, *Rokoko*]

The Magic Lantern [Sigmar Polke, *Laterna Magica*]

Mrs. Autumn and Her Two Daughters [Sigmar Polke, *Frau Herbst und ihre zwei Tochter*]

The End (Or The Falling Out) [Felix Gonzales-Torres, *Untitled (The End)*]

The Tyranny of Everyday Life [Ken Warneke, *The Tyranny of Everyday Life*]

Children's Games [Sigmar Polke, *Jeux d'enfants*]

In the Garden [Paula Rego, *In the Garden*]

Envy and Avarice [Sigmar Polke, *Neid und Habgier II*]

Spots [Sigmar Polke, *Flechen*]

Etched Murmurs (Or The Common Green Libretto) [Dorothea Tanning, *Etched Murmurs*]

Catastrophe Theory IV [Sigmar Polke, *Katastrophentheorie IV*]

Catastrophe Theory III [Sigmar Polke, *Katastrophentheorie III*]

Catastrophe Theory II [Sigmar Polke, *Katastrophentheorie II*]

This Is How You Sit Correctly (After Goya) [Sigmar Polke, *So sitzen Sie richtig (nach Goya)*]

Going Out [Paula Rego, *Going Out*]

It's Always Been Like This [Sigmar Polke, *Das was schon immer so*]

Allegory [Philip Guston, *Allegory*]

Blue Thought Circle [Sigmar Polke, *Blauer Gedankenkreis*]

Cursive Landscape [Jean Dubuffet, *Paysage cursif*]

Alice in Wonderland [Sigmar Polke, *Alice im Wunderland*]

Minnie Mouse [Willem de Kooning, *Minnie Mouse*]

Lovers (Or The Tropic Bride) [Sigmar Polke, *Libesparr*]

Doll [Sigmar Polke, *Puppe*]

In Memory of My Feelings — Frank O'Hara [Jasper Johns, *In Memory of My Feelings — Frank O'Hara*]

Man and Woman [Eokoh Hosoe, No. 24 from the Man and Woman series]

Abstract Painting, Blue [Ad Reinhardt, *Abstract Painting, Blue*]

Study for a Portrait [Francis Bacon, *Study for a Portrait*]

Masquerade [Max Beckman, *Masquerade*]

Birthday [Dorothea Tanning, *Birthday*]

Physiomythological Diluvian Picture [Max Ernst and Hans Arp, *Physiomythological Diluvian Picture*]

Les Demoiselles d'Avignon [Pablo Picasso, *Les Demoiselles d'Avignon*]

The Eye Like a Strange Balloon Mounts Toward Infinity [Odilon Redon, *L'oeil comme un ballon bizarre se dirigevers L'Infini*]

What Moonlight Will Do for Ruins [Mary Jo Bang, *What Moonlight Will Do for Ruins*]

4Q. Laurence Lieberman. *Hour of the Mango Black Moon.* Leeks, UK: Peepal Tree Press, 2004. Poems on the paintings and sculptures of three Caribbean visionary painters. The poems on paintings, eighteen of which are reproduced in color:

After Two Paintings by Stanley Greaves. 1. Madonna with Pumpkin 2. The Neophyte

The Baxter Street Waltz [Stanley Greaves, *Mrs. Baxter*]

The Maverick Hatter [Stanley Greaves, *Hatman*]

Acuity [Stanley Greaves, *Biscuity Story #1*]

Door Stop Amours [Stanley Greaves, *The Visitor*]

Fable of Mismatched Pairs [Stanley Greaves, *Plantation Boots*]

School for Pancaking [Stanley Greaves, *Mr. Facial, No. 2*]

Mapping the Sargasso City [Stanley Greaves, *Prologue: There's a Meeting Here Tonight*]

Hour of Three Black Suns [Stanley Greaves, *The Annunciation*]

Fable of Sky-borne Bananas [Stanley Greaves, *Banana Manna #2*]

Magus with Reverse Bananas [Stanley Greaves, *Magus with Reverse Bananas*]

Hour of the Mango Black Moon [Stanley Greaves, *Morning Mangoes*]

Earl Mug Handle [Ras Akyem Ramsey, *King of Spades*]

Breath from the Mouths of Gloves [Ras Akyem Ramsey, *Scarred*]

Moby at Ringside [Ras Akyem Ramsey, *Moby Dick*]

Stick Paramours [Ras Akyem Ramsey, *Mantis*]

The Grandeur of FootSoles [Ras Akyem Ramsey, *The Sins of Daniel*]

When the Waters Returned [Ras Akyem Ramsey, *Moses*]

Requiem with Trumpeting Elephants [Ras Akyem Ramsey, *Nemesis II*]

Crush into These Blakk [sic] *Feet,* [Ras Akyem Ramsey, *Altar for Jean-Michel Basquiat*]

Marooned [Ras Ishi Butcher, *Isolation*]

Shark at the Gate [Ras Ishi Butcher, *Barb and Thorns*]

Whip Tail of the One-eyed Chief [Ras Ishi Butcher, *400 Years Remix*]

Soil Eyes [Ras Ishi Butcher, *400 Years Remix*]

Aerial Geographies [Ras Ishi Butcher, *High Chambers III*]

Omnivorous [Ras Ishi Butcher, *Starve*]

4R. Rennie McQuilkin. *Private Collection: Poems and Writers Guide.* Simsbury, CT: Antrim House, 2005. Poems written over a period of forty years in

response to works of art ranging from known masterpieces to crayon drawings, graffiti and household objects. The poems on paintings:

In Wyeth [Andrew Wyeth, *Distant Thunder*; *Hay Ledge*; and *Christina's World*]

The Rev. Robert Walker Skates [Sir Henry Raeburn, *The Reverend Robert Walker Skating on Duddingston Loch*]

Sister Marie Angelica Plays Badminton [David Inshaw, *The Badminton Game*]

Last Minute [Winslow Homer, *Sleigh Ride*]

In the Garden [Gustav Courbet, *The Stonebreaker*]

Two Ladies Waltzing [Winslow Homer, *A Summer Night*]

Baptism [John Steuart Curry, *Baptism in Kansas*]

First Snow in the Garden of the Geishas [*Giant Snowball*, eighteenth-century Japanese print]

Young Woman with Wine and Gallants [Pieter de Hooch, *A Woman Drinking with Two Men, and a Serving Woman*]

Five Ways of Looking at a Lightning Rod [Andrew Wyeth, *Northern Point*]

The Rector's Wife [Robert Marx, painting of unknown title]

Pendergast's Garage [Edward Hopper, *Gas*]

A Pair of Hoppers [Edward Hopper, *Office at Night* and *Hotel by a Railroad*]

Brueghel's Players [Pieter Brueghel the Elder, *The Hunters in the Snow*]

Dancing at the Gallows [Pieter Brueghel the Elder, *Magpie on the Gallows*]

Tommie's Tune [Catherine Kingcome, *Tommy's Music/The Source*]

Lair of the Word [Rembrandt van Rijn, *St. Jerome and the Lion*]

Wise Man, Key West [Jacob Lawrence, *Beggar No. 1*]

4S. Elsa Marston. *Songs of Ancient Journeys: Animals in Rock Art.* New York: George Braziller, 2005. A collection of short poems inspired by the rock art, reproduced in color photographs, of the American Southwest, mostly of creatures native to this landscape:

Snake	Lizard	Deer
Bighorn Sheep	Butterfly	Rabbit
Duck	Bison	Dog
Mountain Lion	Elk	Handprint
Turtle	Bear Print	

4T. Jean Gallagher. *Stubborn.* Oberlin, OH: Oberlin College Press, 2006.

Particular Annunciation [Fra Angelico, *Annunciation*]

Annunciation/Expulsion [Giovanni di Paolo]

Annuncio di morte a Maria [Duccio, *Annunciation*]

Spin [Bicci di Lorenzo, *St. Nicholas Providing Dowries to Three Virgins*]

A Short Film about the New Math [Giotto, *Noli Me Tangere*]

Two Sermons [Workshop of Giotto, *St. Francis Preaching to the Birds*]

How Many [Sassetta, *St. Thomas Aquinas in Prayer*]

Detail of Paradise [Giovanni di Paolo, *Paradise*]

Catherine Cycle [seven poems on Giovanni di Paolo's series of paintings on Catherine of Sienna]

Stubborn [twenty eight poems on Duccio's *Maestà Altarpiece*]

4U. Brian Strand. *Poiema: A Selection of Ekphrastic Poems.* Rothesay, Isle of Butte, Scotland: Q.Q. Press, 2006.

In the Gallery [Leonardo da Vinci, *Mona Lisa*]

Epitaph for George [Paolo Uccello, *St. George and the Dragon*]

Rule Britannia [Francoise Taylor, *King Arthur* (engravings)]

Equinity [George Stubbs, horse paintings]

Sylvan Scenes [John Constable, *Spring, East Bergholt Common*]

Cockney Visions [John Constable]

Point to Point [F.C. Turner, *Vale of Aylesbury Steeplechase*]

Blue Nude II [Henri Matisse, *Blue Nude*]

North and South [Pablo Picasso]

Through the Ages [Vincent Van Gogh, *Sunflowers*]

Immanuel [Graham Sutherland, *Christ in Glory*]

One Spring Day in Arras [John Nash, *Over the Top*]

Like Fading Flowers [John Constable, *A Study of Poppies*]

Blue Rider [Julius Exeter]

Go Between (die Brucke) [Ernst Ludwig Kirchner, *The Bridge*]

Muted [Alfons Walde, *Still Life*]

Bella [Marc Chagall, *The Birthday*]

Perspectives [Georgia O'Keeffe, *City Nights*]

Abstract Harmony [Georgia O'Keeffe]

Shipboard Girl [Roy Lichtenstein, *Shipboard Girl*]

Comic Strip [Roy Lichtenstein]

Introversion [Roy Lichtenstein, *Mirror #6*]

Burnt In [Jasper Johns, *Three Flags*]

Paradox [Mark Rothko]

Unframed [Mark Rothko]

Abstract Expressions 1 [Willem de Kooning]

Gouache Cut-Out [Henri Matisse]

4V. Francine Sterle. *Nude in Winter.* Dorset, VY: Tupelo Press, 2006.

Green Violinist [Marc Chagall]

Schiele's Studio, 1909 [Egon Schiele]

Self-Portrait [Henri Toulouse-Lautrec]

Man and Woman [Max Beckman, *Man and Woman*]

Saints for Sale [Berenice Abbott, *Saints for Sale*]

The Batman [Germaine Richier, *The Batman*]

Albion Rose [William Blake, *Albion Rose*]

Harmony [Remedios Varo, *Harmony*]

Madonna in Prayer [Giovanni Battista Salvi da Sassoferrato, *Madonna in Prayer*]

Peaches [Claude Monet, *Peaches*]

Two Fox Running [Sterling Rathsack]

Please Touch [Marcel Duchamp, cover for catalogue of *Le Surréalisme* en 1947]

Satyr and Maenad [Fresco in the Fourth Style, House of the Epigrams, Pompeii]

J.Y.M. Seated III [Frank Auerbach, *J.Y.M. Seated III*]

The Guitar Lesson [Balthus, *The Guitar Lesson*]

Jan van Riemsdyck's Drawing for Tabula XXVI in William Hunter's "Anatomy of the Human Gravid Uterus," 1774, a British Obstetrical Atlas

Dalí's Edibles [*Salvador Dalí*]

Ophelia [Antoine Préault, *Ophelia*]

Lilith [Kiki Smith, *Lilith*]

The Little Hart [Frida Kahlo, *The Little Hart*]

Self-Portrait as an Allegory of Painting [Artemisia Gentileschi, *Self-Portrait as an Allegory of Painting*]

You Cannot Step Twice into the Same Stream [Eleanor Bishop Speare, *You Cannot Step Twice into the Same Stream*]

Dancer with Red Stockings [Edgar Degas, *Dancer with Red Stockings*]

The Trodden Weed [Andrew Wyeth, *The Trodden Weed*]

Renoir

Pink Angels [Willem de Kooning, *Pink Angels*]

Man Pushing Door [Jean Ipousteguy, *Man Pushing Door*]

The Hand of Death [Käthe Kollwitz, *Self-Portrait with Hand of Death*]

Still Life

Buttoned-down Landscape [Dorothy Hall, *Buttoned-down Landscape*]

Parable of the Blind [Pieter Brueghel the Elder, *Parable of the Blind*]

The Yellow Christ [Paul Gauguin, *The Yellow Christ*]

1947-RNo. 2 [Clyfford Still, *1947-RNo. 2*]

Rag in Window [Alice Neel, *Rag in Window*]

Self Portrait [Alice Bailly, *Self-Portrait*]

Array IV [Sarah Walker, *Array IV*]

Nocturne in Blue and Gold: Old Battersea Bridge [James McNeill Whistler, *Nocturne in Blue and Gold: Old Battersea Bridge*]

On a Painting in "Onley's Arctic" [Toni Onley, unidentified painting from Onley's *Arctic: Diaries and Paintings of the High Arctic*]

Sheer Curtains [Luc Tuymans, *Sheer Curtains*]

Red Vision [Leonor Fini, *Red Vision*]

Nietzsche Contemplates Robert Ryman's "Courier II" [Robert Ryman, *Courier II*]

Before the Caves [Helen Frankenthaler, *Before the Caves*]

Solitude [Edward Hopper, *Solitude*]

Autumn Rhythm [Jackson Pollock, *Autumn Rhythm*]

The Uncertainty of the Poet [Giorgio de Chirico, *The Uncertainty of the Poet*]

Dreaming of Picasso

Untitled (rear view of nude) [Man Ray]

Pelvis I (Pelvis with Blue) [Georgia O'Keeffe, *Pelvis I*]

4W. Mary Kaiser. *Falling into Velázquez*. Sleepy Hollow, NY: Slapering Hol Press, 2006.

Falling into Velázquez [Diego Velázquez, *Las Meninas*]

Back [Paul Cézanne, William Hogarth, John Ruskin]

Eakins Makes a Hot Day [Thomas Eakins, *The Pair-Oared Shell*]

The Resistance of Bones [Thomas Eakins]

Naked in Philadelphia [Thomas Eakins, *William Rush and His Model*]

Organized Labor [Diego Rivera, *Detroit Industry*, or *Man and Machine*]

Monet/Corset Shop [Claude Monet, *Rouen Cathedral*]

Late Study in Flesh and Oil [Édouard Manet]

Monkey, Cat, and Dead Hummingbird [Frida Kahlo, *Self-Portrait*]

Joan Mitchell Painting [Joan Mitchell]

The Illusionist [Gerhard Richter, *Annunciation after Titian*, *Abstract Picture*, and *Two Candles*]

4X. Audrey Carangelo. *On the Street: Poems about Paintings*. New York: Scholastic, Inc., 2006.

Dance on the Bridge [Faith Ringgold, *Dancing on the George Washington Bridge*]

Snapshot of My Street [Allan Rohan Crite, *Shadows and Sunlight*]

At the Table [Malcah Zeldis, *Thanksgiving*]

Spring Breeze [Jacob Lawrence, *Street Scene (Boy with Kite)*]

Speed to the Dock [William H. Johnson, *Ferry Boat Trip*]

Dreams [Maria Izquierdo, *Family Portrait*]

Sleet on the Street [Red Grooms, *Slushing*]

4Y. Canvas Press *Collection* series, ed. James Gapinski

Collection: Ekphrastic Poems by Robert Schuler and Janet Butler, No. 1. Delafield, WI: Canvas Press, 2007.

Robert Schuler

Joan Miró, "Chiffres et Constellations," 1941

Seurat at Gravelines

Van Gogh, "Landscape with House and Ploughman"

Janet Butler

Mother Mild, "Madonna col bambino" by Piero della Francesca (1472–74)

A Renaissance Portrait: Mary Magdalene by Il Perugino, Renaissance Painter

Collection: *Ekphrastic Poems by Nilofar Shaikh and F.J. Bergmann*, No. 2. Delafield, WI: Canvas Press, 2007.

> Nilofar Shaikh, *Salvador Dali, "Dream Caused by the Flight of a Bumble Bee around a Pomegranate One Second before Waking Up"*
>
> F.J. Bergmann, *The Green Sun Is Not a Sun* (after the cover image by Michael Burkard from James Wagner's *the false sun recordings*)

Collection: *Ekphrastic Poems by Alberto Nessi and Erocka Ghersi*, No. 3. Delafield, WI: Canvas Press, 2007.

Alberto Nessi
The Temptation of St. Benedict of Ambrogio da Fossano, called Il Bergognone, trans. Brendan and Anna Connell

Erika Ghersi
The Dream (1910) by Henri Rousseau, trans. Toshiya Kamei

4Z. Basil King. *77 Beasts: Basil King's Beastiary.* East Rockaway, NY: Marsh Hawk Press, 2007.

Arshile Gorky, *Diary of a Seducer*
Pablo Picasso, *Portrait of D.M.*
Georges de La Tour, *The New-Born Child*
Fairfield Porter, *A Sudden Change of Sea*
Georgia O'Keeffe, *Sky above Clouds III*
Édouard Manet, *Bar at the Folies-Bergère*
Édouard Manet, *Déjeuner sur l'herbe*
Alice Neel, *Self Portrait*
Giovanni Battista Piranesi, *Carceru d'invenzione No. X*
Winslow Homer, *Kissing the Moon*
Kurt Schwitters, *Glass Flower*
Max Beckman, various Self Portraits
John Frederick Kensett, *Sunset on the Sea*
Willem de Kooning, *Gotham News*
Cy Twombly
Albert Pinkham Ryder
Larry Rivers, *Last Civil War Vet*
Dan Rice, *#13*
Mark Rothko, *Red, Brown, & Black* (1958)
Giorgione (Giorgio Barbarelli), *The Tempest*
Marc Chagall, *The Praying Rabbi*
Philip Guston, *The Room*
Paul Gauguin, *The Yellow Christ*
Titian (Tiziano Vecellio), *Woman in Furs*
Andy Warhol, *Marilyn Monroe*
Rembrandt van Rijn, *Two Self Portraits*
Rembrandt van Rijn, *Self Portrait with Palette and Brush* (Rijkmuseum and Staatliche Gemaldedgalerie)
Rembrandt van Rijn, *Self Portrait* (1667)

Rembrandt van Rijn, *Self Portrait* (1669)
John Constable, *Study of Cirrus Clouds*
Henri Matisse, *Piano Lesson*
John Chamberlain
Giorgio Morandi, *Nature Morte* (1960)
George Ault, *New Moon*
Esteban Vicente, *Interiors*
William Blake, *Two Watercolors*
Egon Schiele
R(onald) B(rooks) Kitaj, *The Jewish Rider*
Piet Mondrian, *Composition No. 2* (1922)
Juan Gris, *Woman with a Basket*
Basil King, *Left-Handed Pitcher*
Basil King, *The Manager*
Frank Stella
Charles Demuth, *My Egypt*
Diego Velazquez, *The Maids of Honor*
Diego Velazquez, *The Maids of Honor (Las Meninas), 1656: Two*
Diego Velazquez, *The Maids of Honor (Las Meninas), 1656: Three*
Diego Velazquez, *The Maids of Honor (Las Meninas), 1656: Four*
Diego Velazquez, *The Maids of Honor (Las Meninas), 1656: Five*
Jan van Eyck/Basil King
Dan Flavin
Josef Albers, *Homage to the Square: Ascending* (1953)
Georges Rouault, *Clown with a Green Cap*
Thomas Eakins, *Home Scene*
Emily Carr, *Wood Interior*
Edward Hicks, *Noah's Ark*
Elsie Driggs, *Pittsburgh*
Walt Kuhn, *Roberto*
Fitz Hugh Lane/John Frederick Kensett
Marsden Hartley, *Painting No. 48*
Marsden Hartley, *Mont Saint-Victorie, Aix-en-Provence* (1927)
Marsden Hartley, *New England Sea View—Fish House*
Marsden Hartley, *Carnelian Country*
Marsden Hartley, *Fisherman's Last Supper*
Marsden Hartley, *Abelard the Drowned, Master of the Phantom*
Marsden Hartley, *The Wave*
Balthus (Count Balthasar Klossowski de Rola), *Nude in Front of a Mantel*
Jean-Michel Basquiat
Bill Traylor
Jean-Auguste-Dominique Ingres, *Madame Moitessier*
Joseph Mallord William Turner, *Rain, Steam, and Speed: The Great Western Railway*
Joseph Mallord William Turner, *The Lake: Petworth, Fighting Bucks*
Bradley Walker Tomlin, *No. 20*
Franz Kline, *Cardinal*

Edward Hopper, *Office in a Small City*
Anonymous, *The Unicorn in Captivity*
Gustave Courbet, *The Trout*
Paul Klee, *Abstract Trio*
Leonardo da Vinci
Jean-Francois Millet, *The Shepherd Tending His Flock*
Camille Pissarro, *Self Portrait*
Thomas Cole/Frederick Edwin Church
Claude Monet, *Water Lilies* (1920)
Claude Monet, *Camille Monet on Her Deathbed, 1979: One*
Claude Monet, *Woman with a Parasol—Madame Monet and Her Son*
Claude Monet, *The Bridge with Water Lilies, 1919*
Claude Monet, *Camille Monet on Her Deathbed, 1979: Two*
Barnett Newman
Arthur Dove
Jean-Antoine Watteau, *Pierrot (Called Gilles)*
Paul Cézanne, *Madame Cézanne in a Red Dress*
Paul Cézanne, *Achile Emperaire*
Ralph Albert Blakelock, *Moonlight*
Vincent van Gogh, *A Pair of Boots*
Vincent Van Gogh, *Theo/Vincent*
Eugène Delacroix, *Women of Algiers*
Edvard Munch, *Ashes*
Robert Rauschenberg, *Bed*

4Za. Gerald Locklin. *The Cézanne/Pissarro Poems.* Huntington Beach, CA: World Parade Books, 2007. Poems based on the exhibition and the catalogue for "Cézanne and Pissarro: Pioneering Modern Painting, 1865–1885," Los Angeles County Museum of Art, December 2005.

Cézanne: "Still Life with Bread and Eggs," 1865
Cézanne: "Still Life with Kettle," 1869
Pissarro: "Still Life," 1876
Cézanne: "The Artist's Father"
Pissarro: "The Banks of the Marne in Winter," 1866
Pissarro: "Square at La Roche-Guyon"
Cézanne's "Uncle Dominique"
Pissarro: "Portrait of Cezanne," 1874
Cezanne: "Still Life with Soup Tureen," 1874
Pissarro: "Route de Gisors: The House of Pere Galien, Pontoise," 1873
Cézanne: "Self-Portrait," 1873–76
Pissarro: "Self-Portrait," 1873
Cézanne and Pissarro: Drawings and Sketches of Each Other
Two Versions of Louveciennes, 1871 [Pissarro] *& 1873* [Cézanne]
"The Conversation" [Pissarro] *and "The House of the Hanged Man"* [Cézanne] *(with a nod to Fershteh Daftari)*
"Village Street" [Pissarro] *and "The House of Doctor Cachet"* [Cézanne]

Still Lifes of the 1870s (with a nod to Jennifer Field)
Auvers-sur and Pontoise
Two Versions of "The Orchard, Saint Denis, at Pontoise," 1878
Turning Points
Gardens, 1872
The Social Worker and the Licensed Contractor: The Late 1870s/Early 1880s
Cézanne: "Pines and Rocks," 1897
Pissarro: "View of Cote des Grouettes," Pontoise, 1878
Pissarro: "Railway Crossing at Le Fastis," 1873–74
Cézanne: "L'Estaque," 1879–83
Pissarro: "Rock Landscape, Montfoucault," 1874
Cézanne: "The Pool at Jas de Bouffon," 1878
Two Views of Jalais Hills, Pontoise
Two Versions of Pontoise, 1882 [Cézanne, *Houses at Pontoise*; Pissarro, *Path and Hills, Pontoise*]
Pissarro was a Person [Pissarro, *L'Ermitage at Pontoise*; Cézanne, *Mill on the Coulouvre, Near Pontoise*]
The Summing Up
"Ave atque Vale": The Chrysalis of Modernism

4Zb. Robert Wynne. *Museum of Parallel Art: Poems.* Huntington Beach, CA: Tebot Bach, 2008. A series of poems on paintings that do not exist — what John Hollander calls "notional ekphrasis." Wynne's unusual ploy is to have one artist comment on the paintings of another, these pairings often apparent in the titles:

Art Appreciation
Currier & Ives' *The Scream*
Anne Geddes' *Guernica*
Theodor Geisel's *Madonna & Child*
Kindergarten Gothic
Goliath
Fernando Botero's *Blue Boy*
Rene Magritte's *Still Life*
Norman Rockwell's *Saturn Devouring One Of His Children*
Sandro Botticelli's *The Birth of Dogs Playing Poker*
William Wegman's *Portrait of Giovanni Arnolfini and His Wife*
Paul Delvaux's *The Rehearsal*
Ansel Adams' *Three Musicians*
Piet Mondrian's *Starry Night*
Nude Descending a Staircase
Wassily Kandinsky's *Campbell's Soup Can*
Andy Warhol's *Haystacks*
Jean-Michel Basquiat's *Marilyn*
Pablo Picasso's *Still Life with Weeping Woman*
Vincent Van Gogh's *Mona Lisa*
Pablo Picasso's *Portrait of His Mother: Arrangement in Blue and Gold, No. 1*
Giuseppe Arcimboldo's *George Washington*
The Ceiling of the Cistine Chapel

Jackson Pollock's *Landscape with the Fall of Icarus*
Yves Klein's *A Bigger Splash*
Roy Lichtenstein's *Sunday Afternoon on the Island of la Grande Jatte*
Michelangelo's *Venus de Milo — Restored*
Georgia O'Keeffe's *Irises*
Walt Disney's *The Last Judgment*
Edward Hopper's *Nighthawks at The Last Supper*
Dan Flavin's *The Kiss*
Marc Chagall's *Velvet Elvis*
Christo's *Piss Christ*
Thomas Kinkade's *The Crucifixion*
Claude Monet's *Persistence of Memory*
Claes Oldenburg's *Soft Thinker*
Self-Portrait: Salvador Dali with Water Lilies

4Zc. Therese L. Broderick. *Within View: Poems Inspired by Artworks.* Saratoga Springs, NY: Leonard Design, 2008. Thirteen poems of works of art. Those on paintings:

Small Tease [Sally Easterly, *Girl with Red Hair*]
Oxbow [Stephen Hannock, *The Oxbow, After Church, After Cole, Flooded*]
Les Dindons [Claude Monet, *Les Dindons*]
Touches of Red [Helen M. Turner, *Morning News*]
Death on the Ridge Road [Grant Wood, *Death on the Ridge Road*]
Full Moon [Roger Holton, *Full Moon*]
What Still Hangs [Paul Laird Broderick, untitled painting]

4Zd. Alan Catlin, *Effects of Sunlight in the Fog.* Treadwell, NY: Bright Hill Press, 2008.

James McNeill Whistler
Nocturne
Nocturne: Blue and Gold
Nocturne in Blue & Silver
Nocturne in Grey and Silver
Chelsea in Ice
Red and Gold: Salute Sunset
Nocturne in Blue and Gold: The Falling Rocket (No. 50)
Symphony in White, No. 2

George Inness
Home at Montclair

Claude Monet
Waterloo Bridge: Effect of Sunlight in the Fog

Houses of Parliament: Effect of Sunlight in the Fog
Views of Charing Cross Bridge

Winslow Homer
Perils of the Sea
The Life Brigade
The Houses of Parliament
The Wreck of the Iron Crown
The Gale
A Voice from the Cliffs
Girl with Red Stockings

Edvard Munch
The Seine at St. Cloud

Pierre Bonnard
Bonnard, wife in her bath

4Ze. Frank Waaldjik. *Trijntje Fop.* http://home. hetnet.nl/~sufra/trijntjefop1.htm. More than 100 light verse poems by a Dutch visual artist that refer, often glancingly, to well-known art works. "Trijntje Fop," the nom de plume of the Dutch poet Kees Stip, derives from the Dutch satirist Multatuli (pseudonym of Eduard Douwes Dekker). "Trijntje Fop" was the name of a character in a short poem in Multatuli *Ideas*: "My name is Tryjntje Fop / And I have a cap on my head." The name has come to stand for light verse about animals with human characteristics. The poems ordinarily have six lines with an *aabbcc* rhyme scheme, and are replete with puns, spoonerisms, and other paranomastic devices. They typically begin with "Op n ..." ("On a ..."), as in *On an Octopus* or *On a Walrus*. The first ten poems that refer to paintings are:

Op n Zebra [Pablo Picasso, *Guernica*]
Op n Rogh [Vincent Van Gogh, *Still Life with Fish*]
Op n Leeuwerik [Henri Matisse, *Drawing with Scissors*]
Op n Valk [Rembrandt, *Paradise Birds*]
Op n Kip [El Greco, *The Holy Family*]
Op n Nijlpaardenteek [Joseph Beuys, *Drawing*]
Op n Neushoorn [*The Garden of Earthly Delights*, right panel]
Op n Tijger [Henri Rousseau, *Tiger in a Tropical Storm*]
Op n Brandgans [Leonardo da Vinci, *Mona Lisa*]
Op n Walrus [Pieter Brueghel the Elder, *Landscape with the Fall of Icarus*]

5. Journals and Web Sites

Ekphrasis: A Poetry Journal. Ed. Laverne Firth and Carol Firth. Sacramento, CA: Firth Press. Issued twice annually, beginning in 1997. Each volume contains six issues.

A Prairie Schooner Portfolio: Ekphrastic Poems. Prairie Schooner 79, no. 4 (Winter 2005): 21–62.

Beauty/Truth: A Journal of Ekphrastic Poetry. Ed. James Gapinski. Delafield, WI: Beauty/Truth Press. Vol. 1, no. 1 (Fall 2006) and continuing.

Cæsura: The Journal of the Poetry Center San Jose. Fall 2007

Mississippi Review 14, no. 4 (October 2008). Ekphrasis issue. http://www.mississippireview.com/2008/Vol14No4-Oct08/

The Hiss Quarterly, 5, no. 3 (August–November 2008): *Ekphrasmagoria.* http://www.thehissquarterly.net/eck/rearview.html

Big City Lit. May 2002. Ekphrasis issue. http://www.bigcitylit.com/may2002/contents/poetry.html#Preface

Student Communication contains an "Art Poems Blog" with numerous poems about paintings. http://la883communication.blogspot.com/2008/09/art-poems-blog.html.

6. List of Poets with Their Ekphrastic Works

This list, alphabetical by poet, includes the name of the poet and the title of the poem (first line), the name of the painter and the title of the painting, when not obvious in the poem's title (second line), and the source of the poem (third line).

AAFJES, Bertus, *Altaarstuk naar Jan van Eyck*
Adam and Eve from the van Eyck altarpiece,
Source: Korteweg and Heijn (2F, above), 65

Aafjes, Bertus, *Meester Frans*
Franz Hals, *The Governors of the Old Men's Almhouse at Haarlem*
Source: Korteweg and Heijn (2F, above), 109–10

Aafjes, Bertus, *Portret van Titus in het Louvre*
Rembrandt van Rijn, *Portrait of Titus*
Source: Korteweg and Heijn (2F, above), 142

Aafjes, Bertus, *Het Joodse Bruidje*
Rembrandt van Rijn, *Portrait of Isaac and Rebecca (The Jewish Bride)*
Source: Korteweg and Heijn (2F, above), 147

AARON, Jonathan, *Kurt Schwitters' Real Name*
Kurt Schwitters, *Merz, 19, 1920*
Source: Hollander and Weber (1H, above), 16–18

ABEL, Lionel, *On Man Considered as an Instrument for Hurting (as represented in the painting of Matta)*
Roberto Matta
Source: *Art News* 58 (March 1959): 44–5

ABLON, Steven, *Crows in the Wheatfields*
Vincent Van Gogh, *Wheatfield with Crows*
Source: *Ekphrasis* 1, no. 1 (Summer 1997): 15

ABSE, Dannie, *Crepuscolo*
Michelangelo, *Crepuscolo*
Source: Abse (2D, above), 42–3

Abse, Dannie, *The Merry-go-Round at Night*
Mark Gertler, *The Merry-go-Round*
Source: Adams (1B, above), 82–3

Abse, Dannie, *Brueghel in Naples*
Pieter Brueghel the Elder, *Landscape with the Fall of Icarus*
Source: Benton and Benton, *Picture Poems* (2H, above), 14–15

ACKERMAN, Diane, *Watercolor by Paul Klee*
Paul Klee, *Dance You Monster to My Soft Song*
Source: Diane Ackerman, *Origami Bridges: Poems* (New York: HarperCollins, 2002), 107

ADAMS, Anna, *Totes Meer — by Paul Nash, 1940–41*
Paul Nash, *Totes Meer (Dead Sea)*
Source: Anna Adams, *Green Resistance: New and Selected Poems* (London: Enitharmon, 1996), 20; Abse (2D, above), 132; and Benton and Benton, *Painting with Words* (2G, above), 46–7

Adams, Anna, *Perspective Is Bunk*
Meindert Hobbema, *The Avenue at Middelharnis*
Source: Benton and Benton, *Picture Poems* (2H, above), 28–9

Adams, Anna, *The Mysteries of Perspective*
Meindert Hobbema, *The Avenue at Middelharnis*
Source: Benton and Benton, *Picture Poems* (2H, above), 28–9

Adams, Anna, *To Titus, Rembrandt's Son*
Rembrandt van Rijn, *Portrait of Titus*
Source: Benton and Benton, *Picture Poems* (2H, above), 44–5

Adams, Anna, *"Prince Baltasar Carlos in Silver," by Velásquez, and "Miss Cicely Alexander," by Whistler*
Source: Benton and Benton, *Picture Poems* (2H, above), 54–5

Adams, Anna, *Jean Arnolfini and His Wife*
Jan Van Eyck, *The Arnolfini Marriage*
Source: Benton and Benton, *Double Vision* (2E, above), 21–3

Adams, Anna, *Boulogne Sands*
Philip Wilson Steer, *Boulogne Sands*
Source: Anna Adams, *Green Resistance: New and Selected Poems* (London: Enitharmon, 1996), 21; and

Benton and Benton, *Painting with Words* (2G, above), 7–8

Adams, Anna, *Three Women Who Live in Art: A Triptych. 2. "Mother with Two Children" by Egon Schiele. 3. A Duccio Madonna and Child*
Source: Anna Adams, *Green Resistance: New and Selected Poems* (London: Enitharmon, 1996), 64–5

Adams, Anna, *The Dismantling of the Yellow House at Arles*
Vincent Van Gogh
Source: Anna Adams, *Green Resistance: New and Selected Poems* (London: Enitharmon, 1996), 17–19

ADAMS, Lavonne J., *Close-up, Lake George*
Georgia O'Keeffe
Source: *Poet Lore* 103, no. 1–2 (Spring–Summer 2008): 28

ADAMS, Leah Grace, *Little Space*
Edward Hopper, *Room in New York*
Source: Janovy (1O, above), 21

ADAMS, Max, *Love at First Sight*
Lowell Fox, *Skateboard II*
Source: http://lowellfox.com/page5-contributingpoets/index.htm#skateboard_II

ADCOCK, Betty, *Untitled Triptych*
Anselm Kiefer, *Untitled*, 1980–86
Source: Betty Adcock, *Intervale* (Baton Rouge: Louisiana State University Press, 2001), 46–8; and Paschal (1G, above), 137–9

AGEE, Chris, *The Ivy Room*
Tony O'Malley, *Ghost of a Place*
Source: Reid and Rice (1J, above), 66–7

AGEE, Jonis, *In The Family Hour*
Jules Olitski, *Absolom Passage—18*
Source: Tillinghast (1F, above), 84–7

AGOSIN, Marjorie, Untitled [1 and 2]
Lesley Dill, *Clothe My Naked Body, Print Tapestries ... Poem Wedding Dress*
Source: http://www.wellesley.edu/DavisMuseum/whatsnew/museumcast.xml; podcast available at site: dmcc_poetry04.mp3

AGUIAR, Marta-Alexandra Silva, *Nighthawks*
Edward, Hopper, *Nighthawks*
Source: http://www.redbubble.com/people/malexaguiar/writing/818518-nighthawks

AISENBERG, Nadya, *Humility*
Agnes Martin, pencil drawing
Source: *Ekphrasis* 1, no. 3 (Spring–Summer 1998): 37

AITCHISON, James, *Uncertain Grace*
Sir Henry Raeburn, *Rev. Robert Walker Skating at Duddingston Loch*
Source: Abse (2D, above), 75–6

ALBERTI, Rafael, *Blue*
More than a dozen painters from Fra Angelico to Picasso
Source: Abse (2D, above), 109–11

Alberti, Rafael, *Botticelli*
Sandro Botticelli, *The Birth of Venus*
Source: Kranz (2B, above), 111

Alberti, Rafael. For additional Alberti poems on painters, see 4J, above

ALDERSON, Jo Bartels, *To Gilbert Stuart from His Subject*
Gilbert Stuart, *Mrs. Aaron Davis*
Source: *Wisconsin Poets* (1E, above), 18–19

ALDRICH, Thomas Bailey, *Sargent's "Portrait of Edwin Booth"*
Source: *An American Anthology, 1787–1900*, ed., Edmund Clarence Stedman (Boston: Houghton Mifflin, 1900), 381

ALEXANDER, Elizabeth, *Bearden*
Romare Bearden
Source: *The Venus Hottentot Poems* (St. Paul, MN: Graywolf Press, 2004), 33; rpt. in Elizabeth Alexander and Lyrae Van Clief-Stefanon, *Poems in Conversation and a Conversation* (Sleepy Hollow, NY: Slapering Hol Press, 2008), 15

Alexander, Elizabeth, *"Reclining Nude," c. 1977, Romare Bearden*
Source: Elizabeth Alexander and Lyrae Van Clief-Stefanon, *Poems in Conversation and a Conversation* (Sleepy Hollow, NY: Slapering Hol Press, 2008), 13–14

Alexander, Elizabeth, *Painting (Frida Kahlo)*
Source: Elizabeth Alexander, *The Venus Hottentot Poems* (St. Paul, MN: Graywolf Press, 2004), 37

Alexander, Elizabeth, *Monet at Giverny*
Source: Elizabeth Alexander, *The Venus Hottentot Poems* (St. Paul, MN: Graywolf Press, 2004), 38

Alexander, Elizabeth, *Tanner's "Annunciation"*
Henry O. Tanner, *The Annunciation*
Source: Elizabeth Alexander, *American Sublime* (St. Paul, MN: Graywolf Press, 2005), 90

Alexander, Elizabeth, *Islands Number Four*
Agnes Martin, *Islands No. 4*, ca. 1961
Source: Hollander and Weber (1H, above), 80–1

ALLBERY, Debra, *Figure/Ground*
Franz Kline, *To Win*
Source: Tillinghast (1F, above), 62–3

Allbery, Debra, *Courbet*
Source: *Courtland Review* Spring 2008. http://www.cortlandreview.com/features/08/spring/allbery.html

Allbery, Debra, *How To Explain Pictures to a Dead Hare*
Joseph Beuys
Source: *Courtland Review* Spring 2008. http://www.cortlandreview.com/features/08/spring/allbery.html

ALLGREN, Joe, *The Way*
El Greco, *Pieta*
Source: http://127.0.0.1:4664/cache?event_id=191847&schema_id=6&q=%22will+greenway%27s+course+pac%22&s=RLbGG84Ki7pwWxb4d-rsoWuHfYk

Allgren, Joe, *Ekphrasis: After El Greco's "Fable"*
Source: http://www.agentofchaos.com/a04_poems.html#allgren02

ALLMAN, John, *After Paintings by Jonathan Green: "Formal," "The Wash," "Feast," and "Blues Singer"*
Source: *Ekphrasis* 3, no. 5 (Spring–Summer 2005): 36–9

Allman, John, *William Morris Boating up the Thames to Kelmscott Manor*
Source: John Allman, *Clio's Children* (New York: New Directions, 1985), 21–5

Allman, John, *Creatures of Heaven and Earth*
Ten poems on illustrations in the calendar for 1983 by the Metropolitan Museum of Art: *Ruffled Grouse in the Forest*; *Animals and Birds of the Forest*; *Three-Tailed Cat Clinging to a Peony Branch*; *Pigs in the Meadow*; *Birds on a Fence*; *Bullfight*; *Camels Led by an Angel*; *Imperial Dragon with Flaming Pearl*; *Darius and the Herdsmen*; and *Pastoral Scene*
Source: John Allman, *Scenarios for a Mixed Landscape* (New York: New Directions, 1986), 47–56

ALLNUTT, Gillian, *The Death of Pietro Faldi*
Antonio Pisanello, *Princesse de la Maison d'Este*
Source: Gillian Allnutt, *Nantucket and the Angel* (Newcastle upon Tyne, UK: Bloodaxe Books, 1997), 28

Allnutt, Gillian, *After Vermeer's "Lady and Her Maid-servant"*
Jan Vermeer, *Lady with Her Maid Servant*
Source: Gillian Allnutt, *Nantucket and the Angel* (Newcastle upon Tyne, UK: Bloodaxe Books, 1997), 29

Allnutt, Gillian, *Preparing the Icon: Andrej Rublev (c. 1370–c. 1430) Instructs His Apprentices*
Source: Gillian Allnutt, *Blackthorn* (Newcastle upon Tyne: Bloodaxe Books, 1994), 46

ALLSTON, Washington, *Sonnet on Rembrandt: Occasioned by His Picture of Jacob's Dream*
Source: *Lectures on Art and Poems* (1850) and *Monaldi* (1841) (Gainesville, FL: Scholars' Facsimiles and Reprints, 1967), 274

Allston, Washington, *Sonnet on the Group of Three Angels before the Tent of Abraham, by Raffaelle, in the Vatican*
Raphael, *Abraham and the Three Angels*
Source: *Lectures on Art and Poems* (1850) and *Monaldi* (1841) (Gainesville, FL: Scholars' Facsimiles and Reprints, 1967), 274; and in Hollander (2I, above), 133

Allston, Washington, *Sonnet on Seeing the Picture of Aeolus by Pelligrino Tibaldi, in the Institute at Bologna*
Source: *Lectures on Art and Poems* (1850) and *Monaldi* (1841) (Gainesville, FL: Scholars' Facsimiles and Reprints, 1967), 275

Allston, Washington, *Sonnet on the Pictures by Rubens in the Luxembourg Gallery*
Source: *Lectures on Art and Poems* (1850) and *Monaldi* (1841) (Gainesville, FL: Scholars' Facsimiles and Reprints, 1967), 277

Allston, Washington, *To My Venerable Friend, The President of the Royal Academy*
Benjamin West
Source: *The Poets and Poetry of America*, ed., Rufus W. Griswold (Philadelphia: Parry and Macmillan, 1858), 94–5

ALSTEIN, Marc van, *Breugel, de jagers in de sneeuw*
Pieter Brueghel the Elder, *Hunters in the Snow*
Source: Korteweg and Heijn (2F, above), 90

ALVI, Moniza, *Only Dali, or the Gods*
Salvador Dali, *Metamorphosis of Narcissus*
Source: Benton and Benton, *Picture Poems* (2H, above), 16–17

Alvi, Moniza, *Swinging*
Wassily Kandinsky, *Swinging*
Source: Benton and Benton, *Picture Poems* (2H, above), 34–5

Alvi, Moniza, *I Would Like to be a Dot in a Painting by Miró*
Joan Miró, *Mural, March 20, 1961*
Source: Benton and Benton, *Painting with Words* (2G, above), 42–3

AMES, Evelyn, *Van Gogh: (1) The Field; (2) A Tea Garden; (3) Flowering Stems*
Source: Evelyn Ames, *The Hawk from Heaven* (New York: Dodd, Mead, 1957), 17–19

AMIN, Shurooq, *Tehura*
Paul Gauguin, *The Seed of Aroei*
Source: *Ekphrasis* 4, no. 3 (Spring–Summer 2007): 24–5

Amin, Shurooq, *Georgia's Plains*
Georgia O'Keeffe, *Series I—From the Plains*
Source: *Beauty/Truth: A Journal of Ekphrastic Poetry* 1, no. 1 (Fall–Winter 2006): 26

Amin, Shurooq, *Paneled Lyricism*
Wassily Kandinsky, *Panel for Edward R. Campbell No. 4*
Source: *Beauty/Truth: A Journal of Ekphrastic Poetry* 1, no. 1 (Fall–Winter 2006): 27–8

ANDERS, Richard, *Musées Royaux des Beaux Arts*
Pieter Brueghel the Elder, *Landscape with the Fall of Icarus*
Source: Richard Anders, *Preußische Zimmer* (Darmstadt: Bläschke, 1975); and Achim Aurnhammer and Dieter Martin, eds., *Mythos Ikarus: Texte von Ovid bis Wolf Biermann* (Leipzig: Reclam, 2001), 209.

ANDERSON, Jack, *Still Life Variations (Hommage à Georges Roualt)*
Source: *College Art Journal* 19 (Fall 1959): 75–7

ANDERSON, John M., *Manhunt for Osama: Book of Kells, AD 800*
Source: *Beloit Poetry Journal* 59, no. 2 (Winter 2008–09): 32

Anderson, John M., *The Baghdad Zoo: Albrecht Durer, 1515*
An unidentified etching by Albrecht Dürer
Source: *Beloit Poetry Journal* 59, no. 2 (Winter 2008/09): 33

ANDERSON, Kath M., *As Could the Sea*
Milton Avery, *Haircut by the Sea*
Source: Holcomb (1I, above), 18–21

ANDERSON, Nathalie F., *Daylight Raid from my Studio Window, 7 July 1917*
Sir John Lavery, *Daylight Raid from my Studio Window, 7 July 1917*
Source: Reid and Rice (1J, above), 70–1

ANDREEVSKI, Petre M., *The Handsome Goat*
Dimitar Manev, *Woman and Goat*
Source: Martinovski (2K, above), 115

ANDRUETTO, Maria Teresa, *The Pears*
Pablo Picasso, *Dish of Pears*
Source: Greenberg, *Side* (2M, above), 14–15

ANKER, Robert, *Kleine Geschichte des historischen Materialismus. De val van Icarus*
Pieter Brueghel the Elder, *Landscape with the Fall of Icarus*
Source: Robert Anker, *Gedichten* (Leuven, 1981)

Anker, Robert. *Landschap met de val van Icarus*
Pieter Brueghel the Elder, *Landscape with the Fall of Icarus*
Source: Robert Anker, *Van het balkon* (Amsterdam: Querido, 1983), 21, and Korteweg and Heijn (2F, above), 85

Anker, Robert, *De thuiskomst van de jagers*
Pieter Brueghel the Elder, *Hunters in the Snow*
Source: Korteweg and Heijn (2F, above), 94

ANONYMOUS, *Lines Suggested by David's Picture of Napoleon Asleep in His Study..."*
Source: *Emerald and Baltimore Literary Gazette*, 1 March 1843: 426.

Anonymous, *On the Picture of a Young Lady Drawn in the Picture of Diana*
Source: *Boston Gazette*, 15 September 1755

Anonymous (unidentified high school student), *Nighthawks*
Edward Hopper, *Nighthawks*
Source: http://www.theWriteGallery.com/writing/hoppers_nighthawks.html

ANTESKI, Ivica, *Bright Balls*
Vincent Van Gogh, *Starry Night*
Source: Martinovski (2K, above), 99

ANTONY, Katie, *Brewing*
Nathan Oliveira, *Couple in Bed*
Source: *Beauty/Truth: A Journal of Ekphrastic Poetry* 1, no. 1 (Fall–Winter 2006): 7

APOLLINAIRE, Guilliame, *Pablo Picasso*
Source: *Yale French Studies* 21 (1958): 10

APPLEWHITE, James, *On Winslow Homer's "Weaning the Calf"*
Source: Paschal (1G, above), 56–8

ARAGON, Louis, *Discours pour les grands jours d'un jeune home appelé Pablo Picasso*
Pablo Picasso, *Guernica*
Source: Maurisson and Verlet (2L, above), 135–42

ARCHER, Colin, *Nebuchadnezzar*
William Blake, *Nebuchadnezzar*
Source: Adams (1B, above), 34–7

ARENDT, Erich, *Pieter Brueghel III*
Pieter Brueghel the Elder, *Landscape with the Fall of Icarus*
Source: Erich Arendt, *Aus fünf Jahrzehnten: Gedichte* (Rostock: Hinstorff, 1968), 112–13; and Achim Aurnhammer and Dieter Martin, eds., *Mythos Ikarus: Texte von Ovid bis Wolf Biermann* (Leipzig: Reclam, 2001), 190–1

ARETINO, Pietro, *Sonnet*
Titian, *Portrait of Francesco Maria della Rovere, Duke of Urbino*
Source: Hollander (2I, above), 107

ARMITAGE, Simon, *Millet: The Gleaners*
Jean-François Millet, *The Gleaners*
Source: Simon Armitage, *Kid* (London: Faber and Faber, 1992), 71

ARNBACK, Birthe, *Mona Lisa*
Leonardo da Vinci, *Mona Lisa*
Source: Kranz (2B, above), 137

ASH, John, *Poor Boy: Portrait of a Painting*
Henry Wallis, *Chatterton*

Source: Abse (2D, above), 86–7; and Benton and Benton, *Double Vision* (2E, above), 80

ASHBERY, John, *The Double Dream of Spring*
Giorgio de Chirico, *The Double Dream of Spring*
Source: John Ashbery, *The Double Dream of Spring* (New York: Dutton, 1970), 41–2; rpt. in Ashbery's *The Mooring of Starting Out: The First Five Books of Poetry* (Hopewell, NJ: Ecco Press, 1997), 254–5

Ashbery, John, *Self-Portrait in a Convex Mirror*
Francesco Parmigianino, *Self-Portrait*
Source: *Self-Portrait in a Convex Mirror: Poems by John Ashbery* (New York: Viking, 1975), 68–83

Ashbery, John, *Carvaggio and His Followers*
Caravaggio, Mattia Preti, Luca Giordano
Source: John Ashbery, *Your Name Here* (New York: Farrar, Straus and Giroux, 2000), 19–20

Ashbery, John, *Victrola floribunda*
Dorothea Tanning, *Victrola floribunda*
Source: Dorothea Tanning, *Another Language of Flowers* (New York: Braziller, 1998), plate 10

Ashbery, John. On Ashbery's extended poem on Henry Darger, see 3D, above.

ASHER, Sandy, *Pas des Trois*
Jackson Pollock, *Number 27*
Source: Greenberg, *Heart* (2J, above), 64–5

ASKEW, J. Stiles, *Edward Hopper's "Office at Night, 1940"* (part 1 of *Moments*)
Source: *Rattle* 14, no. 1 (Summer 2008): 10–11

ASSAM, Nigel, *Saint Thomas*
Caravaggio, *The Incredulity of Saint Thomas*
Source: *Ekphrasis* 2, no. 3 (Fall–Winter 2003): 35

ATIK, Anne, *Against Rembrandt*
Rembrandt van Rijn
Source: Anne Atik, *Offshore* (London: Enitharmon, 1992), 12–13

Atik, Anne, *"Als Ich Can" 17 June 1439*
Jan van Eyck, *Portrait of a Man (Self-Portrait?)*
Source: Anne Atik, *Offshore* (London: Enitharmon, 1992), 14–16

Atik, Anne, *At the Wallace Collection: "Titus" and "Lady with a Fan"*
Rembrandt van Rijn, *Titus*; Diego Velázquez, *The Lady with a Fan*
Source: Anne Atik, *Offshore* (London: Enitharmon, 1992), 17–18

ATTHILL, Robin, *Van Gogh*
Vincent Van Gogh, images from several paintings
Source: *Poems from New Writing 1936–1946*, ed. John Lehman (London: John Lehman, 1947), 82

ATWOOD, Margaret, *Manet's Olympia*
Édouard Manet, *Olympia*

Source: Margaret Atwood, *Morning in the Burned House: New Poems* (Boston: Houghton Mifflin, 1995), 24–5.

AUBERT, Alvin, *Abstractions/from Paintings by William H. Johnson (1901–1970)*
William H. Johnson, painting of a tree; *Street Musicians*; and *Ezekiel*
Source: Alvin Aubert, *If Winter Come: Collected Poems 1967–1992* (Pittsburgh, PA: Carnegie Mellon University Press, 1994), 54–6

AUDEN, W.H., *Musée des Beaux Arts*
Pieter Brueghel the Elder, *Landscape with the Fall of Icarus*
Source: W.H. Auden, *Collected Poems* (New York: Random House, 1976), 146–7; Hollander (2I, above), 249; Abse (2D, above), 16; Kehl (2A, above), 106–7; Kranz (2B, above), 78; Benton and Benton, *Double Vision* (2E, above), 95; and Thomas R. Arp and Greg Johnson, eds., *Perrine's Sound and Sense: An Introduction to Poetry*, 12th ed. (Boston: Thomson Higher Education, 2008), 344

Auden, W.H., and Charles Kallman, Libretto for Stravinsky's opera *The Rake's Progress*
William Hogarth, *The Rake's Progress*
Source: *Libretti and Other Dramatic Writings by W. H. Auden, 1939–1973* (Princeton: Princeton University Press, 1993)

AULL, Felice, *Alice Neel Paints a Portrait*
Alice Neel, *Self-Portrait at 75*
Source: *Ekphrasis* 3, no. 5 (Spring–Summer 2005): 42

AWALT, Chris, *And What Is to Stop a Van Gogh*
Vincent Van Gogh
Source: *Ducts.org* 21 (Summer 2008). http://www.ducts.org/content/and-what-is-to-stop-a-van-gogh/

BAAREN, Theo van, *De zwerver*
Hieronymus Bosch, *The Prodigal Son*
Source: Korteweg and Heijn (2F, above), 70

BABYLON, Frans, *Rembrandt*
Rembrandt van Rijn, *Self-Portrait* (1667)
Source: Korteweg and Heijn (2F, above), 152

BACKUS, Barbara, *The City*
Stephen Hannock, *American City with Restored Park*
Source: *Texts with Vistas* (3I, above)

BAKER, Carlos, *On a Landscape of Sestos*
Unidentified landscape
Source: Helen Plotz, ed., *Eye's Delight: Poems of Art and Architecture* (New York: Greenwillow Books, 1983), 30

Baker, Carlos, *A Chinese Mural*
Unidentified mural

Source: Helen Plotz, ed. *Eye's Delight: Poems of Art and Architecture* (New York: Greenwillow Books, 1983), 31

BAKER, David, *White Violets and Coal Mine*
Charles Burchfield, *White Violets and Coal Mine*
Source: David Baker, *Midwest Eclogues* (New York: Norton, 2005), 41–5

Baker, David, *The Judas-Horse*
George Catlin
Source: David Baker, *Midwest Eclogues* (New York: Norton, 2005), 20–1

BAKEVSKI, Petre, *Between Illusion and Reality—the Lake of Vangel Naumovski*
Vangel Naumovski
Source: Martinovski (2K, above), 116

BAKKEN, Christopher, *Detail from "The Martyrdom of San Mauricio," El Greco*
El Greco, *The Martyrdom of San Mauricio*
Source: Christopher Bakken, *Goat Funeral* (Riverdale-on-Hudson, NY: Sheep Meadow Press, 2006), 48.

BALL, Angela, *The Bath*
Pierre Bonnard, *The Bath*
Source: *Ekphrasis* 4, no. 2 (Fall–Winter 2006): 6

BANG, Mary Jo, *Landscape with the Fall of Icarus*
Pieter Brueghel the Elder, *Landscape with the Fall of Icarus*
Source: *New Yorker* (12 March 2007); rpt. in Bang's *Elegy* (St. Paul, MN: Greywolf, 2007), 24

Bang, Mary Jo, *Hell*
Hieronymus Bosch, right triptych of *The Garden of Earthly Delights*
Source: *Prairie Schooner* 79, no. 4 (Winter 2005): 50–1; rpt. in Bang's *Elegy* (St. Paul, MN: Greywolf, 2007), 39

Bang, Mary Jo. For thirty-eight of Bang's poems that "rewrite" paintings, see 4P, above.

BANKS, Rebekah, *In Window, from Within*
Georgia O'Keeffe, *New York, Night*
Source: Janovy (1O, above), 11

BARBIERO, Daniel, *Frederic Church's "West Rock"*
Source: *Ekphrasis* 4, no. 4 (Fall–Winter 2007): 38–9

BARKER, Francis, *Just Passing*
Vincent Van Gogh, *Cornfield with Crows*
Source: Benton and Benton, *Double Vision* (2E, above), 40–1

BARKER, George, *Two Poems for Painters: 1. To Kit Barker 2. To Francis Bacon*
Source: George Barker, *Collected Poems* (London: Faber & Faber, 1986), 356–7

Barker, George, *The Images of Hieronymus Bosch*

Source: George Barker, *Street Ballads* (London: Faber & Faber, 1992), 46–7

Barker, George, *Funeral Eulogy for Robert Colquhoun*
Source: George Barker, *Collected Poems* (London: Faber and Faber, 1987), 437–40

Barker, George, *For Patrick Swift*
Source: George Barker, *Street Ballads* (London: Faber and Faber, 1992), 6–7

BARKER, Wendy, *Light Pink Octagon*
Richard Tuttle, Tintex-dyed canvas, 1967
Source: *Georgia Review* (Summer 2008): 245

BAR-NADAV, Hadara, *Birds of Prey*
Kiki Smith, *Come Away from Her*
Source: Hadara Bar-Nadav, *A Glass of Milk to Kiss Goodnight* (Chesterfiled, MO: IntuiT House, 2007), 13

Bar-Nadav, Hadara, *Sustenance and the Ark*
Enrique Martinez Celaya, *The Helper*
Source: Hadara Bar-Nadav, *A Glass of Milk to Kiss Goodnight* (Chesterfiled, MO: IntuiT House, 2007), 24

Bar-Nadav, Hadara, *Musical Accompaniment for Edward Hopper*
Edward Hopper, *Room in New York*
Source: Hadara Bar-Nadav, *A Glass of Milk to Kiss Goodnight* (Chesterfiled, MO: IntuiT House, 2007), 36

Bar-Nadav, Hadara, *Accumulation under the Tongue*
Marcel Duchamp, *The Bride Stripped Bare by Her Bachelor's, Even: The Large Glass*
Source: Hadara Bar-Nadav, *A Glass of Milk to Kiss Goodnight* (Chesterfiled, MO: IntuiT House, 2007), 49–50

Bar-Nadav, Hadara, *The Last Gesture*
Salvador Dali, *The Hand*
Source: Hadara Bar-Nadav, *A Glass of Milk to Kiss Goodnight* (Chesterfiled, MO: IntuiT House, 2007), 55

BARNETT, Ruth Anderson, *In the Studio*
Artemisia Gentileschi, *Judith Slaying Holofernes*
Source: *Ekphrasis* 2, no. 4 (Fall–Winter 2001): 9

BARNETT, Z. Daniel, *Nighthawks at the Diner*
Edward Hopper, *Nighthawks*
Source: http://www.thisisby.us/index.php/content/nighthawks_at_the_diner

BARTLETT, Elizabeth, *Millbank*
Gwen Johns, *Young Woman Holding a Black Cat*
Source: http://wwwfp.education.tas.gov.au/English/hugopaul.htm; and Adams (1B, above), 79–81

BARLOW, Joel, *American Painters*
Benjamin West, John Singleton Copley, John Trumbull, et al.

Source: *Beauties of Poetry, British and American* (Philadelphia: M. Casey, 1794): 171–2

BARTON, John, *Sunday Sun*
Paul Cadmus, *Sunday Sun*
Source: *Beauty/Truth: A Journal of Ekphrastic Poetry* 1, no. 2 (Spring–Summer 2007): 4–5

BARTSCH, Kurt, *Die Revolutionsfeier*
Marc Chagall, *The Revolution*
Source: Kranz (2B, above), 247

BARTZ, Erica, *Opulence*
Frank Duveneck, *Laughing Boy*
Source: Janovy (1O, above), 33

BASTELAERE, Dirk van, *Jan van Eyck, de Arnolfini-bruiloft (1434)*
Jan van Eyck, *Arnolfini Wedding Portrait*
Source: Korteweg and Heijn (2F, above), 66

BASTIAANSE, Frans, *Rembrandt spreekt:*
Rembrandt van Rijn, *Self-Portrait* (1668)
Source: Korteweg and Heijn (2F, above), 145

BATYKEFER, Errin, *Horizontal Horse's or Mule's Skull with Feather*
Georgia O'Keeffe, *Horizontal Horse's or Mule's Skull with Feather, 1936*
Source: *Ekphrasis* 4, no. 5 (Spring–Summer 2008): 16

Batykefer, Errin, *Apple Family*
Georgia O'Keeffe, *Apple Family II*
Source: *Prairie Schooner* 82, no. 3 (Fall 2008): 158

Batykefer, Errin, *Pink and Yellow Hollyhocks*
Georgia O'Keeffe, *Pink and Yellow Hollyhocks*
Source: *Prairie Schooner* 82, no. 3 (Fall 2008): 159

BAUDELAIRE, Charles, *Les Aveugles*
Pieter Brueghel, *The Parable of the Blind*
Source: *Baudelaire in English*, eds., Carol Clark and Robert Sykes (Harmondsworth: Penguin, 1997), 129

Baudelaire, Charles, *"Bohémiens en voyage"* from *Les Fleurs du Mal*
Jacques Callot, *Les Bohémiens en marche*
Source: Hollander (2I, above), 179; and Maurisson and Verlet (2L, above), 85–6

Baudelaire, Charles, *Les Phares* (*The Beacons*)
Peter Paul Rubens, Leonardo da Vinci, Rembrandt van Rijn, Michelangelo, Jean-Antoine Watteau, Francisco Goya, Eugène Delacroix
Source: *The Flowers of Evil*, trans. William Aggeler (Fresno, CA: Academy Library Guild, 1954); and http://fleursdumal.org/poem/105; also in Maurisson and Verlet (2L, above), 82–4

Baudelaire, Charles, *Salon de 1855*
Eugène Delacroix, *Sur la Chasse aux lions* (*The Lion Hunt*)
Source: Maurisson and Verlet (2L, above), 78–9

BAUER, Grace, *Apres "Le Dejeuner en fourrure"*
Meret Oppenheim, *Le Dejeuner en fourrure*
Source: *Ekphrasis* 1, no. 3 (Spring–Summer 1998): 34–5

BAUER, Walter, *Brueghel: Die Blinden*
Pieter Brueghel the Elder, *The Parable of the Blind*
Source: Kranz (2B, above), 101–3

Bauer, Walter, *"Der zweite Mai"*
Francisco Goya, *The Third of May, 1808: The Execution of the Defenders of Madrid*
Source: Kranz (2B, above), 198

BAUGHER, Janée J., *Woman Reading a Letter, 1662–63*
Jan Vermeer, *Woman Reading a Letter*
Source: *Ekphrasis*, 4, no. 5 (Spring–Summer 2008): 5

Baugher, Janée J., *Cimon and Pero, 1630*
Peter Paul Rubens, *Cimon and Pero*
Source: *Ekphrasis* 4, no. 1 (Spring–Summer 2006): 28

Baugher, Janée J., *Empire of Light*
René Magritte, *Empire of Light*
Source: *Fine Madness* (Seattle, WA) 30 (December 2007); and http://www.jackstraw.org/programs/writers/WritersForum/04/Janee_main.html

Baugher, Janée J., *"Le Verrou," 1784*
Jean-Honoré Fragonard, *Le Verrou*
Source: *The Raven Chronicles* (Seattle, WA) 13, no. 2 (July 2008)

Baugher, Janée J., *The Hope of a Man Condemned to Death, I, II, III, 1974*
Joan Miró, *The Hope of a Man Condemned to Death* (triptych)
Source: *J Journal* (New York), 1, no. 1 (June 2008)

Baugher, Janée J., *"Military Manoeuvres," 1891*
Richard Thomas Moynan, *Military Manoeuvres*
Source: *StringTown* (Spokane, WA) 9 (October 2006)

Baugher, Janée J., *"Der Kindergarten," 1884*
Johann Sperl, *Der Kindergarten*
Source: *Art Access* (Seattle, WA) 15, no. 1 (February 2006)

Baugher, Janée J., *"Portrait of Mona Lisa," 1503*
Leonardo da Vinci, *Mona Lisa*
Source: *Mona Poetica Anthology* (Waupaca, WI: May Apple Press, 2005)

Baugher, Janée J., *The Execution of Lady Jane Grey*
Paul Delaroche, *The Execution of Lady Jane Grey*
Source: *Heliotrope* (Spokane, WA) 8 (April 2005)

Baugher, Janée J., *"To the Studios," 1977*
Frank Auerbach, *To the Studios*
Source: *Heliotrope* (Spokane, WA) 8 (April 2005)

Baugher, Janée J., "*La Chambre de Van Gogh à Arles*," *1889*
Vincent van Gogh, *Room at Arles*
Source: *LitRag* (Seattle, WA) 18 (November 2004)

Baugher, Janée J., "*Hotel Room*," *1931*
Edward Hopper, *Hotel Room*
Source: *Switched-on Gutenberg* (online) 9 (October 2004)

Baugher, Janée J., *Poet Describing/Painter/Describing Poet*
Georg Bazelitz, *Der Dichter*
Source: *Art Access* (Seattle, WA) 7, no. 1 (February 1998)

Baugher, Janée, *Samson and Delilah, 1608*
Peter Paul Rubens, *Samson and Delilah*
Source: *Ekphrasis* 5, no. 2 (Fall–Winter 2009): 20

Baugher, Janée J., *Coordinates of Yes*
Unpublished collection of ekphrastic poems (Baugher's M.F.A. thesis, 2001)
Source: This 86-page manuscript is available from the library of Eastern Washington University (PS3552 .A8365 C66). It includes:

> *Venus mit dem Orgelspieler* [Titian, *Venus with the Organ Player*]
> *Die Mutter* [Pieter de Hooch, *The Mother*]
> *La Chambre de Van Gogh à Arles* [Vincent Van Gogh, *Room at Arles*]
> *Portrait de l' Artiste* [Vincent Van Gogh, *Self-Portrait*, 1889]
> *L'Atelier du Peintre, Allégorie Réelle* [Gustave Courbet, *The Painter in his Studio, Real Allegory*]
> *La Cathédrale de Rouen le Portail, Temps Gris* [Claude Monet, *The Great Door of Rouen Cathedral, Grey Day*]
> *Portrait of Mona Lisa, 1503* [Leonardo da Vinci, *Mona Lisa*]
> *Les Raboteurs de Parquet* [Gustave Caillebotte, *The Floorscapers*]
> *Chatterton, 1856* [Henry Wallis, *Chatterton*]
> *Ophelia* [Sir John Everett Millais, *Ophelia*]
> *The Execution of Lady Jane Grey* [Paul Delaroche, *The Execution of Lady Jane Grey*]
> *To the Studios, 1977* [Frank Auerbach, *To the Studios*]
> *The Lady of Shallot, 1888* [John William Waterhouse, *The Lady of Shalott*]
> *Samson and Delilah, 1608* [Peter Paul Rubens, *Samson and Delilah*]
> *Girl with a White Dog, 1950* [Lucien Freud, *Girl with a White Dog*]
> *The Bath, 1925* [Pierre Bonnard, *The Bath*]
> *Military Manoeuvres, 1891* [Richard Thomas Moynan, *Military Manoeuvres*]

> *The Wounded Poacher, 1881* [Henry Jones Thaddeus, *The Wounded Poacher*]
> *Study of a Nude, 1952* [Francis Bacon, *Study of a Nude*]
> *Second Version of Triptych, 1944* [Francis Bacon, *Second Version of Triptych*]

BAUS, Eric, *A red dress*
Mequitta Ahuja, *Tsunami Generation*
Source: Geha and Nichols (1N, above), 27–9

BAXTER, Charles, *A Disappearance*
James McNeill Whistler, *Sea and Rain*
Source: Tillinghast (1F, above), 38–9

BEACH, Judi K., *Tomato and Knife*
Richard Diebenkorn, *Tomato and Knife*
Source: *Rattle*, 2 July 2008. http://www.rattle.com/blog/2008/07/tomato-and-knife-by-judi-k-beach/

BEAUMONT, Jeanne Marie, *...Of a Street*
Giorgio de Chirico, *Mystery and Melancholy of a Street*
Source: *Ekphrasis* 3, no. 2 (Fall–Winter 2003): 29–30

BECKER, Robin, *Angel Supporting St. Sebastian*
Eustache Le Sueur, *Angel Supporting St. Sebastian*
Source: Robin Becker, *Domain of Perfect Affection* (Pittsburgh, PA: University of Pittsburgh Press, 2006), 33

Becker, Robin, *Head of an Angel*
Albrecht Dürer, *Head of an Angel*
Source: Robin Becker, *Domain of Perfect Affection* (Pittsburgh, PA: University of Pittsburgh Press, 2006), 63

Becker, Robin, *Head of an Old Man*
Andrea del Sarto, *Head of a Bald Old Man*
Source: Robin Becker, *Domain of Perfect Affection* (Pittsburgh, PA: University of Pittsburgh Press, 2006), 50

Becker, Robin, *Simple Dark*
Lambert Doomer, *Village Street with a Barn*
Source: Robin Becker, *Domain of Perfect Affection* (Pittsburgh, PA: University of Pittsburgh Press, 2006), 37

Becker, Robin, *With Two Camels and One Donkey*
Paul Klee, *With Two Camels and One Donkey*
Source: Robin Becker, *Domain of Perfect Affection* (Pittsburgh, PA: University of Pittsburgh Press, 2006), 73

Becker, Robin, *Orienteer: The Childhod Drawings of William Steeple Davis, 1884–1961*
Source: Robin Becker, *Domain of Perfect Affection* (Pittsburgh, PA: University of Pittsburgh Press, 2006), 39–41

Becker, Robin, *Chagall*
Marc Chagall, *David and Beersheba*

Source: Robin Becker, *Giacometti's Dog* (Pittsburgh, PA: University of Pittsburgh Press, 1990), 45

Becker, Robin, *Built on Water*
Tintoretto
Source: Robin Becker, *Giacometti's Dog* (Pittsburgh, PA: University of Pittsburgh Press, 1990), 55

Becker, Robin, *Rome of the Imagination*
Andrea Mantegna
Source: Robin Becker, *Giacometti's Dog* (Pittsburgh, PA: University of Pittsburgh Press, 1990), 53

BEER, Nicky, *Still Life with Half-Turned Woman and Questions*
Vilhelm Hammershoi, unidentified still life
Source: Heather McHugh, ed., *The Best American Poetry 2007* (New York: Scribner, 2007), 8–9; appeared orig. in *Beloit Poetry Journal.* http://www.bpj.org/poems/beer_stilllife.html

BEER, Patricia, *Yacht Approaching the Coast*
J.M.W. Turner, *Yacht Approaching the Coast*
Source: Adams (1B, above), 44–5

Beer, Patricia, *Early Work (at the Van Gogh exhibition)*
Vincent Van Gogh
Source: Patricia Beer, *Friend of Heraclitus* (Manchester, UK: Carcanet, 1993), 30

BEERS, Todd, *Ralph Blakelock's "Landscape with Trees"*
Source: Holcomb (1I, above), 32–3

BELIN, Mel, *At the Exhibit*
Henri Matisse, *Anemones with a Black Mirror*
Source: *Beltway Poetry Quarterly* 10, no. 1 (Winter 2009). http://washingtonart.com/beltway/contents.html

BELITT, Ben, *The Bathers: A Triptych*
Jacques-Louis David, *Marat's Assassination*, Thomas Eakins, *The Swimming Hole*, and Edgar Degas, *Woman Bathing*
Source: Ben Belitt, *This Scribe, My Hand* (Baton Rouge: Louisiana State University Press, 1998), 26–9

Belitt, Ben, *Battlepiece*
Paolo Uccello, *Battaglia di San Romano*
Source: Ben Belitt, *This Scribe, My Hand* (Baton Rouge: Louisiana State University Press, 1998), 135–9

BELL, Martin, *Variations on Francis Bacon*
Francis Bacon, unidentified painting
Source: Martin Bell, *Complete Poems* (Newcastle upon Tyne, UK: Bloodaxe Books, 1988), 146

BELL, Marvin, *O'Keeffe Left to Herself*
Georgia O'Keeffe
Source: *Gettysburg Review* 3, no. 2 (Spring 1990): 329

Bell, Marvin, *Paul Klee Tells His Story to the Children*
Paul Klee, *Fairy Tales*
Source: Holcomb (1I, above), 34–6

Bell, Marvin, *Big French Bread*
Red Grooms, *French Bread*
Source: Greenberg, *Heart* (2J, above), 44–5

Bell, Marvin, *Florence*
Wassily Kandinsky, *Red Square*; Michelangelo, *Sistene Chapel*; Paolo Veronese, *The Last Supper*
Source: Marvin Bell, *These Green-Going-To-Yellow* (New York: Atheneum, 1985), 64–5

BENITZ, Sandy Sue, *Flaming June*
Lord Frederic Leighton, *Flaming June*
Source: *Beauty/Truth: A Journal of Ekphrastic Poetry* 1, no. 3 (Fall–Winter 2007): 5–6

BENN, Gottfried, *Da fiel uns Ikarus vor die Füße*
Pieter Brueghel the Elder, *Landscape with the Fall of Icarus*
Source: Gottfried Benn, *Gesammelte Werke*, vol. 1 (München: Deutscher Taschenbuch-Verlag, 1975), 26

Benn, Gottfried, *Ikarus*
Pieter Brueghel the Elder, *Landscape with the Fall of Icarus*
Source: Gottfried Benn, *Gesammelte Werke*, vol. 1 (München: Deutscher Taschenbuch-Verlag, 1975), 46–7

BENNETT, Bruce, *Perspectives: A Triptych*
Ralston Crawford, *Whitestone Bridge*; Edwin Dickinson, *Snow on Quai, Sanary*; and Wayne Thiebaud, *River Pond*
Source: Holcomb (1I, above), 38–41

BENSLEY, Connie, *The Badminton Game*
David Inshaw, *The Badminton Game*
Source: Adams (1B, above), 144–5; and Benton and Benton, *Painting with Words* (2G, above), 38–9

BENSON, Elizabeth Polk, *Botticelli*
Sandro Botticelli
Source: *College Art Journal* 19 (Fall 1959): 77

BENTON, Michael, *Alfred Wallace Day-Dreams in the Bath*
Alfred Wallace, *Penzance Harbour*
Source: Benton and Benton, *Picture Poems* (2H, above), 49

Benton, Michael, *Experiment with an Air Pump*
Joseph Wright of Derby, *An Experiment on a Bird in the Air Pump*
Source: Benton and Benton, *Picture Poems* (2H, above), 56

Benton, Michael, *Suzon*
Édouard Manet, *A Bar at the Folies-Bergère*
Source: Benton and Benton, *Painting with Words* (2G, above), 58

Benton, Michael, *In Limbo*
Édouard Manet, *A Bar at the Folies-Bergère*
Source: Benton and Benton, *Painting with Words*
(2G, above), 59

BENTON, Peter, *Time—Gentle Men*
René Magritte, *Golconda*
Source: Benton and Benton, *Picture Poems* (2H,
above), 39

Benton, Peter, *Perspectives*
Paolo Uccello, *A Hunt in a Forest*
Source: Benton and Benton, *Picture Poems* (2H,
above), 50–1

Benton, Peter, *Waterfall*
M.C. Escher, *Waterfall*
Source: Benton and Benton, *Painting with Words*
(2G, above), 33

Benton, Peter, *To My Daughter*
Jan Vermeer, *Head of a Girl*
Source: Benton and Benton, *Painting with Words*
(2G, above), 52–3

Benton, Peter, *Alice at 70*
Sir John Everett Millais, *Autumn Leaves*
Source: Benton and Benton, *Painting with Words*
(2G, above), 62–3

BERDESHEVSKY, Margo, *Even with No Hand to
Hold It*
Pablo Picasso, *Caballo corneado*
Source: *Beauty/Truth: A Journal of Ekphrastic Poetry*
1, no. 2 (Spring–Summer 2007): 16; rpt. in *Ca-
dence of Hooves: A Celebration of Horses*, ed., Suzan
Jantz (Igo, CA: Yarroway Mountain Press, 2008)

BERG, Carol L., *Pink Camillia*
Georgia O'Keeffe, *Untitled* (Pink Camellia)
Source: *The Quarterly* 5, no. 3. http://thehissquart
erly.net/eck/berg.html

BERGER, Bruce, *Mimesis*
Claude Monet, small painting in the Frick Collec-
tion
Source: *Ekphrasis* 1, no. 1 (Summer 1997): 44

BERGMANN, F.J., *The Green Sun Is Not a Sun* (after
the cover image by Michael Burkard from James
Wagner's *the false sun recordings*)
Source: *Collection: Ekphrastic Poems by Nilofar
Shaikh and F.J. Bergmann*, No. 2 (Delafield, WI:
Canvas Press, 2007), 4–5

Bergmann, F.J., *The Culture of the Impractical*
Georgia O'Keeffe, *Oriental Poppies*
Source: *Beauty/Truth: A Journal of Ekphrastic Poetry*
1, no. 1 (Fall–Winter 2006): 16

Bergmann, F.J., *Captivity*
Ann Callandro, *Shadows*
Source: *Tattoo Highway* 15. http://www.tattoohighw
ay.org/15/fjbcontest.html

BERGSTROM, Heather Brittain, *Mimesis*
Remedios Varo, *Mimesis*
Source: *Ekphrasis* 2 (Fall–Winter 2000): 15

BERKE, Judith, *The Red Room*
Henri Matisse, *The Red Room*
Source: Buchwald and Roston (2C, above), 55

BERKSON, Bill, *On Four Hearts*
Lynn O'Hare, *Blind*, 1979
Source: Vanderlip (1A, above), 42

Berkson, Bill, *Source*
Philip Guston, *Midnight Pass Road*, 1975
Source: Vanderlip (1A, above), 44

BERNARD, Christopher, *Nymphéas*
Claude Monet, the *Nymphéas* (*Waterlilies*) series
Source: *Ekphrasis* 1, no. 3 (Spring–Summer 1998):
66–7

BERNETT, Paula Marafino, *No Room for Failure*
Dinah Worman, *ABCDEF Crow*
Source: *The Hiss Quarterly* 5, no. 3. http://thehiss
quarterly.net/eck/bernett.html

BERNIER-GRAND, Carmen T., *Quetzalcoatl*
Diego Rivera, *Pan American Unity*
Source: Greenberg, *Side* (2M, above), 22–3

BERNLEF, J., *Riviergezicht met roeiboot*
Jan van Goyen, *View of the River*
Source: Korteweg and Heijn (2F, above), 117

Bernlef, J., *Een ontmoeting met Pieter Saenredam*
Pieter Saenredam, *The St. Bavo Church in Haar-
lem*
Source: Korteweg and Heijn (2F, above), 118–19

BERNSTEIN, Charles, *Slap Me Five, Cleo, Mark's
History*
Bernard Duvivier, *Cleopatra Captured by Roman
Soldiers*
Source: Holcomb (1I, above), 42–7; and http://
www.epoetry.org/issues/issue5/text/poems/cbl.
htm

BERRY, James, *"Fin d'Arabesque" by Edgar Degas*
Source: Benton and Benton, *Picture Poems* (2H,
above), 18–19

Berry, James, *The Arrest—on Seeing Matisse's Paint-
ing "The Snail"*
Source: Adams (1B, above), 113–15

Berry, James, *A Corner of the Artist's Room, Paris*
Gwen John, *A Corner of the Artist's Room, Paris*
Source: Benton and Benton, *Picture Poems* (2H,
above), 32–3; and http://wwwfp.education.tas.
gov.au/English/hugopaul.htm

BERRYMAN, John, *Winter Landscape*
Pieter Brueghel the Elder, *Hunters in the Snow*
Source: John Berryman, *Homage to Mistress Brad-
street and Other Poems* (New York: Noonday,

1968), 35; rpt. in *Selected Poems*, ed. Kevin Young (New York: Library of America, 2004), 8–9; and Benton and Benton, *Painting with Words* (?.G, above), 77–8

Berryman, John, *Rembrandt van Rijn obit 8 October 1669*
Source: John Berryman, *Henry's Fate and Other Poems* (New York: Farrar, Strauss & Giroux, 1977), 41

BEST, B.J., *Jacket on a Chair*,
Paul Cézanne, *Jacket on a Chair*
Source: *Beauty/Truth: A Journal of Ekphrastic Poetry* 1, no. 2 (Spring–Summer 2007): 9

Best, B.J., *Three Musicians*
Pablo Picasso, *Three Musicians*
Source: *Beauty/Truth: A Journal of Ekphrastic Poetry* 1, no. 2 (Spring–Summer 2007): 10

BETJEMAN, Sir John, *Meditation on a Constable Picture*
John Constable
Source: John Betjeman, *Collected Poems* (London: John Murray, 1977), 314

Betjeman, Sir John, *On an Old-Fashioned Watercolour of Oxford*
Unidentified painting
Source: John Betjeman, *Collected Poems* (Boston: Houghton Mifflin, 1971), 110

Betjeman, Sir John, *On a Portrait of a Deaf Man*
Unidentified portrait
Source: John Betjeman, *Collected Poems* (London: John Murray, 1977), 79–80

Betjeman, Sir John, *On a Painting by Julius Olsson R.A.* (1958)
Unidentified seacape
Source: John Betjeman, *Collected Poems* (London: John Murray, 1977), 298

BEVINGTON, Helen, *Nature Study, After Dufy*
Raoul Dufy
Source: *The New Yorker Book of Poems* (New York: Viking Press, 1969), 478

Bevington, Helen, *Turner's Sunrise*
J.M.W. Turner, one of Turner's sunrise paintings
Source: Helen Plotz, ed. *Eye's Delight: Poems of Art and Architecture* (New York: Greenwillow Books, 1983), 9

BHATT, Sujat, *Rooms by the Sea*
Edward Hopper, *Rooms by the Sea*
Source: Sujat Bhatt, *Monkey Shadows* (Manchester, UK: Carcanet, 1991), 92–3

Bhatt, Sujat, *Sunlight in a Cafeteria*
Edward Hopper, *Sunlight in a Cafeteria*
Source: Sujat Bhatt, *Monkey Shadows* (Manchester, UK: Carcanet, 1991), 95–6

Bhatt, Sujat, *Franz Marc's "Blaue Fohlen"*
Source: Sujat Bhatt, *Monkey Shadows* (Manchester, UK: Carcanet, 1991), 94

Bhatt, Sujat, *Portrait of a Double Portrait*
Eugène Brands, *Dubbel portret van zwangere vrouw* (*Double Portrait of a Pregnant Woman*)
Source: Sujat Bhatt, *Monkey Shadows* (Manchester, UK: Carcanet, 1991), 97

Bhatt, Sujat, *The Mad Woman in the Attic*
Hartmut Eïng, various paintings
Source: Sujat Bhatt, *Monkey Shadows* (Manchester, UK: Carcanet, 1991), 75–7

Bhatt, Sujat, *The Fish Hat*
Pablo Picasso, *Femme assise au chapeau poisson* (*Sitting Woman with Fish Hat*)
Source: Sujat Bhatt, *Monkey Shadows* (Manchester, UK: Carcanet, 1991), 78–80

Bhatt, Sujata, *The Wild Woman of the Forest*
Emily Carr
Source: Sujat Bhatt, *The Stinking Rose* (Manchester, UK: Carcanet, 1995), 14

Bhatt, Sujata, *The Light Teased Me*
Georgia O'Keeffe, *Red Poppy*
Source: Sujat Bhatt, *The Stinking Rose* (Manchester, UK: Carcanet, 1995), 23

Bhatt, Sujata, *Cow's Skull—Red, White and Blue*
Georgia O'Keeffe, *Cow's Skull—Red, White and Blue*
Source: Sujat Bhatt, *The Stinking Rose* (Manchester, UK: Carcanet, 1995), 24

Bhatt, Sujata, *Parrots*
Frida Kahlo, *Me and My Parrots*
Source: Sujat Bhatt, *The Stinking Rose* (Manchester, UK: Carcanet, 1995), 27

Bhatt, Sujata, *What Does the Flower of Life Say, Frida*
Frida Kahlo, *Flower of Life*
Source: Sujat Bhatt, *The Stinking Rose* (Manchester, UK: Carcanet, 1995), 28

Bhatt, Sujata, *Nothing Is Black, Really Nothing*
Frida Kahlo
Source: Sujat Bhatt, *The Stinking Rose* (Manchester, UK: Carcanet, 1995), 30–2

Bhatt, Sujata, *Pelvis with Moon*
Georgia O'Keeffe, *Pelvis with Moon*
Source: Sujat Bhatt, *The Stinking Rose* (Manchester, UK: Carcanet, 1995), 35

Bhatt, Sujata, *Paula Modersohn-Becker Speaks to Herself*
Paula Modersohn-Becker, *Selbstbildnis am 6. Hochzeitstag*
Source: Sujat Bhatt, *The Stinking Rose* (Manchester, UK: Carcanet, 1995), 91–2

Bhatt, Sujata, *For Paula Modersohn-Becker*
Source: Sujata Bhatt, *Brunizem* (Manchester, UK:, Carcanet, 1988), 76

Bhatt, Sujata, *Lizard, Iguana, Chameleon, Salamander*
Jakobine von Dömming, series of paintings
Source: Sujata Bhatt, *The Stinking Rose* (Manchester, UK: Carcanet, 1995), 97–8

Bhatt, Sujata, *Is It a Voice?*
Edvard Munch, *The Voice*
Source: Sujata Bhatt, *Augatora* (Manchester, UK: Carcanet, 2000), 87

BIALOSKY, Jill, *Ironing*
Pablo Picasso, *A Woman Ironing*
Source: Jill Bialosky, *The End of Desire* (New York: Knopf, 1997), 46

BIERDS, Linda, *The Geographer*
Jan Vermeer, *The Geographer*
Source: Linda Bierds, *The Profile Makers* (New York: Henry Holt, 1997), 13–15

Bierds, Linda, *Altamira: What She Remembered*
Altamira cave paintings
Source: Linda Bierds, *The Profile Makers* (New York: Henry Holt, 1997), 21–2

Bierds, Linda, *The Three Trees*
Rembrandt van Rijn, *The Three Trees*
Source: Linda Bierds, *The Profile Makers* (New York: Henry Holt, 1997), 9–10

Bierds, Linda, *Adelard the Drowned*
Marsden Hartley, *Adelard the Drowned, Master of the "Phantom"*
Source: Linda Bierds, *The Stillness, the Dancing* (New York: Henry Holt, 1988), 32–3

Bierds, Linda, *The Anatomy Lesson of Dr. Nicolaas Tulp: Amsterdam, 1632*
Rembrandt van Rijn, *The Anatomy Lesson of Dr. Nicolaas Tulp*
Source: Linda Bierds, *The Stillness, the Dancing* (New York: Henry Holt, 1988), 57–9; rpt. in Bierds's *Flight: New and Selected Poems* (New York: G.P. Putnam's Sons, 2008), 22–4

Bierds, Linda, *Wedding*
Jan Van Eyck, *Arnolfini Wedding Portrait*
Source: Linda Bierds, *The Stillness, the Dancing* (New York: Henry Holt, 1988), 55–6; rpt. in Bierds's *Flight: New and Selected Poems* (New York: G.P. Putnam's Sons, 2008), 26–7

Bierds, Linda, *Lautrec*
Henri de Toulouse-Lautrec
Source: Linda Bierds, *Flight: New and Selected Poems* (New York: G.P. Putnam's Sons, 2008), 84–5

Bierds, Linda, *Testament: Vermeer in December*
Jan Vermeer

Source: Linda Bierds, *The Seconds* (New York: G.P. Putnam's Sons, 2001), 18–19; rpt. in *Flight: New and Selected Poems* (New York: G.P. Putnam's Sons, 2008), 138–9

Bierds, Linda, *Portrait of Man with a Lily: After the Miniature by Hans Holbein the Younger*
Hans Holbein the Younger
Source: Linda Bierds, *The Seconds* (New York: G.P. Putnam's Sons, 2001), 11–12

Bierds, Linda, *From the Vacuum Tube*
Joseph Wright of Derby, *An Experiment on a Bird in the Air Pump*
Source: Linda Bierds, *The Seconds* (New York: G.P. Putnam's Sons, 2001), 16–17

Bierds, Linda, *Winter Landscape with Gallows*
Hendrick Avercamp, *Winter Landscape on the River Ijsel Near Kampen*
Source: Linda Bierds, *The Seconds* (New York: G.P. Putnam's Sons, 2001), 23–8

Bierds, Linda, *From the Bayberry Bush*
William Merritt Chase, *The Bayberry Bush*
Source: Linda Bierds, *The Seconds* (New York: G.P. Putnam's Sons, 2001), 61–2

Bierds, Linda, *Wyeth One: A Midnight Letter*
N.C. Wyeth
Source: Linda Bierds, *The Seconds* (New York: G.P. Putnam's Sons, 2001), 75–6

Bierds, Linda, *Wyeth Two: Winter Wealth*
N.C. Wyeth and Andrew Wyeth
Source: Linda Bierds, *The Seconds* (New York: G.P. Putnam's Sons, 2001), 61–2

Bierds, Linda, *Circus Riders*
Marc Chagall, *Circus Riders*
Source: Linda Bierds, *The Seconds* (New York: G.P. Putnam's Sons, 2001), 85–8; rpt. in Bierds's *Flight: New and Selected Poems* (New York: G.P. Putnam's Sons, 2008), 153–6

Bierds, Linda, *Dürer Near Fifty*
Albrecht Dürer
Source: Linda Bierds, *Flight: New and Selected Poems* (New York: G.P. Putnam's Sons, 2008), 191

Bierds, Linda, *Fragments from Venice: Albrecht Dürer*
Albrecht Dürer
Source: Linda Bierds, *Flight: New and Selected Poems* (New York: G.P. Putnam's Sons, 2008), 196–7

Bierds, Linda, *Accountancy: Dürer in Antwerp*
Albrecht Dürer
Source: Linda Bierds, *Flight: New and Selected Poems* (New York: G.P. Putnam's Sons, 2008), 202–3

Bierds, Linda, *Exhibition of a Rhinoceros at Venice*
Pietro Longhi, *Exhibition of a Rhinoceros at Venice*
Source: Linda Bierds, *Flight: New and Selected Poems* (New York: G.P. Putnam's Sons, 2008), 204–5

BILGERE, George, *View of the City of Delft*
Jan Vermeer, *View of Delft*
Source: George Bilgere, *Haywire: Poems* (Logan: Utah State University Press, 2006), 38

BIRD, Valerie, *Captive Flesh*
William Hogarth, *The Graham Children*
Source: Benton and Benton, *Picture Poems* (2H, above), 30–1

Bird, Valerie, *The Three Musicians*
Pablo Picasso, *The Three Musicians*
Source: Benton and Benton, *Picture Poems* (2H, above), 42–3

Bird, Valerie, *Looking Back*
L.S. Lowry, *A Fight*
Source: Benton and Benton, *Painting with Words* (2G, above), 16

Bird, Valerie, *Faux Pas*
Atkinson Grimshaw, *Liverpool Docks by Midnight*
Source: Benton and Benton, *Painting with Words* (2G, above), 17

BIRNEY, Earle, *El Greco: Espolio*
El Greco, *El Espolio* (*The Disrobing of Christ*)
Source: Earle Birney, *Selected Poems 1940–1996* (Toronto: McClelland and Stewart, 1966) 18; and Abse (2D, above), 58

BISCHOFF, Friedrich, *Der Stutz des Ikarus (nach dem Gemälde von Pieter Brueghel d. Ä.)*
Pieter Brueghel the Elder, *Landscape with the Fall of Icarus*
Source: Henri Nannen, ed., *Glanz von innen. Dichter über Bildwerke, die sie lieben* (München: Bruckmann, 1943), 96–8; Kranz (2B, above), 84; and Achim Aurnhammer and Dieter Martin, eds., *Mythos Ikarus: Texte von Ovid bis Wolf Biermann* (Leipzig: Reclam, 2001), 191–2

BISHOP, Elizabeth, *Large Bad Picture*
Unnamed painting by Bishop's great uncle, George Hutchinson
Source: Elizabeth Bishop, *The Complete Poems 1927–1979* (New York: Farrar Straus Giroux, 1983), 11.

Bishop, Elizabeth, *Poem*
Unnamed miniature painting by Bishop's great uncle, George Hutchinson
Source: Elizabeth Bishop, *The Complete Poems 1927–1979* (New York: Farrar Straus Giroux, 1983), 176–7

BISHOP, John Peale, *A Recollection*
Unidentified Venetian portrait of a woman
Source: *The Collected Poems of John Peale Bishop* (New York: Scribner, 1975), 71–2

BISHOP, Judith, *Rembrandt's Presentation in the Temple*

Rembrandt van Rijn, *The Presentation in the Temple*
Source: Judith Bishop, *Event* (Cambridge, UK: Salt Publishing, 2007), 16

Bishop, Judith, *Sorretto da Quattro Angeli*
Giovanni Bellini, *Christo Morto Sorretto da Quattro Angeli*
Source: Judith Bishop, *Event* (Cambridge, UK: Salt Publishing, 2007), 51–2

BISHOP, Morris, *Museum Thoughts*
Light verse on works by Albrecht Dürer, Horace Vernet, Eduard Daelen, Anon. (*The Poet Courted by the Muses*), Edwin Landseer, and Peter Paul Rubens
Source: Morris Bishop *The Best of Bishop* (Ithaca, NY: Cornell University Press, 1980), 207–21, with black and white reproductions

Bishop, Morris, *Rubens' "La Petite Pelisse"*
Peter Paul Rubens, *La Petite Pelisse*
Source: Kehl (2A, above), 94–5

BISHOP-DUBJINSKY, G., *Pissarro's One Pure Note*
Camille Pissarro
Source: *31 New American Poets*, ed. Ron Schreiber (New York: Hill and Wang, 1969), 9

BJORNVIG, Thorkild, *Mona Lisa*
Leonardo da Vinci, *Mona Lisa*
Source: Kranz (2B, above), 137

BLACKBURN, Thomas, *Francis Bacon*
Francis Bacon, *Study for Portrait on a Folding Bed*
Source: Abse (2D, above), 130

BLACKHAWK, Terry, *Totem, 1907*
Emily Carr, *Zunoqua of the Cat Village*
Source: *Ekphrasis* 3, no. 5 (Spring–Summer 2005): 41

Blackhawk, Terry, *Recalling "The Diver"*
Jasper Johns, *Diver*
Source: *Ekphrasis* 4, no. 3 (Spring–Summer 2007): 8–9

Blackhawk, Terry, *A Peaceable Kingdom*
Ed Fraga, *La Santa E Gloriosa* Carne,
Source: *Ekphrasis* 5, no. 2 (Fall–Winter 2009): 8

BLAINE, David, *Arrangement for Upright Bass*
Lowell Fox, *Jazz Riff*
Source: http://lowellfox.com/page5-contributingp oets/index.htm#jazzriff

Blaine, David, *Third Time's the Charm*
Lowell Fox, *Errol's*
Source: http://lowellfox.com/page5-contributingp oets/index.htm#errols

Blaine, David, *Reflections on a Work by Michelangelo*
Lowell Fox, *Two*

Source: http://lowellfox.com/page5-contributingp
oets/index.htm#two0

BLAKELY, Roger, *Winslow Homer, "Prisoners from the Front"*
Source: Buchwald and Roston (2C, above), 82

BLAND, Peter, *Bonnard at Le Cannet—1942*
Pierre Bonnard
Source: Peter Bland, *Selected Poems* (Manchester, UK: Carcanet, 1998), 70

Bland, Peter, *Viewing Primitives*
Henri Rousseau
Source: Peter Bland, *Selected Poems* (Manchester, UK: Carcanet, 1998), 71

Bland, Peter, *So Late in the Day: The Paintings of Claude Lorrain*
Source: Peter Bland, *Selected Poems* (Manchester, UK: Carcanet, 1998), 71

Bland, Peter, *River Landscape with Horseman and Peasants*
Aelbert Cuyp, *River Landscape with Horseman and Peasants*
Source: Peter Bland, *Selected Poems* (Manchester, UK: Carcanet, 1998), 140–1

Bland, Peter, *Gauguin in Auckland 1891*
Paul Gauguin
Source: Peter Bland, *Selected Poems* (Manchester, UK: Carcanet, 1998), 84

Bland, Peter, *Homage to Van Der Velden*
Petrus Van der Velden
Source: Peter Bland, *Selected Poems* (Manchester, UK: Carcanet, 1998), 111

Bland, Peter, *Embarkations: Paintings by Claude Lorraine*
Source: Peter Bland, *Selected Poems* (Manchester, UK: Carcanet, 1998), 144

BLEAKNEY, Jean, *Village by the Sea*
Norah McGuinness, *Village by the Sea*
Source: Reid and Rice (1J, above), 96–7

BLOEM, Rein, *Bosch*
Hieronymus Bosch, *The Conjuror*
Source: Korteweg and Heijn (2F, above), 69

BLUE, Jane, *Coffee*
Richard Diebenkorn, *Coffee*
Source: *Ekphrasis* 3, no. 1 (Spring–Summer 2003): 17

Blue, Jane, *Thoughts on Paul Klee's Title: Operation (Near-Sighted Anatomist, Two Nudes)*
Source: *Ekphrasis* 2, no. 1 (Spring–Summer 2000): 32

BOBROWSKI, Johannes, *An Runge*
Philipp Otto Runge, *Selbstbildnis*
Source: Kranz (2B, above), 202

BOBROWSKI, Juliane, *Pieter Brueghel: Landschaft mit Ikarus*
Pieter Brueghel the Elder, *Landscape with the Fall of Icarus*
Source: *Tagzeit gleich Tagzeit. Gedichte und Geschichten* (Berlin Ost, 1984), 21

BOGAN, Louise, *St. Christopher*
Giorgio Vasari, *St. Christopher*
Source: *Art News* 57 (September 1958): 24–5

BOGEN, Deborah, *The Artist's Revelations: 1. Albers' Homage to the Square; 2. Diebenkorn's Knife; 3. Matisse's Blue Cut Outs; 4. Picasso's Woman with Book*
Joseph Albers, *Homage to the Square*; Richard Diebenkorn; Henri Matisse; Pablo Picasso, *Woman with Book*
Source: *La Foeva*. http://www.lafovea.org/debora h_bogen.html

BOLAND, Eavan, *Canaletto in the National Gallery of Ireland*
Antonio Canaletto, *St. Mark's Square, Venice*
Source: Eavan Bolan, *The Journey and Other Poems* (Manchester, UK: Carcanet, 1987), 53; and *New Collected Poems* (New York: Norton, 2008), 157

Boland, Eavan, *Domestic Interior*
Jan van Eyck, *Arnolfini Wedding Portrait*
Source: Eavan Bolan, *New Collected Poems* (New York: Norton, 2008), 91–2

Boland, Eavan, *Fruit on a Straight-Sided Tray*
Frances Kelly, still life composition by Kelly (Boland's mother)
Source: Eavan Bolan, *New Collected Poems* (New York: Norton, 2008), 97–8

Boland, Eavan, *On Renoir's "The Grape Pickers"*
Pierre-Auguste Renoir, *The Grape Pickers*
Source: Eavan Bolan, *New Collected Poems* (New York: Norton, 2008), 114

Boland, Eavan, *Object Lessons*
Pastoral scene on a coffee mug
Source: Eavan Bolan, *New Collected Poems* (New York: Norton, 2008), 167–8

Boland, Eavan, *Still Life*
William Harnett, *Woman Begging at Clonakilty* and *The Old Violin*
Source: Eavan Bolan, *Domestic Violence* (New York: Norton, 2007), 19

Boland, Eavan, *From the Painting "Back from Market" by Chardin*
Jean-Baptiste-Siméon Chardin, *Back from Market*
Source: Eavan Boland, *New Collected Poems* (New York: Norton, 2008), 17

Boland, Eavan, *Degas's Laundresses*
Edgar Degas, *The Laundresses*

Source: Eavan Boland, *New Collected Poems* (New York: Norton, 2008), 108–9

Boland, Eavan, *Woman Posing*
Jean-Auguste-Dominique Ingres, *Mrs. Charles Badham, Born Margaret Campbell*
Source: Eavan Boland, *New Collected Poems* (New York: Norton, 2008), 110

Boland, Eavan, *Self-Portrait on a Summer Evening*
Jean-Baptiste-Siméon Chardin, unidentified, perhaps imaginary, painting of ordinary life
Source: Eavan Boland, *New Collected Poems* (New York: Norton, 2008), 129–30

Boland, Eavan, *Growing Up*
Pierre–Auguste Renoir, *Girlhood*
Source: Eavan Boland, *New Collected Poems* (New York: Norton, 2008), 144–5

Boland, Eavan, *On the Gift of "The Birds of America" by John James Audubon*
Source: Eavan Boland, *New Collected Poems* (New York: Norton, 2008), 168–9

Boland, Eavan, *An Old Steel Engraving*
Unidentified engraving
Source: Eavan Boland, *New Collected Poems* (New York: Norton, 2008), 184

Boland, Eavan, *A Woman Painted on a Leaf*
Unidentified curio painting
Source: Eavan Boland, *New Collected Poems* (New York: Norton, 2008), 241–2

BOLAND, John, *Boon Companions*
Harry Kernoff, *Boon Companions*
Source: Reid and Rice (1J, above), 100–1

BOLSTER, Stephanie, *Deux personages dan la nuit: Poems from Paintings by Jean Paul Lemieux*
Paul Lemieux, *Intérieur* (1930), *Le Train de midi* (1956), *Les Beaux Jours* (1937), *Le Far-West* (1955), *L'Orpheline* (1956), *Le Champ de trèfles* (1971), *Le Floride* (1965), *1910 Remembered* (1962), *Deux personages dans la nuit* (1989), *Les Beaux Jours*, reprise.
Source: Stephanie Bolster, *Two Bowls of Milk* (Toronto: McClelland & Stewart, 1999), 39–49

Bolster, Stephanie, *Seawolf Inside Its Own Dorsal Fin*
Robert Davidson, *Seawolf Inside Its Own Dorsal Fin*
Source: Stephanie Bolster, *Two Bowls of Milk* (Toronto: McClelland & Stewart, 1999), 5

Bolster, Stephanie, *Still Life with Braid*
Gérard de Lairesse, *Female Dissected Body, Seen from the Back*
Source: Stephanie Bolster, *Two Bowls of Milk* (Toronto: McClelland & Stewart, 1999), 55–6

Bolster, Stephanie, *Out/Cast*
Colette Whiten, *September 1975*

Source: Stephanie Bolster, *Two Bowls of Milk* (Toronto: McClelland & Stewart, 1999), 57–8

Bolster, Stephanie, *To Dolly*
Alex Colville, *Three Sheep*
Source: Stephanie Bolster, *Two Bowls of Milk* (Toronto: McClelland & Stewart, 1999), 65–6

Bolster, Stephanie, *The Beheld*
Fred Ross, *The Lovers*
Source: Stephanie Bolster, *Two Bowls of Milk* (Toronto: McClelland & Stewart, 1999), 67

Bolster, Stephanie, *Blood*
Rita Letendre, *Atara*
Source: Stephanie Bolster, *Two Bowls of Milk* (Toronto: McClelland & Stewart, 1999), 71

Bolster, Stephanie, *Fear of Desire*
Lucas Cranach the Elder, *Venus*
Source: Stephanie Bolster, *Two Bowls of Milk* (Toronto: McClelland & Stewart, 1999), 72–3

Bolster, Stephanie, *Fear of Enormity*
Gustav Klimt, *Hope I*
Source: Stephanie Bolster, *Two Bowls of Milk* (Toronto: McClelland & Stewart, 1999), 74

Bolster, Stephanie, *Fear of the Twenty-First Century*
Jack Shadbolt, *Transformations No. 5*
Source: Stephanie Bolster, *Two Bowls of Milk* (Toronto: McClelland & Stewart, 1999), 75–6

BOLT, Thomas, *Thomas Eakins: "Max Schmidt in a Single Scull"*
Source: Thomas Bolt, *Out of the Woods* (New Haven: Yale University Press, 1989), 20

BOLZ, Judy, *Details from a Pair of Sixfold Screens*
Tawaraya Sōtatsu
Source: *Beltway Poetry Quarterly* 10, no. 1 (Winter 2009). http://washingtonart.com/beltway/contents.html

BONDS, Diane, *The Life of the Body*
Edward Hopper, *People in the Sun*
Source: Levin (3J, above), 71

Bonds, Diane, *The Forest in Winter at Sunset*
Théodore Rousseau, *The Forest in Winter at Sunset*
Source: *Ekphrasis* 2, no. 1 (Spring–Summer 2000): 9

Bonds, Diane, *Detail from "The Prose of Life"*
Vasily Baksheev, *The Prose of Life*
Source: *Ekphrasis* 1, no. 4 (Fall–Winter 1998): 32

BONNEFOY, Yves, *Sur une Pietà de Tintoret*
Jacopo Robusti Tintoretto, *Pietà*
Source: Maurisson and Verlet (2L, above), 151

BOOTH, Philip, *Marin*
John Marin
Source: *America in Poetry*, ed., Charles Sullivan (New York: Harry N. Abrams, 1988), 126

BORGES, Jorge Luis, *Ritter, Tod, and Teufel I* and *II*
Albrecht Dürer, *Knight, Death, and the Devil*
Source: Jorge Luis Borges, *In Praise of Darkness* (New York: Dutton, 1974), 96–9; rpt. in *Selected Poems*, vol. 2 (New York: Penguin, 2000)

BORUCH, Marianne, *Light*
Edward Hopper, *Summer Evening*
Source: Levin (3J, above), 66

Boruch, Marianne, *Still Life*
Unidentified Dutch still life
Source: *Grace, Fallen from* (Wesleyan University Press, 2008); rpt. in *Innisfree* 7 (September 2008), 16–17.

BOSVELD, Jennifer, *Wholeness Only in a Lack Of*
Jackson Pollock, *Naked Man with Knife*
Source: *Elastic Ekphrastic: Poetry on Art/Poets on Tour through Galleries*, ed. Jennifer Bosveld (Johnstown, OH: Pudding House Publications, 2003), 65

Bosveld, Jennifer, *Man and Dog*
George Bellows, *Man and Dog*
Source: *Elastic Ekphrastic: Poetry on Art/Poets on Tour through Galleries*, ed. Jennifer Bosveld (Johnstown, OH: Pudding House Publications, 2003), 67

Bosveld, Jennifer, *New World Order: Policy* (2000)
Todd DeVriese, *New World Order: Policy*
Source: *Elastic Ekphrastic: Poetry on Art/Poets on Tour through Galleries*, ed. Jennifer Bosveld (Johnstown, OH: Pudding House Publications, 2003), 68

Bosveld, Jennifer, *Mountain*
Edward Boccia, *A Poet Reading*
Source: *Ekphrasis* 2, no. 1 (Spring–Summer 2000): 35

Bosveld, Jennifer. For sixty-three poems by Bosveld on the art of Edward Boccia, see 3B, above.

BOSWELL, Partridge, *Midsummer Dance*
Andres Zorn, *Midsommardans*
Source: *Ekphrasis* 2, no. 4 (Fall–Winter 2001): 22

BOTKIN, Nancy, *Strike a Pose*
René Magritte, *The Lovers I*
Source: *Ekphrasis* 5, no. 1 (Spring–Summer 2009): 13

Botkin, Nancy, *Rooms by the Sea*
Edward Hopper, *Rooms by the Sea*
Source: *Ekphrasis* 5, no. 1 (Spring–Summer 2009): 22

BOTTRALL, Ronald, *Icarus*
Pieter Brueghel the Elder, *Landscape with the Fall of Icarus*
Source: *The Collected Poems* (London: Sidgwick & Jackson, 1961), 131; and Kranz (2B, above), 80

Bottrall, Ronald, *Galatea*
Raphael, *Triumph of Galatea*
Source: Kranz (2B, above), 145

BOULLY, Jenny, *The Mother's Reflections*
Pablo Picasso, *Mother and Child on the Seashore*
Source: *Ekphrasis* 1, no. 6 (Fall–Winter 1999): 17

BOUTELLE, Annie, *Disproportionate: Berthe Morisot's "The Mozart Sonata"*
Source: *Ekphrasis* 2 (Fall–Winter 2000): 6–7

Boutelle, Annie, *Alone*
Paula Modersohn-Becker, *Worpswede*
Source: *Ekphrasis* 3, no. 3 (Spring–Summer 2004): 17–18

Boutelle, Annie, *Manet's "Marguerite de Conflans"*
Édouard Manet, *Marguerite de Conflans Wearing a Hood*
Source: *Ekphrasis* 3, no. 3 (Spring–Summer 2004): 22

BOUTENS, P.C., *Meisje met dood vogeltje*
South Netherlands School, *Girl with a Dead Bird*
Source: Korteweg and Heijn (2F, above), 75

Boutens, P.C., *Jonge Titus*
Rembrandt van Rijn, *Titus at His Desk*
Source: Korteweg and Heijn (2F, above), 134

Boutens, P.C., *Zelfportret. Het atelier van Vermeer van Delft in de verzameling Czernin*
Johannes Vermeer, *Allegory of Painting (Het schildersatelier)*
Source: Korteweg and Heijn (2F, above), 173

BOUWERS, Lenze L., *"hun viermaster, bonkig schip van geweld"*
Hendrick Vroom, *De Amsterdamse viermaster "De Hollandse Tuyn" en andere schepen*
Source: Korteweg and Heijn (2F, above), 101

Bouwers, Lenze L., *"jij bent m'bruidegom, ik ben je bruid"*
Rembrandt van Rijn, *Portrait of Isaac and Rebecca (The Jewish Bride)*
Source: Korteweg and Heijn (2F, above), 151

Bouwers, Lenze L., *"koortsoogjes van dit lieve, bleke kind"*
Gabriël Mets (Metsy), *The Sick Child*
Source: Korteweg and Heijn (2F, above), 167

Bouwers, Lenze L., *"rood, wit, blauw, geel: Een Meyd die melk uytgiet"*
Johannes Vermeer, *The Milkmaid*
Source: Korteweg and Heijn (2F, above), 170

Bouwers, Lenze L., *"die kleine jongen op dat schilderij"*
Adriaen Backer, *Regentesses of the Civic Orphanage in Amsterdam*
Source: Korteweg and Heijn (2F, above), 175

BOWERS, Edgar, *Of an Etching*
Unnamed etching
Source: Edgar Bowers, *Collected Poems* (New York: Knopf, 1997), 112

BOWMAN, Shawn, *House by the Railroad*
Edward Hopper, *House by the Railroad*
Source: *Beauty/Truth: A Journal of Ekphrastic Poetry* 1, no. 3 (Fall–Winter 2007): 13

BRABANDER, Gerard den, *De anatomische les*
Rembrandt van Rijn, *The Anatomy Lesson of Dr. Joan Deyman* and *The Anatomy Lesson of Dr. Nicolaes Tulp*
Source: Korteweg and Heijn (2F, above), 135

BRADLEY, George, *Filippo Brunelleschi, Florence, 1425*
On Brunelleschi's lead-backed mirror and panel, non-extant, used to demonstrate perspective
Source: George Bradley, *The Paradise of Assassin* (Charlottesville, VA: Alderman Press, 1978), 11; rpt. in Bradley's *Terms to Be Met* (New Haven, CT: Yale University Press, 1986), 34

Bradley, George, *In the Flemish Gallery*
Unidentified painting (paintings?) of an angel and a woman
Source: George Bradley, *Terms to Be Met* (New Haven, CT: Yale University Press, 1986), 36

Bradley, George, *Christ Pantocrator in San Giorgio dei Greci* (Venice)
Giovanni Kyprios, fresco of *The Last Judgment*
Source: George Bradley, *Terms to Be Met* (New Haven, CT: Yale University Press, 1986), 33

BRADSHAW, Bob, *Claude Monet: Camille on her Death Bed*
Source: *Mississippi Review* 14, no. 4 (October 2008). http://www.mississippireview.com/2008/Vol14No 4-Oct08/1404-100108-Bradshaw.html

Bradshaw, Bob, *On Chagall's World*
Marc Chagall, unidentified wedding painting
Source: *Apple Valley Review* 2, no. 2 (Fall 2007). http://www.applevalleyreview.com/

BRADY, Dan, *Molly Sees Saturn Devouring His Sons*
Francisco Goya, *Saturn Devouring His Children*
Source: *Beltway Poetry Quarterly* 10, no. 1 (Winter 2009). http://washingtonart.com/beltway/conte nts.html

BRANDES, Rand, *Jimbo Blue*
Basil Blackshaw, *The Barn* (*Blue II*)
Source: Reid and Rice (1J, above), 110–11

BRANDSTAETTER, Roman, *Piesn o moim Chrystusie*
Pieter Brueghel the Elder, *Landscape with the Fall of Icarus*
Source: German trans. of the original Polish published as *Das Lied von meinem Christus* (Wien: Herder, 1961), 125

BRAVERMAN, Kate, *Bar Scene*
Douglas Warner Gorsline, *Bar Scene*
Source: Holcomb (1I, above), 48–52

BREBNER, Diana, *Eleven Paintings by Mary Pratt* (*Christmas Fire, Salmon between Two Sinks, Silver Fish on Crimson Foil, Salmon on Saran, Red Currant Jelly, Preserves, Eggs in an Egg Crate, Roast Beef, Paperwhites in Crystal on Tinfoil, Venus from a Northern Pond*, and *Bonfire by the River*)
Source: Diana Brebner, *Ishtar Gate: Last and Selected Poems* (Montreal; Kingston: McGill–Queen's University Press, 2004), 52–70

Brebner, Diana, *Catherina Vermeer*
Source: Diana Brebner, *Ishtar Gate: Last and Selected Poems* (Montreal; Kingston: McGill–Queen's University Press, 2004), 46

Brebner, Diana, *Restoration*
Jan Vermeer, *Head of a Girl*
Source: Diana Brebner, *Ishtar Gate: Last and Selected Poems* (Montreal; Kingston: McGill–Queen's University Press, 2004), 47

Brebner, Diana, *Mauritshuis*
Jan Vermeer, *Head of a Girl*; Carel Fabritius, *The Goldfinch*
Source: Diana Brebner, *Ishtar Gate: Last and Selected Poems* (Montreal; Kingston: McGill–Queen's University Press, 2004), 48

BRECHBÜHL, Beat, *Giorgione: Das ländische Konzert*
Concert Champêtre or *Concert in the Open Air*, once ascribed to Giorgione but now thought to be by Titian
Source: Kranz (2B, above), 142–3

Brechbühl, Beat, *Salvador Dali: Die brennende Giraffe*
Salvador Dali, *Giraffe on Fire*
Source: Kranz (2B, above), 259–60

BRENNAN, Tim J., *The Irony of Dreams*
Willem de Kooning, *Night*
Source: http://www.northography.com/MIA/tjb_ 01.php

Brennan, Tim J., *The Truth about Peaches*
Vincent Van Gogh, *Portrait of Dr. Gachet*
Source: http://www.northography.com/MIA/peac hes.php

BRETON, André, *André Derain*
Source: Maurisson and Verlet (2L, above), 121–2

BRIAN, Janeen, *It's a Dog-Dust Day*
Tom Roberts, *A Break Away*
Source: Greenberg, *Side* (2M, above), 62–3

BRIDGES, Robert, *Testament of Beauty*, Book 3
Titian, *Sacred and Profane Love*
Source: Hollander (2I, above), 239–41

BRINNIN, John Malcolm, *Le Creazione degli Animali*
Tintoretto, *The Creation of the Animals*
Source: Kehl (2A, above), 142–3

BROCK, Edwin, *Arrangement in Grey and Black*
James McNeill Whistler, *Arrangement in Grey and Black No. 1: Portrait of the Artist's Mother*
Source: Edwin Brock, *And Another Thing* (London: Enitharmon, 1999), 16

BRODERICK, Therese, *The Figure*
Philip Leslie Hale, *Landscape with Figure*
Source: http://theresebroderick.wordpress.com/2008/11/17/hale/

Broderick, Therese, *Sixteen*
Claude Monet, *Wild Poppies*
Source: http://theresebroderick.wordpress.com/2008/11/17/monet-3/

Broderick, Therese, *To the Painter Who Painted the Wedding March Entirely from Memory*
Theodore Robinson, *The Wedding March*
Source: http://theresebroderick.wordpress.com/2008/11/17/robinson/

Broderick, Therese, *Fernando Botero's "Mona Lisa, Age 12"*
Source: http://theresebroderick.wordpress.com/2008/11/17/botero/

Broderick, Therese, *Amelia Pelaez Del Casal's "Still Life in Red"*
Source: http://theresebroderick.wordpress.com/2008/11/17/del-casal/

Broderick, Therese, *Diego Rivera's "Flower Festival: Feast of Santa Anita"*
Source: http://theresebroderick.wordpress.com/2008/11/17/rivera/

Broderick, Therese, *Gego's "Autobiography of a Line"*
Gego (Gertrude Goldschmidt), *Autobiography of a Line*
Source: http://theresebroderick.wordpress.com/2008/11/17/gego/

Broderick, Therese, *Grace Hartigan's "Pale Horse Pale Rider"*
Source: http://theresebroderick.wordpress.com/2008/11/17/hartigan/

Broderick, Therese, *Anne Lindberg's "parallel 10 (plumbago)," 2007*
Source: http://theresebroderick.wordpress.com/2008/11/17/lindberg/

Broderick, Therese, *The Knight in Exile*
Ihsan Alnasrawi, *Exiled*
Source: http://myweb.tiscali.co.uk/ihsan/traditional/exiled.htm

Broderick, Therese, *Julie, Age Nine*
Elisabeth-Louise Vigée-Le Brun, *Self-Portrait with Daughter*

Source: http://poetryaboutart.wordpress.com/2008/11/11/elisabeth-louise-vigee-le-brun/

Broderinck, Therese, *Holiday Card Postmarked from Holland*
Hendrick Avercamp, *IJsvermaak bij een dorp*
Source: http://theresebroderick.wordpress.com/2008/12/16/avercamp/

Broderick, Therese, *Mandelbrot Set*
Artist unknown, visual rendering of the mathematical Mandelbrot set
Source: http://theresebroderick.wordpress.com/2008/11/17/mandelbrot/

Broderick, Therese, *Nighthawks*
Edward Hopper, *Nighthawks*
Source: http://theresebroderick.wordpress.com/2008/12/28/hopper/

Broderick, Therese, Untitled limerick
Van Howell, Caricature of Northrop Frye
Source: http://theresebroderick.wordpress.com/2008/12/09/van-howell/

Broderick, Therese, *The Mist...*
Shoyoun Kwon, *The Mist*
Source: http://theresebroderick.wordpress.com/2008/12/02/shoyoun-kwon/

Broderick, Therese, *Biopsy*
Claude Monet, *Camille Monet sur son lit de mort*
Source: http://theresebroderick.wordpress.com/2008/11/page/3/

Broderick, Thesese, *Landscape in France*
Paul Gauguin, *Landscape at Pouldu*
Source: http://theresebroderick.wordpress.com/2009/01/29/gauguin-2/

Broderick, Therese, *Validation*
William K. Moore, *Invalido*
Source: http://everyphototellsastory.blogspot.com/

Broderick, Therese, *Raucous*
Holly Friesen, *Blue with Raven*
Source: http://theroaringinside.blogspot.com/2009/04/ekphrasis.html

Broderick, Therese. For additional poems by Broderick, see 4Zc, above.

BRODSKY, George, *Gauguin's Tahitian Olympia*
Paul Gauguin, *Manao Tupapau* or *Spirit of the Dead Watching*
Source: *Poetry* 40 (June 1932): 135

BRODSKY, Joseph, *At Karel Weilink's* [Willink's] *Exhibition*
Various paintings of the Dutch figurative painter Carel Willink
Source: Joseph Brodsky, *To Urania* (New York: Farrar, Straus and Giroux, 1988), 119–21

BRONK, William, *On a Picture by Vincent Canadé*
Vincent Canadé, *Double Self-Portrait*

Source: William Bronk, *Life Supports: New and Collected Poems* (San Francisco: North Point, 1981), 94–5

BROOKBANKS, Rhys, *The Lighthouse Man*
Bill Burke, *The Lighthouse Man*
Source: http://www.otago.ac.nz/deepsouth/2007/brookbanks07.pdf

BROOKS, Patricia, *On Thomas Doughty's "Fishing by a Waterfall, 1835–40"*
Source: *Ekphrasis* 4, no. 3 (Spring–Summer 2007): 14

BROSMAN, Catherine Savage, *At the Museum: Women and Men*
Renoir, Manet, Morisot, Van Gogh, et al.
Source: Catherine Savage Brosman, *Journeying from Canyon de Chelly* (Baton Rouge: Louisiana State University Press, 1990), 18–19

BROWN, John, *Where Uncle When*
A. Romilly Fedden, *The Fun of the Fair*
Source: Reid and Rice (1J, above), 68–9

BROWN, Ford Madox, *The Last of England*
Brown's own *The Last of England*
Source: Hollander (2I, above), 167

BROWN, George MacKay, *Henry Moore: "Woman Seated in the Underground"*
Source: Adams (1B, above), 104–5

BROWN, Kurt, *Train of Clocks*
Jean Dubuffet, *Train of Clocks*
Source: *Ekphrasis* 2, no. 6 (Fall–Winter 2002): 6

Brown, Kurt, *Tree of Fluids,*
Jean Dubuffet, *Tree of Fluids*
Source: *Ekphrasis* 2, no. 6 (Fall–Winter 2002): 7

Brown, Kurt, *I Live in a Happy Country*
Jean Dubuffet, *I Live in a Happy Country*
Source: *Ekphrasis* 2, no. 6 (Fall–Winter 2002): 8

Brown, Kurt, *Artful Hubbub*
Jean Dubuffet, *Artful Hubbub*
Source: *Ekphrasis* 2, no. 6 (Fall–Winter 2002): 9

BROWN, Mary L., *Wheatfield with Crows*
Vincent Van Gogh, *Wheatfield with Crows*
Source: *Ekphrasis* 3, no. 6 (Fall–Winter 2005): 37

Brown, Mary L., *What You Need to Charm Birds*
Rufino Tamayo, *Encantador de pájaros*
Source: *Ekphrasis* 4, no. 4 (Fall–Winter 2007): 34

Brown, Mary L., *The Whole Moon Too Much for the Head to Bear*
René Magritte, *Le Chef d'Oeuvre Ou les Mystères de l'Horizon*
Source: *Ekphrasis* 5, no. 1 (Spring–Summer 2009): 14

BROWN, Michael R., *The Sistene Ceiling*
Michelangelo, Sistene Chapel paintings

Source: Michael R. Brown, *The Confidence Man* (Princeton, NJ: Ragged Sky Press, 2006), 3

BROWN, Michael R., *The Rijks Museum*
Jan Vermeer, *The Love Letter*; Rembrandt, *Night Watch*
Source: Michael R. Brown, *The Confidence Man* (Princeton, NJ: Ragged Sky Press, 2006), 5

BROWN, Michael R., *Inside Van Gogh*
Vincent Van Gogh, *The Sun Flowers*; self-portraits
Source: Michael R. Brown, *The Confidence Man* (Princeton, NJ: Ragged Sky Press, 2006), 6

BROWN, Michael R., *Rusman's Gallery*
Banner of Japanese carnival
Source: Michael R. Brown, *The Confidence Man* (Princeton, NJ: Ragged Sky Press, 2006), 9

BROWN, Simon Phillip, *Flag Bearer*
Kai Watson, *Flag Bearer*
Source: http://simonsword.blogspot.com/2009/07/poems-inspired-by-art-of-kai-watson-pt2.html

Brown, Simon Phillip, *(Positive) Vibrations*
Kai Watson, *Positive Vibrations*
Source: http://simonsworld.blogspot.com/2009/07.poems-inspired-by-art-of-kai-watson-pt2.html

Brown, Simon Phillip, *Sentenced*
Kai Watson, *Sentenced*
Source:http://simonsworld.blogspot.com/2009_05_01_archive.html

Brown, Simon Phillip, *Conflict of Interest*
Kai Watson, *Conflict of Interest*
Source: http://simonsworld.blogspot.com/2009_05_01_archive.html

BROWNING, Robert, *Fra Lippo Lippi*
Fra Filippo Lippi
Source: Robert Browning, *The Poems*, ed. John Pettigrew (Harmondsworth: Penguin, 1981), 540–50

Browning, Robert, *Andrea del Sarto*
Source: Robert Browning, *The Poems*, ed. John Pettigrew (Harmondsworth: Penguin, 1981), 643–50

Browning, Robert, *Pictor Ignotus*
The "unknown painter" is perhaps Fra Bartolommeo
Source: Robert Browning, *The Poems*, ed. John Pettigrew (Harmondsworth: Penguin, 1981), 397–8

BROWNJOHN, Alan, *The Boyhood of Raleigh*
J.E. Millais, *The Boyhood of Raleigh*
Source: Adams (1B, above), 58–60

Brownjohn, Alan, *The Twins*
British School, 17th Century, *The Cholmondeley Sisters*
Source: Benton and Benton, *Picture Poems* (2H, above), 8–9

BRUCE, George, *An Interview with Rembrandt*
Rembrandt van Rijn

Source: George Bruce, *Perspectives: Poems 1970–86* (Aberdeen, Scotland: Aberdeen University Press, 1987), 44

Bruce, George, *Rembrandt in Age*
Rembrandt van Rijn, *Self-Portrait*
Source: George Bruce, *Perspectives: Poems 1970–86* (Aberdeen, Scotland: Aberdeen University Press, 1987), 45

Bruce, George, *Woman Pitten Back Nicht*
Rembrandt van Rijn, *A Woman in Bed*
Source: George Bruce, *Perspectives: Poems 1970–86* (Aberdeen, Scotland: Aberdeen University Press, 1987), 45

Bruce, George, *The Nichtwatch*
Rembrandt van Rijn, *The Nightwatch*
Source: George Bruce, *Perspectives: Poems 1970–86* (Aberdeen, Scotland: Aberdeen University Press, 1987), 46

Bruce, George, *A Hind's Daughter*
Sir James Guthrie, *A Hind's Daughter*
Source: George Bruce, *Perspectives: Poems 1970–86* (Aberdeen, Scotland: Aberdeen University Press, 1987), 47

Bruce, George, *The Vegetable Stall*
W.Y. Macgregor, *The Vegetable Stall*
Source: George Bruce, *Perspectives: Poems 1970–86* (Aberdeen, Scotland: Aberdeen University Press, 1987), 47

Bruce, George, *Epistle 4: To Ruby (5), Holly (3), Shirley and Timothy Cumming*
Pieter Brueghel the Elder, *Landscape with the Fall of Icarus* and *Hunters in the Snow*
Source: George Bruce, *Pursuit* (Edinburgh: Scottish Cultural Press, 1999), 26

Bruce, George, *Epistle 5: A Thank-You to John Bellamy*
John Bellamy, *Allegory*
Source: George Bruce, *Pursuit* (Edinburgh: Scottish Cultural Press, 1999), 27

Bruce, George, *Gillies*
Sir William Gillies, *Self-Portrait*
Source: George Bruce, *Pursuit* (Edinburgh: Scottish Cultural Press, 1999), 29

Bruce, George, *The Chair: Poet's and Painter's*
Vincent Van Gogh, *The Yellow Chair* and various other paintings by Van Gogh
Source: George Bruce, *Pursuit* (Edinburgh: Scottish Cultural Press, 1999), 45–8

Bruce, George, *Pursuit*
Paul Cézanne
Source: George Bruce, *Pursuit* (Edinburgh: Scottish Cultural Press, 1999), 49–56

Bruce, George, *Velázquez*
Diego Velázquez, *An Old Woman Cooking Eggs* and *Water-seller of Seville*
Source: George Bruce, *Pursuit* (Edinburgh: Scottish Cultural Press, 1999), 57

BRUCE, Suzanne. For Bruce's poems on Janet Manalo's paintings, see 3M, above.

BRUCHAC, Joseph, *Paddling at Dusk*
Winslow Homer, *Paddling at Dusk*
Source: Holcomb (1I, above), 54–7

BRUMBAUGH, Thomas B., *The Family of Lucien Bonaparte by Ingres*
Source: *Art Journal* 20 (Fall 1960), 18

Brumbaugh, Thomas B., *After Turner*
J.M.W. Turner
Source: *College Art Journal* 19 (Summer 1960): 352.

Brumbaugh, Thomas B., *El Greco: A Poem*
Source: *Art Journal* 28 (Summer 1969): 397

Brumbaugh, Thomas B., *Two Poems: About René Magritte; At Edward Malbone's Grave*
Source: *Art Journal* 22 (Summer 1963): 245

BRUNING, Henri, *Claudius Civilis*
Rembrandt van Rijn, *The Conspiracy of Claudius Civilis*
Source: Korteweg and Heijn (2F, above), 144

BRYANT, William Cullen, *An Indian at the Burial Place of His Fathers*, stanza 10
James Henry Beard, *The Last of the Red Man*
Source: *Art in America* 40 (Winter 1952): 33

Bryant, William Cullen, *A Scene on the Banks of the Hudson*
Asher B. Durand, *Landscape, Summer Morning*
Source: William Cullen Bryant, *Poems* (New York: Worthington Co., 1892), 194–5

Bryant, William Cullen, *A Forest Hymn*
Asher B. Durand, *The Primeval Forest*
Source: William Cullen Bryant, *Poems* (New York: Worthington Co., 1892), 38–42

Bryant, William Cullen, *After the Tempest*
William Hart, *After the Storm*, and Ogilvie Clifton, *Sunshine after Shower*
Source: *Art in America* 40 (Winter 1952): 33

Bryant, William Cullen, *The Battle Field*
Constant Mayer, *North and South: An Episode of the War*
Source: *Art in America* 40 (Winter 1952): 33

Bryant, William Cullen, *The Past*
Cephas Giovanni Thompson, *The Sibyl*
Source: *Art in America* 40 (Winter 1952): 33

Bryant, William Cullen, *The Death of Flowers*
Jervis McEntee, *Autumn Scene*

Source: William Cullen Bryant, *Poems* (New York: Worthington Co., 1892), 274–6

Bryant, William Cullen, *To Cole, the Painter Departing for Europe*
Thomas Cole
Source: *America in Poetry*, ed. Charles Sullivan (New York: Harry N. Abrams, 1988), 40

BRYLL, Ernest, *"Wciaz o Ikarach glosza..."*
Pieter Brueghel the Elder, *Landscape with the Fall of Icarus*
Source: Ernest Bryll, *Sztuka stosowana* (Warsaw, 1966); in Henryk Bereska, ed., *Polnische Lyrik aus fünf Jahrzehnten* (Berlin-Weimar: Aufbau-Verlag, 1977), 387; and Achim Aurnhammer and Dieter Martin, eds., *Mythos Ikarus: Texte von Ovid bis Wolf Biermann* (Leipzig: Reclam, 2001), 206; German trans., 207

BUCKLEY, Christopher, *Edward Hopper's "Portrait of Orleans, 1950"*
Source: *Cæsura* (Fall 2007): 1

Buckley, Christopher. For twelve of Buckley's poems on paintings, see 4G, above.

BUCKNELL, Lucy, *Creationze della Donna*
Bartolo di Fredi, *Creation of Eve*
Source: *Ekphrasis* 2, no. 4 (Fall–Winter 2001): 5–6

BUDEK, Herbert, *Aphrodite*
Sandro Botticelli, *The Birth of Venus*
Source: Kranz (2B, above), 116

BUDY, Andrea Hollander, *Self-Portrait between Clock and Bed*
Edvard Munch, *Self Portrait: Between Clock and Bed*
Source: Andrea Hollander Budy, *Woman in the Painting: Poems* (Pittsburgh, PA: Autumn House, 2006), 77

Budy, Andrea Hollander, *Woman Holding a Letter*
Jan Vermeer, *Woman Reading a Letter*
Source: Andrea Hollander Budy, *Woman in the Painting: Poems* (Pittsburgh, PA: Autumn House, 2006), 7

BUKOWSKI, Charles, *Van Gogh*
Vincent Van Gogh
Source: Charles Bukowski, *what matters most is how well you walk through the fire* (New York: Viking Press, 1999), 96–7

BURCHELL, Graham, *View of Delft*
Jan Vermeer, *View of Delft*
Source: *Beauty/Truth: A Journal of Ekphrastic Poetry* 1, no. 2 (Spring–Summer 2007): 17–18

Burchell, Graham, *Mussels on Rocks*
Jan Vermeer, *Street in Delft*
Source: *Beauty/Truth: A Journal of Ekphrastic Poetry* 1, no. 2 (Spring–Summer 2007): 19

Burchell, Graham. For additional poems by Burchell on Vermeer, see 3a, above.

BURFORD, William, *On the Portrait of a Young Monk by Sofonsiba Anguissola*
Source: William Burford, *Man Now* (Dallas, TX: Southern Methodist University Press, 1954), 36

Burford, William, *Tintoretto's Senator in the Frick Collection*
Source: William Burford, *Man Now* (Dallas, TX: Southern Methodist University Press, 1954), 33

BURGESS, Kathleen, *Greenhouse*
Masumi Hayashi, *"Ohio Penitentiary Laundry Room,"* 1996
Source: *Elastic Ekphrastic: Poetry on Art/Poets on Tour through Galleries*, ed. Jennifer Bosveld (Johnstown, OH: Pudding House Publications, 2003), 24–5

Burgess, Kathleen, *The Catch*
Lynda McClanahan, *Red Head with Flowers*
Source: *Elastic Ekphrastic: Poetry on Art/Poets on Tour through Galleries*, ed. Jennifer Bosveld (Johnstown, OH: Pudding House Publications, 2003), 26

BURKARD, Michael, *Murnau—After the Painting by Wassily Kandinsky*
Source: Michael Burkard, *Fictions from the Self* (New York: Norton, 1988), 95–8

BURNETT, Roberta, *After Passing Picasso's "Le Moulin de la Galette"*
Source: *Beauty/Truth: A Journal of Ekphrastic Poetry* 1, no. 3 (Fall–Winter 2007): 18–19

BURNS, Mary Ellen, *Still Portrait in a Turning World*
Jacques-Louis David, *Antoine-Laurent Lavoisier and His Wife*
Source: *Beauty/Truth: A Journal of Ekphrastic Poetry* 1, no. 1 (Fall–Winter 2006): 20–1

BURNS, Richard, *Awakening*
Frances Richards, *Les Illuminations*
Source: Adams (1B, above), 136–7

BURT, John, *The Principle of Flickering*
Kasimir Malevich, *The Knifegrinder*, 1912–13
Source: Hollander and Weber (1H, above), 6–9

BURT, Stephen, *Franz Kline: Ravenna*
Source: Hollander and Weber (1H, above), 84–5

BUTLER, Janet, *Mother Mild, "Madonna col bambino"* by Piero della Francesca (1472–74), and *A Renaissance Portrait: "Mary Magdalene" by Il Perugino, Renaissance Painter*
Source: *Collection: Ekphrastic Poems by Robert Schuler and Janet Butler*, No. 1 (Delafield, WI: Canvas Press, 2007), 8–9.

BYER, Kathryn Stripling, *June Pastoral*
Willard Leroy Metcalf, *June Pastoral*
Source: Paschal (1G, above), 76–7

BYNNER, Witter, *On a Painting by Paul Thevanaz*
Source: *Anthology of Magazine Verse for 1929 and Yearbook of American Poetry*, ed. William S. Braithwaite (New York: George Sully and Co., 1929), 43

Bynner, Witter, *Paul Thevanaz*
Source: Wittner Bynner, *Caravan* (New York: Knopf, 1925), 35–7

BYRD, Gregory, *Tintoretto Painting His Dead Daughter*
Leon Gogniet, *Tintoretto Painting His Dead Daughter*
Source: *Ekphrasis* 3, no. 1 (Spring–Summer 2003): 18

Byrd, Gregory, *Groundhog Day*
Andrew Wyeth, *Groundhog Day*
Source: *Ekphrasis* 3, no. 1 (Spring–Summer 2003): 19

BYRNE, Edward, *In the Artist's Studio, 1894*
Winslow Homer, *The Artist's Studio in an Afternoon Fog* and other images from Homer's paintings
Source: *Ekphrasis* 1, no. 6 (Fall–Winter 1999): 16

Byrne, Edward, *Summer Evening: Truro, 1947*
Edward Hopper, *Summer Evening*
Source: *Ekphrasis* 1, no. 6 (Fall–Winter 1999): 49–51

CABRAL, Olga, *Picasso's Women*
Pablo Picasso, Images of women from numerous paintings
Source: Buchwald and Roston (2C, above), 16–17

Cabral, Olga, *Hokusai's Wave*
Katsushika Hokusai, *The Great Wave at Kanagawa*
Source: Buchwald and Roston (2C, above), 53

Cabral, Olga, *Mother and Sister of the Artist*
Édouard Vuillard, *Mother and Sister of the Artist*
Source: Buchwald and Roston (2C, above), 88

CAGE, John, Untitled
Jasper Johns, *Study for "Skin with O'Hara Poem,"* 1963–65
Source: Vanderlip (1A, above), 46

Cage, John, Untitled
Robert Rauschenberg, *Half a Grandstand (Spread),* 1978
Source: Vanderlip (1A, above), 48

CALLAGHAN, Catherine A. For twenty-eight poems by Callaghan on M.C. Escher's prints, see 3G, above.

ČALOVSKI, Todor, *Explosion of Colours*
Gligor Čemerski
Source: Martinovski (2K, above), 134–5

CAMERA SHY [blogger's pen name], *Nighthawks (on looking at Edward Hopper's painting, Nighthawks)*
Source: http://beckettsmartyr.blogspot.com/2006/11/nighthawks-on-looking-at-edward.html

CAMERON, Esther, *Brueghel's Netherlandish Proverbs*
Pieter Brueghel the Younger, *Netherlandish Proverbs*
Source: *Ekphrasis* 2, no. 1 (Spring–Summer 2000): 10

CAMPBELL, David, *Women and Ladies*
Paolo Uccello, *St. George and the Dragon*; Lucas Cranach the Elder, *Cupid Complaining to Venus*; Diego Velázquez, *Kitchen Scene with Christ in the House of Martha and Mary*; Francisco Goya, *Dona Isabel de Porcel*
Source: David Campbell, *Words with a Black Orpington* (Sydney: Angus & Robertson, 1978), 23

Campbell, David, *Enigmas in Cave and Stone*
Cave paintings and rock engravings
Source: David Campbell, *Words with a Black Orpington* (Sydney: Angus & Robertson, 1978), 14–15

Campbell, David, *Femme aux Pigeons*
Pablo Picasso, *La Femme aux Pigeons*
Source: David Campbell, *Words with a Black Orpington* (Sydney: Angus & Robertson, 1978), 17

Campbell, David, *Absinth Drinkers*
Pablo Picasso, *The Absinthe Drinkers*
Source: David Campbell, *Words with a Black Orpington* (Sydney: Angus & Robertson, 1978), 18

Campbell, David, *Heidelberg*
Paul Klee
Source: David Campbell, *Words with a Black Orpington* (Sydney: Angus & Robertson, 1978), 52

Campbell, David, *Bayeux Tapestry*
Source: David Campbell, *Words with a Black Orpington* (Sydney: Angus & Robertson, 1978), 48

Campbell, David, *The Wolf of Gubbio*
Sasetta, *St. Francis and the Wolf of Gubbio*
Source: David Campbell, *Deaths and Pretty Cousins* (Canberra: Australian National University Press, 1975), 39–40

Campbell, David, *Deaf Man's House*
Frnacisco Goya, *The Third of May, 1808: The Execution of the Defenders of Madrid* and *Saturn Devouring His Children*
Source: David Campbell, *Deaths and Pretty Cousins* (Canberra: Australian National University Press, 1975), 40

Campbell, David, *On an Engraving by Jacques Callot*
Source: David Campbell, *Deaths and Pretty Cousins* (Canberra: Australian National University Press, 1975), 41

Campbell, David, *Rote Brücke*
Paul Klee, *Red Bridge*
Source: David Campbell, *Deaths and Pretty Cousins* (Canberra: Australian National University Press, 1975), 42–4

Campbell, David, *Suzanne Valadon*
Auguste Renoir, Maurice Utrillo, Edgar Degas
Source: David Campbell, *Deaths and Pretty Cousins* (Canberra: Australian National University Press, 1975), 43–4

Campbell, David, *Cézanne*
Paul Cézanne
Source: David Campbell, *Deaths and Pretty Cousins* (Canberra: Australian National University Press, 1975), 45–6

Campbell, David, *Les Demoiselles d'Avignon*
Pablo Picasso, *Les Demoiselles d'Avignon*
Source: David Campbell, *Deaths and Pretty Cousins* (Canberra: Australian National University Press, 1975), 46–7

Campbell, David, *Matisse*
Henri Matisse
Source: David Campbell, *Deaths and Pretty Cousins* (Canberra: Australian National University Press, 1975), 47–8

Campbell, David, *Modigliani*
Amedeo Modigliani
Source: David Campbell, *Deaths and Pretty Cousins* (Canberra: Australian National University Press, 1975), 48–9

Campbell, David, *Balthus Girls*
Balthus, *Le chambre* and other unnamed paintings
Source: David Campbell, *Deaths and Pretty Cousins* (Canberra: Australian National University Press, 1975), 49–50

Campbell, David, *Hoosick Falls: Grandma Moses*
Source: David Campbell, *Deaths and Pretty Cousins* (Canberra: Australian National University Press, 1975), 51

CAMPBELL, Pris, *Paradise*
Lowell Fox, *Wonderin'*
Source: http://lowellfox.com/page5-contributingp oets/index.htm#wonderin0

CAMPBELL, Thomas, *Lines: On a Picture of a Girl in the Attitude of Prayer, by the Artist Gruse, in the Possession of Lady Stepney*
Source: *The Complete Poetic Works of Thomas Campbell* (Boston: Phillips, Sampson and Co., 1854), 267–8

CAMPIGLIO, Stephen, *La Résponse imprévue/The Unexpected Answer*
René Magritte, *The Unexpected Answer*
Source: *Ekphrasis* 1, no. 3 (Spring–Summer 1998): 29

Campiglio, Stephen, *L'Explication/The Explication*
René Magritte, *The Explication*
Source: *Ekphrasis* 2, no. 1 (Spring–Summer 2000): 25

Campiglio, Stephen, *Reptiles*
M.C. Escher, *Reptiles*
Source: *Ekphrasis* 5, no. 2 (Fall–Winter 2009): 13

CAMPION, Dan, *Time Slot*
George Inness, *The Home of the Heron*
Source: *Ekphrasis* 5, no. 2 (Fall–Winter 2009): 31

CANNADY, Criss E., *In the Sitting Room of the Opera*
After a sketch by Edgar Degas
Source: Buchwald and Roston (2C, above), 88

Cannady, Criss E., *Sunlight in a Cafeteria*
Edward Hopper, *Sunlight in a Cafeteria*
Source: Buchwald and Roston (2C, above), 89

CANNON, Diane, *Phenomena Alter Tide*
Paul Jenkins, *Phenomena Alter Tide*
Source: http://hermes.hrc.ntu.edu.tw/lctd/genre/ek phrasis/ekphrasis_right.htm

CANTRELL, Charles, *La Chambre*
Balthus, *La Chambre*
Source: *Ekphrasis* 4, no. 3 (Spring–Summer 2007): 23

CARDONA, Jacinto Jesús, *Bato Con Khakis*
César A. Martinez, *Bato Con Khakis*
Source: Greenberg, *Heart* (2J, above), 13

CARDONA-HINE, Alvaro, *Geo-Politics*
Sebastiano del Piombo, *Cardinal Bandinello Saudi, His Secretary and Two Geographers*
Source: Buchwald and Roston (2C, above), 83

CARDUNA, Carlo, *Brueghels Blinde*
Pieter Brueghel the Elder, *The Parable of the Blind*
Source: Kranz (2B, above), 103

CAREY, Erin, *All Strung Out*
Frank Tuchfarber, *The Old Violin*
Source: Janovy (1O, above), 22–3

CARLISLE, Wendy Taylor, *Between This Island and Key West*
Luis Cruz Azaceta, *The Fragile Crossing*
Source: *Ekphrasis* 4, no. 2 (Fall–Winter 2006): 45

CARLSON-BRADLEY, Martha, *Why I Was Not Seduced*
Caravaggio, *Bacchus*
Source: *Ekphrasis* 3, no. 1 (Spring–Summer 2003): 8

CARPENTER, William, *Evening Wind*
Edward Hopper, *Evening Wind*
Source: Levin (3J, above), 24; and in Carpenter's *The Hours of Morning* (Charlottesville: University Press of Virginia, 1981), 24–5

Carpenter, William, *Lighthouse Hill*
Edward Hopper, *Lighthouse Hill*

Source: William Carpenter, *Rain* (Boston: North-easter University Press, 1985), 49; and Levin (3J, above), 46

Carpenter, William, *Monhegan*
Edward Hopper, Monhegan, Maine, paintings
Source: William Carpenter, *Rain* (Boston: North-eastern University Press, 1985), 49; and Levin (3J, above), 48

Carpenter, William, *Night Shadows*
Edward Hopper, *Night Shadows*
Source: William Carpenter, *Rain* (Boston: North-eastern University Press, 1985), 49; and Levin (3J, above), 50

Carpenter, William, *A Station of Monet*
Claude Monet, *St. Lazere Station: The Arrival of the Train from Normandy*
Source: William Carpenter, *The Hours of Morning: Poems 1976–79* (Charlottesville: University Press of Virginia, 1981), 54–5

Carpenter, William, *Nighthawks*
Edward Hopper, *Nighthawks*
Source: William Carpenter, *The Hours of Morning: Poems 1976–79* (Charlottesville: University Press of Virginia, 1981), 25

Carpenter, William, *Early Sunday Morning*
Edward Hopper, *Early Sunday Morning*
Source: William Carpenter, *Rain* (Boston: North-eastern University Press, 1985), 50

Carpenter, William, *Gas*
Edward Hopper, *Gas*
Source: William Carpenter, *The Hours of Morning: Poems 1976–79* (Charlottesville: University Press of Virginia, 1981), 26

Carpenter, William, *New York Movie*
Edward Hopper, *New York Movie*
Source: William Carpenter, *Rain* (Boston: North-eastern University Press, 1985), 47

Carpenter, William, *Cézanne at Mont Sainte-Victoire*
Paul Cézanne, Marsden Hartley
Source: William Carpenter, *The Hours of Morning: Poems 1976–79* (Charlottesville: University Press of Virginia, 1981), 13–15

Carpenter, William, *Friends of de Chirico*
Giorgio de Chirico, *Melancholy and Mysteries of the Street*
Source: William Carpenter, *The Hours of Morning: Poems 1976–79* (Charlottesville: University Press of Virginia, 1981), 18

Carpenter, William, *The Artist's Hand (Three Views)*
Edward Hopper, *The Artist's Hand* [*Three Views*]
Source: William Carpenter, *The Hours of Morning: Poems 1976–79* (Charlottesville: University Press of Virginia, 1981), 24

Carpenter, William, *Taken from Van Gogh*
Vincent Van Gogh, *Wheat Field with Crows, Self-Portrait*
Source: William Carpenter, *The Hours of Morning: Poems 1976–79* (Charlottesville: University Press of Virginia, 1981), 41–3

CARPER, Thomas, *Her Portrait*
Jean-Baptiste-Camille Corot, *Mlle. Alexina Ledoux*
Source: Thomas Carper, *Fiddle Lane* (Baltimore: Johns Hopkins University Press, 1991), 63

Carper, Thomas, *Paint*
Vincent Van Gogh, *Wheat Field with Crows*
Source: Thomas Carper, *Fiddle Lane* (Baltimore: Johns Hopkins University Press, 1991), 64

CARR, Ruth, *The Three Dancers*
John Luke, *The Three Dancers*
Source: Reid and Rice (1J, above), 84–5

CARRIER, Constance, *Brueghel: The Fall of Icarus*
Pieter Brueghel the Elder, *Landscape with the Fall of Icarus*
Source: Constance Carrier, *The Middle Voice* (Denver: Swallow, 1955), 37

CARRUTH, Hayden, *Matisse*
Source: Hayden Carruth, *The Crow and the Heart, 1946–1959* (New York: Macmillan, 1959), 23

Carruth, Hayden, *Mondrian*
Source: *Art News* 57 (September 1958), 24–5; rpt. in Carruth's *The Crow and the Heart, 1946–1959* (New York: Macmillan, 1959), 62

Carruth, Hayden, *Museum Piece*
Unnamed painting of the creation of Eve
Source: *The Crow and the Heart, 1946–1959* (New York: Macmillan, 1959), 85

Carruth, Hayden, *William H. Macdowell*
Thomas Eakins, *William H. Macdowell*
Source: Holcomb (1I, above), 58–9

Carruth, Hayden, *Cave Painting*
Source: Hayden Carruth, *Asphalt Georgics* (New York: New Directions, 1985), 53–5

Carruth, Hayden, *Museum Piece*
Painting of the birth of Eve
Source: Hayden Carruth, *Collected Shorter Poems, 1946–1991* (Port Townsend, WA: Copper Canyon Press, 1992), 22–3

CARSON, Anne, *"Seated Figure with Red Angle" (1988) by Betty Goodwin*
Source: Ann Carson, *Decreation* (New York: Knopf, 2005), 97–101

Carson, Anne, *Canicula di Anna*
Perugino
Source: Anne Carson, *Plainwater* (New York: Vintage), 49–90

CARSON, Ciaran, *Engraving from a Child's Encyclopedia*
Etching of an Alpine scene by an unidentified engraver
Source: Ciaran Carson, *Collected Poems* (Loughcrew, Oldcastle, Ireland: Gallery Press, 2008), 35

Carson, Ciaran, *Théodore Géricault: "Farrier's Signboard," 1814*
Source: Ciaran Carson, *Collected Poems* (Loughcrew, Oldcastle, Ireland: Gallery Press, 2008), 459–60

Carson, Ciaran, *Francisco Goya: "The Third of May 1808," 1814*
Source: Ciaran Carson, *Collected Poems* (Loughcrew, Oldcastle, Ireland: Gallery Press, 2008), 463

Carson, Ciaran, *Edward Hopper: "Early Sunday Morning," 1910*
Source: Ciaran Carson, *Collected Poems* (Loughcrew, Oldcastle, Ireland: Gallery Press, 2008), 468–9

CARTER, Alan, *Vincent's Teardrops*
Vincent Van Gogh
Source: *Beauty/Truth: A Journal of Ekphrastic Poetry* 1, no. 2 (Spring–Summer 2007): 32–3

CARTER, Ann Babson, *Cobb's Barns*
Edward Hopper, *Cobb's Barns*
Source: Levin (3J, above), 53

CASE, Susan H., *Panoramic Nude, Grand Hotel Villa Serbelloni*
Source: http://www.nycbigcitylit.com/may2002/contents/poetryasingles.html

CASHDAN, Liz, *Writing Edward Hopper*
Edward Hopper, *Automat, Office at Night,* and *Nighthawks*
Source: Liz Cashdan, *The Same Country* (Nottingham, UK: Five Leaves Publications, 2006), 5

Cashdan, Liz, *Resurrection*
Alexei G. Venezianov, *Sleeping Shepherd Boy*
Source: Liz Cashdan, *The Same Country* (Nottingham, UK: Five Leaves Publications, 2006), 6

Cashdan, Liz, *Mary Elwell Paintings*
Mary Elwell, painting of a reading room interior and her self-portrait
Source: Liz Cashdan, *The Same Country* (Nottingham, UK: Five Leaves Publications, 2006), 9–10

Cashdan, Liz, *One Way or Another*
Pat Hodson, *Flotsam*
Source: Liz Cashdan, *The Same Country* (Nottingham, UK: Five Leaves Publications, 2006), 20–1

CASSELLS, Cyrus, *Love Poem with the Wind of Calvary—Rosso Fiorentino's "Deposition from the Cross"*
Source: Cyrus Cassells, *Beautiful Signor* (Chicago: Third World Press, 1997), 59

CATLIN, Alan, *Girl with Red Stockings, 1882*
Winslow Homer, *Girl with Red Stockings*
Source: *Aurorean* (Spring–Summer 2008)

Catlin, Alan, *O'Keeffe Requirements*
Georgia O'Keeffe
Source: *Chronogram* 28 September 2007. http://capital-region.chronogram.com/issue/2007/10/Poetry/Poetry-Alan-Catlin

Catlin, Alan, *"The Arduous Nowhere" I* and *"The Arduous Nowhere" II*
Stephen Hannock, *The Arduous Nowhere*
Source: *Chronogram* 28 September 2007. http://capital-region.chronogram.com/issue/2007/10/Poetry/Poetry-Alan-Catlin

Catlin, Alan, *The Artist's Studio in Afternoon Fog 1894*
Winslow Homer, *The Artist's Studio in Afternoon Fog*
Source: *Chronogram* 27 March 2008. http://capital-region.chronogram.com/issue/2008/4/Poetry/The-Artist-s-Studio-in-Afternoon-Fog-1894

Caitlin, Alan, *"You're Innocent When You Dream"*
Stan Rice, *You're Innocent When You Dream*
Source: Alan Catlin, *Self-Portrait of the Artist Afraid of His Self-Portrait* (Greensboro, NC: March Street Press, 2008), 1

Catlin, Alan, *Self-Portraits with Self-Portraits by Munch*
Edvard Munch
Source: Alan Catlin, *Self-Portrait of the Artist Afraid of His Self-Portrait* (Greensboro, NC: March Street Press, 2008), 6

Catlin, Alan, *Self-Portrait with Warhol*
Andy Warhol
Source: Alan Catlin, *Self-Portrait of the Artist Afraid of His Self-Portrait* (Greensboro, NC: March Street Press, 2008), 7

Catlin, Alan, *Self-Portraits with Portraits of J.M.W Turner*
Source: Alan Catlin, *Self-Portrait of the Artist Afraid of His Self-Portrait* (Greensboro, NC: March Street Press, 2008), 8

Catlin, Alan, *The Crime Scene*
Stan Rice, *The Crime Scene*
Source: Alan Catlin, *Self-Portrait of the Artist Afraid of His Self-Portrait* (Greensboro, NC: March Street Press, 2008), 9

Catlin, Alan, *Self-Portrait with Chagall*
Marc Chagall
Source: Alan Catlin, *Self-Portrait of the Artist Afraid of His Self-Portrait* (Greensboro, NC: March Street Press, 2008), 11

Catlin, Alan, *Self-Portrait with Views of Mt. Fuji*
Various *ukiyo-e* woodblock images of Mt. Fuji
Source: Alan Catlin, *Self-Portrait of the Artist Afraid*

Cavafy, C.P., *On the Ship*
Unidentified drawing
Source: C.P. Cavafy; Stratis Haviaras, trans.; Dana
 Bonstrom, ed., *The Canon: The Original One
 Hundred and Fifty-Four Poems* (Cambridge, MA:
 Harvard University Press, 2007), 235

Cavafy, C.P., *Painted*
Unidentified painting
Source: C.P. Cavafy; Stratis Haviaras, trans.; Dana
 Bonstrom, ed., *The Canon: The Original One
 Hundred and Fifty-Four Poems* (Cambridge, MA:
 Harvard University Press, 2007), 145

Cavafy, C.P., *Portrait of a Twenty-Three Year Old
 Made by his Friend of the Same Age, an Amateur*
Unidentified painting
Source: C.P. Cavafy; Stratis Haviaras, trans.; Dana
 Bonstrom, ed., *The Canon: The Original One
 Hundred and Fifty-Four Poems* (Cambridge, MA:
 Harvard University Press, 2007), 361

CAVANAUGH, Elaine, *Pietà*
Colijn de Coter, *Bernatsky Triptych: The Lamenta-
 tion*
Source: *Wisconsin Poets* (1E, above), 10–11

CEDERING, Siv, *Sit a While*
Romare Bearden, *Black Manhattan*
Source: Greenberg, *Heart* (2J, above), 16

ČEJKOVSKA, Vera, *Bosch*
Hieronymus Bosch
Source: Martinovski (2K, above), 86

Čejkovska, Vera, *The Garden of Earthly Delights*
Hieronymus Bosch, *The Garden of Earthly Delights*
Source: Martinovski (2K, above), 86–7

CELAN, Paul, *Under a Picture*
Vincent Van Gogh, *Crows over Cornfield*
Source: *Poems of Paul Celan*, trans. Michael Ham-
 burger (New York: Persea, 1995), 109; German
 original, p. 108, and in Kranz (2B, above), 214

CHADZINIKOLAU, Nikos, *Pejzaz z Ikarem Bruegela*
Pieter Brueghel the Elder, *Landscape with the Fall
 of Icarus*
Source: Nikos Chadzinikolau, *Exodus* (Poznan:
 Wydawn Poznanskie), 47

CHAMBERS, S.J., *Ecce Ancilla Domini!*
Dante Gabriel Rossetti, *Annunciation*
Source: *The Hiss Quarterly* 5, no. 3. http://thehiss
 quarterly.net/eck/chambers.html

CHANDRA, Deborah, *The Peacock*
Joseph Stella, *The Peacock*
Source: Greenberg, *Heart* (2J, above), 9

CHAPMAN, Robin, *Self-Portrait with Bandaged Ear*
Vincent Van Gogh, *Self-Portrait with Bandaged Ear*
Source: *Ekphrasis* 2, no. 6 (Fall–Winter 2002): 43

CHAPPELL, Fred, *The Voyagers*
Jan Vermeer, *The Astronomer*
Source: Fred Chappell, *First and Last Words* (Baton
 Rouge: Louisiana State University Press, 1989), 22

Chappell, Fred, *The Phantom Pattern: A Pantoum*
Frank Stella, *Raqqa II*
Source: Paschal (1G, above), 120–1

CHAR, René, *Les Casseurs de Cailloux*
Gustave Courbet, *The Stonebreakers*
Source: Kranz (2B, above), 209; German trans., *Die
 Steinklopfer*, Kranz (2B, above), 210

CHENEY, John Vance, *The Man with the Hoe: A
 Reply*
Jean-Francois Millet, *The Man with the Hoe*
Source: *An American Anthology, 1787–1900*, ed.,
 Edmund Clarence Stedman (Boston: Houghton
 Mifflin, 1900), 586–7

CHERNER, Anne, *To Mark Rothko of "Untitled
 (Blue, Green)," 1969*
Source: Buchwald and Roston (2C, above), 18

Cherner, Anne, *To Morris Louis of the "Blue Veil"
 1958–9*
Source: Buchwald and Roston (2C, above), 19

Cherner, Anne, *To Helen Frankenthaler of "Circe,"
 1974*
Source: Buchwald and Roston (2C, above), 20

CHERRY, Kelly, *Rothko*
Mark Rothko, *Untitled, 1968*
Source: *Wisconsin Poets* (1E, above), 58–9

CHESTER, Tessa Rose, *The Artist's Wife*
Paul Klee
Source: Tessa Rose Chester, *Provisions of Light* (Ox-
 ford: Oxford University Press, 1996), 1

Chester, Tessa Rose, *Lights, no. 4*
René Magritte, *L'empire des lumières*
Source: Tessa Rose Chester, *Provisions of Light* (Ox-
 ford: Oxford University Press, 1996), 8–9

CH'ING, Lo, *Cat Heaven*
Lo Ch'ing, *Cat Heaven*
Source: Greenberg, *Side* (2M, above), 60–1

CHMIELARZ, Sharon, *The Beekeepers*
Pieter Brueghel the Elder, *The Beekeepers*
Source: *Ekphrasis* 4, no. 4 (Fall–Winter 2007): 35–6

Chmielarz, Sharon, *The Ornithologist and the Poet in
 the Evil Emperor's Garden* and *The Tree of Life*
*An American Vision: Henry Francis du Pont's Win-
 terthur Museum* (exhibition)
Source: http://www.northography.com/MIA/shar
 on.php

Chmielarz, Sharon, *"Diana and Actaeon" by Jacob
 Jordaens, c. 1640,*
Source: *Ekphrasis* 5, no. 1 (Spring–Summer 2009): 5

CHRISTENSEN, Claus Handberg, *Untitled*
Kristofer Hultenberg, *Untitled*
Source: http://electricveneer.com/clients/inekphras
 is/ekphrasis.html

CHRISTIAENS, Dirk, *Dulle Griet*
Pieter Brueghel the Elder, *Mad Meg*
Source: Korteweg and Heijn (2F, above), 86

CHRISTIAN, Charles, *Salvator Rosa*
Salvator Rosa, *Self-Portrait*
Source: http://wordsandvision.blogharbor.com/bl
 og/_archives/2008/12/23/4033244.html

Christian, Charles, *Chagall: Fiddling While Zion
 Burns*
Marc Chagall, *Fiancées of the Eifel Tower*
Source: http://wordsandvision.blogharbor.com/bl
 og/_archives/2008/12/23/4033244.html

Christian, Charles, *Lenka: She Knows*
Vladimir Tretchikoff, *Lenka*
Source: http://wordsandvision.blogharbor.com/bl
 og/_archives/2008/12/23/4033244.html

CHUBB, Thomas Caldecot, *A Chinese Painting*
Unidentified painting
Source: Thomas Caldecot Chubb, *The White God
 and Other Poems* (New Haven, CT: Yale Univer-
 sity Press, 1968), 37

CLAESSON, Carmen, *Seagull Boats*
John H. Thwachtman, *Bark and Schooner*
Source: Janovy (1O, above), 15

CLAESSON, Monica, *Untold Voyage*
Jacob Lawrence, *Paper Boats*
Source: Janovy (1O, above), 6–7

CLARK, Jeff, *Against*
Monique Prieto, *Tide*
Source: Geha and Nichols (1N, above), 81–6

CLARK, Margaret, *On Realizing There Are Too Many
 Poems about Onions, Pears, and Brueghel's Paint-
 ings*
Pieter Brueghel the Elder, images from *The Triumph
 of Death* and other works
Source: *Rattle* 13, no. 2 (Winter 2007): 23

CLARK, T.J., *Landscape with a Calm*
Nicolas Poussin, *Landscape with a Calm*
Source: Lyn Hejinian, ed., *The Best American Poetry
 2004* (New York: Scribner, 2004), 53–4

CLARK, Tom, *Caravaggio and the Birth of the
 Baroque Romantic*
Source: Tom Clark, *Fractured Karma* (Santa Rosa,
 CA: Black Sparrow Press, 1990), 88–9

Clark, Tom, *After Cézanne*
Paul Cézanne
Source: Tom Clark, *Easter Sunday* (Minneapolis,
 MN: Coffee House Press, 1987), 16

Clark, Tom, *Caspar David Friedrich and the Inte-
 rior Dictation of Landscape*
Source: Tom Clark, *Disordered Ideas* (Santa Rosa,
 CA: Black Sparrow Press, 1987), 24–5

Clark, Tom, *Friedrich's Dream*
Caspar David Friedrich
Source: Tom Clark, *Disordered Ideas* (Santa Rosa,
 CA: Black Sparrow Press, 1987), 26

Clark, Tom, *Friedrich's Vision*
Caspar David Friedrich
Source: Tom Clark, *Disordered Ideas* (Santa Rosa,
 CA: Black Sparrow Press, 1987), 27

Clark, Tom, *Friedrich's Vision (II)*
Caspar David Friedrich
Source: Tom Clark, *Disordered Ideas* (Santa Rosa,
 CA: Black Sparrow Press, 1987), 28

Clark, Tom, *Friedrich's Vision Rejoinder*
Caspar David Friedrich
Source: Tom Clark, *Disordered Ideas* (Santa Rosa,
 CA: Black Sparrow Press, 1987), 29

Clark, Tom, *Friedrich & the Beyond*
Caspar David Friedrich
Source: Tom Clark, *Easter Sunday* (Minneapolis,
 MN: Coffee House Press (1987), 64

CLARKE, Gillian, *The Rothko Room*
Mark Rothko, *Red on Maroon*
Source: Gillian Clarke, *Collected Poems* (Man-
 chester, UK: Carcanet, 1997), 106–7; and Abse
 (2D, above), 134, and Adams (1B, above), 116–
 18

Clarke, Gillian, *The Artist's Room*
Gwen John, *A Corner of the Artist's Room, Paris*
Source: Benton and Benton, *Picture Poems* (2H,
 above), 32–3; and http://wwwfp.education.tas.
 gov.au/English/hugopaul.htm

Clarke, Gillian, *Red Poppy: From a Painting by Geor-
 gia OKeeffe*
Source: Gillian Clarke, *Collected Poems* (Manches-
 ter, UK: Carcanet, 1997), 107–8

CLAUDIUS, Hermann, *Mona Lisa*
Leonardo da Vinci, *Mona Lisa*
Source: Kranz (2B, above), 129

Claudius, Herman *Rembrandt*
Rembrandt van Rijn, *David spielt die Harfe vor Saul
 (David Playing the Harp before Saul)*
Source: Kranz (2B, above), 177–8

CLAUS, Hugo, *Visio Tondalis*
Hieronymus Bosch, *The Vision of Tondalus*
Source: Korteweg and Heijn (2F, above), 71

Claus, Hugo, *In het museum van Chicago*
Joachim Patinier, *Saint Hieronymus*
Source: Korteweg and Heijn (2F, above), 73

Claus, Hugo, *Het land (Egyptisch)*
Pieter Brueghel the Elder, *The Numbering at Bethlehem* and *The Massacre of the Innocents*
Source: Korteweg and Heijn (2F, above), 98

Claus, Hugo, *Rembrandt van Rijn*
Rembrandt van Rijn, *Sophonisba Receiving the Poisoned Cup* and *Rembrandt and Saskia*
Source: Korteweg and Heijn (2F, above), 125

CLEWELL, David, *Man Ray Stares into the Future of Jazz: 1919*
Man Ray, *Jazz*
Source: Greenberg, *Heart* (2J, above), 66–7

CLUYSENAAR, Anne, [*Jocund. Jocund after such pleasures*]
Jan van Eyck, *Arnolfini Wedding Portrait*
Source: Anne Cluysenaar, *Timeslips: New and Selected Poems* (Manchester, UK: Carcanet, 1997), 64–5

COATES, Florence Earle, *The Angelus*
Jean-François Millet, *The Angelus*
Source: *The Home Book of Verse: American and English*, ed. Burton E. Stevenson (New York: Holt, 1922), 36–46

COCTEAU, Jean, *La Jeune Femme* and *Das Mädchens*
Pablo Picasso, paintings of girls
Source: Kranz (2B, above), 245

Cocteau, Jean, *Broken Poem for Picasso*
Source: *Yale French Studies* 21 (1958): 14

COFFEY, Brian, *Painterly: Remembering Chagall*
Marc Chagall
Source: Brian Coffey, *Poems And Versions 1929–1990* (Dublin: The Dedalus Press, 1991), 208–9

COHEN, Beatrice R., *The First Lady of the World*
Stephen Hannock, *Nocturne for the River Keeper, Green Light*
Source: *Texts with Vistas* (31, above)

COHEN, K., *Safe*
Rachel Rawlins, *Lily*
Source: *qarrtsiluni. online literary magazine.* http://qarrtsiluni.com/category/ekphrasis

COHEN, Nan, *Five Lines from the Artist's Notes*
Akseli Gallen-Kallela, *Lemminkainen's Mother*
Source: Nan Cohen, *Rope Bridge* (Cincinnati, OH: Cherry Grove, 2005), 49–50

COHEN, Susan, *At the Radiation Clinic*
Vincent Van Gogh, *Olive Trees*
Source: *Ekphrasis* 4, no. 5 (Spring–Summer 2008): 24

COHN, Hans W., *Ikarus*
Pieter Brueghel the Elder, *Landscape with the Fall of Icarus*

Source: Hans W. Cohn, *Gedichte* (Gütersloh: S. Mohn, 1964), 21

COLBY, Joan, *The Magician*
Marc Chagall, *The Magician*
Source: Buchwald and Roston (2C, above), 76; originally published in Colby's *Chagall Poems* (Nacogdoches, TX: Seven Deadly Sins Press, 1980)

Colby, Joan, *Equestrienne*
Marc Chagall, *The Equestrienne*
Source: Buchwald and Roston (2C, above), 77; originally published in Colby's *Chagall Poems* (Nacogdoches, TX: Seven Deadly Sins Press, 1980)

Colby, Joan, *After Edward Hopper—Nighthawks*
Source: http://www.radiantturnstile.com/Radiant%20Turnstile/Joan_Colby_V3.html

COLE, Henri, *Self-Portrait as Four Styles of Pompeian Wall Painting*
Source: *The Best American Poetry 1998*, ed. John Hollander (New York: Scribner Poetry, 1998), 111–13

COLE, Thomas, Untitled poem
Thomas Cole, *The Oxbow of the Connecticut River Near Northhampton*
Source: *American Paintings: A Catalogue of the Collection of the Metropolitan Museum of Art* (Greenwich, CT: New York Graphics Society, 1965), 228

Cole, Thomas, *Song of a Spirit*
Thomas Cole, *Schroon Mountain, Adirondacks*
Source: Louis Legrand Noble, *The Life and Works of Thomas Cole* (Cambridge: Harvard University Press, 1964), 179

COLE, Thomas Robert, *La Grande Jatte: Sunday Afternoon*
Georges Seurat, *La Grande Jatte*
Source: *New Poems by American Poets*, ed. Rolfe Humphries (New York: Ballentine Books, 1953), 34–5

COLEMAN, Wanda, *I Remember Romance in the Chevy Graveyard—after a painting by Laura Alvarez*
Source: Wanda Coleman, *Bathwater Wine* (Santa Rosa, CA: Black Sparrow Press, 1998), 49–50

COLLINS, Billy, *The Brooklyn Museum of Art*
One of the Hudson River paintings of Frederick Edwin Church
Source: Billy Collins, *Sailing Alone around the Room* (New York: Random House, 2001), 17

Collins, Billy, *Sweet Talk*
Leonardo da Vinci, *Mona Lisa*; Eugène Delacroix, *Odalesque*; Edward Hopper, *High Noon*
Source: *American Poetry Review*, September 1995; and at http://valerie6.myweb.uga.edu/intertextuality.html#three

Collins, Billy, *Musée des Beaux Arts Revisited*
Hieronymus Bosch, *The Temptation of St. Anthony*
Source: Billy Collins, *Picnic, Lightning* (Pittsburgh: University of Pittsburgh Press, 1998), 59–60

Collins, Billy, *Student of Clouds*
Various paintings by John Constable
Source: Billy Collins, *Questions about Angels* (Pittsburgh: University of Pittsburgh Press, 1991), 9–10

Collins, Billy, *Candle Hat*
Francisco Goya, *Self Portrait* (ca. 1790–95)
Source: Billy Collins, *Questions about Angels* (Pittsburgh: University of Pittsburgh Press, 1991), 11–12

Collins, Billy, *Metropolis*
Various still lifes
Source: Billy Collins, *The Art of Drowning* (Pittsburgh: University of Pittsburgh Press, 1995), 24–5

COMANINI, Gregorio, *Vertumnus*
Giuseppe Arcimboldi (or Arcimboldo), *Rudolf II as Vertumnus*
Source: Kranz (2B, above), 161

CONNOR, Julia, *After Nathan Oliveira's "Figure with a Black Background"*
Source: *Ekphrasis* 4, no. 4 (Fall–Winter 2007): 12

CONQUEST, Robert, *The Rokeby Venus*
Diego Velázquez, *The Rokeby Venus*
Source: Robert Conquest, *New and Collected Poems* (London: Hutchinson, 1998), 11–12; and Hollander (2I, above), 263

Conquest, Robert, *A Painting by Paul Klee*
Source: Robert Conquest, *New and Collected Poems* (London: Hutchinson, 1988), 12

Conquest, Robert, *Another Klee*
Paul Klee, *Around the Fish*
Source: Robert Conquest, *New and Collected Poems* (London: Hutchinson, 1988), 17–18

Conquest, Robert, *"Self Portrait* (ca. 1790–95)*" by Salvator Rosa*
Source: Robert Conquest, *New and Collected Poems* (London: Hutchinson, 1988), 18

COOLEY, Peter, *Olive Trees in a Mountain Landscape*
Vincent Van Gogh, *Olive Trees in a Mountain Landscape*
Source: *Ekphrasis* 2, no. 1 (Spring–Summer 2000): 6

Cooley, Peter, *Starry Night*
Vincent Van Gogh, *Starry Night*
Source: *Ekphrasis* 2, no. 1 (Spring–Summer 2000): 52

Cooley, Peter. For additional poems by Cooley on Vincent Van Gogh, see 3V, above.

Cooley, Peter, *Rembrandt, "The Polish Rider"*
Source: *Ekphrasis* 5, no. 2 (Fall–Winter 2009): 29

Cooley, Peter, *Rembrandt, "Ecce Homa"*
Source: *Ekphrasis* 5, no. 2 (Fall–Winter 2009): 30

COPE, Wendy, *The Uncertainty of the Poet*
Giorgio de Chirico, *The Uncertainty of the Poet*
Source: Wendy Cope, *Serious Concerns* (London: Faber and Faber, 1992); Adams (1B, above), 98–9, and Benton and Benton, *Painting with Words* (2G, above), 40–1

COPP, Corina, *Pale Tomato (Illume)*
Anna Schachte, *Tunnel of Love*
Source: Geha and Nichols (1N, above), 91–4

COREY, Stephen, *Poppy Fields Near Giverny*
Claude Monet, *Poppy Fields Near Giverny*
Source: Stephen Corey, *All These Lands You Call One Country* (Columbia: University of Missouri Press, 1992), 41–2

Corey, Stephen, *The Painting Comes Home*
Charles Burchfield, *Six O'Clock*
Source: Greenberg, *Heart* (2J, above), 58

CORN, Alfred, *Pages from a Voyage*, part 11, *Montefontaine*
Jean-Baptiste-Camille Corot, *Recollection of Montefontaine*
Source: Alfred Corn, *Stake: Poems 1972–1992* (Washington, DC: Counterpoint, 1999), 20

Corn, Alfred, *La Madeleine*, part 7, *La Maddalena*
Caravaggio, *Maddalena*
Source: Alfred Corn, *Stake: Poems 1972–1992* (Washington, DC: Counterpoint, 1999), 202

Corn, Alfred, *Seeing All the Vermeers*
On sixteen of Jan Vermeer's paintings
Source: Alfred Corn, *Contradictions* (Port Townsend, WA: Copper Canyon, 2002), 71–7

CORSO, Gregory, *Rembrandt— Self Portrait*
Source: Gregory Corso, *Mindfield: Selected Poems* (New York: Thunder's Mouth Press, 1989), 209

Corso, Gregory, *Vermeer*
Composite of several Jan Vermeer's paintings: *The Little Street, Milkmaid, Officer and Laughing Girl,* et al.
Source: Gregory Corso, *Mindfield: Selected Poems* (New York: Thunder's Mouth Press, 1989), 216

Corso, Gregory, *Botticelli's "Spring"*
Sandro Botticelli, *La Primavera*
Source: Gregory Corso, *Mindfield: Selected Poems* (New York: Thunder's Mouth Press, 1989), 28

Corso, Gregory, *Uccello*
Paolo Uccello, *Battle of San Romano: The Counter-Attack by Micheletto da Cotignola*

Source: Gregory Corso, *Mindfield: Selected Poems* (New York: Thunder's Mouth Press, 1989), 29

Corso, Gregory, *Ecce Homo*
Master Theodoric, *Ecce Home*
Source: Gregory Corso, *Gasoline & The Vestal Lady on Brattle* (San Francisco: City Lights Books, 1958), 34

Corso, *Full Length Portrait of St. Francis*
Unidentified painting
Source: Gregory Corso, *Long Live Man* (New York: New Directions, 1962), 38–9

COSTIN, Calistrat, *Bruegel*
Pieter Brueghel the Elder, *Landscape with the Fall of Icarus*
Source: Calistrat Costin, *Planete* (Iasi: Junimea, 1974), 59–60

COTE, Charlotte A., *Young Woman in Black*
Homer Boss, *Young Woman in Black*
Source: *Wisconsin Poets* (1E, above), 30–1

COVER, Doug, *The Albion Collection*
Twenty-seven poems in this booklet describing the poet's own paintings
Source: http://www.dougcover.com/poems_about_paintings.htm

COWPER, William, *Sonnet to George Romney, Esq., on His Picture of Me in Crayons, etc.*
Source: *The Complete Poetical Works of William Cowper, Esq.* (New York: D. Appleton and Co., 1854), 227

Cowper, William, *On Flaxman's Penelope*
John Flaxman, *Penelope Surprised by the Suitors*
Source: *The Complete Poetical Works of William Cowper, Esq.* (New York: D. Appleton and Co., 1854), 235

Cowper, William, *On His Portrait*
Lemuel Abbot, *Portrait of Cowper*
Source: Helen Plotz, ed., *Eye's Delight: Poems of Art and Architecture* (New York: Greenwillow Books, 1983), 14

COX, Eleanor Rogers, *To a Portrait of Whistler in the Brooklyn Art Museum*
Giovanni Boldini, *Portrait of Whistler*
Source: *Home Book of Modern Verse*, ed., Burton E. Stevenson (New York: Holt, 1925), 1017–18

Cox, Eleanor Rogers, *Whistler's White Girl*
James McNeill Whistler, *The White Girl*
Source: *Poetry* 11 (October 1917): 25

CRANCH, Christopher, *October Afternoon* and *October*
Christopher Cranch, *An Autumnal Study*
Source: Christopher Cranch, *The Bird and the Bell with Other Poems* (Boston: James R. Osgood and Co., 1875), 119–20

CRANE, Hart, *Poem: To Brooklyn Bridge* and *Atlantis*
Joseph Stella, *New York Interpreted: The Bridge*
Source: Hart Crane, *Collected Poems*, ed. Waldo Frank (New York: Liveright, 1946), 55–60

Crane, Hart, *Sunday Morning Apples: To William Sommer, Painter*
Source: *New Anthology of American Poetry*, ed. Selden Rodman (New York: Random House, 1938), 263

CRANFORD, Barbara, *No One There*
Unidentified self-portrait
Source: *Beauty/Truth: A Journal of Ekphrastic Poetry* 1, no. 1 (Fall–Winter 2006): 25

Cranford, Barbara, *Looking at Rothko*
Mark Rothko, *Yellow and Gold*
Source: *Beauty/Truth: A Journal of Ekphrastic Poetry* 1, no. 2 (Spring–Summer 2007): 23

CRASE, Douglas, *Blue Poles: Jackson Pollock*
Jackson Pollock, *Blue Poles: Number 11, 1952*
Source: *American Review 25*; rpt. in Crase's *The Revisionist* (Boston: Little, Brown, 1981), 69

CREELEY, Robert, *As If*
Édouard Vuillard, *Portrait of Lugné Poë*
Source: Holcomb (1I, above), 66–7

CRICHTON SMITH, Iain, *Botticelli's "Primavera"*
Source: Iain Crichton Smith, Collected Poems (Manchester, UK: Carcanet, 1995), 379

Crichton Smith, Iain, *"Don Quixote" by Daumier*
Source: Iain Crichton Smith, *Collected Poems* (Manchester, UK: Carcanet, 1995), 377

Crichton Smith, Iain, *"The Tiger" by Franz Marc*
Source: Iain Crichton Smith, *Collected Poems* (Manchester, UK: Carcanet, 1995), 376–7

Crichton Smith, Iain, *Detail from "The Triumph of Death" by Breughel*
Source: Iain Crichton Smith, *Collected Poems* (Manchester, UK: Carcanet, 1995), 377–8

Crichton Smith, Iain, *Goya*
Source: Iain Crichton Smith, *Collected Poems* (Manchester, UK: Carcanet, 1995), 379

Crichton Smith, Iain, *Van Gogh and the Visitors*
Source: Iain Crichton Smith, *Collected Poems* (Manchester, UK: Carcanet, 1995), 357–8

CROFT, Sally, *Georgia O'Keeffe's "The Shanty"*
Source: *Ekphrasis* 1, no. 2 (Winter 1997–1998): 34

CRONIN, Anthony, *Lines for a Painter*
Patrick Swift, *Tree in Camden Town*
Source: Abse (2D, above), 149–51

Cronin, Anthony, *Riveters*
William Cronin, *Riveting*
Source: Reid and Rice (1J, above), 31–3

CRONWALL, Brian, *Looking at Georgia O'Keeffe's "Black Place 1"*
Source: *Ekphrasis* 2, no. 4 (Fall–Winter 2001): 20

CROOK, Noel, *J.M.W. Turner's Suns*
J.M.W. Turner, various unnamed paintings
Source: *Shenandoah* 58, no. 3 (Winter 2008): 38

CROOKER, Barbara, *Impressionism*
Auguste Renoir, *Le Moulin de la Galette*; Claude Monet, *Waterlilies*; Vincent Van Gogh, *Café Terrace at Night*
Source: Barbara Crooker, *Radiance* (Cincinnati, OH: Word Press, 2005), 18

Crooker, Barbara, *White Lilacs*
Édouard Manet, *White Lilacs in a Crystal Vase*
Source: Barbara Crooker, *Radiance* (Cincinnati, OH: Word Press, 2005), 38

Crooker, Barbara, *Iris*
Vincent Van Gogh, *Irises*
Source: Barbara Crooker, *Radiance* (Cincinnati, OH: Word Press, 2005), 40

Crooker, Barbara, *Sunflowers*
Vincent Van Gogh, images from several paintings
Source: Barbara Crooker, *Radiance* (Cincinnati, OH: Word Press, 2005), 46

Crooker, Barbara, *All There Is To Say*
Paul Cézanne, *Still Life with Onions and Bottle*
Source: Barbara Crooker, *Radiance* (Cincinnati, OH: Word Press, 2005), 53

Crooker, Barbara, *Van Gogh's Crows*
Vincent Van Gogh, *Wheat Field with Crows*
Source: Barbara Crooker, *Radiance* (Cincinnati, OH: Word Press, 2005), 76

Crooker, Barbara, *Nature Morte au Plat et Pommes*
Paul Cézanne, *Still Life with Apples*
Source: Barbara Crooker, *Radiance* (Cincinnati, OH: Word Press, 2005), 78

CROSSLEY-HOLLAND, Kevin, *In "The Garden Tent"*
Thomas Churchyard, *The Garden Tent*
Source: Adams (1B, above), 52–3

Crossley-Holland, Kevin, *The Painting-Room* (10 poems)
Poems 1, 3, 5, 7 and 9 take details from John Constable's drawings and paintings as their starting-points. 1. *The Cornfield*; 3. *The Mill Stream* and *Flatford Mill*; 5. *Maria Bicknell* and *A Church Porch*; 7. *Boat Building*; *A Boat Passing a Lock*; and *A View on the Stour near Dedham* and *Sketch for Stratford Mill*; 9. *The White Horse*
Source: Kevin Crossley-Holland, *Poems from East Anglia* (London: Enitharmon, 1997), 59–67

Crossley-Holland, Kevin, *Waterslain: 13 The Great Painter*
Sir Matthew Smith

Source: Kevin Crossley-Holland, *Poems from East Anglia* (London: Enitharmon, 1997), 34–5

CROZIER, Andrew, *Cardiff Docks, after Sickert*
Walter Sickert
Source: Andrew Crozier, *All Where Each Is* (London: Allardyce, Barnett, 1985), 254

CRUCEFIX, Martyn, *At the National Gallery*
Canaletto, Van Gogh, et al
Source: Martyn Crucefix, *Beneath Tremendous Rain* (London: Enitharmon, 1990), 71; and Abse (2D, above), 18–20

Crucefix, Martyn, *While There Is War*
Peter Coker, *Table and Chair*
Source: *Courtland Review* Spring 2008. http://www.cortlandreview.com/features/08/spring/crucefix.html

Crucefix, Martyn, *George and the Dragon: 1. Uccello 2. Moreau*
Paolo Uccello, *St. George and the Dragon*; Gustave Moreau, *St. George and the Dragon*
Source: Martyn Crucefix, *Beneath Tremendous Rain* (London: Enitharmon, 1990), 76; *Uccello* rpt. in Benton and Benton, *Double Vision* (2E, above), 30–1

Crucefix, Martyn, *The Gleaners*
Jean Françoise Millet, *The Gleaners*
Source: Martyn Crucefix, *Beneath Tremendous Rain* (London: Enitharmon, 1990), 70

CRUZ, Victor Hernández, *Miró*
Joan Miró
Source: *American Poet* 34 (Spring 2008): 48; rpt. from Cruz's *The Mountain in the Sea* (Minneapolis, MN: Coffee House Press, 2006)

Cruz, Victor Hernández, *Juan Gris: Poem with Still Life*
Juan Gris, *Harlequin with a Guitar*
Source: *American Poet* 34 (Spring 2008): 49; rpt. from Cruz's *Maraca: New and Selected Poems, 1965–2000* (Minneapolis, MN: Coffee House Press, 2001)

CUMMINGS, E.E., *Picasso*
Images from various Picasso paintings
Source: E.E. Cummings, *Poems 1923–1954* (New York: Harcourt, Brace and Co., 1954), 144

CUNNINGHAM, J.V., *On Correggio's Leda*
Antonio da Corregio, *Leda and the Swan*
Source: *The Poems of J.V. Cunningham* (Athens, OH: Swallow Press/Ohio University Press, 1997), 97

CURNOW, Allen, *The Fall of Icarus*
Pieter Brueghel the Elder, *Landscape with the Fall of Icarus*
Source: Allen Curnow, *Collected Poems: 1933–1973* (Wellington: A.H. & A.W. Reed, 1974), 125; and

in Achim Aurnhammer and Dieter Martin, eds., *Mythos Ikarus: Texte von Ovid bis Wolf Biermann* (Leipzig: Reclam, 2001), 193, German trans., 194

CURRY, Neil, *Rembrandt van Rijn*
Source: Neil Curry, *Ships in Bottles* (London: Enitharmon, 1988), 62

Curry, Neil, *Vincent*
Vincent Van Gogh
Source: Neil Curry, *Ships in Bottles* (London: Enitharmon, 1988), 69

Curry, Neil, *Cave Paintings*
Unidentified cave paintings
Source: Neil Curry, *Ships in Bottles* (Petersfield, UK: Enitharmon, 1988), 21

Curry, Neil, *Chatterton*
Henry Wallis, *Chatterton*
Source: Neil Curry, *Ships in Bottles* (Petersfield, UK: Enitharmon, 1988), 67

Curry, Neil, *Vincent*
Vincent Van Gogh
Source: Neil Curry, *Ships in Bottles* (Petersfield, UK: Enitharmon, 1988), 69

CURTIS, Tony, *Spring Fed*
Andrew Wyeth, *Spring Fed*
Source: Abse (2D, above), 114

Curtis, Tony, *Lottie Stafford's Neck*
Sir William Orpen, *The Wash House*
Source: *Thumbscrew* (Winter–Spring 2000): 61

Curtis, Tony, *William Orpen & Yvonne Aubicq in the Rue Dannon*
Sir William Orpen
Source: Tony Curtis, *Selected Poems* (Bridgend, Wales: Poetry Wales Press, 1986), 17–19

Curtis, Tony, *Five Andrew Wyeth Poems: 1. At the Royal Academy. 2. Spring Fed. 3. Pine Baron. 4. Chambered Nautilus. 5. Winter 1946*
Andrew Wyeth, *Witching Hour, Spring Fed, Pine Baron, Chambered Nautilus,* and *Winter 1946*
Source: Tony Curtis, *Selected Poems* (Bridgend, Wales: Poetry Wales Press, 1986), 118–22

Curtis, Tony, *Gallery: Twelve Poems after Paintings by Lucien Freud. 1. Portrait; 2. Nude with Legs; 3. Caroline with White Dog; 4. Dark Chocolate; 5. Big; 6. December Light; 7. Woman on a Quay; 8. Self-Portrait; 9. Girl in Bed; 10. Naked Girl with Egg; 11. The Bateman Sisters; 12. Male Nudes*
Source: Tony Curtis, *What Darkness Covers* (Todmorden, Lancs.: Arc Publications, 2003), 43–58

Curtis, Tony. For Curtis's poems on John Digby's collages, see 3E, above.

CUSHMAN, Stephen, *The Plowmen*
Käthe Kollwitz, *The Ploughmen*, 1906
Source: Hollander and Weber (1H, above), 2–3

Cushman, Stephen, *Woman with the Arrow*
Rembrandt van Rijn, *The Woman with the Arrow*
Source: *Beltway Poetry Quarterly* 10, no. 1 (Winter 2009). http://washingtonart.com/beltway/contents.html

CUTTS, Simon, From *Pianostool Footnotes*
Edward Hopper, *Sun in an Empty Room*
Source: Levin (3J, above), 73

CZERNIAWSKI, Adam, *A View of Delft*
Jan Vermeer, *A View of Delft*
Source: Adam Czerbiawski, *Selected Poems*, trans. Iain Higgins (Amsterdam: Harwood Academic Publishers, 2000), 9–10

Czerniawski, Adam, *Paul Klee: A Gloss*
Source: Adam Czerbiawski, *Selected Poems*, trans. Iain Higgins (Amsterdam: Harwood Academic Publishers, 2000), 24

Czerniawski, Adam, *Girl at the Window*
Caspar David Friedrich, *Girl at the Window*
Source: Adam Czerbiawski, *Selected Poems*, trans. Iain Higgins (Amsterdam: Harwood Academic Publishers, 2000), 93–4

CZERSKI-BRANT, Jan, *Boschs Antonius*
Hieronymus Bosch, *Versuchung des hl. Antonius* (*The Temptation of St. Anthony*)
Source: Kranz (2B, above), 73

DABESKI, Petko, *The Words of the Etching and the Pelerine*
Unidentified etching
Source: Martinovski (2K, above), 89

DABYDEEN, David. For a long poem on J.M.W. Turner, see 3Ua, above.

DACEY, Philip, *The Agnew Clinic*
Thomas Eakins, *The Agnew Clinic*
Source: *Ekphrasis* 2 (Fall–Winter 2000): 22–3

Dacey, Philip, *Thomas Eakins: Remembering Cushing*
Thomas Eakins, *Portrait of Frank Hamilton Cushing*
Source: *Ekphrasis* 3, no. 2 (Fall–Winter 2003): 23–4

Dacey, Philip, *Thomas Anschutz's "The Ironworkers at Noontime"*
Source: *Ekphrasis* 3, no. 4 (Fall–Winter 2004): 25

Dacey, Philip, *Eakins and Rokeby*
Diego Velázquez, *The Rokeby Venus*
Source: *Measure* 2 (2007): 58

Dacey, Philip. For twenty poems by Dacey on Thomas Eakins, see 3F, above.

DACUS, Rachel, *Portrit of Lady with Red Flowers*
Henri Matisse, portrait of his wife
Source: Rachel Dacus, *Femme au chapeau* (Cincinnati, OH: David Robert Books, 2005), 13

Dacus, Rachel, *My Father's Self-Portrait from Art School*
Source: Rachel Dacus, *Femme au chapeau* (Cincinnati, OH: David Robert Books, 2005), 14

Dacus, Rachel, *Virgin as the Letter M*
Neri da Rimini, *Annunciation of the Letter M* (illuminated manuscript)
Source: Rachel Dacus, *Femme au chapeau* (Cincinnati, OH: David Robert Books, 2005), 54

Dacus, Rachel, *Unknown Woman*
Joos Van Cleve, part of diptych, *Portrait of an Unknown Man and His Wife* (in the Uffizi)
Source: Rachel Dacus, *Femme au chapeau* (Cincinnati, OH: David Robert Books, 2005), 55

Dacus, Rachel, *Femme au chapeau*
Henri Matisse, *Femme au chapeau*
Source: Rachel Dacus, *Femme au chapeau* (Cincinnati, OH: David Robert Books, 2005), 56

DALEY, Tom, *In Robert Thom's Painting "The Governor Who Healed the Sick"*
Robert Thom, *The History of Pharmacy* series of paintings
Source: Tom Daley, *Canticles & Inventories* (Cambridge, MA: Wyngaerts Hoeck Press, 2005), 26–7

DANCING BEAR, J.P., *The Red Horse*
Julie Speed
Source: *Shenandoah* 58, no. 1 (Spring–Summer 2008)

DANIELS, Jim, *Illuminating the Saints*
Caravaggio, *The Calling of Saint Matthew*
Source: Jim Daniels, *The Revolt of the Crash-Test Dummies* (Spokane and Cheney: Eastern Washington University Press, 2007), 63–5

DANIELS, Kate, *Hundertwasser and the Six-Year-Olds*
Friedensreich Hundertwasser, *The Miraculous Draft*
Source: Kate Daniels, *The White Wave* (Pittsburgh, PA: University of Pittsburgh Press, 1984), 17–18

Daniels, Kate, *Niobe of the Painting—after Maurice-Denis's "La petite fille à la robe rouge"*
Maurice Denis, *Little Girl in a Red Dress*
Source: Kate Daniels, *The Niobe Poems* (Pittsburgh, PA: University of Pittsburgh Press, 1988), 46

Daniels, Kate, *Ars Poetica*
Henry Koerner, *My Parents*
Source: Kate Daniels, *The Niobe Poems* (Pittsburgh, PA: University of Pittsburgh Press, 1988), 53–4

DANZIGER, Jazzy, *"The Sacrifice of Isaac" (Uffizi)*
Caravaggio, *The Sacrifice of Isaac*
Source: *Boxcar Poetry Review* January 2009. http://www.boxcarpoetry.com/018/danziger_jazzy_001.html

DAVIDSON, Chad, *"The Calling of St. Matthew": X-Ray Photograph*
Caravaggio, *The Calling of St. Matthew*
Source: *Prairie Schooner* 79, no. 4 (Winter 2005): 30–32

DAVIDSON, Phebe, *An Eye to See*
Elemore Morgan, Jr., *Early Homesite*
Source: *Ekphrasis* 3, no. 6 (Fall–Winter 2005): 26

Davidson, Phebe, *The Brahms Waltz*
Robert McGill Mackall, *The Brahms Waltz*
Source: *Beauty/Truth: A Journal of Ekphrastic Poetry* 1, no. 1 (Fall–Winter 2006): 14–15

Davidson, Phebe, *The Wasp*
Thomas Satterwhite Noble, *The Price of Blood*
Source: *Beauty/Truth: A Journal of Ekphrastic Poetry* 1, no. 2 (Spring–Summer 2007): 14–15

DAVIE, Donald, *Limited Achievement*
Giovanni Battista Piranesi, *Prisons*, plate 6
Source: Donald Davie, *Collected Poems* (Chicago: University of Chicago Press, 1991), 70–1

Davie, Donald, *Lincolnshire*
Thomas Gainsborough, portrait of a lady
Source: Donald Davie, *Collected Poems* (Manchester, UK: Carcanet, 1990), 260

Davie, Donald, *Cherry Ripe: On a Painting by Juan Gris*
Juan Gris, *The Cherries*
Source: Donald Davie, *Collected Poems* (Manchester, UK: Carcanet, 1990), 69

DAVIES, Idris, *El Greco*
Source: *The Collected Poems of Idris Davies*, ed., Islwyn Jenkins (Llandysul: Gomer Press, 1980), 69

DAVIES, W.H., *The Bird of Paradise*
W.R. Sickert, *The Blackbird of Paradise*
Source: Abse (2D, above), 153

DAVIS, Carol Ann, *Small Boy*
Hans Memling, *Angel Holding an Olive Branch*
Source: Carol Ann Davis, *Psalm* (Dorset, VT: Tupelo, 2007), 15.

DAVIS, Dick, *Rembrandt's "Return of the Prodigal Son"*
Source: Dick Davis, *A Kind of Love: Selected and New Poems* (Fayetteville: University of Arkansas Press, 1991), 58

Davis, Dick, *Rembrandt Dying*
Rembrandt van Rijn
Source: Dick Davis, *A Kind of Love: Selected and New Poems* (Fayetteville: University of Arkansas Press, 1991), 59–60

Davis, Dick, *On a Painting by Guardi*
Francesco Guardi, one of Guardi's lagoon paintings
Source: Dick Davis, *A Kind of Love: Selected and*

New Poems (Fayetteville: University of Arkansas Press, 1991), 61

Davis, Dick, *Leonardo*
Leonardo da Vinci, *The Last Supper*
Source: Dick Davis, *A Kind of Love: Selected and New Poems* (Fayetteville: University of Arkansas Press, 1991), 55

Davis, Dick, *With John Constable*
Source: Dick Davis, *A Kind of Love: Selected and New Poems* (Fayetteville: University of Arkansas Press, 1991), 88

Davis, Dick, *On an Etching by J.S. Cotman*
Source: Dick Davis, *A Kind of Love: Selected and New Poems* (Fayetteville: University of Arkansas Press, 1991), 93

Davis, Dick, *Lady with a Theorbo*
John Michael Wright, *Lady with a Theorbo*
Source: Dick Davis, *A Kind of Love: Selected and New Poems* (Fayetteville: University of Arkansas Press, 1991), 127

DAVISON, Peter, *Low Lands*
Jacob van Ruysdael, *The Jewish Cemetery* and *The Stag*
Source: Peter Davison, *Praying Wrong: New and Selected Poems, 1957–1984* (New York: Atheneum, 1984), 12

DAWE, Gerald, *The Fox*
John Luke, *The Fox*
Source: Reid and Rice (1J, above), 112–13

DAWES, Kwame, *Sanctuary*
Vincent Van Gogh, *Starry Night*
Source: Kwame Dawes, *Midland* (Athens: Ohio University Press, 2001), 23

Dawes, Kwame, *Sun Strokes*
Aubrey Williams, *Sunspot Maximum*
Source: Kwame Dawes, *Midland* (Athens: Ohio University Press, 2001), 26–8

Dawes, Kwame, *Baptism*
Karl Parboosingh, *Jamaican Gothic*
Source: Kwame Dawes, *Midland* (Athens: Ohio University Press, 2001), 57–8

Dawes, Kwame, *Grace*
Vincent Van Gogh, *Potato Eaters*
Source: Kwame Dawes, *Midland* (Athens: Ohio University Press, 2001), 55

DAY, Lucille Lang, *Pygmalion*
Paul Delvaux, *Pygmalion*
Source: *Ekphrasis* 5, no. 1 (Spring–Summer 2009): 6

DAY, Marilyn Zembo, *Poet Views Stephen Hannock Painting*
Stephen Hannock, *Artist after We Lost, and Holmes Got Away*
Source: *Texts with Vistas* (3I, above)

DAY-LEWIS, C., *Florence: Works of Art: An Italian Visit*
Italian Renaissance masters
Source: *The Complete Poems of C. Day Lewis* (London: Sinclair-Stevenson, 1992), 452–4

Day-Lewis, C. *Annunciation: Leonardo*
Leonardo da Vinci, *Annunciation*
Source: *The Complete Poems of C. Day Lewis* (London: Sinclair-Stevenson, 1992), 457

Day-Lewis, C. *The Expulsion: Masaccio*
Masaccio, Frescoes in Santa Maria del Carmine, Florence,
Source: *The Complete Poems of C. Day Lewis* (London: Sinclair-Stevenson, 1992), 700

Day-Lewis, C., *Perseus Rescuing Andromeda: Piero di Cosimo*
Source: *The Complete Poems of C. Day Lewis* (London: Sinclair-Stevenson, 1992, 458–9

Day-Lewis, C., *A Picture by Renoir*
Auguste Renoir, unidentified painting of four girls, two stooping for a ball
Source: *The Complete Poems of C. Day Lewis* (London: Sinclair-Stevenson, 1992), 684–5

DEAGON, Ann, *George the Knife Does Windows* and *Iron Ann Sees Red*
George Bireline, *L–1962*
Source: Paschal (1G, above), 102–3

DE BALKER, Habakuk II (pseudonym for H.H. ter Balkt), *Roggeveld geschilderd door Breughel*
Pieter Brueghel the Elder, *The Corn Harvest*
Source: Korteweg and Heijn (2F, above), 97

de Balker, Habakuk II (pseudonym for H.H. ter Balkt), *Het landschap met de sparretak (Hercules Seghers)*
Hercules Seghers, *Landschap met sparretak*
Source: Korteweg and Heijn (2F, above), 113

DECILLIS, Diane Shipley, *Ignore the Orange*
Hartmut Austen, unidentified painting
Source: *The MacGuffin* 23, no. 2 (Winter 2006): 77

DEFREESE, Allison, *They Tell of Leda Finding, Once*
Leonardo da Vinci, *Leda and the Swan*
Source: *Ekphrasis* 3, no. 4 (Fall–Winter 2004): 8–9

DE LA MARE, Walter, *Brueghel's Winter*
Pieter Brueghel the Elder, *The Hunters in the Snow*
Source: Hollander (2I, above), 243; and Kranz (2B, above), 96

de la Mare, Walter, *Portrait of a Boy: Velázquez*
Diego Velázquez, *Portrait of a Boy*
Source: Walter de la Mare, *Poems* (London: John Murray, 1906), 99

de la Mare, Walter, *Still Life*
Jean-Baptiste Chardin, *Still Life with Bottle, Glass*

and Loaf (thought now to be a nineteenth-century imitation of Chardin)
Source: Helen Plotz, ed., *Eye's Delight: Poems of Art and Architecture* (New York: Greenwillow Books, 1983), 8

DELANEY, Frank, *Dream of the Moth*
Colin Middleton, *Dream of the Moth*
Source: Reid and Rice (1J, above), 86–7

DELANTY, Greg, *After Viewing "The Bowling Match at Castlemary, Cloyne" (1847)*
Daniel MacDonald, *The Bowling Match at Castlemary, Cloyne (1847)*
Source: http://www.english.emory.edu/classes/paintings&poems/bowling.html

DELBANCO, Nicholas, *Dancer from the Dance*
Max Beckman, *Begin the Beguine*
Source: Tillinghast (1F, above), 102–5

DENBY, Edwin, *Alex Katz Paints His North Window*
Source: Edwin Denby, *Collected Poems* (New York: Full Court Press, 1975), 140

DENGLER, Ann, *Questions for Christina Olson*
Andrew Wyeth, *Christina's World*
Source: *Ekphrasis* 1, no. 6 (Fall–Winter 1999): 39

DENHAM, Robert, *Analogy: For Dan Leidig*
Diego Velázquez, *Las Meninas*
Source: Iron Mountain Press Broadside, Emory, VA, 2003

DeNICOLA, Deborah, *Van Gogh's Room*
Vincent Van Gogh, *Van Gogh's Bedroom in Arles*
Source: *Ekphrasis* 3, no. 4 (Fall–Winter 2004): 17–18

DeNicola, Deborah, *Maine Art*
Peter Poskus, *August Light, Monhegan 1935*
Source: *Ekphrasis* 3, no. 6 (Fall–Winter 2005): 27

DeNicola, Deborah, *The Lenten Rose*
Cheri Martell, *The Lenten Rose*
Source: *Ekphrasis* 4, no. 1 (Spring–Summer 2006): 9

DeNicola, Deborah, *The River of Life*
William Blake, *The River of Life*
Source: *Ekphrasis* 1, no. 5 (Spring–Summer 1999): 48–9

DENNISTON, Edward, *Killary Harbour View*
Paul Henry, *Dawn, Killary Harbour*
Source: Reid and Rice (1J, above), 78–9

DENNEY, Reuel, *William Rowe's Horses*
Source: Ruel Denny, *The Connecticut River and Other Poems* (New Haven, CT: Yale University Press, 1939), 16

Denney, Reuel, *A Wine for Li Po's Picture*
Li Po, unidentified landscape
Source: Reuel Denney, *In Praise of Adam* (Chicago: University of Chicago Press, 1961), 59

DEPREZ, Carol, *American Gothic*
Grant Wood, *American Gothic*
Source: *Beauty/Truth: A Journal of Ekphrastic Poetry* 1, no. 3 (Fall Winter 2007): 29

DERLETH, August, *The Spider on "The View of Toledo"*
El Greco, *View of Toledo*
Source: August Derleth, *Collected Poems, 1937–1967* (New York: Candlelight Press, 1967), 130–1

DEUTSCH, Babette, *Ballade for Braque*
Georges Braque
Source: *The Collected Poems of Babette Deutsch* (New York: Doubleday, 1969), 105

Deutsch, Babette, *Cézanne*
Paul Cézanne
Source: *The Collected Poems of Babette Deutsch* (New York: Doubleday, 1969), 160

Deutsch, Babette, *Disasters of War: Goya at the Museum*
Source: *The Collected Poems of Babette Deutsch* (New York: Doubleday, 1969), 134

Deutsch, Babette, *Homage to Braque*
Source: *The Collected Poems of Babette Deutsch* (New York: Doubleday, 1969), 7

Deutsch, Babette, *Homage to Paul Klee*
Source: *The Collected Poems of Babette Deutsch* (New York: Doubleday, 1969), 95

DEVENISH, Alan, *Icarus Again*
Pieter Brueghel the Elder, *Landscape with the Fall of Icarus*
Source: *Exploring Literature*, ed., Frank Madden (New York: Longman, 2007), 1463

DEVLIN, Denis, *The Tomb of Michael Collins*
"The poem began as a series of meditations on Dürer's series of woodcuts, the *Kleine Passion*.... Devlin's poem developed away from its origin; he omitted and added to the Dürer series and changed Dürer's order and interpretations. For example, he began like Dürer, with the Fall and the Expulsion from Paradise, though Dürer ends with the Last Judgement, and added the sections on the Good and Bad Thieves" (J.C.C. Mays's note).
Source: *Collected Poems of Denis Devlin*, ed. J.C.C. Mays (Dublin: Dedalus Press, 1989), 283–5

DICKER, Harold, *The Boxers*
George Bellows, *Dempsey and Firpo*
Source: Allen De Loach, ed., *The East Side Scene: (An Anthology of a Time and a Place)* (Buffalo: State University of New York Press, 1968)

DIGGES, Deborah, *The Rainbow Bridge in the Painting of the Sung Dynasty*
Source: Deborah Digges, *Trapeze* (New York: Knopf, 2004), 15–17

DILLARD, R.H.W., *The Great Dream of Henri Rousseau*
Source: R.H.W. Dillard, *Just Here, Just Now* (Baton Rouge: Louisiana State University Press, 1994), 4

Dillard, R.H.W., *Three Friends*
Raoul Dufy, Fernand Léger, J.M.W. Turner
Source: R.H.W. Dillard, *After Borges* (Baton Rouge: Louisiana State University Press, 1972), 19–21

DILWORTH, Rachel, *The Starry Day*
Vincent Van Gogh, *Starry Night*
Source: *Ekphrasis* 2, no. 4 (Fall–Winter 2001): 40

DIMOSKI, Slave Gorgo, *Blue and Dark*
Vangel Naumovski, *Polar Galaxy*
Source: Martinovski (2K, above), 120

DINE, Carol, *Blossoming Chestnut Branches*
Vincent Van Gogh, *Blossoming Chestnut Branches*
Source: *The Bitter Oleander* 14, no. 2 (Autumn 2008): 27

DI PIERO, W.S., *Vincent Van Gogh's "Self-Portrait: 1887"*
Source: W.S. Di Piero, *Skirts and Slacks* (New York: Knopf, 2001), 33–4

Di Piero, W.S., *"Girl with a Pearl Earring" by Johannes Vermeer*
Source: W.S. Di Piero, *Skirts and Slacks* (New York: Knopf, 2001), 53–4

Di Piero, W.S., *Second Horn*
Vittore Carpaccio, *St. George and the Dragon*
Source: W.S. Di Piero, *Chinese Apples: New and Selected Poems* (New York: Knopf, 2007), 55–6

Di Piero, W.S., *Emmaus*
Caravaggio, *Supper at Emmaus*
Source: W.S. Di Piero, *Chinese Apples: New and Selected Poems* (New York: Knopf, 2007), 93–4

Di Piero, W.S., *The Restorers*
Filippino Lippi, Strozzi Chapel frescoes in the Basilica of Santa Maria Novella, depicting scenes from the lives of the Apostles; Masaccio, *The Holy Trinity* in the Basilica
Source: W.S. Di Piero, *Chinese Apples: New and Selected Poems* (New York: Knopf, 2007), 101–2

Di Piero, W.S., *On a Picture by Cézanne*
Images from a number of Cézanne's paintings
Source: W.S. Di Piero, *Chinese Apples: New and Selected Poems* (New York: Knopf, 2007), 144

Di Piero, W.S., *Adam's Garden*
Tintoretto, *Cain and Abel*
Source: W.S. Di Piero, *Chinese Apples: New and Selected Poems* (New York: Knopf, 2007), 87–8

DOBSON, Austin, *A Familiar Epistle to——Esq. of——with a Life of the Late Ingenious Mr. Wm. Hogarth*

William Hogarth
Source: Austin Dobson, *Collected Poems* (London: Kegan Paul, Trench, Trübner & Co., 1913), 306–8

Dobson, Austin, *The Death of Procis: A Version Suggested by the So-Named Picture of Piero di Cosimo in the National Gallery*
Source: Austin Dobson, *Collected Poems* (London: Kegan Paul, Trench, Trübner & Co., 1913), 167–9

Dobson, Austin, *The Story of Rosina: An Incident in the Life of Françoise Boucher*
Source: Austin Dobson, *Collected Poems* (London: Kegan Paul, Trench, Trübner & Co., 1913), 34–43

Dobson, Austin, *After Watteau*
Jean-Antoine Watteau, *L'embarquement pour Cythère (Pilgrimage to Cythera)*
Source: Austin Dobson, *Collected Poems* (London: Kegan Paul, Trench, Trübner & Co., 1913), 476

DOBSON, Rosemary, *Painter of Antwerp*
Pieter Brueghel the Elder, *Landscape with the Fall of Icarus*
Source: Rosemary Dobson, *Collected Poems* (Aukland, NZ: Angus and Robertson, 1991), 32; and at http://wwwfp.education.tas.gov.au/English/hugopaul.htm

Dobson, Rosemary, *Wonder*
Jan van Eyck, *Arnolfini Wedding Portrait*
Source: Rosemary Dobson, *Collected Poems* (Aukland, NZ: Angus and Robertson, 1991), 31

Dobson, Rosemary, *The Bystander*
Pieter Brueghel the Elder, *Landscape with the Fall of Icarus* and other paintings on the theme of the bystander
Source: Rosemary Dobson, *Collected Poems* (Aukland, NZ: Angus and Robertson, 1991), 56

Dobson, Rosemary, *Still Life*
Unidentified still life
Source: Rosemary Dobson, *Collected Poems* (Aukland, NZ: Angus and Robertson, 1991), 30–1

Dobson, Rosemary, *The Martyrdom of St. Sebastian*
Unidentified Flemish painting
Source: Rosemary Dobson, *Collected Poems* (Aukland, NZ: Angus and Robertson, 1991), 59

Dobson, Rosemary, *The Raising of the Dead*
Unknown fifteenth-century Sienese painter, *S. Bernadino Resuscitates a Dead Child*
Source: Rosemary Dobson, *Collected Poems* (Aukland, NZ: Angus and Robertson, 1991), 55

Dobson, Rosemary, *Paintings*
Two unidentified paintings and William Hogarth's *The Graham Children*
Source: Rosemary Dobson, *Collected Poems* (Aukland, NZ: Angus and Robertson, 1991), 57

Dobson, Rosemary, *Painter of Umbria*
An imaginary painter and his picture of the Virgin
Source: Rosemary Dobson, *Collected Poems* (Aukland, NZ: Angus and Robertson, 1991), 63–4

Dobson, Rosemary, *Detail from an Annunciation by Crivelli*
Carvo Crivelli, *The Annunciation*
Source: Rosemary Dobson, *Collected Poems* (Aukland, NZ: Angus and Robertson, 1991), 57–8

Dobson, Rosemary, *The Mirror*
Jan Vermeer
Source: Rosemary Dobson, *Collected Poems* (Aukland, NZ: Angus and Robertson, 1991), 67

Dobson, Rosemary, *Child with a Cockatoo*
Simon Verelst, *Portrait of Anne, Daughter of the Earl of Bedford*
Source: Rosemary Dobson, *Collected Poems* (Aukland, NZ: Angus and Robertson, 1991), 70–1

Dobson, Rosemary, *For the Painter Ben Nicholson*
Source: Rosemary Dobson, *Collected Poems* (Aukland, NZ: Angus and Robertson, 1991), 135–6

DOBYNS, Stephen, *The Street*
Balthus, *The Street*
Source: http://www.english.emory.edu/classes/paintings&poems/street.html

Dobyns, Stephen, *On the Famous Painting by Rousseau*
Henri Rousseau, *The Sleeping Gypsy*
Source: Stephen Dobyns, *Cemetery Nights* (New York: Penguin, 1987), 74–5

Dobyns, Stephen, *Cezanne and Zola, Cezanne's Success, Cezanne's Outrageousness, Cezanne's Coldness, Cezanne's Anger, Cezanne's Portraits, Cezanne's Ambition, Cézanne's "A Modern Olympia"—1872, Cezanne's "Montagne Sainte-Victoire," Cezanne's Doubt, Cezanne's Fortress, Cezanne's Failure, Cezanne's Seclusion, Cezanne's Love of Poetry, Cézanne and the Love of Color*
Source: Stephen Dobyns, *Body Traffic* (New York: Puffin [Penguin], 1991), 21, 22, 23, 43, 44, 45, 68, 69, 70, 88, 89, 90, 114, 115, 116

Dobyns, Stephen. For Dobyns's poems on thirty-two paintings by Balthus, see 3A, above.

DOHOLLAU, Heather, Poems on Morandi, Balthus, Bonnard, Cézanne, and Poussin
Source: *Les Cinq Jardins et Autres Textes* (Les Rousses: Editions Folle Avoine, 1996)

DOLIN, Sharon, *Black Painting #1–Black Painting # 13*
Joan Mitchell, *Black Paintings* series
Source: Sharon Dolin, *Serious Pink* (New York: Marsh Hawk Press, 2003), 23–6, 29–33, 35–8, 40; *Black Painting #7* appeared originally in *Ekphrasis* 1, no. 2 (Winter 1997–1998): 12

Dolin, Sharon, *It Started with a Woman*
Richard Diebenkorn, *Girl and Three Coffee Cups*
Source: Sharon Dolin, *Serious Pink* (New York: Marsh Hawk Press, 2003), 3

Dolin, Sharon, *Ocean Park No. 64*
Richard Diebenkorn, *Ocean Park No. 64*
Source: Sharon Dolin, *Serious Pink* (New York: Marsh Hawk Press, 2003), 4

Dolin, Sharon, *Seated Woman*
Richard Diebenkorn, *Woman at Table in Strong Light* and *Woman with Newspaper*
Source: Sharon Dolin, *Serious Pink* (New York: Marsh Hawk Press, 2003), 5

Dolin, Sharon, *Sea-Wall*
Richard Diebenkorn, *Seawall*
Source: Sharon Dolin, *Serious Pink* (New York: Marsh Hawk Press, 2003), 6

Dolin, Sharon, *Looking Again*
Richard Diebenkorn, *Seated Nude—Black Background*
Source: Sharon Dolin, *Serious Pink* (New York: Marsh Hawk Press, 2003), 8

Dolin, Sharon, *Sirens*
Richard Diebenkorn, *Ocean Park No. 6*
Source: Sharon Dolin, *Serious Pink* (New York: Marsh Hawk Press, 2003), 9

Dolin, Sharon, *Objects*
Richard Diebenkorn, *Still Life with Letter*
Source: Sharon Dolin, *Serious Pink* (New York: Marsh Hawk Press, 2003), 10

Dolin, Sharon, *Street*
Richard Diebenkorn, *Interior with View of Buildings*
Source: Sharon Dolin, *Serious Pink* (New York: Marsh Hawk Press, 2003), 11

Dolin, Sharon, *Ocean Park No. 43*
Richard Diebenkorn, *Ocean Park No. 43*
Source: Sharon Dolin, *Serious Pink* (New York: Marsh Hawk Press, 2003), 12

Dolin, Sharon, *Ochre*
Richard Diebenkorn, *Ochre*
Source: Sharon Dolin, *Serious Pink* (New York: Marsh Hawk Press, 2003), 13

Dolin, Sharon, *Berkeley Numbers*
Richard Diebenkorn, *Berkeley* series
Source: Sharon Dolin, *Serious Pink* (New York: Marsh Hawk Press, 2003), 14–15

Dolin, Sharon, *Prayer*
Richard Diebenkorn, *Ocean Park No. 24*
Source: Sharon Dolin, *Serious Pink* (New York: Marsh Hawk Press, 2003), 16–17

Dolin, Sharon, *Ocean Park No. 79*
Richard Diebenkorn, *Ocean Park No. 79*

Source: Sharon Dolin, *Serious Pink* (New York: Marsh Hawk Press, 2003), 18

Dolin, Sharon, *Ocean Park No. 45*
Richard Diebenkorn, *Ocean Park No. 45*
Source: Sharon Dolin, *Serious Pink* (New York: Marsh Hawk Press, 2003), 19

Dolin, Sharon, *Ocean Park No. 96*
Richard Diebenkorn, *Ocean Park No. 96*
Source: Sharon Dolin, *Serious Pink* (New York: Marsh Hawk Press, 2003), 20

Dolin, Sharon, *Day Dreams*
Howard Hodgkin, *Day Dreams*
Source: Sharon Dolin, *Serious Pink* (New York: Marsh Hawk Press, 2003), 57

Dolin, Sharon, *After Dinner*
Howard Hodgkin, *After Dinner*
Source: Sharon Dolin, *Serious Pink* (New York: Marsh Hawk Press, 2003), 58

Dolin, Sharon, *Jealousy*
Howard Hodgkin, *Jealousy*
Source: Sharon Dolin, *Serious Pink* (New York: Marsh Hawk Press, 2003), 59

Dolin, Sharon, *The Moon*
Howard Hodgkin, *The Moon*
Source: Sharon Dolin, *Serious Pink* (New York: Marsh Hawk Press, 2003), 60

Dolin, Sharon, *In the Honeymoon Suite*
Howard Hodgkin, *In the Honeymoon Suite*
Source: Sharon Dolin, *Serious Pink* (New York: Marsh Hawk Press, 2003), 61

Dolin, Sharon, *A Small Thing*
Howard Hodgkin, *A Small Thing but My Own*
Source: Sharon Dolin, *Serious Pink* (New York: Marsh Hawk Press, 2003), 62

Dolin, Sharon, *Sad Flowers*
Howard Hodgkin, *Sad Flowers*
Source: Sharon Dolin, *Serious Pink* (New York: Marsh Hawk Press, 2003), 63

Dolin, Sharon, *Down in the Valley*
Howard Hodgkin, *Down in the Valley*
Source: Sharon Dolin, *Serious Pink* (New York: Marsh Hawk Press, 2003), 64

Dolin, Sharon, *Discarded Clothes*
Howard Hodgkin, *Discarded Clothes*
Source: Sharon Dolin, *Serious Pink* (New York: Marsh Hawk Press, 2003), 65

Dolin, Sharon, *Lovers*
Howard Hodgkin, *Lovers*
Source: Sharon Dolin, *Serious Pink* (New York: Marsh Hawk Press, 2003), 66

Dolin, Sharon, *Fruit*
Howard Hodgkin, *Fruit*

Source: Sharon Dolin, *Serious Pink* (New York: Marsh Hawk Press, 2003), 68

Dolin, Sharon, *In the Black Kitchen*
Howard Hodgkin, *In the Black Kitchen*
Source: Sharon Dolin, *Serious Pink* (New York: Marsh Hawk Press, 2003), 69

Dolin, Sharon, *It Can't Be True*
Howard Hodgkin, *It Can't Be True*
Source: Sharon Dolin, *Serious Pink* (New York: Marsh Hawk Press, 2003), 70

Dolin, Sharon, *Gossip*
Howard Hodgkin, *Gossip*
Source: Sharon Dolin, *Serious Pink* (New York: Marsh Hawk Press, 2003), 72

Dolin, Sharon, *Scenes from an Ideal Marriage*
Cy Twombly, *Scenes from an Ideal Marriage*
Source: *Ducts.org* 21 (Summer 2008). http://www.ducts.org/content/scenes-from-an-ideal-marriage/

DONNELLY, Fritz, *Philip Guston: "In 1968 I Became a Movie-Maker"*
Philip Guston, *Outskirts*; *Painting, Smoking, Eating*; and *Head*
Source: http://electricveneer.com/clients/inekphrasis/ekphrasis.html

DONNELLY, Susan, *Rilke Speaks of Angels*
Painting of the Virgin, St. Anne, and angels by Lucas van Leyden
Source: Buchwald and Roston (2C, above), 96–7

DONNELLY, Timothy, *Anything to Fill In the Long Silences*
Juliáo Sarmento, mixed media on canvas (1998)
Source: Timothy Donnelly, *Twenty-seven Props for a Production of Eine Lebenszeit* (New York: Grove Press, 2003), 70–6

DONOVAN, Katie, *The Turning*
George William 'Æ' Russell, *Eventide*
Source: Reid and Rice (1J, above), 50–1

DONOVAN, Matt, *A Damaged Fresco of "The Massacre of the Innocents"*
Giotto di Bondone, *The Massacre of the Innocents*
Source: *Ekphrasis* 2, no. 6 (Fall–Winter 2002): 12–14

DOOLITTLE, Deborah H., *J.M.W Turner's "Caernarvon Castle," N. Wales*
J.M.W. Turner, *Caernarvon Castle*
Source: *Measure* 3, no. 1 (2008): 122

DORESKI, William, *Pond, by Dürer*
Albrecht Dürer, *Pond in the Woods*
Source: *Ekphrasis* 2, no. 4 (Fall–Winter 2001): 25

Doreski, William, *Route de la Ferme, St. Simeon, Honfler*

Claude Monet, *Route de la Ferme, St. Simeon, Honfler*
Source: *Ekphrasis* 1, no. 6 (Fall–Winter 1999): 22

Doreski, William, *Freefall (Trial Proof)*
Helen Frankenthaler, *Freefall (Trial Proof)*
Source: *Ekphrasis* 3, no. 3 (Spring–Summer 2004): 32–3

DORGAN, Theo, *James Joyce on Inishere*
Sean Keating, *Slan Leat a Athair/Goodbye, Father*
Source: Reid and Rice (1J, above), 36–7

DORN, Alfred, *Fearscape*
Hieronymus Bosch, *The Forest That Hears and the Field That Sees*
Source: *Ekphrasis* 1, no. 2 (Winter 1997–1998): 7

Dorn, Alfred, *Truant from the Louvre*
After a sonnet on Botticelli by Maria Sassi and written for a fantasy on the *Mona Lisa*
Source: *Ekphrasis* 1, no. 3 (Spring–Summer 1998): 59

Dorn, Alfred, *Renoir's "Grandes Baigneuses"*
Auguste Renoir, *Grandes Baigneuses*
Source: *Ekphrasis* 1, no. 4 (Fall–Winter 1998): 33

DOTY, Mark, *Elizabeth Bishop, Croton, Watercolor,* 9" × 5¼", n.d.
Source: *The New Breadloaf Anthology of Contemporary American Poetry*, 57; and Doty's *Source* (New York: HarperCollins, 2001), 44–5

Doty, Mark, *American Sublime/St. Johnsbury, Vermont*
Albert Bierstadt, *Domes of the Yosemite*
Source: Mark Doty, *Source* (New York: HarperCollins, 2001), 68–9

Doty, Mark, *Summer Landscape*— Stuart Davis
Source: Mark Doty, *Source* (New York: HarperCollins, 2001), 60–3

Doty, Mark, *Nocturne in Black and Gold*
Partially on James McNeil Whistler's painting of that title
Source: Mark Doty, *Atlantis* (New York: HarperCollins, 1995), 94–8

Doty, Mark, *Four Cut Sunflowers, One Upside Down*
Vincent Van Gogh, *Four Cut Sunflowers*
Source: Mark Doty, *Atlantis* (New York: HarperCollins, 1995), 6–7

Doty, Mark, *Notebook/To Lucian Freud/On the Veil*
Images from various paintings by Freud
Source: Mark Doty, *School of the Arts* (New York: HarperCollins, 2005), 18–27

Doty, Mark, *Van Gogh, Flowering Rosebushes: 1889*
Vincent Van Gogh, *Rosebush in Blossom*
Source: Mark Doty, *Sweet Machine* (New York: HarperCollins, 1998), 13–15

Doty, Mark, *Lilies in New York*
Jim Dine, *Lilies in New York* (drawing)
Source: Mark Doty, *Sweet Machine* (New York: HarperCollins, 1998), 16–20

Doty, Mark, *Door to the River*— de Kooning
Willem de Kooning, *Door to the River*
Source: Mark Doty, *Sweet Machine* (New York: HarperCollins, 1998), 88–92

Doty, Mark, *Nancy outside in July*
Jim Dine, etchings
Source: Mark Doty, *Turtle, Swan* and *Bethlehem in Broad Daylight* (Urbana: University of Illinois Press, 2000), 29–31

DOUGHERTY, Edward A., *The Bridge*
Claude Monet, *Le Bassin aux nymphéas*
Source: *Ekphrasis* 1, no. 5 (Spring–Summer 1999): 13

DOVE, Rita, *There Came a Soul*
Ivan Albright, *Into the World There Came a Soul Called Ida*
Source: Rita Dove, *On The Bus With Rosa Parks* (New York: W. W. Norton, 1999), 58–9; and Hirsch (1D, above), 72–3

Dove, Rita, *The Late Notebooks of Albrecht Dürer*
Albrecht Dürer's notes and sketches
Source: *The Best American Poetry 1989*, ed., Donald Hall (New York: Charles Scribner's Sons, 1989), 37–40

DOWDEN, Edward, *Mona Lisa*
Leonardo da Vinci, *Mona Lisa*
Source: Kranz (2B, above), 125

DOYLE, Sharon, *Squares Created from Pure Color*
Josef Albers, *Homage to the Square*
Source: *Saranac Review* 3 (2008): 135

DRAGER, David, *Christina's World*
Andrew Wyeth, *Christina's World*
Source: *Recycled Poet.* http://dpoetry.wordpress.com/my-poems/christinas-world/

DRAKE, Joseph Rodman, *The National Painting*
John Trumbull, *The Declaration of Independence*
Source: *The Life and Works of Joseph Rodman Drake* (Boston: Merrymount Press, 1935), 313–14; and Hollander (21, above), 149

DRAKE, Leah Bodine, *Leonardo Before His Canvas*
Leonardo da Vinci
Source: *Poetry* 74 (July 1949): 208–9

DROOGSMA, Rachel, *Just in Passing*
Robert Koehler, *Rainy Evening on Hennepin Avenue*
Source: http://www.northography.com/MIA/rachel.php

DRS. P (pseudonym for H.H. Polzer), *Het melkmeisje*
Johannes Vermeer, *The Milkmaid*
Source: Korteweg and Heijn (2F, above), 171

DUBIE, Norman, *Sun and Moon Flowers: Paul Klee, 1879–1940*
Source: Norman Dubie, *The Mercy Seat: Collected and New Poems 1967–2001* (Port Townsend, WA: Copper Canyon, 2001), 56–7

Dubie, Norman, *February: The Boy Brueghel*
An imaginary recreation of a key moment in the young artist's development.
Source: Norman Dubie, *The Mercy Seat: Collected and New Poems 1967–2001* (Port Townsend, WA: Copper Canyon, 2001), 43–4.

Dubie, Norman, *Cockaigne (Homage to Pieter Bruegel, the Elder)*
Pieter Brueghel the Elder, *Land of Cockaigne*
Source: *New Yorker*, 21 August 1978: 28.

Dubie, Norman, *Those Little Untitled Verses in which, at Dawn, Two Obscure Dutch Peasants Struggled with an Auburn Horse*
Willem van de Velde, *The Elder*
Source: Norman Dubie, *The Mercy Seat: Collected and New Poems 1967–2001* (Port Townsend, WA: Copper Canyon, 2001), 48–9.

Dubie, Norman, *Near the Bridge of Saint-Cloud*
Henri Rousseau, *View of the Bridge at Sevres and the Hills at Clamart, St. Cloud and Bellevue*
Source: Norman Dubie, *Groom Falconer* (New York: Norton, 1989), 56–7.

Dubie, Norman, *Elegies for the Ocher Deer on the Walls at Lascaux*
Lascaux cave drawings
Source: Norman Dubie, *The Mercy Seat: Collected and New Poems 1967–2001* (Port Townsend, WA: Copper Canyon, 2001), 69–80

Dubie, Norman, *Chagall*
Marc Chagall
Source: Norman Dubie, *Groom Falconer* (New York: Norton, 1989), 30

Dubie, Norman, *Looking up from Two Renaissance Paintings to the Massacre at Tiananmen Square*
Unidentified paintings of Christ raising Lazarus from the dead
Source: Norman Dubie, *Radio Sky* (New York: Norton, 1991), 20

DUBOIS, Pierre H., *Meisjesportret*
Petrus Christus, *A Young Lady*
Source: Korteweg and Heijn (2F, above), 67

Dubois, Pierre H., *Rembrandt*
Rembrandt van Rijn, *Self-Portrait* (1669)
Source: Korteweg and Heijn (2F, above), 154

DUFFY, Carol Ann, *Standing Female Nude*
Georges Braque, *Bather*
Source: Abse (2D, above), 122

Duffy, Carol Ann, "*Woman Seated in the Underground, 1941*"
Henry Moore, "*Woman Seated in the Underground*"
Source: Adams (1B, above), 106–7

Duffy, Carol Ann, *The Virgin Punishing the Infant*
Max Ernst, *The Blessed Virgin Chastises the Infant Jesus Before Three Witnesses*
Source: Benton and Benton, *Painting with* Words (2G, above), 65–6, and http://courses.nus.edu.sg/course/ellpatke/EN3246/ekphrastic%20poems%20&%20images.htm

Duffy, Carol Ann, "*Time Transfixed*" *by René Magritte*
Source: Benton and Benton, *Picture Poems* (2H, above), 36–7

DUGAN, Alan, *On Alexander and Aristotle, on a Black and Red Greek Plate*
Source: Alan Dugan, *Poems Seven: New and Complete Poetry* (New York: Seven Stories Press, 2001), 170–1

DUHIG, Ian, *Watercolour*
Sampson Towgood Roch(e), *Rustics Dancing outside an Inn*
Source: Reid and Rice (1J, above), 80–1

DUNCAN, Robert Edward, *The Fire Passages 13*
Piero di Cosimo, *The Forest Fire*; Hieronymus Bosch, *Hell*
Source: Robert Duncan, *Bending the Bow* (New York: New Directions, 1968), 40–5

DUNGY, Camille, *Got*
Jean Dubuffet, *Fugitive*
Source: *Ekphrasis* 2, no. 6 (Fall–Winter 2002): 10

DUNHAM, Rebecca, *Conversion of Saint Paul*
Caravaggio, *The Conversion of St. Paul*
Source: *Cadence of Hooves: A Celebration of Horses*, ed. Suzan Jantz (Igo, CA: Yarroway Mountain Press, 2008)

DUNMORE, Helen, *At the resurrection (after Stanley Spencer)*
Sir Stanley Spencer, *The Resurrection*
Source: Helen Dunmore, *The Raw Garden* (Newcastle upon Tyne, UK: Bloodaxe Books, 1988), 43

DUNN, Douglas, *The Gallery*
Jean-Honore Fragonard, *The Swing*; Francosco Goya, *The Third of May, 1808: The Execution of the Defenders of Madrid*
Source: Douglas Dunn, *Selected Poems 1964–1983* (London: Faber and Faber, 1986), 197

Dunn, Douglas, *E.A. Walton Thinks of Painting "The Daydream"*
Source: Douglas Dunn, *Selected Poems 1964–1983* (London: Faber and Faber, 1986), 168

DUNN, Stephen, *Impediment*
Edward Hopper, *Eleven A.M.*
Source: Levin (3J, above), 23

Dunn, Stephen, *Midwest*
After the paintings of David Ahlsted
Source: Stephen Dunn, *Landscape at the End of the Century* (New York: Norton, 1991), 30–1

DUNNING, Nick, *From a Picture by Bridget Riley*
Bridget Riley, *Study for Cataract, 1967*
Source: Benton and Benton, *Painting with Words* (2G, above), 32

DUPONT, Lonnie Hall, *Dark*
Rembrandt van Rijn, *Portrait of a Young Jew*
Source: *Ekphrasis* 3, no. 6 (Fall–Winter 2005): 21

DURCAN, Paul. For forty-five of Durcan's poems on paintings in the National Gallery of Ireland, see 1C, above.

DYROFF, Jan M., *Formalities (On El Greco's "The Burial of Count Orgaz")*
Source: *Art Journal* 28 (Spring 1969): 289

DŽEPAROSKI, Ivan, *A Knight, Death and the Devil*
Albrecht Dürer, *Knight, Death, and the Devil*
Source: Martinovski (2K, above), 96

Džeparoski, Ivan, *A Starry Night*
Vincent Van Gogh, *Starry Night*
Source: Martinovski (2K, above), 96–7

Džeparoski, Ivan, *The Red Concert*
Raoul Dufy, *Red Concert*
Source: Martinovski (2K, above), 97

EADY, Cornelius, *Jacob Lawrence: Summer Street Scene*
Jacob Lawrence, *Summer Street Scene in Harlem*
Source: Holcomb (1I, above), 68–70

Eady, Cornelius, *Romare Bearden Retrospective at The Brooklyn Museum*
Source: Cornelius Eady, *The Gathering of My Name* (Pittsburgh, PA: Carnegie Mellon University Press, 1991); and in Nicholas Christopher, ed., *Walk on the Wild Side* (New York: Touchstone/Simon and Schuster, 1994), 50–1

EATON, Charles Edward, *A Story of Response*
Jean-Baptiste Oudry, *Swan Attacked by a Dog*
Source: Paschal (1G, above), 29–33

EBERHART, Richard, *Throwing the Apple*
D.H. Lawrence, *Adam Throwing the Apple*
Source: *Art News* 58 (March 1959): 44–5

EDELMAN, David, *Painting Guida*
Paintings of Judas by Leonardo da Vinci, Fra Filippo Lippi, and Peter Paul Rubens
Source: *Ekphrasis* 3, no. 1 (Spring–Summer 2003): 33–4

EGEMO, Constance, *The Great Wave Off Kanagawa*

Katsushika Hokusai, *The Great Wave at Kanagawa*
Source: Buchwald and Roston (2C, above), 52

EIJKELBOOM, Jan, *Pieter de Roovere als ambachtsheer van Hardinxveld*
Aelbert Cuyp, *Portrait of Pieter de Roovere as Lord of the Manor of Hardinxveld*
Source: Korteweg and Heijn (2F, above), 159

EKKERS, Remco, *"Gewandeld in het landschap"*
Paulus Potter, *The Young Steer*
Source: Korteweg and Heijn (2F, above), back cover

ELLIOT, Alistair, *Susanna Undressing*
Rembrandt van Rijn, *Susanna Surprised by the Elders*
Source: Alistair Elliot, *My Country: Collected Poems* (Manchester, UK: Carcanet, 1989), 25

ELON, Florence, *Dream Fresco*
Michelangelo, *Creation of Man (Creation of Adam)*
Source: *Southern Review* 7, n.s. (October 1971): 1062

ELSBERG, John, *On Looking at Adolf Hitler's Watercolors*
Source: *Ekphrasis* 1, no. 3 (Spring–Summer 1998): 22

Elsberg, John, *Primaries*
Frank Stella
Source: *Ekphrasis* 1, no. 4 (Fall–Winter 1998): 18

ELTON, W.R., *Hopper: In the Café*
Edward Hopper, *Chop Suey*
Source: Levin (3J, above), 57

ÉLUARD, Paul, *À Marc Chagall*
Marc Chagall
Source: Kranz (2B, above), 248

Éluard, Paul, *Victory and Guernica*
Pablo Picasso, *Guernica*
Source: *Yale French Studies* 21 (1958): 12–13

Éluard, Paul, *To Pablo Picasso*
Source: *Yale French Studies* 21 (1958): 11–12

Éluard, Paul, *Max Ernst* and *Georges Braque*
Source: Maurisson and Verlet (2L, above), 123–4

EMENEY, Johanna, *A Rabbit, Two Thrushes and Some Straw on a Stone Table*
Jean-Siméon Chardin, *A Rabbit, Two Thrushes and Some Straw on a Stone*
Source: http://www.guardian.co.uk/books/2006/oct/23/poetry

EMMENS, J.A., *Meesterwerk*
Rembrandt van Rijn, *David Playing the Harp before Saul*
Source: Korteweg and Heijn (2F, above), 140

EMRICH, Jeanne, *"even as I sleep"* [haiku]
Susan Frame, untitled painting
Source: http://members.aol.com/HAIGA/Emrich.html

ENGELMAN, Jan, *Lezende Titus*
Rembrandt van Rijn, *Titus Reading*
Source: Korteweg and Heijn (2F, above), 136

ENGLE, Paul, *Venus and the Lute Player*
Titian, *Venus and the Lute Player*
Source: *Poetry* 101 (October–November 1962): 39,
and Kehl (2A, above), 112–13

Engle, Paul, *Blind Man*
Pablo Picasso, *The Blind Man's Meal*
Source: Kehl (2A, above), 120–1

ENRIGHT, D.J., *God Creating Adam*
William Blake, *Elohim Creating Adam*
Source: D.J. Enright, *Collected Poems 1948–1998*
(Oxford: Oxford University Press, 1998), 413–14;
Abse (2D, above), 77; and Adams (1B, above),
30–2

Enright, D.J., *Home and Colonial: Henri Rousseau's
"Tropical Storm with a Tiger"*
Source: D.J. Enright, *Collected Poems 1948–1998*
(Oxford: Oxford University Press, 1998), 221–3;
and Abse (2D, above), 91–3

Enright, D.J. *The Laughing Hyena, after Hokusai*
Katsushika Hokusai
Source: D.J. Enright, *Collected Poems 1948–1998*
(Oxford: Oxford University Press, 1998), 25

Enright, D.J., *Hokusai's Mad Poet*
Katsushika Hokusai, *Mad Poet*
Source: D.J. Enright, *Collected Poems 1948–1998*
(Oxford: Oxford University Press, 1998), 45

ERADAM, Yusuf, *Two Leaves in Snow*
Reha Yalnizcik, *Two Leaves in Snow*
Source: Greenberg, *Side* (2M, above), 16–17

ESHELMAN, Clayton, *Guernica*
Pablo Picasso, *Guernica*
Source: *College Art Journal* 19 (Fall 1959): 75–7

Eshelman, Clayton, *Soutine*
Chaim Soutine
Source: *Open Poetry*, ed., Ronald Gross and George
Quasha (New York: Simon & Schuster, 1973),
80–6

ESPAILLAT, Rhina P., *Corot, "Man Scything by a
Willow-Plot"*
Jean Baptiste-Camille Corot, *Man Scything by a
Willow Grove*
Source: *Ekphrasis* 1, no. 6 (Fall–Winter 1999):
26

Espaillat, Rhina P., *Portrait of Don Manuel Osorio
de Zuñiga*
Francisco de Goya, *Portrait of Don Manuel Osorio de
Zuñiga*
Source: *Ekphrasis* 1, no. 6 (Fall–Winter 1999):
27

Espaillat, Rhina P., *On the Ambivalence of Angels:
"Expulsion from Paradise." Giovanni di Paolo*
Source: *Ekphrasis* 1, no. 4 (Fall–Winter 1998): 6

Espaillat, Rhina P., *"The Bath." Mary Cassatt*
Source: *Ekphrasis* 1, no. 4 (Fall–Winter 1998): 7

Espaillat, Rhina P., *Nothing New*
Jean Baptiste-Camille Corot, *Souvenir of Monte-
fontaine*
Source: *Ekphrasis* 1, no. 5 (Spring–Summer 1999): 22

Espaillat, Rhina P., *Pentimento*
Vermeer
Source: *Ekphrasis* 1, no. 5 (Spring–Summer 1999): 23

Espaillat, Rhina P., *"Paul Helleu Sketching with His
Wife," John Singer Sargent*
Source: *Ekphrasis* 2, no. 1 (Spring–Summer 2000):
36

ETTER, Dave, *The Red Nude*
Unnamed painting
Source: *31 New American Poets*, ed. Ron Schreiber
(New York: Hill and Wang, 1969), 42–3; rpt. in
Etter, Dave, *The Last Train to Prophetstown* (Lin-
coln: University of Nebraska Press, 1968), 85

Etter, Dave, *Down by the Riverside*
Thomas Hart Benton, *Down by the Riverside*
Source: Greenberg, *Heart* (2J, above), 7

EVANS, Justin, *Contemplating Diego Rivera's "Dream
of a Sunday Afternoon in Alameda Park"*
Source: *Boxcar Poetry Review* January 2009. http://
www.boxcarpoetry.com/018/danziger_jazzy_001.h
tml

EVANS, Oliver, *The Art of Mr. Pavel Tchelitchew*
Source: *Poetry* 70 (September 1947): 302

EVASCO, Marjorie, *Solsequiem*
Pablo Picasso, *Maternidad* (1905)
Source: http://marnek.blogspot.com/2007/11/pict
ura-poiesis-ekphrastic-edition-of.html

EVENHUIS, Eddy, *Rembrandt en Saskia*
Rembrandt van Rijn, *The Prodigal Son in the Tav-
ern (Rembrandt and Saskia)*
Source: Korteweg and Heijn (2F, above), 122

EVERETT, Jacqueline, *Resurrection at Benson*
Stanley Spencer, *Resurrection at Cookham*
Source: http://www.guardian.co.uk/books/2006/oc
t/23/poetry

EWART, Gavin, *Freud*
Lucien Freud
Source: Gavin Ewart, *Collected Poems 1980–1990*
(London: Hutchinson, 1991), 427–8

FAGLES, Robert. For forty-one poems by Fagles on
Van Gogh, see 3Vb, above.

FAHRBACH, Helen, *To the Children Dancing on the
Strand*

George William 'AE' Russell, *Children Dancing on the Strand*
Source: *Wisconsin Poets* (1E, above), 32–3

FAILOR, Cassie, Untitled
Robert Henri, *Woods Interior*
Source: Janovy (1O, above), 27

FAIN, Sharon, *Ferry on the Rokugu River*
Utagawa Hiroshige, *Kawasaki*
Source: *Ekphrasis* 3, no. 6 (Fall–Winter 2005): 30

Fain, Sharon, *Crossing the Okitsu*
Utagawa Hiroshige, *Otiksu River*
Source: *Ekphrasis* 3, no. 6 (Fall–Winter 2005): 34

FALLON, Peter, *A Thanksgiving*
William John Hennessy, *Fête Day in a Cider Orchard, Normandy*
Source: Reid and Rice (1J, above), 102–4

FAMBROUGH, Monica, *Don't you think salt is pretty?*
Amy Sillman, *Untitled*
Source: Geha and Nichols (1N, above), 103–6

FANTHORPE, U.A., *Not My Best Side*
Paolo Uccello, *St. George and the Dragon*
Source: U.A. Fanthorpe, *Side Effects* (Calstock, Cornwall: Peterloo Press, 1978); rpt. in Fanthorpe's *Collected Poems 1978–2003* (Calstock, Cornwall: Peterloo Poets, 2005), 42–3; Abse (2D, above), 26–8; and Benton and Benton, *Double Vision* (2E, above), 32–3

Fanthorpe, U.A., *Woman Ironing*
Edgar Degas, *La Repasseuse*
Source: U.A. Fanthorpe, *Safe as Houses* (Calstock, Cornwall: Peterloo Press, 1995); rpt. in Fanthorpe's *Collected Poems 1978–2003* (Calstock, Cornwall: Peterloo Poets, 2005), 330–1; Benton and Benton, *Picture Poems* (2H, above), 22–3; and http://wwwfp.education.tas.gov.au/English/hugopaul.htm

Fanthorpe, U.A., *Four Dogs: 3. El Perro (Goya)*
Francisco Goya, *Perro semihundido*
Source: U.A. Fanthorpe, Fanthorpe's *Collected Poems 1978–2003* (Calstock, Cornwall: Peterloo Poets, 2005), 68–9

Fanthorpe, U.A., *The Doctor*
Sir Luke Fildes, *The Doctor*
Source: U.A. Fanthorpe, *Collected Poems 1978–2003* (Calstock, Cornwall: Peterloo Poets, 2005), 191, and Adams (1B, above), 62–3

Fanthorpe, U.A., *Underground*
Henry Moore, *A Shelter Sketchbook*
Source: U.A. Fanthorpe, *Collected Poems 1978–2003* (Calstock, Cornwall: Peterloo Poets, 2005), 381–3

Fanthorpe, U.A., *Portraits of Tudor Statesmen*
Tudor portraits in general

Source: Christopher Ricks, ed., *The Oxford Book of English Verse* (Oxford: Oxford University Press, 1999), 643

Fanthorpe, U.A., *La Débâcle. Temps Gris*
Claude Monet, *Break-up of the Ice Near Lavacourt*
Source: Benton and Benton, *Double Vision* (2E, above), 59–61

FARRÉS, Ernest, *Cape Cod Evening*
Edward Hopper, *Cape Cod Evening*
Source: Greenberg, *Side* (2M, above), 64–5

FASEL, Ida, *On the Verge*
Edgar Degas, *Dance Rehearsal at the Opéra the Rue Le Pelletier*
Source: *Ekphrasis* 2, no. 2 (Fall–Winter 2000): 18

Fasel, Ida, *As I See Him*
Édouard Manet, *Portrait of Théodore Duret*
Source: *Ekphrasis* 2, no. 6 (Fall–Winter 2002): 38

Fasel, Ida, *Flaming June*
Frederic Lord Leighton, *Flaming June*
Source: *Ekphrasis* 1, no. 6 (Fall–Winter 1999): 24

Fasel, Ida, *Rembrandt by Rembrandt*
Source: *Ekphrasis*, 1, no. 1 (Summer 1997): 48

Fasel, Ida, *Hard Times*
Georges de la Tour, *Job and His Wife*
Source: *Ekphrasis* 1, no. 4 (Fall–Winter 1998): 52–3

Fasel, Ida, *He Wept Bitterly*
Georges de la Tour, *St. Peter's Tears*
Source: *Ekphrasis* 1, no. 4 (Fall–Winter 1998): 54

Fasel, Ida, *Like No Yellow in the World*
Pierre Bonnard, *Nude in the Bath*
Source: *Ekphrasis* 1, no. 5 (Spring–Summer 1999): 20–1

Fasel, Ida, *Suspended*
René Magritte, *L'idee (The Idea)*
Source: *Ekphrasis* 2, no. 1 (Spring–Summer 2000): 26

Fasel, Ida, *Georges de la Tour's "Repentant Magdalene with the Night Light"*
Source: *Ekphrasis* 1, no. 6 (Fall–Winter 1999): 46–8

FAVEREY, Hans, *"De boom als larix" (uit de reeks "Hommage à Hercules Seghers")*
Hercules Seghers, various drawings
Source: Korteweg and Heijn (2F, above), 114

Faverey, Hans, *Adriaen Coorte*
Adriaen Coorte, *Exotic Birds, Three Medlars with a Butterfly, Still Life with Hopvogel, Still Life with Shells, Still Life with Strawberries in a Wan Likom*
Source: Korteweg and Heijn (2F, above), 179–81

FEARING, Kenneth, *John Standish, Artist*
Source: Kenneth Fearing, *New and Selected Poems* (Bloomington: Indiana University Press, 1956), 5

FEAVER, Vicki, *Oi yoi yoi*
Roger Hilton, *Oi yoi yoi*
Source: Abse (2D, above), 125, and Adams (1B, above), 134–5

Feaver, Vicki, *The Avenue*
Meindert Hobbema, *The Avenue at Middelharnis*
Source: Benton and Benton, *Picture Poems* (2H, above), 28

FEEN-DIEHL, Sandra J., *Identical Twin*
Kelly Novak, *Split Growth*
Source: *Elastic Ekphrastic: Poetry on Art/Poets on Tour through Galleries*, ed. Jennifer Bosveld (Johnstown, OH: Pudding House Publications, 2003), 66

FEINSTEIN, Elaine, *The Convalescent*
Gwen John, *The Convalescent*
Source: Elaine Feinstein, *Daylight* (Manchester, UK: Carcanet, 1997), 19

FELDMAN, Irving, *Who Is Dora? What Is She?*
Pablo Picasso, *Dora Maar Seated*
Source: Abse (2D, above), 26–8

Feldman, Irving, *"Se Aprovechan"*
Goya, *Caprichos, no. 16*
Source: Hollander (2I, above), 289

Feldman, Irving, *Artist and Model*
Pablo Picasso, *Suite de 180 dessins*
Source: Irving Feldman, *The Pripett Marshes and Other Poems* (New York: Viking, 1965), 6–11

Feldman, Irving, *Portrait de Femme*
Pablo Picasso, *Portrait de Femme*
Source: Irving Feldman, *The Pripett Marshes and Other Poems* (New York: Viking, 1965), 16–17

FENNELLY, Beth Ann, *Bertha Morisot: Retrospective*
Source: Beth Ann Fennelly, *Unmentionables* (New York: Norton, 2008)

FERLINGHETTI, Lawrence, *In Goya's Greatest Scenes We Seem to See*
Francisco Goya, *Disasters of War* series
Source: Lawrence Ferlinghetti, *A Coney Island of the Mind* (New York: New Directions, 1958), 9–10

Ferlinghetti, Lawrence, *14* [*don't let that horse*]
Marc Chagall, *Equestrienne* and other images from Chagall's paintings
Source: Lawrence Ferlinghetti, *A Coney Island of the Mind* (New York: New Directions, 1958), 29

Ferlinghetti, Lawrence, *Short Story on a Painting by Gustav Klimt*
Gustav Klimt, *The Kiss*
Source: Lawrence Ferlinghetti, *Who Are We Now?* (New York: New Directions, 1974), 15–16; Abse (2D, above), 106–8; and Benton and Benton, *Double Vision* (2E, above), 24–6

Ferlinghetti, Lawrence, *Monet's Lilies Shuddering*
Claude Monet, *Lilies*
Source: Lawrence Ferlinghetti, *Who Are We Now?* (New York: New Directions, 1974), 53

Ferlinghetti, Lawrence, *The "Moving Waters" of Gustav Klimt*
Source: Lawrence Ferlinghetti, *Who Are We Now?* (New York: New Directions, 1974), 17–18

Ferlinghetti, Lawrence, *The Wounded Wilderness of Morris Graves*
Source: Lawrence Ferlinghetti, *A Coney Island of the Mind* (New York: New Directions, 1958), 25–6

Ferlinghetti, Lawrence, *Sarollo's Women in Their Picture Hats*
Joachim Sarolla
Source: Lawrence Ferlinghetti, *Pictures of the Gone World*, in *The New American Poetry*, ed. Donald M. Allen (New York: Grove Press, 1960), 128

Ferlinghetti, Lawrence, *The Painter's Dream*
Refers to scores of painters and paintings, mostly modern
Source: Lawrence Ferlinghetti, *These Are My Rivers* (New York: New Directions, 1993), 18–19

Ferlinghetti, Lawrence, *42* [In the catalog raisonné]
Hieronymus Bosch
Source: Lawrence Ferlinghetti, *A Far Rockaway of the Heart* (New York: New Directions, 1997), 54–7

Ferlinghetti, Lawrence, *Returning to Paris with Pissarro*
Camille Pissarro, *Paris: Rain*
Source: Larwence Ferlinghetti, *European Poems and Transitions* (New York: New Directions, 1988), 15–16

Ferlinghetti, Lawrence, *Seeing a Woman as in a Painting by Berthe Morisot*
Source: Larwence Ferlinghetti, *European Poems and Transitions* (New York: New Directions, 1988), 20–21

Ferlinghetti, Lawrence, *A Note after Reading the Diaries of Paul Klee*
Source: Larwence Ferlinghetti, *European Poems and Transitions* (New York: New Directions, 1988), 101

Ferlinghetti, Lawrence, *Expressionist History of German Expressionism*
Franz Marc, Max Ernst, Ernst Ludwig Kirchner, Emile Nolde, Max Pechstein, et al.
Source: Larwence Ferlinghetti, *European Poems and Transitions* (New York: New Directions, 1988), 102–3

Ferlinghetti, Lawrence, *40* [*When the painter Pissarro lay dying*]

Source: Lawrence Ferlinghetti, *A Far Rockaway of the Heart* (New York: New Direction, 1997), 52

Ferlinghetti, Lawrence, *Matisse at the Modern, Magritte at the Met*
Henri Matisse, René Magritte
Source: Lawrence Ferlinghetti, *These Are My Rivers* (New York: New Directions, 1993), 9–14

Ferlinghetti, Lawrence, *The "Moving Waters" of Gustav Klimt*
Source: Lawrence Ferlinghetti, *Wild Dreams of a New Beginning* (New York: New Directions, 1998), 17–18

FERRARELLI, Rina, *Portrait of a Young Man*
Sandro Botticelli, *Portrait of a Young Man*
Source: Greenberg, *Side* (2M, above), 50–1

FERRER, Renée, *Gallop*
Malola (Maria Gloria Echauri), *Tornado*
Source: Greenberg, *Side* (2M, above), 18–19

FERRY, David, *Cythera*
Jean-Antoine Watteau, *Le Pélerinage à l'isle de Cythère*
Source: Hollander (2I, above), 321

FHARES, Alexander (pseudonym of Alexander L. Czoppelt), *Ikarus*
Pieter Brueghel the Elder, *Landscape with the Fall of Icarus*
Source: *Die Horen* 17 (1972): 252; in Kranz (2B, above), 86; and in Achim Aurnhammer and Dieter Martin, eds., *Mythos Ikarus: Texte von Ovid bis Wolf Biermann* (Leipzig: Reclam, 2001), 208–9

FIELD, Michael (Katherine Harris Bradley and Edith Cooper), *La Gioconda, by Leonardo da Vinci*
Leonardo da Vinci, *Mona Lisa*
Source: Kranz (2B, above), 127

Field, Michael (Katherine Harris Bradley and Edith Cooper). For twenty poems by "Field" on Renaissance paintings, see 4A.

FINCH, Annie, *Still Life*
Jan Vermeer
Source: *Ekphrasis* 2, no. 6 (Fall–Winter 2002): 35

FINCH, Robert, *After Brueghel*
Pieter Brueghel the Elder, *Landscape with the Fall of Icarus*
Source: Robert Finch, *Dover Beach Revisited and Other Poems* (Toronto: Macmillan Co. of Canada, 1961), 89–91

FINKEL, Donald, *The Great Wave: Hokusai*
Katsushika Hokusai, *The Great Wave at Kanagawa*
Source: *Poetry* 93, no. 5 (February 1959): 311

Finkel, Donald, *"The Dream": Rousseau*
Henri Rousseau, *The Dream*
Source: Kehl (2A, above), 182–4

Finkel, Donald, *More Light*
Edward Hopper, *Nighthawks*
Source: Greenberg, *Heart* (2J, above), 68–9

FINLAY, Charles Coleman, *Edward Hopper's "Morning Sun"*
Source: *Ekphrasis* 1, no. 5 (Spring–Summer 1999): 6–7

FISCHER, Barbara, *Luminous Zag: Night*
Louise Nevelson, *Luminous Zag: Night*
Source: *Ekphrasis* 4, no. 4 (Fall–Winter 2007): 27–8

FISH, Larry, *Our Art Teacher*
Andrew Wyeth
Source: http://crownedwithlaurels.blogspot.com/2009/01/our-art-teacher.html

FISHER, Roy, *The Elohim*
William Blake, *Elohim Creating Adam*
Source: Adams (1B, above), 32–3

Fisher, Roy, *Chirico*
Giorgio de Chirico
Source: Roy Fisher, *Poems: 1955–1987* (Oxford: Oxford University Press, 1988), 31–2

Fisher, Roy, *Five Morning Poems from a Picture by Manet*
Edouard Manet, *The Boy with the Cherries*
Source: Roy Fisher, *Poems: 1955–1987* (Oxford: Oxford University Press, 1988), 7–11

FISHER-WIRTH, Ann, *Girl Holding a Doll*
Paul Cézanne, *Girl Holding a Doll*
Source: *Ekphrasis* 1, no. 6 (Fall–Winter 1999): 28

Fisher-Wirth, Ann, *"The Healer," After Magritte*
René Magritte, *The Healer*
Source: *Ekphrasis* 4, no. 2 (Fall–Winter 2006): 36

Fisher-Wirth, Ann, *Patio with Black Door*
Georgia O'Keeffe, *Patio with Black Door*
Source: *Ekphrasis* 1, no. 6 (Fall–Winter 1999): 36–7

FISHMAN, Charles, *Road with Cypress and Star*
Vincent Van Gogh, *Road with Cypress and Star*
Source: http://www.nycbigcitylit.com/may2002/contents/poetryasingles.html

FITZMAURICE, Gabriel, *The Solitary Digger*
Paul Henry, *The Potato Digger*
Source: Reid and Rice (1J, above), 18–19

FIXEL, Lawrence, *How Tall Was Toulouse-Lautrec?*
Source: Lawrence Fixel, *Truth, War, and the Dream-Game* (Minneapolis, MN: Coffee House Press, 1991), 117–18

Fixel, Lawrence, *The Door to Have* [I and II]
Georgia O'Keeffe
Source: Lawrence Fixel, *Truth, War, and the Dream-Game* (Minneapolis, MN: Coffee House Press, 1991), 128–9

FLANDERS, Jane, *Van Gogh's Bed*
Vincent Van Gogh, *Bed in Arles*
Source: *An Introduction to Literature,* eds., Sylvan
 Barnett, et al. 14th ed. (New York: Longman,
 2006), 894; and http://mog.com/extraordinaryp
 oems/blog_post/145374

Flanders, Jane, *Cloud Painter*
John Constable
Source: http://www.dwpoet.com/flanders.html

FLECKER, James Elroy, *Resurrection*
Piero della Francesca, *The Resurrection* (in the
 Palazzo Pubblico at Borgo San Selopcro)
Source: *The Collected Poems of James Elroy Flecker*
 (New York: Doubleday, Page and Co., 1916), 80

Flecker, James Elroy, *On Turner's Polyphemus*
J.M.W. Turner, *Ulysses Deriding Polyphemus*
Source: *The Collected Poems of James Elroy Flecker*
 (New York: Doubleday, Page and Co., 1916), 56;
 and Kranz (2B, above), 201

FLIS, Brad, *Customs*
Whiting Tennis, *Bovine*
Source: Geha and Nichols (1N, above), 107–9

FLORY, Sheldon, *Winter Dreams*
Emile Albert Gruppé, *Winter Landscape*
Source: *Ekphrasis* 1, no. 3 (Spring–Summer 1998):
 46

FOERSTER, Robert, *Brueghel's "Harvesters"*
Pieter Brueghel the Elder, *The Harvesters*
Source: http://www.english.emory.edu/classes/pai
 ntings&poems/foerster.html

FORBES, Duncan, *Red Rooms, Blue Trees*
Henri Matisse
Source: Duncan Forbes, *Taking Liberties* (London:
 Enitharmon, 1993), 10

FORBES, John, *On Tiepolo's "The Banquet of Cleopa-
 tra"*
Giambattista Tiepolo, *The Banquet of Cleopatra*
Source: John Forbes, *Collected Poems* (Blackheath,
 New South Wales: Brandl & Schlesinger, 2001),
 189

FORD, Frank, *Nighthawks, after Hopper*
Edward Hopper, *Nighthawks*
Source: http://www.ftrain.com/plain_connlight_n
 ighthawks.html

FORD, Susan Allen, *Saint Luke Painting the Virgin
 and Child*
Rogier van der Weyden, *Saint Luke Painting the Vir-
 gin and Child*
Source: *Ekphrasis* 3, no. 5 (Spring–Summer 2005):
 27–8

FORREST-THOMSON, Veronica, *Contours—
 Homage to Cézanne*
Source: Veronica Forest-Thompson, *Collected Poems*

and Translations (East Sussex, UK: Allardyce,
 Barnett, 1990), 219

Forrest-Thomson, Veronica, *Clown (by Paul Klee)*
Source: Veronica Forest-Thompson, *Collected Poems
 and Translations* (East Sussex, UK: Allardyce,
 Barnett, 1990), 213

Forrest-Thomson, Veronica, *Ambassador of Autumn
 (by Paul Klee)*
Source: Veronica Forest-Thompson, *Collected Poems
 and Translations* (East Sussex, UK: Allardyce,
 Barnett, 1990), 217

Forrest-Thompson, Veronica, *The White Magician*
Leonardo da Vinci
Source: Veronica Forest-Thompson, *Collected Poems
 and Translations* (East Sussex, UK: Allardyce,
 Barnett, 1990), 260

FOSTER, Gloria, *Peach Trees in Blossom*
Vincent Van Gogh, *Peach Trees in Blossom*
Source: *Ekphrasis* 1, no. 3 (Spring–Summer 1998): 7

FOSTER, Linda Nemec, *The Reinvention of Myth*
Wilma Lok, mixed media
Source: *Ekphrasis* 1, no. 6 (Fall–Winter 1999): 8

Foster, Linda Nemec, *Double Self-Portrait*
Andy Warhol, *Double Self-Portrait*
Source: *Ekphrasis* 4, no. 2 (Fall–Winter 2006): 11

Foster, Linda Nemec, *Lunch Break: The Faceless
 Man in Rivera's Detroit Mural*
Diego Rivera, *Detroit Industry Mural*
Source: *Ekphrasis* 4, no. 2 (Fall–Winter 2006): 37

Foster, Linda Nemec, *Trinity*
Magdelena Abakanowicz, *Drawings: Cycle Corps*
Source: *Ekphrasis* 4, no. 4 (Fall–Winter 2007): 16–
 17

Foster, Linda Nemec, *The Son's Dream*
Bruce Erikson, *The Son's Dream*
Source: *Ekphrasis* 3, no. 3 (Spring–Summer 2004):
 30

FOWLER, Douglas, *Lightness*
Alan Bean, *That's How It Felt to Walk on the Moon*
Source: *Beauty/Truth: A Journal of Ekphrastic Poetry*
 1, no. 1 (Fall–Winter 2006): 33

Fowler, Douglas, *New Moon Rising*
Chen Chi, *New Moon Rising*
Source: *Beauty/Truth: A Journal of Ekphrastic Poetry*
 1, no. 1 (Fall–Winter 2006): 34

FOWLER, James, *Gallery Portrait in the Palace of
 King Philip IV*
Diego Velázquez, *Portrait of Philip IV*
Source: *Ekphrasis* 1, no. 1 (Summer 1997): 38

Fowler, James, *Rus*
Marc Chagall, unidentified painting
Source: *Ekphrasis* 1, no. 2 (Winter 1997–1998): 14

Fowler, James, *Slaughter*
Rembrandt van Rijn, *The Slaughtered Ox*
Source: *Ekphrasis* 1, no. 3 (Spring–Summer 1998): 53

Fox, Ida, *Kline and Stein*
Franz Kline
Source: *Art News* 56 (January 1958): 43–4

Fox-Wilson, Jessica, *In Mud-Colored Dreams, We Watch Our Distant City*
Rick Mobbs, *Standing in the Shadows*
Source: http://9to5poet.com/2008/07/21/ekphrasis/

Fraley, Jason, *Self-Portrait With A Brand New God*
Helen Beckman Kaplan, *Empire*
Source: *Broadsided: Switcheroo IV*, November 2008.
 http://www.broadsidedpress.org/switcheroo/nov08.shtml

Francis, Robert, *Picasso and Matisse*
Source: Robert Francis, *Like Ghosts of Eagles: Poems, 1966–1974* (Amherst: University of Massachusetts Press, 1974), 28.

Frank, D.M., *Sommer in Auvers*
Vincent Van Gogh, *Crows over Cornfield*
Source: Kranz (2B, above), 214

Frank, Linda, On Frank's poems about Frida Kahlo, see 3K, above.

Frank, Peter, *Parergon: Deadline City*
Tobi Zausner, *The Poet Drinks*, 1978–79
Source: Vanderlip (1A, above), 76

Frankenstein, John, *Niagara*
Frederic Edwin Church, *Niagara*
Source: *American Art: Its Awful Attitude. A Satire* (Cincinnati, 1864); rpt. (Bowling Green, OH: Bowling Green University Popular Press, 1972), 55–80

Frary, Mary Louise, *Introductory Comments by Sir Thomas Butler of Offrey*
Peter Lely, *Thomas Butler, Earl of Ossory, First Duke of Ormonde*
Source: *Wisconsin Poets* (1E, above), 14–15

Fraser, G.S., *A Night (after Giorgio de Chirico)*
Source: G.S. Fraser, *Poems of G S. Fraser* (Leicester, UK: Leicester University Press, 1981), 32

Fraser, Kathleen, *Six Poems from "Magritte Series"*
René Magritte, *La Baigneuse Du Clair Au Sombre* (*Bather between Light and Dark*), *L'Invention Collective* (*Collective Invention*), *La Valeurs Personnelles* (*Personal Values*), *Les Jours Giantesques* (*The Titanic Days*), *La Reproduction Interdite* (*Not To Be Reproduced*)
Source: Kathleen Fraser, *Il Cuore: The Heart: Selected Poems, 1970–1995* (Hanover, NH: Wesleyan University Press, 1997), 15–20

Fraser, Kathleen, *Giotto: ARENA*
Giotto di Bondone, Giotto's frescoes in the Arena Chapel, Padua
Source: Kathleen Fraser, *Il Cuore: The Heart: Selected Poems, 1970–1995* (Hanover, NH: Wesleyan University Press, 1997), 119–37

Fraser, Kathleen, *La La at the Cirque Fernando, Paris*
Edgar Degas, *Miss La La at the Cirque Fernando*
Source: Kathleen Fraser, *Il Cuore: The Heart: Selected Poems, 1970–1995* (Hanover, NH: Wesleyan University Press, 1997), 158–68.

Fraser, Kathleen, *Cue or Starting Point*
Sandra Iliescu, drawings
Source: Kathleen Fraser, *Il Cuore: The Heart: Selected Poems, 1970–1995* (Hanover, NH: Wesleyan University Press, 1997), 180–3

Fraser, Kathleen, *WING*
Mel Bochner, drawings
Source: Kathleen Fraser, *Il Cuore: The Heart: Selected Poems, 1970–1995* (Hanover, NH: Wesleyan University Press, 1997), 184–93

Frazier, C. Hood, *Colors Shone Through*
Liz Jones, *Color Mesh # II* (mixed media)
Source: *Ekphrasis* 1, no. 5 (Spring–Summer 1999): 51

Frech, Stephen, *Woman Bathing*
Rembrandt van Rijn, *Woman Bathing*
Source: *Ekphrasis* 2, no. 6 (Fall–Winter 2002): 25; rpt. in Frech's *If Not for These Wrinkles of Darkness* (Buffalo, NY: White Pine Press, 2001), 53

Frech, Stephen, *Descent from the Cross*
Rembrandt van Rijn, *The Descent from the Cross*
Source: Stephen Frech, *If Not for These Wrinkles of Darkness* (Buffalo, NY: White Pine Press, 2001), 16

Frech, Stephen, *Christ at Emmaus*
Rembrandt van Rijn, *Pilgrims at Emmaus*
Source: Stephen Frech, *If Not for These Wrinkles of Darkness* (Buffalo, NY: White Pine Press, 2001), 24

Frech, Stephen, *The Denial of Peter*
Rembrandt van Rijn, *Peter Denying Christ*
Source: Stephen Frech, *If Not for These Wrinkles of Darkness* (Buffalo, NY: White Pine Press, 2001), 58

Frech, Stephen, *Self-Portrait with Saskia: The Prodigal Son in the Tavern*
Rembrandt van Rijn, *The Prodigal Son in the Tavern (Rembrandt and Saskia)*
Source: Stephen Frech, *If Not for These Wrinkles of Darkness* (Buffalo, NY: White Pine Press, 2001), 29–30

Frech, Stephen, *Return of the Lost Son*
Rembrandt van Rijn, *The Return of the Prodigal Son*

Source: Stephen Frech, *If Not for These Wrinkles of Darkness* (Buffalo, NY: White Pine Press, 2001), 63

Frech, Stephen, *Simeon in the Temple*
Rembrandt van Rijn, *Simeon with the Christ Child in the Temple*
Source: Stephen Frech, *If Not for These Wrinkles of Darkness* (Buffalo, NY: White Pine Press, 2001), 22

Frech, Stephen, *The Adoration of the Shepherds*
Rembrandt van Rijn, *The Adoration of the Shepherds*
Source: Stephen Frech, *If Not for These Wrinkles of Darkness* (Buffalo, NY: White Pine Press, 2001), 44

Frech, Stephen, *The Hog*
Rembrandt van Rijn, *The Hog*
Source: Stephen Frech, *If Not for These Wrinkles of Darkness* (Buffalo, NY: White Pine Press, 2001), 45

FREEMAN, Molly, *Tired Child*
Louis le Brocquy, *Tired Child*
Source: Reid and Rice (1J, above), 82–3

FREISINGER, Randall R., "*The Discovery*" (1956)
Norman Rockwell, *The Discovery*
Source: pdf file at http://www.whatishol.com/

Freisinger, Randall R., "*Girl at Mirror*" (1954)
Norman Rockwell, *Girl at Mirror*
Source: pdf file at http://www.whatishol.com/

Freisinger, Randall R., "*Girl with Black Eye*" (1953)
Norman Rockwell, *Girl with Black Eye*
Source: pdf file at http://www.whatishol.com/

Freisinger, Randall R., "*The Runaway*" (1958)
Norman Rockwell, *The Runaway*
Source: pdf file at http://www.whatishol.com/

FREUND, Mitchell J. *Daylight Shadow*
Robert Motherwell, *Two Figures with Stripe*
Source: *Beauty/Truth: A Journal of Ekphrastic Poetry* 1, no. 1 (Fall–Winter 2006): 4

FRICKE, Arthur Davidson, *A Watteau Melody*
Jean-Antoine Watteau
Source: Arthur Davidson Fricke, *Selected Poems* (New York: George H. Doran Co., 1926), 26–7

FRIMAN, Alice R., *Leda and the Swan*
Tintoretto, *Leda and the Swan*
Source: Buchwald and Roston (2C, above), 81

Friman, Alice R., *The Rope*
Pablo Picasso, *Boy Leading a Horse*
Source: *Cadence of Hooves: A Celebration of Horses*, ed. Suzan Jantz (Igo, CA: Yarroway Mountain Press, 2008)

Friman, Alice R., *Modigliani's Girls*
Amedeo Modigliani, images from various paintings
Source: *Prairie Schooner* 82, no. 3 (Fall 2008): 66–7

Friman, Alice R., *Leonardo's Roses*
Leonardo da Vinci, *Lady with an Ermine*
Source: *Ekphrasis* 3, no. 3 (Spring–Summer 2004): 20

FRITH, Carol, *Anonymous Man*
René Magritte, *The Reckless Sleeper*
Source: *Cæsura* (Fall 2007): 18

Frith, Carol, *Absent Shadows*
Karel Appel, *People, Birds and Sun*
Source: *MacGuffin* 24, no. 3 (Spring–Summer 2008): 99

FRÖDING, Gustav, *Mona Lisa*
Leonardo da Vinci, *Mona Lisa*
Source: Kranz (2B, above), 129

FROMMER, David, *Swinging Man*
Bruce McLean, *Construction of the Grey Flag*
Source: Adams (1B, above), 148–9

FROST, Lars, *The Daughters of Edward Darley Boit, 1882*
John Singer Sargent, *The Daughters of Edward Darley Boit*
Source: http://electricveneer.com/clients/inekphrasis/ekphrasis.html

FULLER, John, *The Money of Their Colour; or, The American Expressionists*
Willem de Kooning, Franz Kline, Mark Rothko, Barnett Newman
Source: Abse (2D, above), 136–7

FUSSINER, Howard, *Uccello's "A Battle of San Romana"*
Paolo Uccello, *Battle of San Romano: The Counter-Attack by Micheletto da Cotignola*
Source: *College Art Journal* 19 (Summer 1960): 306

Fussiner, Howard, *Bonnard*
Pierre Bonnard
Source: *College Art Journal* 18 (Fall 1958): 71

Fussiner, Howard, *Giotto*
Giotto di Bondone
Source: *Art Journal* 21 (Winter 1961–62): 96

Fussiner, Howard, *Mondrian*
Piet Mondrian
Source: *College Art Journal* 18 (Summer 1959): 357

FULTON, Alice, *Close (Joan Mitchell's "White Territory")*
Source: Alice Fulton, *Felt* (New York: Norton, 2000), 5–8, and Tillinghast (1F, above), 70–3; rpt. in Fulton's *Cascade Experiment* (New York: W.W. Norton, 2004), 157–60

Fulton, Alice, *The Magistrate's Escape*
René Magritte, *La Golconde*
Source: Buchwald and Roston (2C, above), 79

GAERTNER, Johannes A., "*La Reve*" by Henri Rousseau
Source: *College Art Journal* 18 (Spring 1959): 225

Gaertner, Johannes A., *"The Persistence of Memory"* by Salvador Dali
Source: *College Art Journal* 17 (Summer 1958): 381

GALLAGHER, Jean. For forty-three poems by Gallagher on paintings, see 4T, above.

GALLAGHER, Tess, *From Moss-Light to Hopper with Love*
Edward Hopper
Source: Lyons and Weinberg (3Ja, above), 77–9

GALVIN, Brendan, *An Illuminated Page from the Celtic Manuscript Book of Lough Glen*
Source: Brendan Galvin, *The Strength of a Named Thing* (Baton Rouge: Louisiana State University Press, 1999), 42–3

GALVIN, Martin, *Gallery at the Tate*
Edvard Munch, *Sick Child*
Source: *Ekphrasis* 1, no. 5 (Spring–Summer 1999): 40, and in *Beltway Poetry Quarterly* 10, no. 1 (Winter 2009). http://washingtonart.com/beltway/contents.html

Galvin, Martin, *Mary Cassatt*
Source: *Ekphrasis* 3, no. 3 (Spring–Summer 2004): 19

GANDER, Forrest, *Landscape with a Man Being Killed by a Snake*
Nicolas Poussin, *Landscape with a Man Being Killed by a Snake*
Source: Forrest Gander, *Science & Steepleflower* (New York: New Directions, 1998), 84–5

GAPINSKI, James, *Edge*
Ellsworth Kelly, *Study for "Ormession"*
Source: *qarrtsiluni. online literary magazine.* http://qarrtsiluni.com/category/ekphrasis

GAREBIAN, Keith. For Garebian's poems on Frida Kahlo, see 3Ka, above.

GARNIER, Parris, *Still Life with Bivalve*
Unidentified still life
Source: *Beltway Poetry Quarterly* 10, no. 1 (Winter 2009). http://washingtonart.com/beltway/contents.html

GARRETT, George, *David*
Caravaggio, *David with the Head of Goliath*
Source: Kehl (2A, above), 192–3

GARRIGUE, Jean, *An Improvisation on the Theme of the Lady and the Unicorn*
The Lady and the Unicorn, tapestry in the Musée de Cluny
Source: Jean Garrigue, *Selected Poems* (Urbana: University of Illinois Press, 1992), 105–6

GASCOYNE, David, *Entrance to a Lane*
Graham Sutherland, *Entrance to a Lane*
Source: David Gascoyne, Selected Poems (London: Enitharmon, 1994), 247; and Adams (1B, above), 108–9

Gascoyne, David, *Salvador Dalí*
Source: David Gascoyne, *Selected Poems* (London: Enitharmon, 1994), 39

GAUDY, Franz Freiherr von, *Die väterliche Ermahnung*
Gerard Terborch, *Die väterliche Ermahnung* (*The Fatherly Admonition*)
Source: Kranz (2B, above), 165–6

GAUTIER, Théophile, *Sur le Prométhée du Musée da Madrid*
José de Ribera, *Tityos*
Source: Théophile Gautier, *Premières Poesies* (Paris, 1870), 321. German trans., Kranz (2B, above), 183

Gautier, Théophile, *Watteau*
Jean-Antoine Watteau
Source: Jean-Antoine Watteau, *Poésies completes*, ed. René Jasinski, vol. 2 (Paris: Nizet, 1970), 75.

GEERDS, Koos, *"Winterlandschap van Hendrick Avercamp"*
Hendrick Avercamp, *Skating Scene Near a City*
Source: Korteweg and Heijn (2F, above), 111

GENTRY, Do, *The Chagall Cup*
Marc Chagall, unidentified painting
Source: *Ekphrasis* 1, no. 3 (Spring–Summer 1998): 10

GEORGE, DAVID, *The Flayed Ox*
Marc Chagall, *The Flayed Ox* (*Le boeuf écorché*)
Source: *Ekphrasis* 2, no. 4 (Fall–Winter 2001): 28–9

George, David, *The Acrobat*
March Chagall, *The Acrobat*
Source: *Ekphrasis* 2, no. 4 (Fall–Winter 2001): 30

George, David, *The Deadman*
Marc Chagall, *The Dead Man*
Source: *Ekphrasis* 1, no. 1 (Summer 1997): 41

George, David, *The Dream*
Marc Chagall, *The Dream*
Source: *Ekphrasis* 1, no. 1 (Summer 1997): 42

George, David, *The Harbour at Bordeaux*
Édouard Manet, *The Harbour at Bordeaux*
Source: *Ekphrasis* 1, no. 1 (Summer 1997): 43

George, David, *Boulogne Harbour by Moonlight*
Édouard Manet, *Moonlight over Boulogne Harbour*
Source: *Ekphrasis* 1, no. 2 (Winter 1997–1998): 17

George, David, *Rocky Cove*
Edward Hopper, *Rocky Cove*
Source: *Ekphrasis* 1, no. 3 (Spring–Summer 1998): 64

George, David, *The Woman in Compartment C*
Edward Hopper, *Compartment C, Car 293*
Source: *Ekphrasis* 1, no. 4 (Fall–Winter 1998): 29

George, David, *The Train Station: Gare Saint-Lazare*
Édouard Manet, *Gare Saint-Lazare*

Source: *Ekphrasis* 1, no. 5 (Spring–Summer 1999): 27

GEORGE, Kristine O'Connell, *Pantoum for These Eyes*
Kiki Smith, *Untitled (Fluttering Eyes)*
Source: Greenberg, *Heart* (2J, above), 42–3

GEORGE, Stefan, *König und Harfner*
Rembrandt van Rijn, *David spielt die Harfe vor Saul* (*David Playing the Harp before Saul*)
Source: Kranz (2B, above), 175

GEORGES, Danielle, *A Painting at the Met*
Unidentified painting of horses
Source: *Cadence of Hooves: A Celebration of Horses*, ed. Suzan Jantz (Igo, CA: Yarroway Mountain Press, 2008)

GERBER, Dan, *Stag's Head: Albrecht Dürer, 1504*
Source: Dan Gerber, *A Primer on Parallel Lives* (Port Townsend, WA: Copper Canyon, 2007), 61

GERHARDT, Ida G.M., *Het weerzien*
Salamon van Ruysdael, *Ferry on a River*
Source: Korteweg and Heijn (2F, above), 121

Gerhardt, Ida G.M., *Christus als hovenier*
Rembrandt van Rijn, *Christ Appearing to Mary Magdalene*
Source: Korteweg and Heijn (2F, above), 126

Gerhardt, Ida G.M., *Confrontatie*
Jan Asselijn, *The Threatened Swan*
Source: Korteweg and Heijn (2F, above), 157

GERY, John, *Paraclete Almost*
J.M.W. Turner, *Europa and the Bull*
Source: *Ekphrasis* 2, no. 4 (Fall–Winter 2001): 7–8

GETTY, Sarah, *The Census at Bethlehem*
Pieter Brueghel the Elder, *The Census at Bethlehem*
Source: *Ekphrasis* 4, no. 1 (Spring–Summer 2006): 17

GEWANTER, David, *Goya's The Third of May, 1808*
Source: *Literature: Reading Fiction, Poetry, and Drama* (compact ed.), ed., Robert DiYanni (New York: McGraw-Hill, 2000), 504

GHERSI, Erika, *The Dream (1910) by Henri Rousseau*, trans. Toshiya Kamei
Source: *Collection: Ekphrastic Poems by Alberto Nessi and Ericka Ghersi*, No. 3 (Delafield, WI: Canvas Press, 2007), 5

GIBSON, Becky Gould, *Study in Blue*
Gerard Terborch, *Eine junge Dame am Frisiertisch um 1657*
Source: *Ekphrasis* 4, no. 1 (Spring–Summer 2006): 31

GIBSON, Stephen, *Invasion of the Honey Tree*
Piero di Cosimo, *The Discovery of Honey*
Source: *Alimentum* 5 (Winter 2008): 25

Gibson, Stephen, *Masaccio's "The Expulsion from the Garden of Eden"*
Source: Stephen Gibson, *Masaccio's Expulsion* (Chesterfield, MO: MARGIE, Inc./IntuiT House, 2008), 17

Gibson, Stephen, *Bosch in Venice*
Hieronymus Bosch
Source: Stephen Gibson, *Masaccio's Expulsion* (Chesterfield, MO: MARGIE, Inc./IntuiT House, 2008), 19

Gibson, Stephen, *The Battle of Lepanto*
Unknown artist, *The Battle of Lepanto* (Venice)
Source: Stephen Gibson, *Masaccio's Expulsion* (Chesterfield, MO: MARGIE, Inc./IntuiT House, 2008), 20–1; and *Ploughshares* 31, no. 1 (Spring 2005): 37–8

Gibson, Stephen, *The Rape of Europa*
Giovanni Battista Tiepolo, *The Rape of Europa*
Source: Stephen Gibson, *Masaccio's Expulsion* (Chesterfield, MO: MARGIE, Inc./IntuiT House, 2008), 22

Gibson, Stephen, *Impromptu on Masaccio's "Expulsion from the Graden"*
Source: Stephen Gibson, *Masaccio's Expulsion* (Chesterfield, MO: MARGIE, Inc./IntuiT House, 2008), 27–8

Gibson, Stephen, *"The Rape of Europa" by P. Veronese*
Source: Stephen Gibson, *Masaccio's Expulsion* (Chesterfield, MO: MARGIE, Inc./IntuiT House, 2008), 29

Gibson, Stephen, *Titian's "The Rape of Europa" as an Allegory of Iraq*
Source: Stephen Gibson, *Masaccio's Expulsion* (Chesterfield, MO: MARGIE, Inc./IntuiT House, 2008), 30

Gibson, Stephen, *On Wall Mosaics Showing How the Body of St. Mark Was Smuggled Out of Alexandria, Egypt*
Mosaics, Cathedral of Saint Mark, Venice
Source: Stephen Gibson, *Masaccio's Expulsion* (Chesterfield, MO: MARGIE, Inc./IntuiT House, 2008), 34

Gibson, Stephen, *A PETA Interpretation of Leonardo's "Lady with Weasel"*
Leonardo da Vinci, *The Lady with an Ermine*
Source: Stephen Gibson, *Masaccio's Expulsion* (Chesterfield, MO: MARGIE, Inc./IntuiT House, 2008), 37

Gibson, Stephen, *"Hunting Scene" by Piero di Cosimo*
Source: Stephen Gibson, *Masaccio's Expulsion* (Chesterfield, MO: MARGIE, Inc./IntuiT House, 2008), 45

Gibson, Stephen, *"Profile of a Young Woman"—Piero di Cosimo*
Source: Stephen Gibson, *Masaccio's Expulsion* (Chesterfield, MO: MARGIE, Inc./IntuiT House, 2008), 46

Gibson, Stephen, *On a Renaissance Painting of a Gentlewoman and Her Two Daughters*
Unidentified painting in the Uffizi, Florence
Source: Stephen Gibson, *Masaccio's Expulsion* (Chesterfield, MO: MARGIE, Inc./IntuiT House, 2008), 47

Gibson, Stephen, *A PETA Georgics for Giulio Romano's "Lady at Her Toilet"*
Source: Stephen Gibson, *Masaccio's Expulsion* (Chesterfield, MO: MARGIE, Inc./IntuiT House, 2008), 48

Gibson, Stephen, *"The Crusaders Assault Constantinople" by J. Palma the Younger*
Jacopo Palma the Younger, *The Crusaders Assault Constantinople*
Source: Stephen Gibson, *Masaccio's Expulsion* (Chesterfield, MO: MARGIE, Inc./IntuiT House, 2008), 58–9

Gibson, Stephen, *"The War of Chioggia" by P. Veronese*
Paolo Veronese, *The War of Chioggia*
Source: Stephen Gibson, *Masaccio's Expulsion* (Chesterfield, MO: MARGIE, Inc./IntuiT House, 2008), 60–1

Gibson, Stephen, *Domenico Ghirandaio's "The Massacre of the Innocents"*
Source: Stephen Gibson, *Masaccio's Expulsion* (Chesterfield, MO: MARGIE, Inc./IntuiT House, 2008), 63

Gibson, Stephen, *The Anatomy Lesson of Dr. Nicolaas Tulp*
Rembrandt van Rijn, *The Anatomy Lesson of Dr. Nicolas Tulp*
Source: *Shenandoah* 58, no. 2 (Fall 2008): 81

GILBERT, Celia, *The Still Lifes of Giorgio Morandi*
Source: *Georgia Review* 34, no. 3 (Fall 1980): 592

GILBERT, Dorothy, *Fox Woman: Thoughts on Two Prints by Yoshitoshi and Hiroshige*
Tsukioka Yoshitoshi and Utagawa Hiroshige
Source: *Tattoo Highway* 15. http://www.tattoohighway.org/15/dgfox.html

GILBERT, Sandra, *December 1, 1993: Paris, Looking at Monet*
Source: Sandra Gilbert, *Ghost Volcano* (New York: Norton, 1995), 107–8

GILDNER, Gary, *A Word*
Arthur Dove, *That Red One*
Source: Greenberg, *Heart* (2J, above), 19

GILMAN, Susan Jane, *The Dead Sea from Masada, 1987*
Edward Lear, *The Dead Sea, from Masada*
Source: Tillinghast (1F, above), 46–8

GINSBERG, Allen, *Cézanne's Ports*
Paul Cézanne, *L'Estaque*
Source: Allen Ginsberg, *Empty Mirror: Early Poems* (New York: Totem Press, 1961), 12.

Ginsberg, Allen, *Epigram on a Painting of Golgotha*
Unidentified painting
Source: Allen Ginsberg, *Collected Poems: 1947–1980* (New York: Harper & Row, 1984), 33

Ginsberg, Allen, *Śākyamuni Coming Out from the Mountain*
Liang Kai (Sung Dynasty), *Śākyamuni Emerging from the Mountains*
Source: Allen Ginsberg, *Collected Poems: 1947–1980* (New York: Harper & Row, 1984), 90–1

GLASER, Kirk, *Questions of Origin*
Odilon Redon, *Les Origines*
Source: *Ekphrasis*, 3, no. 4 (Fall–Winter 2004): 44–5

GLASSSUBWAY [web name of blogger], *Nighthawks*
Edward Hopper, *Nighthawks*
Source: http://glasssubway.livejournal.com/2008/11/19/

GLEASON, Kate, *Companion Pieces*
Vincent Van Gogh, *Gauguin's Armchair* and *Vincent's Chair with His Pipe*
Source: *Ekphrasis* 5, no. 1 (Spring–Summer 2009): 15–16

GLENN, Karen, *Woman with Crow*
Pablo Picasso, *Woman with Crow*
Source: *Ekphrasis* 1, no. 1 (Summer 1997): 36

GLIXMAN, Elizabeth P., *She Could Not Escape from This Story Even Though She Knew It Was Not True*
John Singer Sargent, *Daughters of Edward Darley Boit*
Source: *The Hiss Quarterly* 5, no. 3. http://thehissquarterly.net/eck/glixman.html

Glixman, Elizabeth P., *I Am Not Small Like An Ant, Prays Toulouse Lautrec*
Henri de Toulouse-Lautrec, *Aristide Bruant in His Cabaret*
Source: *The Hiss Quarterly* 5, no. 3. http://thehissquarterly.net/eck/glixman.html

Glixman, Elizabeth P., *Painted Stories from the Dutch: Eight Poems. 1. Wilderness. 2. Bathsheba in Blue. 3. Spirit & Matter. 4. It Is All This Now. 5. Dowries. 6. The World as Art. 7. The Bride. 8. And So It Is*
Jan Vermeer, *Woman in Blue Reading a Letter* and *The Music Lesson*; Rembrandt van Rijn, *Syndic of the Draper's Guild; The Syndics of the Clothmaker's*

Guild; Willem Kalf, *Still Life with Lobster, Drinking Horn, and Glasses*; Jan Davidszoon de Heem; and other seventeenth-century Dutch masters
Source: Elizabeth P. Glixman, *A White Girl Lynching* (Columbus, OH: Pudding House Publications, 2008)

GLÜCK, Louise, *Descending Figure: 2. The Sick Child*
Gabriel Metsu (Metsy), *The Sick Child*
Source: Louise Glück, *The First Four Books of Poems* (Hopewell, NJ: Ecco Press, 1995), 113

GOES, Albrecht *Landschaft der Selle*
Vincent Van Gogh, *Crows over Cornfield*
Source: Kranz (2B, above), 214

GOLDBERGER, Iefke, *Demon of Shipwrecks*
Eugene Brands, *Demon of Shipwrecks*
Source: *Wisconsin Poets* (1E, above), 46–7

GOLDMAN, Michael, *The Rothko Paintings*
Mark Rothko
Source: *Poetry* 99 (March 1962): 366

GOLDSTEIN, Laurence, *English Drawings and Watercolors, 1550–1850*
Jacques Le Moyne de Morgues, *A Young Daughter of the Picts*
Source: *Poetry* 182 (September 2002): 339–40

GÓNGORA Y ARGOTE, Luis de, *Inschrift für das Grab Dominico Grecos*
El Greco, *Portrait of Fray Felix Hortensio Paravicino*
Source: Kranz (2B, above), 163 (German trans. of the Spanish sonnet)

GOOD, Ruth, *Mountains and Other Outdoor Things*
Harvey Dinnerstein
Source: Buchwald and Roston (2C, above), 46–7

GOODHEART, Jessica, *The Tree of Houses*
Paul Klee, *The House Tree*
Source: *Cider Press Review* 8 (2007): 64

GOODISON, Lorna, *Guernica*
Pablo Picasso, *Guernica*
Source: Lorna Goodison, *Controlling the Silver* (Urbana: University of Illinois Press, 2005), 94–5

Goodison, Lorna, *Cézanne after Émile Zola*
Paul Cézanne, Mont Saint-Victorie paintings
Source: Lorna Goddison, *Travelling Mercies* (Toronto: McClelland and Stewart, 2001), 67

GOODJOHN, Bunny, *To My Mentor*
Gustav Klimt, *Tod und Leben* (*Life and Death*)
Source: *Ekphrasis* 3, no. 2 (Fall–Winter 2003): 19–20

GOODMAN, Paul, *Ballade to Venus*
Rembrandt van Rijn, *Venus and Cupid*
Source: *Art News* 57 (May 1958): 28–9

Goodman, Paul, *Evening*
Rameau and Cézanne
Source: *Poetry* 78 (April 1951): 20–1

GOODWIN, Jude, *Fishing Boats on the Beach at Saintes-Maries-De-La-Mer*
Vincent Van Gogh, *Fishing Boats on the Beach at Saintes-Maries-De-La-Mer*
Source: http://www.guardian.co.uk/books/2006/oct/23/poetry

GORDON, Noah Eli, *Color System*
Joanne Greenbaum, *Color System*
Source: Geha and Nichols (1N, above), 51–4

GOULD, Roberta, *Child Portrait, Rousseau*
Henri Rousseau, *Portrait of a Child*
Source: Roberta Gould, *Only Rock and Other Poems* (New York: Folder Editions, 1985).

Gould, Roberta, *Nuit Enchantee*
Henri Rousseau, *Nuit Enchantee*
Source: Roberta Gould, *Only Rock and Other Poems* (New York: Folder Editions, 1985).

Gould, Roberta, *After Hieronymus Bosch*
Hieronymus Bosh, Unnaned painting
Source: Roberta Gould, *Only Rock and Other Poems* (New York: Folder Editions, 1985).

Gould, Roberta, *Hotel Patzcuatro*
Unnamed painting on a hotel wall
Source: Roberta Gould, *Only Rock and Other Poems* (New York: Folder Editions, 1985).

GRAFTON, Grace Marie. For forty-eight poems about women's paintings, see 4N, above

GRAHAM, Jorie, *Two Paintings by Gustav Klimt*
Gustav Klimt, *Beech Forest* and *Nude*
Source: Jorie Graham, *The Dream of the Unified Field: Selected Poems 1974–1994* (Hopewell, NJ: Ecco Press, 1995), 42–4

Graham, Jorie, *At Luca Signorelli's "Resurrection of the Body"*
Source: Jorie Graham, *The Dream of the Unified Field: Selected Poems 1974–1994* (Hopewell, NJ: Ecco Press, 1995), 45–8

Graham, Jorie, *San Sepolcro*
Piero della Francesca, *Madonna del Parto*
Source: Jorie Graham, *The Dream of the Unified Field: Selected Poems 1974–1994* (Hopewell, NJ: Ecco, 1995), 21–2

Graham, Jorie, *The Field*
Anselm Kiefer, *The Order of the Angels*
Source: Hirsch (1D, above), 126–31

Graham, Jorie, *The Violinist at the Window, 1918*
Henri Matisse, *Le Violoniste à la fenêtre*
Source: *Poetry* 191, no. 6 (March 2008): 475–6

Graham, Jorie, *For Mark Rothko*
Source: Jorie Graham, *Hybrids of Plants and Ghosts* (Princeton, NJ: Princeton University Press, 1980), 36–7

Graham, Jorie, *Pollock and Canvas*
Jackson Pollock
Source: Jorie Graham, *The End of Beauty* (New York: Ecco Press, 1987), 81–9

Graham, Jorie, *Le Manteau de Pascal*
René Magritte, *Pascal's Coat*
Source: Jorie Graham, *The Errancy* (Hopewell, NJ: Ecco Press, 1997), 64–70

Graham, Jorie, *The Break of Day*
Stephen Schultz, poems composed to accompany a series of paintings by Schultz
Source: Jorie Graham, *Materialism* (Hopewell, NJ: Ecco Press, 1993), 113–27

GRAHAM, Taylor, *Desnudo, en la Playa de Portice*
Mariano Fortuny y Marsal, *Desnudo en la Playa de Portice*
Source: *Ekphrasis* **3, no. 1 (Spring–Summer 2003): 6**

Graham, Taylor, *The Picture of Dorian Gray*
Paola Piglia, frontispiece for the Franklin Library
Source: *Ekphrasis* 2, no. 6 (Fall–Winter 2002): 39

Graham, Taylor, *Red Boats, Argenteuil*
Claude Monet, *Red Boats, Argenteuil*
Source: *Ekphrasis* 3, no. 4 (Fall–Winter 2004): 37

Graham, Taylor, *Waterlilies, 1905*
Claude Monet, *Waterlilies*
Source: *Ekphrasis* 3, no. 6 (Fall–Winter 2005): 40

Graham, Taylor, *Fallen Angel #1*
Kimberly Borsuk, *Fallen Angel #1*
Source: *Ekphrasis* 4, no. 1 (Spring–Summer 2006): 24

Graham, Taylor, *The Last Card You Sent*
N.C. Wyeth, *Wreck of the Covenant*
Source: *Ekphrasis* 4, no. 2 (Fall–Winter 2006): 47

Graham, Taylor, *Kringloop: Cycle*
M.C. Escher, *Kringloop Cycle*
Source: *Ekphrasis* 1, no. 1 (Summer 1997): 34

Graham, Taylor, *Composed as Sleep*
Alix Baer, unnamed oil painting
Source: *Ekphrasis* 1, no. 2 (Winter 1997–98): 39

Graham, Taylor, *The March of Humanity*
David Alfaro Siqueiros, *The March of Humanity* (mural)
Source: *Ekphrasis* 1, no. 3 (Spring–Summer 1998): 63

Graham, Taylor, *Lantern Skaters*
Paul Landry, *Lantern Skaters*
Source: *Ekphrasis* 3, no. 5 (Spring–Summer 2005): 13

Graham, Taylor, *Light of the Climb*
Gustave Doré, *Figures by a Woodland Stream*
Source: *Ekphrasis* 4, no. 3 (Spring–Summer 2007): 16

GRAHAM, W.S., *The Thermal Stair*
Peter Lanyon, *Thermal*
Source: W.S. Graham, *The Thermal Stair* (London: Faber and Faber, 1970), 154–7; and Abse (2D, above), 145–6

Graham, W.S., *The Found Picture*
Unidentified Early Italian landscape
Source: W.S. Graham, *The Thermal Stair* (London: Faber and Faber, 1970), 234–5

GRANIER, Mark, *Bruegel's Babel*
Pieter Brueghel the Elder, *The Tower of Babel*
Source: Mark Granier, *Sky Road* (Cliffs of Moher, Co. Clare, Ireland: Salmon Pub. 2007), 23; and https://www.blogger.com/comment.g?blogID=67 40358940867847508&postID=2188430678454 020345.

GRANT, Alex, *The General's Family Portrait*
Giorgio de Chirico, *The Red Tower*
Source: *Ekphrasis* 3, no. 5 (Spring–Summer 2005): 25

Grant, Alex, *Pontius Pilate*
Juan Correa de Vivar, *Pontius Pilate Washing His Hands*
Source: http://www.redroom.com/blog/alex-gvant/ the-drip-feed-virtual-poetry-reading-11-ekphras is-podcast-and-jesus

GRANT, Shane P., *Memories of Nighthawks*
Edward Hopper, *Nighthawks*
Source: http://www.poemhunter.com/poem/memo ries-of-nighthawks/

GRATTONI, Chris, *Hopper*
Edward Hopper, *Nighthawks*
Source: http://www.cen.uiuc.edu/~dennywu/chrisa rt.html

GRAVES, Robert, *Tilly Kettle*
Source: Robert Graves, *Complete Poems*, vol. 1 (Manchester, UK: Carcanet, 1999), 261–2

GRAY, Agnes Kendrick, *After Whistler*
James McNeil Whistler
Source: *Anthology of Magazine Verse for 1921and Yearbook of American Poetry*, ed., William S. Braithwaite (Boston: Small, Maynard, 1921), 62

GRAY, Jason, *St. Cecelia and an Angel*
Orazio Gentileschi and Giovanni Lanfranco, *St. Cecilia and an Angel*
Source: Jason Gray, *How To Paint the Savior Dead* (Kent, OH: Kent State University Press, 2007), 7

Gray, Jason, *Chiaroscuro*
Caravaggio, *The Taking of Christ*
Source: Jason Gray, *How To Paint the Savior Dead* (Kent, OH: Kent State University Press, 2007), 11

Gray, Jason, *You Put Your Right Hand In, You Take Your Left Hand Out*
Michael Volgemut and his school, woodcuts
Source: Jason Gray, *How To Paint the Savior Dead* (Kent, OH: Kent State University Press, 2007), 12

Gray, Jason, *Chagall in Heaven*
Marc Chagall
Source: Jason Gray, *How To Paint the Savior Dead* (Kent, OH: Kent State University Press, 2007), 14

Gray, Jason, *Your Art History* (part iii, *Case Study (The Annunciation by Jan Van Eyck)*
Source: Jason Gray, *How To Paint the Savior Dead* (Kent, OH: Kent State University Press, 2007), 18

GRAZIANO, Frank, *The Potato Eaters*
Vincent Van Gogh, *The Potato Eaters*
Source: *Beliot Poetry Journal* 28 (1978): 10–15

GREEN, Evan, *Vishnu Veal*
Rockwell Kent, Untitled painting
Source: *Elastic Ekphrastic: Poetry on Art/Poets on Tour through Galleries*, ed. Jennifer Bosveld (Johnstown, OH: Pudding House Publications, 2003), 57

GREEN, Paula, *Glenburn*
Michael Hight, *Glenburn*
Source: Paula Green, *Crosswind* (Aukland, NZ: Aukland University Press, 2004), 31

Green, Paula, *Lemon Stack*
Séraphine Pick, *Lemon Stack*
Source: Paula Green, *Crosswind* (Aukland, NZ: Aukland University Press, 2004), 35

Green, Paula, *Epistamologies: 1–91*
John Reynolds, *Epistamologies: 1–91*
Source: Paula Green, *Crosswind* (Aukland, NZ: Aukland University Press, 2004), 37

Green, Paula, *See-See*
Judy Millar, *See-See*
Source: Paula Green, *Crosswind* (Aukland, NZ: Aukland University Press, 2004), 39

Green, Paula, *Intersection*
Elizabeth Rees, *Intersection*
Source: Paula Green, *Crosswind* (Aukland, NZ: Aukland University Press, 2004), 43

Green, Paula, *Aotearoa-Cloud*
Gretchen Albrecht, *Aotearoa-Cloud*
Source: Paula Green, *Crosswind* (Aukland, NZ: Aukland University Press, 2004),

GREEN, Stephanie, *Night Kitchen*
Siani Rhys James, *Night Kitchen*
Source: http://steph.green1.googlepages.com/poemsonpaintingsandart

Green, Stephanie, *The Parrot*
Rembrandt van Rijn, *Portrait of Catrina Hooghsaet*
Source: http://steph.green1.googlepages.com/poemsonpaintingsandart

Green, Stephanie, *Alternative Hats*
Sir Henry Raeburn, *Rev. Robert Walker Skating on Duddingston Loch*
Source: http://steph.green1.googlepages.com/poemsonpaintingsandart

Green, Stephanie, *Still*
Alison Watt, *Still*
Source: http://steph.green1.googlepages.com/poemsonpaintingsandart

GREEN, Timothy, *After Hopper, Nighthawks, 1942*
Source: *The Pedestal Magazine* 36 (October–December 2006). http://www.thepedestalmagazine.com/gallery.php?item=2024

GREENBERG, Jan, *Diamante for Chuck*
Chuck Close, *Self-Portrait*
Source: Greenberg, *Heart* (2J, above), 48–9

GREENWAY, William, *Man Goeth to His Long Home*
Sir Stanley Spencer, *Man Goeth to His Long Home*
Source: William Greenway, *Ascending Order* (Akron: University of Akron Press, 2003), 81–2

Greenway, William, *Michelangelo's Erection*
Michelangelo, the Sistine chapel paintings
Source: William Greenway, *Ascending Order* (Akron: University of Akron Press, 2003), 71

Greenway, William, *Fishing for Souls*
Adriaen Van der Venne, *Fishing for Souls*
Source: *Ekphrasis*, 3, no. 6 (Fall–Winter 2005): 11–12

Greenway, William, *In the National Gallery*
Horace Vernet, *The Battle of Jemappes*
Source: *Ekphrasis* 2, no. 1 (Spring–Summer 2000): 13

Greenway, William, *In Dürer*
Albrecht Dürer, *Praying Hands*
Source: *Ekphrasis* 2, no. 1 (Spring–Summer 2000): 33

Greenway, William, *Underground*
Lily Furedi, *Subway*
Source: *Ekphrasis* 4, no. 6 (Fall–Winter 2008): 41

Greenway, William, *In the Musée d'Orsay*
Paul Cézanne, Vincent Van Gogh, Claude Monet
Source: William Greenway, *Simmer Dim* (Akron, OH: University of Akron Press, 1999), 76–7

Greenway, William, *Pictures at an Exhibition*
Giovanni Battista Tiepolo, Monet, et al.
Source: *Phantasmagoria* 5, no. 2 (2006): 15

Greenway, William, *White Buildings by Water with Steps Going Down*

J.M.W. Turner, *Dido Building Carthage*, Claude Lorrain, *Seaport with the Embarkation of the Queen of Sheba*
Source: *Ekphrasis* 2, no. 5 (Spring–Summer 2002), and at http://www.cstone.net/~poems/whitegre.htm

GREGER, Debra, *The Man on the Bed*
Edward Hopper, *Excursion into Philosophy*
Source: Levin (3J, above), 69

Greger, Debora, *In Violet*
Unidentified painting of the Virgin Mary
Source: *The Best American Poetry 1989*, ed. Donald Hall (New York: Charles Scribner's Sons, 1989), 65

Greger, Debora, *Zephirium apochripholiae (Windwort)*
Dorothea Tanning, *Zephirium apochripholiae (Windwort)*
Source: Dorothea Tanning, *Another Language of Flowers* (New York: Braziller, 1998), plate 4

Greger, Debora, *Portraits: Self and Other: I. Rembrandt by Himself*
Rembrandt van Rijn, *Self-Portrait in Oriental Dress*
Source: Debora Greger, *Western Art* (New York: Penguin, 2004), 10

Greger, Debora, *Portraits: Self and Other: II. Artist Unknown*
Portrait miniatures
Source: Debora Greger, *Western Art* (New York: Penguin, 2004), 11

Greger, Debora, *Portraits: Self and Other: III. Gainsborough by Himself*
Thomas Gainsborough, *Self-Portrait*
Source: Debora Greger, *Western Art* (New York: Penguin, 2004), 12

Greger, Debora, *Portraits: Self and Other: IV. Self-Portrait with Bittern*
Rembrandt van Rijn, *Self-Portrait with a Dead Bittern*
Source: Debora Greger, *Western Art* (New York: Penguin, 2004), 13

Greger, Debora, *The Mosaic of Creation*
Three scenes from the mosaics of San Marco, Venice: the first and third days of Creation and Adam and Eve
Source: Debora Greger, *Western Art* (New York: Penguin, 2004), 29–31

Greger, Debora, *The Night Wedding*
Paolo Veronese, painting in the Accademia, Venice
Source: Debora Greger, *Western Art* (New York: Penguin, 2004), 37

Greger, Debora, *Musée des Beaux Arts. I. The Art of Painting*

Jan Vermeer, *The Allegory of Painting*
Source: Debora Greger, *Western Art* (New York: Penguin, 2004), 100–1

GREGERSON, Linda, *Bleedthrough*
Helen Frankenthaler, *Sunset Corner*
Source: Tillinghast (1F, above), 64–8

GREGG, Linda, *Official Love Story*
Lucas Cranach, *Nymph of the Spring*
Source: *Chosen by the Lion* (St. Paul, MN: Graywolf Press, 1994), 8–9

GREGORY, Horace, *Venus and the Lute Player*
Titian, *Venus and the Lute Player*
Source: Horace Gregory, *Collected Poems* (New York: Holt, 1964), 116

Gregory, Horace, *Three Allegories of Bellini*
Giovanni Bellini, *Allegory of Prudence*, *Allegory of Inconstancy*, and *Allegory of Purgatory*
Source: Horace Gregory, *Collected Poems* (Henry Holt and Co., 1964), 204–9

GRENNAN, Eamon. *Wildflowers in a Glass of Water*
Luca Signorelli, *Pala di Sant'Onofrio*
Source: Eamon Grennan, *Matter of Fact* (St. Paul, MN: Greywolf Press, 2008), 83–4

Grennan, Eamon, *To gauge the scatter of reflected light Bonnard pinned silver candy-wrappers*
Pierre Bonnard, *Studio with Mimosa*; *Almond Tree in Bloom*; and images from other paintings
Source: Eamon Grennan, *The Quick of It* (St. Paul, MN: Greywolf Press, 2005), 33

Grennan, Eamon, *By leaving always a single stem and a leaf on one Seville orange*
Jean-Baptiste Chardin, *A Green-Neck Duck with a Seville Orange* and images from another painting
Source: Eamon Grennan, *The Quick of It* (St. Paul, MN: Greywolf Press, 2005), 41; orig. pub. as *A Leaf from Chardin* in *Hudson Review* 57, no. 1 (Spring 2004): 99

Grennan, Eamon, *Because I'm seeing it from behind the fine mesh of a window-screen, the tree*
Jean Baptiste-Camille Corot, images from various paintings
Source: Eamon Grennan, *The Quick of It* (St. Paul, MN: Greywolf Press, 2005), 55

Grennan, Eamon, *"All his life," we're told, "Chardin struggled to overcome his lack of natural talent"*
Jean-Baptiste Chardin, images from *The Olive Jar*; *Wild Rabbit with Game Bag and Powder Flask, Partridge, Bowl of Plums, and Basket of Pears*; and *A Green-Neck Duck with a Seville Orange*
Source: Eamon Grennan, *The Quick of It* (St. Paul, MN: Greywolf Press, 2005), 69

Grennan, Eamon, *Woman Holding a Balance*
Jan Vermeer, *Woman Holding a Balance*

Source: Eamon Grennan, *As If It Matters* (St. Paul, MN: Greywolf Press, 1992), 61–4

Grennan, Eamon, *Cavalier and Smiling Girl*
Jan Vermeer, *Officer and Laughing Girl*
Source: Eamon Grennan, *Relations: New and Selected Poems* (St. Paul: Greywolf Press, 1998), 24

Grennan, Eamon, *Vermeer, My Mother, and Me*
Jan Vermeer, *The Little Street*
Source: Eamon Grennan, *Still Life With Waterfall* (St. Paul: Greywolf Press, 2002), 39–40

Grennan, Eamon, *Woman with Pearl Necklace*
Jan Vermeer, *Woman with a Pearl Necklace*
Source: Eamon Grennan, *Relations: New and Selected Poems* (St. Paul: Greywolf Press, 1998), 191

Grennan, Eamon, *The Cave Painters*
Unidentified artists and cave paintings
Source: Eamon Grennan, *Relations: New and Selected Poems* (St. Paul: Greywolf Press, 1998), 101–2

Grennan, Eamon, *Levitations*
Marc Chagall, images from *Half Past Three (The Poet)* and other works
Source: Eamon Grennan, *Relations: New and Selected Poems* (St. Paul: Greywolf Press, 1998), 216–17

Grennan, Eamon, *Work of Art*
Jan Vermeer, *View of Delft*
Source: *Lumina* 7 (2008). http://www.poetrydaily.org/poem.php?date=14233

GREY, John, *"Old Women of Arles" by Gauguin*
Source: *Ekphrasis* 4, no. 5 (Spring–Summer 2008): 8

Grey, John, *"Dance" by Matisse*
Source: *Ekphrasis*, 1, no. 1 (Summer 1997): 45

Grey, John, *Le luxe/by Matisse*
Source: *Ekphrasis* 1, no. 5 (Spring–Summer 1999): 26

Grey, John, *"St. Jerome in the Desert" by Lorenzo Lotto*
Source: *Ekphrasis* 5, no. 1 (Spring–Summer 2009): 18

GRIGSON, Geoffrey, *As Dufy Points*
Raoul Dufy
Source: *Poetry* 121 (December 1972): 132

GRILIKHES, Alexandra, *Melancholia*
Dürer, *Melancholia*
Source: *College Art Journal* 19 (Summer 1960): 330

GRIMES, Ivy, *Audubon—Engraved, Printed, Colored*
John James Audubon, *Blue-Green Warbler*
Source: *Beauty/Truth: A Journal of Ekphrastic Poetry* 1, no. 3 (Fall–Winter 2007): 12

GRITZ, Ona, *Girl with a Pearl Earring*
Jan Vermeer, *Girl with a Pearl Earring*
Source: *Ekphrasis* 3, no. 4 (Fall–Winter 2004): 33

Gritz, Ona, *The Broken Pitcher*
William Bouguereau, *The Broken Pitcher*
Source: *Ekphrasis* 3, no. 5 (Spring–Summer 2005): 26

Gritz, Ona, *Flaming June*
Frederic Leighton, *Flaming June*
Source: *Ekphrasis* 3, no. 3 (Spring–Summer 2004): 11

Gritz, Ona, *Holding Still*
Burton Silverman, *Summer of '82*
Source: *Ekphrasis* 3, no. 5 (Spring–Summer 2005): 29

Gritz, Ona, *Grace*
Ann Callandro, *Shadows*
Source: *Tattoo Highway* 15. http://www.tattoohighway.org/15/ogcontest.html

GROARKE, Vona, *En Plein Air*
Roderic O'Conor, *Field of Corn, Pont Aven*
Source: Reid and Rice (1J, above), 58–9

GROCHOWIAK, Stanislaw, *Ikar*
Pieter Brueghel the Elder, *Landscape with the Fall of Icarus*
Source: Rysard Matuszewski, ed., *Wiersze polskich Poetów wspólczesnych* (Warszawa, 1984)

GUERIN, Christopher, *The Night Café*
Vincent Van Gogh, *The Night Café*
Source: http://www.belvidere.net/christopher/

Guerin, Christopher, *Balthus' "La Patience"*
Source: http://www.belvidere.net/christopher/

Guerin, Christopher, *On Buson's Portrait of Basho*
Source: http://www.belvidere.net/christopher/

Guerin, Christopher, *The Scream*
Edvard Munch, *The Scream*
Source: http://www.belvidere.net/christopher/

Guerin, Christopher, *The Last Painting*
Vincent Van Gogh, *Wheat Field with Crows*
Source: http://www.belvidere.net/christopher/

Guerin, Christopher, *Mystery*
Piet Mondrian, *Rose in a Tumbler*
Source: http://www.belvidere.net/christopher/

Guerin, Christopher, *Rose in a Tumbler*
Piet Mondrian, *Rose in a Tumbler*
Source: http://www.belvidere.net/christopher/

Guerin, Christopher, *St. Jerome*
Jan Van Eyck, *St. Jerome in His Study*
Source: http://www.belvidere.net/christopher/

Guerin, Christopher, *Dulle Griet*
Pieter Brueghel the Elder, *Mad Meg* (detail)
Source: http://www.belvidere.net/christopher/

Guerin, Christopher, *Madame X*
John Singer Sargent, *Portrait of Madame X*
Source: http://www.belvidere.net/christopher/

Guerin, Christopher, *The Bewitched Groom*
Hans Baldung Grien, *The Bewitched Groom*
Source: http://www.belvidere.net/christopher/

Guerin, Christopher, *Being With*
Matta (Roberto Matta Echaurren), *Être Avec*
Source: http://www.belvidere.net/christopher/

Guerin, Christopher, *The Undone Thing*
Ernst, Max. *Approaching Puberty or The Pleiads*
Source: http://www.belvidere.net/christopher/

GUEST, Barbara, *Four Moroccan Studies*
Eugène Delacroix, Moroccan studies
Source: Barbara Guest, *The Blue Stairs* (New York:
 Corinth, 1968), 34–5

Guest, Barbara, *Latitudes (The Art of Fay Lansner)*
Fay Lansner, *Women in Space*, panel III, 1978–79
Source: Vanderlip (1A, above), 50

Guest, Barbara, *Blue Endings*
Robert Fabian, Untitled, 1979
Source: Vanderlip (1A, above), 52

Guest, Barbara, *The Poetess*
Joan Miró, *La Poetesse*
Source: Barbara Guest, *Selected Poems* (Los Angeles:
 Sun and Moon Press, 1995), 78

Guest, Barbara, *The View from Kandinsky's Window*
Wassily Kandinsky
Source: Barbara Guest, *The Collected Poems of Bar-
 bara Guest, ed. Hadley Haden Guest* (Middle-
 town, CT: Wesleyan University Press, 2008),
 212–13

Guest, Barbara, *Dora Maar*
Pablo Picasso, *Dora Maar*
Source: Barbara Guest, *The Collected Poems of Bar-
 bara Guest, ed. Hadley Haden Guest* (Middle-
 town, CT: Wesleyan University Press, 2008),
 218–21

Guest, Barbara, *Constable's Method, Brightening
 Near the Bridge*
John Constable
Source: Barbara Guest, *The Collected Poems of Bar-
 bara Guest, ed. Hadley Haden Guest* (Middletown,
 CT: Wesleyan University Press, 2008), 512–13

GUEVARA, Maurice Kilwein, *Make-up*
Frida Kahlo
Source: Maurice Kilwein Guevara, *Poems of the
 River Spirit* (Pittsburgh, PA: University of Pitts-
 burgh Press, 1996), 43

GULLANS, Charles, *Poussin: The Chrysler "Baccha-
 nal before a Temple"*
Nicolas Poussin, *Bacchanal before a Temple*
Source: *Southern Review* 2, n.s. (April 1966): 354–5

GULOTTA, Nicole, *Compass*
Auguste Renoir, *The Wave*
Source: *Ekphrasis* 5, no. 1 (Spring–Summer 2009): 8

GUNN, Thom, *In Santa Maria del Popolo*
Caravaggio, *The Conversion of St. Paul*
Source: Abse (2D, above), 48; and Gunn's *Col-
 lected Poems* (London: Faber and Faber, 1994),
 93–4

Gunn, Thom, *Phaedra in the Farm House*
Edward Hopper
Source: Lyons and Weinberg (3Ja, above), 59–60

Gunn, Thom, *Before the Carnival: A Painting by
 Carl Timner (1957)*
Source: Thom Gunn, *Collected Poems* (London:
 Faber and Faber, 1994), 44–5

Gunn, Thom, *Thomas Bewick*
Source: Thom Gunn, *Collected Poems* (London:
 Faber and Faber, 1994), 258–9

GUTTELING, Alex, *Botticelli: Primavera*
Sandro Botticelli, *La Primavera*
Source: Kranz (2B, above), 119

GUZEL, Bogomil, *Homer*
Vlado Georgievski, watercolor
Source: Martinovski (2K, above), 121

GUZMAN, Dena Rash, *Stasis*
Lowell Fox, *Cenote*
Source: http://lowellfox.com/page5-contributingp
 oets/index.htm#cenote

Guzman, Dena Rash, *On the gray, on the boat at the
 end of the dock*
Lowell Fox, *Rain on the Lagoon*
Source: http://lowellfox.com/page5-contributingpo
 ets/index.htm#rainonlagoon

Guzman, Dena Rash, *We Three*
Lowell Fox, *January Beach*
Source: http://lowellfox.com/page5-contributingp
 oets/index.htm#januarybeach

Guzman, Dena Rash, *Break Time*
Lowell Fox, *Studio Break*
Source: http://lowellfox.com/page5-contributingpo
 ets/index.htm#studio_break

Guzman, Dena Rash, *Dusk under the Marquee*
Lowell Fox, *1929 Plaza Theatre* (detail)
Source: http://lowellfox.com/page5-contributingpo
 ets/index.htm#plazatheatre1929

GWYNN, R.S., *The Garden Pastoral*
Frederick Carl Frieseke, *The Garden Parasol*
Source: Paschal (1G, above), 88–9

HACKER, Marilyn, *Partial Analysis*
Giovanni di Paolo, *Giudizio Universale*
Source: Marilyn Hacker, *Selected Poems 1965–1990*
 (New York: Norton, 1994), 110

HADAS, Rachel, *Mars and Venus*
Sandro Botticelli, *Mars and Venus*
Source: Hollander (21, above), 335–6

HAGY, Alyson, *The Nymph of the Lo River*
Fei Tan-Hsü, *The Nymph of the Lo River*
Source: Tillinghast (1F, above), 20–1

HAINES, John, *Dürer's Vision*
Albrecht Dürer
Source: John Haines, *The Owl in the Mask of the Dreamer: Collected Poems*, paperback ed. (Minneapolis: Graywolf Press, 1996), 73

Haines, John, *The Middle Ages*
Albrecht Dürer, *The Knight, Death, and the Devil*
Source: John Haines, *The Owl in the Mask of the Dreamer: Collected Poems*, paperback ed. (Minneapolis: Graywolf Press, 1996), 74–5

Haines, John, *Ryder*
Albert Pinkham Ryder, *Jonah*
Source: John Haines, *The Owl in the Mask of the Dreamer: Collected* Poem, paperback ed. (Minneapolis: Graywolf Press, 1996), 88

Haines, John, *Paul Klee*
Paul Klee, Images drawn from Klee's *Salon Tunisien* and other paintings
Source: John Haines, *The Owl in the Mask of the Dreamer: Collected Poems*, paperback ed. (Minneapolis: Graywolf Press, 1996), 88–9

Haines, John, *Death and the Miser*
Hieronymus Bosch, *Death and the Miser*
Source: John Haines, *The Owl in the Mask of the Dreamer: Collected Poems*, paperback ed. (Minneapolis: Graywolf Press, 1996), 196–202

Haines, John, *In the Sleep of Reason*
Francisco Goya, *The Sleep of Reason Brings Forth Monsters*
Source: John Haines, *The Owl in the Mask of the Dreamer: Collected Poems*, paperback ed. (Minneapolis: Graywolf Press, 1996), 240–2

Haines, John, *Days of Edward Hopper*
Edward Hopper, images from a number of Hopper's paintings
Source: John Haines, *The Owl in the Mask of the Dreamer: Collected Poems*, paperback ed. (Minneapolis: Graywolf Press, 1963), 202–8

Haines, John, *Nighthawks*
Edward Hopper, *Nighthawks*
Source: John Haines, *The Owl in the Mask of the Dreamer: Collected Poems*, paperback ed. (Minneapolis: Graywolf Press, 1996), 208–9

Haines, John, *The Fates*
Francisco Goya, one of the *Los Disparates* etchings
Source: John Haines, *The Owl in the Mask of the Dreamer: Collected Poems*, paperback ed. (Minneapolis: Graywolf Press, 1996), 246–7

Haines, John, *The Glutton* and *Tondo of Hell*
Hieronymus Bosch, *The Seven Deadly Sins*
Source: John Haines, *The Owl in the Mask of the Dreamer: Collected Poems*, paperback ed. (Minneapolis: Graywolf Press, 1996), 248–50

Haines, John, *The Night That Ryder Knew*
Marsden Hartley, paintings of the Maine seacoast
Source: John Haines, *The Owl in the Mask of the Dreamer: Collected Poems*, paperback ed. (Minneapolis: Graywolf Press, 1996), 250–1

Haines, John, *Diminishing Credo*
Eugène Delacroix
Source: John Haines, *The Owl in the Mask of the Dreamer: Collected Poems*, paperback ed. (Minneapolis: Graywolf Press, 1996), 254–5

Haines, John, *Stalled Colossus*
Francisco Goya, Goya's "Black" paintings and *The Disasters of War* etchings
Source: John Haines, *The Owl in the Mask of the Dreamer: Collected Poems*, paperback ed. (Minneapolis: Graywolf Press, 1996), 259–62

Note: Some of the poems by Haines just listed are not included in the hardcover edition of *The Owl in the Mask of the Dreamer* (St. Paul, MN: Graywolf, 1993).

HAISLIP, John, *Man in the Blue Box*
Francis Bacon, *Man in a Blue Box*
Source: John Haislip, *Not Every Year* (Seattle: University of Washington Press, 1971), 40

HALITI, Sadije, *Mona Lisa*
Source: Martinovski (2K, above), 101

HALL, Donald, *The Scream*
Edvard Munch, *The Scream*
Source: Hollander (2I, above), 285–6

Hall, Donald, *The Kiss*
Edvard Munch, *The Kiss*
Source: Donald Hall, *White Apples and the Taste of Stone: Selected Poems 1946–2006* (New York: Houghton Mifflin, 2006), 21–2

Hall, Donald, *Marat's Death*
Edvard Munch, *The Death of Marat*
Source: Donald Hall, *White Apples and the Taste of Stone: Selected Poems 1946–2006* (New York: Houghton Mifflin, 2006), 20–1

Hall, Donald, *"Between the Clock and the Bed"*
Edvard Munch, *Between the Clock and the Bed*
Source: Donald Hall, *White Apples and the Taste of Stone: Selected Poems 1946–2006* (New York: Houghton Mifflin, 2006), 22

Hall, Donald, *The Thirteenth Inning*
John Singer Sargent, *The Daughters of Edward D. Boit*
Source: Donald Hall, *The Old Life* (Boston: Houghton Mifflin, 1996), 15–24

HALLECK, Fitz-Greene, *Red Jacket*
Robert W. Weir, *Red Jacket*
Source: *Werner's Readings and Recitations*, No. 10 (New York: Edgar S. Werner and Co., 1892), 151–3

HALPERN, Daniel, *Walking in the 15th Century*
Piero della Francesca, *Madonna del Parto*
Source: Daniel Halpern, *Selected Poems* (New York: Knopf, 1994), 168–9

Halpern, Daniel, *Nude*
Jean-Antoine Watteau, pencil sketch of sleeping nude
Source: Daniel Halpern, *Selected Poems* (New York: Knopf, 1994), 168–9

HAMBURGER, Michael, *Lines on Brueghel's "Icarus"*
Pieter Brueghel the Elder, *Landscape with the Fall of Icarus*
Source: Michael Hamburger, *Collected Poems, 1941–1994* (London: Anvil Press, 1995); Kranz (2B, above), 82; and Achim Aurnhammer and Dieter Martin, eds., *Mythos Ikarus* (Leipzig: Reclam Bibliothek, 1998), 200–1, German trans. 201

Hamburger, Michael, *A Painter Painted*
Lucian Freud, *Francis Bacon*
Source: Abse (2D, above), 128, and Adams (1B, above), 122–3

HAMELINK, Jacques, *Hercules Seghers*
Hercules Seghers, *Rocky Landscape with Stroller*
Source: Korteweg and Heijn (2F, above), 112

HAMILTON, David, *After Claes Oldenburg*
Claes Oldenburg, *Crusoe Umbrella*
Source: *Ekphrasis* 2, no. 4 (Fall–Winter 2001): 37

HAMILTON, Marion Ethel, *Gauguin*
Paul Gauguin
Source: *The Music Makers: An Anthology of Recent American Poetry*, ed., Stanton A. Coblentz (New York: Bernard Ackeman, 1945), 89

HAMILTON, Saskia, *Bruges*
Unnamed paintings about St. Anthony and St. Jerome
Source: Saskia Hamilton, *As for Dream Z* (St. Paul, MN: Graywolf Press, 2001), 57

HAMILL, Sam, *In Memoriam, Morris Graves*
Morris Graves
Source: Sam Hamill, *Almost Paradise: New and Selected Poems and Translations* (Boston: Shambhala, 2005), 197–8

HAMPL, Patricia, *Woman Before an Aquarium*
Henri Matisse, *Woman before an Aquarium*
Source: Patricia Hampl, *Woman before an Aquarium* (Pittsburgh: University of Pittsburgh Press, 1978), 19–20; and Hirsch (1D, above), 46–7

Hampl, Patricia, *"The Letter": Mary Cassatt's Aquatint*
Mary Cassatt, *The Letter*
Source: Patricia Hampl, *Woman before an Aquarium* (Pittsburgh: University of Pittsburgh Press, 1978), 18

Hampl, Patricia, *Jan Brueghel's Bouquet*
Jan Brueghel the Elder, *Bouquet*
Source: Patricia Hampl, *Woman before an Aquarium* (Pittsburgh: University of Pittsburgh Press, 1978), 23–4

HARDIE, Kerry, *Spaced Shapes in a Space of Sand*
William Scott, *Egypt Series No. 3*
Source: Reid and Rice (1J, above), 118–19

HARDING, Gunnar, *The Doppelgangers*
Dante Gabriel Rossetti, *How They Met Themselves*
Source: Greenberg, *Side* (2M, above), 20–1

HARJO, Joy, *Naming, Or, There is no such thing as an Indian*
Jaune Quick-to-See Smith, *Indian, Indio, Indigenous*
Source: Greenberg, *Heart* (2J, above), 35

HARMON, William, *Riddle*
Richard Diebenkorn, *Berkeley No. 8*
Source: Paschal (1G, above), 110–11

HARPER, Misty, *There is Discrepancy Whether "Puberty"*
Edvard Munch, *Puberty*
Source: *Prairie Schooner* 79, no. 4 (Winter 2005): 43

HARPUR, James, *A Reproduction of Constable's "Salisbury Cathedral" in a Room on a Greek Island*
John Constable, *Salisbury Cathedral; from the Bishop's Grounds*
Source: Abse (2D, above), 84–5

HARRAH, Camille, *This Was the Most Interesting Painting I Could Find*
Frank Tuchfarber, *The Old Violin*
Source: Janovy (1O, above), 37

HARRIS, Reginald, *The Knockout*
Joseph Sheppherd
Source: *Beltway Poetry Quarterly* 10, no. 1 (Winter 2009). http://washingtonart.com/beltway/contents.html

HARRISON, David, *It's Me*
Andy Warhol, *Marilyn Diptych*
Source: Greenberg, *Heart* (2J, above), 33

HARRISON, Douglas R., *Milk*
Lowell Fox, *Two*
Source: http://lowellfox.com/page5-contributing poets/index.htm#two0

HARRISON, Gregory, *Child with Dove*
Pablo Picasso, *Child With Dove*

Source: Benton and Benton, *Picture Poems* (2H, above), 41

HARRISON, Tony, *John James Audubon (1785–1861)*
Source: Tony Harrison, *Selected Poems* (London: Penguin, 1987), 182

Harrison, Tony, *The Ballad of Babelabour*
Francisco Goya, *A Dog Buried in the Sand*
Source: Tony Harrison, *Selected Poems* (London: Penguin, 1987), 102–3

HARROD, Lois Marie, *Seated Couple*
Egon Schiele, *Seated Couple*
Source: *Ekphrasis* 2 (Fall–Winter 2000): 27

Harrod, Lois Marie, *Magritte's "The Hunters at the Edge of Night"*
Source: *Ekphrasis* 2, no. 4 (Fall–Winter 2001): 24

Harrod, Lois Marie, *Untitled Painting*
Dorothy Dehner, *Untitled*
Source: *Ekphrasis* 3, no. 3 (Spring–Summer 2004): 9

Harrod, Lois Marie, *Why I Work without a Model*
Alan Evan Feltus
Source: *Ekphrasis* 4, no. 3 (Spring–Summer 2007): 18

Harrod, Lois Marie, *One More Annunciation*
Master of Flémalle, *Annunciation*, central panel, Mérode Altarpiece
Source: *Ekphrasis* 4, no. 6 (Fall–Winter 2008): 16–17

HARSENT, David, *Bonnard: Breakfast*
Pierre Bonnard
Source: David Harsent, *Mr. Punch* (Oxford: Oxford University Press, 1984), 30–1

Harsent, David, *Ensor: Masks Confronting Death*
James Ensor
Source: David Harsent, *Mr. Punch* (Oxford: Oxford University Press, 1984), 29

Harsent, David, *Rouault: A Portrait*
Georges Rouault
Source: David Harsent, *Mr. Punch* (Oxford: Oxford University Press, 1984), 24

Harsent, David, *Schiele: Standing Self-Portrait*
Egon Schiele
Source: David Harsent, *Mr. Punch* (Oxford: Oxford University Press, 1984), 27–8

HARTER, Penny, *These Elk*
Diana Thater, *Pape's Pumpkin*
Source: *Ekphrasis* 1, no. 3 (Spring–Summer 1998): 28

HARTLEY, Marsden, *Eagle of the Inner Eye*
Morris Graves's paintings in general
Source: *Selected Poems* (New York: Viking, 1945), 112; and Ray Kass, *Morris Graves: Vision of the Inner Eye* (New York: George Braziller, 1983) 18

Hartley, Marsden, *Perhaps Macabre (to Georgia O'Keeffe)*

Georgia O'Keeffe, *Cow's Skull, Red, White, and Blue*
Source: Marsden Hartley, *Selected Poems* (New York: Viking, 1945), 94–5

Hartley, Marsden, *Modigliani's Death Mask*
Amedeo Modigliani
Source: Marsden Hartley, *Selected Poems*, ed., Henry W. Wells (New York: Viking, 1945), 33–4

Hartley's poems on his own paintings:
　　There Is an Island [*Camden Hills from Baker's Island*] [in Hartley, *Selected Poems* (New York: Viking, 1945), 18]
　　Plover [*Dead Plover*] [ibid., 35]
　　Fisherman's Last Supper [*Fisherman's Last Supper*] [ibid., 30]
　　The Portrait of a Sea Dove, Dead [*Gull*] [ibid., 34–5]
　　Islands in Penobscot Bay [*Islands in Penobscot Bay*] [ibid., 5–7]
　　Albert Ryder — Moonlightist [*Portrait of Albert Pinkham Ryder*] [ibid., 111]
　　Robin Hood Cove, Georgetown, Maine [*Robin Hood Cove, Georgetown, Maine*] [ibid., 19–20]
　　Three Friends (Outline for a Picture) [*Three Friends*] [ibid., 98–9]
　　American Icon — Lincoln [*Weary of the Truth*] [ibid., 46–7]
　　T.S. Eliot. "Ash-Wednesday" [*In the Moraine, Dogtown Common, Cape Ann, 1931*] [inscribed by Hartley on the back of this painting]
　　Untitled fifteen-line poem beginning, "In the Beau Shop"] [*Landscape No. 15*] [inscribed in Hartley's hand on the back of the panel]
　　October Dying [*Landscape No. 16*] [written in Hartley's hand on the back of the painting; see Elizabeth McCausland, *Marsden Hartley* (Minneapolis: University of Minnesota Press, 1952), 14–15]

HARTWICH, Jacqueline, *Go in Where the Surface Pulls*
Marianne Perkins, *Vantage Landscape*
Source: *Ekphrasis* 2 (Fall–Winter 2000): 39

HARVEY, Gayle Elen, *Rooms by the Sea, 1951 (Edward Hopper —)*
Source: *Sow's Ear Poetry Review* 10 (February 2001): 25

Harvey, Gayle Elen, *Magdalene at the Cross*
Renato Guttuso, *The Crucifixion*
Source: *Ekphrasis* 4, no. 5 (Spring–Summer 2008): 32–3

Harvey, Gayle Elen, *Vampire Kissing Fallen Angel #2*
Fritz Scholder, *Vampire Kissing Fallen Angel #2*

Source: *Ekphrasis* 4, no. 5 (Spring–Summer 2008): 38

Harvey, Gayle Elen, *"Study for Homage to the Square" (Joseph Albers—1972)*
Source: *Ekphrasis* 3, no. 2 (Fall–Winter 2003): 8

Harvey, Gayle Elen, *"Ocean Park—109" (Richard Diebenkorn—)*
Source: *Ekphrasis* 3, no. 2 (Fall–Winter 2003): 11–12

Harvey, Gayle Elen, *"Woman, Bird, Stars"*
Joan Miró, *Dona, Ocell, Estels* (*Woman, Bird, Stars*)
Source: *Ekphrasis* 3, no. 4 (Fall–Winter 2004): 6

Harvey, Gayle Elen, *"Bride's Door"*
Helen Frankenthaler, *Bride's Door*
Source: *Ekphrasis* 3, no. 4 (Fall–Winter 2004): 30

Harvey, Gayle Elen, *Still Life with Weather and Crow*
Unidentified painting
Source: *Ekphrasis* 1, no. 2 (Winter 1997–1998): 32

Harvey, Gayle Ellen, *Still Life with Oranges*
Francisco de Zurbarán, *Still Life with Oranges and Lemons*
Source: *Ekphrasis* 1, no. 4 (Fall–Winter 1998): 22

Harvey, Gayle Ellen, *Black-Bird with Snow-Covered Red Hills*
Georgia O'Keeffe, *A Black Bird with Snow-Covered Red Hills*
Source: *Ekphrasis* 1, no. 4 (Fall–Winter 1998): 23

Harvey, Gayle Elen, *Charred Beloved I*
Ashile Gorky, *Charred Beloved I*
Source: *Ekphrasis* 5, no. 2 (Fall–Winter 2009): 6

Harvey, Gayle Elen, *Fugue in Two Colors*
Frantisek Kupka, *Fugue in Two Colors*
Source: *Ekphrasis* 5, no. 2 (Fall–Winter 2009): 16

Harvey, Gayle Elen, *Orchideae Grege*
Georgia O'Keeffe, *An Orchid*
Source: *Ekphrasis* 5, no. 2 (Fall–Winter 2009): 17

Harvey, Gayle Elen, *Wheatfield with Thunderclouds*
Vincent Van Gogh, *Wheatfield with Thunderclouds*
Source: *Ekphrasis* 5, no. 2 (Fall–Winter 2009): 15

HARVEY, Heather, *Narcissus—a sonnet*
Salvador Dali, *Metamorphosis of Narcissus*
Source: Benton and Benton, *Picture Poems* (2H, above), 16

Harvey, Heather, *Fin d'Arabesque*
Edgar Degas, *Fin d'Arabesque*
Source: Benton and Benton, *Picture Poems* (2H, above), 18–19

Harvey, Heather, *Drawing Hands—a Pantoum*
M.C. Escher, *Drawing Hands*
Source: Benton and Benton, *Picture Poems* (2H, above), 24

Harvey, Heather, *A Round—with Colours*
Wassily Kandinsky, *Swinging*

Source: Benton and Benton, *Picture Poems* (2H, above), 34–5

Harvey, Heather, *Time Transfixed*
René Magritte, *Time Transfixed*
Source: Benton and Benton, *Picture Poems* (2H, above), 36–7

Harvey, Heather, *Miss Cicely Alexander*
James Abbott McNeill Whistler, *Miss Cicely Alexander: Harmony in Gray and Green*
Source: Benton and Benton, *Picture Poems* (2H, above), 52–3

Harvey, Heather, *The Badminton Game*
David Inshaw, *The Badminton Game*
Source: Benton and Benton, *Painting with Words* (2G, above), 38–9

HARVEY, Matthea, *Self Portraits (After Paintings by Max Beckmann)*
Max Beckman, *Double Portrait, Carnival, 1925*; *Self-Portrait in Tuxedo, 1927*; *Self-Portrait with Glass Ball, 1936*; *Self-Portrait Yellow-Pink, 1943*; *Self-Portrait with Blue-Black Gloves, 1948*; *Self-Portrait in Blue Jacket, 1950*
Source: Matthea Harvey, *Pity the Bathtub Its Forced Embrace of the Human Form* (Farmington, ME: Alice James Books, 2000), 9–11

HASS, Robert, *Art and Life*
Jan Vermeer, *Woman Pouring Milk*
Source: Robert Hass, *Time and Materials* (New York: Ecco, 2007), 27–30

Hass, Robert, *Time and Materials*
Gerhard Richter, *Abstrakt Bilden*
Source: Robert Hass, *Time and Materials* (New York: Ecco, 2007), 24–6

Hass, Robert, *Czeslaw Milosz: In Memoriam*
Gustav Klimt, *Judith I*; Salvator Rosa, *A Landscape with Figures*; and Edward Hopper, *A Hotel Room*
Source: Robert Hass, *Time and Materials* (New York: Ecco, 2007), 38–40

Hass, Robert, *Against Botticelli*
Sandro Botticelli, *Primavera;* Hieronymus Bosch; Francisco Goya
Source: Robert Hass, *Praise* (New York: Ecco Press, 1979), 10–12

Hass, Robert, *Not Going to New York: A Letter*
Pierre Bonnard
Source: Robert Hass, *Praise* (New York: Ecco Press, 1979), 43–6

HAWINKELS, Pé H.H, *De val van Icarus*
Pieter Brueghel the Elder, *Landscape with the Fall of Icarus*
Source: Pé Hawinkels, *Bosch & Bruegel* (Utrecht: Ambo, 1968), 75–6

Hawinkels, Pé H.H., *Jheronymus Bosch* [a poem of some two thousand lines]
Hieronymus Bosch, *The Garden of Earthly Delights* and other paintings
Source: *Raam* 39 (1969): 1–61

Hawinkels, Pé H.H., *"De bruiloft van Kana"*
Hieronymus Bosch, *The Marriage Feast at Cana*
Source: Korteweg and Heijn (2F, above), 68

Hawinkels, Pé H.H., *"De thuiskomst van de jagers"*
Pieter Brueghel the Elder, *Hunters in the Snow*
Source: Korteweg and Heijn (2F, above), 88

Hawinkels, Pé, *"De korenoogst"*
Pieter Brueghel the Elder, *The Corn Harvest*
Source: Korteweg and Heijn (2F, above), 96

HAYDEN, Robert, *Monet's "Water Lilies"*
Source: Robert Hayden, *Words in the Mourning Time* (New York: October House), 1970), 55; rpt. in Hirsch (1D, above), 18–19

HAYES, Jana, *Gas*
Edward Hopper, *Gas*
Source: *Ekphrasis* 1, no. 3 (Spring–Summer 1998): 60–1

HAYNA, Lois Beebe, *"Red Poppy" Georgia O'Keeffe*
Source: *Ekphrasis* 1, no. 2 (Winter 1997–1998): 19

HAYS, H.R., *Douanier Rousseau* [Henri Rousseau] and *Paul Gauguin*
Source: H.R. Hays, *Selected Poems, 1933–67* (San Francisco: City Lights, 1968), 22, 23

Hays, H.R. *A Painter Commits Suicide: for Mark Rothko*
Source: H.R. Hays, *Inside My Own Skin: Poems 1968–71* (Santa Cruz, CA: Kayak Books, 1975), 47

Hays, H.R., *W.J. Hays, Artist*
Source: H.R. Hays, *Selected Poems, 1933–67* (San Francisco: City Lights, 1968), 55

HAZELTON, Marilyn, *Six Tulips*
Charles Sheeler, *Tulips*
Source: *Ekphrasis* 1, no. 1 (Summer 1997): 32

HEANEY, Seamus, *Summer 1969*
Francisco Goya, *The Third of May*, *Panic*, and *Two Strangers*
Source: Seamus Heaney, *New Selected Poems 1966–1987* (London: Faber and Faber, 1990), 87–8; Abse (2D, above), 60; and Benton and Benton, *Double Vision* (2E, above), 104–6

Heaney, Seamus, *The Guttural Muse*
Barrie Cooke, *Big Tench Lake*
Source: Reid and Rice (1J, above), 52–3

HEARNE, Vicki, *Gauguin's White Horse*
Paul Gauguin, *The White Horse*
Source: Hollander (2I, above), 327–8

Hearne, Vicki, *St. Luke Painting the Virgin*
Rogier van der Weyden, *St. Luke Painting the Virgin*
Source: Vicki Hearne, *Parts of Light* (Baltimore: Johns Hopkins University Press, 1994); and *The Best American Poetry 1992*, ed., Charles Simic (New York: Collier Books, 1992), 91–3

HEATH-STUBBS, John, *Homage to George Stubbs*
George Stubbs, *Horse Attacked by a Lion*
Source: Adams (1B, above), 24–5

HECHT, Anthony, *At the Frick*
Giovanni Bellini, *St. Francis in Ecstasy*
Source: Hollander (2I, above), 259

Hecht, Anthony, *The Road to Damascus*
Francesco Ubertini, *The Conversion of St. Paul*
Source: Holcomb (1I, above), 76–8

Hecht, Anthony, *Ascepius formidabilis (Griefbane)*
Dorothea Tanning, *Ascepius formidabilis (Griefbane)*
Source: Dorothea Tanning, *Another Language of Flowers* (New York: Braziller, 1998), plate 6

Hecht, Anthony, *Matisse: Blue Interior with Two Girls—1947*
Source: Anthony Hecht, *Flight Among the Tombs* (New York: Knopf, 1998), 67–8

HEERIKHUIZEN, F.W. van, *Het Meisje op Vermeer's Atelier*
Johannes Vermeer, *Allegory of Painting (Het schilder-satelier)*
Source: Korteweg and Heijn (2F, above), 174

HEINZELMAN, Kurt, *Jacobus Vrel*
Jacobus Vrel, *The Little Nurse*
Source: *Ekphrasis* 4, no. 3 (Spring–Summer 2007): 28–9

HEISELER, Bernt von, *Zu einem Bild von Hieronymus Bosch*
Source: Kranz (2B, above), 73

HEJDUK, John, *Annunciation*
Leonardo da Vinci, *Annunciation*
Source: John Hejduk, *Such Places as Memory: Poems 1953–1996* (Cambridge, MA: MIT Press, 1998), 5

Hejduk, John, *St. Anne Content*
Leonardo da Vinci, *The Virgin and Child with Saint Anne* (both the painting and charcoal draft of same)
Source: John Hejduk, *Such Places as Memory: Poems 1953–1996* (Cambridge, MA: MIT Press, 1998), 7

Hejduk, John, *A Dutch Interior*
Jan Vermeer, *The Guitar Player* or *Woman with a Lute*
Source: John Hejduk, *Such Places as Memory: Poems 1953–1996* (Cambridge, MA: MIT Press, 1998), 9

Hejduk, John, *Duet*
Unidentified Dutch painting
Source: John Hejduk, *Such Places as Memory: Poems 1953–1996* (Cambridge, MA: MIT Press, 1998), 10

Hejduk, John, *Without Interior*
Jean-Auguste-Dominique Ingres, *The Grand Odalesque*
Source: John Hejduk, *Such Places as Memory: Poems 1953–1996* (Cambridge, MA: MIT Press, 1998), 11

Hejduk, John, *To Madame D'Haussonville*
Jean-Auguste-Dominique Ingres, *Lousie de Broglie, Comtesse D'Haussonville*
Source: John Hejduk, *Such Places as Memory: Poems 1953–1996* (Cambridge, MA: MIT Press, 1998), 12

Hejduk, John, *On a Bridge*
René Magritte, *Homesickness* and other Magritte paintings
Source: John Hejduk, *Such Places as Memory: Poems 1953–1996* (Cambridge, MA: MIT Press, 1998), 13

Hejduk, John, *Oslo Room*
Edvard Munch, *The Day After*
Source: John Hejduk, *Such Places as Memory: Poems 1953–1996* (Cambridge, MA: MIT Press, 1998), 14

Hejduk, John, *The Metronome*
Henri Matisse, *The Piano Lesson*
Source: John Hejduk, *Such Places as Memory: Poems 1953–1996* (Cambridge, MA: MIT Press, 1998), 15

Hejduk, John, *France Is Far*
Edward Hopper, *Early Sunday Morning, Ground Swell, Automat,* and a number of other paintings
Source: John Hejduk, *Such Places as Memory: Poems 1953–1996* (Cambridge, MA: MIT Press, 1998), 16–17

Hejduk, John, *Nature Morte*
Georges Braque, *Atelier V* and *Atelier II*
Source: John Hejduk, *Such Places as Memory: Poems 1953–1996* (Cambridge, MA: MIT Press, 1998), 18

Hejduk, John, *A Monster Slain*
Paolo Uccello, *St. George and the Dragon*
Source: John Hejduk, *Such Places as Memory: Poems 1953–1996* (Cambridge, MA: MIT Press, 1998), 45

Hejduk, John, *A Birth*
Sandro Botticelli, *The Birth of Venus*
Source: John Hejduk, *Such Places as Memory: Poems 1953–1996* (Cambridge, MA: MIT Press, 1998), 46

Hejduk, John, *Silk of Springs*
Sandro Botticelli, *Primavera (Allegory of Spring)*
Source: John Hejduk, *Such Places as Memory: Poems 1953–1996* (Cambridge, MA: MIT Press, 1998), 47

Hejduk, John, *An Umbrian Passage*
Giotto di Bondone, Arena Chapel frescoes
Source: John Hejduk, *Such Places as Memory: Poems 1953–1996* (Cambridge, MA: MIT Press, 1998), 48

Hejduk, John, *Olive Trees in Ochre*
Duccio, unidentified paintings
Source: John Hejduk, *Such Places as Memory: Poems 1953–1996* (Cambridge, MA: MIT Press, 1998), 49

Hejduk, John, *Tuscan Wheat*
Paolo Uccello, unidentified paintings
Source: John Hejduk, *Such Places as Memory: Poems 1953–1996* (Cambridge, MA: MIT Press, 1998), 50

Hejduk, John, *Saint Ursula's Dream*
Titian or Giogione, unidentified painting
Source: John Hejduk, *Such Places as Memory: Poems 1953–1996* (Cambridge, MA: MIT Press, 1998), 51–2

Hejduk, John, *Creation of the Animals Before Braque*
Tintoretto, *Vulcanus Takes Mars and Venus Unawares, Bathing Susanna, The Discovery of St. Mark's Body,* and *The Creation of the Animals*
Source: John Hejduk, *Such Places as Memory: Poems 1953–1996* (Cambridge, MA: MIT Press, 1998), 53

Hejduk, John, *Berlin Winter Mask*
Pieter Brueghel the Younger, *Netherlandish Proverbs* and *The Battle Between Carnival and Lent*
Source: John Hejduk, *Such Places as Memory: Poems 1953–1996* (Cambridge, MA: MIT Press, 1998), 56–7

Hejduk, John, *Eros*
Bronzino (Agnolo di Cosimo), unidentified painting
Source: John Hejduk, *Such Places as Memory: Poems 1953–1996* (Cambridge, MA: MIT Press, 1998), 80

Hejduk, John, *Munch's Night Crossing*
Edvard Munch
Source: John Hejduk, *Such Places as Memory: Poems 1953–1996* (Cambridge, MA: MIT Press, 1998), 86

Hejduk, John, *Seville Blue*
Francisco Goya, *Portrait of the Duchess of Alba*
Source: John Hejduk, *Such Places as Memory: Poems 1953–1996* (Cambridge, MA: MIT Press, 1998), 92

Hejduk, John, *A Dead Oak*
Francisco Goya, unnamed print
Source: John Hejduk, *Such Places as Memory: Poems 1953–1996* (Cambridge, MA: MIT Press, 1998), 93

Hejduk, John, *A Distant Breath*
Francisco Goya, unnamed print
Source: John Hejduk, *Such Places as Memory: Poems 1953–1996* (Cambridge, MA: MIT Press, 1998), 94

Hejduk, John, *Abduction*
Francisco Goya, unnamed print
Source: John Hejduk, *Such Places as Memory: Poems 1953–1996* (Cambridge, MA: MIT Press, 1998), 96

Hejduk, John, *Under the Granite Arches*
Francisco Goya, unnamed print
Source: John Hejduk, *Such Places as Memory: Poems 1953–1996* (Cambridge, MA: MIT Press, 1998), 97

Hejduk, John, *Devouring Angel*
Albrecht Dürer, unnamed print
Source: John Hejduk, *Such Places as Memory: Poems 1953–1996* (Cambridge, MA: MIT Press, 1998), 98

Hejduk, John, *Obsession of Dürer*
Albrecht Dürer
Source: John Hejduk, *Such Places as Memory: Poems 1953–1996* (Cambridge, MA: MIT Press, 1998), 99–107

Hejduk, John, *An Evening Conversation*
Henri Matisse
Source: John Hejduk, *Such Places as Memory: Poems 1953–1996* (Cambridge, MA: MIT Press, 1998), 113–14

Hejduk, John, *The Green Room*
Georges Braque
Source: John Hejduk, *Lines: No Fire Could Burn* (New York : Monacelli Press, 1999), 63

HELLEN, Kathleen, *Blue Nude*
Henri Matisse, *Blue Nude*
Source: *Cæsura* (Fall 2007): 38

HEMSCHEMEYER, Judith, *Dürer Went to Sketch the Whole*
Albrecht Dürer
Source: Judith Hemschemeyer, *I Remember the Room Was Filled with Light* (Middletown, CT: Wesleyan University Press, 1973), 40

HENLEY, William Ernest, *Ballad of a Toyokuni Colour-Print*
Source: William Ernest Henley, *Poems* (London: Macmillan, 1921), 55–6

HENRI, Adrian, *Honeysuckle, Butterfly, Rose*
Dante Gabriel Rossetti, *Venus Verticordia*
Source: Adrian Henri, *Not Fade Away: Poems 1989–1994* (Newcastle upon Tyne, UK: Bloodaxe Books, 1994), 13

Henri, Adrian, *The Triumph of the Innocents*
William Holman Hunt, *The Triumph of the Innocents*
Source: Adrian Henri, *Not Fade Away: Poems 1989–1994* (Newcastle upon Tyne, UK: Bloodaxe Books, 1994), 15

Henri, Adrian, *Venus Rising*
Guercino (Giovanni Francesco Barbieri), *Reclining Nude Woman Lifting a Curtain*
Source: Adrian Henri, *Not Fade Away: Poems 1989–1994* (Newcastle upon Tyne, UK: Bloodaxe Books, 1994), 20

Henri, Adrian, *Regatta*
James Tissot, *Henley Regatta*
Source: Adrian Henri, *Not Fade Away: Poems 1989–1994* (Newcastle upon Tyne, UK: Bloodaxe Books, 1994), 21

HERBERT, W.N., *Fabula*
After a painting by El Greco in the National Gallery of Scotland
Source: W.N. Herbert, *Forked Tongue* (Newcastle upon Tyne, UK: Bloodaxe Books, 1994), 82

HERBERT, Zbigniew, *Old Masters*
Source: Zbigniew Herbert, *Collected Poems, 1956–1999* (New York: Ecco/HarperCollins, 2007), 345–6; and in Abse (2D, above), 14–15

Herbert, Zbigniew, *Mona Lisa*
Leonardo da Vinci, *Mona Lisa*
Source: Zbigniew Herbert, *Collected Poems, 1956–1999* (New York: Ecco/HarperCollins, 2007), 170–2; German trans. in Kranz (2B, above), 134–4

Herbert, Zbigniew, *Still Life*
Unidentified painting
Source: Zbigniew Herbert, *Collected Poems, 1956–1999* (New York: Ecco/HarperCollins, 2007), 145

Herbert, Zbigniew, *Gauguin—The End*
Draws on images from various paintings by Paul Gauguin
Source: Zbigniew Herbert, *Collected Poems, 1956–1999* (New York: Ecco/HarperCollins, 2007), 162–3

Herbert, Zbigniew, *The Passion of Our Lord Painted by Anonymous from the Circle of Rhenish Masters*
Source: Zbigniew Herbert, *Collected Poems, 1956–1999* (New York: Ecco/HarperCollins, 2007), 263

HEREDIA, José-Maria de, *Le Tepidarium*
Théodore Chassériau, *Le Tepidarium*
Source: Maurisson and Verlet (2L, above), 90–1

HERLANDS, E. Ward, *When Edward Hopper Was Painting*

Edward Hopper, *Sunday*
Source: Robert DiYanni, *Poetry: An Introduction* (New York: McGraw-Hill, 2000); and http://bl ogs.myspace.com/index.cfm?fuseaction=blog.vi ew&friendID=2578804&blogID=221483086

HERMLIN, Stephan, *Landschaft mit dem Sturz des Ikarus*
Pieter Brueghel the Elder, *Landscape with the Fall of Icarus*
Source: Stephan Hermlin, *Die Straßen der Furcht* (Singer: Oberbadischer Verlag, 1947), 45; and in Achim Aurnhammer and Dieter Martin eds., *Mythos Ikarus* (Leipzig: Reclam Bibliothek, 1998), 202

HERTMANS, Stefan, *Death on a Pale Horse* (poem trans. by Gregory Ball)
J.M.W. Turner, *Death on a Pale Horse*
Source: Wayne Miller and Kevin Prufer, eds., *New European Poets* (St. Paul, MN: Graywolf, 2008), 302

HERZBERG, Judith, *De boer*
Pieter Brueghel the Elder, *Landscape with the Fall of Icarus*
Source: Judith Herzberg, *Botshol* (Amsterdam: Van Oorschot, 1980), 33, and Korteweg and Heijn (2F, above), 83

Herzberg, Judith, *De zeeman*
Pieter Brueghel the Elder, *Landscape with the Fall of Icarus*
Source: Judith Herzberg, *Botshol* (Amsterdam: Van Oorschot, 1980), 34, and Korteweg and Heijn (2F, above), 83

Herzberg, Judith, *De visser*
Pieter Brueghel the Elder, *Landscape with the Fall of Icarus*
Source: Judith Herzberg, *Botshol* (Amsterdam: Van Oorschot, 1980), 35, and Korteweg and Heijn (2F, above), 83

HESKETH, Phoebe, *Printemps*
Claude Monet, *Spring Landscape*
Source: Phoebe Hesketh, *A Box of Silver Birch* (London: Enitharmon, 1997), 19; and Benton and Benton, *Picture Poems* (2H, above), 40

Hesketh, Phoebe, *Vincent*
Vincent Van Gogh, *Cornfield with Crows* and *Landscape with Cypresses Near Arles*
Source: Phoebe Hesketh, *Netting the Sun: New and Collected Poems* (Petersfield, UK: Enitharmon, 1989), 128; and Benton and Benton, *Double Vision* (2E, above), 43–4

Hesketh, Phoebe, *Letter to Vincent*
Vincent Van Gogh
Source: Phoebe Hesketh, *Netting the Sun: New and*

Collected Poems (Petersfield, UK: Enitharmon, 1989), 129; and Benton and Benton, *Double Vision* (2E, above), 45

Hesketh, Phoebe, *"La belle jardinière": (from the painting by Eugène Grasset, 1896)*
Source: Phoebe Hesketh, *Netting the Sun: New and Collected Poems* (Petersfield, UK: Enitharmon, 1989), 203

HIGGINS, A. Lauren, *Opening*
Mark Rothko, *Yellow Band*
Source: Janovy (1O, above), 31

HIGGINSON, William J., *Shadows*
Phoebe Stone, *Who Are We?* (print)
Source: *Ekphrasis* 1, no. 2 (Winter 1997–98): 36

HILBERRY, Conrad, *Figures in an Improbable Landscape*
Scroll painting by Fan K'un
Source: Conrad Hilberry, *Player Piano* (Baton Rouge: Louisiana State University Press, 1999), 17–18

Hilberry, Conrad, *Egon Schiele: Portrait of Franz Hauer*
Source: Tillinghast (1F, above), 16–19

HILBERT, Ernest, *Saint Michael Casting Satan into Hell*
Circle of Domenico Antonio Vaccaro
Source: http://www.nycbigcitylit.com/may2002/c ontents/poetrybspecialists.html

Hilbert, Ernest, *Andromeda Chained to the Rock*
Anthony van Dyck, *Andromeda Chained to the Rock*
Source: http://www.nycbigcitylit.com/may2002/co ntents/poetrybspecialists.html

HILL, Tobias, *Leonardo's Machines*
Leonardo da Vinci
Source: Tobias Hill, *Zoo* (Oxford: Oxford University Press, 1998), 14–16

HINE, Daryl, *Untitled*
Roger van der Weyden, *Calvary*
Source: Hollander (2I, above), 307–8

Hine, Daryl, *"Lady Sara Bunbury Sacrificing to the Graces," by Reynolds*
Sir Joshua Reynolds, *Lady Sarah Bunbury Sacrificing to the Graces*
Source: Daryl Hine, *Selected Poems* (New York: Scribner, 1981); and Helen Plotz, ed., *Eye's Delight: Poems of Art and Architecture* (New York: Greenwillow Books, 1983), 11

HINSEY, Ellen, *Paula Modersohn-Becker at Worpswede*
Source: Ellen Hinsey, *Cities of Memory* (New Haven, CT: Yale University Press, 1996), 53–4

Hinsey, Ellen, *Munch in Oslo*
Edvard Munch

Source: Ellen Hinsey, *Cities of Memory* (New Haven, CT: Yale University Press, 1996), 55–6

HIRSCH, Edward, *Edward Hopper and the House by the Railroad (1925)*
Edward Hopper, *House by the Railroad*
Source: Levin (3J, above), 29

Hirsch, Edward, *Impressions: Monet*
Source: *New Yorker*, 1 October 1979, 42

Hirsch, Edward, *Evening Star* and *Homage to O'Keeffe*
Georgia O'Keeffe, *Evening Star*
Source: Edward Hirsch, *The Night Parade* (New York: Knopf, 1989), 9, 10–11

Hirsch, Edward, *The Magic Mirror*
Jackson Pollock, *The Magic Mirror*
Source: Edward Hirsch, *Lay Back the Darkness* (New York: Knopf, 2003), 22–3

Hirsch, Edward, *The Horizontal Line (Homage to Agnes Martin)*
Source: Edward Hirsch, *Lay Back the Darkness* (New York: Knopf, 2003), 35–41

Hirsch, Edward, *The Evanescence (After Gerhard Richter, "Abstractes Bild," # 858)*
Source: Edward Hirsch, *Lay Back the Darkness* (New York: Knopf, 2003), 42–4

Hirsch, Edward, *Franz Marc's Lost Painting "Orpheus with the Animals (1907–1908)"*
Source: Edward Hirsch, *Lay Back the Darkness* (New York: Knopf, 2003), 65

Hirsch, Edward, *Earthly Light*
Seventeenth-century Dutch painters
Source: Edward Hirsch, *Earthly Measures* (New York: Knopf, 1994), 83–4

Hirsch, Edward, *Pilgrimage*
Caravaggio, *Madonna di Loreto* (*Madonna dei Pelligrini*)
Source: Edward Hirsch, *Earthly Measures* (New York: Knopf, 1994), 27–9

Hirsch, Edward, *Luminist Paintings at the National Gallery*
Hudson River School landscape painters
Source: Edward Hirsch, *Earthly Measures* (New York: Knopf, 1994), 69–70

Hirsch, Edward, *The Chardin Exhibition*
Jean-Baptiste-Siméon Chardin, *The Silver Goblet* and other still lifes
Source: Edward Hirsch, *Special Orders: Poems* (New York: Knopf, 2008), 14–15

Hirsch, Edward, *Soutine: A Show of Still Lifes*
Chaim Soutine, *Carcass of Beef* and other still lifes and landscapes
Source: Edward Hirsch, *Special Orders: Poems* (New York: Knopf, 2008), 21–4

Hirsch, Edward, *Matisse*
Source: Buchwald and Roston (2C, above), 24–5

HIRSCHORN, Norbet, *Degas' Father Listening to Lorenzo Pagans Playing the Guitar*
Edgar Degas, *Lorenzo Pagans and Auguste de Gas, the Artist's Father*
Source: *Ekphrasis* 1, no. 3 (Spring–Summer 1998): 40

HIRSHFIELD, Jane, *Late Self-Portrait by Rembrandt*
Source: Jane Hirshfield, *After: Poems* (New York: Harper, 2007), 39

HITTINGER, Matthew, *Decomposition*
Braque, Georges, *Fruit Dish*
Source: Matthew Hittinger, *Pear Slip* (New York: Spire Press, 2007), 23–4

Hittinger, Matthew, *This Is Not about Pears*
Cézanne, Paul, *Trois Poires* and *Pots of Flowers and Pears*
Source: Matthew Hittinger, *Pear Slip* (New York: Spire Press, 2007), 13–15

Hittinger, Matthew, *The Problematic Pear*
Pissarro, Camille, *Still Life: Apples and Pears in a Round Basket*
Source: *Beauty/Truth: A Journal of Ekphrastic Poetry* 1, no. 3 (Fall–Winter 2007): 22–4; rpt. in Matthew Hittinger, *Pear Slip* (New York: Spire Press, 2007), 10–12

Hittinger, Matthew, *Pear Palimpset*
Van Gogh, Vincent, *Still Life with Grapes, Pears and Lemons*; *Still Life with Grapes, Apples, Pear and Lemons*; and *Still Life with Pears*
Source: Matthew Hittinger, *Pear Slip* (New York: Spire Press, 2007), 18–19

Hittinger, Matthew, *Lamp*
Elizabeth Bishop, *Lamp*
Source: *Beauty/Truth: A Journal of Ekphrastic Poetry* 1, no. 3 (Fall–Winter 2007): 25–6

HIX, H.L., *Cy Twombly, "Night Watch"*
Source: *Poetry* 191, no. 6 (March 2008): 492

Hix, H.L., *Cy Twombly, "Beyond (A System for Passing)"*
Source: *Poetry* 191, no. 6 (March 2008): 493

HOFFMAN, Daniel, *Friend Benjamin, thee has done well indeed, thy native genius*
Benjamin West, *Penn's Treaty with the Indians*
Source: Hoffman, Daniel, *Brotherly Love* (New York: Random House, 1981), 36–41; and Abse (2D, above), 68

Hoffman, Daniel, *To the Maker of "A Peaceable Kingdom"*
Edward Hicks, *A Peaceable Kingdom*
Source: Hoffman, Daniel, *Brotherly Love* (New York: Random House, 1981), 164–8

HOFMANN, Michael, *Nighthawks*
Obliquely to Edward Hopper, *Nighthawks*
Source: Michael Hofmann, *Acrimony* (London: Faber and Faber, 1986). Also in his *Selected Poems* (London: Faber and Faber, 2008), 29

Hofmann, Michael, *The Late Richard Dadd, 1817–1886*
Source: Michael Hofmann, *Corona, Corona* (London: Faber and Faber, 1993), 5–6

Hofmann, Michael, *Max Beckmann: 1915*
Source: Michael Hofmann, *Corona, Corona* (London: Faber and Faber, 1993), 7–8

HOFSTADTER, Marc Elihu. For one-hundred-ten poems on paintings by Jackson Pollock, Mark Rothko, Chang Dai-Chen, and fourteen California Impressionists, see 4M, above.

HOGGARD, James, *Nighthawks*
Edward Hopper, *Nighthawks*
Source: http://www.janushead.org/JHSpg99/hoggard.cfm

HOLDEN, Jonathan, "*The Swing*," by Honoré Fragonard
Source: Jonathan Holden, *The Names of the Rapids* (Amherst: University of Massachusetts Press, 1985), 13

Holden, Jonathan, "*Early Sunday Morning*," by Edward Hopper
Source: Jonathan Holden, *The Names of the Rapids* (Amherst: University of Massachusetts Press, 1985), 33–4

Holden, Jonathan, "*Snap the Whip*," by Winslow Homer
Source: Jonathan Holden, *The Names of the Rapids* (Amherst: University of Massachusetts Press, 1985), 36

HOLLAND, Hannah, *The Uncertainty of the Poet*
Giorgio de Chirico, *The Uncertainty of the Poet*
Source: Benton and Benton, *Painting with Words* (2G, above), 40–1

HOLLANDER, Jean, *6 a.m. walk on old snow*
Pieter Brueghel the Elder, *The Hunters in the Snow*
Source: *Ekphrasis* 2, no. 4 (Fall–Winter 2001): 23

HOLLANDER, John, *Effet de Neige*
Monet, *Le Route de la ferme St.-Siméon*
Source: John Hollander, *Harp Lake* (New York: Knopf, 1985), 36–40; rpt. in Hollander (21, above), 339–42

Hollander, John, *To the Rokeby Venus*
Diego Velázquez, *The Rokeby Venus*
Source: John Hollander, *Harp Lake* (New York: Knopf, 1985), 42–4

Hollander, John, *An Old Engraving*
Unidentified engraving
Source: *New York Review of Books*, 27 September 1979; rpt. in Hollander's *Harp Lake* (New York: Knopf, 1985), 45

Hollander, John, *Baigneuse*
Jules Scalert, *Baigneuse*
Source: John Hollander, *Harp Lake* (New York: Knopf, 1985), 45

Hollander, John, *Two Glosses on René Magritte*
René Magritte, *The Eternally Obvious* and *Attempt of the Impossible*
Source: John Hollander, *Figurehead and Other Poems* (New York: Knopf, 1999), 58–60

Hollander, John, *Edward Hopper's Seven A.M. (1948)*
Edward Hopper, *Seven A.M.*
Source: John Hollander, *Tesserae and Other Poems* (New York: Knopf, 1993), 10; rpt. in Levin (3J, above), 26

Hollander, John, *Sunday A.M. Not in Manhattan*
Edward Hopper, *Early Sunday Morning*
Source: John Hollander, *The Night Mirror* (New York: Atheneum, 1971), 70; rpt. in Levin (3J, above), 43

Hollander, John, *Icarus before Knossos*
The Very Rich Hours of the Duke of Berry (ca. 1410)
Source: John Hollander, *A Crackling of Thorns* (New Haven: Yale University Press, 1958), 1–5

Hollander, John, *Rooms by the Sea*
Edward Hopper, *Rooms by the Sea*
Source: John Hollander, *Picture Window* (New York: Knopf, 2003), 19–20; and Hollander and Weber (1H, above), 72–4

Hollander, John, *To Andrew Forge, on Receipt of His Wash Drawing, Life-Size, of the Huge Dobsonfly*
Source: John Hollander, *Picture Window* (New York: Knopf, 2003), 55–6

Hollander, John, *Sun in an Empty Room*
Edward Hopper, *Sun in an Empty Room*
Source: John Hollander, *Figurehead and Other Poems* (New York: Knopf, 1999), 58–60; and Lyons and Weinberg (3Ja, above), 87–8

Hollander, John, *An Old Image (Alciati's Emblem #165)*
Andrea Alciati, *Emblems*
Source: John Hollander, *Figurehead and Other Poems* (New York: Knopf, 1999), 55–6

Hollander, John, *Emblem*
Woodblock print from a 16th–17th-century emblem book
Source: John Hollander, *Figurehead and Other Poems* (New York: Knopf, 1999), 57

Hollander, John, *Charles Sheeler's "The Artist Looks at Nature" (1943)*
Source: John Hollander, *Figurehead and Other Poems* (New York: Knopf, 1999), 64–7; and Hirsch (1D, above), 83–5

Hollander, John, *Las Hildanderas*
Diego Velázquez, *Las Hildanderas o "La Fabula de Aracne"*
Source: John Hollander, *Figurehead and Other Poems* (New York: Knopf, 1999), 9–11

Hollander, John, *Ave aut Vale*
Saul Steinberg, untitled drawing
Source: John Hollander, *Harp Lake* (New York: Knopf, 1988), 34–5

Hollander, John, *The Altarpiece Finished*
Hubert and Jan van Eyck, *Ghent Altarpiece*, Jean-Honoré Fragonard, *The Swing*; Philip Guston, *Beggar's Joys*, Paul Klee, *The Twittering Machine*
Source: John Hollander, *Movie-Going* (New York: Atheneum, 1962), 20–1

HOLLANDER, Martha, *Ogata Kôrin on His Field of Irises*
Ogata Kôrin, *Irises*
Source: *Partisan Review* 53 (1986); rpt. in Hollander's *The Game of Statues* (New York: Atlantic Monthly Press, 1990), 48–52

Hollander, Martha, *The Games of Statues*
Pieter Brueghel the Elder, *Children's Games* and *The Numbering at Bethlehem*
Source: *Partisan Review* 53 (1986); rpt. in Hollander's *The Game of Statues* (New York: Atlantic Monthly Press, 1990), 1–2

Hollander, Martha, *In the Museum*
Vincent Van Gogh
Source: Martha Hollander, *The Game of Statues* (New York: Atlantic Monthly Press, 1990), 85–6

Hollander, Martha, *Giorgione's Tempest: Another Story*
Source: *Poetry* 159 (February 1992): 272

Hollander, Martha, *Vermeer's Girl Asleep at a Table*
Source: *Paris Review* 145 (Winter 1997–98)

Hollander, Martha, *The Phantom Cart by Salvador Dali, 1933*
Source: Hollander and Weber (1H, above), 34–6

HOLM, Maureen, *Altman's Akhmatova*
Nathan Altman, *Portrait of Anna Akhmatova*
Source: http://www.nycbigcitylit.com/may2002/contents/poetryasingles.html

HOLMES, Oliver Wendell, *Illustration of a Picture "A Spanish Girl in Reverie"*
Washington Allston, *A Spanish Girl in Reverie*
Source: *The Complete Poetical Works of Oliver Wendell Holmes* (Boston: Houghton Mifflin, 1923), 325

HOLUB, Miroslav, *The Earliest Angels*
Paul Klee, *Strange Glance*
Source: Hirsch (1D, above), 124–5

HOMEISTER, Carla, *Calla, Calla, I say,*
Robert Maplethorpe, *Calla Lily* (photolithograph)
Source: *Ekphrasis* 3, no. 1 (Spring–Summer 2003): 12

Homeister, Carla, *Open Ended*
George Morrison, *Untitled*
Source: *Ekphrasis* 3, no. 3 (Spring–Summer 2004): 38

HOOKER, Jeremy, *Edvard Munch: "The Sick Child"*
Source: Jeremy Hooker, *Our Lady of Europe* (London: Enitharmon 1997), 55; and Adams (1B, above), 86–7

Hooker, Jeremy, *Vincent*
Vincent Van Gogh
Source: Jeremy Hooker, *Our Lady of Europe* (London: Enitharmon, 1997), 41–2

Hooker, Jeremy, *Pictures of Bruges*
Lanceloot Blondeel, *St. Luke Painting the Virgin's Portrait*
Source: Jeremy Hooker, *Our Lady of Europe* (London: Enitharmon, 1997), 59–61

Hooker, Jeremy, *After Rembrandt: "Saul and David"*
Source: Jeremy Hooker, *Our Lady of Europe* (London: Enitharmon, 1997), 39

Hooker, Jeremy, *After Rembrandt: "The Anatomical Lesson"*
Source: Jeremy Hooker, *Our Lady of Europe* (London: Enitharmon, 1997), 40

Hooker, Jeremy, *Homer Dictating*
Rembrandt van Rijn, *Homer*
Source: Jeremy Hooker, *Our Lady of Europe* (London: Enitharmon, 1997), 95–6

Hooker, Jeremy, *"That trees are men walking"*
David Jones
Source: Jeremy Hooker, *Our Lady of Europe* (London: Enitharmon, 1997), 130–4

Hooker, Jeremy, *Master of the Leaping Figures*
Master of the Leaping Figures (Winchester Bible)
Source: Jeremy Hooker, *Master of the Leaping Figures* (Petersfield, UK: Enitharmon, 1987), 9–10

Hooker, Jeremy, *On a Child's Painting*
Unidentified painting
Source: Jeremy Hooker, *Master of the Leaping Figures* (Petersfield, UK: Enitharmon, 1987), 38

HOPE, A.D., *Massacre of the Innocents: After Cornelis van Haarlem*
Cornelis van Haarlem, *Massacre of the Innocents*
Source: A.D. Hope, *Collected Poems* (New York: Viking, 1968), 16

Hope, A.D., *Circe: After the Painting by Dosso Dossi*
Dosso Dossi (Giovanni di Niccolò de Luteri), *Circe and Her Lovers in a Landscape*
Source: A.D. Hope, *Collected Poems* (New York: Viking, 1968), 71

Hope, A.D., *Gauguin's Menhir, Tahiti*
Paul Gauguin, Tahiti paintings
Source: A.D. Hope, *A Late Picking: Poems 1965–1974* (Sydney, Australia: Angus & Robertson, 1974)

HOPES, David Brendan, *The Forest Fire*
Piero di Cosimo
Source: *Ekphrasis* 3, no. 2 (Fall–Winter 2003): 13

Hopes, David Brendan, *Gerard Seghers: "The Denial of St. Peter"*
Source: Paschal (1G, above), 18–19

HOROWITZ, Nathan, *The Conference*
Emma Kidd, *Bobbing Whales*
Source: *qarrtsiluni. online literary magazine.* http://qarrtsiluni.com/category/ekphrasis

HOSTOVSKY, Paul, *Picture of a House*
Unidentified drawing by poet's daughter
Source: *Ekphrasis* 3, no. 4 (Fall–Winter 2004): 10

Hostovsky, Paul, *Dear Edvard Munch*
Edvard Munch, *The Scream*
Source: *Cæsura* (Fall 2007):14–15

Hostovsky, Paul, *Woman with Chrysanthemums by Degas*
Edgar Degas, *Woman with Chrysanthemums*
Source: *Cæsura* (Fall 2007):16–17

HOWARD, Richard, *Giovanni da Fiesole on the Sublime, or Fra Angeligo's "Last Judgment"*
Source: *Poetry* 117 (October 1970): 1–3; rpt. in Howard's *Inner Voices: Selected Poems, 1963–2003* (New York: Farrar, Straus and Giroux, 2004), 86–7; and Hollander (2I, above), 311–12

Howard, Richard, *Personal Values*
René Magritte, *Personal Values*
Source: Richard Howard, *Inner Voices: Selected Poems, 1963–2003* (New York: Farrar, Straus and Giroux, 2004), 162–3

Howard, Richard, *Vocational Guidance, with Special Reference to the "Annunciation" of Simone Martini*
Source: Richard Howard, *Inner Voices: Selected Poems, 1963–2003* (New York: Farrar, Straus and Giroux, 2004), 172–5

Howard, Richard, *Thebais*
Gherado Starnina, *Thebais*
Source: Richard Howard, *Inner Voices: Selected Poems, 1963–2003* (New York: Farrar, Straus and Giroux, 2004), 187–90

Howard, Richard, *Henri Fantin-Latour "Un coin de table," 1873*

Source: Richard Howard, *Inner Voices: Selected Poems, 1963–2003* (New York: Farrar, Straus and Giroux, 2004), 388–9; and Hirsch (1D, above), 30–1

Howard, Richard, *Dorothea Tanning's "Cousins"*
Source: Richard Howard, *Inner Voices: Selected Poems, 1963–2003* (New York: Farrar, Straus and Giroux, 2004), 345–6

Howard, Richard, *Homage to Antonio Canaletto*
Source: Richard Howard, *Inner Voices: Selected Poems, 1963–2003* (New York: Farrar, Straus and Giroux, 2004), 356–9

Howard, Richard, *The Job Interview with André Breton, 1957*
Source: Richard Howard, *Inner Voices: Selected Poems, 1963–2003* (New York: Farrar, Straus and Giroux, 2004), 169–71

Howard, Richard, *Lee Krasner: "Porcelain," a Collage*
Source: Richard Howard, *Inner Voices: Selected Poems, 1963–2003* (New York: Farrar, Straus and Giroux, 2004), 375–6

Howard, Richard, *Portrait in Pastel of the Volunteer: Friedrich-August Klaatsch, 1813*
Source: Richard Howard, *Inner Voices: Selected Poems, 1963–2003* (New York: Farrar, Straus and Giroux, 2004), 414–16

Howard, Richard, *Eugène Delacroix, "Moorish Conversation," 1832*
Eugène Delacroix, *Moorish Conversation*
Source: Richard Howard, *Trappings* (New York: Turtle Point Press, 1999), 70–2

Howard, Richard, *Family Values I–V*
A five-poem sequence about five different paintings representing Milton dictating *Paradise Lost* to his daughters: Henry Fuseli, Eugène Delacroix, George Romney, Mihàly Munkàcsy, and René Magritte.
Source: Richard Howard, *Trappings* (New York: Turtle Point Press, 1999), 17–37

Howard, Richard, *Disclaimers*
Peter Paul Rubens, *The Rape of the Sabine Women*
Source: Richard Howard, *Trappings* (New York: Turtle Point Press, 1999), 11

Howard, Richard, *Like Most Revelations*
Morris Louis
Source: Richard Howard, *Like Most Revelations* (New York: Pantheon, 1994), 3, and in *The Best American Poetry 1992*, ed. Charles Simic (New York: Collier Books, 1992), 106

Howard, Richard, *Bonnard: A Novel*
Pierre Bonnard
Source: Richard Howard, *The Damages* (Middle-

town, CT: Wesleyan University Press, 1967), 53–5

Howard, Richard, *Cyanea barballata (Dalliance)*
Dorothea Tanning, *Cyanea barballata (Dalliance)*
Source: Dorothea Tanning, *Another Language of Flowers* (New York: Braziller, 1998), plate 7

Howard, Richard, *The Rape of the Daughters of Leucippus by Castor and Pollux*
Peter Paul Rubens, *The Rape of the Daughters Of Leucippus by Castor and Pollux*
Source: Charles Wright, ed.; David Lehman, series ed.; *The Best American Poetry 2008* (New York: Scribner, 2008), 55–8; orig. pub. in *Five Points.*

Howard, Richard, *Impersonations*
Henri Rousseau, *Portrait of Pierre Loti*
Source: Richard Howard, *Lining Up* (New York: Atheneum, 1984), 54–60

Howard, Richard, *Eugène Delacroix*
Source: Richard Howard, *Lining Up* (New York: Atheneum, 1984), 14–15

Howard, Richard, *Honoré Daumier*
Source: Richard Howard, *Misgivings* (New York: Atheneum, 1979), 29–30

Howe, Susan, *Later afternoon fog*
Winslow Homer, *The Artist's Studio in an Afternoon Fog*
Source: Holcomb (1I, above), 90–2

Hoxha-Dija, Radije, *The Drama of Omer Kaleshi*
Omer Kaleshi
Source: Martinovski (2K, above), 127

Hristova-Jocik, Svetlana, *The Fire and the Square*
Albrecht Dürer, Magic square in *Melancholia*
Source: Martinovski (2K, above), 90–1

Hubbard, Sue, *The Convalescent*
Gwen John, *The Convalescent*
Source: Sue Hubbard, *Everything Begins with the Skin* (London: Enitharmon, 1994), 24

Hubbard, Sue, *Experiment with an Air Pump*
Joseph Wright of Derby, *An Experiment on a Bird in the Air Pump*
Source: Sue Hubbard, *Everything Begins with the Skin* (London: Enitharmon, 1994), 54

Hubbard, Sue, *The Painter's Family*
Giorgio de Chirico,
Source: Sue Hubbard, *Everything Begins with the Skin* (London: Enitharmon, 1994), 17

Hubbard, Sue, *The Beach at Trouville*
Eugène Louis Boudin, *Beach at Trouville*
Source: Sue Hubbard, *Everything Begins with the Skin* (London: Enitharmon, 1994), 37

Hubbard, Sue, *Woman Bathing in a Stream*
Rembrandt van Rijn, *Woman Bathing in a Stream*
Source: Sue Hubbard, *Everything Begins with the Skin* (London: Enitharmon, 1994), 62

Hubbard, Sue, *Nude with a Blue Cushion*
Amedeo Modigliani, *Nude on a Blue Cushion*
Source: Sue Hubbard, *Everything Begins with the Skin* (London: Enitharmon, 1994), 73

Hubbard, Sue, *Vermeer's Kitchen Maid*
Jan Vermeer, *The Kitchen Maid*
Source: Sue Hubbard, *Everything Begins with the Skin* (London: Enitharmon, 1994), 30

Hubbell, Lindley Williams, *Malevich*
Kasimir Malevich, *Supremist Composition*
Source: Lindley Williams Hubbell, *Seventy Poems* (Denver: Swallow, 1965), 29

Hubbell, Lindley Williams, *Mondrian*
Piet Mondrian
Source: Lindley Williams Hubbell, *Seventy Poems* (Denver: Swallow, 1965), 32

Hubert, Raymond, *La chute d'Icare*
Pieter Brueghel the Elder, *Landscape with the Fall of Icarus*
Source: Raymond Hubert, *Carême-prenant* (Bruxelles: La Renaissance du livre, 1969), 71

Hübner, Johannes, *San Girolamo von Carpaccio*
Vittore Carpaccio, *St. Jerome Leads the Lion to the Monastery*
Source: Kranz (2B, above), 123

Huck, Kate, *Erasures*
Artemisia Gentileschi, *Judith Beheading Holofernes*
Source: *Ekphrasis* 2, no. 3 (Fall–Winter 2003): 36

Hudgins, Andrew, *The Cestello Annunciation*
Sandro Botticelli, *The Cestello Annunciation*
Source: Andrew Hudgins, *The Never-Ending* (Boston: Houghton Mifflin, 1991), 4

Hudgins, Andrew, *Lamentation over the Dead Christ*
Sandro Botticelli, *Lamentation over the Dead Christ with Saints*
Source: Andrew Hudgins, *The Never-Ending* (Boston: Houghton Mifflin, 1991), 11

Hudon, Daniel, *Gigantic Days*
René Magritte, *Titanic Days*
Source: *The Hiss Quarterly* 5, no. 3. http://thehissquarterly.net/eck/hudon.html

Hudon, Daniel, *The Month of the Grape Harvest*
René Magritte, *The Month of the Grape Harvest*
Source: *The Hiss Quarterly* 5, no. 3. http://thehissquarterly.net/eck/hudon.html

Hughes, Langston, *For the Portrait of an African Boy after the Manner of Gauguin*
Paul Gauguin
Source: *The Collected Poems of Langston Hughes*, ed.

Arnold Rampersad (New York: Alfred A. Knopf, 1995), 32

Hughes, Langston, *Cubes*
Picasso; Cubism
Source: *The Collected Poems of Langston Hughes*, ed. Arnold Rampersad (New York: Alfred A. Knopf, 1995), 175–6

HUGO, Richard, *The Prado: Bosch: S. Antonio*
Hieronymus Bosch, *The Temptation of St. Anthony*
Source: *Making Certain it Goes On: The Collected Poems of Richard Hugo* (New York: Norton, 1983), 184–5

Hugo, Richard, *Brueghel in the Doria*
Pieter Brueghel the Elder, *Naval Battle in the Bay of Naples* (*Hafen von Neapel*)
Source: *Making Certain it Goes On: The Collected Poems of Richard Hugo* (New York: Norton, 1983), 111–12

Hugo, Richard, *Northwest Retrospective: Mark Tobey*
Source: *Making Certain it Goes On: The Collected Poems of Richard Hugo* (New York: Norton, 1983), 47–8

Hugo, Richard, *Bouquets from Corley*
Ward Corley
Source: *Making Certain it Goes On: The Collected Poems of Richard Hugo* (New York: Norton, 1983), 95–6

Hugo, Richard, *S. Miniato: One by Aretino*
Spinello Aretino, frescoes at San Miniato al Monte
Source: *Making Certain it Goes On: The Collected Poems of Richard Hugo* (New York: Norton, 1983), 109–10

Hugo, Richard, *The Prado: Number 2671, Anonimo Español*
Anonymous Spanish painter and unidentified painting
Source: *Making Certain it Goes On: The Collected Poems of Richard Hugo* (New York: Norton, 1983), 185–6

Hugo, Richard, *George Stubbs at Yale*
George Stubbs, *Horse Attacked by a Lion*
Source: *Making Certain it Goes On: The Collected Poems of Richard Hugo* (New York: Norton, 1983), 442–3

HULSE, Michael, *Carnation, Lily, Lily, Rose*
John Singer Sargent, *Carnation, Lily, Lily, Rose*
Source: Adams (1B, above), 64–5

HUSAIN, Dan, *Christina*
Andrew Wyeth, *Christina's World*
Source: http://shamethepoem.blogspot.com/2005/12/ecphrasis-christinas-world.html

HUSSEY, Nora, *Fault Lines*
Kerr Eby, *Shadows*

Source: http://www.wellesley.edu/DavisMuseum/whatsnew/museumcast.xml; podcast available at site: dmcc_poetry03.mp3

INGERSOLL, Wendy Elizabeth, *Looking at "Flowers in a Crystal Vase" by Édouard Manet*
Source: *Cæsura* (Fall 2007): 13.

IRWIN, Mark, *Vermeer*
Jan Vermeer, *The Lace Maker, Woman Pouring Milk, Woman in Blue Reading a Letter, Allegory of Painting, Officer and Laughing Girl*, and *Woman Holding a Balance*
Source: *Atlantic Monthly* 248 (1981): 19

ISLAMI, Abdulazis, *Lily of the Valley*
Bajram Salihu
Source: Martinovski (2K, above), 131

ISSALY, Françoise, *Oscillation*
Francoise Issaly, *Inner/Outer Circles No. 17*
Source: *Paintings & Poems/Poems & Paintings* (Santa Barbara, CA: Artamo, 2007), 1

IUPPA, M.J., *Mother's Dream*
Fairfield Porter, *The Beginning of the Fields*
Source: Holcomb (1I, above), 100–1

JACOBS, Bruce A., *The Jefferson Brothers Go Out for Mackerel*
Roy De Forest, *The Dipolar Girls Take a Voyage on the St. Lawrence*
Source: Holcomb (1I, above), 102–5

JACOBSON, Robin Leslie, *The Laundryman at the Brothel*
Henri de Toulouse-Lautrec, *The Laundryman at the Brothel*
Source: *Ekphrasis* 3, no. 3 (Spring–Summer 2004): 6

JACOBSTEIN, Roy, *Melancholy and Mystery of a Street*
Giorgio de Chirico, *Mystery and Melancholy of a Street*
Source: Roy Jacobstein, *A Form of Optimism* (Boston: Northeastern University Press, 2006), 31

JAMES, John, *Lines for Richard Long*
Richard Long, *Slate Circle*
Source: Adams (1B, above), 146–7

JAMES, M.R., *After La Siesta*
Vincent Van Gogh, *The Siesta*
Source: http://www.guardian.co.uk/books/2006/oct/23/poetry

JANEVSKI, Slavko, *The Sower*
El Greco, *The Parable of the Sower*
Source: Martinovski (2K, above), 70

Janevski, Slavko, *A Procession in Yellow*
Vincent Van Gogh, *The Sunflowers*
Source: Martinovski (2K, above), 71

Janevski, Slavko, *Customs Office*
Henri Rousseau
Source: Martinovski (2K, above), 72

Janevski, Slavko, *Flamenco*
Pablo Picasso
Source: Martinovski (2K, above), 73

Janevski, Slavko, *Wedding*
Marc Chagall
Source: Martinovski (2K, above), 74

Janevski, Slavko, *Flocks*
Joan Miró
Source: Martinovski (2K, above), 75

Janevski, Slavko, *The Clown*
Spase Kunoski
Source: Martinovski (2K, above), 122–3

JANIK, Phyllis, *Sleeping Peasants*
Pablo Picasso, *Sleeping Peasants*
Source: Buchwald and Roston (2C, above), 50–1

JARRELL, Randall, *The Knight, Death, and the Devil*
Albrecht Dürer, *The Knight, Death, and the Devil*
Source: Hollander (2I, above), 255–6; and Kehl (2A, above), 124–6

Jarrell, Randall, *The Old and New Masters*
Georges de la Tour, *St. Sebastian Mourned by St. Irene*; Hugo van der Goes, *Nativity*; Paolo Veronese, *The Wedding at Cana*
Source: Randall Jarrell, *Selected Poems*, ed. William H. Pritchard (New York: Farrar, Straus and Giroux, 1990), 94–5

JDEED, Wafaa S., *Forest*
Wafaa S. Jdeed, *Forest*
Source: Greenberg, *Side* (2M, above), 36–7

JEFFERY, David T., *Nighthawks*
Edward Hopper, *Nighthawks*
Source: http://physics.nmt.edu/~jeffery/poemp/p+0020032.html

JELLEMA, C.O., *Fyt fecit*
Jan Fyt, *Still Life with Hare, Fruit, and Parrot*
Source: Korteweg and Heijn (2F, above), 156

Jellema, C.O., *De kettinghond*
Paulus Potter, *Dog on a Chain*
Source: Korteweg and Heijn (2F, above), 160

Jellema, C.O., *Van Hoogstraten. Zelfportret*
Samuel van Hoogstraten, *Self-Portrait*
Source: Korteweg and Heijn (2F, above), 161

Jellema, C.O., *Reflecties op Ruysdael*
Jacob van Ruisdael, *View of Haarlem with the Bleaching Fields, Country House in a Park, An Oak beside a Fen, Deer Hunt in a Swampy Forest, The Jewish Cemetery, Bentheim Castle*, and *The Ray of Sunlight*
Source: Korteweg and Heijn (2F, above), 162–5

JENKS, Allison Eir, *Waiting*
Kathy Prendergast, *Waiting*
Source: Allison Eir Jenks, *The Palace of Bones* (Athens: Ohio University Press, 2002), 5

JENNINGS, Elizabeth, *Rembrandt's Late Self-Portraits*
Source: Elizabeth Jennings, *New Collected Poems* (Manchester, UK: Carcanet, 2002), 105; and Helen Plotz, ed., *Eye's Delight: Poems of Art and Architecture* (New York: Greenwillow Books, 1983), 12

Jennings, Elizabeth, *Mantegna's Agony in the Garden*
Andrea Mantegna, *The Agony in the Garden*
Source: Elizabeth Jennings, *New Collected Poems* (Manchester, UK: Carcanet, 2002), 44

Jennings, Elizabeth, *Caravaggio's "Narcissus" in Rome*
Michelangelo Merisi da Caravaggio, *Narcissus*
Source: Elizabeth Jennings, *New Collected Poems* (Manchester, UK: Carcanet, 2002), 79

Jennings, Elizabeth, *Goya*
Francisco Goya
Source: Elizabeth Jennings, *New Collected Poems* (Manchester. UK: Carcanet, 2002), 176

Jennings, Elizabeth, *Chardin*
Jean-Siméon Chardin
Source: Elizabeth Jennings, *New Collected Poems* (Manchester, UK: Carcanet, 2002), 176

Jennings, Elizabeth, *In Praise of Giotto*
Giotto di Bondone
Source: Elizabeth Jennings, *New Collected Poems* (Manchester, UK: Carcanet, 2002), 256

Jennings, Elizabeth, *Still Life*
Paul Cézanne, Jean-Baptiste-Siméon Chardin, Vincent Van Gogh
Source: Elizabeth Jennings, *New Collected Poems* (Manchester, UK: Carcanet, 2002), 279

Jennings, Elizabeth, *The Nature of Prayer*
Vincent Van Gogh, *The Church at Auvers* (*The Crooked Church*)
Source: Elizabeth Jennings, *New Collected Poems* (Manchester, UK: Carcanet, 2002), 104

Jennings, Elizabeth, *Mondrian*
Piet Mondrian
Source: Elizabeth Jennings, *New Collected Poems* (Manchester, UK: Carcanet, 2002), 104–5

Jennings, Elizabeth, *Samuel Palmer and Chagall*
Source: Elizabeth Jennings, *New Collected Poems* (Manchester, UK: Carcanet, 2002), 75–6

Jennings, Elizabeth, *Bonnard*
Pierre Bonnard
Source: Elizabeth Jennings, *New Collected Poems* (Manchester, UK: Carcanet, 2002), 85

Jennings, Elizabeth, *Cézanne*
Paul Cézanne
Source: Elizabeth Jennings, *New Collected Poems* (Manchester, UK: Carcanet, 2002), 134

Jennings, Elizabeth, *For Paul Klee*
Source: Elizabeth Jennings, *New Collected Poems* (Manchester, UK: Carcanet, 2002), 297–8

Jennings, Elizabeth, *Spring*
Sandro Botticelli, *Primavera*
Source: *Southern Review* 12 (April 1976): 358

Jennings, Elizabeth, *Klee's Last Years*
Paul Klee
Source: *Southern Review* 12 (April 1976): 354

JENSON, Karen, *Archangel Plays*
Lowell Fox, *Jazz Riff*
Source: http://lowellfox.com/page5-contributingpoets/index.htm#jazzriff

Jenson, Karen, *Once a Child*
Lowell Fox, *Two Moms in the Park*
Source: http://lowellfox.com/page5-contributingpoets/index.htm#twomoms

JOHNSON, Adam, *Edvard Munch*
Edvard Munch, *Night in St. Cloud, Evening on Karl Johan, The Scream, Madonna,* et al.
Source: Adam Johnson, *The Playground Bell* (Manchester, UK: Carcanet, 1994), 58

JOHNSON, Amryl, *The Deluge*
Francis Danby, *The Deluge*
Source: Adams (1B, above), 56–7

JOHNSON, Angela, *From Above*
Faith Ringgold, *Tar Beach*
Source: Greenberg, *Heart* (2J, above), 25

JOHNSON, James Weldon, *Before a Painting*
Unidentified painting
Source: James Weldon Johnson, *Fifty Years and Other Poems* (Boston: Cornhill, 1921), 24

JOHNSON, Linnea, *Ascension*
Edgar Degas, *Woman Ironing*
Source: *Nimrod*, Fall–Winter 1995; rpt. in *Ekphrasis* 2 (Fall–Winter 2000): 11–12

Johnson, Linnea, *Our Red Hair*
Henri de Toulouse-Lautrec, *Rue des Moulins*
Source: *Ekphrasis* 2 (Fall–Winter 2000): 13

JOHNSON, Mark, *Sebastian*
Andrea Mantegna, *St. Sebastian*
Source: *Ekphrasis* 1, no. 5 (Spring–Summer 1999): 45

Johnson, Mark, *The Highstrung Gentleman Regards Bacon's Second Version of Triptych*
Francis Bacon, *Second Version of Triptych*
Source: *Ekphrasis* 2, no. 1 (Spring–Summer 2000): 30–1

JOHNSON, Michael L., *Meditation by the Sea*
Meditation by the Sea by an unknown folk artist, derived from a wood engraving by David H. Strother
Source: *Ekphrasis* 1, no. 6 (Fall–Winter 1999): 6–7

Johnson, Michael L., *M.C. Escher's "Circle Limit III"*
M.C. Escher, *Circle Limit III*
Source: Kurt Brown, ed., *Verse & Universe: Poems About Science and Mathematics* (Minneapolis, MN: Milkweed, 1998), 282

JOHNSON, Nicholas, *The Use of Words*
René Magritte, *Forbidden Literature*
Source: http://www.nycbigcitylit.com/may2002/contents/poetryasingles.html

JOHNSON, Nick, *The Sleeping Gypsy*
Henry Rousseau, *The Sleeping Gypsy*
Source: Buchwald and Roston (2C, above), 49

JOHNSON, Ronald, *Assorted Jungles: Rousseau*
Four of Henri Rousseau's paintings
Source: Ronald Johnson, *Valley of the Many-Colored Grasses* (New York: Norton, 1969), 99–104

Johnson, Ronald, *Three Paintings by Arthur Dove: I. Plant Forms; II. Cows in Pasture; III. Moon*
Source: *The Young American Poets*, ed. Paul Carroll (Chicago: Follett, 1968), 213–16

Johnson, Ronald, *Turner, Constable, and Stubbs*
J.M.W. Turner, John Constable, and George Stubbs
Source: Ronald Johnson, *The Book of the Green Man* (New York: W.W. Norton, 1967), 57

Johnson, Ronald, *Ark 75*, Arches IX (from Van Gogh's Letters)
Vincent Van Gogh
Source: Ronald Johnson, *Ark* (Pittsburgh, PA: University of Pittsburgh Press, 1996), no pagination

JOKOSTRA, Peter, *Unter einem Bild Mirós*
Joan Miró, *Personen und Hund vor der Sonne*
Source: Kranz (2B, above), 253

JONES, Hettie, *Ladies and Gentlemen, Step Right Up, The Drawer is Open!*
Elizabeth Murray, *Open Drawer*
Source: Greenberg, *Heart* (2J, above), 70–1

JONES, Jennifer Vaughan, *Al Held's American "Bruges III"*
Al Held, *Bruges III*
Source: *Wisconsin Poets* (1E, above), 62–3

JONES, Jill, *Angle of the Sun*
Margaret Olley, *Chinese Screen and Yellow Room*
Source: http://jillesjon.googlepages.com/ekphrasis

JONG, Martien J.G. de, *Capodimonte*
Pieter Brueghel the Elder, *The Parable of the Blind*
Source: Korteweg and Heijn (2F, above), 100

JONSON, Ben, *The Mind of a Frontispiece to a Book*
Renold Elstrack, engraved title page of Sir Walter
 Raleigh's *History of the World*
Source: Hollander (21, above), 117

JOORIS, Roland, *Breughel*
Pieter Brueghel the Elder, *Hunters in the Snow*
Source: Korteweg and Heijn (2F, above), 95

JORDAN, Barbara, *Carnal Knowledge*
Jan Davidszoon De Heem, *Still Life*
Source: Holcomb (1I, above), 106–8

JORDAN, June, *Roman Poem Number Seventeen*
Roman tomb paintings
Source: June Jordan, *Things That I Do In The Dark*
 (New York: Random House, 1977), 187–8

JOSEPH, Allison, *The Art of Vallejo*
Boris Vallejo
Source: Allison Joseph, *In Every Seam* (Pittsburgh,
 PA: University of Pittsburgh Press, 1977), 62–4

JOSEPH, David, *Sun in an Empty Room*
Edward Hopper, *Sun in an Empty Room*, 1963
Source: *Double Take* 7 (Spring 2001): 44

JOSEPH, Jenny, *A Chair in My House: After Gwen
John*
Gwen John, *Woman Reading*
Source: http://wwwfp.education.tas.gov.au/English/
 hugopaul.htm; Adams (1B, above), 76–8; and
 Benton and Benton, *Double Vision* (2E, above),
 109–10

Joseph, Jenny, *Altarpiece*
Pierre Bonnard, *Torso of Nude Woman before Mir-
 ror*; Nicholas Poussin; and other paintings (Dutch
 and Italian)
Source: Jenny Joseph, *Selected Poems* (Newcastle
 upon Tyne, UK: Bloodaxe, 1999), 77–82

JOSEPH, M.K., *Matisse, Picasso, Braque*, and *Rouault*
Source: M.K. Joseph, *Inscription on a Paper Dart:
 Selected Poems 1945–72* (N.p.: Auckland Univer-
 sity Press, 1974), 33–5

JOSEPHS, Laurence, *Trompe L'Oeil*
Unidentified painter and painting
Source: Laurence Josephs, *Cold Water Morning*
 (Saratoga Springs, NY: Skidmore College, 1963),
 15

Josephs, Laurence, *Vermeer: For D.Y.*
Jan Vermeer
Source: *Southern Review* 2, n.s. (January 1966): 99

JOUVE, Pierre–Jean, *Psyché Abandonnée Devant le
 Chateau d'Eros*
Claude Lorrain, *Landscape with Psyche outside the
 Palace of Cupid*
Source: Pierre–Jean Jouve, *Poésie* (Paris: Mercure de
 France, 1964), 314; German trans., Kranz (2B,
 above), 190

JUSTICE, Donald, *Anonymous Drawing*
Source: Donald Justice, *New and Selected Poems*
 (New York: Knopf, 1995), 71

Justice, Donald, *On a Painting by Patient B of the
 Independence State Hospital for the Insane*
Source: Donald Justice, *New and Selected Poems*
 (New York: Knopf, 1995), 52

Justice, Donald, *On a Picture by Burchfield*
Charles Ephrian Burchfield, unidentified painting
Source: Donald Justice, *New and Selected Poems*
 (New York: Knopf, 1995), 3

KAISER, Mary. For eleven of Kaiser's poems on
 paintings, see 4W, above.

KAL, Jan, *De val van Icarus*
Pieter Brueghel the Elder, *Landscape with the Fall
 of Icarus*
Source: Jan Kal, *Fietsen op de Mont-Ventoux* (Am-
 stelveen: Peter Loeb, 1974), 44; and Korteweg
 and Heijn (2F, above), 82

KANTARIS, Sylvia, *Gwen John's Cat*
Gwen John, *Young Woman Holding a Black Cat*
Source: Sylvia Kantaris, *Dirty Washing* (Newcastle
 upon Tyne, UK: Bloodaxe Books, 1989), 115;
 Benton and Benton, *Painting with Words* (2G,
 above), 54–5; and http://wwwfp.education.tas.go
 v.au/English/hugopaul.htm

Kantaris, Sylvia, *Thank Heaven for Little Girls*
Thomas Gotch, *Alleluia*
Source: Sylvia Kantaris, *Dirty Washing* (Newcastle
 upon Tyne, UK: Bloodaxe Books, 1989), 99;
 Adams (1B, above), 68–9; and Benton and Ben-
 ton, *Double Vision* (2E, above), 37–8

Kantaris, Sylvia, *Growing Pains*
James Abbott McNeill Whistler, *Miss Cicely Alexan-
 der: Harmony in Gray and Green*
Source: Benton and Benton, *Picture Poems* (2H,
 above), 52–3

KARDAS, Pat, *Little Girl with Basket of Apples*
Adolphe-William Bouguereau, *Little Girl with Bas-
 ket of Apples*
Source: *Wisconsin Poets* (1E, above), 26–7

KASISCHKE, Laura *Red Hills and Bones*
Georgia O'Keefe, *Red Hills and Bones*
Source: Greenberg, *Heart* (2J, above), 37

KATZ, Bobbi, *Lessons from a Painting by Rothko*
Mark Rothko, *Untitled*, 1960
Source: Greenberg, *Heart* (2J, above), 55

KATZ, Phyllis B., *Painting the Night*
James McNeil Whistler, *Nocturne—Blue and
 Gold—Old Battersea Bridge*
Source: *Ekphrasis* 5, no. 2 (Fall–Winter 2009): 9

Katz, Phyllis B., *Mary of Burgandy on Seeing Her
 Own Image in Her Books of Hours*

The Master of Mary of Burgundy, *A Book of Hours for Engelbert of Nassau*
Source: *Ekphrasis* 5, no. 2 (Fall–Winter 2009): 21–2

KAUFMAN, Bob, *From a Painting by El Greco*
El Greco, unidentified painting
Source: Bob Kaufman, *The Ancient Rain: Poems, 1956–1978* (New York: New Directions, 1981), 67

Kaufman, Bob, *Bird with Painted Wings*
Numerous Impressionist and Modernist painters
Source: Bob Kaufman, *Solitudes Crowded with Loneliness* (New York: New Directions, 1965), 19

KAVANAGH, P.J., *Don't Forget the Keeper, Sir*
J.M.W. Turner
Source: P.J. Kavanagh, *Collected Poems* (Manchester, UK: Carcanet, 1992), 146

KAY, John, *"Dreams" Vittorio Corcos*
Vittorio Corcos, *Sogni*
Source: *Ekphrasis* 5, no. 1 (Spring–Summer 2009): 7

KAZANTIS, Judith, *The Saltonstall Family*
David des Granges, *The Saltonstall Family*
Source: Adams (1B, above), 20–3

Kazantzis, Judith, *Titian's Assumption of the Virgin: The Apostle*
Source: Judith Kazantzis, *Swimming Through the Grand Hotel* (London: Enitharmon, 1999), 52

KEARNS, Josie, *Joseph Interpreting the Dreams of Pharoah's Servants*
Nöel Hallé, *Joseph Interpreting the Dreams of Pharoah's Servants*
Source: Tillinghast (1F, above), 88–90

KEATS, John, *Ode on a Grecian Urn*
Two (or perhaps as Helen Vendler argues, three) scenes painted on the urn
Source: John Keats, *The Complete Poems*, ed. Miriam Walcott (London: Longman, 1970), 532–8

Keats, John, *On a Leander Gem Which Miss Reynolds, My Kind Friend Gave Me*
One of James Tassie's reproductions of gems engraved with classical scenes, in this case of Leander swimming the Hellespont.
Source: John Keats, *The Complete Poems*, ed. Miriam Walcott (London: Longman, 1970), 107

KEENAN, Deborah, *Folds of a White Dress/Shaft of Light*
Peter Paul Rubens, *The Annunciation*
Source: Buchwald and Roston (2C, above), 92–3

KEENAN, Brian, *Requiem*
Gerard Dillon, *Children Playing on Lagan*
Source: Reid and Rice (1J, above), 63–5

KEES, Weldon, *On a Painting by Rousseau*
Henri Rousseau, *The Cart of Père Juniet*

Source: *Poetry* 58 (June 1941): 127; rpt. in *Collected Poems of Weldon Kees* (Lincoln: University of Nebraska Press, 1975), 25

KEITH, Sally, *The Hunters*
Pieter Brueghel the Elder, *Hunters in the Snow*
Source: Sally Keith, *Dwelling Song* (Athens: University of Georgia Press, 2004), 7–8

KEITHLEY, George, *The Trial of Galileo*
Cristiano Banti, *Galileo before the Inquisition*
Source: *Ekphrasis* 1, no. 2 (Winter 1997–98): 42

KELLEY, Aimee, *A Final Sonnet: Romeo and Juliet (Yellow Couple)*
James Benjamin Franklin, *Untitled*
Source: Geha and Nichols (1N, above), 47–9

KELLY, Bridgit Pegeen, *Botticelli's St. Sebastian*
Source: *Song: Poems* (Brockport, NY: Boa Editions, 1995), 71

KELLY, Robert, *Homage to Nikolai Roerich*
Source: Robert Kelly, *The Convections* (Santa Rosa, CA: Black Sparrow Press, 1978), 92

Kelly, Robert, *Blue Nude*
Henri Matisse, *Blue Nude*
Source: Robert Kelly, *Kill the Messenger* (Santa Rosa, CA: Black Sparrow Press, 1979), 181–3

Kelly, Robert, *A Red-Figured Cup of the Onesimos Painter*
Onesimos (Athenian vase painter)
Source: Robert Kelly, *The Mill of Particulars* (Santa Rosa, CA: Black Sparrow Press, 1973), 43

Kelly, Robert, *Arnolfini's Wedding*
Jan Van Eyck, *Arnolfini Wedding Portrait*
Source: Robert Kelly, *The Mill of Particulars* (Santa Rosa, CA: Black Sparrow Press, 1973), 119–26

Kelly, Robert, *Poussin*
Nicolas Poussin
Source: Robert Kelly, *Not This Island Music* (Santa Rosa, CA: Black Sparrow Press, 1987), 34

Kelly, Robert, *On a Portrait of Joseph Priestley*
Unidentified portrait painter
Source: Robert Kelly, *Not This Island Music* (Santa Rosa, CA: Black Sparrow Press, 1987), 77–8

Kelly, Robert, *Of William Mount, the "Luminist"*
Source: Robert Kelly, *Red Actions: Selected Poems, 1960–1993* (Santa Rosa, CA: Black Sparrow Press, 1995), 105–6

Kelly, Robert, *The Death of Joseph Stella*
Source: Robert Kelly, *Spiritual Exercises* (Santa Rosa, CA: Black Sparrow Press, 1981), 60–1

KELLY-DEWITT, Susan, *Undergrowth with Two Figures, 1890*
Vincent Van Gogh, *Undergrowth with Two Figures*
Source: *Ekphrasis* 3, no. 1 (Spring–Summer 2003): 15

Kelly-DeWitt, Susan, *Bruegel: Landscape with the Fall of Icarus*
Source: *Ekphrasis* 4, no. 1 (Spring–Summer 2006): 16

Kelly-DeWitt, Susan, *Woman with Unicorn*
Raphael, *Woman with Unicorn*
Source: *Ekphrasis* 3, no. 1 (Spring–Summer 2003): 16

Kelly-DeWitt, Susan, *Van Gogh, "Landscape at Twilight"*
Vincent Van Gogh, *Landscape at Twilight*
Source: http://www.mesart.com/art/Poems:Kelly-DeWitt; and Kelly-DeWitt's *Book of Insects* (Berkeley, CA: Spruce Street Press, 2003)

Kelly-DeWitt, Susan, *Chagall's "Bride and Groom"*
Marc Chagall, *Bride and Groom*
Source: http://www.mesart.com/art/Poems:Kelly-DeWitt

Kelly-DeWitt, Susan, *The Sea, Cape-Split*
John Marin, *The Sea, Cape-Split, Maine*
Source: *Ekphrasis* 3, no. 5 (Spring–Summer 2005): 14

KEMP, Pierre, *Het Rood van het Joodse Bruidje*
Rembrandt van Rijn, *Portrait of Isaac and Rebecca* (*The Jewish Bride*)
Source: Korteweg and Heijn (2F, above), 150

KEMPHER, Ruth Moon, *The Lover — A Painting by Remedios Varo*
Source: *Ekphrasis* 4, no. 5 (Spring–Summer 2008): 39

Kempher, Ruth Moon, *Portrait: Untitled*
Unfinished portrait by ex-husband
Source: *Ekphrasis* 4, no. 2 (Fall–Winter 2006): 13

KENDIG, Diane, *On Frida Kahlo's "Self-Portrait as a Tehuana"*
Source: *Ekphrasis* 1, no. 1 (Summer 1997): 33

KENNEDY, Lillian B., *What I Remember Most*
Samuel Bak, images from Bak's paintings, especially his *Chess Revisited* series
Source: *Beauty/Truth: A Journal of Ekphrastic Poetry* 1, no. 3 (Fall–Winter 2007): 20–1

KENNEDY, X.J., *Nude Descending a Staircase*
Marcel Duchamp, *Nude Descending a Staircase*
Source: X.J. Kennedy, *Nude Descending a Staircase* (New York: Doubleday, 1961), 69; Abse (2D, above), 120; and Kehl (2A, above), 188–9

Kennedy, X.J., *Song: Hello, Dali*
Salvador Dali, *Self-Portrait as Mona Lisa* and other paintings
Source: X.J. Kennedy, *Peeping Tom's Cabin: Comic Verse 1928–2008* (Rochester, NY: Boa Editions, 2007), 35.

Kennedy, X.J., *Stuart Davis: Premier, 1957*
Stuart Davis, *Premier, 1957*
Source: Greenberg, *Heart* (2J, above), 17

KENNELLY, Brendan, *Designing Friday*
Edward Burra, *Dublin Street Scene No. 1*
Source: Reid and Rice (1J, above), 98–9

Kennelly, Brendan, *Herself and Himself*
Edward Burra, *Dublin Street Scene No. 1*
Source: Reid and Rice (1J, above), 129

KENYON, Jane, *Mosaic of the Nativity: Serbia, Winter 1993*
Source: Jane Kenyon, *Collected Poems* (St. Paul, MN: Graywolf Press, 2005), 273

KESSLER, Jascha, *Requiem for an Abstract Artist: Jackson Pollock, Dead August 1956, at the Wheel of His Convertible*
Source: *American Poems: A Contemporary Collection*, ed., Jascha Kessler (Carbondale: Southern Illinois University Press, 1964), 164–5

KETTLEHACK, Guy, *Ekphrasis ("Number 31, 1950")*
Jackson Pollock, *Number 31, 1950*
Source: http://www.autumnskypoetry.com/issues/Number7/Kettelhack.html

KHALVATI, Mimi, *A Persian Miniature*
Source: Mimi Khalvati, *In White Ink* (Manchester, UK: Carcanet, 1991), 48–9

KIETHLY, George, *Tintoretto*
Tintoretto, *The Crucifixion*
Source: *Ekphrasis* 2, no. 1 (Spring–Summer 2000): 48–9

KILLEBREW, Paul, *I Lack a Certain Presence of Mind*
Jules de Balincourt, *The Watchtower*
Source: Geha and Nichols (1N, above), 35–7

KILLEN, Chris, *Nighthawks*
Edward Hopper, *Nighthawks*
Source: *The Ragged Edge*, 2001. http://www.ragged-edge-mag.com/

KIMMELMAN, Burt, *Edvard Munch's "Despair"*
Source: *Courtland Review* Spring 2008. http://www.cortlandreview.com/features/08/spring/kimmelman.html

KING, Alan, *The Lovers*
Jacob Lawrence, *The Lovers*
Source: *Beltway Poetry Quarterly* 10, no. 1 (Winter 2009). http://washingtonart.com/beltway/contents.html

KING, Basil. For ninety-eight of King's poems on paintings and painters, see 4Z, above.

KING, Pat, *Hopper's "Nighthawks"*
Source: Forthcoming in *Encore 2008* (San Antonio, TX: National Federation of State Poetry Societies, 2009)

KINNELL, Galway, *Hitchhiker*
Edward Hopper
Source: Lyons and Weinberg (3Ja, above), 15–16

KINSELLA, John, *Lilith Invites the Great Poet Czeslaw Milosz into Bosch's "Garden of Earthly Delights"*
Source: Thomas Kinsella, *Poems 1980–1994* (Newcastle upon Tyne, UK: Bloodaxe Books, 1998), 197–8

Kinsella, John, *Beyond Dürer's Nativity*
Albrecht Dürer, *Nativity*
Source: John Kinsella, *Poems 1980–1994* (Newcastle upon Tyne, UK: Bloodaxe Books, 1998), 206

Kinsella, John, *Wheatbelt Gothic or Discovering a Wyeth*
Andrew Wyeth
Source: John Kinsella, *Poems 1980–1994* (Newcastle upon Tyne, UK: Bloodaxe Books, 1998), 209

Kinsella, John, *Vonal-Ksz*
Victor Vasarely, *Vonal Ksz*
Source: John Kinsella, *Poems 1980–1994* (Newcastle upon Tyne, UK: Bloodaxe Books, 1998), 252–5

Kinsella, John, *On Andy Warhol's "Baseball" and "Gold Marilyn Monroe"*
Source: John Kinsella, *Poems 1980–1994* (Newcastle upon Tyne, UK: Bloodaxe Books, 1998), 256

Kinsella, John, *On Andy Warhol's "Marilyn Six-Pack"*
Source: John Kinsella, *Poems 1980–1994* (Newcastle upon Tyne, UK: Bloodaxe Books, 1998), 256

Kinsella, John, *On Andy Warho's "Optical Car Crash"*
Source: John Kinsella, *Poems 1980–1994* (Newcastle upon Tyne, UK: Bloodaxe Books, 1998), 256–7

Kinsella, John, *On Warhol's "Marilyn Monroe's Lips" and "Red Disaster"*
Source: John Kinsella, *Poems 1980–1994* (Newcastle upon Tyne, UK: Bloodaxe Books, 1998), 257

Kinsella, John, *A 1963 "Lavender Disaster" and Andy Warhol*
Source: John Kinsella, *Poems 1980–1994* (Newcastle upon Tyne, UK: Bloodaxe Books, 1998), 258

Kinsella, John, *On Warhol's "Tunafish Disaster" and "Red Elvis"*
Source: John Kinsella, *Poems 1980–1994* (Newcastle upon Tyne, UK: Bloodaxe Books, 1998), 258–9

Kinsella, John, *On Warhol's "Blue Electric Chair" and "Statue of Liberty"*
Source: John Kinsella, *Poems 1980–1994* (Newcastle upon Tyne, UK: Bloodaxe Books, 1998), 259

Kinsella, John, *The Humble Gents Social Club/"Mustard Race Riot"*
Andy Warhol, *Mustard Race Riot*
Source: John Kinsella, *Poems 1980–1994* (Newcastle upon Tyne, UK: Bloodaxe Books, 1998), 260

Kinsella, John, *"Diamond Dust Joseph Beuys" à la Andy Warhol*
Source: John Kinsella, *Poems 1980–1994* (Newcastle upon Tyne, UK: Bloodaxe Books, 1998), 260

Kinsella, John, *Morris Graves' "Blind Bird" Is Given Sight*
Source: John Kinsella, *Poems 1980–1994* (Newcastle upon Tyne, UK: Bloodaxe Books, 1998), 261–2

Kinsella, John, *Helen Frankenthaler's "Interior Landscape"*
Source: John Kinsella, *Poems 1980–1994* (Newcastle upon Tyne, UK: Bloodaxe Books, 1998), 263

Kinsella, John, *On Kenneth Noland's "Turnsole," 1961*
Source: John Kinsella, *Poems 1980–1994* (Newcastle upon Tyne, UK: Bloodaxe Books, 1998), 266

Kinsella, John, *A Page on Balthus*
Balthus, *The Street*; *Portrait of André Derain*; and *The Living Room*
Source: John Kinsella, *Poems 1980–1994* (Newcastle upon Tyne, UK: Bloodaxe Books, 1998), 267

Kinsella, John, *On Susan Rothenberg's "Red Banner," 1979*
Source: John Kinsella, *Poems 1980–1994* (Newcastle upon Tyne, UK: Bloodaxe Books, 1998), 268

Kinsella, John, *Lilith Spies on Adam and Eve*
Arthur Boyd, *The Expulsion*
Source: John Kinsella, *Poems 1980–1994* (Newcastle upon Tyne, UK: Bloodaxe Books, 1998), 269

Kinsella, John, *Beyond Paul Klee's "Death and Fire"*
Source: John Kinsella, *Poems 1980–1994* (Newcastle upon Tyne, UK: Bloodaxe Books, 1998), 270

Kinsella, John, *Warhol at Wheatlands*
Andy Warhol
Source: John Kinsella, *Poems 1980–1994* (Newcastle upon Tyne, UK: Bloodaxe Books, 1998), 345

Kinsella, John, *On Warhol's "Camouflage Statue of Liberty" & Being Refused Entry into the United States by US Immigration*
Source: John Kinsella, *Poems 1980–1994* (Newcastle upon Tyne, UK: Bloodaxe Books, 1998), 347

Kinsella, John, *mondrian/laboratory/mounting pedestals*
Piet Mondrian, *Starry Sky above the Sea*
Source: John Kinsella, *Poems 1980–1994* (Newcastle upon Tyne, UK: Bloodaxe Books, 1998), 183

Kinsella, John, *Interpreting the Swan River Through the Eyes of Frances Possessed by Arthur Boyd's Bathers at Shoalhaven*
Arthur Boyd, *Bathers at Shoalhaven*
Source: John Kinsella, *Poems 1980–1994* (Newcastle upon Tyne, UK: Bloodaxe Books, 1998), 247

Kinsella, John, *Full Fathom Five*
Jackson Pollock, *Full Fathom Five*
Source: John Kinsella, *Poems 1980–1994* (Newcastle upon Tyne, UK: Bloodaxe Books, 1998), 248–50

Kinsella, John, *The Healing of the Circle*
Jackson Pollock, *The Moon Woman Cuts the Circle*
Source: John Kinsella, *Poems 1980–1994* (Newcastle upon Tyne, UK: Bloodaxe Books, 1998), 251

Kinsella, John, *Lavender Mist*
Jackson Pollock, *Lavender Mist*
Source: John Kinsella, *Poems 1980–1994* (Newcastle upon Tyne, UK: Bloodaxe Books, 1998), 251

Kinsella, John, *The Machinist*
Pablo Picasso, *Les Demoiselles d'Avignon*
Source: John Kinsella, *Poems 1980–1994* (Newcastle upon Tyne, UK: Bloodaxe Books, 1998), 187

KIRBY, David, *The Impressionists*
Impressionist painters in general
Source: *Shenandoah* 58, no.1 (Spring-Summer 2008): 32–4

Kirby, David, *Dear Rubens*
Peter Paul Rubens, *The Birth of Marie de' Medici* and other paintings by Rubens.
Source: *Ducts.org* 21 (Summer 2008). http://www.ducts.org/content/category/poetry/

KIRK, Kathleen, *Édouard Manet— Le Déjeuner sur l'herbe (1863)*
Source: *Ekphrasis* 3, no. 6 (Fall–Winter 2005): 41

Kirk, Kathleen, *Hotel Room*
Edward Hopper, *Hotel Room*
Source: *Ekphrasis* 4, no. 1 (Spring–Summer 2006): 34

Kirk, Kathleen, *Hagar in the Desert*
Pompeo Batoni, *Hagar in the Desert*
Source: *Ekphrasis* 4, no. 2 (Fall–Winter 2006): 10

Kirk, Kathleen, *The Ghost of Banquo*
Théodore Chassériau, *The Ghost of Banquo*
Source: *Ekphrasis* 4, no. 4 (Fall–Winter 2007): 25

Kirk, Kathleen, *The Fairy Tale*
William Merritt Chase, *The Fairy Tale*
Source: *Ekphrasis* 4, no. 3 (Spring–Summer 2007): 35

Kirk, Kathleen, *Portage*
Winslow Homer, *Osprey's Nest*
Source: *Ekphrasis* 4, no. 6 (Fall–Winter 2008): 23

Kirk, Kathleen, *Nostalgia*
Winslow Homer, *For to Be a Farmer's Boy*
Source: *Ekphrasis* 4, no. 6 (Fall–Winter 2008): 27

Kirk, Kathleen, *Under the Tree*
Arthur Hacker, *The Cloister or the World*
Source: *Beauty/Truth: A Journal of Ekphrastic Poetry* 1, no. 1 (Fall–Winter 2006): 10–11

Kirk, Kathleen, *Angel of Death*
Evelyn de Morgan, *The Angel of Death*
Source: *Beauty/Truth: A Journal of Ekphrastic Poetry* 1, no. 1 (Fall–Winter 2006): 12

Kirk, Kathleen, *Flight into Egypt*
Federico Barocci, *Flight into Egypt*
Source: *Beauty/Truth: A Journal of Ekphrastic Poetry* 1, no. 1 (Fall–Winter 2006): 13

Kirk, Kathleen, *Silver Sun*
Arthur Dove, *Silver Sun*
Source: *Beauty/Truth: A Journal of Ekphrastic Poetry* 1, no. 3 (Fall–Winter 2007): 27

Kirk, Kathleen, *The Cot*
John Sloan, *The Cot*
Source: *Beauty/Truth: A Journal of Ekphrastic Poetry* 1, no. 3 (Fall–Winter 2007): 28

Kirk, Kathleen, *Nocturne*
James McNeil Whistler, *Nocturne— Blue and Silver: Cermorne Lights*
Source: *Beauty/Truth: A Journal of Ekphrastic Poetry* 1, no. 2 (Spring–Summer 2007): 24

KIRKPATRICK, Kathryn, *Bird Goddess*
Susan Seddon Boulet, *The Goddess Paintings*
Source: *Ekphrasis* 4, no. 2 (Fall–Winter 2006): 23

Kirkpatrick, Kathryn, *Aphrodite*
Susan Seddon Boulet, *The Goddess Paintings*
Source: *Ekphrasis* 3, no. 3 (Spring–Summer 2004): 12

KIRKUP, James, *A Picture by Claude*
Claude Lorrain, an amalgam from Lorraine's pictures in the National Gallery (London)
Source: James Kirkup, *A Correct Compassion and Other Poems* (London: Oxford University Press, 1952), 17; German trans., Kranz (2B, above), 186

KIRSCH, Sarah, *Brueghel-Bild*
Pieter Brueghel the Elder, *The Hunters in the Snow*
Source: Kranz (2B, above), 95

Kirsch, Sarah, *Chagall in Witebsk*
Marc Chagall, *The Revolution*
Source: Kranz (2B, above), 247

KIRSCHTEN, Robert. For forty of Kirschten's poems on paintings, see 4K, above.

KITCHEN, Judith, *Springtime in the Pool*
Charles Ephraim Burchfield, *Springtime in the Pool*
Source: Holcomb (1I, above), 110–12

KLEIN, Rosemary, *Moonlight, Wood Island Light: Maine 1894*
Winslow Homer, *Moonlight, Wood Island Light*
Source: *Ekphrasis* 1, no. 4 (Fall–Winter 1998): 25

Klein, Rosemary, *Image Birthed as Language*
Marc Chagall, *Lost in the Lilacs*
Source: *Ekphrasis* 1, no. 5 (Spring–Summer 1999): 36

KLETNIKOV, Eftim, *The Prayer at the Mount of Olives*
Vladimir Georgievski, *The Prayer at the Mount of Olives*
Source: Martinovski (2K, above), 124

KLINKENBIJL, Cor, *Mona Lisa*
Leonardo da Vinci, *Mona Lisa*
Source: Kranz (2B, above), 132–3

KLÜNNER, Lothar, *Femme au Corsage bleu: Zu dem Bilde Pablo Picassos*
Pablo Picasso, *Woman with Hat Seated in an Armchair*
Source: Kranz (2B, above), 243

KNIES, Elizabeth, *Late Monet*
Claude Monet
Source: Elizabeth Knies, *White Peonies* (Durham, NH: Oyster River Press, 2001), 21

KNIGHT, Lynne. For fifteen poems on the French Impressionists, see 4L, above.

KNUDSEN, Erik, *Ordnung der Welt*
Francisco Goya, *The Third of May, 1808: The Execution of the Defenders of Madrid*
Source: Erik Knudsen, *Digte 1945–1958* (Kopenhagen: Gyldendal); German trans., Kranz (2B, above), 197

KOEGLER, Karen, *"Six Persimmons" by Mu-Ch'i*
Source: *Ekphrasis* 2, no. 4 (Fall–Winter 2001): 43.

KOENIG, Théodore, *A Pierre Brueghel*
Pieter Brueghel the Elder, *Landscape with the Fall of Icarus*
Source: Théodore Koenig, *La métamorose* (Bruxelles: Phantomas; Paris: Diffusion, Argon, 1980), 55

KOERTGE, Ron, *Ringside*
George Bellows, *Stag at Sharkey's*
Source: Greenberg, *Heart* (2J, above), 22–3

KOLLAR, Sybil, *An Old Lover's Painting That Looks Something Like a Whale*
Martin Bloom, unidentified oil painting
Source: *Ekphrasis* 1, no. 3 (Spring–Summer 1998): 25

KOMUNYAKAA, Yusef, *Guernica*
Pablo Picasso, *Guernica*
Source: *American Poetry Review* May–June 2008, and at *Poetry Daily*, 15 July 2008: http://poetrydaily.org/poem.php?date=14076

KONESKI, Blaže, *A Visit to a Museum*
Claude Monet, *Red Lines*, Pablo Picasso, *Guernica*
Source: Martinovski (2K, above), 69

Koneski, Blaže, *Guté's Burial*
Unidentified painter and painting
Source: Martinovski (2K, above), 125

KONOPKA, Autumn, *Wheatfield under Threatening Skies*
Vincent Van Gogh, *Wheatfield with Crows*
Source: *Ekphrasis* 3, no. 6 (Fall–Winter 2005): 38–9

KOOSER, Ted, *Four Civil War Paintings by Winslow Homer*
Winslow Homer, *Sharpshooter; The Bright Side; Prisoners From the Front;* and *The Veteran in a New Field*
Source: Ted Kooser, *Delights & Shadows* (Port Townsend, WA: Copper Canyon, 2004), 46–50

KOPELKE, Kendra, *Woman in the Sun*
Edward Hopper, *A Woman in the Sun*
Source: *Beltway Poetry Quarterly* 10, no. 1 (Winter 2009). http://washingtonart.com/beltway/contents.html

Kopelke, Kenrda, *Western Motel*
Edward Hopper, *Western Motel*
Source: http://raven.ubalt.edu/scd/samples/kopelke.html

KOPLAND, Rutger, *"Winter van Breughel, de heuvel met de jagers"*
Pieter Brueghel the Elder, *Hunters in the Snow*
Source: Korteweg and Heijn (2F, above), 89

KRAMER, Aaron, *Portrait by Alice Neel*
Alice Neel, Unindentified male portrait
Source: Helen Plotz, ed., *Eye's Delight: Poems of Art and Architecture* (New York: Greenwillow Books, 1983), 5

KRANZ, Gisbert, *Bruegel*
Pieter Brueghel the Elder, *Landscape with the Fall of Icarus*
Source: Gisbert Kranz, *Niederwald und andere Gedichte* (Lüdenschied: Klaren, 1984), 89; and Achim Aurnhammer and Dieter Martin, eds., *Mythos Ikarus: Texte von Ovid bis Wolf Biermann* (Leipzig: Reclam, 2001), 211

KRAPF, Norbert, *At Dürer's Self-Portrait*
Albrecht Dürer, *Self-Portrait*
Source: Norbert Krapf, *Blue-Eyed Grass: Poems of Germany* (St. Louis, MO: Time Being Books, 1997), 24

Krapf, Norbert, *Rural Lines after Brueghel: 1. Returning from the Hunt; 2. Making Hay; 3. Harvesting Wheat; 4. Bringing Home the Herd; 5. A Gloomy Day*
Pieter Brueghel the Elder, *Hunters in the Snow, Hay*

Making, The Corn Harvest, The Return of the Herd, and *The Gloomy Day*
Source: *Poetry* 124 (September 1974): 338–42; rpt. in Norbert Krapf, *Blue-Eyed Grass: Poems of Germany* (St. Louis, MO: Time Being Books, 1997), 43–7. *Returning from the Hunt, Harvesting Wheat,* and *A Gloomy Day* are also in Buchwald and Roston (2C, above), 66–9

Krapf, Norbert, *Stag Hunt*
Lucas Cranach the Elder, *The Stag Hunt of the Elector Frederick the Wise*
Source: Norbert Krapf, *Blue-Eyed Grass: Poems of Germany* (St. Louis, MO: Time Being Books, 1997), 51–2

Krapf, Norbert, *Village in Snowstorm*
Lucas van Valckenborch, *Winter*
Source: Norbert Krapf, *Blue-Eyed Grass: Poems of Germany* (St. Louis, MO: Time Being Books, 1997), 48

Krapf, Norbert, *Lines Drawn from Dürer*
Albrecht Dürer, sketchbook; *Portrait of Frederick the Wise, Portrait of Oswalt Krell, The Four Horsemen of the Apocalypse, The Prodigal Son, The Large Turf, Self-Portrait* (1500), illustrations for Emperor Maximilian's prayer book, sketches of his wife Agnes, et al.
Source: Norbert Krapf, *Blue-Eyed Grass: Poems of Germany* (St. Louis, MO: Time Being Books, 1997), 53–67

Krapf, Norbert, *Dürer's Piece of Turf*
Albrecht Dürer, *The Large Turf*
Source: Buchwald and Roston (2C, above), 22–3

Krapf, Norbert, *Helga in Night Shadow*
Andrew Wyeth, *Night Shadow*
Source: *Ekphrasis* 2, no. 1 (Spring–Summer 2000): 37

KREILING, Jean L., *Winslow Homer's "Breezing Up"*
Winslow Homer, *Breezing Up (A Fair Wind)*
Source: *Ekphrasis* 2, no. 1 (Spring–Summer 2000): 14

KREITER-FORONDA, Carolyn, *Nude Descending in All Directions*
Marcel Duchamp, *Nude Descending a Staircase (No. 2)*
Source: *Beltway Poetry Quarterly* 10, no. 1 (Winter 2009). http://washingtonart.com/beltway/contents.html

KRESS, Leonard, *After Dance of Death*
Hans Holbein, *Dance of Death*
Source: http://www.guardian.co.uk/books/2006/oct/23/poetry

KREYMBORG, Alfred, *Cézanne*
Paul Cézanne

Source: *The New Poetry: An Anthology*, ed. Harriet Monroe and Alice Corbin Henderson (New York: Macmillan, 1917), 152

KRIEL, Margot, *The Annunciation*
Leonardo da Vinci, *The Annunciation*
Source: Buchwald and Roston (2C, above), 95

KRIEWALD, G.L., *Descent from the Cross*
Unknown Flemish master, ca. 1450
Source: *Beauty/Truth: A Journal of Ekphrastic Poetry* 1, no. 2 (Spring–Summer 2007): 31

KRISAK, Len, *View of Mt. Fuji, #64*
Katsushika Hokusai, *View of Mt. Fuji*
Source: *Ekphrasis* 1, no. 6 (Fall–Winter 1999): 18

KROHN, Silvia, *After Having Seen Chagall's Fiancés at the Eiffel Tower Next to a Sky Sharing Goats with a Yellow Violin Dream*
Marc Chagall, *Les Fiancés de la Tour Eiffel*
Source: *New Generation: Poetry Anthology*, ed., Fred Wolven and Duane Locke (Ann Arbor, MI: Review Book, 1971), 64.

KROLL, Ernest, *Marc Chagall*
Source: *Poetry* 83 (October 1953): 16

Kroll, Ernest, *Marin No More in Maine*
John Marin
Source: *Poetry* 85 (November 1954): 131

KRONEN, Steve, *After Viewing Twelve Versions of Madonna and Child*
Images from Madonna/Child artists and paintings in general
Source: Steve Kronen, *Empirical Evidence* (Athens, GA: University of Georgia Press, 1992), 3–4

KROUSE, Kerry, *Wax and Gold V*
Wosene Worke Korsof, *Wax and Gold V*
Source: *Mississippi Review* 14, no. 4 (October 2008). http://www.mississippireview.com/2008/Vol14No4-Oct08/1404-100108-00introduction.html

KRUEGER, Angela DeSantis, *The Transitive Moment*
Arthur Dove, *Moon*
Source: *Ekphrasis* 4, no. 6 (Fall–Winter 2008): 21

KULAVKOVA, Katica, *The Holy Family*
Visions from the paintings of the Italian masters from the seventeenth century
Source: Martinovski (2K, above), 83–5

KULP, Ruth A. Meyers, *The Annunciation by Tanner*
Henry Ossawa Tanner, *The Annunciation*
Source: *Ekphrasis*, 3, no. 6 (Fall–Winter 2005): 9–10

KUMBAROSKI, Razme, *The Magic Seeker*
Max Ernst
Source: Martinovski (2K, above), 93

KUMBIER, William A., *In Black and White*
Paul Delvaux, *La ville inquiète*
Source: *Ekphrasis* 1, no. 3 (Spring–Summer 1998):
 30

KUMIN, Maxine, *Gardner Museum Fenway, Boston*
John Singer Sargent, *Portraits of Mrs. Isabella Gardner*
Source: Maxine Kumin, *Halfway* (New York: Holt,
 Rinehart and Winston, 1961), 66–7

Kumin, Maxine, *A Calling*
Georgia O'Keeffe
Source: Maxine Kumin, *Selected Poems, 1960–1990*
 (New York: Norton, 1997), 275

KÜNERT, Gunert, *The Scream*
Edvard Munch, *The Scream*
Source: Greenberg, *Side* (2M, above), 38–9

KUNITZ, Stanley, *Words for the Unknown Makers: A
 Garland of Commemorative Verses*
Suite of poems on the exhibition "The Flowering
 of American Folk Art 1776–1876," Whitney Mu-
 seum, February–March 1974
Source: *The Poems of Stanley Kunitz* (London:
 Secker & Warburg, 1979), 8–14

Kunitz, Stanley, *The Sea, That Has No Ending*
Philip Guston, *Green Sea*
Source: Stanley Kunitz, *Passing Through* (New York:
 Norton, 1995), 153–5; and Hirsch (1D, above),
 98–9

Kunitz, Stanley, *The Artist*
Mark Rothko
Source: Stanley Kunitz, *Passing Through* (New York:
 Norton, 1995), 63

Kunitz, Stanley, *Chariot*
Varujan Boghosian
Source: Stanley Kunitz, *Passing Through* (New York:
 Norton, 1995), 144–5

KUSHNER, Dale, *Landscape with Heart: Hans Hoff-
 man in Manhattan*
Hans Hofmann, *August Light*
Source: *Wisconsin Poets* (1E, above), 50–1

KUSTERS, Wiel, *Bruegel: Dulle Griet*
Pieter Brueghel the Elder, *Mad Meg*
Source: Korteweg and Heijn (2F, above), 87

KUZMIN, Mikhail, *Fuji in a Saucer*
Katsushika Hokusai, *One Hundred Views of Mt. Fuji*
Source: http://etc.dal.ca/kuzmin/fuji_poem.html;
 orig. appeared in *Nezdeshnie vechera: Stikhi, 1914–
 1920* [*Otherworldly Evenings: Poems 1914–1920*]
 (Petrograd: Golike and Wilborg 1921)

LACABA, Jose F., *Sampayan*
Heber Bartolome, *Sinampay*
Source: http://kapetesapatalim.blogspot.com/200
 8/02/ekphrasis-sampayan.html

Lacaba, Jose F., *Sunday Afternoon on the Island of La
 Grande Jatte*
Georges Seurat, *La Grand Jatte*
Source: http://72.14.205.104/search?q=cache:VA8
 P7ATj9qkJ:https://208.101.115.3/cgi-bin/nph-n
 oc.pl/111110A/http/kapetesapatalim.blogspot.com/
 2008/04/ekphrasis-seurat-botticelli.html+ekphras
 is+OR+ecphrasis&hl=en&ct=clnk&cd=4&gl=us
 &lr=lang_tl

Lacaba, Jose F., *"The Birth of Venus" Uncensored*
Sandro Botticelli, *The Birth of Venus*
Source: http://72.14.205.104/search?q=cache:VA8
 P7ATj9qkJ:https://208.101.115.3/cgi-bin/nph-n
 oc.pl/111110A/http/kapetesapatalim.blogspot.com/
 2008/04/ekphrasis-seurat-botticelli.html+ekphras
 is+OR+ecphrasis&hl=en&ct=clnk&cd=4&gl=us
 &lr=lang_tl

LAING, Dilys, *St. Giotto of Assisi*
Giotto di Bondone, *St. Francis Giving His Mantel to
 a Poor Knight*
Source: *Collected Poems of Dilys Laing* (Cleveland:
 Press of Case Western Reserve University, 1967),
 19

Laing, Dilys, *Six Picassos*
Pablo Picasso
Source: *Collected Poems of Dilys Laing* (Cleveland:
 Press of Case Western Reserve University, 1967),
 34

Laing, Dilys, *Song After Seven Glasses by Picasso*
Pablo Picasso
Source: *Collected Poems of Dilys Laing* (Cleveland:
 Press of Case Western Reserve University, 1967),
 8–9

Laing, Dilys, *Picasso's Candlefire*
Pablo Picasso, *Still Life with Candlestick*
Source: *Poetry* 97 (March 1961): 362, rpt. in *Collected
 Poems of Dilys Laing* (Cleveland: Press of Case
 Western Reserve University, 1967), 345

Laing, Dilys, *Explaining van Gogh*
Vincent Van Gogh
Source: *Collected Poems of Dilys Laing* (Cleveland:
 Press of Case Western Reserve University, 1967),
 411

LALLY, Michael, *Obsession, Possession, and Doing
 Time*
Pierre Bonnard, unidentified painting
Source: Michael Lally, *Cant Be Wrong* (Minneapo-
 lis, MN: Coffee House Press, 1996), 80–3

LAMANTIA, Philip, *Horse Angel*
Henry Fuseli, *The Nightmare*
Source: Philip Lamantia, *Bed of Sphinxes: New &
 Selected Poems 1943–1993* (San Francisco, CA:
 City Lights Books, 1997), 89

LAMB, Charles, *On the Celebrated Picture of Lionardi da Vinci, Called "The Virgin of the Rocks"*
Leonardo da Vinci, *The Virgin of the Rocks*
Source: *The Works of Charles and Mary Lamb*, vol. 5 (New York: G.P. Putnam's Sons, 1903), 39

LAMB, Mary, *Lines, On the Same Picture Being Removed to Make Place for a Portrait of a Lady by Titian*
Leonardo da Vinci, *Modesty and Vanity* (also known as *Prudence and Beauty*)
Source: *The Works of Charles and Mary Lamb*, vol. 5 (New York: G.P. Putnam's, 1903), 39–40

Lamb, Mary, *Lines Suggested by a Picture of Two Females by Lionardo da Vinci*
Leonardo da Vinci, *Modesty and Vanity* (also known as *Prudence and Beauty*)
Source: *The Works of Charles and Mary Lamb*, vol. 5 (New York: G.P. Putnam's Sons, 1903), 38

LAMOTHE, Lorene, *Girls on the Bridge, 1899*
Edvard Munch, *Girls on the Bridge*
Source: *Ekphrasis* 3, no. 4 (Fall–Winter 2004): 13

Lamothe, Lorene, *Mermaid in Full Moonlight*
Paul Delvaux, *A Siren in Full Moonlight*
Source: *Ekphrasis* 3, no. 4 (Fall–Winter 2004): 14

LAMPONIUS, Dominicus, *Hieronymo Boschio Pictori* [German trans. *An der Maler Hieronymus Bosch*]
Hieronymus Bosch
Source: Kranz (2B, above), 75

LAMPRON, Alana B., *Mindful*
Lowell Fox, *January Beach*
Source: http://lowellfox.com/page5-contributingpoets/index.htm#januarybeach

LAM THI MY DA, *The Color of Phai Street*
Bùi Xuân Phái, *Small Street*
Source: Greenberg, *Side* (2M, above), 12–13

LANDFAIR, Alexander, *From the Artist's Notebook*
Pierre Bonnard, *Le Bol de Lait* (*The Bowl of Milk*)
Source: *Spoon River Poetry Review* (Spring–Fall 2008)

LANE, Liz, *Nighthawks (Edward Hopper, 1942)*
Source: http://www2.bc.edu/~dohertyp/web_site/nighthawks.htm; appeared orig. in *Stylus* (Boston College)

LANGLAND, Joseph, *Hunters in the Snow: Brueghel*
Source: Joseph Langland, *Collected Poems* (Amherst: University of Massachusetts Press, 1991), 98–9

Langland, Joseph, *The Fall of Icarus: Brueghel*
Pieter Brueghel the Elder, *Landscape with the Fall of Icarus*
Source: Joseph Langland, *Collected Poems* (Amherst: University of Massachusetts Press, 1991), 97; *The Wheel of Summer* (New York: Dial Press, 1963),

113–14; Kehl (2A, above), 108–9; and Benton and Benton, *Double Vision* (2E, above), 95

Langland, Joseph, *Henri Matisse*
Source: Joseph Langland, *Collected Poems* (Amherst: University of Massachusetts Press, 1991), 100

LARKIN, Eve, *Migration of Butterflies by Moonlight*
Charles Burchfield, *Migration of Butterflies by Moonlight*
Source: *Wisconsin Poets* (1E, above), 56–7

LARKIN, Mary Ann, *Farmer Plowing*
Ross Moffett
Source: *Beltway Poetry Quarterly* 10, no. 1 (Winter 2009) http://washingtonart.com/beltway/contents.html

LARSEN, Lance, *With Chagall as My Tail Wind*
Marc Chagall, images from multiple Chagall paintings
Source: *Salmagundi* 160–61 (Fall 2008–Winter 2009):166

LARWILL, Jim, *Season's Warmth*
John P. Hiscock, *Season's Warmth*
Source: http://jphiscock.ca/section.php?ID=12&Lang=En&Nav=Section

Larwill, Jim, *Moon Water*
John P. Hiscock, *Moon Water*
Source: http://jphiscock.ca/section.php?ID=12&Lang=En&Nav=Section

Larwill, Jim, *Back Road to Dignity*
John P. Hiscock, *Back Road to Dignity*
Source: http://jphiscock.ca/section.php?ID=12&Lang=En&Nav=Section

Larwill, Jim, *Divinity Sky*
John P. Hiscock, *Divinity Sky*
Source: http://jphiscock.ca/section.php?ID=12&Lang=En&Nav=Section

Larwill, Jim, *The Old Place*
John P. Hiscock, *The Old Place*
Source: http://jphiscock.ca/section.php?ID=12&Lang=En&Nav=Section

LASDUN, James, *The Calling of the Apostle Matthew*
Unidentified painting of the calling of Matthew
Source: James Lasdun, *Woman Police Officer in Elevator* (New York: Norton, 1997), 11–12

LASKOWSKI-CAUJOLLE, E.M., *Awakening*
Jack N. Mohr, *Eruption II*
Source: *Paintings & Poems/Poems & Paintings* (Santa Barbara, CA: Artamo, 2007), 4

Laskowski-Caujolle, E.M., *My Picasso*
Jack N. Mohr, *Red Night*
Source: *Paintings & Poems/Poems & Paintings* (Santa Barbara, CA: Artamo, 2007), 4

Laskowski-Caujolle, E.M., *Fire*
Jack N. Mohr, *The Fire*

Source: *Paintings & Poems/Poems & Paintings* (Santa Barbara, CA: Artamo, 2007), 4

Laskowski-Caujolle, E.M., *Beyond Pathways*
Michael Moon, *Beyond Pathways No. 31*
Source: *Paintings & Poems/Poems & Paintings* (Santa Barbara, CA: Artamo, 2007), 5

Laskowski-Caujolle, E.M., *Big City Girl*
Julia Pinkham, *Girl Disappearing*
Source: *Paintings & Poems/Poems & Paintings* (Santa Barbara, CA: Artamo, 2007), 6

LASKY, Dorothea, *Go On There, Boy*
Dana Schutz, *Missing Link Finds Superman*
Source: Geha and Nichols (1N, above), 95–8

LATTIMORE, Richmond, *Poussin's World: Two Pictures*
Nicholas Poussin
Source: Richmond Lattimore, *Sestina for a Far-Off Summer: Poems 1957–1962* (Ann Arbor: University of Michigan Press, 1962), 25

Lattimore, Richmond, *Tudor Portrait*
William Sonmans, *Portrait of Henry VIII*
Source: Richmond Lattimore, *Poems* (Ann Arbor: University of Michigan Press, 1962), 59–60, and in Helen Plotz, ed., *Eye's Delight: Poems of Art and Architecture* (New York: Greenwillow Books, 1983), 22–3

Lattimore, Richmond, *Max Schmitt in a Single Scull*
Thomas Eakins, *Max Schmitt in a Single Scull*
Source: Richmond Lattimore, *Sestina for a Far-off Summer* (Ann Arbor: University of Michigan Press, 1962), 5; and Helen Plotz, ed., *Eye's Delight: Poems of Art and Architecture* (New York: Greenwillow Books, 1983), 15

Lattimore, Richmond, *The Father*
Pablo Picasso
Source: Richmond Lattimore, *Sestina for a Far-Off Summer: Poems 1957–1962* (Ann Arbor: University of Michigan Press, 1962), 7; and Helen Plotz, ed, *Eye's Delight: Poems of Art and Architecture* (New York: Greenwillow Books, 1983), 16

LAUGHLIN, James, *The Flemish Double Portrait*
Fifteenth-century portrait in the Hermitage of two aristocratic women
Source: James Laughlin, *Poems New and Selected* (New York: New Directions, 1997), 101

Laughlin, James, *Two for One*
Egon Schiele
Source: James Laughlin, *A Commonplace Book of Pentastichs* (New York: New Directions, 1998), 11

Laughlin, James, *The Blindfolded Lovers*
René Magritte, *Les Amants*
Source: James Laughlin, *A Commonplace Book of Pentastichs* (New York: New Directions, 1998), 49

Laughlin, James, *Odd Goings-on in Philadelphia*
Thomas Eakins
Source: James Laughlin, *A Commonplace Book of Pentastichs* (New York: New Directions, 1998), 70

Laughlin, James, *Artaud on Van Gogh*
Source: James Laughlin, *A Commonplace Book of Pentastichs* (New York: New Directions, 1998), 79

Laughlin, James, *"L'argent n'a pas d'odeur"*
Rosa Bonheur, *L'Orage*
Source: James Laughlin, *The Man in the Wall* (New York: New Directions, 1993), 27

Laughlin, James, *Skiing in Tahiti*
Paul Gauguin
Source: James Laughlin, *The Man in the Wall* (New York: New Directions, 1993), 38

Laughlin, James, *The Kiss*
Gustav Klimt, *The Kiss*
Source: James Laughlin, *The Man in the Wall* (New York: New Directions, 1993), 94

Laughlin, James, *The Country Road*
Marjorie Phillips, *The Country Road*
Source: James Laughlin, *Poems New and Selected* (New York: New Directions, 1998), 110–11

LAUTERBACH, Ann, *Edward Hopper's Way*
Images from various of Hopper's paintings
Source: Lyons and Weinberg (3Ja, above), 35–9

LAUTERMILCH, Steven, *Quarry*
David Freed, *Reflection*
Source: *Ekphrasis* 3, no. 6 (Fall–Winter 2005): 28

Lautermilch, Steven, *Why the Stone Remains Silent*
M.C. Escher, *Day and Night*
Source: *Ekphrasis* 4, no. 4 (Fall–Winter 2007): 14–15

Lautermilch, Steven, *Painting in Red Ochre and Sandstone*
Ute drawing, Cottonwood Canyon, Uintah Peninsula
Source: *Ekphrasis* 3, no. 5 (Spring–Summer 2005): 23–4

Lautermilch, Steven, *A Young Tree*
Emily Carr, *A Young Tree*
Source: *Ekphrasis* 4, no. 6 (Fall–Winter 2008): 11

Lautermilch, Steven, *Confession and Penance: "The Bathers," 1898–1907*
Paul Cézanne, *The Bathers*
Source: *Comstock Review* 21, no. 2 (Fall–Winter 2007): 8–9

LAVILLA-HAVELIN, Jim, *A Showery Day, Lake George*
John Frederick Kensett, *A Showery Day, Lake George*
Source: Holcomb (1I, above), 116–8

LAW, Thomas, *Niagara*
Frederic Edwin Church, *Niagara*
Source: Thomas Law, *Ballston Springs* (New York: S. Gould, 1806), 8–10

LAWRENCE, C.T., *My Year of Riding with Death*
Jean-Michel Basquiat, *Riding with Death*
Source: *Ekphrasis* 1, no. 5 (Spring–Summer 1999): 46

LAWRENCE, D.H., *Michel Angelo*
Michelangelo, *The Creation of Adam* (Sistine Chapel)
Source: *The Complete Poems of D.H. Lawrence* (New York: Viking, 1971), 69

Lawrence, D.H., *Corot*
Unidentified Corot paintings Lawrence had seen at a London art gallery
Source: *The Complete Poems of D.H. Lawrence* (New York: Viking, 1971), 68–9

Lawrence, D.H., *The Fall of Day*
Dante Gabriel Rossetti, *Sunset Wings*
Source: D.H. Lawrence, *Complete Poems* (Harmondsworth: Penguin, 1993), 854–5

LAZZERONI, Elaine, *Self and Shadow*
Salvador Dali, *The Great Masturbator*
Source: *Ekphrasis* 1, no. 2 (Winter 1997–98): 38

LEADER, Mary, *Girl at Sewing Machine*
Edward Hopper, *Girl at Sewing Machine*
Source: Mary Leader, *Red Signature* (St. Paul, MN: Graywolf Press, 1997); and http://www.english.emory.edu/classes/paintings&poems/sewing.html

LEALE, B.C., *Sketch by Constable*
John Constable, *Willy Lott's House Near Flatford Mill*
Source: Abse (2D, above), 82; and Benton and Benton, *Double Vision* (2E, above), 58

Leale, B.C., *Van Gogh, July 1890*
Vincent Van Gogh, *Wheatfield under Threatening Skies with Crows* (*Cornfield with Crows*)
Source: Benton and Benton, *Double Vision* (2E, above), 39–41

Leale, B.C., *The Scream*
Edvard Munch, *The Scream*
Source: Benton and Benton, *Double Vision* (2E, above), 101

LEE, Bridget-Rose, *Nighthawks*
Edward Hopper, *Nighthawks*
Source: *Quarterly Literary Review Singapore* 4, no. 2 (January 2005) http://www.qlrs.com/poem.asp?id=408

LEE, Li-Young, *The Father's House*
Li-Lin Lee, *Corban Ephphatha I*
Source: Hirsch (1D, above), 118–21

LEE, Sueyeun Juliette, *Down the mountain (an afternoon appearance of man and mystery)*

Lamar Peterson, *Untitled*
Source: Geha and Nichols (1N, above), 73–6

LEEFLANG, Ed, *Als Paulus*
Rembrandt van Rijn, *Self-Portrait as the Apostle Paul*
Source: Korteweg and Heijn (2F, above), 143

Leeflang, Ed, *Adriaen Coorte*
Adriaen Coorte, *Still Life with Asparagus, Gooseberries, and Strawberries*
Source: Korteweg and Heijn (2F, above), 178

LEHMAN, David, *Edvard Munch*
Source: *Poetry* 123 (December 1973): 142

LEHMAN, Gary Paul, *Unless I Feel the Wound*
Caravaggio, *The Incredulity of St. Thomas*
Source: *Mississippi Review* 14, no. 4 (October 2008). http://www.mississippireview.com/2008/Vol14No4-Oct08/1404-100108-Lehmann.html

LEIDIG, Dan, *Collage*
Rachel Denham, *The Gold Watch*
Source: Dan Leidig, *Time Out* (Abingdon, VA: Sow's Ear Press, 2000), [ii]

LEITHAUSER, Brad, *The Tigers of Nanzen-Ji*
Japanese screen painting
Source: Brad Leithauser, *Cats of the Temple* (New York: Knopf, 1986), 55–7

LELAND, Kurt, *Self-Portrait*
Vincent Van Gogh, *Self-Portrait*
Source: *Ekphrasis* 1, no. 4 (Fall–Winter 1998): 16–17

LEMAY, Shawna, *Doe in a Mint-Green Clearing.*
Rachel Ruysch
Source: Shawna Lemay, *All the God-Sized Fruit* (Montreal: McGill-Queens University Press, 1999), 12–15

Lemay, Shawna, *Leaves or Paper or Wood*
Paula Modersohn-Becker, *Self Portrait*
Source: Shawna Lemay, *All the God-Sized Fruit* (Montreal: McGill-Queens University Press, 1999), 16–22

Lemay, Shawna, *Pink Undertones*
Peter Paul Rubens, *Marie d'Medici, Queen of France, Landing in Marseilles*
Source: Shawna Lemay, *All the God-Sized Fruit* (Montreal: McGill-Queens University Press, 1999), 28–9

Lemay, Shawna, *The Drapes Floating All around Me*
Caravaggio, *Death of the Virgin*
Source: Shawna Lemay, *All the God-Sized Fruit* (Montreal: McGill-Queens University Press, 1999), 35–8

Lemay, Shawna, *Take It Back: An Ode to a Shrimp Woman*
Jean-Auguste-Dominique Ingres, *Grand Odalisque*
Source: Shawna Lemay, *All the God-Sized Fruit*

(Montreal: McGill-Queens University Press, 1999), 35–8

Lemay, Shawna, *A Thousand Words*
Giuseppe Arcimboldo, *Summer*
Source: Shawna Lemay, *All the God-Sized Fruit* (Montreal: McGill-Queens University Press, 1999), 38–46

Lemay, Shawna, *Even Venus Had to Learn to Love*
Diego Velázquez, *The Rokeby Venus*
Source: Shawna Lemay, *All the God-Sized Fruit* (Montreal: McGill-Queens University Press, 1999). 46–52

Lemay, Shawna, *Dead Skin Dust*
Leonardo da Vinci, *The Last Supper*
Source: Shawna Lemay, *All the God-Sized Fruit* (Montreal: McGill-Queens University Press, 1999)

Lemay, Shawna, *The Artemisia Gentilischi Poems*
Artemisia Gentilischi
Source: Shawna Lemay, *All the God-Sized Fruit* (Montreal: McGill-Queens University Press, 1999), 89–109

Lemay, Shawna, *The Inferior Realms*
Antonio Visentini, *San Marco Piazza*
Source: Shawna Lemay, *Against Paradise* (Toronto: McClelland & Stewart, 2001), 53–4

Lemay, Shawna, *Judith II, Galleria d'Arte Moderna, Venice*
Gustav Klimt, *Judith II*
Source: Shawna Lemay, *Against Paradise* (Toronto: McClelland & Stewart, 2001), 55–6

Lemay, Shawna, *Whose Name Is Fluid*
Bellini, Titian, Canaletto
Source: Shawna Lemay, *Against Paradise* (Toronto: McClelland & Stewart, 2001), 57–8

Lemay, Shawna, *Detail of Giovanni Bellini's "Young Woman with a Mirror"*
Source: Shawna Lemay, *Against Paradise* (Toronto: McClelland & Stewart, 2001), 60

Lemay, Shawna, *Detail of Accessory, Titian's "Madonna and Child with Saints John the Baptist and Catherine"*
Source: Shawna Lemay, *Against Paradise* (Toronto: McClelland & Stewart, 2001), 61

Lemay, Shawna, *Shower of Gold, Detail of Titian's "Danae"*
Source: Shawna Lemay, *Against Paradise* (Toronto: McClelland & Stewart, 2001), 62

Lemay, Shawna, *Passages of Red*
Titian
Source: Shawna Lemay, *Against Paradise* (Toronto: McClelland & Stewart, 2001), 63

Lemay, Shawna, *The Heart, a Cold Blood-Orange*
Vittore Carpaccio, *The Dream of St. Ursula*
Source: Shawna Lemay, *Against Paradise* (Toronto: McClelland & Stewart, 2001), 64–5

Lemay, Shawna, *Saint Ursula Revisited*
Vittore Carpaccio, *The Dream of St. Ursula*
Source: Shawna Lemay, *Against Paradise* (Toronto: McClelland & Stewart, 2001), 66–7

Lemay, Shawna, *Lower Right-Hand Corner*
J.M.W. Turner, *Juliet and Her Nurse*
Source: Shawna Lemay, *Against Paradise* (Toronto: McClelland & Stewart, 2001), 68–9

LENSE, Edward, four poems by Lense based on stencil drawings
Walter King, *Internal Scenarios*
Source: *Internal Scenarios: A Painterly and Poetic Collaboration* (Johnstown, Ohio: Pudding House Publications, 2003)

LEOPOLD, Nikia, *Healing with Shadows*
Masaccio, *The Life of St. Peter*
Source: *Ekphrasis* 4, no. 5 (Spring–Summer 2008): 34

LESCH, Beverly, *New York Movie*
Edward Hopper, *New York Movie*
Source: *Ekphrasis* 1, no. 3 (Spring–Summer 1998): 44

Lesch, Beverly, *The Heart of Things*
El Greco, *View of Toledo*
Source: *Ekphrasis* 1, no. 4 (Fall–Winter 1998): 46

LESLIE, Juliana, *The Life of Marginal Fauna*
Sandra Scolnik, *Self-Portrait, Undeveloped*
Source: Geha and Nichols (1N, above), 99–101

LESLIE, Nathan, *The Meat Stall*
Pieter Aertens, *A Meat Stall with the Holy Family Giving Alms*
Source: *Ekphrasis* 2, no. 4 (Fall–Winter 2001): 27

LESSER, Rika, *Opposite Corners*
Sylvia Plimack Mangold, *Opposite Corners*, 1973
Source: Hollander and Weber (1H, above), 92–4

LEVERTOV, Denise, *The Servant-Girl at Emmaus (A Painting by Velázquez)*
Source: Denise Levertov, *Breathing the Water* (New York: New Directions, 1987), 66

Levertov, Denise, *The Postcards: A Triptych*
Paintings of a Minoan Snake Goddess, Jean-Siméon Chardin's *Still Life with Plums*, and Mohammedan angels
Source: Buchwald and Roston (2C, above), 100–1

Levertov, Denise, *The Book Without Words (From a painting by Anselm Kiefer)*
Source: Denise Levertov, *A Door in the Hive* (New York: New Directions, 1989), 40

Levertov, Denise, *Soutine (Two Paintings)*
Chaim Soutine, *Still Life with Fish* and *Street of Cagnes-sur-Ner*
Source: Denise Levertov, *A Door in the Hive* (New York: New Directions, 1989), 54

Levertov, Denise, *Wings in the Pedlar's Pack*
Marc Chagall
Source: Denise Levertov, *A Door in the Hive* (New York: New Directions, 1989), 89

Levertov, Denise, *Nativity: An Altarpiece*
Unidentified altarpiece of the Nativity
Source: Denise Levertov, *A Door in the Hive* (New York: New Directions, 1989), 91

Levertov, Denise, *The Composition (Woman at the Harpsichord, Emmanuel de Witte, 1617–1692 Musée des Beaux Arts, Montreal)*
Source: Denise Levertov, *Evening Train* (New York: New Directions, 1992), 24–5

Levertov, Denise, *An Old Friend's Self-Portrait*
Unidentified portrait
Source: Denise Levertov, *Poems, 1968–1972* (New York: New Directions, 1987), 199

LEVINE, Jeffrey, *Odalisque*
Henri Matisse, *Après le bain*
Source: *Ekphrasis* 2, no. 4 (Fall–Winter 2001): 10

Levine, Jeffrey, *Arabia Petra*
David Roberts, *Masque of Omar Shewing the Site of the Temple*
Source: *Ekphrasis*, 3, no. 6 (Fall–Winter 2005): 19–20

Levine, Jeffrey, *Other Effets de Neige, After Monet*
Claude Monet, *Effets de Neige*
Source: *Ekphrasis* 3, no. 6 (Fall–Winter 2005): 36

Levine, Jeffrey, *Oil on Linen*
Baccio Maria Bacci, *Afternoon in Fiesole*
Source: *Ekphrasis* 4, no. 1 (Spring–Summer 2006): 21

Levine, Jeffrey, *Souvenir de Biskra*
Henri Matisse, *Blue Nude*
Source: *Ekphrasis* 4, no. 1 (Spring–Summer 2006): 27

Levine, Jeffrey, *Half Matter in the Material World*
Rembrandt van Rijn, *Bathsheba at Her Bath*
Source: *Ekphrasis* 4, no. 4 (Fall–Winter 2007): 6–7

Levine, Jeffrey, *Lucretia, Just After*
Rembrandt van Rijn, *Lucretia*
Source: *Ekphrasis* 4, no. 4 (Fall–Winter 2007): 8–9

Levine, Jeffrey, *The Anatomy Lesson of Dr. Nicholas Tulp*
Rembrandt van Rijn, *Anatomy Lesson of Dr. Nicholas Tulp*
Source: *Ekphrasis* 4, no. 4 (Fall–Winter 2007): 22–3

Levine, Jeffrey, *Finger Painting*
Unidentified painting by poet's son
Source: Jeffrey Levine, *Mortal Everlasting* (Columbus, OH: Pavement Saw Press, 2002), 14

LEVINE, Philip, *A Glass of Sea Water or a Pinch of Salt*
Lionel Feininger, *Carnival in Arcueil*
Source: Hirsch (1D, above), 106–7

LEVIS, Larry, *Edward Hopper, "Hotel Room," 1931*
Source: Levin (3J, above), 18

Levis, Larry, *Turban*
Pieter Brueghel the Elder and Rembrandt, *Self-Portrait*
Source: Larry Levis, *The Widening Spell of the Leaves* (Pittsburgh: University of Pittsburgh Press, 1991), 38

Levis, Larry, *Swirl & Vortex*
Caravaggio, *David and Goliath*
Source: Larry Levis, *The Widening Spell of the Leaves* (Pittsburgh, PA: University of Pittsburgh Press, 1991), 34–5

LEVY, Constance, *Madinat as Salam*
Frank Stella, *Madinat as Salam III*
Source: Greenberg, *Heart* (2J, above), 40–1

LEWIS, J. Patrick, *Map*
Jasper Johns, *Map*
Source: Greenberg, *Heart* (2J, above), 52–3

LEWIS, Owen, *Guernica*; *At The Moulin Rouge*; *La Belle Jardiniere*; *Mezzetin*; et al.
Pablo Picasso, *Guernica*; Henri Toulouse-Lautrec, *At The Moulin Rouge*; Raphael, *La Belle Jardiniere*; Jean-Antoine Watteau, *Mezzetin*, and other paintings
Source: Seymour Bernstein, *New Pictures at an Exhibition* (Seymour Bernstein Music, 1987)

LIARDET, Tim, *A Futurist Looks at a Dog*
Giacomo Balla, *Dynamism of a Dog on a Lead*
Source: *New Welsh Review* 72 (Summer 2006). http://www.poetrymagazines.org.uk/magazine/record.asp?id=19323

Liardet, Tim, *The Blood Choir*
Francisco Goya, *Pilgrimage to St. Isidore*
Source: *New Welsh Review* 72 (Summer 2006). http://www.poetrymagazines.org.uk/magazine/record.asp?id=19323

LIEBERMAN, Laurence. For poems on the paintings of Stanley Greaves, Ras Akyem Ramsey, and Ras Ishi Butcher, see 4Q, above.

LIFSHIN, Lyn, *Georgia O'Keeffe*
Source: Lyn Lifshin, *Cold Comfort: Selected Poems 1970–1996* (Santa Rosa, CA: Black Sparrow, 1997), 169

Lifshin, Lyn, *Picasso Standing Near Some Germans after He Painted "Guernica"*
Source: Lyn Lifshin, *Cold Comfort: Selected Poems 1970–1996* (Santa Rosa, CA: Black Sparrow, 1997), 201

Lifshin, Lyn, *The Woman in the Painting*
Unidentified female nude torso
Source: *Ekphrasis* 2, no. 4 (Fall–Winter 2001): 11

Lifshin, Lyn, *Card Players*
Romare Bearden, *Card Players*
Source: *Ekphrasis* 3, no. 4 (Fall–Winter 2003): 26

Lifshin, Lyn, *Georgia O'Keeffe's Turquoise Trail Intaglios*
Source: *Ekphrasis* 2, no. 1 (Spring–Summer 2000): 51

LIGHTHART, Annie, *Boys in a Pasture*
Winslow Homer, *Boys in a Pasture*
Source: *Ekphrasis* 3, no. 3 (Spring–Summer 2004): 29

LIMANI, Numan, *A Belated Question*
Gouri Madhit
Source: Martinovski (2K, above), 132

LINDBERG, Mary K., *The Monet Exhibition in Los Angeles*
Claude Monet, *Lady in the Garden*
Source: *Beauty/Truth: A Journal of Ekphrastic Poetry* 1, no. 1 (Fall–Winter 2006): 17

Lindberg, Mary K., *He Does Not Lie Down to Paint*
Michelangelo, Sistine Chapel ceiling
Source: *Beauty/Truth: A Journal of Ekphrastic Poetry* 1, no. 2 (Spring–Summer 2007): 6–7

LINDROP, Grevel, from *Vignettes: Poems for Twenty-One Wood Engravings by Thomas Bewick*
Thomas Bewick, *Roadmender*
Source: Benton and Benton, *Double Vision* (2E, above), 17

LINDSAY, Nina, *Vanishing Point*
Benozzo Gozzoli, *The Dance of Salome*
Source: *Ekphrasis* 2 (Fall–Winter 2000): 20–1

Lindsay, Nina, *Arrangements*
Mary Cassatt, *Girl Arranging Her Hair*
Source: *Ekphrasis* 1, no. 3 (Spring–Summer 1998): 13

Lindsay, Nina, *Sketchbook: Evening*
Ellen Day Hale, *First Night in Venice*
Source: *Ekphrasis* 1, no. 4 (Fall–Winter 1998): 19

LINFOR, Cali, *Valentine: On observing da Vinci's sketches of the Uterus*
Leonardo da Vinci, *Foetus in the Uterus*
Source: *Ekphrasis* 3, no. 1 (Spring–Summer 2003): 14

LINNEY, Romulus, *To an Artist's Daughter*
William Merritt Chase, *The Artist's Daughter, Alice*
Source: Paschal (1G, above), 82–3

LITTLE, Barbara, *"A Genie Serves a Continental Breakfast, Angel Brings the Desired"*
Paul Klee, *Genius Serves a Small Breakfast (An Angel Brings What is Desired)*
Source: *Beauty/Truth: A Journal of Ekphrastic Poetry* 1, no. 3 (Fall–Winter 2007): 17

LOCKLIN, Gerald. The author of more than 130 books and chapbooks, Locklin has written hundreds of ekphrastic poems. They are too voluminous to list here, but readers can find a detailed index of Locklin's poems by Joy Thomas — *Gerald Locklin: An Index to His Work, 1960–2003* (more than 3000 poems in the Locklin Collection at California State University, Long Beach; 149 pp., 82,587 words). An electronic version of the printed form of the *Index*, fully searchable, is available at http://www.csulb.edu/library/Locklin/. See also 4Za, above.

LOESCHER, Richard A., *My Handkerchief*
Antonio Tapies, *Cracked White*
Source: *Wisconsin Poets* (1E, above), 48–9

LOGAN, John, *Nighthawks: After Hopper's Painting*
Edward Hopper, *Nighthawks*
Source: John Logan, *The Collected Poems* (Brockport, NY: Boa Editions, 1989), 475

Logan, John, *Gallery Walk: Fifteen Italian Drawings, 1780–1890*
Felice Giani, *Odysseus and the Greeks in the Caves of Polyphemus*; Telemeco Signorini, *Study of a Nude Girl*; Vincente Cabianca, *Nuns at the Seashore*; Giuseppe Cades, *The Rape of Lucretia*; Bartolomeo Pinelli, *Interior of a Roman Inn*; Giancinto Gigante, *View of Lake Averno*; Giuseppe Cades, *Academic Male Nude*; Andrea Appiani, *Cartoon for Apollo and Daphne*; Andrea Appiani, *Tondo Portrait of Napoleon Bonaparte*; Vincenzo Camuccini, *Romulus and Remus*; Andrea Appiani, *Head of a Woman*; Antonio Canova, *Lady Reclining in a Chair*; Tomasso Minardi, *Academic Male Nude with a Staff*; Cesare Mariani, *Studies of a Reclining Female Nude*; Giuseppe Cammarano, *Amor and Psyche*
Source: John Logan, *The Collected Poems* (Brockport, NY: Boa Editions, 1989), 469–74

Logan, John, *Spirit of the Dead Watching*
Paul Gauguin, *Spirit of the Dead Watching*
Source: John Logan, *The Collected Poems* (Brockport, NY: Boa Editions, 1989), 476

Logan, John, *The Yellow Christ*
Paul Gauguin, *The Yellow Christ*
Source: John Logan, *The Collected Poems* (Brockport, NY: Boa Editions, 1989), 477

Logan, John, *The Dream: A Reflection on Morris Graves's Paintings*

Source: John Logan, *The Collected Poems* (Brockport, NY: Boa Editions, 1989), 478

Logan, John, *Three Poems on Morris Graves's Paintings*
Morris Graves, *Bird on a Rock, Spirit Bird*, and *Moor Swan*
Source: John Logan, *The Collected Poems* (Brockport, NY: Boa Editions, 1989), 234–5, and Buchwald and Roston (2C, above), 64–5

Logan, John, *March. The Museum. Buffalo. de Chirico*
Giorgio de Chirico, *The Anguish of Departure*
Source: John Logan, *The Collected Poems* (Brockport, NY: Boa Editions, 1989), 310–12

LØGSTRUP, Johanne, *Couple*
Elina Brotherus, *Chez Oliver*
Source: http://electricveneer.com/clients/inekphrasis/ekphrasis.html

LOHF, Kenneth A., *Picasso at Vallauris*
Pablo Picasso
Source: *Poetry* 94 (April 1959): 26

LONCAR, Michael, *picasso shag*
Pablo Picasso, *Two Girls Reading*
Source: Tillinghast (1F, above), 36–7

LONG, Tom, *Nighthawks*
Edward Hopper, *Nighthawks*
Source: http://users.visi.net/~longt/poems/Nighthawks.htm

LONGLEY, Michael, *Man Lying on a Wall*
Lowry, L.S., *Man Lying on a Wall*
Source: Abse (2D, above), 126; and Benton and Benton, *Double Vision* (2E, above), 11–12

Longley, Michael, *Yellow Bungalow*
Gerard Dillon, *Yellow Bungalow*
Source: Reid and Rice (1J, above), 26–7

LONGO, Perie, *On Our Way to Wherever*
Suha Sin, *Threshold No. 20*
Source: *Paintings & Poems/Poems & Paintings* (Santa Barbara, CA: Artamo, 2007), 7

LOTZ, Erich, *Die Parabel von den Blinden*
Pieter Brueghel the Elder, *The Parable of the Blind*
Source: Kranz (2B, above), 100

LOVEDAY, John, *The Bowl of Milk*
Pierre Bonnard, *The Bowl of Milk*
Source: Adams (1B, above), 74–5; and Benton and Benton, *Painting with Words* (2G, above), 10

LOVELACE, Richard, *To My Worthy Friend ... Hampton-Court*
Sir Peter Lely, *Charles I and the Duke of York*
Source: Hollander (2I, above), 121

LOWELL, Amy, *A Bather: After a Picture by Anders Zorn*

Source: *Complete Works of Amy Lowell* (Boston: Houghton Mifflin, 1925), 223

Lowell, Amy, *One of the "Hundred Views of Mt. Fuji"*
Katsushika Hokusai, *One Hundred Views of Mt. Fuji*
Source: *Poetry* 9 (March 1917), and http://etc.dal.ca/kuzmin/lowell_poem.html; the poem appeared in a slightly different form in Lowell's anthology *Pictures of the Floating World* (1919)

LOWELL, James Russell, *On a Portrait of Dante by Giotto*
Source: *Complete Poetical Works of James Russell Lowell* (Boston: Houghton Mifflin, 1896), 87

LOWELL, Robert, *Rembrandt*
Rembrandt van Rijn, *The Jewish Bride, The Slaughtered Ox*, and *Bathsheba with King David's Letter*
Source: Robert Lowell, *Collected Poems* (New York: Farrar, Straus and Giroux, 2003), 466

Lowell, Robert, *Muses of George Grosz*
Various satirical images from Grosz
Source: Robert Lowell, *Collected Poems* (New York: Farrar, Straus and Giroux, 2003), 497

Lowell, Robert, *Marriage*
Jan van Eyck, *The Arnolfini Wedding Portrait*
Source: Robert Lowell, *Collected Poems* (New York: Farrar, Straus and Giroux, 2003), 780–2

Lowell, Robert, *Cranach's Man-Hunt*
Lucas Cranach the Elder, *The Stag-Hunt of the Elector Frederick the Wise*
Source: Robert Lowell, *Collected Poems* (New York: Farrar, Straus and Giroux, 2003), 460

Lowell, Robert, *Charles V by Titian*
Titian, *Portrait of Charles V on Horseback*, also titled *Charles V at the Battle of Mühlberg*
Source: Robert Lowell, *Collected Poems* (New York: Farrar, Straus and Giroux, 2003), 460

Lowell, Robert, *Old Prints: Decatur, Old Hickory*
Prints of Stephen Decatur and Andrew Jackson
Source: Robert Lowell, *Collected Poems* (New York: Farrar, Straus and Giroux, 2003), 481

LUCIE-SMITH, Edward, *Rubens to Helene Fourment*
Peter Paul Rubens, *La Pélisse*
Source: Abse (2D, above), 52–3

Lucie-Smith, Edward, *On Looking at Stubbs's "Anatomy of the Horse"*
George Stubbs, *Anatomy of the Horse*
Source: Abse (2D, above), 66

Lucie-Smith, Edward, *Caravaggio Dying*
Source: http://www.artafterscience.com/caravaggio/caravaggio_dying.htm

Lucie-Smith, Edward, *Five Morsels in the Form of Pears*

William Scott, *Pears*
Source: Adams (1B, above), 131–3

LUDVIGSON, Susan, *Inventing My Parents*
Edward Hopper, *Nighthawks*
Source: Susan Ludvigson, *Everything Winged Must Be Dreaming* (Baton Rouge: Louisiana State University Press, 1993), 20; rpt. in Ludvigson's *Sweet Confluence* (Baton Rouge: Louisiana State University Press, 2000), 78; and Levin (3J, above), 40

Ludvigson, Susan, *The Pal Lunch*
Edward Hopper, *Nighthawks*
Source: Susan Ludvigson, in *Everything Winged Must Be Dreaming* (Baton Rouge: Louisiana State University Press, 1993), 35; rpt. in Ludvigson's *Sweet Confluence* (Baton Rouge: Louisiana State University Press, 2000), 84

Ludvigson, Susan, *Rehearsals*
Henri Rousseau, *The Sleeping Gypsy*
Source: *Everything Winged Must Be Dreaming* (Baton Rouge: Louisiana State University Press, 1993), 34

Ludvigson, Susan, *Dreaming the Summer Nights: Scandinavian Paintings from the Turn of the Century* 1. *Wounded Angel by Hugo Sinberg, 1903*; 2. *By Lamplight by Harriet Backer, 1890*; 3. *Riddartfjarden in Stockholm by Eugene Jansson, 1898*; 4. *After Sunset by Kitty L. Kielland, 1886*; 5. *Symposium (The Problem) by Askeli Gallen-Kallela, 1894*; 6. *The Sick Girl by Ejnar Nielsen, 1896*; 7. *Boys Bathing in the Sea on a Summer Evening by Peder Severin Kroyer, 1899*; 8. *The Storm by Edvard Munch*; 9. *The Voice by Edvard Munch, ca. 1893*; 10. *Ashes by Edvard Munch, 1896*; 11. *Dance on the Shore by Edvard Munch, 1900–1902*
Source: Susan Ludvigson, *To Find the Gold* (Baton Rouge: Louisiana State University Press, 1990), 56–62

Ludvigson, Susan, *Nobleman with His Hand on His Chest (after the painting by El Greco)*
Source: Susan Ludvigson, *The Swimmer* (Baton Rouge: Louisiana State University Press, 1984), 37

Ludvigson, Susan, *The Garden of Earthly Delights (after the painting by Hieronymus Bosch)*
Source: Susan Ludvigson, *The Swimmer* (Baton Rouge: Louisiana State University Press, 1984), 38

Ludvigson, Susan, *Keeping the Truth Alive (after drawings by Heinrich Kley)*
Source: Susan Ludvigson, *The Swimmer* (Baton Rouge: Louisiana State University Press, 1984), 39

LUDWIN, Peter, *Terezin Concentration Camp: The Children's Drawings Speak*
Source: *Comstock Review* 21, no. 2 (Fall–Winter 2007): 40–1

LUNDAY, Robert, *"The Stone Surgery" by Bosch*
Hieronymus Bosch, *Extraction of the Stone of Madness*
Source: http://lundayeng12307.blogspot.com/2009/08/ekphrasis=example=with=image=and.html

LYNCH, K.A., *The Hard Season*
Helen Beckman Kaplan, *Empire*
Source: *Broadsided: Switcheroo IV*, November 2008. http://www.broadsidedpress.org/switcheroo/nov08.shtml

LYNCH, Thomas, *Art History, Chicago*
Georges Seurat, *Sunday Afternoon on the Island of La Grande Jatte*
Source: Thomas Lynch, *Still Life in Milford* (New York: Norton, 1998), 19–20

Lynch, Thomas, *"Still Life in Milford"— Oil on Canvas by Lester Johnson*
Source: Thomas Lynch, *Still Life in Milford* (New York: Norton, 1998), 134–36; and Tillinghast (1F, above), 22–4

LYNN, Joanne Barrie, *Cow's Skull with Calico Roses*
Georgia O'Keeffe, *Cow's Skull with Calico Roses*
Source: *Ekphrasis* 4, no. 4 (Fall–Winter 2007): 32

MCAULEY, Leon, *Negative (4)*
Mark Francis, *Negative (4)*
Source: Reid and Rice (1J, above), 105–7

MCCANN, Janet, *Fra Angelico's "The Annunciation"*
Source: *Ekphrasis* 2 (Fall–Winter 2000): 10

MCCARTHY, Laura. *Ephprasis x 11: Prose Poems Based on the Paintings of Remedios Varo*
Source: Oakland, CA: Exiled-in-America Press, 2000, and http://www.deepoakland.org/UserFiles/Image/McCarthy_Ekphrasis.pdf

MCCARTHY, Mary, *Untitled*
Stephen Hannock
Source: *Texts with Vistas* (3I, above)

McCarthy, Mary, *Judy Meets Stephen*
Stephen Hannock, *Portrait of the Artist with Oscar and Skin Cancer*
Source: *Texts with Vistas* (3I, above)

MCCARTHY, Tom, *Landscape*
Bernard Von Eichman, *Landscape*
Source: *Ekphrasis* 2 (Fall–Winter 2000): 37

McCarthy, Tom, *Outside*
Louis Siegriest
Source: *Ekphrasis* 1, no. 1 (Summer 1997), 9

McCarthy, Tom, *The Red House*
Bernard Von Eichman, *The Red House*
Source: *Ekphrasis* 1, no. 2 (Winter 1997–98): 37

MCCLATCHY, J.D., *After Magritte*
Source: J.D. McClatchy, *Ten Commandments* (New York: Knopf, 1998), 81

McClatchy, J.D. *Nephaster cyaneus (Cloudstar)*
Dorothea Tanning, *Nephaster cyaneus (Cloudstar)*
Source: Dorothea Tanning, *Another Language of Flowers* (New York: Braziller, 1998), plate 8

MCCLELLAND, Douglas. For twenty-two of McClelland's poems on painters, see 4F, above.

MCCLURE, Michael, *Old Warhols*
Andy Warhol, *Marilyn Monroe's Lips*; *Blue Electric Chair*; *Five Deaths Eleven Times in Orange*; *Dollar Signs*; *Myths: Mickey Mouse*
Source: Michael McClure, *Simple Eyes & Other Poems* (New York: New Directions, 1994), 6

MCCLURE, Mike, *Ode to Jackson Pollock*
Source: *Evergreen Review* 11 (Autumn 1958): 124–6; rpt. in McClure's *Selected Poems* (New York: New Directions, 1986), 10–12

MCCORD, David, *Thirteen American Watercolors: Winslow Homer, John Singer Sargent, Dodge McKnight, Frank W. Benson, Charles Hopkinson, Edward Hopper, Eliot O'Hara, Charles E. Burchfield, John Lavalle, Harry Sutton, Jr., John Whorf, Millard Sheets, Andrew Wyeth*
Source: David McCord, *The Old Bateau and Other Poems* (Boston: Little, Brown, 1953), 31–4

MCCORMACK, Virginia, *Thoughts in the Louvre before Leonardo's "St. John in the Wilderness"*
Source: *Anthology of Magazine Verse for 1928 and Yearbook of American Poetry*, ed., William S. Braithwaite (New York: Harold Vinal, 1928), 272

MCCULLY, Chris, *Rembrandt: Self-Portrait Aged 63*
Source: Chris McCully, *Time Signatures* (Manchester, UK: Carcanet, 1993), 44

McCully, Chris, *Uccello: The Battle of San Romano (1475)*
Source: Chris McCully, *Time Signatures* (Manchester, UK: Carcanet, 1993), 49

MACDIARMID, Hugh, *A Point in Time*
William Johnstone, *A Point in Time*
Source: Hugh MacDiarmid, *Complete Poems*, vol. 2 (Manchester, UK: Carcanet, 1994), 1069

MacDiarmid, Hugh, *Wedding of the Winds*
William Johnstone, *Wedding of the Winds*
Source: Hugh MacDiarmid, *Complete Poems*, vol. 2 (Manchester, UK: Carcanet, 1994), 1069

MacDiarmid, Hugh, *Conception*
William Johnstone, *Conception*
Source: Hugh MacDiarmid, *Complete Poems*, vol. 2 (Manchester, UK: Carcanet, 1994), 1069–70

MacDiarmid, Hugh, *Composition (1934)*
William Johnstone, *Composition (1934)*
Source: Hugh MacDiarmid, *Complete Poems*, vol. 2 (Manchester, UK: Carcanet, 1994), 1070–1

MacDiarmid, Hugh, *Knight*
William Johnstone, *Knight*
Source: Hugh MacDiarmid, *Complete Poems*, vol. 2 (Manchester, UK: Carcanet, 1994), 1073

MacDiarmid, Hugh, *Of William Johnstone's Art*
William Johnstone
Source: Hugh MacDiarmid, *Complete Poems*, vol. 2 (Manchester, UK: Carcanet, 1994), 1073–4

MacDiarmid, Hugh, *Ode to the North Wind*
William Johnstone, *Ode to the North Wind*
Source: Hugh MacDiarmid, *Complete Poems*, vol. 2 (Manchester, UK: Carcanet, 1994), 1074–5

MacDiarmid, Hugh, *Of William Johnstone's Exhibition*
William Johnstone
Source: Hugh MacDiarmid, *Complete Poems*, vol. 2 (Manchester, UK: Carcanet, 1994), 1075–6

MACDONALD, Cynthia, *Mary Cassatt's "Twelve Hours in the Pleasure Quarter"*
Mary Cassatt, *Woman Bathing*, 1891
Source: Hirsch (1D, above), 43–5

MCDONALD, Walter, *Rembrandt and the Art of Mercy*
Rembrandt van Rijn, *Bathsheba at Her Bath* and other Rembrandt paintings
Source: Walter McDonald, *Counting Survivors* (Pittsburgh, PA: University of Pittsburgh Press, 1995), 44

MCDONNELL, Sean, *Francis Bacon*
Francis Bacon's paintings
Source: *Prairie Schooner* 79, no. 4 (Winter 2005): 44–5

MCDONOUGH, Jill, *October 8, 1789: Rachel Wall*
Woodcut illustration of a hanging by an unidentified artist; the crude woodcut can be seen at http://etd.library.pitt.edu/ETD/available/etd-12082005–165901/unrestricted/gottlieb.pdf, p. 57
Source: Jill McDonough, *Habeas Corpus* (Cambridge, UK: Salt Publishing, 2008); and at http://poetrydaily.org/poem.php?date=14248

MCELROY, Colleen J., *Juan de Pareja*
Diego Velázquez, *Juan de Pareja*
Source: Colleen J. McElroy, *Bone Flames* (Middletown, CT: Wesleyan University Press, 1987), 61–2

MCENTYRE, Marilyn Chandler. For McEntyre's poems on Vermeer, see 3X, above.

MCFEE, Michael, *The Gospel According to Minnie Evans*
Minnie Evans, *The Eye of God*
Source: Paschal (1G, above), 118–19

MCGOUGH, Roger, *The Boyhood of Raleigh*
J.E. Millais, *The Boyhood of Raleigh*
Source: Adams (1B, above), 60–1, and Benton and Benton, *Double Vision* (2E, above), 19–20

McGREEVY, Thomas, *Gioconda*
Leonardo da Vinci, *Mona Lisa*
Source: Kranz (2B, above), 131

McGUCKIAN, Medbh, *Hazel Lavery: The Green Coat*
John Lavery, *The Green Coat*
Source: Reid and Rice (1J, above), 93–5

McGuckian, Medbh, *Road 32, Roof 13–23, Grass 23*
Gwen John
Source: Medbh McGuckian, *Marconi's Cottage* (Winston-Salem, NC: Wake Forest University Press, 1992), 42–3

MacHINERY, Cattery (pseud.), *I'm Sorry You Had to Leave Reine*
Dag Hol, *Reine, Lofoten*
Source: http://clatterymachinery.wordpress.com/category/ekphrasis/

McKEE, Louis, *At MOMA: Hopper's "House by the Railroad," 1925*
Edward Hopper, *House by the Railroad*
Source: *Ekphrasis* 1, no. 4 (Fall–Winter 1998): 12

MACKINNON, Margaret, *An Afternoon During Time of War*
Katsushika Hokusai, *Amido Waterfall on the Kiso Highway*
Source: *Poet Lore* 103, no. 1–2 (Spring–Summer 2008): 12

McLAGAN, Elizabeth, *From "The Suicide of Lucretia"*
Master of the Sacred Blood (Sternberg Palace)
Source: *Ekphrasis* 3, no. 3 (Spring–Summer 2004): 7–8

McLATCHEY, M.B., *Wash Day*
Grandma Moses, *Wash Day*
Source: *Ekphrasis* 4, no. 2 (Fall–Winter 2006): 18–19

McLatchey, M.B., *The Arrangement*
Paul Cézanne, *Flowers in a Vase*
Source: *Beauty/Truth: A Journal of Ekphrastic Poetry* 1, no. 1 (Fall–Winter 2006): 22–3

McLatchey, *Girl at Piano*
Roy Lichtenstein, *Girl at Piano*
Source: *Beauty/Truth: A Journal of Ekphrastic Poetry* 1, no. 1 (Fall–Winter 2006): 24

McLELLAND, Isaac, Jr., *Lines Suggested by a Picture of Washington Allston*
Source: *The Poets and Poetry of America*, ed. Rufus W. Griswold (Philadelphia: Parry and McMillan, 1858), 456.

McMAHON, Mel, *Huck Finn*
Aloysius O'Kelly, *Huckleberry Finn*
Source: Reid and Rice (1J, above), 108–9

McMANAMAN, Ryan, *A Mountainous Morning in the Forest*
Marsden Hartley, *Painting Number One, 1913*
Source: Janovy (1O, above), 19

McNEELY, Jamie, *River Woman*
Jose-Jean Maldonado
Source: http://www.nycbigcitylit.com/may2002/contents/poetrybspecialists.html#McNeely

MacNEICE, Louis, *Poussin*
Nicholas Poussin
Source: MacNeice, Louis, *Collected Poems* (London: Faber and Faber, 1979), 4; and Helen Plotz, ed., *Eye's Delight: Poems of Art and Architecture* (New York: Greenwillow Books, 1983), 10

MacNeice, Louis, *Nature morte (Even so it is not so easy to be dead)*
Pierre Chardin, *Still Life with Herrings*
Source: Louis MacNeice, *Collected Poems* (London: Faber and Faber, 1979), 21

McNEW, Sandra, *Self-Portrait*
Pierre Bonnard, *Self-Portrait*
Source: *Ekphrasis* 3, no. 5 (Spring–Summer 2005): 5

McNULTY, Tim. For eight poems by McNulty on Morris Graves, see 3H, above.

McQUADE, Molly, *Selbstbildnis mit Schnurrbart*
Egon Schiele, *Self-Portrait with Moustache*
Source: *Ekphrasis* 2, no. 3 (Fall–Winter 2003): 40

McQuade, Molly, *Mrs. Mucha's Necklace*
Alphonse Mucha, Art Nouveau design for a necklace
Source: *Ekphrasis* 4, no. 2 (Fall–Winter 2006): 14–15

McQUILKIN, Eleanor A., *Sullivan Street*
Everett Shinn, *Sullivan Street*
Source: Holcomb (1I, above), 124–5

McQUILKIN, Rennie, *Noon at the Gallery*
Gustave Courbet, *The Stonebreaker*
Source: Holcomb (1I, above), 126–7

McQuilkin, Rennie. For eighteen poems by McQuilkin on paintings, see 4R, above.

McVAY, Craig, *Time and Space Unbound*
Bridget Bogel, Untitled (oil and collage on vellum)
Source: *Elastic Ekphrastic: Poetry on Art/Poets on Tour through Galleries*, ed. Jennifer Bosveld (Johnstown, OH: Pudding House Publications, 2003), 42–3

MACHADO, Manuel, *Sandro Botticelli (La Primavera)*
Source: Manuel Machado, *Antologia*, 6th ed. (Madrid: Espasa-Calpe, 1959), 105; the German trans., *Sandro Botticelli: Der Frühling*, is in Kranz (2B, above), 119

Machado, Manuel, *Die Gionconda* [German trans. from the Spanish]
Leonardo da Vinci, *Mona Lisa*
Source: Manuel Machado, *Obras completas*, vol. 2 (Madrid: Editorial Mundo Latino, 1923), 63–4; *Die Gionconda*, the German trans. from the Spanish, is in Kranz (2B, above), 128

Machado, Manuel, *Felipe IV*
Diego Velázquez, composite of portraits of Philip IV and his brother Don Carlos.
Source: Manuel Machado, *Obras completas*, vol. 1 (Madrid: Editorial Mundo Latino, 1923), 45–6.

Machado, Manuel, *Las Concepciones de Murillo*
Bartolomé Esteban Murillo, two of Murrillo's paintings entitled *The Immaculate Conception*
Source: Manuel Machado, *Obras completas*, vol. 2 (Madrid: Editorial Mundo Latino, 1923), 41–2

Machado, Manuel, *Carlos V*
Titian, *Portrait of the Emperor Charles V on Horseback*
Source: Manuel Machado, *Obras completas*, vol. 2 (Madrid: Editorial Mundo Latino, 1923), 67–8

Machado, Manuel, *La anunciación*
Fra Angelico, *Annunciation*
Source: Manuel Machado, *Obras completas*, vol. 2 (Madrid: Editorial Mundo Latino, 1923), 51–2

Machado, Manuel, *Die anatomische Vorlesung*
Rembrandt van Rijn, *The Anatomy Lesson*
Source: Manuel Machado, *Apolo. Teatro pictórico* (Madrid: V. Prieto y Compañía editores, 1911), 173; German trans., Kranz (2B, above), 173

Machado, Manuel, *Goya, Die Erschießung der Aufständischen* [German trans. from the Spanish]
Francisco Goya, *The Third of May, 1808: The Execution of the Defenders of Madrid*
Source: Manuel Machado, *Apolo. Teatro pictórico* (Madrid: V. Prieto y Compañía editores, 1911), 174; German trans., Kranz (2B, above), 198

Machado, Manuel, *El caballero de la mano al pecho*
El Greco, *El caballero de la mano al pecho*
Source: Manuel Machado, *Antologia*, 6th ed. (Madrid: Espasa-Calpe, 1959), 129

Machado, Manuel, *La Infanta Margarita*
Diego Velázquez, *Portrait of Infanta Margarita*
Source: Manuel Machado, *Antologia*, 6th ed. (Madrid: Espasa-Calpe, 1959), 137

Machado, Manuel, *"Las Lanzas" de Velázquez*
Diego Velázquez, *Las Lanzas* (*The Surrender of Breda*)
Source: Manuel Machado, *Antologia*, 6th ed. (Madrid: Espasa-Calpe, 1959), 141

MACKOVIC, Aimee, *On Au Cafe, dit L'Absinthe*
Edgar Degas, *Au Cafe, dit L'Absinthe*
Source: Aimee Mackovic, *A Sentenced Woman* (Georgetown, KY: Finishing Line Press, 2007), 4

Mackovic, Aimee, *Lisa's Lament*
Leonardo da Vinci, *Mona Lisa*
Source: Aimee Mackovic, *A Sentenced Woman* (Georgetown, KY: Finishing Line Press, 2007), 7

MADIGAN, Mark, *Letter to Monet*
Claude Monet, *London, the Houses of Parliament: Sun Breaking through a Fog*
Source: *Poetry* 150 (1987): 160

MAGEE, Wes, *The Harbour Wall*
Alfred Wallace, *Penzance Harbour*
Source: Benton and Benton, *Picture Poems* (2H, above), 49

MAGOWAN, Robin, *Pastoral*
Aristodemos Kaldis
Source: Buchwald and Roston (2C, above), 57

Magowan, Robin, *Kaldis Painting*
Aristodemos Kaldis
Source: *Ekphrasis* 4, no. 3 (Spring–Summer 2007): 10

MAHON, Derek, *Girls on the Bridge*
Edvard Munch, *Girls on the Bridge*
Source: Derek Mahon, *Collected Poems* (Loughcrew, Ireland: Gallery Books, 1999), 152–3; rpt. in Abse (2D, above), 116–17, and in Benton and Benton, *Double Vision* (2E, above), 99

Mahon, Derek, *St. Eustace*
Antonio Pisanello, *Saint Eustace*
Source: Derek Mahon, *Antartica* (Dublin: Gallery Press, 1986), 28

Mahon, Derek, *The Hunt by Night*
Paolo Uccello, *A Hunt in the Forest*
Source: Derek Mahon, *Collected Poems* (Loughcrew, Ireland: Gallery Books, 1999), 150–1

Mahon, Derek, *Courtyards in Delft*
Pieter de Hooch, *Courtyards in Delft*
Source: Derek Mahon, *Collected Poems* (Loughcrew, Ireland: Gallery Books, 1999), 105–6

Mahon, Derek, *Shapes and Shadows*
William Scott, *Shapes and Shadows*
Source: Derek Mahon, *Collected Poems* (Loughcrew, Ireland: Gallery Books, 1999), 278–9; and Reid and Rice (1J, above), 90–2

Mahon, Derek, *Portrait of the Artist*
Vincent Van Gogh
Source: Derek Mahon, *Collected Poems* (Loughcrew, Ireland: Gallery Books, 1999), 23

Mahon, Derek, *The Studio*
Edvard Munch
Source: Derek Mahon, *Collected Poems* (Loughcrew, Ireland: Gallery Books, 1999), 36

Mahon, Derek, *A Lighthouse in Maine*
Edward Hopper, *The Lighthouse at Two Lights*
Source: Derek Mahon, *The Hunt by Night* (London: Oxford University Press 1982; Wake Forest University Press, 1983); and *Selected Poems: 1962–1978* (New York: Oxford University Press, 1979), 44

MAJOR, Devorah, *Saint Jerome in His Study*
Claude Vignon, *Saint Jerome in His Study*
Source: *Ekphrasis* 4, no. 4 (Fall–Winter 2007): 26

MAKUCK, Peter, *Wyeth's Winter*
Andrew Wyeth, *Winter 1946*
Source: Paschal (1G, above), 96–7

MALANGA, Gerard, *Joan Miró and His Daughter Dolores*
Balthus, *Joan Miró and His Daughter Dolores*
Source: Gerard Malanga, *Three Diamonds* (Santa Rosa, CA: Black Sparrow Press, 1991), 18–19

MALITO, Giovanni, *La Gioconda: Suite*
Leonardo da Vinci, *Mona Lisa*
Source: *Ekphrasis* 1, no. 5 (Spring–Summer 1999): 18–19

MALNACK, Linda, *Balm*
Darren Waterston, unidentified monotype
Source: *Ekphrasis* 4, no. 1 (Spring–Summer 2006): 7

Malnack, Linda, *Somnus V*
Darren Waterston, unidentified monotype
Source: *Ekphrasis* 4, no. 1 (Spring–Summer 2006): 8

MALYON, Carol, *To Prince Edward Island*
Alex Colville, *To Prince Edward Island*
Source: Greenberg, *Side* (2M, above), 52–3

MANN, Charles Edward, *Woman in the Blue Hat*
Joel-Peter Witkin, *Woman in the Blue Hat*
Source: *Ekphrasis* 4, no. 5 (Spring–Summer 2008): 7

Mann, Charles Edward, *Still Life, Marseilles, 1992*
Joel-Peter Witkin, *Still Life, Marseilles, 1992*
Source: *Ekphrasis* 4, no. 5 (Spring–Summer 2008): 14

Mann, Charles Edward, *Feast of Fools*
Joel-Peter Witkin, *Feast of Fools*
Source: *Ekphrasis* 4, no. 5 (Spring–Summer 2008): 15

Mann, Charles Edward, *Satiro*
Joel-Peter Witkin, *Satiro*
Source: *Ekphrasis* 4, no. 5 (Spring–Summer 2008): 17

MANY, Paul, *Early Sunday Morning*
Edward Hopper, *Early Sunday Morning*
Source: *Cæsura* (Fall 2007): 50–1

MARCUS, Adrianne, *Monet: Rouen Cathedral, 1894*
Source: *Ekphrasis*, 3, no. 4 (Fall–Winter 2004): 43

MARIAH, Paul, *From Concordances with Dali*
Salvador Dali, six paintings
Source: *Poetry* 118 (May 1971): 66–70

MARIANI, Paul L., *Mountain View with Figures*
Unidentified painting
Source: Paul Mariani, *The Great Wheel* (New York: Norton, 1996), 47

Mariani, Paul L., *Shadow Portrait*
David Alfaro Siqueiros, *Portrait of Hart Crane*
Source: Paul Mariani, *The Great Wheel* (New York: Norton, 1996), 3

Mariani, Paul L., *On the Sublime*
J.M.W. Turner, *The Burning of the House of Lords*
Mariani, Paul L., *Salvage Operations* (New York: Norton, 1990), 155–6

MARINO, Giovanni Battista, *"The Magdalen," by Titian*
Titian, *The Magdalen*
Source: Giovanni Battista Marino, *La Galeria*, ed., M. Pieri (Padua, 1979), 71–4

MARITAIN, Raïssa, *La chute d'Icare (d'après Breughel)*
Pieter Brueghel the Elder, *Landscape with the Fall of Icarus*
Source: Raïssa Maritain, *Lettre de nuit* (Paris: Desclée de Brouwer, "Courrier des Iles," 1939); rpt. in *Poèmes et Essais* (Paris and Paris: Desclée De Brouwer, 1968), 60; *Œuvres completes*, vol. 15, from *Cercle d'Études Jacques and Raïssa Maritain* (Freiburg/Schweiz: Editions Universitaires/Paris: Éditions Saint-Paul, 1995), 548; Achim Aurnhammer and Dieter Martin, eds., *Mythos Ikarus: Texte von Ovid bis Wolf Biermann* (Leipzig: Reclam, 2001), 189–90; and Kranz (2B, above), 83

MARKHAM, Edwin, *The Man with the Hoe*
Jean Millet, *The Man with the Hoe*
Source: *An American Anthology 1787–1900*, ed., Edmund Clarence Stedman (Boston: Houghton Mifflin, 1900), 541–2; and in Hollander (21, above), 227–8

MARSHALL, Jack, *Self-Portrait, Cézanne*
Source: Jack Marshall, *Arabian Nights* (Minneapolis, MN: Coffee House Press, 1986), 93–5

MARSTON, Elsa. For fourteen of Marston's poems inspired by Native American rock art, see 4S, above.

MARTI, Kurt, *joan miro*
Source: Kranz (2B, above), 254

MARTÍNEZ, Dionisio D., *In yet another language*
Gustave Courbet, *L'origine du monde*

Source: *Prairie Schooner* 79, no. 4 (Winter 2005): 38–9

Martínez, Dionisio D., *Flood*
Humberto Calzada, the sections of the poem take their titles from Calzada's "water paintings," which triggered the poem as a whole
Source: Dionisio D. Martínez, *Bad Alchemy* (New York: Norton, 1995), 67–73

Martínez, Dionisio D., *Middle Men*
Michelangelo
Source: Dionisio D. Martínez, *Bad Alchemy* (New York: Norton, 1995), 92–3

MARVELL, Andrew, *The Gallery*
Various unnamed emblem books and paintings of Venus and others
Source: *The Poems of Andrew Marvell*, ed. G. A. Aitken (London: Lawrence & Bullen, 1892), 61–3

MARVIN, Pamela, *Oxbow Portrait after Church and Cole*
Stephen Hannock, *The Oxbow, After Church, After Cole, Flooded*
Source: *Texts with Vistas* (31, above)

Marvin, Pamela, *Portrait of the Artist and Oscar*
Stephen Hannock, *Portrait of the Artist with Oscar and Skin Cancer*
Source: *Texts with Vistas* (31, above)

MARWOOD, Lorraine, *Ned Kelly*
Sidney Nolan, *Ned Kelly*
Source: Greenberg, *Side* (2M, above), 32–3

MARZ, Roy, *Annunciation of the Unknown Master: Galleria Accademia, Florence*
Source: *Poetry* 84 (June 1954): 150; rpt. in Roy Marz, *The Island-Maker* (Ithaca, NY: Ithaca House, 1982), 84–5

Marz, Roy, *The Donatello Annunciation: Santa Croce*
Source: *Poetry* 84 (June 1954): 152; rpt. in Roy Marz, *The Island-Maker* (Ithaca, NY: Ithaca House, 1982), 86–7

Marz, Roy, *Leonardo on the Annunciations*
Source: *Poetry* 84 (June 1954): 149; rpt. in Roy Marz, *The Island-Maker* (Ithaca, NY: Ithaca House, 1982), 84

Marz, Roy, *Virgin to Angel as Bird: Botticelli*
Sandro Botticelli, *Annunciation*
Source: *Poetry* 84 (June 1954): 151; rpt. in Roy Marz, *The Island-Maker* (Ithaca, NY: Ithaca House, 1982), 85–6

Marz, Roy *The Cat at the Last Supper*
Domenico Ghirlandaio, *Last Supper*
Source: Roy Marz, *The Island-Maker* (Ithaca, NY: Ithaca House, 1982), 71

MASSON, Lou, *Waterlilies (1914–1915)*
Claude Monet, *Waterlilies*
Source: *Ekphrasis* 4, no. 5 (Spring–Summer 2008): 25–6

MASTERSON, Dan, *Early Sunday Morning*
Edward Hopper, *Early Sunday Morning*
Source: Greenberg, *Heart* (2J, above), 14–15

Masterson, Dan, *Tableau Vivant*
Vincent Van Gogh, *The Potato Eaters*
Source: *Mudlark Poster* No. 59 (2005). http://www.unf.edu/mudlark/posters/masterson.html

Masterson, Dan, *Old Woman with a Broom*
George Luks, *Old Woman with a Broom*
Source: *Mudlark Poster* No. 59 (2005). http://www.unf.edu/mudlark/posters/masterson.html

Masterson, Dan, *Sticks*
Henri Matisse, *Jazz Icarus*
Source: *Mudlark Poster* No. 59 (2005). http://www.unf.edu/mudlark/posters/masterson.html

Masterson, Dan, *The Jackdaws at Thor Ballylee*
Barbara Morris, *Dance*
Source: *Mudlark Poster* No. 59 (2005). http://www.unf.edu/mudlark/posters/masterson.html

Masterson, Dan, *Born to Kill*
J.M.W. Turner, *Gamecock*
Source: *Mudlark Poster* No. 59 (2005). http://www.unf.edu/mudlark/posters/masterson.html

Masterson, Dan, *Mailing a Package to a GI in Iraq*
James Montgomery Flagg, *I Want You for the U.S. Army*
Source: *Mudlark Poster* No. 59 (2005). http://www.unf.edu/mudlark/posters/masterson.html

Masterson, Dan, *On His Own*
George Grosz, *The Wanderer*
Source: *Innisfree Poetry Journal* 1 (September 2005). http://www.authormark.com/article_666.shtml

Masterson, Dan, *Bully Boss & Candle Boy*
Giuseppe Arcimboldo, *Summer*
Source: *Innisfree Poetry Journal* 6 (March 2008). http://authormark.com/artman2/publish/Innisfree_6_21/DAN_MASTERSON.shtml

Masterson, Dan, *The Vigil of Judas Iscariot*
Salvador Dali, *Crucifixion or Corpus Hipercubicus*
Source: *Innisfree Poetry Journal* 6 (March 2008). http://authormark.com/artman2/publish/Innisfree_6_21/DAN_MASTERSON.shtml

MASTRANGELO, Linda, *Village Idiot*
Marc Chagall, *The Village Idiot*
Source: *Ekphrasis* 3, no. 1 (Spring–Summer 2003): 7

MATTHEWS, Harry, *Agripedium vorax Saccherii (Clog Herb)*

Dorothea Tanning, *Agripedium vorax Saccherii (Clog Herb)*
Source: Dorothea Tanning, *Another Language of Flowers* (New York: Braziller, 1998), plate 2.

MATTHEWS, Richard, *Die Muhle Brennt— Richard*
Georg Bazelitz, *Die Muhle Brennt*
Source: http://www.poets.org/viewmedia.php/pr mMID/16260

MAXWELL, Jennifer, *After Van Gogh's Winter Garden*
Vincent Van Gogh, *Winter Garden*
Source: http://www.guardian.co.uk/books/2006/o ct/23/poetry

MAYER, Gerda, *Sir Brooke Boothby*
Joseph Wright of Derby, *Sir Brooke Boothby*
Source: Abse (2D, above), 71; and Adams (1B, above), 26–7

MAYES, Frances, *The Dream of Saint Ursula (after Carpaccio's painting)*
Vittore Carpaccio, *The Dream of St. Ursula*
Source: Frances Mayes, *After Such Pleasures* (New York: Seven Woods Press, 1979)

MAYO, E.L., *El Greco*
Source: *Mid-Century American Poets*, ed. John Ciardi (New York: Twayne Publishers, 1950), 154

MEEHAN, Paula, *Quitting the Bars*
Hector McDonnell, *Bewley's Restaurant II*
Source: Reid and Rice (1J, above), 20–1

MEEKER, Marjorie, *For Rockwell Kent's "Twilight of Man"*
Source: *Poetry* 31 (November 1927): 67

MEINKE, Peter, *Impressionist*
Camille Pissarro, *The River Oise Near Pontoise*
Source: *Ekphrasis* 3, no. 1 (Spring–Summer 2003): 5

Meinke, Peter, *Lordship Lane Station*
Camille Pissarro, *Lordship Lane Station*
Source: *Ekphrasis* 2, no. 6 (Fall–Winter 2002): 5

Meinke, Peter, *Two Poems after Pissarro*
Camille Pissaro, *Lordship Lane Station* and *Festival at L'Hermitage*
Source: Peter Meinke, *Night Watch on the Chesapeake* (Pittsburgh, PA: University of Pittsburgh Press, 1987), 10–11

Meinke, Peter, *Pissarro Painting "Young Woman Bathing Her Feet"*
Source: Peter Menike, *Scars* (Pittsburgh, PA: University of Pittsburgh Press, 1966), 38

MEISCHEN, David, *Sunday Afternoon with Seurat*
Georges Seurat, *A Sunday Afternoon on the Island of La Grande Jatte*
Source: *Cider Press Review* 9 (2008): 120

MELISSEN, Sipko, *A 123*
Jan Van Goyen, *Landscape with Two Oaks*
Source: Korteweg and Heijn (2F, above), 116

Melissen, Sipko, *Gezicht over de Amstel*
Rembrandt van Rijn, *View over the Amstel*
Source: Korteweg and Heijn (2F, above), 129

Melissen, Sipko, *Gezicht op Sloten*
Rembrandt van Rijn, *View of Sloten*
Source: Korteweg and Heijn (2F, above), 130

Melissen, Sipko, *Pieter de Hooch*
Pieter de Hooch, *A Courtyard in Delft: A Woman Spinning (Twee vrouwen op een binnenplaats)*
Source: Korteweg and Heijn (2F, above), 166

MELVILLE, Herman, *The Temeraire*
J.M.W. Turner, *The Fighting "Téméraire"*
Source: Hollander (2I, above), 197–8

Melville, Herman, *Formerly a Slave*
Elihu Vedder, *Jane Jackson*
Source: Hollander (2I, above), 33

MEMMER, Philip, *Empire of Lights*
René Magritte, *L'empire des lumières*
Source: Philip Memmer, *Threat of Pleasure* (Cincinnati, OH: Word Press, 2008), 79

MENARD, Luta, Untitled
Albert Bierstadt, *River Landscape*
Source: Janovy (1O, above), 43

MERLO, Luis Martínez de, *Portrait of Prince Baltasar Carlos de Caza*
Diego Velázquez, *Portrait of Prince Baltasar Carlos de Caza*
Source: Greenberg, *Side* (2M, above), 34–5

MÉRODE, Willem de, *Madonna van Quinten Metsijs*
Quinten Metsijs (or Massijs or Matsijs), *The Virgin at Prayer*
Source: Korteweg and Heijn (2F, above), 74

Mérode, Willem de, *Dullaert*
Philips Koninck, *Portrait of Heiman Dullaert*
Source: Korteweg and Heijn (2F, above), 158

MERRILL, James, *The Book of Ephriam*
Two sections describe Giorgione's *Tempesta*, viewed in Venice. [Part of the description draws on Nancy Thompson De Grummond, "Giorgione's Tempest: The Legend of St. Theodore," *L'Arte* 5, no. 18 (Giugno-Dicembre 1972): 5–53]
Source: James Merrill, *The Book of Ephriam* in *The Changing Light at Sandover* (New York: Atheneum, 1984.

Merrill, James, *Dancing, Joyously Dancing*
Pieter Brueghel the Elder, *The Kermess*
Source: James Merrill, *Collected Poems* (New York: Knopf, 2001), 14

Merrill, James, *Merrillium trovatum* [from Merrill's *Declaration Day*]
Dorothea Tanning, *Merrillium trovatum*
Source: Dorothea Tanning, *Another Language of Flowers* (New York: Braziller, 1998), plate 1.

MERRIAM, Eve, *Going Seventy*,
Louise Nevelson, Georgia O'Keeffe, Alice Neel, and Louise Bourgeois
Source: Eve Merriman, *Embracing the Dark* (Cambridge, MA: Garden Street Press, 1995), 50–1.

MERTON, Thomas, *Chagall*
Marc Chagall
Source: *The Collected Poems of Thomas Merton* (New York: New Directions, 1977), 962–4.

Merton, Thomas, *The Restoration of the Pictures*
Napoleone Coccetti, murals in the Palazzo Taverna
Source: *The Collected Poems of Thomas Merton* (New York: New Directions, 1977), 968–9.

MERWIN, W.S., *Voyage to Labrador*
Alfred Wallis, *Voyage to Labrador*
Source: Hollander (2I, above), 277

Merwin, W.S., *Crepusculka glacialis (var. Flos cuculi)*
Dorothea Tanning, *Crepusculka glacialis (var. Flos cuculi)*
Source: Dorothea Tanning, *Another Language of Flowers* (New York: Braziller, 1998), plate 9

MEYERS, Steve, *The Isenheim Altarpiece, Colmar*
Matthais Grünewald, *The Isenheim Altarpiece*
Source: *Ekphrasis* 4, no. 3 (Spring–Summer 2007): 12

Meyers, Steve, *Blake's "The Lord Answering Job"*
Source: *Ekphrasis* 4, no. 3 (Spring–Summer 2007): 20

MEYERS, Susan, *Light, Its Absence*
Theodore Wendel, *Girl with Turkeys, Giverny*
Source: *Ekphrasis* 3, no. 3 (Spring–Summer 2004): 31

Meyers, Susan, *Late Boat*
Rie Muñoz, *Late Boat*
Source: *Ekphrasis* 4, no. 6 (Fall–Winter 2008): 22

MEZEY, Robert, *Evening Wind*
Edward Hopper, *Evening Wind*
Source: Levin (3J, above), 24

MICHAELIS, Sophus, *David spielt vor Saul*
Rembrandt van Rijn, *David spielt die Harfe vor Saul* (*David Playing the Harp before Saul*)
Source: Kranz (2B, above), 178–9

MICHELANGELO, untitled extended sonnet
Michelangelo, Sistine Chapel ceiling
Source: Nims, John Frederick, ed., *The Complete Poems of Michelangelo* (Chicago: University of Chicago Press, 1998), 10–11

MICHAELS, Judy Rowe, *To Picasso's "Melancholy Woman"*
Source: *Ekphrasis* 3, no. 5 (Spring–Summer 2005): 31

MIDDLETON, Christopher, *A Landscape by Delacroix*
Eugène Delacroix
Source: Christopher Middleton, *Intimate Chronicles* (Riverdale-on-Hudson, NY: Sheep Meadow Press, 1996), 49

Middleton, Christopher, *Monet's "Weeping Willow"*
Source: Christopher Middleton, *Intimate Chronicles* (Riverdale-on-Hudson, NY: Sheep Meadow Press, 1996), 39

Middleton, Christopher, *A Picture Which Magritte Deferred*
Source: Christopher Middleton, *Intimate Chronicles* (Riverdale-on-Hudson, NY: Sheep Meadow Press, 1996), 53–4

Middleton, Christopher, *Musa Paradisiaca*
Jean Bouchet, *Musa Paradisiaca*
Source: Christopher Middleton, *Intimate Chronicles* (Riverdale-on-Hudson, NY: Sheep Meadow Press, 1996), 50

Middleton, Christopher, *Bonnard*
Pierre Bonnard
Source: Christopher Middleton, *111 Poems* (Manchester, UK: Carcanet, 1983), 53

Middleton, Christopher, *The Execution of Maximilian*
Edouard Manet, *The Execution of the Emperor Maximilian*
Source: Christopher Middleton, *Intimate Chronicles* (Riverdale-on-Hudson, NY: Sheep Meadow Press, 1996), 57–8

Middleton, Christopher, *A Bunch of Grapes*
Michelangelo, *Sybilla Delphica*
Source: Christopher Middleton, *111 Poems* (Manchester, UK: Carcanet, 1983), 17–18

Middleton, Christopher, *A Drive in the Country/ Henri Toulouse-Lautrec*
Henri Toulouse-Lautrec, *A Drive in the Country*
Source: Christopher Middleton, *111 Poems* (Manchester, UK: Carcanet, 1983), 109–11

MIKOLOWSKI, Ken, *You Are What You Art*
Franz Kline, *To Win*
Source: Tillinghast (1F, above), 60–1

MILES, George Henry, *On Raphael's San Sisto Madonna*
Source: *The Catholic Anthology*, ed. Thomas Walsh (New York: Macmillan, 1943), 268

MILES, Jeff, *Late Evening from Ryogoku Bridge*
Toshi Yoshida, block print (1939)
Source: *Ekphrasis* 3, no. 6 (Fall–Winter 2005): 31

Miles, Jeff, *Tanabata Festival Dinner Menu*
Takehisa Yumeji, woodblock print
Source: *Ekphrasis* 4, no. 2 (Fall–Winter 2006): 27–8

Miles, Jeff, *Shiobara, Tochigi Prefecture*
Kawase Hasui, block print (1946)
Source: *Ekphrasis* 3, no. 6 (Fall–Winter 2005): 32

MILLER, Andrew, *Vincent Van Gogh, The Potato Eaters, 1885, Sequence*
Source: *Ekphrasis* 4, no. 5 (Spring–Summer 2008): 19–23

Miller, Andrew, *Francisco de Goya, "Tampoco," 1805*
Source: *Ekphrasis* 3, no. 1 (Spring–Summer 2003): 42–4

Miller, Andrew, *Vermeer, The Laughing Girl with Her Officer, 1667*
Source: *Ekphrasis* 3, no. 4 (Fall–Winter 2004): 34–5

Miller, Andrew, *Watson and the Shark*
John Singleton Copley, *Watson and the Shark*
Source: *Ekphrasis* 4, no. 2 (Fall–Winter 2006): 42–3

MILLER, Greg, *Holy Conversation*
Vittore Carpaccio, *La Sainte Conversation*
Source: *Ekphrasis* 4, no. 5 (Spring–Summer 2008): 37

MILLER, Jamie, *Title: Juxtaposition of Peace*
Unidentified artist, *Juxtaposition of Peace*
Source: *Columbia Poetry Review* no. 21 (Spring 2008): 17

MILLER, Leslie Adrienne, *Portrait "Trouvé"*
Unknown Artist (found portrait)
Source: *Ekphrasis* 1, no. 4 (Fall–Winter 1998): 26–8

Miller, Leslie Adrienne, *On Leonardo's Drawings in two parts: Aim* and *Wandering Uterus*
Leonardo da Vinci, anatomical drawings from the *Notebooks*
Source: Heather McHugh, ed., *The Best American Poetry 2007* (New York: Scribner, 2007), 70–2

MILLER, Peggy, *Musa acuminate, It Isn't the fruit*
Suelly Kretzmann, *Natureza Morto com Fruta*
Source: *Ekphrasis* 3, no. 5 (Spring–Summer 2005): 32

MILLS, Barriss, *La Grande Jatte*
Georges Seurat, *La Grande Jatte*
Source: *Parvenus & Ancestors* (New York: Vagrom Chapbooks, 1959), 22–3

MILOSZ, Czeslaw, *O!/Gustav Klimt (1962–1918)/Judith (detail)*
Gustav Klimt, *Judith I*
Source: *American Poetry Review* 30, no. 6 (November–December 2001): 28; rpt. in Milosz's *New and Collected Poems* 1931–2001 (New York: Ecco/HarperCollins, 2001), 684

Milosz, Czeslaw, *O!/Salvator Rosa (1615–1673)/A Landscape with Figures*
Source: *American Poetry Review* 30, no. 6 (November–December 2001): 28; rpt. in Milosz's *New and Collected Poems* 1931–2001 (New York: Ecco/HarperCollins, 2001), 685

Milosz, Czeslaw, *O!/Edward Hopper (1882–1967)/A Hotel Room*
Source: *American Poetry Review* 30, no. 6 (November–December 2001): 28; rpt. in Milosz's *New and Collected Poems* 1931–2001 (New York: Ecco/HarperCollins, 2001), 686

Milosz, Czeslaw, *Pastels by Degas*
Edgar Degas, *Woman Combing Her Hair*
Source: *American Poetry Review* 30, no. 6 (November–December 2001), 30; rpt. in Milosz's *New and Collected Poems* 1931–2001 (New York: Ecco/HarperCollins, 2001), 723

Milosz, Czeslaw, *Realism*
Dutch masters
Source: Czeslaw Milosz, *New and Collected Poems (1931–2001)*. New York: Ecco/HarperCollins, 2001), 606

MILTNER, Robert, *Painting on Smoke*
Wendy Collin Sorin, *Painting on Smoke*
Source: *The Poetic Image* (Cleveland, OH: Poets' League of Greater Cleveland/ Zygote Press, Fall 2000), 21

Miltner, Robert, *Calculating Machine*
Wendy Collin Sorin, *Calculating Machine*
Source: *The Poetic Image* (Cleveland, OH: Poets' League of Greater Cleveland/ Zygote Press, Fall 2000), 22

Miltner, Robert, *The Connection between Roman Numerals and Letters*
Wendy Collin Sorin, *The Connection between Roman Numerals and Letters*
Source: *The Poetic Image* (Cleveland, OH: Poets' League of Greater Cleveland/ Zygote Press, Fall 2000), 23

Miltner, Robert, *A System of Familiar Philosophy*
Wendy Collin Sorin, *A System of Familiar Philosophy*
Source: *The Poetic Image* (Cleveland, OH: Poets' League of Greater Cleveland/ Zygote Press, Fall 2000), 24

MINCZESKI, John, *Another Sunset*
Alvaro Cardona-Hine
Source: Buchwald and Roston (2C, above), 60

Minczeski, John, *Renaissance/A Triptych*
Unnamed paintings of the Annunciation and Leda
Source: Buchwald and Roston (2C, above), 98–9

MINNICK, Norman, *Ingres' Valpinçon Bather*
Jean-Auguste-Dominique Ingres, *The Bather of Valpinçon*
Source: *Ekphrasis* 3, no. 3 (Spring–Summer 2004): 14

MIROLLO, Gabriella, *Room in New York*
Edward Hopper, *Room in New York*
Source: *Ekphrasis* 1, no. 6 (Fall–Winter 1999): 31

MITCHELL, Adrian, *Edward Hopper*
Source: Adrian Mitchell, *Blue Coffee: Poems 1985–1996* (Newcastle upon Tyne, UK: Bloodaxe Books, 1996), 45

Mitchell, Adrian, *Footnote on the Edward Hopper Exhibition*
Source: Adrian Mitchell, *Blue Coffee: Poems 1985–1996* (Newcastle upon Tyne, UK: Bloodaxe Books, 1996), 45

Mitchell, Adrian, *Two Paintings by Manuel Mendive*
Source: Adrian Mitchell, *Heart on the Left: Poems: 1953–1984* (Newcastle upon Tyne, UK: Bloodaxe Books, 1997), 121

MITCHELL, Emily, *A Place*
Spencer Gore, *Letchworth*
Source: Adams (1B, above), 84–5

MITCHELL, Felicia, *Rembrandt's Beggars at the Knoxville Museum of Art*
Rembrandt van Rijn, *Beggar Etchings*
Source: *Cæsura* (Fall 2007): 28–9

MITCHELL, J.K., *The Greek Lovers*
Illustration of an engraving by Asher B. Durand, after a painting by Robert W. Weir
Source: *American Monthly Magazine* 4, n.s. (April 1838): 338–40

MITCHELL, Mark, *After Picasso, 1901*
Pablo Picasso, *Boy with a Pipe*
Source: *Ekphrasis* 1, no. 3 (Spring–Summer 1998): 36

MITCHELL, Stephen, *Vermeer*
Jan Vermeer, *Woman with a Water Jug*
Source: Stephen Mitchell, *Parables and Portraits* (New York: Harper & Row, 1990), 83

MOLE, John, *An Amateur Watercolourist to Thomas Girtin*
Thomas Girtin, *The White House*
Source: Adams (1B, above), 50–1

Mole, John, *Olé*
Pablo Picasso, *The Three Musicians*
Source: Benton and Benton, *Picture Poems* (2H, above), 42–3

Mole, John, *Entr'acte*
Pierre-Auguste Renoir, *The Box (la Loge)*
Source: Benton and Benton, *Double Vision* (2E), 8–9

MOMADAY, N. Scott, *Before an Old Painting of the Crucifixion: The Mission Carmel, June, 1960*
Source: *Quest for Reality*, ed. Yvor Winters and Kenneth Fields (Chicago: Swallow Press, 1969), 188, and Kehl (2A, above), 206–8

MONROE, Harriet, *Dürer's Portrait of Himself*
Source: *Poetry* 23 (March 1924): 296

Monroe, Harriet, *Fra Angelico's Annunciation*
Source: *Poetry* 23 (March 1924): 296

Monroe, Harriet, *Titian on Charles V, Philip II, and the Empress Isabel*
Source: *Poetry* 23 (March 1924): 294–5

Monroe, Harriet, *The Romney*
George Romney
Source: *Home Book of Modern Verse*, ed. Burton E. Stevenson (New York: Holt, 1925), 403–4

Monroe, Harriet, *Botticelli*
Source: Harriet Monroe, *Chosen Poems: A Selection from My Books of Verse* (New York: Macmillan, 1935), 166

Monroe, Harriet, *El Greco*
Source: *Poetry* 23 (March 1924): 295

Monroe, Harriet, *Goya*
Francisco Goya
Source: *Poetry* 23 (March 1924): 297–8

Monroe, Harriet, *Murillo*
Bartolomé Esteban Murillo
Source: *Poetry* 23 (March 1924): 296

Monroe, Harriet, *Rubens*
Peter Paul Rubens
Source: *Poetry* 23 (March 1924): 297

Monroe, Harriet, *Velásquez*
Diego Velázquez
Source: *Poetry* 23 (March 1924): 293–4

MONTAG, Tom, *In Its Four Voices—Silent Messengers: Connecting with D'Amico #2*
Marja-Leena Rathje, *D'Amico #2*
Source: *qarrtsiluni. online literary magazine.* http://qarrtsiluni.com/2007/04/29/ekphrasis-15-marja-leena-rathje-karen-damico-tom-montag-erika-rathje/#more-186

MONTAGUE, John, *The Yachtsman's Jacket*
Edward McGuire, *John Montague*
Source: Reid and Rice (1J, above), 60–2

MOODY, Mark, *Basket of Pears*
Édouard Manet, *Basket of Pears*
Source: *Ekphrasis*, 3, no. 4 (Fall–Winter 2004): 47–8

MOOIJ, J.J.A., *De watermolen*
Meindert Hobbema, *A Watermill*
Source: Korteweg and Heijn (2F, above), 176

Mooij, J.J.A. For twenty-six of Mooij's sonnets on painters, see 4E, above.

MOONEY, Martin, *The Ginger Jar*
Louis le Brocquy, *Girl in White*
Source: Reid and Rice (1J, above), 54–5

MOORE, Hubert, *Count Guryev Speaks*
Jean-Auguste-Dominique Ingres, *Portrait of Count Guryev*
Source: Hubert Moore, *Rolling Stock* (Petersfield, UK: Enitharmon, 1991), 54

Moore, Hubert, *Hitching Westward, 1950*
Sir Stanley Spencer, wall paintings
Source: Hubert Moore, *Rolling Stock* (Petersfield, UK: Enitharmon, 1991), 45

Moore, Hubert, *Her Gift*
Edvard Munch, *Puberty*
Source: Hubert Moore, *Namesakes* (London: Enitharmon, 1988), 36

MOORE, Jacqueline, *Manet's Lilies in a Crystal Vase*
Édouard Manet, *Flowers in a Crystal Vase*
Source: *Ekphrasis* 2, no. 6 (Fall–Winter 2002): 21

MOORE, Jillian, *For Witkin's "Woman Once a Bird" III*
Joel-Peter Witkin, *Woman Once a Bird*
Source: *Ekphrasis* 3, no. 4 (Fall–Winter 2004): 7

MOORE, Marianne, *Charity Overcoming Envy*
Anon., *Tapestry*
Source: Hollander (2I, above), 297

Moore, Marianne, *Leonardo da Vinci's St. Jerome*
Leonardo da Vinci, unfinished sketch in the Vatican
Source: *The New Yorker Book of Poems* (New York: Viking, 1969), 380–81, and Kehl (2A, above), 88–90

Moore, Marianne, *No Better than "a Withered Daffodil"*
Sir Isaac Oliver, *Portrait of Sir Philip Sidney*
Source: *Art News* 58 (March 1959): 44–5

MOORE, T. Sturge, *From Pallas and the Centaur by Sandro Botticelli*
Source: *The Pageant* 1 (1896): 229

Moore, T. Sturge, *On a Picture by Puvis de Chavannes*
Pierre Puvis de Chavannes,
Source: *The Dial* 2 (1892): 15; rpt. in Moore's *The Vinedresser and Other Poems* (London: At the Sign of the Unicorn, 1899), 50

Moore, T. Sturge, *On a Drawing by C.H.S.*
Source: *The Dial* 2 (1892): 18

Moore, T. Sturge, *From Pygmalion, by Edward Burne-Jones*
Source: *The Dial* 2 (1892): 18

Moore, T. Sturge, *From Sappho's Death: Three Pictures by Gustave Moreau*

Source: T. Sturge Moore, *The Vinedresser and Other Poems* (London: At the Sign of the Unicorn, 1899), 51–2

Moore, T. Sturge, *From Titian's "Bacchanal" in the Prado at Madrid*
Source: T. Sturge Moore, *The Gazelles and Other Poems* (Duckworth: London, 1904), xix

MOORE–NIVER, Heather M., *Afield*
Carolyn Edlund, *Where Cows Once Grazed*
Source: http://quoth-the-redhead.blogspot.com/2008/03/poetry-in-ink-oils.html

MORGAN, Chris, The Family at Polperro
Bernard Fleetwood Walker, *The Family at Polperro*
Source: http://www.birmingham.gov.uk/GenerateContent?CONTENT_ITEM_ID=146289&CONTENT_ITEM_TYPE=0&MENU_ID=5247

Morgan, Chris, *The Last of England*
Ford Maddox Brown, *The Last of England*
Source: http://www.birmingham.gov.uk/GenerateContent?CONTENT_ITEM_ID=146291&CONTENT_ITEM_TYPE=0&MENU_ID=5247

MORGAN, Edwin, *The Bench*
Tom Phillips, *Benches*
Source: Adams (1B, above), 138–40

Morgan, Edwin, *Dialogue II: Hieronymus Bosch and Johann Faust*
Source: Edwin Morgan, *The Whittrick: a Poem in Eight Dialogues*, in *Collected Poems* (Manchester, UK: Carcanet, 1996), 82–6

Morgan, Edwin, *The Room*
René Magritte, *Souvenir de voyage III*
Source: Edwin Morgan, *Collected Poems* (Manchester, UK: Carcanet, 1996), 511–12

MORIARTY, Mimi, *Letter to Stephen Hannock*
Stephen Hannock
Source: *Texts with Vistas* (3I, above)

MORRIS, Harry, *Stanzas to be Placed under Fouquet's "Madonna"*
Jean Fouquet, *Madonna*
Source: Harry Morris, *The Sorrowful City* (Gainesville: University of Florida Press, 1965), 26

MORRIS, William, *The Blue Closet*
Dante Gabriel Rossetti, *The Blue Closet*
Source: *Victorian Poetry and Poetics*, eds. Walter E. Houghton and G. Robert Stange (Boston: Houghton Mifflin, 1959), 595–6

Morris, William, *The Tune of Seven Towers*
Dante Gabriel Rossetti, *The Tune of Seven Towers*
Source: *Victorian Poetry and Poetics*, eds. Walter E. Houghton and G. Robert Stange (Boston: Houghton Mifflin, 1959), 596

MORRISSEY, Sinéad, *Eileen*
Sir John Lavery, *Eileen, Her First Communion*
Source: Reid and Rice (1J, above), 38–9

MORRISON, Blake, *Teeth*
Francis Bacon, *Seated Figure*
Source: Adams (1B, above), 128–30

MORSE, Samuel French, *The Sleeping Gypsy (Henri Rousseau)*
Source: Samuel French Morris, *The Changes* (Denver: Swallow, 1964), 83

Morse, Samuel French, *The Peaceable Kingdom*
Edward Hicks, *The Peaceable Kingdom*
Source: Samuel French Morris, *The Changes* (Denver: Swallow, 1964), 48

MORTENSEN, Arthur, *A Different Sacrament*
Jean-Antoine Watteau, *The Italian Comedians*
Source: *Ekphrasis* 1, no. 3 (Spring–Summer 1998): 12

MOSS, Howard, *"Around the Fish": After Paul Klee*
Paul Klee, *Around the Fish*
Source: Kehl (2A, above), 156–7

Moss, Howard, *Buried City*
Lascaux cave paintings and unnamed paintings in an art gallery
Source: Howard Moss, *Buried City* (New York: Atheneum, 1975), 51–6

MOSS, Thylias, *Picturing the Good Brown Life in John Phillip's The Highlander's Home (Sunshine in the Cottage)*
John Philip, *The Highlander's Home*
Source: Tillinghast (1F, above), 32–5

MOSSON, Greg, *The Miser*
James McNeill Whistler, *The Miser*
Source: *Beauty/Truth: A Journal of Ekphrastic Poetry* 1, no. 2 (Spring–Summer 2007): 13

MOUDRY, Nick, *The proper perspective*
Mark Grotjahn, *Untitled (Black Butterfly Pink MG03)*
Source: Geha and Nichols (1N, above), 55–8

MOYLAN, Christopher, *The Flaying of Marsyas*
Painting of *The Flaying of Marsyas* by Titian, Guido Reni, or Perugino
Source: *Ekphrasis* 1, no. 2 (Winter 1997–1998): 18

MUCHHALA, C.J., *Artistic License*
Bernar Venet, *Undetermined Line*
Source: *Wisconsin Poets* (1E, above), 66–7

MUELLER, Anna, *Dishes*
Amya Ermak-Bower, *Whatever It Takes to See the Sunrise*
Source: *Broadsided. Switcheroo* April 2007. http://www.broadsidedpress.org/switcheroo/april07.shtml

MUELLER, Lisel, *A Nude by Edward Hopper*
Edward Hopper, *Girlie Show*
Source: Lisel Mueller, *Alive Together* (Baton Rouge: Louisiana State University Press, 1996), 95; rpt in *20th Century Rising Tides: American Women Poets*, ed., Laura Chester and Shanon Barba (New York: Washington Square Press, 1973), 135–6; and Levin (3J, above), 46–7

Mueller, Lisel, *American Literature*
Edward Hopper, *Sun in an Empty Room*
Source: Lisel Mueller, *Alive Together* (Baton Rouge: Louisiana State University Press, 1996), 31; rpt. in Levin (3J, above), 72–3

Mueller, Lisel, *Paul Delvaux, The Village of the Mermaids*
Source: Lisel Mueller, *Alive Together* (Baton Rouge: Louisiana State University Press, 1996), 210

Mueller, Lisel, *Monet Refuses the Operation*
Claude Monet, *St. Lazare Station: The Arrival of the Train from Normandy, Rouen Cathedral: Full Sunlight, The Japanese Footbridge and the Water Lily Pond, London, the Houses of Parliament: Sun Breaking through the Fog, London, the Houses of Parliament: Stormy Sky, Western Portal of Rouen Cathedral—Harmony in Blue*, and *The Four Poplars*
Source: Lisel Mueller, *Second Language* (Baton Rouge: Louisiana State University Press, 1986), 59–60

Mueller, Lisel, *The Cook: After Vermeer*
Jan Vermeer, *Woman Pouring Milk*
Source: Lisel Mueller, *The Need to Hold Still* (Baton Rouge: Louisiana State University Press, 1980), 30

Mueller, Lisel. See also *The Artist's Model, ca. 1922* and *After Whistler* in *Alive Together* (Baton Rouge: Louisiana State University Press, 1996), 146, 166

MULDOON, Paul, *Anthony Green: "The Second Marriage"*
Anthony Green, *Mr and Mrs Stanley Joscelyne: The Second Marriage*
Source: Paul Muldoon, *Moy Sand and Gravel* (New York: Farrar, Straus and Giroux, 2002), 35, and Reid and Rice (1J, above), 42–3

Muldoon, Paul, *John Luke: "The Fox"*
John Luke, *The Fox*
Source: Paul Muldoon, *Moy Sand and Gravel* (New York: Farrar, Straus and Giroux, 2002), 34

Muldoon, Paul, *Paul Klee: "They're Biting"*
Source: Paul Muldoon, *Poems: 1968–1998* (New York: Farrar, Straus and Giroux, 2001), 172–3; Adams (1B, above), 96–7; and Benton and Benton, *Double Vision* (2E, above), 15–16

Muldoon, Paul, *The Bearded Woman, by Ribera*
Jusepe de Ribera, *Magdelena Ventura, Husband and Son*
Source: Paul Muldoon, *Poems: 1968–1998* (New York: Farrar, Straus and Giroux, 2001), 57–8

MUMFORD, Erika, *Woman Painter of Mithila*
Mithila (Bihar) wall decoration
Source: Buchwald and Roston (2C, above), 24–5

MURA, David, *Fresh from the Island Angel*
Pacita Abad, *How Mali Lost Her Accent*
Source: Greenberg, *Heart* (2J, above), 26–7

MURRAY, Joan, *Interlude*
John Koch, *Interlude*
Source: Holcomb (1I, above), 132–5

MUSHER, Andrea, *This Painting Can't Be Reproduced*
Helen Frankenthaler, *Pistachio*
Source: *Wisconsin Poets* (1E, above), 60–1

MUSKE-DUKES, Carol, *A Fresco*
Unidentified fresco of the Expulsion from Eden
Source: Carol Muske-Dukes, *Wyndmere* (Pittsburgh, PA: University of Pittsburgh Press, 1985), 38–9

MUSLIM, Kristine Ong, *Myopic*
Ann Callandro, *Shadows*
Source: *Tattoo Highway* 15. http://www.tattoohighway.org/15/komcontest.html

MYRON [pseud.], *Lines Occasioned by Seeing a Portrait of the Goddess of Liberty Treading the Keys of the Bastille under Her Feet, and Feeding a Bald Eagle; Finely Executed by Mr. E. Savage*
Edward Savage, *Liberty in the Form of the Goddess of Youth Giving Support to the Bald Eagle,*
Source: *A Family Tablet: Containing a Selection of Original Poetry* (Boston: William Spotswood, 1796), 157–62

MYRVAAGNES, Naomi, *The Annunciation*
Fra Angelico, *The Annunciation*
Source: *Ekphrasis* 2, no. 6 (Fall–Winter 2002): 36

NADOO, Beverley, *Big Woman's Talk*
Sonia Boyce, *Big Woman's Talk*
Source: Benton and Benton, *Picture Poems* (2H, above), 10–11

NAKAYASU, Sawako, *In the Form of*
Echo Eggebrecht, *Barnswallow*
Source: Geha and Nichols (1N, above), 43–5

NASUFI, Vahit, *What Do You Say Omer Kaleshi*
Omer Kaleshi
Source: Martinovski (2K, above), 126

NATHAN, Leonard, *Van Gogh*
Vincent Van Gogh, *Crows over Cornfield*
Source: Leonard Nathan, *Dear Blood* (Pittsburgh, PA: University of Pittsburgh Press, 1980), 67

Nathan, Leonard, *Altamire*
Altamira cave paintings
Source: Leonard Nathan, *Holding Patterns* (Pittsburgh, PA: University of Pittsburgh Press, 1982), 33

NAWAB, Nimah Ismail, *The Vision*
Shahzia Sikander, *The Illustrated Page Series*
Source: Greenberg, *Side* (2M, above), 74–5

NEELD, Judith, *Landscape Artist*
Ernest Lawson, *Spring Night, Harlem River*
Source: *Ekphrasis* 1, no. 3 (Spring–Summer 1998): 48

NELSON, Rhonda J., *Roots*
Frida Kahlo, *Roots, the Pedregal*
Source: *Ekphrasis* 4, no. 1 (Spring–Summer 2006): 25

NELSON, Sandra, *When a Woman Holds a Letter*
Jan Vermeer, *The Love Letter*
Source: *Exploring Literature*, ed., Frank Madden (New York: Longman, 2007), 1471

NEMEROV, Howard, *Brueghel: The Triumph of Time*
Pieter Brueghel the Elder, *Triumph of Time*
Source: *Art Journal* 32 (Winter 1972–73): 157–62; rpt. in Nemerov's *Trying Conclusions* (Chicago: University of Chicago Press, 1991), 46; and *Collected Poems* (Chicago: University of Chicago Press, 1977), 417–8

Nemerov, Howard, *The Book of Kells*
Source: Howard Nemerov, *Collected Poems* (Chicago: University of Chicago Press, 1977), 132

Nemerov, Howard, *Lightning Storm on Fuji*
Katsushika Hokusai, *Rainstorm Beneath the Summit*
Source: Howard Nemerov, *Collected Poems* (Chicago: University of Chicago Press, 1977), 155–6

Nemerov, Howard, *The World as Brueghel Imagined It*
Pieter Brueghel the Elder
Source: Howard Nemerov, *Trying Conclusions* (Chicago: University of Chicago Press, 1991), 52–3; and *Collected Poems* (Chicago: University of Chicago Press, 1977), 429–30

Nemerov, Howard, *The Painter Dreaming in the Scholar's House*
Paul Klee and Paul Terence Feeley
Source: Howard Nemerov, *Trying Conclusions* (Chicago: University of Chicago Press, 1991), 53–7; and *Collected Poems* (Chicago: University of Chicago Press, 1977), 432–6

Nemerov, Howard, *Hope*
Pieter Brueghel the Elder, *Hope*
Source: *Gnomes & Occasions* (Chicago: University of Chicago Press, 1973), 51

Nemerov, Howard, *Vermeer*
Jan Vermeer
Source: Howard Nemerov, *The Next Room of the Dream* (Chicago: University of Chicago Press, 1962), 37; and *Collected Poems* (Chicago: University of Chicago Press, 1977), 257–8

Nemerov, Howard, *The Most Expensive Picture in the World*
Rembrandt van Rijn, *Aristotle Contemplating the Bust of Homer*
Source: Helen Plotz, ed., *Eye's Delight: Poems of Art and Architecture* (New York: Greenwillow Books, 1983), 34

Nemerov, Howard, *Metamorphoses*
Saul Steinberg
Source: Helen Plotz, ed., *Eye's Delight: Poems of Art and Architecture* (New York: Greenwillow Books, 1983), 41

NESBIT, Edith, *To Our Lady (For a Picture by Giovanni Bellini)*
Source: Edith Nesbit, *Ballads and Verses of The Spiritual Life* (London: Elkin Mathews, 1911)

NESSI, Alberto, *The Temptation of St. Benedict of Ambrogio da Fossano, called Il Bergognone*, trans. Brendan and Anna Connell
Source: *Collection: Ekphrastic Poems by Alberto Nessi and Erocka Ghersi*, No. 3 (Delafield, WI: Canvas Press, 2007), 3; published orig. in Nessi's *Blu cobalto con cenere* (Casagrande, 2000).

NEUMEYER, Peter, *America Talks*
Jacob Lawrence, *Barber Shop*
Source: Greenberg, *Heart* (2J, above), 34

NEVERS, Gillian, *The True Story*
Engel Rooswyck, *Adam and Eve*
Source: *Beauty/Truth: A Journal of Ekphrastic Poetry* 1, no. 2 (Spring–Summer 2007): 30

NEWELL, James, F, *On Self-Portrait*
Louise-Elisabeth Vigée-Lebrun, *Self-Portrait*
Source: http://lesboisarts.blogspot.com/2008/04/art-history-on-self–portrait.html

NEWMANN, Joan, *Give Me to Drink*
Colin Middleton, *Give Me to Drink*
Source: Reid and Rice (1J, above), 34–5

NEWTH, Rebecca, *In Segovia*
Francisco Goya, *Two Old Men Eating*
Source: *Ekphrasis* 2, no. 3 (Fall–Winter 2003): 3

NGUYEN, Hoa, *I Said Apprenend To Seize*
Nina Bovasso, *Silver-Roofed Structure*
Source: Geha and Nichols (1N, above), 39–41

NIATUM, Duane, *The Flower Merchant*
Pablo Picasso, *Composition: The Peasants*
Source: *Weber Journal* 12, no. 3 (Fall 1995). http://

weberjournal.weber.edu/archive/archive%20B%20Vol.%2011–16.1/Vol.%2012.3/12.3Niatum.htm

NICHOLS, Grace, *Turner to His Critic*
J.M.W. Turner, *Snow Storm—Steamboat off a Harbour's Mouth*
Source: Greenberg, *Side* (2M, above), 48–9

Nichols, Grace. For a number of additional poems by Nichols, see 1K, above.

NI CHUILLEANAIN, Eilean, *Apocalyptic*
Jack Butler Yeats, *The End of the World*
Source: Reid and Rice (1J, above), 120–1

NICK, Dagmar, *Der Hafen von Greifswald*
Caspar David Friedrich, *Greifswalder Hafen* (*Greifswald Harbor*)
Source: Kranz (2B, above), 205

NICKELS, Mark, *The Harvesters*
Peter Brueghel the Elder, *The Harvesters*
Source: http://www.nycbigcitylit.com/may2002/contents/poetryasingles.html

NICOLL, Andrew, *Lady Agnew of Lochnaw Sits for Her Portrait*
John Singer Sargent, *Lady Agnew of Lochnaw*
Source: *The Hiss Quarterly* 5, no. 3 http://thehissquarterly.net/eck/nicoll.html

NILES, Bo, *Mère et Soeur de L'Artiste*
Edouard Vuillard, *Mère et Soeur de L'Artiste*
Source: *Ekphrasis* 5, no. 2 (Fall–Winter 2009): 18

NISHIMOTO, Naoko, *On Dawn*
Ei-Kyu, *Dawn*
Source: Greenberg, *Side* (2M, above), 72–3

NOLDE, Carol, *Fox Hunt*
Winslow Homer, *The Fox Hunt*
Source: *Ekphrasis* 1, no. 3 (Spring–Summer 1998): 18

NORDHOLT, J.W. Schulte, *Marchesa Balbi*
Anthony van Dyck, *Portrait of Marchesa Balbi*
Source: Korteweg and Heijn (2F, above), 120

Nordholt, J.W. Schulte, *Rembrandt*
Rembrandt van Rijn, *Hendrickje in Bed*
Source: Korteweg and Heijn (2F, above), 128

Nordholt, J.W. Schulte, *Bathseba*
Rembrandt van Rijn, *Bathsheba Reading King David's Letter*
Source: Korteweg and Heijn (2F, above), 132–3

NORONHA, Lalita, *Sisterhood*
Thomas Couture, *Woman in Profile*
Source: *Beltway Poetry Quarterly* 10, no. 1 (Winter 2009). http://washingtonart.com/beltway/contents.html

NORRIS, Kathleen, *Kitchen Trinity*
Andrew Rublev, *The Holy Trinity*
Source: Kathleen Norris, *Little Girls in Church*

(Pittsburgh, PA: University of Pittsburgh Press, 1995), 6

NORSE, Harold, *Monet's Venice*
Claude Monet, *Venice, Palazzo da Mula*
Source: *Art News* 56 (January 1958): 43–4

NORTON, Camille, *The Green Baize Table*
Quinten Metsys, *The Banker and His Wife*
Source: *Ekphrasis* 3, no. 3 (Spring–Summer 2004): 26–7; and in Norton's *Corruption* (New York: Harper, 2005), 3–4

Norton, Camille, *Index of Prohibited Images: John in the Wild IV*
Caravaggio, *John in the Wild IV*
Source: Camille Norton, *Corruption* (New York: Harper, 2005), 5–6

Norton, Camille, *Index of Prohibited Images: Judith and Holofernes*
Caravaggio, *Judith and Holofernes*
Source: Camille Norton, *Corruption* (New York: Harper, 2005), 7

Norton, Camille, *Index of Prohibited Images: Medusa*
Caravaggio, *Medusa* (1597)
Source: Camille Norton, *Corruption* (New York: Harper, 2005), 8

Norton, Camille, *The Ideal City*
Anonymous, *The Ideal City* (ca. 1475)
Source: Camille Norton, *Corruption* (New York: Harper, 2005), 23–4

Norton, Camille, *In the Small Refectory*
Domenico Ghirlandaio, *Last Supper*
Source: Camille Norton, *Corruption* (New York: Harper, 2005), 25–6

Norton, Camille, *Still Life with Oranges and Walnuts*
Luis Meléndez, *Still Life with Oranges and Walnuts*
Source: Camille Norton, *Corruption* (New York: Harper, 2005), 35

Norton, Camille, *Incomprehensible Triangles*
Jo Small, *Incomprehensible Triangles*, a series of paintings
Source: Camille Norton, *Corruption* (New York: Harper, 2005), 39–40

Norton, Camille, *Wild Animals I Have Known*
Sue Johnson, *Frog Prince No. 2, The Ugly Duckling, The Clone Lover, The Home of the Hydromedusa,* and *Paul Bunyan and His Blue Ox, Babe*
Source: Camille Norton, *Corruption* (New York: Harper, 2005), 75–80

NORWOOD, Nick, *Delftly Stilled*
Jan Vermeer, unidentified still life
Source: Nick Norwood, *The Soft Blare* (Montgomery, AL: River City Publishing, 2003)

Norwood, Nick, *Vermeer's Window*
Jan Vermeer, unidentified painting, though doubt-less either *Woman with a Pearl Necklace* or *Woman Writing a Letter*
Source: *The Soft Blare* (Montgomery, AL: River City Publishing, 2003)

NOVEMBER, Baruch, *Vesuvius Flows into Jacob More*
Jacob More, *Mount Vesuvius in Eruption*
Source: http://www.nycbigcitylit.com/may2002/contents/poetryasingles.html

November, Baruch, *The Dawn of Jacques-Louis David*
Jacques-Louis David, *The Funeral of Patroclus*
Source: http://www.nycbigcitylit.com/may2002/contents/poetryasingles.html

NOWLIN, Linda, *Revisiting Bonnard: The Nudes*
Pierre Bonnard, *The Bath, The Tub, Nude in the Bath, The Red Garters,* and *Nude at the Bathtub*
Source: *New Republic* 24 April 1989: 36

NOYES, Alfred *The Highwayman*
Charles Keeping, "*The Highwayman*" illustrations
Source: Benton and Benton, *Painting with Words* (2G, above), 18–20

NYE, Naomi Shihab, *The World, Starring You*
Florine Stettheimer, *The Cathedrals of Broadway*
Source: Greenberg, *Heart* (2J, above), 72–3

NYHART, Nina, *Two Poems after Paul Klee: Captive Pierrot* and *The Runner*
Paul Klee, *Captive Pierrot* and *The Runner at the Goal*
Source: *Poetry* 152, no. 3 (June 1988): 141–2

Nyhart, Nina, *Stern Visage*
Paul Klee, *Stern Visage*
Source: *Ploughshares* 15, no. 4 (Winter 1989): 155–6

OATES, Joyce Carol, *Edward Hopper, Nighthawks*
Source: Joyce Carol Oates, *The Time Traveler* (New York: Dutton, 1989), 40–2; Levin (3J, above), 36–7; Hirsch (1D, above), 64–5; and *The Best American Poetry 1991*, ed. Mark Strand (New York: Collier Books, 1991), 183–4

Oates, Joyce Carol, *Marsyas Flayed by Apollo*
Titian, *Marsyas Flayed by Apollo*
Source: Joyce Carol Oates, *The Time Traveler* (New York: Dutton, 1989), 37

Oates, Joyce Carol, *Winslow Homer's "The Gulf Stream," 1902*
Source: Joyce Carol Oates, *The Time Traveler* (New York: Dutton, 1989), 38–9

OBERMAYER, Roberta, *The Damned*
Luca Signorelli, *The Damned Cast into Hell*
Source: *Ekphrasis* 1, no. 6 (Fall–Winter 1999): 44–5

O'BRIEN, Lawrence, *Clover*
John Down, *Provincetown, Summer*
Source: *Ekphrasis* 5, no. 1 (Spring–Summer 2009): 21

O'CALLAGHAN, Conor, *Inside*
Robert Ballagh, *Inside No. 3*
Source: Reid and Rice (1J, above), 56–7

O'CALLAHAN, Julie, *Nighthawks*
Edward Hopper, *Nighthawks*
Source: Benton and Benton, *Double Vision* (2E, above), 101–2, and http://wwwfp.education.tas.gov.au/English/hugopaul.htm

O'Callahan, Julie, *Automat*
Edward Hopper, *Automat*
Source: http://wwwfp.education.tas.gov.au/English/hugopaul.htm

O'Callaghan, Julie, *The Road to the West*
John Luke, *The Road to the West*
Source: Reid and Rice (1J, above), 24–5

O'Callaghan, Julie, *Dancer*
Edgar Degas, *Ballet Rehearsal* and *Dancer Tying Her Shoe Ribbon*
Source: Benton and Benton, *Painting with Words* (2G, above), 12

O'Callaghan, Julie, *Spring*
Giuseppe Arcimbolo, *Spring*
Source: Benton and Benton, *Painting with Words* (2G, above), 14

O'Callaghan, Julie, *Winter*
Giuseppe Arcimbolo, *Winter*
Source: Benton and Benton, *Painting with Words* (2G, above), 15

O'CONNELL, Richard, *Two Portraits of Velázquez*
Diego Velázquez, *The Buffoon Sebastian de Morra* and *The Child of Vallecas*
Source: *Measure* 2 (2007): 129

ODAM, Joyce, *Cascade*
Rose Garrard, *Madonna Cascade* (triptych)
Source: *Ekphrasis* 2, no. 3 (Fall–Winter 2003): 33

Odam, Joyce, *The Two Doors*
Andrew Wyeth, *Open and Closed*
Source: *Ekphrasis* 3, no. 1 (Spring–Summer 2003): 35

Odam, Joyce, *A Tide of Great Indifference*
Morris Graves, *Shore Birds*
Source: *Ekphrasis* 2, no. 6 (Fall–Winter 2002): 23

Odam, Joyce, *Neon Love*
Emil Nolde, *Paar am Weintisch*
Source: *Ekphrasis* 2, no. 4 (Fall–Winter 2001): 42

Odam, Joyce, *A Theme of Red*
Mark Rothko, *Four Darks in Red*
Source: *Ekphrasis* 1, no. 6 (Fall–Winter 1999): 23

Odam, Joyce, *Manet*
Édouard Manet, *Lilacs Blancs dans un Vase de Verre*
Source: *Ekphrasis*, 3, no. 4 (Fall–Winter 2004): 46

Odam, Joyce, *Pale Blue Square*
Robert Ryman, *After Léger 1982*

Source: *Ekphrasis* 4, no. 1 (Spring–Summer 2006): 13

Odam, Joyce, *The Old Comedienne*
Henri Toulouse-Lautrec, *The Clowness Cha-U-Kao*
Source: *Ekphrasis* 4, no. 2 (Fall–Winter 2006): 22

Odam, Joyce, *Woman on the Train*
Estelle Tambak, *Woman on Train*
Source: *Ekphrasis* 1, no. 1 (Summer 1997): 20

Odam, Joyce, *The Box of Lines*
Piet Mondrian, *Composition in Red, Yellow, and Blue*
Source: *Ekphrasis* 1, no. 1 (Summer 1997): 21

Odam, Joyce, *de Kooning's "Woman I"*
Willem de Kooning, *Woman I*
Source: *Ekphrasis* 1, no. 4 (Fall–Winter 1998): 36–7

Odam, Joyce, *Reversal*
Gloria Gaddis, *Point of View*
Source: *Ekphrasis* 3, no. 3 (Spring–Summer 2004): 15

Odam, Joyce, *Full Moon in Pond through Trees When it Begins to Rain*
M.C. Escher, *Puddle*
Source: *Ekphrasis* 3, no. 3 (Spring–Summer 2004): 37

Odam, Joyce, *After Chagall*
Marc Chagall, *The Cattle Dealer*
Source: *Ekphrasis* 4, no. 3 (Spring–Summer 2007): 11

Odam, Joyce, *The Dimensionless Summer*
Frank Wesson Benson, *Calm Morning*
Source: *Ekphrasis* 4, no. 6 (Fall–Winter 2008): 28

Odam, Joyce, *Triangles of Time*
Yves Tanguy, *The Furniture of Time*
Source: *Ekphrasis* 5, no. 1 (Spring–Summer 2009): 31

O'DEA, Traci, *Matisse's "Blue Nude" Model Looks in the Mirror*
Source: *Ekphrasis* 4, no. 4 (Fall–Winter 2007): 20

O'DONOGHUE, Bernard, *The Potato Gatherers*
George William 'Æ' Russell, *The Potato Gatherers*
Source: Reid and Rice (1J, above), 88–9

O'DOWD, Tish, *"I wish I were a girl again, half savage and hardy, and free..."*
Camille Pissarro, *Young Girl Knitting*
Source: Tillinghast (1F, above), 98–101

O'DRISCOLL, Dennis, *Variations on Yellow*
Patrick Scott, *Yellow Device*
Source: Reid and Rice (1J, above), 22–3

O'DWYER, Caley, *Violet, Black, Orange, Yellow on White and Red*
Marc, Rothko, *Violet, Black, Orange, Yellow on White and Red*
Source: *Ekphrasis* 5, no. 2 (Fall–Winter 2009): 25

O'Dwyer, Caley, *Yellow Greens*
Marc, Rothko, *Yellow Greens*
Source: *Ekphrasis* 5, no. 2 (Fall–Winter 2009): 26

O'Dwyer, Caley, *Black on Maroon*
Marc, Rothko, *Black on Maroon*
Source: *Ekphrasis* 5, no. 2 (Fall–Winter 2009): 27

O'GORMAN, Ned, *L'Annunciazione; from Bellini*
Giocanni Bellini, *The Annunciation*
Source: *Poetry* 90 (August 1957): 299–300

O'HARA, Frank, *On Looking at "La Grand Jatte" the Czar Wept Anew*
Georges Seurat, *A Sunday on La Grande Jatte*
Source: *The Collected Poems of Frank O'Hara*, ed., Donald M. Allen (New York: Knopf, 1971), 118

O'Hara, Frank, *Variations on the "Tree of Heaven" (In the Janis Gallery)*
Joseph Albers, *Tree of Heaven*
Source: *The Collected Poems of Frank O'Hara*, ed., Donald M. Allen (New York: Knopf, 1971), 349

O'Hara, Frank, *Why I Am Not a Painter*
Michael Goldberg, *Sardines*
Source: *The Collected Poems of Frank O'Hara*, ed., Donald M. Allen (New York: Knopf, 1971), 261

O'Hara, Frank, *Early Mondrian*
Piet Mondrian
Source: *The Collected Poems of Frank O'Hara*, ed., Donald M. Allen (New York: Knopf, 1971), 37

O'Hara, Frank, *For Bob Rauschenberg*
Source: *The Collected Poems of Frank O'Hara*, ed., Donald M. Allen (New York: Knopf, 1971), 322

O'Hara, Frank, *Hieronymus Bosch*
Source: *The Collected Poems of Frank O'Hara*, ed., Donald M. Allen (New York: Knopf, 1971), 121

O'Hara, Frank, *Poem*
Mario Schifano
Source: *The Collected Poems of Frank O'Hara*, ed., Donald M. Allen (New York: Knopf, 1971), 477

O'Hara, Frank, *Sonnet for Larry Rivers and His Sister*
Source: *The Collected Poems of Frank O'Hara*, ed., Donald M. Allen (New York: Knopf, 1971), 138

O'Hara, Frank, *Walking with Larry Rivers*
Source: *The Collected Poems of Frank O'Hara*, ed., Donald M. Allen (New York: Knopf, 1971), 82

O'Hara, Frank, *On Seeing Larry Rivers' "Washington Crossing the Delaware" at the Museum of Modern Art*
Source: *The Collected Poems of Frank O'Hara*, ed., Donald M. Allen (New York: Knopf, 1971), 233–4

O'Hara, Frank, *Digression on "Number 1, 1948"*
Jackson Pollock, *Number 1 (1948)*

Source: *The Collected Poems of Frank O'Hara*, ed., Donald Allen (Berkeley: University of California Press, 1995), 260

O'Hara, Frank, *Oh, the changing dialectic of our world*
Grace Hartigan, *Oh, the Changing Dialectic of our World*
Source: *The Art of Poetry*, catalogue of exhibition at National Collection of Fine Arts, Washington, DC, Nov. 19, 1976 to Jan. 23, 1977, listing no. 22.

O'Hara, Frank, *About Courbet*
Gustave Courbet
Source: *Art News* 56 (January 1958): 43–4

OLINKA, Sharon, *Samvara and Vajravarahi in Union*
Nepalese painting, *Samvara and Vajravarahi in Union*
Source: http://www.nycbigcitylit.com/may2002/contents/poetryasingles.html

OLIVER, Raymond, *Fourteenth-Century Fresco, St. Pierre, Bançion*
Source: *Southern Review* 7, n.s. (July 1971): 866

OLSON, Charles, *An "Enthusiasm"*
Fitz Hugh Lane
Source: *Gloucester Daily Times*, 9 October 1965; rpt. in John Wilmerding, *Fitz Hugh Lane* (New York: Praeger Publishers, 1971), 94–5

Olson, Charles, *For Cy Twombly Faced with His First Chicago & N.Y. Shows*
Source: *The Collected Poems of Charles Olson* (Berkeley: University of California Press, 1987), 244

OLSON, John, *Patch Work*
Christopher Patch, *Reading Room*
Source: Geha and Nichols (1N, above), 69–71

O'MALLEY, Mary, *The Annunciation*
Juan de Valdés Leal, *Annunciation*
Source: Tillinghast (1F, above), 96–7

OOSTERHUIS, Huub, *De val van Icarus*
Pieter Brueghel the Elder, *Landscape with the Fall of Icarus*
Source: Huub Oosterhuis, *Tot op vandaag: gedichten* (Bilthoven: Ambo, 1975), 44, and Korteweg and Heijn (2F, above), 81

OPRY, Linda, *Hiroshima*
Jacqueline Black, *Departed*
Source: http://www.poetryvlog.com/lopyr.html

O'REILLEY, Mary Rose, *Portrait of Madame Monet on Her Deathbed*
Claude Monet, *Camille Monet sur son lit de mort*
Source: Mary Rose O'Reilley, *Half Wild: Poems* (Baton Rouge: Louisiana State University Press, 2006), 39

ORMOND, John, *Certain Questions for Monsieur Renoir*
Auguste Renoir, *La Parisienne*
Source: Abse (2D, above), 88–90

ORMSBY, Frank, *Annadale*
Colin Middleton, *Lagan: Annadale, October*
Source: Reid and Rice (1J, above), 116–17

ØRNSBO, Jess, *Mona Lisa*
Leonardo da Vinci, *Mona Lisa*
Source: Kranz (2B, above), 138

O'ROURKE, Meghan, *The Window at Arles*
Vincent Van Gogh's work at Arles
Source: Charles Wright, ed., *The Best American Poetry 2008* (New York: Scribner, 2008), 84–5

OROZCO, Olga, *Botines con lazos*
Vincent Van Gogh, *A Pair of Boots*
Source: Olga Orozco, *La noche a la deriva* (México: Universidad Nacional Autónoma de México, 1984; Córdoba: Alción, 1995)

ORR, Gregory, *Paradise Corner, This Dazzling, Blue Peninsula, Too Bright, Schoolroom of the Sky, Floating World, Yes,* and *Zip Zap*
Poems on paintings of those titles by Orr's wife Trisha
Source: Greg Orr, *Meridian* 5 (Spring 2000): 72 ff.

Orr, Gregory, *Annunciation*
Simone Martini, *The Annunciation*
Source: Greg Orr, *City of Salt* (Pittsburgh: University of Pittsburgh Press, 1995), 40

Orr, Gregory, *In the Art Museum*
Unidentified Dutch landscape
Source: Greg Orr, *City of Salt* (Pittsburgh: University of Pittsburgh Press, 1995), 38

Orr, Gregory, *After Piero Cosimo's "Venus and Sleeping Mars"*
Source: Greg Orr, *City of Salt* (Pittsburgh: University of Pittsburgh Press, 1995), 33; rpt. as *After Piero di Cosimo's "Venus, Mars, and Amor"* in Orr's *The Caged Owl* (Port Townsend, WA: Copper Canyon, 2002), 197

Orr, Gregory, *A Story Sassetta Paints*
Sassetta (Stefano di Giovanni), *The Meeting of St. Anthony and Saint Paul*
Source: Greg Orr, *Salt Wings: New and Selected Poems* (New York: Poetry East, 1980), n.p.; rpt. in Orr's *The Red House* (New York: Harper & Row, 1980), 53; in *New and Selected Poems* (Middletown, CT: Wesleyan University Press, 1988), 33; and in *The Caged Owl* (Port Townsend, WA: Copper Canyon, 2002), 142

Orr, Gregory, *After Botticelli's "Birth of Venus"*
Source: Gregory Orr, *The Caged Owl* (Port Townsend, WA: Copper Canyon, 2002), 170

ORSMAN, Chris, *The Ice Fleet Sails*
J.M.W. Turner, *Snowstorm*
Source: Chris Orsman, *South* (London: Faber and Faber, 1999), 71–3

Ó SEARCAIGH, Cathal, *Transfigured*, trans. Frank Sewell
Hans Iten, *Five Trees by a River*
Source: Reid and Rice (1J, above), 47–9

O'SULLIVAN, Vincent, *Blame Vermeer*
Jan Vermeer, *The Milkmaid*
Source: Vincent O'Sullivan, *Blame Vermeer* (Wellington, NZ: Victoria University Press, 2007), title poem

OSGOOD, Frances S., *The Boy Painter*
Benjamin West
Source: *The American Female Poets*, ed. Caroline May (Philadelphia: Lindsay and Blakiston, 1848), 394

OSHEROW, Jacqueline, *Views of "La Leggenda della Vera Croce"*
Piero della Francesca, *La Leggenda della Vera Croce*
Source: Jacqueline Osherow, *Dead Men's Praise* (New York: Grove Press, 1999), 5–18

OSSIP, Kathleen, *The Nature of Things*
Robert Lostutter's paintings
Source: *The Best American Poetry 2001*, ed. Robert Hass (New York: Scribner Poetry, 2001), 177

OSTRIKER, Alice Suskin, *A Minor Van Gogh (He Speaks)*
Vincent Van Gogh, *Landscape with Plowman*
Source: Alice Suskin Ostriker, *The Little Space: Poems Selected and New, 1968–1998* (Pittsburgh, PA: University of Pittsburgh Press, 1998), 61

Ostriker, Alice Suskin, *From the Prado Rotunda: The Family of Charles IV, and Others*
Francisco Goya, *The Family of Charles IV, The Nude Maja, The Madhouse*
Source: Alice Suskin Ostriker, *The Little Space: Poems Selected and New, 1968–1998* (Pittsburgh, PA: University of Pittsburgh Press, 1998), 220

Ostriker, Alice Suskin, *A Chinese Fan Painting*
Source: Alice Suskin Ostriker, *The Little Space: Poems Selected and New, 1968–1998* (Pittsburgh, PA: University of Pittsburgh Press, 1998), 222

Ostriker, Alice Suskin, *O'Keeffe*
Georgia O'Keeffe
Source: Alice Suskin Ostriker, *The Little Space: Poems Selected and New, 1968–1998* (Pittsburgh, PA: University of Pittsburgh Press, 1998), 223

Ostriker, Alice Suskin, *Anselm Kiefer*
Source: Alice Suskin Ostriker, *The Little Space: Poems Selected and New, 1968–1998* (Pittsburgh, PA: University of Pittsburgh Press, 1998), 224

Ostriker, Alice Suskin, *Caravaggio: The Painting of Force and Violence*
Caravaggio, *The Sacrifice of Isaac, 1601–2*
Source: *American Poetry Review*, September–October 2000: 30

Ostriker, Alice Suskin, *Redon*
Odilon Redon
Source: *American Poetry Review*, September–October 2000: 30

Ostriker, Alice Suskin, *A Morning at the Museum*
Robert Rauschenberg, Roy Lichtenstein, Frank Stella, Mark Rothko, Jine Dine, et al.
Source: *Prairie Schooner* 79, no. 4 (Winter 2005): 24–8

Ostriker, Alicia Suskin, *At the Van Gogh Museum*
Vincent Van Gogh, *Vincent's House in Arles* (*The Yellow House*)
Source: Alicia Suskin Ostriker, *The Crack in Everything* (Pittsburgh, PA: University of Pittsburgh Press, 1996), 14

Ostriker, Alicia Suskin, *The Studio (Homage to Alice Neel)*
Source: Alicia Suskin Ostriker, *The Crack in Everything* (Pittsburgh, PA: University of Pittsburgh Press, 1996), 17

Ostriker, Alicia Suskin, *Waterlilies and Japanese Bridge*
Claude Monet, *Waterlilies and Japanese Bridge*
Source: Alice Suskin Ostriker, *The Little Space: Poems Selected and New, 1968–1998* (Pittsburgh, PA: University of Pittsburgh Press, 1998), 62–3

Ostriker, Alicia Suskin, *Surviving*
Paula Modersohn-Becker
Source: Alice Suskin Ostriker, *The Little Space: Poems Selected and New, 1968–1998* (Pittsburgh, PA: University of Pittsburgh Press, 1998), 79–85

Ostriker, Alicia Suskin, *From the Prado Rotunda: The Family of Charles IV, and Others*
Francisco Goya, *The Family of Charles IV*; *The Madhouse*, et al.
Source: Alice Suskin Ostriker, *The Little Space: Poems Selected and New, 1968–1998* (Pittsburgh, PA: University of Pittsburgh Press, 1998), 220–1

OUGHTON, John, *Barmaid*
Lowell Fox, *Barmaid*
Source: http://lowellfox.com/page5-contributingpoets/index.htm#Barmaid

OWEN, Gareth, *Siesta*
John Frederick Lewis, *The Siesta*
Source: Adams (1B, above), 66–7, and Benton and Benton, *Double Vision* (2E, above), 27–8

Owen, Gareth, *Icarus by Mobile*
Pieter Brueghel the Elder, *Landscape with the Fall of Icarus*

Source: Benton and Benton, *Picture Poems* (2H, above), 12–13, and at http://wwwfp.education.tas.gov.au/English/hugopaul.htm

OWENS, Lesley, *After All*
Wolf Kahn, *Big Black Barn*
Source: *Louisville Review* 64 (Fall 2008): 20

OYELEYE, Olusola, *Big Woman's Talk*
Sonia Boyce, *Big Woman's Talk*
Source: Benton and Benton, *Picture Poems* (2H, above), 10–11

PADEL, Ruth, *Ruins of Holy Island on Lough Derg*
Bartholomew Colles Watkins, *Ecclesiastical Ruins on Inniscaltra*
Source: Reid and Rice (1J, above), 44–6

PADGETT, Ron, *Joe Brainard's Painting "Bingo"*
Source: *An Anthology of New York Poets*, ed., Ron Padgett and David Shapiro (New York: Random House, 1970), 457–8; rpt. in Padgett's *Great Balls of Fire* (Minneapolis, MN: Coffee House Press, 1990), 84

Padgett, Ron, *Ode to the Futurist Painters and Poets*
Source: Ron Padgett, *Great Balls of Fire* (Minneapolis, MN: Coffee House Press, 1990), 51

PALIEKARA, Marcella, *Vincent's Blessing*
Vincent Van Gogh, *Starry Night*
Source: *Beauty/Truth: A Journal of Ekphrastic Poetry* 1, no. 1 (Fall–Winter 2006): 29

Paliekara, Marcella, *The Meaning of a Kiss*
Gustav Klimt, *The Kiss*
Source: *Beauty/Truth: A Journal of Ekphrastic Poetry* 1, no. 2 (Spring–Summer 2007): 8

PALMER, Carl, *Her Candle*
Godfried Schalken, *Woman with a Candle*
Source: *Beauty/Truth: A Journal of Ekphrastic Poetry* 1, no. 3 (Fall Winter 2007): 30–1

PALMER, Michael, *A Vitruvian Figure by Juan Gris*
Juan Gris, unidentified painting
Source: Michael Palmer, *The Lion Bridge: Selected Poems 1972–1995* (New York: New Directions, 1998), 9

PANKEY, Eric, *Detail from "The Lamentation Over the Dead Christ"*
Images from a number of paintings of the Lamentation
Source: Eric Pankey, *The Pear as One Example: New & Selected Poems 1984–2008* (Keene, NY: Ausable, 2008), 92

Pankey, Eric, *Diptych*
Rogier van der Weyden, *Crucifixion Diptych*
Source: Eric Pankey, *The Pear as One Example: New & Selected Poems 1984–2008* (Keene, NY: Ausable, 2008), 56

PAPE, Greg, *American Flamingo*
John James Audubon, *The American Flamingo*
Source: *Atlantic Monthly* 282, no. 1 (July 1998): 81;
 rpt. in Greg Pape, *American Flamingo* (Carbon-
 dale: Southern Illinois University Press, 2005).

PARAVICINO Y ARTEAGA, Hortensio Félix, *Auf das
 Portrait, das Greco vom ihm malte*
El Greco, *Portrait of Fray Felix Hortensio Paravicino*
Source: Kranz (2B, above), 163

PARDLO, Gregory, *Restoring O'Keeffe*
Georgia O'Keeffe
Source: Gregory Pardlo, *Totem* (Philadelphia:
 American Poetry Review, 2007), 85

Pardlo, Gregory, *Title It Shotgun Wound*
Jackson Pollock
Source: Gregory Pardlo, *Totem* (Philadelphia:
 American Poetry Review, 2007), 10

PARHAM, Robert, *Of "The Old Guitarist"*
Pablo Picasso, *The Old Guitarist*
Source: *Ekphrasis* 4, no. 4 (Fall–Winter 2007): 24

Parham, Robert, *Father, Plowing*
Rosa Bonheur, *Plowing at Nivernais*
Source: *Ekphrasis* 3, no. 5 (Spring–Summer 2005):
 18

PARISH, Elizabeth, *Self Portrait (Rembrandt)*
Rembrandt van Rijn, *Self Portrait*
Source: http://www.guardian.co.uk/books/2006/o
 ct/23/poetry

PARK, Carma Lynn, *Death of Orpheus*
Henry Levy, *Death of Orpheus*
Source: *Beauty/Truth: A Journal of Ekphrastic Poetry*
 1, no. 3 (Fall–Winter 2007): 14

PARKER, Pamela Johnson, *Collective Origins as
 Ulysses: Uxoria*
Kevin Morrow, *Collective Origins*
Source: *Broadsided: Switcheroo V*, April 2009.
 http://www.broadsidedpress.org/switcheroo/april
 09.shtml

PASTAN, Linda, *Fresco*
Masaccio, *The Expulsion from the Garden*
Source: Linda Pastan, *Carnival Evening: New and
 Selected Poems 1968–1998* (New York: Norton,
 1999), 99; and in Abse (2D, above), 25

Pastan, Linda, *Carnival Evening*
Henri Rousseau, *Carnival Evening*
Source: Linda Pastan, *Carnival Evening: New and
 Selected Poems 1968–1998* (New York: Norton,
 1999), 39

Pastan, Linda, *Le Sens de la Nuit*
René Magritte, *Meaning of Night*
Source: Linda Pastan, *Carnival Evening: New and
 Selected Poems 1968–1998* (New York: Norton,
 1999), 5

Pastan, Linda, *Ideal City*
Oil on canvas, Central Italy, c. 1500
Source: Linda Pastan, *Carnival Evening: New and
 Selected Poems 1968–1998* (New York: Norton,
 1999), 266

Pastan, Linda, *Still Life*
Source: Linda Pastan, *Carnival Evening: New and
 Selected Poems 1968–1998* (New York: Norton,
 1999), 36

Pastan, Linda, *Vermillion*
Pierre Bonnard
Source: Linda Pastan, *Carnival Evening: New and
 Selected Poems 1968–1998* (New York: Norton,
 1999), 284

Pastan, Linda, *Woman Holding a Balance*
Jan Vermeer, *Woman Holding a Balance*
Source: Linda Pastan, *Carnival Evening: New and
 Selected Poems 1968–1998* (New York: Norton,
 1999), 38

Pastan, Linda, *Courbet's "Still Life with Apples and
 Pomegranate"*
Source: Linda Pastan, *Carnival Evening: New and
 Selected Poems 1968–1998* (New York: Norton,
 1999), 275

Pastan, Linda, *Three Skulls on an Oriental Rug:
 Cezanne, Oil on Canvas*
Paul Cézanne, *Three Skulls on an Oriental Rug*
Source: *Beltway Poetry Quarterly* 10, no. 1 (Winter
 2009) http://washingtonart.com/beltway/pastan
 6.html

Pastan, Linda, *Le sense de la nuit*
René Magritte, *The Maeaning of Night*
Source: *Beltway Poetry Quarterly* 6, no. 3 (Summer
 2005). http://washingtonart.com/beltway/pasta
 n.html

Pastan, Linda, *In the Realm of Pure Color*
Paul Gauguin, *The Loss of Virginity*
Source: Linda Pastan, *Heroes in Disguise* (New York:
 Norton, 1991), 11

Pastan, Linda, *Woman Sewing Beside a Window*
Edward Vuillard, *Woman Sewing Before a Garden*
Source: Linda Pastan, *Heroes in Disguise* (New York:
 Norton, 1991), 6

Pastan, Linda, *The Keeper*
Tintoretto, *Creation of the Animals*
Source: Linda Pastan, *Heroes in Disguise* (New York:
 Norton, 1991), 5

Pastan, Linda, *Maria im Rosenhaag*
Martin Schongauer, *Maria im Rosenhaag*
Source: Linda Pastan, *Heroes in Disguise* (New York:
 Norton, 1991), 36

Pastan, Linda, *Letters*
John Henry Twachtman

Source: Linda Pastan, *Heroes in Disguise* (New York: Norton, 1991), 37

Pastan, Linda, *Boundaries,*
Claude Monet, *Water Lilies*
Source: *Gettysburg Review* 21, no. 4 (Winter 2008), and at http://poetrydaily.org/poem.php?date=14246

PATER, Walter, *Mona Lisa*
Leonardo da Vinci, *Mona Lisa*
Source, Kranz (2B, above), 126; and Kehl (2A, above), 76–7

PATTERSON, Veronica, *My Edward Hopper Eye, My Claude Monet*
Source: http://colopoets.unco.edu/pattersonVpoems.htm#edward

PAULIN, Tom, *Marc Chagall, "Over the Town"*
Source: Tom Paulin, *The Wind Dog* (London: Faber & Faber, 1999), 19–20

Paulin, Tom, *Vitebsk*
Marc Chagall
Source: Tom Paulin, *The Wind Dog* (London: Faber & Faber, 1999), 63

Paulin, Tom, *On*
Jack Butler Yeats, *Through the Silent Lands*
Source: Reid and Rice (1J, above), 16–17

Paulin, Tom, *Klee/Clover*
Paul Klee
Source: Tom Paulin, *Walking a Line* (London: Faber and Faber, 1994), 1–2

PAU-LLOSA, Ricardo, *Las Meninas*
Diego Velázquez, *Las Meninas*
Source: *Shenandoah* 42, no. 1 (Spring 1992)

Pau-Llosa, Ricardo, *The Raft of the Medusa*
Théodore Géricault, *The Raft of the Medusa*
Source: *Prairie Schooner* 68, no. 4 (Winter 1994)

Pau-Llosa, Ricardo, *St. George and the Notary*
David Manzur
Source: *Partisan Review* 39, no. 3 (1982); rpt. in Pau-Llosa's *Sorting Metaphors* (Tallahassee, FL: Anhinga Press, Anhinga Poetry Prize, 1983)

Pau-Llosa, Ricardo, *Battlefields,*
Alejandro Obregón and Antonio Henrique Amaral
Source: *Carolina Quarterly* 38, no. 1 (Fall 1985); rpt. in Pau-Llosa's *Bread of the Imagined* (Tempe, AZ: Bilingual Press, Arizona State University, 1992)

Pau-Llosa, Ricardo, *The Island of Mirrors*
Humberto Calzada
Source: *Denver Quarterly* 21, no. 3 (Winter 1987); rpt. in Pau-Llosa's *Bread of the Imagined* (Tempe, AZ: Bilingual Press, Arizona State University, 1992)

Pau-Llosa, Ricardo, *The Intruder*
Julio Larraz
Source: *Denver Quarterly* 23, nos. 3–4 (Winter–Spring 1989); rpt. in Pau-Llosa's *Bread of the Imagined* (Tempe, AZ: Bilingual Press, Arizona State University, 1992)

Pau-Llosa, Ricardo, *Nude Man Bending into a Mirror*
Arnaldo Roche-Rabell
Source: *Downtown* [SoHo, New York City] 175 (20–27 December 1989), 8A–9A; rpt. in Pau-Llosa's *Bread of the Imagined* (Tempe, AZ: Bilingual Press, Arizona State University, 1992)

Pau-Llosa, Ricardo, *Divided Forest*
Sebastián Spreng
Source: *Indiana Review* 15, no. 1 (Spring 1992)

Pau-Llosa, Ricardo, *Amelia Peláez*
Amelia Peláez
Source: *Onthebus* 4, no. 2 and 5, no. 1 (Fall 1992; double issue); rpt. in Pau-Llosa's *Cuba* (Pittsburgh, PA: Carnegie Mellon University Press, 1993)

Pau-Llosa, Ricardo, *La Historia me Absolverá*
Paul Sierra
Source: *Planet* (Wales, UK) 96 (December 1992–January 1993)

Pau-Llosa, Ricardo, *Wifredo Lam*
Wifredo Lam
Source: *The Journal* 16, no. 2 (Fall–Winter 1992); rpt. in Pau-Llosa's *Cuba* (Pittsburgh, PA: Carnegie Mellon University Press, 1993)

Pau-Llosa, Ricardo, *Agustín Fernández*
Agustín Fernández
Source: *Guadalupe Review* 2 (October 1992); rpt. in Pau-Llosa's *Cuba* (Pittsburgh, PA: Carnegie Mellon University Press, 1993)

Pau-Llosa, Ricardo, *One More Time the Blind Man Asks Himself If There Is Anybody Out There*
Arnaldo Roche-Rabell
Source: *Downtown* [SoHo, New York City] 220 (26 May 26–9 June 1993)

Pau-Llosa, Ricardo, *Fidelio Ponce de León*
Fidelio Ponce de León
Source: *Columbia: A Magazine of Poetry and Prose* (Fall–Winter 1993); rpt. in Pau-Llosa's *Cuba* (Pittsburgh, PA: Carnegie Mellon University Press, 1993)

Pau-Llosa, Ricardo, *Carlos Enríquez*
Carlos Enríquez
Source: *Footwork* 23 (1994); rpt. in Pau-Llosa's *Cuba* (Pittsburgh, PA: Carnegie Mellon University Press, 1993)

Pau-Llosa, Ricardo, *The Raft of the Medusa*
Carlos Enríquez, *The Raft of the Medusa*

Source: *Prairie Schooner* 68, no. 4 (Winter 1994); rpt. in Pau-Llosa's *The Mastery Impulse* (Pittsburgh, PA: Carnegie Mellon University Press, 2003)

Pau-Llosa, Ricardo, *Tinted Steam*
J.M.W. Turner, *Tinted Stream*
Source: *Chants* (Spring 1995)

Pau-Llosa, Ricardo, *That Day the Body Became a Hand, Rivers*
Pablo Soria
Source: *Caliban* 15 (Winter 1996)

Pau-Llosa, Ricardo, *La Habana Oscura*
Glexis Nova
Source: *Mid-American Review* 17, no. 1 (1997); rpt. in Pau-Llosa's *Vereda Tropical* (Pittsburgh, PA: Carnegie Mellon University Press, 1999)

Pau-Llosa, Ricardo, *Years of Exile*
Humberto Calzada
Source: *Iowa Review* 28, no. 1 (1998); rpt. in Pau-Llosa's *The Mastery Impulse* (Pittsburgh, PA: Carnegie Mellon University Press, 2003)

Pau-Llosa, Ricardo, *Interior for Norma Desmond*
Eduardo Michaelsen
Source: *Verse* 15, no. 1–2 (Fall 1998); rpt. in Pau-Llosa's *The Mastery Impulse* (Pittsburgh, PA: Carnegie Mellon University Press, 2003)

Pau-Llosa, Ricardo, *Dog Sleep*
Julio Rosado del Valle
Source: *Crazyhorse* 60 (Spring 2001); rpt. in Pau-Llosa's *The Mastery Impulse* (Pittsburgh, PA: Carnegie Mellon University Press, 2003)

Pau-Llosa, Ricardo, *Si vis pacem para bellum*
Carlos Ulloa (collage)
Source: *Quarterly West* 53 (Fall–Winter 2001–2002); rpt. in Pau-Llosa's *The Mastery Impulse* (Pittsburgh, PA: Carnegie Mellon University Press, 2003)

Pau-Llosa, Ricardo, *Winter Landscape with a Bird Trap*
Pieter Brueghel the Elder, *Winter Landscape with a Bird Trap*
Source: *TriQuarterly* 117 (Fall 2003); rpt. in Pau-Llosa's *Parable Hunter* (Pittsburgh, PA: Carnegie Mellon University Press, 2008)

Pau-Llosa, Ricardo, *Seven*
Hieronymus Bosch (painted panel)
Source: *Southern Review* 40, no. 3 (Summer 2004); rpt. in Pau-Llosa's *Parable Hunter* (Pittsburgh, PA: Carnegie Mellon University Press, 2008)

Pau-Llosa, Ricardo, *Tahiti, 1900*
Paul Gauguin
Source: *Ascent* 29, no.2 (Winter 2005)

Pau-Llosa, Ricardo, *Brújula*
Julio Rosado del Valle

Source: *Bellingham Review* 28, no. 2, issue 56 (Fall 2005); rpt. in Pau-Llosa's *Parable Hunter* (Pittsburgh, PA: Carnegie Mellon University Press, 2008)

Pau-Llosa, Ricardo, *Hunters in the Snow*
Pieter Brueghel the Elder, *Hunters in the Snow*
Source: *TriQuarterly* 125 (Spring–Summer 2006); rpt. in Pau-Llosa's *Parable Hunter* (Pittsburgh, PA: Carnegie Mellon University Press, 2008)

Pau-Llosa, Ricardo, *Sound in Art*
William Fellini
Source: *Ascent* 31, no. 1 (Fall 2007)

Pau-Llosa, Ricardo, *Dark Diver*
Daniel Dallmann
Source: Ricardo Pau-Llosa, *Vereda Tropical* (Pittsburgh, PA: Carnegie Mellon University Press, 1999)

Pau-Llosa, Ricardo, *Four*
Francisco Zurbarán
Source: Ricardo Pau-Llosa, *Parable Hunter* (Pittsburgh, PA: Carnegie Mellon University Press, 2008)

PAVLICEK-WEHRLI, Marie, *After*
Enguerrand Quarton, *The Avignon Pietà*
Source: *Ekphrasis* 5, no. 4 (Spring–Summer 2008): 30

PAVLOVSKI, Radovan, *The Hymn of the Colours*
Vincent Van Gogh
Source: Martinovski (2K, above), 82

Pavlovski, Radovan, *A Cornfield with Ravens*
Vincent van Gogh, *Wheat Field with Ravens*
Source: Martinovski (2K, above), 82

PEACOCK, Molly, *Girl and Friends View Naked Goddess*
Pier Celestino Gilardi, *A Visit to the Gallery*
Source: Tillinghast (1F, above), 26–7; and in Peacock's *The Second Blush* (New York: W.W. Norton, 2008), 41–2

PEARCE, Martin, *On First Seeing Glenn Brown's "Little Death"*
Glenn Brown, *Little Death*
Source: http://www.guardian.co.uk/books/2006/oct/23/poetry

PECK, Gail, *Inside*
After artwork by Vilem T. Eisner, a child at Terezin Concentration Camp
Source: *Cave Wall* 3 (Winter–Spring 2008). http://www.cavewallpress.com/poem3_1.htm

PECK, John, *Let Us Call This the Hill of Sōtatsu*
Tawaraya Sōtatsu
Source: John Peck, *Collected Shorter Poems 1966–1996* (Manchester, UK: Carcanet, 1999), 72–3

Peck, John, *Rhyme Prose Four*
Oscar Ruegg, *Rhyme Prose Four*
Source: John Peck, *Collected Shorter Poems 1966–1996* (Manchester, UK: Carcanet, 1999), 102–3

PECKHAM, Ellen, *Artemesia*
Artemisia Gentileschi, *Judith Slaying Holofernes* and *Venus and Cupid*
Source: http://www.nycbigcitylit.com/may2002/contents/poetryasingles.html

PELEGRIN, Alison, *Helicopter Hands*
Rolland Golden, Hurricane Katrina paintings
Source: *Ducts.org* 21 (Summer 2008). http://www.ducts.org/content/helicopter-hands/

PERLBERG, Mark, *Garden Vision (after the painting by Paul Klee)*
Source: Mark Perlberg, *The Impossible Toystore: Poems* (Baton Rouge: Louisiana State University Press, 2000), 24

Perlberg, Mark, *"Self Portrait": Camille Pissarro*
Source: Mark Perlberg, *The Impossible Toystore: Poems* (Baton Rouge: Louisiana State University Press, 2000), 25

Perlberg, Mark M., *The House Tree (Painting by Paul Klee)*
Paul Klee, *The House Tree*
Source: *The New Yorker* (May 17, 1969): 44

PERRAULT, Charles, *La Peinture*
Charles le Brun
Source: Maurisson and Verlet (2L, above), 26–9

PERREAULT, John, *I (for Sylvia Sleigh)*
Sylvia Sleigh, *A.I.R. Group Portrait*, 1978
Source: Vanderlip (1A, above), 58

Perreault, John, *II (for Ira Joel Haber)*
Ira Joel Haber, *My Landscape Grows Older When I'm Not with You*, 1974
Source: Vanderlip (1A, above), 60

PERRON, E. du, *Adriana de Buuck* and *Reprise (na 6 jaar)*
Pieter Pourbus, *Portrait of Jacquemijne Buuck*
Source: Korteweg and Heijn (2F, above), 78

PETERS, Andrew Fusek, and Polly Peters, *Nighthawks (After Edward Hopper)*
Source: Andrew Fusek Peters and Polly Peters, *Attitude Uncensored* (Hodder, 2002), and at http://www.poetryarchive.org/poetryarchive/singlePoem.do?poemId=6077

PETERSON, Jim, *The Song of the Lark*
Jules Breton, *The Song of the Lark*
Source: *Ekphrasis* 1, no. 4 (Fall–Winter 1998): 34

PETIT, Pascale, *My Son Is Beautiful as the Sun (after a painting by Guillermo Kuitka)*
Source: Pascale Petit, *Heart of a Deer* (Manchester, UK: Enitharmon, 1998), 18

PETRIE, Paul, *On Looking at a Vermeer*
Jan Vermeer
Source: *Poetry* 97 (October 1960): 18

Petrie, Paul, *Renoir*
Pierre–Auguste Renoir
Source: *Poetry* 97 (October 1960): 17

PETROVSKI, Trajan, *The Old Olive Tree*
Vasko Taškovski
Source: Martinovski (2K, above), 128

PETTY, Gayle M., *The Persistence of Memory*
Salvador Dali, *The Persistence of Memory*
Source: http://www.elsinore.net/gayle/persistence.htm

Petty, Gale M., *Purple Bongos at the Bus Stop*
Rachel, *Purple Bongos at the Bus Stop*
Source: http://www.elsinore.net/gayle/bongos.htm

Petty, Gayle M., *The Fiddler*
Marc Chagall, *The Fiddler*
Source: http://www.elsinore.net/gayle/fiddler.htm

Petty, Gayle M., *Married Couple*
George Grosz, *The Married Couple*
Source: http://www.elsinore.net/gayle/married.htm

Petty, Gayle M., *If You Are Consumed*
Suzanne Kosmalski, *Memoirs of a River*
Source: http://www.elsinore.net/gayle/consumed.htm

Petty, Gayle M., *Scream*
Edvard Munch, *The Scream*
Source: http://www.elsinore.net/gayle/scream.htm

Petty, Gayle M., *The Boulevard de Clichy under Snow*
Norbert Goeneutte, *The Boulevard de Clichy under Snow*
Source: http://www.elsinore.net/gayle/clichy.htm

Petty, Gayle M., *Rooftops*
Gustave Caillebotte, *Rooftops under Snow*
Source: http://www.elsinore.net/gayle/rooftops.htm

Petty, Gayle M., *Still Life*
Pierre Auguste Renoir, *Strawberries*
Source: http://www.elsinore.net/gayle/still.htm

Petty, Gayle M., *Winter Landscape*
John Fabian Carlson, *March Idyl*
Source: http://www.elsinore.net/gayle/winter.htm

Petty, Gayle M., *Moon Highway*
J.M.W. Turner, *Tours: Sunset*
Source: http://www.elsinore.net/gayle/moon.htm

Petty, Gayle M., *Rain*
Gustave Caillebotte, *Paris: A Rainy Day*
Source: http://www.elsinore.net/gayle/rain.htm

Petty, Gayle M., *Starting Over*
Claude Monet, *La corniche de monaco*
Source: http://www.elsinore.net/gayle/starting.htm

Petty, Gayle M., *The Good Mother for My Inner Child*
Mary Cassat, *La Toilette*
Source: http://www.elsinore.net/gayle/goodmother.htm

Petty, Gayle M., *Max Ernst Messes with the Accountant*
Max Ernst, *The Butterfly Collection*
Source: http://www.elsinore.net/gayle/maxernst.htm

Petty, Gayle M., *A French Beach, 1817*
Pierre Bonnard, *L'estérel*
Source: http://www.elsinore.net/gayle/french.htm

Petty, Gayle M., *Ida at the Window*
Marc Chagall, *Ida at the Window*
Source: http://www.elsinore.net/gayle/ida.htm

Petty, Gayle M., *Keeper of the Light*
Piotr Szyhalski, *Get People to Like You*
Source: http://www.elsinore.net/gayle/light.htm

Petty, Gayle M., *The Oarsmen's Luncheon*
Pierre Auguste Renoir, *Luncheon of the Boating Party*
Source: http://www.elsinore.net/gayle/oarsmen.htm

Petty, Gayle M., *Madame Roulin*
Vincent Van Gogh, *La berceuse*
Source: http://www.elsinore.net/gayle/roulin.htm

Petty, Gayle M., *Nighthawk*
Edward Hopper, *Nighthawks*
Source: http://www.elsinore.net/gayle/nighthawk.htm

Petty, Gayle M., *Self-Portrait with Seven Fingers*
March Chagall, *Self-Portrait with Seven Fingers*
Source: http://www.elsinore.net/gayle/seven.htm

Petty, Gayle M., *St. Mary's from Oriel Lane*
J.M.W. Turner, *St. Mary's from Oriel Lane*
Source: http://www.elsinore.net/gayle/stmarys.htm

Petty, Gayle M., *Sunflowers*
Vincent Van Gogh, *Sunflowers*
Source: http://www.elsinore.net/gayle/sunflowers.htm

Petty, Gayle M., *The Bridge*
Claude Monet, *Water-lily Pond*
Source: http://www.elsinore.net/gayle/bridge.htm

Petty, Gayle M., *The Waitress*
Edouard Manet, *The Waitress*
Source: http://www.elsinore.net/gayle/waitress.htm

Petty, Gayle M., *Winter Trees in Oil*
James Richard Petty, *Trees*
Source: http://www.elsinore.net/gayle/wintering.htm

Petty, Gayle M., *Wanting Only Impressionism*
James Richard Petty, *Ferns*
Source: http://www.elsinore.net/gayle/wanting.htm

PEYER, Rudolf, *Kornfeld mit Raben: Dem Lezten Bild Van Goghs*
Vincent Van Gogh, *Crows over Cornfield*
Source: Kranz (2B, above), 215

PIANTA [sic], *Second Consort: Poems Based on "Lady Guoguo's Spring Outing"*
Zhang Xuan, *Lady Guoguo's Spring Outing*
Source: *Ekphrasis* 4, no. 6 (Fall–Winter 2008): 8–9

PICCIONE, Anthony, *Entering Genesee Gorge*
Thomas Cole, *Genesee Scenery*
Source: Holcomb (11, above), 136–8

PIERCY, Marge, *The Peaceable Kingdom*
Edward Hicks, *The Peaceable Kingdom*
Source: Todd Getlin, ed., *Campfires of the Resistance: Poetry from the Movement* (Indianapolis: Bobbs-Merrill, 1971), 215–17

PILIBOSIAN, Helene, *Mannequins Will Tell*
Charles Sheeler, *Windows*
Source: *Ekphrasis* 4, no. 6 (Fall–Winter 2008): 37–8

PILINSZKY, János, *Van Gogh's Prayer*
Vincent Van Gogh
Source: *Poetry* 191, no. 6 (March 2008): 489

PILLIN, William, *The Ascensions*
Marc Chagall
Source: *Poetry* 91 (November 1957): 104–5

PILLING, Christopher. For Pilling's poems on Henri Matisse, see 3N, above.

PINKERTON, Helen. For fifteen of Pinkerton's poems on paintings, see 4C, above.

PINSKY, Robert, *On "Eve Tempted by the Serpent" by Defendente Ferrari, and In Memory of Congresswoman Barbara Jordan of Texas*
Attributed to Defendente Ferrari, *Eve Tempted by the Serpent*
Source: Tillinghast (1F, above), 74–5

PIONTEK, Heinz, *Bruegelscher Oktober*
Pieter Brueghel the Elder, *The Return of the Herd*
Source: Kranz (2B, above), 90

PITCHFORD, David M., *What Within the Looking Glass?*
Diego Velázquez, *The Rokeby Venus*
Source: http://bitterhermit.wordpress.com/category/ekphrasis/

Pitchford, David M., *Gardens of Our Own Agony*
Jacopo Ligozzi, *Agony*
Source: http://bitterhermit.wordpress.com/category/ekphrasis/

Pitchford, David M., *Prayer for the Dying: Meditation for the Living* and *For Kith and Kin*
William-Adolphe Bouguereau, *Douleur Damour*
Source: http://bitterhermit.wordpress.com/category/ekphrasis/

Pitchford, David M., *Wake Me*
William-Adolphe Bouguereau, *Dawn*
Source: http://bitterhermit.wordpress.com/2008/
08/

Pitchford, David M., *Beyond the Age of Sacrifice*,
John William Waterhouse, *Narcissus and Echo*
Source: http://bitterhermit.wordpress.com/categor
y/ekphrasis/

Pitchford, David M., *Nyneve, What but My Soul
Suffices?*
Unidentified Pre–Raphaelite painting of Merlin and
Nyneve
Source: http://bitterhermit.wordpress.com/categor
y/ekphrasis/

PITTER, Ruth, *The Spanish Painting*
Unidentified painting of the Resurrection
Source: Ruth Pitter, *Collected Poems* (London:
Enitharmon, 1996), 85–6

Pitter, Ruth, *The Chimneypiece*
George William Russell ('Æ'), unidentified painting
Source: Ruth Pitter, *Collected Poems* (London:
Enitharmon, 1996), 117

Pitter, Ruth, *The Saint's Progress*
An unidentified early Italian painting
Source: Ruth Pitter, *Collected Poems* (London:
Enitharmon, 1996), 123–4

PLATH, Sylvia, *Yadwigha, on a Red Couch, Among
Lilies: A Sestina for the Douanier*
Henri Rousseau, The *Dream*
Source: Sylvia Plath, *Collected Poems* (New York:
Harper & Row, 1981), 85–6

Plath, Sylvia, *Snakecharmer*
Henri Rousseau, *The Snake Charmer*
Source: Sylvia Plath, *Collected Poems* (New York:
Harper & Row, 1981),79

Plath, Sylvia, *The Disquieting Muses*
Giorgio de Chirico, *The Disquieting Muses*
Source: Sylvia Plath, *Collected Poems* (New York:
Harper & Row, 1981), 74–6

Plath, Sylvia, *On the Decline of Oracles*
Giorgio de Chirico, *The Enigma of the Oracle*
Source: Sylvia Plath, *Collected Poems* (New York:
Harper & Row, 1981), 78

Plath, Sylvia, *Two Views of a Cadaver Room* (the sec-
ond view)
Pieter Brueghel the Elder, *The Triumph of Death*
Source: Sylvia Plath, *Collected Poems* (New York:
Harper & Row, 1981), 114, and Kehl (2A, above),
202–3

Plath, Sylvia, *In Brueghel's Panorama*
Pieter Brueghel the Elder, *The Triumph of Death*
Source: Benton and Benton, *Double Vision* (2E,
above), 91

PLATT, Donald, *Die Kruppelmappe*
Heinrich Hoerle, *Die Kruppelmappe* (lithographs)
Source: *Seneca Review* 18, no. 1 (Spring 2008): 45–9

PLUMLY, Stanley, *Samuel Scott's "A Sunset, with a
View of Nine Elms"*
Samuel Scott, *A Sunset, with a View of Nine Elms*
Source: Stanley Plumly, *Old Heart: Poems* (New
York: Norton, 2007), 95

PLUTZIK, Hyam, *To the Painter Paul Klee*
Source: Hyam Plutzik, *The Collected Poems* (Brock-
port, NY: Boa Editions, 1987), 223

Plutzik, Hyam, *The Sad Birds of Hilda Altschule,
Painter*
Source: Hyam Plutzik, *The Collected Poems* (Brock-
port, NY: Boa Editions, 1987), 245

Plutzik, Hyam, *Concerning the Painting "Afternoon
in Infinity" by Attilio Salemme*
Source: Hyam Plutzik, *The Collected Poems* (Brock-
port, NY: Boa Editions, 1987), 255

POCH, John, *Reprieve*
Jacques-Louis David, *The Death of Socrates*
Source: *Ekphrasis* 1, no. 6 (Fall–Winter 1999): 43

POE, Edgar Allan, *Ulalume*
Robert W. Weir, *Siege Battery*
See description in Irene Weir, *Robert W. Weir, Artist*
(New York: Field-Doubleday, 1947), 60

POGONOWSKA, Anna, *Vincent Van Gogh*
Vincent Van Gogh, *Crows over Cornfield* and other
Van Gogh paintings
Source: Kranz (2B, above), 213 (German trans.)

POLLITT, Katha, *Woman Asleep on a Banana Leaf*
T'ang Yin, *Sleeping Beauty on a Long Banana Leaf*
Source: Buchwald and Roston (2C, above), 80

POLZER, H.H. See Drs. P, above

POMEROY, Ralph, *Sentry Seurat*
Georges Seurat
Source: *Poetry* 99 (January 1962): 230

POND, Joan, *Nighthawk at Phillies*
Edward Hopper, *Nighthawks*
Source: http://trfn.clpgh.org/tpq/dayjob.html

PONSOT, Marie, *The Split Image of Attention*
Illuminated manuscript, *The Book of Dimma*, Trin-
ity College, Dublin
Source: Marie Ponsot, *The Bird Catcher* (New York:
Knopf, 1998), 43

POOLE, Peggy, *Polishing Pans*
Marianne Stokes, *Polishing Pans*
Source: Benton and Benton, *Picture Poems* (2H,
above), 48

POPA, Allan, poems on five artists [in Filipino]:
 Liwanag Ayon kay Hopper
 Liwanag Ayon kay Monet

Liwanag Ayon kay Vermeer
Liwanag Ayon kay Bonnard
Liwanag Ayon kay de Chirico
Source: Allan Popa, *Kundi Akala* (Quezon City:
 High Chair, 2004)

POPE, Deborah, *Les Voyeurs*
Claude Monet, *Les Voyeurs*
Source: Deborah Pope, *Mortal World* (Baton Rouge:
 Louisiana State University Press, 1995), 32–3

Pope, Deborah, *Frank Benson, "Portrait of My
 Daughters"*
Source: Deborah Pope, *Fanatic Heart* (Baton
 Rouge: Louisiana State University Press, 1992), 44

Pope, Deborah, *Klimt, "The Fulfillment"*
Gustav Klimt, *Fulfillment*
Source: Deborah Pope, *Fanatic Heart* (Baton
 Rouge: Louisiana State University Press, 1992), 45

Pope, Deborah, *Rousseau, "Les Joueurs," 1908*
Henri Rousseau, *The Football Players*
Source: Deborah Pope, *Fanatic Heart* (Baton
 Rouge: Louisiana State University Press, 1992), 46

Pope, Deborah, *Plainspoken*
Georgia O'Keeffe, *Cebolla Church*
Source: Deborah Pope, *Falling Out of the Sky* (Baton
 Rouge: Louisiana State University Press, 1999), 8–
 10, and Paschal (1G, above), 98–9

Pope, Deborah, *The Woman Question*
Frederick Frieseke, *The Garden Parasol*
Source: Deborah Pope, *Falling Out of the Sky* (Baton
 Rouge: Louisiana State University Press, 1999),
 18–19

Pope, Deborah, *On Lichtenstein's "Bananas and
 Grapefruit"*
Roy Lichtenstein, *Bananas and Grapefruit #3*
Source: Greenberg, *Heart* (2J, above), 56–7

POPOVSKI, Ante, *The Yellow Christ*
Paul Gauguin, *The Yellow Christ*
Source: Martinovski (2K, above), 80–1

PORAD, Francine, *"jutting rock"* [haiku]
Susan Frame, untitled painting
Source: http://members.aol.com/HAIGA/Porad.h
 tml

PORTER, Peter, *Looking at a Melozzo da Forli*
Melozzo da Forli, *Annunciation*
Source: Abse (2D, above), 46–7

Porter, Peter, *Orcagna–Detail from the fresco, The
 Last Judgement, The Inferno—Santa Croce, Flo-
 rence*
Source: Peter Porter, *Collected Poems* (Oxford: Ox-
 ford University Press, 1984), 191

Porter, Peter, *Sir Joshua Reynolds—Lady Mary
 Leslie—Iveagh Bequest, Kenwood*

Source: Peter Porter, *Collected Poems* (Oxford: Ox-
 ford University Press, 1984), 191

Porter, Peter, *Domenico Veneziano—Profile Head of
 a Young Woman—Kaiser Friedrick Museum, Berlin*
Source: Peter Porter, *Collected Poems* (Oxford: Ox-
 ford University Press, 1984), 192

Porter, Peter, *Pisanello—La Principessa di Trebi-
 zonda—detail from fresco, Santa Anastasia, Verona*
Source: Peter Porter, *Collected Poems* (Oxford: Ox-
 ford University Press, 1984), 192

Porter, Peter, *J.M.W. Turner—The Parting of Hero
 and Leander—National Gallery, London*
Source: Peter Porter, *Collected Poems* (Oxford: Ox-
 ford University Press, 1984), 192

Porter, Peter, *Peter Phillips—Random Illusion No.
 4—Tate Gallery*
Source: Peter Porter, *Collected Poems* (Oxford: Ox-
 ford University Press, 1984), 193

Porter, Peter, *Albrecht Altdorfer—Landscape with a
 Footbridge—National Gallery, London*
Source: Peter Porter, *Collected Poems* (Oxford: Ox-
 ford University Press, 1984), 193

Porter, Peter, *Richard Hamilton—Interior II—Tate
 Gallery*
Source: Peter Porter, *Collected Poems* (Oxford: Ox-
 ford University Press, 1984), 193

Porter, Peter, *Piero di Cosimo—detail from The Fight
 between the Lapiths and Centaurs—National
 Gallery, London*
Source: Peter Porter, *Collected Poems* (Oxford: Ox-
 ford University Press, 1984), 194

Porter, Peter, *Masolino—Adam and Eve—detail from
 the fresco in the Church of the Carmines, Flor-
 ence*
Source: Peter Porter, *Collected Poems* (Oxford: Ox-
 ford University Press, 1984), 194

Porter, Peter, *Giotto—Portrait of Dante—Bargello,
 Florence*
Source: Peter Porter, *Collected Poems* (Oxford: Ox-
 ford University Press, 1984), 194

Porter, Peter, *Pinturicchio—La Storia della For-
 tuna—Mosaic, Siene Cathedral*
Source: Peter Porter, *Collected Poems* (Oxford: Ox-
 ford University Press, 1984), 195

Porter, Peter, *A Portrait by Giulio Romano*
Giulio Romano, *Portrait of Jeanne of Aragon*
Source: Peter Porter, *Collected Poems* (Oxford: Ox-
 ford University Press, 1984), 241–2

Porter, Peter, *A Chagall Postcard*
Marc Chagall
Source: Peter Porter, *Possible Worlds* (Melbourne;
 Oxford: Oxford University Press, 1989), 17

Porter, Peter, *From "The Tiverton Book of the Dead"*
Vittore Carpaccio, *The Legend of St. Ursula: The Arrival of the English Ambassadors*; and Hans Memling, *St. Ursula Shrine* (Bruges)
Source: Peter Porter, *Millennial Fables* (Oxford: Oxford University Press, 1994), 71–2

Porter, Peter, *The Lion of Antonello da Messina*
Antonello da Messina, *St. Jerome in His Study*
Source: Peter Porter, *Dragons in Their Pleasant Palaces* (London: Oxford University Press, 1997)

POSAMENTIER, Evelyn, *Portrait of the Dinner Table*
John Singer Sargent, *A Dinner Table at Night*
Source: http://www.nycbigcitylit.com/may2002/contents/poetrybspecialists.html

Posamentier, Evelyn, *Woman with Orange Umbrella*
Elmer Bishoff, *Woman with Orange Umbrella*
Source: http://www.nycbigcitylit.com/may2002/contents/poetrybspecialists.html

Posamentier, Evelyn, *Woman Seated in an Armchair*
Pablo Picasso, *Woman Seated in an Armchair*
Source: http://www.nycbigcitylit.com/may2002/contents/poetrybspecialists.html

POUND, Ezra, *Of Jacopo del Sellaio*
Jacopo del Sellaio, *Venus Reclining*
Source: *Selected Poems of Ezra Pound* (New York: New Directions, 1957), 23; and Abse (2D, above), 34

Pound, Ezra,, *To Whistler, American*
James McNeill Whistler, *Brown and Gold—de Race* and *Grenat et Or—Le Petit Cardinal*
Source: Ezra Pound, *Personae: The Shorter Poems*, rev. ed., ed. Lea Baechler and A. Walton Litz (New York: New Directions, 1990), 249

POWELL, Joseph, *Vermeer's Lost Painting: Self-Portrait*
Jan Vermeer
Source: *Ekphrasis* 2, no. 6 (Fall–Winter 2002): 41

Powell, Joseph, *Vermeer's Lost Painting: "Man Washing His Hands in a Room with Sculptures"*
Source: *Ekphrasis* 3, no. 3 (Spring–Summer 2004): 34–5

POWELL, Lynn, *After Bonsignori*
Francesso Bonsignori, *Virgin Adoring the Sleeping Child*
Source: Lynn Powell, *Old and New Testaments* (Madison: University of Wisconsin Press, 1995), 9

POWELL, Neil, *"Sur la Terrasse": A Painting by David Hockney*
Source: Neil Powell, *Selected Poems* (Manchester, UK: Carcanet, 1998), 59

POWER, Marjorie, *On Meeting Owl Woman*
Gene Collins
Source: *Ekphrasis* 1, no. 1 (Summer 1997): 18

Power, Marjorie, *Poem in Flame Blue*
Gene Collins, *Self Portrait*
Source: *Ekphrasis* 1, no. 4 (Fall–Winter 1998): 14–15

PREST, Judith, *Blue Wind Hat*
Ann Hughes, *Cave*
Source: Judith Prest, *Wildwoman's Scrapbook* (Duanesburg, NY: Spirit Wind, 2002), 34

Prest, Judith, *Where I Come From*
René Magritte, *La grande guerre*
Source: Judith Prest, *Wildwoman's Scrapbook* (Duanesburg, NY: Spirit Wind, 2002), 6–7

PREVALLET, Kristin, *Asteroid*
Laura Owens, *Untitled*
Source: Geha and Nichols (1N, above), 63–8

PRÉVERT, Jacques, *Promenade de Picasso (Picasso Goes for a Stroll)*
Source: *Yale French Studies* 21 (1958), 14–14; French text at http://www.geocities.com/marxist_lb/Jacques_Prevert.htm

Prévert, Jacques, *Lanterne magique de Picasso (Picasso's Magic Lantern)*
Source: Jacques Prévert, *Paroles: Selected Poems* (San Francisco: City Lights Books, 1958)

PRICE, Jonathan, *Experiment with an Air Pump by Joseph Wright of Derby*
Joseph Wright of Derby, *Experiment with an Air-Pump*
Source: Abse (2D, above), 72

PRICE, Mary Gallagher, *The Mourning Madonna*
Andrea Vanni, *The Mourning Madonna*
Source: *Wisconsin Poets* (1E, above), 8–9

PRIME, Patricia, *La Fenêtere Ouverte*
Henri Matisse, *La Fenêtere Ouverte*
Source: http://haibuntoday.blogspot.com/2008/05/patricia-prime-la-fentre-ouverte.html

PRINCE, F.T. *Soldiers Bathing*
Aristotile da Sangallo (after Michelangelo), *Battle of Cascina Cartoon*
Source: Abse (2D, above), 36

PRINGLE, Robert, *A Refusal to Mourn the Death, by Derivatives, of an Artist in Columbus*
Walter King
Source: *Elastic Ekphrastic: Poetry on Art/Poets on Tour through Galleries*, ed. Jennifer Bosveld (Johnstown, OH: Pudding House Publications, 2003), 56

PRIOR, Matthew, *A Flower Painted by Simon Verelst*
Simon Verelst, unidentified still life
Source: *The Poetical Works of Matthew Prior*, vol. 2 (London: William Pickering, 1835), 4

Prior, Matthew, *Picture of Seneca Dying in a Bath, by Jordain ... etc.:*

Jacques Jordain, *Seneca Dying in a Bath*
Source: *The Poetical Works of Matthew Prior* (London: George Bell, 1907), 29

Prior, Matthew, *Seeing the Duke of Ormond's Picture at Sir Godfrey Kneller's*
Unidentified portrait of James Duke of Ormond
Source: *The Poetical Works of Matthew Prior* (London: George Bell, 1907), 57–9

PROUST, Marcel, *Antoine van Dyck*
Anton van Dyck, *Portrait of James Stuart, Duke of Lennox and Richmond*
Source: Marcel Proust, *Les Plaisers et les Jours* (Paris, 1924), 136; and at http://poesie.webnet.fr/poem es/France/proust/4.html; German trans., Kranz (2B, above), 169

Marcel Proust, *Albert Cuyp*
Albert Cuyp, *Der Ausritt* (*The Ride*)
Source: Marcel Proust, *Les Plaisers et les Jours* (Paris, 1924), 181; German trans., Kranz (2B, above), 181

Marcel Proust, *Antoine Watteau*
Source: Marcel Proust, *Les Plaisers et les Jours* (Paris, 1924), 135; and *American Poetry Review* September–October 2007

Marcel Proust, *Paul Potter*
Source: Marcel Proust, *Les Plaisers et les Jours* (Paris, 1924), 135

[All four of Proust's "Portraits de peintres" can be found at http://www.mediatheque.cg68.fr/livre_ num/plaisir.pdf. For Spanish translations by José Lezama Lima of the poems on Cuyp, Watteau, Van Dyck, see *Nadie parecía* (La Habana) 7 (March–April 1943): 12]

PROVOOST, Anne, *Memling's Sibylle Sambetha*
Hans Memling, *Portrait of a Young Woman*
Source: Greenberg, *Side* (2M, above), 42–3

PRUFER, Kevin, *Caravaggio's Bent Narcissus*
Caravaggio, *Narcissus*
Source: *Prairie Schooner* 79, no. 4 (Winter 2005): 28–30

PUGH, Christina, *When*
Catherine McCarthy
Source: *Ekphrasis* 2, no. 1 (Spring–Summer 2000): 39

Pugh, Christina, *"The Annunciation," Attributed to Petrus Christus*
Source: *Ekphrasis* 2, no. 1 (Spring–Summer 2000): 46

PURPURA, Lia, *Red Cluster, Mid-Summer*
Georg Baselitz, sketch
Source: *Prairie Schooner* 79, no. 4 (Winter 2005): 37

PUZISS, Maria, *Following Van Gogh (Avignon, 1982)*
Vincent Van Gogh
Source: Buchwald and Roston (2C, above), 54

PYBUS, Rodney, *Out of the Blue*
Jan Vermeer, *Woman in Blue*
Source: Rodney Pybus, *Cicadas in Their Summers: New & Selected Poems: 1965–1985* (Manchester, UK: Carcanet, 1988), 55–6

QUAGLIANO, Tony, *Edward Hopper's "Lighthouse at Two Lights"*
Edward Hopper, *Captain Upton's House*
Source: Levin (3J, above), 44

Quagliano, Tony, *The Edward Hopper Retrospective*
Edward Hopper, *Four Lane Road* and *Gas*,
Source: Levin (3J, above), 64; and Buchwald and Roston (2C, above), 38–9

QUINN, Justin, *Approach to the City*
Antonín Mánes, painting of two horsemen riding into Prague
Source: Justin Quinn, *The 'O'o'a'a' Bird* (Manchester, UK: Carcanet, 1995), 44–5

RAAB, Lawrence, *After Edward Hopper*
Edward Hopper, *Moonlight Interior*
Source: Levin (3J, above), 20

Raab, Lawrence, *The Dream of Rousseau*
Henri Rousseau, *The Sleeping Gypsy*
Source: Lawrence Raab, *Mysteries of the Horizon* (New York: Doubleday, 1972), 62–4

Raab, Lawrence, *Magritte: The Song of the Glass Keys and the Cape of Storms*
René Magritte, *The Cape of Storms*
Source: Lawrence Raab, *Mysteries of the Horizon* (New York: Doubleday, 1972), 60–1

RADAVICH, David, *St. Martin and the Beggar*
El Greco, *St. Martin and the Beggar*
Source: *Ekphrasis* 1, no. 4 (Fall–Winter 1998): 45

RADER, Bennett, *View*
Jackson Pollock, Untitled, ca. 1951, Museum of Modern Art, Avnet Collection 28968
Source: *Elastic Ekphrastic: Poetry on Art/Poets on Tour through Galleries*, ed. Jennifer Bosveld (Johnstown, OH: Pudding House Publications, 2003), 34

RAGLAND, Samantha, *On Looking at "The Banjo Lesson" by Henry Ossawa Tanner*
Source: *Ekphrasis* 4, no. 3 (Spring–Summer 2007): 13

RAMBERG, Michael, *The White Night*
Adolf Fassbender, *The White Night*
Source: http://www.northography.com/MIA/mra mberg.php

RAMKE, Bin, *Figure in Landscape*
Numerous paintings of female bathers
Source: Bin Ramke, *The Erotic Light of Gardens* (Middletown, CT: Wesleyan University Press, 1989), 21–3

RAMSEY, Jarold, *Running West*
Asher Brown Durand, *Genesee Oaks*
Source: Holcomb (1I, above), 140–3

RANDALL, Gregory, *Almond Tree in Blossom*
Pierre Bonnard, *Almond Tree in Blossom*
Source: *Louisville Review* 64 (Fall 2008): 46

RAPIN, Simone, *Bruxelles. Au Musée: La chute d'Icare de Brueghel*
Pieter Brueghel the Elder, *Landscape with the Fall of Icarus*
Source: Simone Rapin, *En Belgique: Chevalet de vie. Poèmes* (Couillet, Belgique, rue de la Côte 6: [Mme Ray Guilmain], 1976), 31

RASCHE, Friedrich, *Picasso-Mensch*
Pablo Picasso, portraits
Source: Kranz (2B, above), 244

RATCLIFF, Carter, *Mr. Minotaur Builds a Labyrinth*
Rafael Ferrer, *A-af*, 1979
Source: Vanderlip (1A, above), 62

Ratcliff, Carter, *To Light*
Willem de Kooning, *Untitled XXII*, 1977
Source: Vanderlip (1A, above), 64

RATHERMAN, Sarah Jane, *Telephone to Nowhere*
Salvador Dali, *Mountain Lake*
Source: Adams (1B, above), 100–01

RAU, Christina M., *The Embrace*
Paul Rut, *In Fide*
Source: *Beauty/Truth: A Journal of Ekphrastic Poetry* 1, no. 1 (Fall–Winter 2006): 32

RAWSON, Joanna, *Self-Portraits by Frida Kahlo*
Source: Joanna Rawson, *Quarry* (Pittsburgh, PA: University of Pittsburgh Press, 1998), 23

RAY, David, *A Midnight Diner by Edward Hopper*
Edward Hopper, *Nighthawks*
Source: Levin (3J, above), 33; and Ray's *Hearthstones* (Lakewood, CO: Micawber Fine Editions, 1998), 96–7

Ray, David, *Automat*
Edward Hopper, *Automat*
Source: Levin (3J, above), 54

Ray, David, *The Card Players*
Paul Cézanne, *The Card Players*
Source: David Ray, *Music of Time: Selected and New Poems* (Omaha, NB: Backwaters Press, 2006), 22

Ray, David, *The Bellini in the Corner*
Giovanni Bellini, *San Giobbe Altarpiece*
Source: David Ray, *Hearthstones* (Lakewood, CO: Micawber Fine Editions, 1998), 82

Ray, David, *Dante Gabriel Rossetti*
Source: David Ray, *Hearthstones* (Lakewood, CO: Micawber Fine Editions, 1998), 77–8

Ray, David, *On a Fifteenth-Century Flemish Angel*
Unidentified painter and painting
Source: David Ray, *Hearthstones* (Lakewood, CO: Micawber Fine Editions, 1998), 81

Ray, David, *Richard St. George, Esquire, Orders his Portrait from Henry Fuseli*
Source: David Ray, *Hearthstones* (Lakewood, CO: Micawber Fine Editions, 1998), 83–6

Ray, David, *In the Gallery Room*
John Constable, *Dell* and *Low Ebb*
Source: David Ray, *Hearthstones* (Lakewood, CO: Micawber Fine Editions, 1998), 88

Ray, David, *Vincent*
Vincent Van Gogh, *The Starry Night, Sunflowers,* and other paintings
Source: David Ray, *Hearthstones* (Lakewood, CO: Micawber Fine Editions, 1998), 89–91

Ray, David, *Arles*
Vincent Van Gogh
Source: David Ray, *Hearthstones* (Lakewood, CO: Micawber Fine Editions, 1998), 92–3

Ray, David, *"in the Bosch painting"*
Hieronymus Bosch, unidentified painting
Source: David Ray, *At the Heart of All Poverty* (Garden City, NY: Doubleday, 1984), 106

Ray, David, *The Bathers*
Paul Cézanne, *The Bathers*
Source: David Ray, *On Wednesday I Cleaned Out My Wallet* (San Francisco: Pancake Press, 1985), 22

Ray, David, *Eight Woodcuts*
Utagawa Hiroshige
Source: David Ray, *Demons in the Diner* (Ashland, OH: The Ashland Poetry Press, 1999), 2–7

RAY, Judy, *Vincent's "Olive Grove"*
Vincent Van Gogh, *Olive Grove*
Source: Judy Ray, *Pigeons in the Chandeliers* (Fulton, MO: Timberline Press, 1993), 46

RAYBURN, Ann, *Seduction*
Elihu Vedder, *Cup of Death*
Source: *Beltway Poetry Quarterly* 10, no. 1 (Winter 2009). http://washingtonart.com/beltway/contents.html

RAYMOND, Vicki, *The Golden Age: Alte Pinakothek*
Lucas Cranach the Elder, *The Golden Age*
Source: Vicki Raymond, *Selected Poems* (Manchester, UK: Carcanet, 1993), 17

READ, Thomas Buchanan, *Church's "Heart of the Andes"*
Frederic Edwin Church, *The Heart of the Andes*
Source: *Poetical Works of Thomas Buchanan Read* (Philadelphia: Lippincott, 1866), vol. 2, 414–15

READING, Peter, *Spring Letter. 3. Primavera*
Sandro Botticelli, *Primavera*
Source: Peter Reading, *Collected Poems: 1: Poems 1970–1984* (Newcastle upon Tyne, UK: Bloodaxe Books, 1995), 40–1

REDGROVE, Peter, *Into the Rothko Installation*
Mark Rothko
Source: Adams (1B, above), 118–21

REED, Jeremy, *Summer: Young September's Corn Field*
Alan Reynolds, *Summer: Young September's Corn Field*
Source: Adams (1B, above), 110–12

Reed, Jeremy, *Andy Warhol*
Source: Jeremy Reed, *Pop Stars* (London: Enitharmon, 1994), 93

REHWALDT-ALEXANDER, James, Untitled
Max Weber, *Night*
Source: Janovy (1O, above), 5

REICHARD, William, *Ten Yellow Tulips with a Portrait of Ev*
Unidentified artist, *Portrait of Ev*
Source: *Ekphrasis* 1, no. 5 (Spring–Summer 1999): 38–9

Reichard, William, *For Grant Wood*
Grant Wood, *American Gothic*
Source: *Ekphrasis* 1, no. 5 (Spring–Summer 1999): 37

REICHOLD, Jane, "*blood-red skies*" [haiku]
Susan Frame, untitled painting
Source: http://members.aol.com/HAIGA/Reichold.html

REID, Christopher, *One Star in the Michelin*
Claude Monet
Source: Christopher Reid, *In the Echoey Tunnel* (London: Faber and Faber, 1991), 11–12

REIDEL, James, *Landscape with the Stygian Lake*
Joachim Patinir, *Landscape with the Stygian Lake*
Source: *Ekphrasis* 1, no. 3 (Spring–Summer 1998): 43

REISDORF, Phyllis, *A Musical Company*
Anthonie Palamedesz, *The Musical Company*
Source: *Wisconsin Poets* (1E, above), 12–13

RELLER, Monica A., *Tres Caras* and *Three Faces*
Héctor Poleo, *Memory of the Future*
Source: *Ekphrasis* 1, no. 2 (Winter 1997–98): 46–7

REMBISH, Cathy J., "*Les Demoiselles D'Avignon*"
Pablo Picasso, *Les Demoiselles D'Avignon*
Source: *Ekphrasis* 1, no. 2 (Winter 1997–1998): 26

RENDLEMAN, Danny, *Poem*
Philippe de Champaigne, *Christ Healing the Deaf-Mute*
Source: Tillinghast (1F, above), 80–2

RENDŽOV, Mihail, *Dandelion*
Tanas Lulovski
Source: Martinovski (2K, above), 129

RENKER, Skip, *The Prince of Or*
Paul Klee, *Black Prince*
Source: *Ekphrasis* 1, no. 1 (Summer 1997): 26

RENNERFELDT, Quinn, *The Mona Lisa*
Leonardo da Vinci, *Mona Lisa*
Source: *Cider Press Review* 8 (2007): 47

REXROTH, Kenneth, *The Dragon and the Unicorn, II*
Eugene Fromentin, François Marius Granet, et al.
Source: Kenneth Rexroth, *Selected Poems* (New York: New Directions, 1984), 56–60

REYNOLDS, Marie, *The White Door*
Utagawa Hiroshige, *Night Scene at Saruwaka-cho*
Source: *Ekphrasis* 4, no. 2 (Fall–Winter 2006): 29

REYNOLDS, Oliver, *Education Debate at the Burrell*
Théodule Ribot
Source: Oliver Reynolds, *The Oslo Tram* (London: Faber and Faber, 1991), 52–5

REZNIKOFF, Charles, *19* ["We have a print of Marc Chagall's picture of a green-faced Jew"]
Marc Chagall, *Jew in Green*
Source: Charles Reznikoff, *Poems 1918–1975: The Complete Poems of Charles Reznikoff* (Santa Rosa, CA: Black Sparrow Press, 1989), 121

RIBEIRO, Antonio, *Jawlenskys letzte Bilder*
Alexej Jawlensky, Unnamed painting
Source: German trans. of the Portuguese, Kranz (2B, above), 241

Ribeiro, Antonio, *Max Ernst*
Max Ernst, *The Last Forest*
Source: Kranz (2B, above), 261

RICE, Adrian, *The Mason's Tongue*
Colin Middleton, *Head*
Source: Reid and Rice (1J, above), 74–5

RICE, Nicky, *Brueghel: Peasant Wedding*
Pieter Brueghel the Elder, *The Peasant Wedding*
Source: Nicky Rice, *Coming Up to Midnight* (London: Enitharmonm 1994)

RICH, Adrienne, *Pictures by Vuillard*
Edouard Vuillard
Source: *Adrienne Rich's Poetry*, ed. Barbara and Albert Gelpi (New York: Norton, 1975), 4

Rich, Adrienne, *Love in the Museum*
Diego Velázquez, François Boucher, Jan Vermeer
Source: *Adrienne Rich's Poetry*, ed., Barbara and Albert Gelpi (New York: Norton, 1975), 5

Rich, Adrienne, *Mourning Picture*
Edwin Romanzo Elmer, *Mourning Picture*

Source: *Adrienne Rich's Poetry*, ed., Barbara and Albert Gelpi (New York: Norton, 1975), 31–2, and Kehl (2A, above), 178–9

Rich, Adrienne, *Rauschenberg's Bed*
Robert Rauschenberg, *Bed*
Source: Adrienne Rich, *Fox* (New York: Norton, 2001), 59

Rich, Adrienne, *Pictor mysteriosa (Burnt Umbrage)*
Dorothea Tanning, *Pictor mysteriosa (Burnt Umbrage)*
Source: Dorothea Tanning, *Another Language of Flowers* (New York: Braziller, 1998), plate 5

Rich, Adrienne, *Emily Carr*
Emily Carr, *Skidegate Pole*
Source: Adrienne Rich, *Your Native Land, Your Life* (New York: W. W. Norton & Company, 1986), 64–5

Rich, Adrienne, *Lovers Are Like Children*
March Chagall, *Equestrienne (L'écuyère)*
Source: Adrienne Rich, *Collected Early Poems: 1930–1970* (New York: W. W. Norton & Company, 1993), 123

Rich, Adrienne, *Paula Becker to Clara Westhoff*
Paula Modersohn-Becker
Source: Adrienne Rich, *The Dream Of A Common Language: Poems 1974–1977* (New York: W. W. Norton, 1978), 42–4

RICH, Susanna, *Back to you, Robin*
Robin Landa, unidentified picture
Source: *Beauty/Truth: A Journal of Ekphrastic Poetry* 1, no. 2 (Spring–Summer 2007): 29

RICHARDSON, Norma, *On Looking into the Mona Lisa*
Leonardo da Vinci, *Mona Lisa*
Source: Norma Richardson, *Peeling Back the Dark* (San Francisco: San Francisco Bay Press Publishing, 2008.

RICHMAN, Liliane, *Marc Chagall, "Le Dur Désir de Durer"*
Source: *Ekphrasis* 1, no. 2 (Winter 1997–1998): 15

RIDLER, Anne, *Backgrounds to Italian Paintings: 15th Century*
Piero della Francesca, *Triumph of Montefeltro*
Source: Abse (2D, above), 32–3

Ridler, Anne, *Piero della Francesca*
Source: Anne Ridler, *Collected Poems* (Manchester, UK: Carcanet, 1994), 88

RIEDL, Cate, *Talking Back to the Portrait Hanging on the Wall*
Grant Wood, *Portrait of Nan*
Source: *Wisconsin Poets* (1E, above), 38–9

RIGBY, Karen, *Design for a Flying Machine*
Leonardo da Vinci, design from the Notebooks

Source: Karen Rigby, *Savage Machinery* (Georgetown, KY: Finishing Line Press, 2008), 3

Rigby, Karen, *Cebolla Church*
Georgia O'Keeffe, *Cebolla Church*
Source: Karen Rigby, *Savage Machinery* (Georgetown, KY: Finishing Line Press, 2008), 5

Rigby, Karen, *Edward Hopper's Women*
Source: Karen Rigby, *Savage Machinery* (Georgetown, KY: Finishing Line Press, 2008), 13

Rigby, Karen, *The Story of Adam and Eve*
Boucicaut Master and Workshop, illuminated manuscript
Source: Karen Rigby, *Savage Machinery* (Georgetown, KY: Finishing Line Press, 2008), 20–2

Rigby, Karen, *Horse Skull with White Rose*
Georgia O'Keeffe, *Horse Skull with White Rose*
Source: Karen Rigby, *Festival Bone* (Easthampton, MA: Adastra, 2004), n.p.

Rigby, Karen, *Vitruvian Man: Study of Two Figures*
Leonardo da Vinci, *Vitruvian Man*
Source: Karen Rigby, *Festival Bone* (Easthampton, MA: Adastra, 2004), n.p.

RIGSBEE, David, *The Hopper Light*
Edward Hopper, *Methodist Church, Provincetown*
Source: David Rigsbee, *The Hopper Light* (L'Epervier Press, 1988), 27–8

Rigsbee, David, *Morandi*
Giorgio Morandi
Source: David Rigsbee, *Scenes on an Obelisk* (Johnstown, Ohio: Pudding House Publications, 2000).

RILKE, Rainer Maria, *David singt vor Saul*
Rembrandt van Rijn, *David spielt die Harfe vor Saul (David Playing the Harp before Saul)*
Source: Kranz (2B, above), 176–7

Rilke, Ranier Maria, *Duino Elegies: The Fifth Elegy*
Pablo Picasso, *Les Saltimbanques (The Acrobats)*
Source: Ranier Maria Rilke, *The Duino Elegies*, trans. J.B. Leishman and Stephen Spender (New York: Norton, 1963), 47–53

RIMBAUD, Arthur, *Poésies* ("Au milieu, l'Empereur...")
Parody of popular graphic representation of Napoleon III
Source: Maurisson and Verlet (2L, above), 105–6

RIVKIN, Sophia, *Agnes Martin's "White Flower"*
Source: *Ekphrasis* 4, no. 4 (Fall–Winter 2007): 13

ROBB, Casey, *Choosing Cherries, 1940*
Balthus, *Le Cerisier*
Source: *Ekphrasis* 1, no. 5 (Spring–Summer 1999): 12

ROBBINS, Liz, *Blueberry Highway*
Marsden Hartley, *Blueberry Highway, Dogtown*
Source: *Ekphrasis*, 3, no. 6 (Fall–Winter 2005): 25

ROBERTS, Kim, *Richard Diebenkorn's "Figure on a Porch"*
Source: *Ekphrasis* 1, no. 5 (Spring–Summer 1999): 8

ROBINS, Corinne, *Les Demoiselles d'Avignon*
Pablo Picasso, *Les Demoiselles d'Avignon*
Source: *The Best American Poetry 2002*, ed., Robert Creeley (New York: Scribner, 2002), 142–3

ROBINSON, Edward Arlington, *Rembrandt to Rembrandt*
Source: *Selected Poems of Edward Arlington Robinson*, ed., Morton Dauwen Zabel (New York: Collier, 1965), 198–206

ROBINSON, Peter, *On Van Gogh's "La Crau"*
Vincent Van Gogh, *Le Crau with Peach Trees in Blossom*
Source: Peter Robinson, *Entertaining Fates* (Manchester, UK: Carcanet, 1992), 78

ROE, Richard, *A Dance at the Degas Exhibit*
Edgar Degas, *Woman after Bath*
Source: *Beauty/Truth: A Journal of Ekphrastic Poetry* 1, no. 1 (Fall–Winter 2006): 30–1

ROGER, David, *Percy*
David Hockney, *Mr and Mrs Clark and Percy*
Source: Adams (1B, above), 141–3

ROGERS, Denise M., *Ars Poetica*
George Trubert, *Death Stepping from a Coffin*
Source: *Ekphrasis*, 3, no. 6 (Fall–Winter 2005): 18

ROGOFF, Jay, *Six Poems from Venera*
Kate Leavitt, *Venera*
Source: *The Saratoga Poetry Zone, Unbottled* (Saratoga: J.M. Blumberg, 1997), n.p.

Rogoff, Jay, *Mysteries*
Unidentified trompe l'oeil
Source: Jay Rogoff, *The Long Fault* (Baton Rouge: Louisiana State University Press, 2008), 25–6

Rogoff, Jay, *Three Women*
John Currin, *Stamford After-Brunch*
Source: Jay Rogoff, *The Long Fault* (Baton Rouge: Louisiana State University Press, 2008), 71–2

ROLAND HOLST, A., *De prins weergekeerd*
Anthonie Mor van Dashorst, *Portrait of William of Orange*
Source: Korteweg and Heijn (2F, above), 77

ROMER, Stephen, *The Flaying of Marsyas*
Titian, *The Flaying of Marsyas*
Source: Stephen Romer, *Idols* (New York: Oxford University Press, 1986), 9

Romer, Stephen, *The Other House*
John Stevens
Source: Stephen Romer, *Plato's Ladder* (New York: Oxford University Press, 1997), 16–17

RONEY-O'BRIEN, Susan, *After "Birthday" by Marc Chagall*
Source: *Ekphrasis* 4, no. 6 (Fall–Winter 2008): 14–15

RONK, Martha, *Why knowing is (& Matisse's "Woman with a Hat")*
Henri Matisse, *Woman with a Hat*
Source: Martha Ronk, *Why/Why Not?* (Berkeley: University of California Press, 2003); and http://www.poets.org/viewmedia.php/prmMID/16582

RONSARD, Pierre de, *Ode XXIX*
Unidentified painting of "des amours de Vénus et de Mars"
Source: Maurisson and Verlet (2L, above), 24–5

ROONEY, M.S., *"The Starry Night"*
Vincent Van Gogh, *The Starry Night*
Source: *Ekphrasis* 3, no. 4 (Fall–Winter 2004): 16

ROPER, Mark, *The Watcher*
George William 'Æ' Russell, *The Watcher*
Source: Reid and Rice (1J, above), 76–7

ROSELIEP, Raymond, *Man at a Picasso Exhibit*
Pablo Picasso
Source: *College Art Journal* 19 (Fall 1959): 75–7

ROSEN, Connie, *Andromeda*
Edward Burne-Jones, *The Rescue of Andromeda*
Source: Benton and Benton, *Double Vision* (2E, above), 34–5

ROSENBERG, Isaac, *Raphael*
Isaac Rosenberg, *The Collected Poems of Isaac Rosenberg*, ed., Gordon Bottomley and Denys Harding (London: Chatto & Windus, 1977), 164–7

ROSENBERG, Liz, *The Little Red Shoe*
Perle Hessing, poem based on commentary by Hessing in her book of paintings
Source: Liz Rosenberg, *Children of Paradise* (Pittsburgh, PA: University of Pittsburgh Press, 1994), 36

Rosenberg, Liz, *Van Gogh's Potato Eaters*
Vincent Van Gogh, *The Potato Eaters* and *A Pair of Boots*
Source: Liz Rosenberg, *Children of Paradise* (Pittsburgh, PA: University of Pittsburgh Press, 1994), 61

ROSENFELD, Natania, *Four Rabbits by Soutine*
Chaim Soutine, *Hanging Hare*; *Hare with Forks*; and *Flayed Rabbit*
Source: *Ekphrasis* 4, no. 5 (Spring–Summer 2008): 12–13

ROSENLÖCHER, Thomas, *Breughels Ikarus*
Pieter Brueghel the Elder, *Landscape with the Fall of Icarus*
Source: Thomas Rosenlöcher, *Die Dresdner Kunstausübung. Gedichte* (Frankfurt am Main: Suhr-

kamp, 1996), 76; and Achim Aurnhammer and Dieter Martin, eds., *Mythos Ikarus: Texte von Ovid bis Wolf Biermann* (Leipzig: Reclam, 2001), 212

ROSSER, J. Allyn, *Sea and Rain*
James McNeill Whistler, *Sea and Rain*
Source: Tillinghast (1F, above), 40–1

ROSSETTI, Christina, *In an Artist's Studio*
Unidentified artist
Source: Joseph Parisi and Kathleen Welton, eds., *100 Essential Modern Poems by Women* (Chicago: Ivan R. Dee, 2008), 30; and Edward Hirsch and Eavan Boland, eds., *The Making of a Sonnet: A Norton Anthology* (New York: W.W. Norton, 2008), 167

ROSSETTI, Dante Gabriel, *For Spring*
Sandro Botticelli, *Primavera*
Source: Hollander (2I, above), 217; and Kranz (2B, above), 120

Rossetti, Dante Gabriel, *For "Our Lady of the Rocks" by Leonardo da Vinci*
Leonardo da Vinci, *Virgin of the Rocks*
Source: Hollander (2I, above), 151

Rossetti, Dante Gabriel, *For "The Wine of Circe" by Edward Burne-Jones*
Source: *The Collected Works of Dante Gabriel Rossetti*, vol. 2 (London: Ellis and Scrutton, 1886), 350

Rossetti, Dante Gabriel, *For an Annunciation*
Unidentified early German painting
Source: *The Collected Works of Dante Gabriel Rossetti*, vol. 2 (London: Ellis and Scrutton, 1886), 343

Rossetti, Dante Gabriel, *For an Allegorical Dance of Women*
Andrea Mantegna, *Parnassus*
Source: *The Collected Works of Dante Gabriel Rossetti*, vol. 2 (London: Ellis and Scrutton, 1886), 346

Rossetti, Dante Gabriel, *For Virgin and Child*
Hans Memmelinck, *Virgin and Child from the Diptych of Martin von Nieuwenhove*
Source: *The Collected Works of Dante Gabriel Rossetti*, vol. 2 (London: Ellis and Scrutton, 1886), 348

Rossetti, Dante Gabriel, *For Ruggerio and Angelica*
Jean-Auguste-Dominique Ingres, *Angelica Saved by Ruggerio*
Source: *The Collected Works of Dante Gabriel Rossetti*, vol. 2 (London: Ellis and Scrutton, 1886), 347

Rossetti, Dante Gabriel, *For a Marriage of St. Catherine*
Hans Memmelinck, *Triptych of the Mystic Marriage of St. Catherine*
Source: *The Collected Works of Dante Gabriel Rossetti*, vol. 2 (London: Ellis and Scrutton, 1886), 349

Rossetti, Dante Gabriel, *For the Holy Family*
Michelangelo, *Holy Family* (*Doni Tondo*)
Source: *The Collected Works of Dante Gabriel Rossetti*, vol. 2 (London: Ellis and Scrutton, 1886), 351

Rossetti, Dante Gabriel, *For A Venetian Pastoral by Giorgone*
Titian, *Concert Champêtre* (once thought to be by Giorgione; now ascribed to Titian)
Source: Hollander (2I, above), 157; German trans. in Kranz (2B, above), 141

Rossetti, Dante Gabriel, *Last Visit to the Louvre*
Peter Paul Rubens, Antonio da Correggio, Claude Lorrain, et al.
Source: *The Collected Works of Dante Gabriel Rossetti*, vol. 2 (London: Ellis and Scrutton, 1886), 71

Rossetti, Dante Gabriel, *For a Picture*
Dante Gabriel Rossetti, *The Girlhood of the Virgin Mary*
Source: Dante Gabriel Rossetti, *The Poetical Works*, ed. William Michael Rossetti (Boston: Little, Brown, 1913) 1:281–2.

ROSSI, Cristina Peri, *Babel*
Pieter Brueghel the Elder, *The Tower of Babel*
Source: Greenberg, *Side* (2M, above), 66–7

ROSSITER, Charles, *At the National Gallery, Washington, DC*
Amedeo Modigliani
Source: Charles Rossiter, *No, I Didn't Steal This Baby I'm the Daddy* (Albany, NY: APD, 1995), n.p.

ROSTON, Ruth, *Two Windows by Magritte*
René Magritte, *The Postcard* and *The Golden Legend*
Source: Buchwald and Roston (2C, above), 56

ROTHENBERG, Jerome, *That Dada Strain*
Dadaism
Source: Jerome Rothenberg, *That Dada Strain* (New York: New Directions, 1983), 3–26

Rothenberg, Jerome, *Pictures of the Crucifixion*
Four paintings of scenes from the Crucifixion in Prague
Source: Jerome Rothenberg, *Seedings & Other Poems* (New York: New Directions, 1996), 46–7

ROUSSEAU, Henri, *Inscription pour Le Rêve*
Henri Rousseau, verse on his own painting, *The Dream*
Source: Herschel B. Chipp, ed., *Theories of Modern Art: A Source Book by Artists and Critics* (Berkeley: University of California Press, 1984), 129

ROWBOTHAM, Colin, *Vace/Faces*
Anon., *Vase/Faces*
Source: Benton and Benton, *Picture Poems* (2H, above), 25

Rowbotham, Colin, *The Artist, Arles 1890*
Vincent Van Gogh, *Cornfield with Crows*
Source: Benton and Benton, *Double Vision* (2E, above), 40–1

ROWDEN, Justine. For fourteen of Rowden's poems on paintings, see 1L, above.

RÓZEWICZ, Tadeusz, *Prawa i obowiazki = A Didactic Tale*
Pieter Brueghel the Elder, *Landscape with the Fall of Icarus*
Source: Tadeusz Rózewicz, *"The Survivor" and Other Poems* (Princeton, NJ: Princeton University Press, 1976), 76

ROZGA, Margaret, *Sleeping Country Girl*
Giuseppe Angeli, *Sleeping Country Girl*
Source: *Wisconsin Poets* (1E, above), 16–17

RUARK, Gibbons, *Watching You Sleep under Monet's Water Lilies*
Source: Gibbons Ruark, *Passing through Customs* (Baton Rouge: Louisiana State University Press, 1999), 86

Ruark, Gibbons, *Swamp Mallows*
Ben Berns, *Swamp Mallows*
Source: Paschal (1G, above), 130–31

RUBIN, Stan Sanvel, *Blue Shutters*
Edwin Dickinson, *Snow on Quai, Sanary*
Source: Holcomb (1I, above), 144–6

RUDOLF, Anthony, *Edward Hopper*
Edward Hopper, *Dauphinée House*
Source: Levin (3J, above), 49

RUEBNER, Tuvia, *Pessel umassecha*
Pieter Brueghel the Elder, *Landscape with the Fall of Icarus*
Source: Tuvia Ruebner, *Pesel u-masekhah* (Tel Aviv: ha-Kibuts ha-meuhad, 1982)

Ruebner, Tuvia, *The Ambassadors*
Hans Holbein the Younger, *The Ambassadors*
Source: *Mississippi Review* 14, no. 4 (October 2008). http://www.mississippireview.com/2008/Vol14No4-Oct08/1404-100108-Ruebner.html

RUKEYSER, Muriel, *Waterlily Fire*
Claude Monet, *Waterlilies* (triptych)
Source: *A Muriel Rukeyser Reader*, ed., Jan Heller Levi (New York: Norton, 1994), 201–2

Rukeyser, Muriel, *Käthe Kollwitz*
Source: *A Muriel Rukeyser Reader*, ed., Jan Heller Levi (New York: Norton, 1994), 214–19

Rukeyser, Muriel, *Ryder*
Albert Pinkham Ryder, *Toilers of the Sea, A Pale Horse, The Flying Dutchman,* and *Jonah*
Source: Muriel Rukeyser, *The Collected Poems* (New York: McGraw-Hill, 1978), 190–2

Rukeyser, Muriel, *Painters*
Cave painters
Source: Muriel Rukeyser, *The Collected Poems* (New York: McGraw-Hill, 1978), 543

RUMENS, Carol, *Nadir*
Tony O'Malley, *Farm in Winter*
Source: Reid and Rice (1J, above), 40–1

Rumens, Carol, *Double Exposure*
Gustav Klimt, *Fulfillment*
Source: Carol Rumens, *Thinking of Skins: New & Selected Poems* (Newcastle upon Tyne, UK: Bloodaxe Books, 1993), 78–80

RUMMELL, Mary Kay, *Olive Trees*
Vincent Van Gogh, *Olive Trees*
Source: http://www.northography.com/MIA/mkr_01.php

RUNCIMAN, Lex, *Young Woman Standing at a Virginal*
Jan Vermeer, *Young Woman Standing at a Virginal*
Source: *Ekphrasis* 4, no. 2 (Fall–Winter 2006): 9

RUSSELL, Rusty, *Pico Escondido*
Michael C. McMillen, *Pico Escondido*
Source: *Wisconsin Poets* (1E, above), 68–9

RUSS, Lawrence, *Edward Hopper's "Nighthawks"*
Source: *Off the Record: An Anthology of Poetry by Lawyers*, ed., James R. Elkins, *The Legal Studies Forum* 28, nos. 1–2 (2004): 185–6

RUSSO, Gianna, *Approaching Infinity*
Peg Trezevant, *Approaching Infinity*
Source: *Ekphrasis* 4, no. 2 (Fall–Winter 2006): 25

RYDER, Albert P., *In Splendor Rare, the Moon*
Albert P. Ryder, *The Lover's Boat, or Moonlight on the Waters*
Source: Text of poem in Lloyd Goodrich, *Albert Ryder* (New York: Braziller, 1959), 114

SABATIER, Robert, *Icare*
Pieter Brueghel the Elder, *Landscape with the Fall of Icarus*
Source: Robert Sabatier, *Les Châteaux de millions d'années, poèmes: suivi de Icare et autres poèmes* (Paris: A. Michel, 1976), 106

SACHS, Carly, *Self-Portrait with Cigarette*
Edvard Munch, *Self-Portrait with Cigarette*
Source: *Ekphrasis* 4, no. 2 (Fall–Winter 2006): 39

SACRÉ, James, *Woman in Blue*
Henri Matisse, *Woman in Blue*
Source: Greenberg, *Side* (2M, above), 70–1

SADOFF, Ira, *Hopper's "Nighthawks" (1942)*
Edward Hopper, *Nighthawks*
Source: *Settling Down* (Boston: Houghton Mifflin, 1975), 35–36; and in Levin (3J, above), 38, and Buchwald and Roston (2C, above), 72

Sadoff, Ira, *February: Pemaquid Point*
Edward Hopper, *Pemaquid Light*
Source: Levin (3J, above), 59

Sadoff, Ira, *Vermeer: Girl Interrupted at Her Music*
Jan Vermeer, *Girl Interrupted at Her Music*
Source: *Va. Quarterly Review* 52 (Winter 1976): 112–13

Sadoff, Ira, *Vermeer: The Officer and the Laughing Girl*
Jan Vermeer, *The Officer and the Laughing Girl*
Source: *Va. Quarterly Review* 52 (Winter 1976): 112–13

Sadoff, Ira, *Seurat*
Georges Seurat, *Sunday Afternoon on La Grande Jatte*
Source: Buchwald and Roston (2C, above), 73

SAFIR, Natalie, *Matisse's Dance*
Henri Matisse, *Dance*
Source: Robert DiYanni, *Literature* (New York: McGraw-Hill, 2004), chap. 10

ST. JOHN, Cindy *see page 186*

SR. THOMASINO, Gregory *see page 187.*

SALEH, Dennis, *Magritte, Study for "Luna"*
Source: *Ekphrasis* 1, no. 1 (Summer 1997): 12–13

Saleh, Dennis, *De Chirico, Mannequin*
Giorgio de Chirico, Mannequin series
Source: *Cider Press Review* 8 (2007): 41

SALEMI, Joseph S., *On Antonello da Messina's "The Annunciation"*
Source: *Ekphrasis* 1, no. 5 (Spr.–Sum. 1999): 42–3

SALTER, Mary Jo, *The Rebirth of Venus*
Sandro Botticelli, *Birth of Venus*
Source: *Measure* 3, no. 1 (2008): 2–3; rpt. in Mary Jo Salter, *A Phone Call to the Future: New and Selected Poems* (New York: Knopf, 2008), 61–2

Salter, Mary Jo, *The Annunciation*
Unidentified painting of the Annunciation
Source: Mary Jo Salter, *Unfinished Painting* (New York: Knopf, 1989), 14

Salter, Mary Jo, *"Late Spring"*
Li Shih-Cho, *Late Spring*
Source: Mary Jo Salter, *Unfinished Painting* (New York: Knopf, 1989), 15–17

Salter, Mary Jo, *"Geraniums before Blue Mountain"*
August Macke, *Geraniums before Blue Mountain*
Source: Mary Jo Salter, *A Phone Call to the Future: New and Selected Poems* (New York: Knopf, 2008), 17–19

Salter, Mary Jo, *Young Girl Peeling Apples*
Nicolaes Maes, *Young Girl Peeling Apples*
Source: Mary Jo Salter, *A Phone Call to the Future: New and Selected Poems* (New York: Knopf, 2008), 100–01

SAMARAS, Nicholas, *The Balthus Poems*
Balthus (Balthazar Klossowski de Rola)
Source: *Courtland Review* Spring 2008. http://www.cortlandreview.com/features/08/spring/samaras.html

SANDERS, Edward, *The Cutting Prow*
Henri Matisse
Source: Edward Sanders, *Thirsting for Peace in a Raging Century: Selected Poems 1961–1985* (Minneapolis, MN: Coffee House Press, 1987), 151–3

SANDY, Stephen, *Et Quid Amabo Nisi Quod Aenigma Est*
Brueghel's paintings
Source: Stephen Sandy, *The Thread* (Baton Rouge: Louisiana State University Press, 1998), 27–8

Sandy, Stephen, *Serial*
Mark Rothko, *Untitled*, 1934
Source: Hollander and Weber (1H, above), 76–7

SANGHARAKSHITA, Bikshu, *Tobias and the Angel*
Gionanni Savoldo, *Tobias and the Angel*
Source: Bikshu Sangharakshita, *Hercules and the Birds and Other Poems* (Cambridge, UK: Windhorse Publications, 1990), 20

Sangharakshita, Bikshu, *The Temptation of St. Anthony*
Paolo Veronese, *The Temptation of St. Anthony*
Source: Bikshu Sangharakshita, *Hercules and the Birds and Other Poems* (Cambridge, UK: Windhorse Publications, 1990), 21

Sangharakshita, Bikshu, *Salome*
Titian, *Salome*
Source: Bikshu Sangharakshita, *Hercules and the Birds and Other Poems* (Cambridge, UK: Windhorse Publications, 1990), 22

Sangharakshita, Bikshu, *The Adoration of the Magi*
Andrea Schiavone, *The Adoration of the Magi*
Source: Bikshu Sangharakshita, *Hercules and the Birds and Other Poems* (Cambridge, UK: Windhorse Publications, 1990), 23

Sangharakshita, Bikshu, *The Lion of St. Mark*
Vittore Carpaccio, *The Lion of St. Mark*
Source: Bikshu Sangharakshita, *Hercules and the Birds and Other Poems* (Cambridge, UK: Windhorse Publications, 1990), 24

SARAI, Sarah, *St. Sarah Sarai Carrying the Infant Christ Child*
Follower of Dieric Bouts, *Saint Christopher and the Infant Christ*
Source: *Mississippi Review* 14, no. 4 (October 2008). http://www.mississippireview.com/2008/Vol14No4-Oct08/1404-100108-Sarai.html

SARGENT, Robert, *Monet's "Poplars on the Epte" 1891*
Source: *Ekphrasis* 1, no. 3 (Spring–Summer 1998): 24

Sargent, Robert, *Daumier Lithograph: A Concert Singer*
Honoré Daumier, *Concert Singer*
Source: *Ekphrasis* 1, no. 4 (Fall–Winter 1998): 56

SAROYAN, Aram, *The Goldfish Bowl by Matisse*
Henri Matisse, *Goldfish Bowl*
Source: Aram Saroyan, *Day & Night: Bolinas Poems* (Santa Rosa, CA: Black Sparrow Press, 1998), 191

SARTON, May, *Nativity: Piero della Francesca*
Piero della Francesca, *The Nativity*
Source: *New Poems by American Poets, No. 2*, ed., Rolfe Humphries (New York: Ballantine Books, 1957), 137

Sarton, May, *These Pure Arches : A Painting by Chirico "The Delights of the Poet"*
Giorgio di Chirico, *The Delights of the Poet*
Source: May Satron, *Collected Poems* (New York: Norton, 1993), 89

Sarton, May, *Still Life in Snowstorm*
Jean-Siméon Chardin, *Still Life with Eggs and Fish*
Source: May Sarton, *Collected Poems, 1930–1993* (New York: Norton, 1993), 68

Sarton, May, *Japanese Prints: Four Views of Mt. Fujiyama*
Source: May Sarton, *Collected Poems, 1930–1993* (New York: Norton, 1993), 22

Sarton, May, *Lifting Stone: A Painting by Katharine Sturgis*
Source: May Sarton, *Collected Poems, 1930–1993* (New York: Norton, 1993), 192

Sarton, May, *Dutch Interior: Pieter de Hooch (1629–1682)*
Source: May Sarton, *Collected Poems, 1930–1993* (New York: Norton, 1993), 343

Sarton, May, *The Artist*
Calligraphic designs created by an elephant
Source: May Sarton, *Coming into Eighty* (New York: Norton, 1994), 40–1

Sarton, May, *The Smile*
Stefano Sassetta, *The Smile*
Source: May Sarton, *The Silence Now* (New York: Norton, 1988), 75

SASS, Barbara W., *Mining the Space*
Terry Winters, *Extending Pathways*
Source: *Beauty/Truth: A Journal of Ekphrastic Poetry* 1, no. 2 (Spring–Summer 2007): 25

SASSOON, Siegfried, O*n Some Portraits by Sargent*
John Singer Sargent
Source: Siegfried Sassoon, *Collected Poems 1908–1956* (London: Faber and Faber, 1984), 152–3

Sassoon, Siegfried, *In the Turner Rooms (at the Tate Gallery)*

J.M.W. Turner
Source: Siegfried Sassoon, *Collected Poems 1908–1956* (London: Faber and Faber, 1984), 151

Sassoon, Siegfried, "*View of Old Exeter*"
J.B. Pyne, *View of Old Exeter*
Source: Siegfried Sassoon, *Collected Poems 1908–1956* (London: Faber and Faber, 1984), 242–3

SATYAMURTI, Carol, *Leaving Present*
René Magritte, *Time Transfixed*
Source: Benton and Benton, *Picture Poems* (2H, above), 38

Satyamurti, Carole, *The Balcony: After Manet*
Édouard Manet, *The Balcony*
Source: Carole Satyanurti, *Selected Poems* (Oxford: Oxford University Press, 1998), 54; and Benton and Benton, *Painting with Words* (2G, above), 60–1

Satyamurti, Carole, *Best Friends*
James Abbott McNeill Whistler, *Miss Cicely Alexander: Harmony in Gray and Green*
Source: Benton and Benton, *Picture Poems* (2H, above), 52–3

Satyamurti, Carole, *The Uncertainty of the Poet*
Giorgio de Chirico, *The Uncertainty of the Poet*
Source: Carole Satyamurti, *Selected Poems* (Oxford: Oxford University Press, 1998), 33–4

Satyamurti, Carole, "*Woman Bathing in a Stream*": *Rembrandt*
Source: Carole Satyamurti, *Selected Poems* (Oxford: Oxford University Press, 1998), 53

SAUNDERS, Kay, *Seated Boy with a Portfolio*
François Bonvin, *Seated Boy with a Portfolio*
Source: *Wisconsin Poets* (1E, above), 20–1

SAVOIE, Terry, *Mondrian: "Diagonal Composition," 1921*
Source: *Ekphrasis* 4, no. 1 (Spring–Summer 2006): 6

Savoie, Terry, *Incredulity*
Caravaggio, *The Incredulity of St. Thomas*
Source: *Ekphrasis* 4, no. 2 (Fall–Winter 2006): 38

SCANNELL, Vernon, *The Long and Lovely Summers*
John Crome, *The Poelingland Oak*, and J.M.W. Turner, *The Thames Near Walton Bridges*
Source: Adams (1B, above), 46–9

Scannell, Vernon, *They Did Not Expect This*
Walter Sickert, *Ennui*
Source: http://www.poetryconnection.net/poets/Vernon_Scannell/5008

SCHACK, Adolf Friedrich von, *Ein Bild Giorgione*
Concert Champêtre or *Concert in the Open Air*, once ascribed to Giorgione but now thought to be by Titian
Source: Kranz (2B, above), 142

SCHARPENBERG, Margot, *Munch*
Edvard Munch, *The Scream*
Source: Kranz (2B, above), 217

SCHEELE, Roy, *Illuminated Ms. of the Maqamat of Hariri*
Yahya ibn Mahmud al-Wasiti, illustrator of the thirteenth-century manuscript
Source: *Prairie Schooner* 82, no. 2 (Spring 2008): 154

Scheele, Roy, *Peaches and Glass Jar*
Unidentified artist, Herculaneum wall painting
Source: *Prairie Schooner* 82, no. 2 (Spring 2008): 153

Scheele, Roy, *Things Lose Color at the Level of the Sky*
Charles Ephriam Burchfield, *Decorative Landscape, Shadow (Willows on Vine Street)*
Source: *Prairie Schooner* 82, no. 2 (Spring 2008): 155

Scheele, Roy, *Farm Scene, Horses and Barn*
Mark Rothko
Source: *Prairie Schooner* 82, no. 2 (Spring 2008): 156

SCHERER, Bruno Stephan, *Leonardo da Vinci: Mona Lisa*
Leonardo da Vinci, *Mona Lisa*
Source: Kranz (2B, above), 139

SCHEVILL, James, *The Peaceable Kingdom of Edward Hicks*
Source: James Schevill, *New and Selected Poems* (Athens: Swallow Press, 2000), 107

Schevill, James, *A Story of Soutine*
Chaim Soutine
Source: *Poet's Choice*, ed., Paul Engle and Joseph Langland (New York: Dial Press, 1962), 188–9

Schevill, James, *Seurat*
Georges Seurat
Source: *Fifteen Modern American Poets*, ed., George P. Elliott (New York: Holt, Rinehart and Winston, 1962), 188

SCHIMMEL, Alyssa, *Chagall's Wedding*
Marc Chagall, *Les Fiancés de la Tour Eiffel*
Source: *Poet Lore* 103, nos. 1–2 (Fall–Winter 2008), and at http://www.poetlore.com/home.php

SCHJELDAHL, Peter, *Alex Katz*
Alex Katz, *August Late Afternoon*
Source: David Shapiro, ed., *Poets and Painters* (Denver: Citron, 1979)

Schjeldahl, Peter, *John Seery*
John Seery, *Gamut*
Source: David Shapiro, ed., *Poets and Painters* (Denver: Citron, 1979)

SCHMIED, Wieland, *Erfahrungen mit Josef Albers*
Source: Kranz (2B, above), 255–6

SCHMITZ, Dennis, *Grossier's "The Passenger Pigeons"*
Jean Grossier, *The Passenger Pigeons*
Source: Dennis Schmitz, *The Truth Squad* (Port Townsend, WA: Copper Canyon, 2002), 19–20

SCHNACKENBERG, Gjertrud, *The Self-Portrait of Ivan Generalić*
School of naïve painter, Hlebine, Yugoslavia
Source: Gjertrud Schnackenberg, *Supernatural Love: Poems 1976–1972* (New York: Farrar, Straus and Giroux, 2000), 71–2

Schnackenberg, Gjertrud, *Soldier Asleep at the Tomb*
Piero della Francesca, *Resurrection*
Source: Gjertrud Schnackenberg, *Supernatural Love: Poems 1976–1972* (New York: Farrar, Straus and Giroux, 2000), 188–96

Schnackenberg, Gjertrud, *Christ Dead*
Andrea Mantegna, *Christ Dead*
Source: Gjertrud Schnackenberg, *Supernatural Love: Poems 1976–1972* (New York: Farrar, Straus and Giroux, 2000), 203–8

Schnackenberg, Gjertrud, *Resurrection*
Piero della Francesca, *Resurrection*
Source: Gjertrud Schnackenberg, *Supernatural Love: Poems 1976–1972* (New York: Farrar, Straus and Giroux, 2000), 217–20

Schnackenberg, Gjertrud, *The Dream of Constantine*
Piero della Francesca, *Constantine's Dream*
Source: Gjertrud Schnackenberg, *Supernatural Love: Poems 1976–1972* (New York: Farrar, Straus and Giroux, 2000), 221–5

SCHNEIDER, Dan, *As the Reason Men Went West*
Carol V. Gray, *A Sign of the Times*
Source: http://www.cosmoetica.com/49%20Gallery.htm

Schneider, Dan, *As Grandma Chin on the Damned Japs*
Caravaggio, *The Death of the Virgin*
Source: http://www.cosmoetica.com/49%20Gallery.htm

Schneider, Dan, *As What America is Left*
Albert Pinkham Ryder, *The Flying Dutchman*
Source: http://www.cosmoetica.com/49%20Gallery.htm

Schneider, Dan, *As the Twentieth Century a Quarter Before*
Thomas Eakins, *The Gross Clinic*
Source: http://www.cosmoetica.com/49%20Gallery.htm

SCHNEIDER, Myra, *Woman in the Bath*
Pierre Bonnard, *Woman in the Bath*

Source: Myra Schneider, *The Panic Bird* (London: Enitharmon, 1998)

Schneider, Myra, *The Red Cupboard*
Pierre Bonnard, *The Red Cupboard*
Source: Myra Schneider, *The Panic Bird* (London: Enitharmon, 1998), 83–4

Schneider, Myra, *Need*
Egon Schiele, *Mother and Daughter*
Source: Myra Schneider, *The Panic Bird* (London: Enitharmon, 1998), 10–11

Schneider, Myra, *Au Salon de la Rue des Moulins*
Henri Toulouse-Lautrec, *Au Salon de la Rue des Moulins*
Source: Myra Schneider, *Exits* (London: Enitharmon, 1994), 33–4

Schneider, Myra, *The Solitary Dog (after a painting by Paul Millichip)*
Source: Myra Schneider, *The Panic Bird* (London: Enitharmon, 1998), 74

SCHULER, Robert, *Notes on Carl Dreyer's "La Passion de Jeanne d'Arc, 1928"*
Source: *Ekphrasis*, 4, no. 5 (Spring–Summer 2008): 6

Schuler, Robert, *Bonnard's "La Salle à manger à la campagne"*
Pierre Bonnard, *La Salle à manger à la campagne*
Source: *Ekphrasis* 3, no. 2 (Fall–Winter 2003): 6

Schuler, Robert, *J.M.W. Turner, "Keelmen Heaving in Coals by Moonlight"*
Source: *Ekphrasis* 3, no. 2 (Fall–Winter 2003): 7

Schuler, Robert, *William Blake, "The Great Red Dragon and the Woman Clothed with the Sun"*
Source: *Ekphrasis* 3, no. 2 (Fall–Winter 2003): 14

Schuler, Robert, *"Venus, a satyr and cupids" 1588, Firenze, the Uffizi*
Annibale Caracci, *Venus, a Satyr and Two Cupids*
Source: *Ekphrasis* 3, no. 1 (Spring–Summer 2003): 10–11

Schuler, Robert, *Van Gogh's "Landscape with Snow"*
Source: *Ekphrasis* 1, no. 5 (Spring–Summer 1999): 44

Schuler, Robert, *Musique Russe*
James Ensor, *Musique Russe*
Source: *Ekphrasis* 3, no. 1 (Spring–Summer 2003): 25

Schuler, Robert, *Dirk Bouts' "The Justice of Otto, the Ordeal by Fire"*
Source: *Ekphrasis* 3, no. 1 (Spring–Summer 2003): 28–30

Schuler, Robert, *Egon Schiele's "Reclining Female Nude with Legs Spread Apart"*
Source: *Ekphrasis* 2, no. 6 (Fall–Winter 2002): 27

Schuler, Robert, *Krishna Adorning Radha's Breast*
Pahari School, Gota Govinda series, *Krishna Adorning Radha's Breast*
Source: *Ekphrasis* 1, no. 6 (Fall–Winter 1999): 40

Schuler, Robert, *Roger van der Weyden, "Descent from The Cross"*
Source: *Ekphrasis*, 3, no. 4 (Fall–Winter 2004): 39–40

Schuler, Robert, *A Short Meditation on Despair: Hugo van der Goes, "The Lamentation"*
Source: *Ekphrasis*, 3, no. 4 (Fall–Winter 2004): 41–2

Schuler, Robert, *Vanity, Vanitas*
Pablo Picasso, *Minotaur, Drinker and Women*
Source: *Ekphrasis* 4, no. 1 (Spring–Summer 2006): 20

Schuler, Robert, *Joan Miró, "Chiffres et Constellations," 1941; Seurat at Gravelines; and Van Gogh, "Landscape with House and Ploughman"*
Source: *Collection: Ekphrastic Poems by Robert Schuler and Janet Butler*, No. 1 (Delafield, WI: Canvas Press, 2007), 3

Schuler, Robert, *Winter, 1886–1996*
Paul Signac, *Boulevard de Clichy*
Source: *Ekphrasis* 1, no. 1 (Summer 1997): 27

Schuler, Robert, *Camille Pissarro's "Chàtaigners à Louveciennes"*
Source: *Ekphrasis* 1, no. 2 (Winter 1997–1998): 13

Schuler, Robert, *Poem on a Painting by Gustave Caillebotte*
Gustave Caillebotte, *Rue de Paris*
Source: *Ekphrasis* 1, no. 3 (Spring–Summer 1998): 42

Schuler, Robert, *Danae*
Gustav Klimt, *Danaë*
Source: *Ekphrasis* 2, no. 1 (Spring–Summer 2000): 341

Schuler, Robert, *Bonnard's "La fenêtre"*
Source: *Ekphrasis* 3, no. 3 (Spring–Summer 2004): 28

Schuler, Robert, *long after midnight, a design à la Chagall*
Marc Chagall, *Rabbi of Vitebsk*
Source: *Ekphrasis* 3, no. 5 (Spring–Summer 2005): 8

Schuler, Robert, *Georges Rouault, "Spring"*
Source: *Ekphrasis* 3, no. 5 (Spring–Summer 2005): 15

SCHULMAN, Grace, *American Solitude*
Edward Hopper, *Study of Portrait of Orleans*
Source: Levin (3J, above), 60–1

SCHULZ, Paula, *Self-Portrait*
Vincent Van Gogh, *Self-Portrait*, 1886–87

Source: *Beauty/Truth: A Journal of Ekphrastic Poetry* 1, no. 2 (Spring–Summer 2007): 20–1

Schulz, Paula, *Starlight on the Rhone*
Vincent Van Gogh, *Starlight on the Rhone*
Source: *Beauty/Truth: A Journal of Ekphrastic Poetry* 1, no. 2 (Spring–Summer 2007): 22

SCHUPAM, Peter, *Henry Fuseli: "Titania and Bottom"*
Source: Adams (1B, above), 24–5

SCHUYLER, James, *Anne Dunn Drawing*
Anne Dunn, *Manhattan*, 1974
Source: Vanderlip (1A, above), 54

Schuyler, James *Looking Forward to See Jane Real Soon*
Jane Freilicher, *The Gardeners*, 1977–78
Source: Vanderlip (1A, above), 56

SCHWARCZ, Vera, *La Dame à Licorne: A Meditation on Buttressed Vision*
Tenture de la Dame à Licorne (fifteenth-century tapestry)
Source: *Ekphrasis* 3, no. 2 (Fall–Winter 2003): 15–17

SCHWARTZ, Delmore, *Seurat's Sunday Afternoon along the Seine*
Georges Seurat, *Sunday Afternoon on the "Ile de la Grande Jatte"*
Source: *Selected Poems* (New York: New Directions, 1967), 190–6; Abse (2D, above), 102–4, and Hirsch (1D, above), 20–5

Schwartz, Delmore, *She Lives with the Furies of Hope and Despair*
Jan Vermeer
Source: Delmore Schwartz, *Vaudeville for a Princess* (New York: New Directions, 1950), 77

SCHWARTZ, Edythe Haendel, *An Encounter with Cy Twombly at the Whitney Museum of American Art*
Cy Twombly, unidentified works on paper
Source: *Cider Press Review* 8 (2007): 48–9

SCHWED, Margaret Peters, *To Degas, on "The Fallen Jockey"*
Edgar Degas, *The Fallen Jockey*
Source: *Ekphrasis*, 3, no. 6 (Fall–Winter 2005): 16–17

SCOTT, Joanna Catherine, *A Theory of Transcendence*
Giorgio Vasari, untitled oil on copper in the Uffizi
Source: *Ekphrasis*, 3, no. 6 (Fall–Winter 2005): 7–8. Also in Scott's *Fainting at the Uffizi* (Sacramento: Frith Press, 2005), 21–2

Scott, Joanna Catherine, *Sacred Allegory: A New Interpretation*
Giovani Bellini, oil painting on wood in the Uffizi

Source: Joanna Catherine Scott, *Fainting at the Uffizi* (Sacramento: Frith Press, 2005), 23–5

Scott, Joanna Catherine, *Rachel Ruysch Looks Back*
Rachel Ruysch, *Floral Still Life*
Source: Holcomb (1I, above), 148–50

SCOTT, NANCY, *Two Players*
Vladimir Makovsky, *Rest on the Way from Kiev*
Source: *Ekphrasis* 5, no. 2 (Fall–Winter 2009): 23–4

SCOTT, Winfield Townley, *Grant Wood's "American Landscape"*
Source: Winfred Townley Scott, *Collected Poems* (New York: Macmillan, 1959), 32–3

Scott, Winfield Townley, *Winslow Homer*
Source: Winfred Townley Scott, *Collected Poems* (New York: Macmillan, 1959), 134–5

Scott, Winfield Townley, *Landscapes*
Waldo Kaufer's paintings
Source: Winfred Townley Scott, *Collected Poems* (New York: Macmillan, 1959), 100–01

SCRUTON, James, *At the National Gallery*
Frederic William Burton, *Piamontini's Wrestlers*; Paul Henry, *Launching the Curragh*; and Jack B. Yeats, *The Liffey Swim*
Source: *Ekphrasis* 1, no. 3 (Spring–Summer 1998): 56–8

Scruton, James, *Lady Writing a Letter with Her Maid*
Jan Vermeer, *Lady Writing a Letter with Her Maid*
Source: *Ekphrasis* 1, no. 5 (Spring–Summer 1999): 24

SCUDÉRY, Georges de, *La naissance de Vénus*
Tableau on the birth of Venus attributed to Paolo Veronese
Source: Maurisson and Verlet (2L, above), 38–41

SCUPHAM, Peter, *Monet's Garden*
Claude Monet
Source: Peter Scupham, *The Ark* (Oxford: Oxford University Press, 1994), 16

SEABROOKE, Brenda, *On a Windy Wash Day Morn*
Grandma Moses, *Wash Day*
Source: Greenberg, *Heart* (2J, above), 38

SEBALD, W.G., ... *As the Snow on the Alps*, part 1 of *After Nature*
Matthias Grünewald, Basel *Crucifixion, Isenheim Altarpiece*, and other paintings by Grünewald
Source: W.G. Sebald, *After Nature* (New York: Random House, 2002), 1–37

SEELIG, Adam. *On Saba's Painting of Moses Seeing the Promised Land*
Saba = Seelig's grandfather
Source: *Midstream* 1 January 2002.

SELINSKY, Pearl Stein, *Pool*
Unidentified David Hockney painting
Source: *Ekphrasis* 1, no. 1 (Summer 1997): 24–5

SEMONES, Charles, *Thomas Eakins Talks to Himself Before Painting "The Swimming Hole"*
Source: *Kentucky Poetry Review* 22 (1986): 15–18

SETTERLIND, Bo, *Auf Botticellis "Frühling"*
Sandro Botticelli, *La Primavera*
Source: Kranz (2B, above), 121

SEXTON, Anne, *Starry Night*
Vincent Van Gogh, *Starry Night*
Source: Anne Sexton, *The Complete Poems of Anne Sexton* (Boston: Houghton Mifflin, 1981), 53; Kehl (2A, above), 170–1; and Benton and Benton, *Double Vision* (2E, above), 46–8

SHAIKH, Nilofarm *Salvador Dali, "Dream Caused by the Flight of a Bumble Bee around a Pomegranate One Second before Waking Up"*
Source: *Collection: Ekphrastic Poems by Nilofar Shaikh and F.J. Bergmann*, No. 2 (Delafield, WI: Canvas Press, 2007), 3

SHANAHAN, Deirdre, *My Mother and a Marc Chagall Painting*
Source: Deirdre Shanahan, *Legal Tender* (Petersfield: Enitharmon, 1988), 41

SHANGE, Ntozake, *La Luta Continua*
Candace Hill-Montgomery, *Glimmering through the African Bush*
Source: Ntozake Shange, *Ridin' the Moon in Texas: Word Paintings* (New York: St. Martin's 1987)

Shange, Ntozake, *Who Needs a Heart*
Linda Graetz, *Who Needs a Heart*
Source: Ntozake Shange, *Ridin' the Moon in Texas: Word Paintings* (New York: St. Martin's 1987)

Shange, Ntozake, *Conversations with the Ancestors*
Arturo Lindsay, *Indigo's Emergency Care for Wounds That Cannot Be Seen*
Source: Ntozake Shange, *Ridin' the Moon in Texas: Word Paintings* (New York: St. Martin's 1987)

SHANKAR, Ravi, *Untitled, Oil Paint on Canvas, 1958*
Mark Rothko, *Untitled, 1958*
Source: *Ekphrasis* 4, no. 5 (Spring–Summer 2008): 40

Shankar, Ravi, *Rodeo Cowboy No. 1, Oil on Canvas, 1978*
Fritz Scholder, *Rodeo Cowboy No. 1*
Source: *Tuesday; An Art Project* 1, no. 2 (2007): unnumbered postcard

SHAPCOTT, Jo, *Leonardo and the Vortex*
Leonardo da Vinci
Source: Jo Shapcott, *Phrase Book* (Oxford: Oxford University Press, 1992), 17

SHAPIRO, Karl, *New Museum*
Abstract expressionist painters

Source: Karl Shapiro, *Collected Poems, 1940–1978* (New York: Random House, 1978), 238–9

SHAPIRO, Lynne, *Door to de Kooning*
Willem de Kooning, *Door to the River*
Source: *The Hiss Quarterly*, 5, no. 3. http://thehiss quarterly.net/eck/shapiro.html

SHAPIRO, Rochelle Jewel, *Threshold*
Henri Matisse, *Harmony in Red*
Source: *Ekphrasis* 5, no. 2 (Fall–Winter 2009): 12

SHARPLES, Alan, *Xu Wei*
Source: Alan Sharples, *A Contract of Silence* (Petersfield, UK: Enitharmon, 1988), 35

SHAUGHNESSY, Brenda, *Project for a Fainting*
After a painting by Dorothea Tanning
Source: Brenda Shaughnessy, *Interior with Sudden Joy* (New York: Farrar, Straus and Giroux, 1999), 51–2

Shaughnessy, Brenda, *Interior with Sudden Joy*
Dorothea Tanning, *Interior with Sudden Joy* (painting reproduced on dust jacket)
Source: Brenda Shaughnessy, *Interior with Sudden Joy* (New York: Farrar, Straus and Giroux, 1999), 79–81

Shaughnessy, Brenda, *Convolotus alchemilia (Quiet-willow window)*
Dorothea Tanning, *Convolotus alchemilia (Quiet-willow window)*
Source: Dorothea Tanning, *Another Language of Flowers* (New York: Braziller, 1998), plate 12

SHECKLER, Kate, *The Island*
Emma Kidd, *Tranquille Coast*
Source: *qarrtsiluni. online literary magazine.* http://qarrtsiluni.com/category/ekphrasis

SHELLEY, Percy Bysshe, *On the Medusa of Leonardo da Vinci in the Florentine Gallery*
Flemish painting done after a lost original by Michelangelo
Source: Hollander (2I, above), 141–2

SHEPHERD, Reginald, *Black Is the Color of My True Love's Hair*
Guido Reni, *Saint Sebastian*
Source: Reginald Shepherd, *Some Are Drowning* (Pittsburgh, PA: University of Pittsburgh Press, 1994), 35

SHINN, Leslie, *Nativity*
Lizbeth Zwerger, book illustration of the Nativity
Source: *Ekphrasis* 3, no. 2 (Fall–Winter 2003): 32

SHOCKLEY, Evie, *mrs. sally foster otis, mother of ten, sits for her portrait*
Gilbert Stuart, *Mrs. Harrison Gray Otis*
Source: *Ekphrasis* 3, no. 6 (Fall–Winter 2005): 43

SHORE, Jane, *The Sleeper Watched: Three Studies, 1. Sleeping Nude*

Pablo Picasso, *Sleeping Nude* (1904)
Source: Jane Shore, *Eye Level* (Amherst: University of Massachusetts Press, 1977), 45

Shore, Jane, *The Sleeper Watched: Three Studies, 2 and 3. Meditation*
Pablo Picasso, *Meditation*
Source: Jane Shore, *Eye Level* (Amherst: University of Massachusetts Press, 1977), 46–7

SHUMAKER, Peggy, *Upset Woman*
Florence Napaaq Malewotkuk, drawing
Source: *Prairie Schooner* 79, no. 4 (Winter 2005): 45–6

SIEGEL, Joan I., *Jean-François Millet: "The Knitting Lesson"*
Source: *Ekphrasis* 2, no. 4 (Fall–Winter 2001): 12

Siegel, Joan I., *Mary Cassatt: "The Bath"*
Source: *Ekphrasis* 2, no. 4 (Fall–Winter 2001): 13

SIEVERS, Kelly, *Madame Matisse*
Henri Matisse, *Madame Matisse*
Source: *Ekphrasis* 4, no. 4 (Fall–Winter 2007): 19

SILANO, Martha, *The Man*
Richard Prince, *"Untitled"* (four single men with interchangeable backgrounds looking to the right)
Source: http://bluepositive.blogspot.com/2009/08/ekphrasis.html

SILLITOE, Alan, *Delacroix's "Liberty Guiding the People"*
Source: *Collected Poems* (London: Harper Collins, 1993), 230–1

SILVERMARIE, Sue, *The Moment before Speaking*
Alma Erdmann, *At the Fortune Tellers*
Source: *Wisconsin Poets* (1E, above), 28–9

SIMMONS, Glori, *The Conversion*
Pablo Picasso, *Mother and Child*
Source: *Ekphrasis* 1, no. 3 (Spring–Summer 1998): 54–5

SIMON, Barbara M., *Helga*
Andrew Wyeth, *Helga*
Source: *Ekphrasis* 1, no. 3 (Spring–Summer 1998): 26–7

SIMON, Paul, *René and Georgette Magritte With Their Dog After the War*
Source: "Paul Simon, Author," 25 November 2008. http://abbeville.wordpress.com/

SIMPSON, Grace, *Monet Invents Impressionism*
Claude Monet, *Sunrise: Impression, Le Havre*
Source: *Ekphrasis* 1, no. 2 (Winter 1997–1998): 33

SIMPSON, Louis, *Magritte Shaving*
René Magritte
Source: Louis Simpson, *Collected Poems* (New York: Paragon House, 1988), 283

SINGER, Julia Klatt, *Married Life*
Roger de la Fresnaye, *Married Life*
Source: http://www.northography.com/MIA/julia.php

SIRR, Peter, *Passion Bed*
Dorothy Cross, *Passion Bed*
Source: Reid and Rice (1J, above), 72–3

SISSMAN, L.E., *American Light: A Hopper Retrospective*
Edward Hopper
Source: *Boston University Journal* 22 (Autumn 1974): 32

SITWELL, Sacheverell, *Landscape with the Giant Orion*
Nicolas Poussin, *Landscape with Orion*
Source: Sacheverell Sitwell, *Canons of Giant Art: Twenty Torsos in Heroic Landscapes* (London: Faber & Faber, 1933)

Sitwell, Sacheverell, *To the Self-Portrait of A. Watteau Playing the Hurdy-Gurdy*
Antoine Watteau, *A Man Playing a Hurdy-Gurdy*
Source: Sackeverell Sitwell, *An Indian Summer: 100 Recent Poems* (London: Macmillan, 1982)

SKLOOT, Floyd, *Cézanne at Sixty-one*
Paul Cézanne
Source: *Prairie Schooner* 82, no. 4 (Winter 2008): 88

SLAVITT, David, *Cézanne Drawing*
Source: David Slavitt, *PS3569.L3* (Baton Rouge: Louisiana State University Press, 1998), 21.

Slavitt, David R., *Jackson Pollock's 13A: Arabesque*
Jackson Pollock, *Number 13A: Arabesque*, 1948
Source: David R. Slavitt's *Falling from Silence* (Baton Rouge: Louisiana State University Press, 1991), 13; and Hollander and Weber (1H, above), 68–9

Slavitt, David R., *Remarks of Goya's Marquesa de Santa Cruz*
Francisco Goya, *La Marquesa de Santa Cruz*
Source: David R. Slavitt, *Falling from Silence* (Baton Rouge: Louisiana State University Press, 1991), 14.

SLEIGH, Tom, *The Mouth*
Gerhard Richter, *Andreas Baader*
Source: *Tri-Quarterly* 120 (2004): 149–50

SMILEVSKI, Vele, *Kandinsky's Advice*
Wassily Kandinsky
Source: Martinovski (2K, above), 94

Smilevski, Vele, *The Anti-Portrait Poem*
René Magritte, *Edward James in Front of "On the Threshold of Liberty"*
Source: Martinovski (2K, above), 95

SMITH, Alexander McCall, *The Peaceable Kingdom*
Edward Hicks, *The Peaceable Kingdom*

Source: http://www.cflat.com/ (poem set to music by Tom Cunningham)

Smith, Alexander McCall, *Tower of Babel*
Pieter Brueghel the Elder, *Tower of Babel*
Source: http://www.cflat.com/ (poem set to music by Tom Cunningham)

Smith, Alexander McCall, *The Skating Minister*
Sir Henry Raeburn, *The Reverend Robert Walker Skating on Duddingston Loch*
Source: http://www.cflat.com/ (poem set to music by Tom Cunningham)

Smith, Alexander McCall, *Birth of Venus*
Sandro Botticelli, *The Birth of Venus*
Source: http://www.cflat.com/ (poem set to music by Tom Cunningham)

Smith, Alexander McCall, *Old Man with a Young Boy*
Domenico Ghirlandaio, *Old Man with a Young Boy*
Source: http://www.cflat.com/ (poem set to music by Tom Cunningham)

SMITH, Claude Clayton, *The Kiss*
Edvard Munch, *The Kiss*
Source: Buchwald and Roston (2C, above), 94

SMITH, Dave, *Chagall and I Prepare Our Colors*
Marc Chagall, clown painting
Source: Dave Smith, *The Fisherman's Whore* (Athens: Ohio University Press, 1974), 73

SMITH, Kevin, *Wish You Were Here*
Gerard Dillon, *Self-contained Flat*
Source: Reid and Rice (1J, above), 124–5

SMITH, Patti, *georgia o'keeffe*
Source: Patti Smith, *Early Work, 1970–1979* (New York: Norton, 1994), 48–9

Smith, Patti, *robert bresson*
Jackson Pollock
Source: Patti Smith, *Early Work, 1970–1979* (New York: Norton, 1994), 142–7

SMITH, Stevie, *Spanish School*
El Greco, Francisco Goya, José de Ribera, et al.
Source: *The Collected Poems of Stevie Smith*, ed., James MacGibbon (Harmondsworth: Penguin Books, 1975), 27–8; and Abse (2D, above), 62–3

Smith, Stevie, *The Lady of the Well-Spring: Renoir's "La Source"*
Auguste Renoir, *La Source*
Source: *The Collected Poems of Stevie Smith*, ed., James MacGibbon (Harmondsworth: Penguin Books, 1975), 311–12

SMITH, William Jay, *Woman at the Piano*
Elie Nadelman, *Woman at the Piano*
Source: Greenberg, *Heart* (2J, above), 8

Smith, William Jay, *Vincent Van Gogh*
Source: Helen Plotz, ed., *Eye's Delight: Poems of Art*

and Architecture (New York: Greenwillow Books, 1983), 32

SMITHYMAN, Kendrick, *Icarus*
Pieter Brueghel the Elder, *Landscape with the Fall of Icarus*
Source: Kendrick Smithyman, *New Zealand Listener* 521 (17 June 1949), 15; rpt. in *Collected Poems 1943–1995*, eds., Margaret Edgcumbe & Peter Simpson (Auckland, New Zealand: Holloway Press, 1947), 125

SNELL, Cheryl, *Guarding Ginevra*
Leonardo da Vinci, *Ginevra de' Benci*
Source: *Beltway Poetry Quarterly* 10, no. 1 (Winter 2009). http://washingtonart.com/beltway/contents.html

SNIDER, Clifton, *Proserpine*
Dante Gabriel Rossetti, *Proserpine*
Source: Clifton Snider, *The Age of the Mother* (Garland, TX: Laughing Coyote, 1992); and http://www.csulb.edu/~csnider/art.poetry.html

Snider, Clifton, *Sophia*
Leonardo da Vinci, *Madonna and Child with St. Anne*
Source: Clifton Snider, *The Age of the Mother* (Garland, TX: Laughing Coyote, 1992); and http://www.csulb.edu/~csnider/art.poetry.html

Snider, Clifton, *The Beguiling of Merlin*
Edward Burne-Jones, *The Beguiling of Merlin*
Source: Clifton Snider, *The Age of the Mother* (Garland, TX: Laughing Coyote, 1992); and http://www.csulb.edu/~csnider/merlin.poem.html

Snider, Clifton, *Aspen in the Wind*
Gustave Caillebotte, *The Floorscrapers*
Source: Clifton Snider, *The Alchemy of Opposites* (St. John, KS: Chiron Review Press, 2000); and http://www.csulb.edu/~csnider/art.poetry.html

Snider, Clifton, *Christina Rossetti*
Source: Clifton Snider, *The Alchemy of Opposites* (St. John, KS: Chiron Review Press, 2000); and http://www.csulb.edu/~csnider/art.poetry.html

SNODGRASS, W.D., *Matisse: "The Red Studio"*
Source: W.D. Snodgrass, *Selected Poems 1957–1987* (New York: Soho, 1987); and in Hollander (2I, above), 303–4, and Kehl (2A, above), 7–8

Snodgrass, W.D., *Vuillard: "The Mother and Sister of the Artist"*
Source: W.D. Snodgrass, *Selected Poems 1957–1987* (New York: Soho, 1987), 107–9

Snodgrass, W.D., *Monet: "Les Nymphéas"*
Source: W.D. Snodgrass, *Selected Poems 1957–1987* (New York: Soho, 1987), 110

Snodgrass, W.D., *Van Gogh, "The Starry Night"*
Source: W.D. Snodgrass, *Selected Poems 1957–1987*

(New York: Soho, 1987), 116–22; and Kehl (2A, above), 170–5

Snodgrass, W.D., *Manet: The Execution of Emperor Maximillian*
Source: W.D. Snodgrass, *Selected Poems 1957–1987* (New York: Soho, 1987), 111–15; and Kehl (2A, above), 161–3

Snodgrass, W.D. For Snodgrass's poems on DeLoss McGraw, see 3L, above.

SNOW, Carol, *Positions of the Body*
Giotto di Bondone, *Lamentation* (*Scenes from the Life of Christ*), and *Arena Chapel frescoes*; Ambroise Vollard; Pablo Picasso, *Guernica*
Source: Carol Snow, *Artist and Model* (New York: Atlantic Monthly Press, 1990), 5–16

Snow, Carol, *Artist and Model I–VI*
Henri Matisse
Source: Carol Snow, *Artist and Model* (New York: Atlantic Monthly Press, 1990), 27–34

Snow, Carol, *Poems after Monet*
Claude Monet
Source: Carol Snow, *Artist and Model* (New York: Atlantic Monthly Press, 1990), 53–63

SNYDER, Gary, *Endless Streams and Mountains*
Chinese scroll painting by an unknown artist (reproduced on the book's endpapers)
Source: Gary Snyder, *Mountains and Rivers without End* (Washington, DC: Counterpoint, 1996), 5–9

SNYDER, Laura, *Red-tailed Hawk*
Ethel Schwabacher, untitled oil
Source: *Ekphrasis* 4, no. 1 (Spring–Summer 2006): 15

Snyder, Laura, *Basket Woman—Slâpu*
Ethel Schwabacher, untitled painting
Source: *Ekphrasis* 4, no. 1 (Spring–Summer 2006): 30

SOBILOFF, Hy, *Communion*
Pablo Picasso, *The Blind Man's Meal*
Source: Kehl (2A, above), 120–1

SOKOL, John, *On a Painting by Degas Known by Two Titles*
Edgar Degas, *Interior (The Rape)*
Source: *Southern Ocean Review* 18. http://www.book.co.nz/sor18.htm

SOLOMON, Laura, *the dream is often of a nest*
Abel Auer, *Untitled*
Source: Geha and Nichols (1N, above), 31–4

SOLOMON, Marvin, *Landscape with Yellow Birds: By Paul Klee*
Source: *Poetry* 96 (August 1960), 296

SOLOMON, Sandy, *Series*
Claude Monet
Source: Sandy Solomon, *Pears, Lake, Sun* (Pittsburgh, PA: University of Pittsburgh Press, 1996), 42–3

SONG, Cathy, *Beauty and Sadness*
Kitagawa Utamaro
Source: Cathy Song, *Picture Bride* (New Haven: Yale University Press, 1983), 37–8

Song, Cathy, *Girl Powdering Her Neck*
Kitagawa Utamaro, *Girl Powdering Her Neck*
Source: Cathy Song, *Picture Bride* (New Haven: Yale University Press, 1983), 39–40

Song, Cathy, *Blue and White Lines after O'Keeffe*
Georgia O'Keeffe, *Black Iris*; *Sunflower for Maggie*; *An Orchid*; *Red Poppy*; and *The White Trumpet Flower*
Source: Cathy Song, *Picture Bride* (New Haven: Yale University Press, 1983), 43–8

Song, Cathy, *From the White Place*
Georgia O'Keeffe
Source: Cathy Song, *Picture Bride* (New Haven: Yale University Press, 1983), 72–4

SOPAJ, Nehas, *(The Flying Dutchman)*
Unidentified painting
Source: Martinovski (2K, above), 88

ŠOPOV, Aco, *Beauty*
Lazar Ličenovski
Source: Martinovski (2K, above), 136

SORNBERGER, Judith, *December 26*
Edward Hays, *Christmas Madonna*
Source: *Ekphrasis* 4, no. 5 (Spring–Summer 2008): 25–6

Sornberger, Judith, *Young Woman with a Water Jug*
Jan Vermeer, *Young Woman with a Water Pitcher*
Source: *Ekphrasis* 1, no. 6 (Fall–Winter 1999): 11

SORRENTINO, Gilbert, *Two for Franz Kline: 1. The Gunnery; 2. The Dark Hallway*
On Kline's black and white pictures
Source: *Poetry* 102 (August 1963): 299; rpt. in Gilbert Sorrentino, *Black and White* (New York: Totem Books, 1964), n.p.

SOUTHEY, Robert, *Stanzas, Addressed to W.R. Turner, Esq. R.A. on His View of the Lago Maggiore from the Town of Arona*
Source: *The Poetical Works of Robert Southey*, vol. 2 (Boston: Little, Brown, 1860), 244–6

Southey, Robert, *On a Picture by J.M. Wright, Esq.*
Source: *The Poetical Works of Robert Southey*, vol. 2 (Boston: Little, Brown, 1860), 246–50

SPAAN, Peter, *Da Vinci. La Gioconda*
Leonardo da Vinci, *Mona Lisa*
Source: Kranz (2B, above), 138

SPACKS, Barry, *Botticelli in Atlantic City*
Sandro Botticelli
Source: *Poetry* 95 (January 1960): 221

SPAROUGH, J. Michael, S.J., *A Meditation on Henry Ossawa Tanner's "The Annunciation"*
Source: *America* 31 March 2008. http://www.americamagazine.org/content/article.cfm?article_id=10719

SPELIERS, Hedwig, *Icaros val*
Pieter Brueghel the Elder, *Landscape with the Fall of Icarus*
Source: Hedwig Speliers, *Het heraldieke dier* (Antwerpen: Manteau 1983)

SPENCER, Jean, *The Hat from Buenos Aires*
Walter King, *Yo Soy Porteño*
Source: *Elastic Ekphrastic: Poetry on Art/Poets on Tour through Galleries*, ed. Jennifer Bosveld (Johnstown, OH: Pudding House Publications, 2003), 47

SPENCER, Jean, *Perceptions in Red and Blue*
Christopher Pekoc, *Chinese Room (Red)* and *Chinese Room (Blue)*, diptych
Source: *Elastic Ekphrastic: Poetry on Art/Poets on Tour through Galleries*, ed. Jennifer Bosveld (Johnstown, OH: Pudding House Publications, 2003), 50

Spencer, Jean, *Hidden*
Jackson Pollock, *Man, Bull, Bird*
Source: *Elastic Ekphrastic: Poetry on Art/Poets on Tour through Galleries*, ed. Jennifer Bosveld (Johnstown, OH: Pudding House Publications, 2003), 51

SPILECKI, Susan, *The Daughter Contemplates Time and Her Mother*
Utagawa Hiroshige, *Hall of Thirty-Nine Bays, Fukagawa* 1857
Source: *Ekphrasis* 1, no. 6 (Fall–Winter 1999): 21

Spilecki, Susan, *The Mother Takes Her Teenage Daughter to Chiyo's Pond*
Utagawa Hiroshige, *Chiyo's Pond in Meguro*
Source: *Ekphrasis* 1, no. 1 (Summer 1997): 10–11

Spilecki, Susan, *Snowy Morning in Koishikawa*
Katsushika Hokusai, *Snowy Morning in Koishikawa*
Source: *Ekphrasis* 1, no. 2 (Winter 1997–1998): 6

Spilecki, Susan, *At the Theater District in Saruwaka, the Newlywed Speaks of Death*
Utagawa Hiroshige, *Night View of Saruwaka-machi*
Source: *Ekphrasis* 1, no. 3 (Spring–Summer 1998): 16

Spilecki, Susan, *Woman on the Dock*
Utagawa Hiroshige, *Yoroi Ferry, Koami-cho*
Source: *Ekphrasis* 1, no. 4 (Fall–Winter 1998): 59

Spilecki, Susan, *The Wife Contemplates Poetry*
Utagawa Hiroshige, *Basho's Hermitage and Camellia Hill*
Source: *Ekphrasis* 1, no. 5 (Spring–Summer 1999): 25

SPILLEBEEN, Willy, *Geen ploeg staat stil*
Pieter Brueghel the Elder, *Landscape with the Fall of Icarus*
Source: Willy Spillebeen, *Gedichten 1959–1973. Een teken van leven* (Antwerpen: Standaard Uitgeverij, 1973), 112; and Korteweg and Heijn (2F, above), 80

SPINOY, Erik, *De jagers in de sneeuw*
Pieter Brueghel the Elder, *Hunters in the Snow*
Source: Korteweg and Heijn (2F, above), 91–3

SPIRENG, Matthew J., *Ivan Albright, Magic Realist*
Source: *Chautauqua Literary Journal* 3 (2006): 110

ST. ONGE, Marian Brown, *In This Hunter's Room*
Neo Rauch, *Jagdzimmer*
Source: http://michaelleong.wordpress.com/2009/08/06/in-defense-of-the-elliptical-new-smoke-an-anthology-of-poetry-inspired-by-neo-rauch-off-the-park-press-2009/

STACH, Carl, *A Poem Obliquely about Bruegel's "Icarus"*
Pieter Brueghel the Elder, *Landscape with the Fall of Icarus*
Source: *Beloit Poetry Journal* 30 (Summer 1980): 15

STAFFORD, William, *Cave Painting*
Source: William Stafford, *The Way It Is: New & Selected Poems* (St. Paul, MN: Graywolf Press, 1998), 152

Stafford, William, *At Lascaux*
Lascaux cave paintings
Source: William Stafford, *The Way It Is: New & Selected Poems* (St. Paul, MN: Graywolf Press, 1998), 155

STALLINGS, A.E., *The Song Rehearsal*
Edgar Degas, *The Song Rehearsal*
Source: A.E. Stallings, *Hapax: Poems* (Evanston, IL: TriQuarterly Books, Northwestern University Press, 2006), 81

Stallings, A.E., *Empty Icon Frame*
Glykophilousa, Virgin of Tenderness
Source: A.E. Stallings, *Hapax: Poems* (Evanston, IL: TriQuarterly Books, Northwestern University Press, 2006), 52–3

Stallings, A.E., *Amateur Iconography: Resurrection*
Unidentified painting of the Harrowing of Hell
Source: A.E. Stallings, *Hapax: Poems* (Evanston, IL: TriQuarterly Books, Northwestern University Press, 2006), 51

STALLWORTHY, Jon, *Toulouse Lautrec at the Moulin Rouge*
Henri de Toulouse-Lautrec, *At the Moulin Rouge*
Source: Jon Stallworthy, *Rounding the Horn: Collected Poems* (Manchester, UK: Cancanet, 1998),

39; Abse (2D, above), 100; and Hirsch (1D, above), 36–7

Stallworthy, Jon, *After "La Desserte"*
Henri Matisse, *La Desserte (Harmony in Red)*
Source: Jon Stallworthy, *Rounding the Horn: Collected Poems* (Manchester, UK: Carcanet, 1998), 98

STANDING, Sue, *Hopper's Women*
Edward Hopper, *House by the Railroad; East Side Interior;* and *Nighthawks*
Source: Levin (3J, above), 31

ST. ANDREWS, B.A., *A Meditation of Vermeer*
Jan Vermeer
Source: *Gettysburg Review* 3, no. 2 (Spring 1990): 415

STANFORD, Ann, *An American Gallery: John James Audubon: "The Passenger Pigeon"*
John James Audubon, *The Passenger Pigeon* in *The Birds of America*
Source: Ann Stanford, *The Descent* (New York: Viking Press, 1970), 39

Stanford, Ann, *Robert Fulton, "Plate the Second"*
Source: Ann Stanford, *The Descent* (New York: Viking Press, 1970), 43–4

Stanford, Ann, *Edward Hicks, "The Peaceable Kingdom"*
Source: Ann Stanford, *The Descent* (New York: Viking Press, 1970), 48–9, and Kehl (2A, above), 136–8

Stanford, Ann, *William Strickland, "View of Ballston Spa, New York"*
Source: Ann Stanford, *The Descent* (New York: Viking Press, 1970), 40

Stanford, Ann, *Winslow Homer, "Snap the Whip"*
Source: Ann Stanford, *The Descent* (New York: Viking Press, 1970), 41–2

Stanford, Ann, *Philip Evergood, "American Tragedy"*
Source: Ann Stanford, *The Descent* (New York: Viking Press, 1970), 46–7

Stanford, Ann, *Dolly Hazelwood, "Untitled"*
Source: Ann Stanford, *The Descent* (New York: Viking Press, 1970), 45

STANLEY, Karen, *Dürer's Great Piece of Turf*
Albrecht Dürer, *The Large Turf*
Source: http://www.guardian.co.uk/books/2006/oct/23/poetry

STANTON, Joseph, *Edward Hopper's "Skyline, Near Washington Square"*
Source: *Ekphrasis* 4, no. 5 (Spring–Summer 2008): 27

Stanton, Joseph, *Heade's "Thunderstorm on Narragansett Bay"*

Martin Johnson Heade, *Thunderstorm on Narragansett Bay*
Source: *Ekphrasis* 1, no. 4 (Fall–Winter 1998): 8

Stanton, Joseph, *Hopper's "Approaching a City"*
Edward Hopper, *Approaching a City*
Source: *Ekphrasis* 1, no. 4 (Fall–Winter 1998): 9

Stanton, Joseph, *Hopper's "Nighthawks"*
Edward Hopper, *Nighthawks*
Source: *Ekphrasis* 1, no. 4 (Fall–Winter 1998): 10–11; rpt. as *Nighthawks* in Stanton's *Imaginary Museum: Poems on Art* (Time Being Books, 1999), 98

Stanton, Joseph, *Variations on a Theme by Winslow Homer*
Winslow Homer, *The Fox Hunt, The Fog Warning,* and *The Gulf Stream*
Source: *Ekphrasis* 3, no. 5 (Spring–Summer 2005): 11–12

Stanton, Joseph. For a number of additional poems by Stanton, see 4I, above.

STAPLES, Catherine, *Anna Kuerner*
Andrew Wyeth, *Ground Hog Day*
Source: *Prairie Schooner* 82, no. 4 (Winter 2008): 31–2

Staples, Catherine, *Fear of Heights*
Andrew Wyeth, *Widow's Walk*
Source: *Prairie Schooner* 82, no. 4 (Winter 2008): 30

Staples, Catherine, *Seafarer*
Andrew Wyeth, *Adrift*
Source: *Prairie Schooner* 82, no. 4 (Winter 2008): 32–3

STARKEY, David, *Sorcerer*
Norton Wright, *Sorcerer*
Source: *Paintings & Poems/Poems & Paintings* (Santa Barbara, CA: Artamo, 2007), 6

Starkey, David, *Lester Leaps In*
Norton Wright, *Lester Leaps In*
Source: *Paintings & Poems/Poems & Paintings* (Santa Barbara, CA: Artamo, 2007), 6

Starkey, David, *Inca Sunrise*
Norton Wright, *Inca Sunrise*
Source: *Paintings & Poems/Poems & Paintings* (Santa Barbara, CA: Artamo, 2007), 6

Starkey, David, *Sheetmetal Series III, No. 3*
Gordon Huether, *Sheetmetal Series III, No. 3*
Source: *Paintings & Poems/Poems & Paintings* (Santa Barbara, CA: Artamo, 2007), 7

STARR, Christine Hope, *A Sadness*
Mark Rothko, *Yellow Band*
Source: Janovy (1O, above), 38–9

STAUFFER-MERLE, Jeanne, *Miró's Head*
Joan Miró, *Head of Man*

Source: *Beauty/Truth: A Journal of Ekphrastic Poetry* 1, no. 1 (Fall–Winter 2006): 18

STEELE, Peter, *San Sepolcro*
Piero della Francesca, *The Resurrection*
Source: Peter Steele, *Invisible Riders* (Sydney: Paper Bark Press, 1999), 50

Steele, Peter, *Picture*
George Stubbs, *Hambletonian, Trainer and Lad*; Richard Dadd, *The Fairy Feller's Master-Stroke*
Source: Peter Steele, *Invisible Riders* (Sydney: Paper Bark Press, 1999), 98–9

Steele, Peter, *Watchman at Three: After Brueghel*
Pieter Brueghel the Elder, *The Tower of Babel*
Source: Peter Steele, *Invisible Riders* (Sydney: Paper Bark Press, 1999), 101

Steele, Peter. For two collections of ekphrastic poems by Steele, see 1M and 4O, above. Steele's *Marching on Paradise* (Melbourne: Longman Cheshire, 1984) opens with a poem that draws on Hans Holbein's portrait of Thomas Moore.

STEIN, Hannah, *Van Gogh: The Woman at "Le Tambourin"*
Vincent Van Gogh, *Agostina Segatori Sitting in the Café du Tambourin*
Source: *Ekphrasis* 2, no. 6 (Fall–Winter 2002): 28

Stein, Hannah, *Klimt's "The Park"*
Gustav Klimt, *The Park*
Source: *Ekphrasis*, 3, no. 6 (Fall–Winter 2005): 23–4

STELLA, Joseph, *Nocturne*
Joseph Stella, *Nocturnes: Night, the Song of the Nightingale,* and *Moon Dawn*
Source: unpublished poem found among Stella's papers; see Irma B. Jaffe, *Joseph Stella* (Cambridge: Harvard University Press, 1970), 92

STERLE, Francine, *The Batman*
Germaine Richier, *The Batman*
Source: *Ekphrasis*, 3, no. 6 (Fall–Winter 2005): 13–14

Sterle, Francine, *Cave Painting*
Source: Francine Sterle, *Every Bird Is One Bird* (Dorset, VT: Tupelo Press, 2001), 55

Sterle, Francine. For forty-eight additional poems on paintings by Sterle, see 4V, above.

STERN, Gerald, *The Jew and the Rooster Are One*
Chaim Soutine, *Dead Fowl*
Source: Gerald Stern, *Odd Mercy* (New York: Norton, 1995), 45–6; and Hirsch (1D, above), 86–7

Stern, Gerald, *Hanging Scroll*
Chinese scroll painting
Source: Gerald Stern, *This Time* (New York: Norton, 1998), 91–2

Stern, Gerald, *The Expulsion*
Masaccio, *The Expulsion from the Garden of Eden*
Source: Gerald Stern, *This Time* (New York: Norton, 1998), 163–5

Stern, Gerald, *My Favorite Farewell*
Unidentified painting of Hector and Andromache
Source: Gerald Stern, *This Time* (New York: Norton, 1998), 209–11

STEVENS, Jeanine, *Sunflower*
Chao Shao-an, *Sunflower* (scroll painting)
Source: *Ekphrasis* 3, no. 1 (Spring–Summer 2003): 32

Stevens, Jeanine, *Ode to Swimming Stags*
Lascaux caves, Dordogne, *Frise des têtes de cerfs*
Source: *Ekphrasis* 3, no. 6 (Fall–Winter 2005): 29

Stevens, Jeanine, *Unprimed Canvas*
Vincent Van Gogh, *View of Auvers with Wheatfield*
Source: *Ekphrasis* 4, no. 4 (Fall–Winter 2007): 29

Stevens, Jeanine, *Sunflowers*
Vincent Van Gogh, *Sunflowers*
Source: *Ekphrasis* 4, no. 4 (Fall–Winter 2007): 30

Stevens, Jeanine, *Trade Goods*
Sydney Prior Hall, *The Sioux Buffalo Dance, Fort Qu'Appelle*
Source: *Ekphrasis* 4, no. 4 (Fall–Winter 2007): 33

Stevens, Jeanine, *Three Acrobats*
Marc Chagall, *The Three Acrobats*
Source: *Ekphrasis* 3, no. 3 (Spring–Summer 2004): 23

Stevens, Jeanine, *Woman Gathering Wild Honey*
Cave painting, Valencia, Spain
Source: *Ekphrasis* 4, no. 6 (Fall–Winter 2008): 10

STEVENS, Wallace, *The Man with the Blue Guitar*
Pablo Picasso, *The Man with the Blue Guitar*
Source: Wallace Stevens, *Collected Poems* (New York: Knopf, 1967), 165–84; and Hirsch (1D, above), 69–70

STEVENSON, Anne, *Brueghel's Snow*
Pieter Brueghel the Elder, *Hunters in the Snow*
Source: Anne Stevenson, *Collected Poems, 1955–1995* (Oxford: Oxford Univewrsity Press,1996), 164–5; Benton and Benton, *Painting with Words* (2G, above), 79; and http://wwwfp.education.ta s.gov.au/English/hugopaul.htm

Stevenson, Anne, *Seven Poems after Francis Bacon:* (1) *Study for a Portrait on a Folding Bed*; (2) *Study of a Dog*; (3) *Three Figures and Portrait*; (4) *Seated Figure*; (5) *Portrait of a Lady*; (6) *Triptych*; and (7) *Study for a Portrait of Van Gogh*
Source: Anne Stevenson, *Collected Poems, 1955–1995* (Oxford: Oxford University Press, 1996), 148–53; *Three Figures and Portrait* and *Seated Figure* are in Adams (1B, above)

Stevenson, Anne, *Hans Memling's Sibylla Sambetha* (1480)
Hans Memling, *Portrait of a Woman (Sibylla Sambetha)*
Source: Anne Stevenson, *Collected Poems, 1955–1995* (Oxford: Oxford University Press, 1996), 172

Stevenson, Anne, *Dreaming of Immortality in a Thatched Hut (After a painting by Chin Ch'ang-T'ang)*
Source: Anne Stevenson, *Collected Poems, 1955–1995* (Oxford: Oxford University Press, 1996), 10

Stevenson, Anne, *The Blue Pool (After the painting by Augustus John)*
Source: Anne Stevenson, *Collected Poems, 1955–1995* (Oxford: Oxford University Press, 1996), 104–5

Stevenson, Anne, *Whistler's "Gentleman by the Sea"*
James McNeill Whistler, *Gentleman by the Sea*
Source: Anne Stevenson, *Granny Scarecrow* (Newcastle upon Tyne, Bloodaxe Books, 2000), 57

STEWART, W.F.M., *Icarus*
Pieter Brueghel the Elder, *Landscape with the Fall of Icarus*
Source: John Lehmann, ed., *Poems from New Writing 1936–1946* (London: J. Lehmann, 1946), 145–6

STICKNEY, Trumbull, *On the Concert*
Giorgione, *Pastoral Concert (Fête champêtre)*
Source: http://poetry.emory.edu/epoet-Author.xml?search=Stickney%2C+Trumbull

STIMPSON, Henry
Wassily Kandinsky, *Improvisation 35*
Source: *Beauty/Truth: A Journal of Ekphrastic Poetry* 1, no. 3 (Fall–Winter 2007): 10–11

STITT, Ellen, *I Try My Best*
Rick Borg, *Motorcycle and Car*
Source: *Elastic Ekphrastic: Poetry on Art/Poets on Tour through Galleries*, ed. Jennifer Bosveld (Johnstown, OH: Pudding House Publications, 2003), 59

Stitt, Ellen, *Christa and Wolfi*
Gerhard Richter, *Christa and Wolfi*
Source: *Elastic Ekphrastic: Poetry on Art/Poets on Tour through Galleries*, ed. Jennifer Bosveld (Johnstown, OH: Pudding House Publications, 2003), 60

STODDARD, Richard Henry, *To Jervis McEntee, Artist*
Source: Richard Henry Stoddard, *The Book of the East and Other Poems* (Boston: James R. Osgood and Co., 1871), 181

STONE, John, *Early Sunday Morning*
Edward Hopper, *Early Sunday Morning*

Source: John Stone, *Renaming the Streets* (Baton Rouge: Louisiana State University Press, 1985), 1; rpt. in Levin (3J, above), 41

Stone, John, *Three for the Mona Lisa*
Leonardo da Vinci, *Mona Lisa*
Source: John Stone, *Renaming the Streets* (Baton Rouge: Louisiana State University Press, 1985), 18

Stone, John, *American Gothic*
Grant Wood, *American Gothic*
Source: John Stone, *Where the Water Begins* (Baton Rouge: Louisiana State University Press, 1998), 13–14

Stone, John, *The Forest Fire*
Piero di Cosimo, *The Forest Fire*
Source: John Stone, *Where the Water Begins* (Baton Rouge: Louisiana State University Press, 1998), 51–2

STRAND, Brian. For twenty-seven poems on paintings by Strand, see 4U, above.

STRAND, Mark, *Two de Chiricos: 1. The Philosopher's Conquest; 2. The Disquieting Muses*
Giorgio de Chirico, *The Philosopher's Conquest* and *The Disquieting Muses*
Source: Mark Strand, *Blizzard of One* (New York: Knopf, 1998), 28–9; and *The Philosopher's Quest*, Hirsch (1D, above), 104–5

STRASSER, Judith, *Red Army in the Don Basin*
Pavel Sokolov-Skalya, *Red Army in the Don Basin*
Source: *Wisconsin Poets* (1E, above), 40–1

STREUBEL, Manfred, *Ikarus*
Pieter Brueghel the Elder, *Landscape with the Fall of Icarus*
Source: Manfred Streubel, *Inventur: ltr. Tagebuch* (Halle and Leipzig: Mitteldeutscher Verlag, 1978), 116

STRONGIN, Lynn, *Van Gogh*
Vincent Van Gogh
Source: *Rising Tide: Twentieth-Century American Women Poets*, ed., Laura Chester and Sharon Barba (New York: Washington Square Press, 1973), 315–16

STRYK, Dan, *Icarus Redeemed*
Suzanne Stryk, unidentified painting
Source: *Shenandoah* 57, no. 3 (Winter 2007): 95–6

STRYK, Lucien, *Three Saints of Nardo di Cione (painted in Florence, 1350)*
Source: Lucien Stryk, *Of Pen and Ink and Paper Scraps* (Athens: Swallow Press, 1989), 43

ST. JOHN, Cindy, *The Heart Is a Beehive*
Elizabeth Terhune, *Among Trees*
Source: *Broadsided: Switcheroo*, April 2008. http://www.broadsidedpress.org/switcheroo/april08.shtml

ST. THOMASINO, Gregory Vincent
A booklet of cryptic, self-referential poems entitled *Ekphrasis: Poems* (Albion, CA: Pygmy Forest Press, 1994). The fifteen poems point to no specific works of art.

STUART, Dabney, *Fish Magic*
Paul Klee, *Fish Magic*
Source: Dabney Stuart, *Long Gone* (Baton Rouge: Louisiana State University Press, 1996), 54–5

Stuart, Dabney. On Stuart's poems on Carroll Cloar's paintings, see 3C, above

STUART, Kiel, *American Gothic*
Grant Wood, *American Gothic*
Source: *Ekphrasis* 1, no. 4 (Fall–Winter 1998): 35

STUART-POWLES, Celia, *The Potato Eaters*
Vincent Van Gogh, *The Potato Eaters*
Source: *Prairie Schooner* 79, no. 4 (Winter 2005): 55–7

STUMPO, Jeff, *Hiroshima Mindstream*
Keith Linton, *Mindstream*
Source: Jeff Stumpo, *Riff Raff* (Greensboro, NC: Unicorn Press, 2007), 15–16; and at http://jeffst umpo.blogspot.com/2009/01/arrangement.html

Stumpo, Jeff, *[In Silva's painting, "Astronaut," the fish stays still]*
Marc Silva, *Astronaut*
Source: Jeff Stumpo, *Riff Raff* (Greensboro, NC: Unicorn Press, 2007), 12

SUK, Julie, *St. Matthew and the Angel*
William Drost, *St. Matthew and the Angel*
Source: Paschal (1G, above), 20–1

SULAK, Marcela, *Ruben's House*
Peter Paul Rubens
Source: *Beltway Poetry Quarterly* 10, no. 1 (Winter 2009). http://washingtonart.com/beltway/conte nts.html

SULEJMAN, Jusuf, *On the Wharf of Cubism*
Source: Martinovski (2K, above), 102

SULLIVAN, Alan, *Self Portrait*
Vincent Van Gogh, *Self-Portrait in Front of the Easel* (1888)
Source: *Ekphrasis* 2, no. 4 (Fall–Winter 2001): 41

SULLIVAN, Nancy, (1) *Prehistoric Cave Painting of a Bison*; (2) *Design on a Greek Amphora: Apollo on a Winged Tripod*; (3) *Buddha Expounding the Doctrine to Yasas, the First Lay Member of the Buddhist Community*; (4) *"A Triptych" by Van Eyck*; (5) *"Spring in Chiang-nan" by Wen Cheng-Ming*; (6) *"Las Meninas" by Velazquez*; (7) *"Portrait of Mrs. Siddons" by Gainsborough*; (8) *"La Gare Saint-Lazere" by Claude Monet*; (9) *"Night Fishing at Antibes" by Picasso*; (10) *"Number 1" by Jackson Pollock (1948)*

Source: *The History of the World as Pictures*, in *A Controversy of Poets*, ed., Paris Leary and Robert Kelly (Garden City, NY: Doubleday, 1965), 446–51

Sullivan, Nancy, *An Edward Hopper Poem*
Source: Nancy Sullivan, *The History of the World as Pictures* (Columbia: University of Missouri Press, 1965), 16

SU SHI, *Two Poems on Guo Xi's "Autumn Mountains in Level Distance"*
Source: Alfreda Murck, *Poetry and Painting in Song China* (Cambridge: Harvard University Asia Center, 2002), 123–4

SUSMAN, Maxine, *Attic Window, Olson House*
Andrew Wyeth, *Wind from the Sea*
Source: *Ekphrasis* 3, no. 2 (Fall–Winter 2003): 5

SUTTON, Virginia Chase, *The Muse Considers*
Édouard Manet, *The Surprised Nymph*
Source: *Ekphrasis* 4, no. 1 (Spring–Summer 2006): 32–3

Sutton, Virginia Chase, *Ode to the Muse*
Frida Kahlo, *The Suicide of Dorothy Hale*
Source: *Ekphrasis* 4, no. 1 (Spring–Summer 2006): 35–6

SWEENEY, James Johnson, *Guernica*
Pablo Picasso, *Guernica*
Source: *Poetry* 56 (June 1940): 128–9

SWEENEY, Matthew, *Lost*
Daniel O'Neill, *Three Friends*
Source: Reid and Rice (1J, above), 122–3

SWENSEN, Cole, *What Happened to Their Eyes*
Giotto di Bodone, *Madonna Ognissanti*; Orcagna (Andrea di Cione), *Strozzi Altarpiece*; Girolamo di Benvenuto, *The Judgment of Paris*; Andrea Mantegna, *Mars and Venus*; and Giovanni Bellini, *Christ Blessing*
Source: Cole Swensen, *Try* (Iowa City: University of Iowa Press, 1999), 3–4

Swensen, Cole, *Noli Me Tangere*
Unknown Spanish painter, early fourteenth century
Source: Cole Swensen, *Try* (Iowa City: University of Iowa Press, 1999), 7–9

Swensen, Cole, *Triune*
Oliver Debré, three unnamed paintings
Source: Cole Swensen, *Try* (Iowa City: University of Iowa Press, 1999), 19–23

Swensen, Cole, *Trio, after the work of Hieronymus Bosch*
Source: Cole Swensen, *Try* (Iowa City: University of Iowa Press, 1999), 25–9

Swensen, Cole, *The Flight into Egypt*
The Flight into Egypt by Rembrandt van Rijn, Hans Memling, Nicolas Poussin, Tintoretto, Adam

Elsheimer, Claude Lorrain; and *Le Repos pendant la fuite en Egypte* by Pierre Patel
Source: Cole Swensen, *Try* (Iowa City: University of Iowa Press, 1999), 33–8

Swensen, Cole, *There*
Francesco Albani, *Les Amours Disarmed on Earth*; Sassetta (Stephano di Giovanni), *St. Francis and the Wolf of Gubbio*; Joachim Patenier, *Rocky Landscape with St. Jerome*; Master of the Manna, *Gathering of Manna*
Source: Cole Swensen, *Try* (Iowa City: University of Iowa Press, 1999), 39–42

Swensen, Cole, *Noli Me Tangere*
French School, 14th century, *Le Parement de Narbonne*; Nicolas Poussin, *Noli Me Tangere*; Correggio, *Noli Me Tangere*; Fra Angelico, *Noli Me Tangere*; Rembrandt, *Noli Me Tangere*; Bronzino (Agnolo di Cosimo), *Noli Me Tangere*; William Etty, *Noli Me Tangere*; Federico Barocci, *Noli Me Tangere*; anonymous eighteenth-century Chinese painter, *Noli Me Tangere*; Titian, *Noli Me Tangere*
Source: Cole Swensen, *Try* (Iowa City: University of Iowa Press, 1999), 43–9

Swensen, Cole, *Story One*
Master of the Death of Saint Nicholas of Münster, *Calvary*
Source: Cole Swensen, *Try* (Iowa City: University of Iowa Press, 1999), 53

Swensen, Cole, *Story Two*
Joos van Cleve, *Altarpiece of the Deposition of Christ*
Source: Cole Swensen, *Try* (Iowa City: University of Iowa Press, 1999), 54

Swensen, Cole, *Story Three*
Giovanni di Paolo, *Saint John in the Wilderness*
Source: Cole Swensen, *Try* (Iowa City: University of Iowa Press, 1999), 55

Swensen, Cole, *Éventail*
Paul Gauguin, *Fan Picture with Landscape after Cézanne*
Source: Cole Swensen, *Try* (Iowa City: University of Iowa Press, 1999), 73

Swensen, Cole. On Swensen's poem on *Tres Riches Heures* of the Duke of Berry, see 3T, above.

SWENSON, May, *De Chirico: Superimposed Interiors*
Source: May Swenson, *To Mix with Time: New and Selected Poems* (New York: Charles Scribner's Sons, 1963), 56–8

Swenson, May, *Naked in Borneo (from a Painting by Tobias)*
Source: *The New Yorker Book of Poems* (New York: Viking, 1969), 473–4; rpt. in Swenson's *New and Selected Things Taking Place* (Boston: Atlantic-Little Brown, 1978), 136–7

Swenson, May, *Merry Christmas. You're on the Right* Raphael, detail of "child-angels"
Source: May Swenson, *Iconographs* (Boston: Houghton Mifflin, 1970), 62

Swenson, May, *A Day Like Rousseau's "Dream"*
Henri Rousseau, *The Dream*
Source: May Swenson, *In Other Words* (New York: Knopf, 1987), 34–5

Swenson, May, *O'Keeffe Retrospective*
Georgia O'Keeffe
Source: May Swenson, *New and Selected Things Taking Place* (Boston: Atlantic-Little Brown, 1978), 26

SWINBURNE, Charles Algernon, *Before the Mirror*
J.A.M. Whistler, *Symphony in White no. 2: The Little White Girl*
Source: Hollander (21, above), 191–3

Swinburne, Charles Algernon, *A Landscape by Courbet*
Gustave Courbet, unidentified painting
Source: *The Complete Works of Algernon Charles Swinburne*, ed., Edmund Gose, vol. 5 (London: T.J. Wise, 1925), 61; German trans., Kranz (2B, above), 211

SYMONDS, Arthur, *Studies in Strange Sins (After Beardsley's Designs)*
Audrey Beardsley, *The Woman in the Moon*
Source: Arthur Symonds, *Selected Writings* (London: Routledge, 2003), 66

SYNGE, John Millington, *The Passing of the Shee: After Looking at One of AE's Pictures*
George William Russell ('Æ')
Source: John Millington Synge, *Collected Plays and Poems* and *The Aran Islands* (London: Everyman, 1996), 232

SZE, Arthur, *Chrysalis*
Roni Horn
Source: http://www.poetryfoundation.org/journal/feature.html?id=182367, and in Sze's *The Ginkgo Light* (Port Townsend, WA: Copper Canyon, 2009)

SZIRTES, George, *The Green Mare's Advice to the Cows*
Marc Chagall, *The Green Mare*
Source: George Szirtes, *Selected Poems 1976–1996* (New York: Oxford University Press,1996), 51–3; and in Adams (1B, above), 91–5

Szirtes, George, *Goya's Chamber of Horrors*
Francisco Goya, *The Straw Manikin (El Pelele)*; *Saturn Devouring His Children*; *Disasters of War*
Source: George Szirtes, *Selected Poems 1976–1996* (New York: Oxford University Press,1996), 26–7

Szirtes, George, *Directing an Edward Hopper*
Source: George Szirtes, *Portrait of My Father in an*

English Landscape (New York: Oxford University Press, 1998), 25

SZYMBORSKA, Wisława, *Brueghel's Two Monkeys*
Pieter Brueghel the Elder, *Two Monkeys*
Source: Wisława Szymborska, *Poems New and Collected 1957–1997* (New York: Harcourt Brace & Co, 1998), 15

Szymborska, Wisława, *Rubens' Women*
Source: Wisława Szymborska, *Poems New and Collected 1957–1997* (New York: Harcourt Brace & Co, 1998), 47

Szymborska, Wisława, *A Byzantine Mosaic*
Source: Wisława Szymborska, *Poems New and Collected 1957–1997* (New York: Harcourt Brace & Co, 1998), 85

Szymborska, Wisława, *A Medieval Miniature*
Limbourg brothers, *Les Très Riches Heures du Duc de Berry*
Source: Wisława Szymborska, *Poems New and Collected 1957–1997* (New York: Harcourt Brace & Co, 1998), 156–7

TABIOS, Eileen, *Boil*
Ann Cooper, *Blue Roses*
Source: *Ekphrasis* 1, no. 2 (Winter 1997–1998): 22

Tabios, Eileen, *Three Poems (Embodied) for Friends*
Eric Gamilanda (oil on rice paper)
Source: *Ekphrasis* 1, no. 4 (Fall–Winter 1998): 20–1

Tabios, Eileen, *The Shapes of Silence*
Theresa Chong, *Black Lightning*
Source: *Ekphrasis* 1, no. 5 (Spring–Summer 1999): 41

TAGGARD, Genevieve, *Called Divine*
El Greco
Source: Genevieve *Taggard, Collected Poems, 1918–1938* (New York: Harper & Row, 1938), 98

TAGGART, John, *Slow Song for Mark Rothko*
Mark Rothko
Source: http://www.thing.net/~grist/l&d/ltagrtl.htm#Slow%20Song%20for%20Mark%20Rothko

TALL, Deborah, *The Artist's Studio in an Afternoon Fog*
Winslow Homer, *The Artist's Studio in an Afternoon Fog*
Source: Holcomb (1I, above), 152–5

TALL GIRL (pseudonym), *mark*
Marja-Leena Rathje, *Nexus IX* and *Nexus X*
Source: *qarrtsiluni. online literary magazine.* http://qarrtsiluni.com/category/ekphrasis

TANOURY, Doug, *The Woods Edge*
John Singer Sargent, *Claude Monet Painting at the Edge of the Wood*
Source: http://tpqonline.org/3poem.html

TANZBERG, Kris (pseudonym for Gisbert Kranz), *bildnis rudolfs des zweiten*
Giuseppe Arcimboldi (Arcimboldo), *Rudolf II as Vertumnus*
Source: Kranz (2B, above), 161

Tanzberg, Kris (pseudonym for Gisbert Kranz), *Ensors Masken*
James Ensor, *The Strange Masks*
Source: Kranz (2B, above), 239–40

Tanzberg, Kris (pseudonym for Gisbert Kranz), *Aufstand des Viadukts*
Paul Klee, *Revolution of the Viaducts*
Source: Kranz (2B, above), 251

Tanzberg, Kris (pseudonym for Gisbert Kranz), *Bruegel*
Pieter Brueghel the Elder, *Landscape with the Fall of Icarus*
Source: Kris Tanzberg, *Bilder und Personen* (Dortmund: Wulff, 1981), 12

TAPLIN, Kim, *Raoul Dufy Exhibition: Hayward Gallery, January 1984*
Source: Kim Taplin, *By the Harbour Wall* (Petersfield, UK: Enitharmon, 1990), 16

TAPSCOTT, Stephen, *Work*
Henri Matisse
Source: Stephen Tapscott, *From the Book of Changes* (Manchester, UK: Carcanet, 1997), 34–5

TAŠKOVSKI, Bratislav, *Having My Photo Taken in front of a Painting by Van Gogh*
Source: Martinovski (2K, above), 98

Taškovski, Bratislav, *The Matador*
Picasso
Source: Martinovski (2K, above), 98

TATE, Allen, *Sonnet: To a Portrait of Hart Crane*
William Lescaze, *Portrait of Hart Crane*
Source: Hollander (2I, above), 109

TAYLOR, Bart Leston, *Post-Impressionism*
Arthur Dove
Source: *The Home Book of Modern Verse*, ed. Burton E. Stevenson (New York: Henry Holt, 1925), 527–8

TAYLOR, Eleanor Ross, *Indigo Mundi*
David Wilkie, *Christopher Columbus in the Convent of La Rábida Explaining His Intended Voyage*
Source: Paschal (1G, above), 40–5

TAYLOR, Henry, *Goodbye to the Goya Girl*
Francisco Goya, *Woman with a Scarf*
Source: Henry Taylor, *The Horse Show at Midnight and An Afternoon of Pocket Billiards* (Baton Rouge: Louisiana State University Press, 1992), 66

TAYLOR, James O., *Van Gogh, Cornfield with Crows*
Source: Benton and Benton, *Double Vision* (2E, above), 40–1

TAYLOR, John, *Brueghel's Farmers*
Source: *Massachusetts Review* 8, no. 1 (Winter 1967)

TAYLOR, Keith, *On the Easy Life of Saints*
Joos van Cleve, *Saint John the Evangelist on Patmos*
Source: Tillinghast (1F, above), 76–8

TEMPLETON, Ray, *Echoes*
Ann Callandro, *Shadows*
Source: *Tattoo Highway* 15. http://www.tattoohighw
ay.org/15/rtcontest.html

TERBORGH, F.C., *Vaart over den Styx*
Joachim Patinir, *Landscape with Charon Crossing the Styx*
Source: Korteweg and Heijn (2F, above), 72

TEIBE, A.N., *Hover & Grasp*
Sergey Muravyev, *Evening Clouds and Bank of River*
Source: *Ekphrasis* 5, no. 1 (Spring–Summer 2009): 9–10

TERRANOVA, Elaine, *Zip*
Barnett Newman, various unnamed Newman paint-
ings, defined by his characteristic "zip" signature
Source: *Ekphrasis* 3, no. 4 (Fall–Winter 2004): 20–1

TERRY, Patricia, *Another Visit to the Musée des Beaux Arts*
Giovanni Battista Tiepolo, *Martirio di san Bar-
tolomeo* and *Martirio di sant'Agata*
Source: *Ekphrasis* 1, no. 6 (Fall–Winter 1999): 35

TESSIMOND, A.S.J., *A Painting by Seurat ("Un di-
manche à la Grande Jatte")*
Georges Seurat, *A Sunday on La Grande Jatte*
Source: *The Collected Poems of A.S.J. Tessimond*, with
translations from Jacques Prévert (Reading, UK:
Whiteknights, 1993), 148

THERIAULT, Jeri, *The Woman in the Painting*
Andrew Wyeth, *The Chambered Nautilus*
Source: *Ekphrasis* 3, no. 6 (Fall–Winter 2005): 42

THIMMESH, Robert F., *de Kooning's "Pastiche"*
Willem de Kooning
Source: *Ekphrasis* 1, no. 3 (Spring–Summer 1998): 52

THOMAS, Lorenzo Roberto, *Destruction of the
Seated Man: After de Kooning's "Seated Man" ca.
1938, Now Destroyed*
Source: *Art Journal* 20 (Winter 1960–61): 83

THOMAS, R.S., *Threshold*
Michelangelo, *The Creation of Adam*
Source: Abse (2D, above), 40

Thomas, R.S., *Father and Son: Ben Shahn*
Ben Shahn, *Father and Son*
Source: Benton and Benton, *Painting with Words*
(2G, above), 37; and http://wwwfp.education.tas.
gov.au/English/hugopaul.htm

Thomas, R.S., *Woman Combing*
Edgar Degas, *Woman Combing Her Hair*

Source: Benton and Benton, *Painting with Words*
(2G, above), 50–1; orig. published in Thomas's
Laboratories of the Spirit (London: Macmillan,
1975), and rpt. in *Collected Poems, 1945–1990*,
new ed. (London: Weidenfeld & Nicolson, 2001),
273

Thomas, R.S., *Nocturne by Ben Shahn*
Source: R.S. Thomas, *H'm* (London: Macmillan,
1972); and in Thomas's *Collected Poems, 1945–
1990*, new ed. (London: Weidenfeld & Nicolson,
2001), 231

Thomas, R.S., *Veneziano: The Annunciation*
Domenico Veneziano, *The Annunciation*
Source: Benton and Benton, *Painting with Words*
(2G, above), 64; orig. published in Thomas's
Laboratories of the Spirit (London: Macmillan,
1975) and rpt. in *Collected Poems, 1945–1990*, new
ed. (London: Weidenfeld & Nicolson, 2001), 288

Thomas, R.S., *On a Portrait of Joseph Hone by Au-
gustus John*
Source: R.S. Thomas, *Collected Poems, 1945–1990*,
new ed. (London: Weidenfeld & Nicolson, 2001),
15; orig. published in *The Stones of the Field* (Car-
marthen: Druid Press, 1946)

Thomas, R.S. *Homage to Paul Klee*
Source: R.S. Thomas, *No Truce with the Furies*
(Newcastle upon Tyne, UK: Bloodaxe Books,
1995), 75

Thomas, R.S. For thirty-two poems by Thomas on
Impressionist and Post-Impressionist paintings,
see 4B, above. For twenty-one of his poems on
twentieth-century painting, see 4D, above.

THOMPSON, Aubrey, *Perspective*
Lilian Westcott Hale, *The Convalescent*
Source: Janovy (1O, above), 17

THOMPSON, Francis, *A Captain of Song (On a Por-
trait of Coventry Patmore by J.S. Sargent, R.A.)*
Source: Francis Thompson, *The Works*, vol. 2 (Lon-
don: Burns and Oates, 1913), 127–8

THOMSON, James ("B.V."), From *The City of
Dreadful Night*
Albrecht Dürer, *Melancholia*
Source: Hollander (2I, above), 209–11

THORNTON, Bethany, *Fetching Jumanah*
Henry Ossawa Tanner, *Horse of the Khedive-Egypt*
Source: Janovy (1O, above), 35

THYMIAN, Jari, *Geographical Content*
Jan Vermeer, *The Officer and the Laughing Girl*
Source: *Ekphrasis* 1, no. 6 (Fall–Winter 1999): 10

Thymian, Jari, *Sor Juana Inés de la Cruz*
Juan Garcia de Miranda, *Sor Juana Inés de la Cruz*
Source: *Ekphrasis* 3, no. 5 (Spring–Summer 2005):
33–4

Thymian, Jari, *Large Rs*
Herbert Bayer, *Wind*
Source: *Ekphrasis* 5, no. 2 (Fall–Winter 2009): 10

TICK, Edward, *Kandinsky: "Improvisation No. 27"*
Wassily Kandinsky, *Improvisation No. 27 (Garden of Love)*
Source: Buchwald and Roston (2C, above), 48

TIMM, Steve, *Face*
Jack Tworkov, *Barrier Series No. 4*
Source: *Wisconsin Poets* (1E, above), 54–5

TODD, Ruthven, *A Sestina for Georges de la Tour*
Source: *Art News* 58 (March 1959): 44–5

TODOROVICH, K.K., *Small Requiem*
Alice Neel, *Dominican Boys on 108th Street*
Source: *Ekphrasis* 1, no. 2 (Winter 1997–1998): 8–9

Todorovich, K.K., *Motionless Mother Holding*
Alice Neel, *Black Spanish American Family*
Source: *Ekphrasis* 1, no. 3 (Spring–Summer 1998): 41

TODOROVSKI, Gane, *The Rebellion of Colours*
Petar Mazev
Source: Martinovski (2K, above), 133

TOMLINSON, Charles, *A Meditation on John Constable*
Source: Charles Tomlinson, *Selected Poems* (New York: New Directions, 1997), 18

Tomlinson, Charles, *Paring the Apple*
Pieter de Hooch, *Woman Peeling Apples with Child*
Source: Charles Tomlinson, *Selected Poems* (New York: New Directions, 1997), 16

Tomlinson, Charles, *Farewell to Van Gogh*
Source: Charles Tomlinson, *Selected Poems* (New York: New Directions, 1997), 20

Tomlinson, Charles, *Cézanne at Aix*
Source: Charles Tomlinson, *Selected Poems* (New York: New Directions, 1997), 21

Tomlinson, Charles, *The Miracle of the Bottle and the Fishes*
Georges Braque, *Bottle and Fishes*
Source: Adams (1B, above), 88–90

TOOREN, J. van, *Brueghels Icarus*
Pieter Brueghel the Elder, *Landscape with the Fall of Icarus*
Source: J. van Tooren, *Verzen van iemand* (Bloemendaal: Stichting Dichtersgroep Dimensie, 1980), 46

TOPAL, Carine, *"...A Soul Called Ida"*
Ivan Albright, *Into the World There Came a Soul Called Ida*
Source: *Ekphrasis* 3, no. 6 (Fall–Winter 2005): 44

Topal, Carine, *La Tentative de L'Impossible*
René Magritte, *La Tentative de L'Impossible*
Source: *Ekphrasis* 4, no. 4 (Fall–Winter 2007): 10

Topal, Carine, *The Broken Column, 1944*
Frida Kahlo, *The Broken Column*
Source: *Cider Press Review* 8 (2007): 46

TORRES, Josette A., *Urban Sprawl*
Ross Racine, *Subdivisions (Forest Lawn)*
Source: http://girlinblack.tumblr.com/

Torres, Josette A., *Pop, Life*
Fernand Léger, *La Vielle*
Source: http://girlinblack.tumblr.com/

Torres, Josette A., *Life as Stick Figure Theatre*
Carlos Merida, *Tres Figuras*
Source: http://girlinblack.tumblr.com/

Torres, Josette A., *Weatherman on a First Date*
Christopher Cannon, *Advent*
Source: http://girlinblack.tumblr.com/

Torres, Josette A., *Day of the Dead*
David F. Driesbach, *All Children Must be Accompanied by Adults*
Source: http://girlinblack.tumblr.com/

Torres, Josette A., *Bend Again*
José Chavez Morado, *Woman Polishing a Stone Slab*
Source: http://girlinblack.tumblr.com/

Torres, Josette A., *Dots, Showers and Wings*
Margaret Van Patten, *Chaos Standing Still*
Source: http://girlinblack.tumblr.com/

Torres, Josette A., *Awkward Tea Time*
Janet Ballweg, *Sweet Talk with an Ex*
Source: http://girlinblack.tumblr.com/

Torres, Josette A., *Grey Day after Spring Break*
Dennis Ichiyama, *Typogram #3*
Source: http://girlinblack.tumblr.com/

Torres, Josette A., *Two Red Kites in the Street*
Mahesh Prajapati, *Wounded Silence*
Source: http://girlinblack.tumblr.com/

Torres, Josette A., *Dear, with Cat (remix)*
Juli Haas, *Dreamer*
Source: http://girlinblack.tumblr.com/

Torres, Josette A., *Waterfront, Blank*
Robert Browning Reed, *Wabash River VI*
Source: http://girlinblack.tumblr.com/

TOWLE, Tony, *Notes on Velásquez*
Diego Velázquez
Source: Tony Towle, *North* (New York: Columbia University Press, 1970), 36

Towle, Tony, *Social Poem*
Jackson Pollock
Source: Tony Towle, *The History of the Invitation: New and Selected Poems 1963–2000* (New York: Hanging Loose Press, 2001)

TOWNSEND, Alison, *Rossetti's "Proserpine"*
Dante Gabriel Rossetti, *Proserpine*
Source: *Ekphrasis* 4, no. 2 (Fall–Winter 2006): 7–8

TRANSTRÖMER, Thomas, *Vermeer*
Jan Vermeer, *Woman in Blue Reading a Letter*
Source: Thomas Tranströmer, *The Great Enigma: New Collected Poems*, trans. Robin Fulton (New York: New Directions, 2006), 190–1

Transtömer, Thomas, *After an Attack*
Vincent Van Gogh, landscape of a wheat field
Source: Thomas Transtömer, *Selected Poems 1954–1986* (Hopewell, NJ: Ecco Press, 1987), 41

TRENDLE, Tammy, *Among Trees*
Elizabeth Terhune, *Among Trees*
Source: *Broadsided: Switcheroo*, April 2008. http://www.broadsidedpress.org/switcheroo/april08.shtml

TRETHEWAY, Eric, *Houses by the Railroad Tracks*
Edward Hopper, *American Landscape*; *Captain Kelly's House*; *New York, New Haven and Hartford*; *House by the Railroad*
Source: Eric Tretheway, *Songs & Lamentations* (Cincinnati, OH: Word Press, 2004), 23–4

Tretheway, Eric, *Boots*
Vincent Van Gogh, *A Pair of Boots*
Source: Eric Tretheway, *Songs & Lamentations* (Cincinnati, OH: Word Press, 2004), 77–8

Tretheway, Eric, *A Disaster of War*
Francisco Goya, *Esto es peor*
Source: Eric Tretheway, *Songs & Lamentations* (Cincinnati, OH: Word Press, 2004), 83–4

TRIMPL, W. Wesley, *To El Greco*
Source: *Poetry* 74 (August 1949): 264–5

TRISTRAM, Emma, *Icarus Again*
Pieter Brueghel the Elder, *Landscape with the Fall of Icarus*
Source: Piero Boitani, *Winged Words: Flight in Poetry and History* (Chicago: University of Chicago Press, 2007), n. 39, 246–7

TROCHIMCZYK, Maja, *The Jungle*
Milford Zornes, *North Burma Jungle Near Shadowsuet*
Source: *Ekphrasis* 5, no. 2 (Fall–Winter 2009): 11

TROUPE, Quincy, *This One's for You, José*
José Bedia, *Al fin un puente* and other paintings
Source: Quincy Troupe, *Avalanche* (Minneapolis, MN: Coffee House Press, 1996), 125–6

Troupe, Quincy, *Robert Colescott's "One-Two Punch" at the Venice Beinale*
Source: Quincy Troupe, *Choruses* (New York: New Directions, 1999), 49–51

Troupe, Quincy, *Fragmented Solos, Patterns & Textures; Other Worlds; The Paintings of Philip Taafe*
Source: Quincey Troupe, *Transcircularities: New and Selected Poems* (Minneapolis, MN: Coffee House Press, 2002), 331–3

TUCHOLSKY, Kurt, *Der Lächeln der Mona Lisa*
Leonardo da Vinci, *Mona Lisa*
Source: Kranz (2B, above), 136

TUCKER, Memye Curtis, *Arrangement in Grey and Black No. 1: Portrait of the Artist's Mother*
James McNeill Whistler, *Arrangement in Grey and Black No. 1: Portrait of the Artist's Mother*
Source: *Ekphrasis* 4, no. 2 (Fall–Winter 2006): 16

Tucker, Memye Curtis, *The Director Prepares*
Henri Matisse, *Still Life*
Source: *Ekphrasis* 4, no. 6 (Fall–Winter 2008):

TUCKERMAN, Henry Theodore, *On a Landscape by Backhuysen*
Ludolf Backhuysen
Source: Henry Theodore Tuckerman, *Poems* (Boston: Ticknor, Reed and Fields, 1851), 153

Tuckerman, Henry Theodore, *On a Portrait of Mrs. Norton*
Source: Henry Theodore Tuckerman, *Poems* (Boston: Ticknor, Reed and Fields, 1851), 155

Tuckerman, Henry Theodore, *Vanderlyn's Ariadne*
John Vanderlyn, *Ariadne Asleep on the Island of Naxos*
Source: Henry Theodore Tuckerman, *Poems* (Boston: Ticknor, Reed and Fields, 1851), 148

Tuckerman, Henry Theodore, *On the Death of Allston*
Washington Allston
Source: Henry Theodore Tuckerman, *Poems* (Boston: Ticknor, Reed and Fields, 1851), 160

TUCKEY, Melissa, *Time's Arrow*
Hiroshi Sugimoto, *Time's Arrow*
Source: *Beltway Poetry Quarterly* 10, no. 1 (Winter 2009). http://washingtonart.com/beltway/contents.html

TURCO, Lewis, *James Henry Beard: The Night before the Battle, 1865*
Source: Holcomb (II, above), 156–9

TURNER, Frederick, *On Goya's Saturn*
Francisco Goya, *Saturn*
Source: Frederick Turner, *April Wind and Other Poems* (Charlottesville: University of Virginia Press, 1991), 60–4

TURNER, J.M.W., Verses accompanying *Thomson's Aeolian Harp*
Source: Andrew Wilton, *Painting and Poetry: Turner's "Verse Book" and His Work of 1804–12* (London: Tate Publishing, 1990)

TURNER, Josie, *Christina of Denmark (Holbein)*
Jans Holbein, *Christina of Denmark*
Source: http://www.guardian.co.uk/books/2006/oct/23/poetry

TUTHILL, Linda, *The Absent Father*
Walter King, *Peace*
Source: *Elastic Ekphrastic: Poetry on Art/Poets on Tour
 through Galleries*, ed. Jennifer Bosveld (John-
 stown, OH: Pudding House Publications, 2003),
 36

Tuthill, Linda, *School of Possibility*
Chaim Soutine, *Melanie the Schoolteacher*
Source: *Elastic Ekphrastic: Poetry on Art/Poets on Tour
 through Galleries*, ed. Jennifer Bosveld (John-
 stown, OH: Pudding House Publications, 2003),
 37

Tuthill, Linda, *Mopping Up*
Ann Hamilton, *Reflection* series
Source: *Elastic Ekphrastic: Poetry on Art/Poets on Tour
 through Galleries*, ed. Jennifer Bosveld (John-
 stown, OH: Pudding House Publications, 2003),
 38

TYLER, Parker, *But Utamaro: Secretly*
Kitagawa Utamaro
Source: *Art News* 57 (March 1958): 44–5

UMANS, Linda, *Soap Bubbles*
Jean Baptiste Simeon Chardin, *A Boy Blowing Soap
 Bubbles*
Source: *Beauty/Truth: A Journal of Ekphrastic Poetry*
 1, no. 1 (Fall–Winter 2006): 5

Umans, Linda, *The Ray*
Jean-Siméon Chardin, *The Ray-Fish*
Source: *Beauty/Truth: A Journal of Ekphrastic Poetry*
 1, no. 1 (Fall–Winter 2006): 6

UNAMUNO, Miguel de, *The Velázquez Christ*. See
 3W, above.

UNGAR, Barbara, *In Tintoretto's "Origin of the Milky
 Way"*
Jacopo Tintoretto, *The Origin of the Milky Way*
Source: Barbara Ungar, *The Origin of the Milky Way*
 (Arlington, VA: Gival Press, 2007)

UPDIKE, John, *The Nouveau Saintes*
Cézanne, et al.
Source: John Updike, *Verse* (Greenwich, CT: Faw-
 cett, 1963), 160

Updike, John, *Two Hoppers*
Edward Hopper, *Girl at a Sewing Machine* and *Hotel
 Room*
Source: Levin (3J, above), 17

Updike, John, *Before the Mirror*
Pablo Picasso, *Girl Before a Mirror*
Source: *New Yorker*, 9 September 1996: 64, and
 http://valerie6.myweb.uga.edu/intertextuality.ht
 ml#three

UPDIKE, Karen, *Still Life with Watermelon*
Severin Roesen, *Still Life with Watermelon*
Source: *Wisconsin Poets* (1E, above), 22–3

URA, Karma, *The Ballad of Pemi Tshewang Tashi*
 (excerpt)
Karma Ura, *Wangdue Dzongan*
Source: Greenberg, *Side* (2M, above), 24–5

URDANG, Constance, *Frida and I*
Frida Kahlo
Source: Constance Urdang, *Alternative Lives* (Pitts-
 burgh, PA: University of Pittsburgh Press, 1990),
 16–17

Urdang, Constance, *Magritte and the American Wife*
René Magritte
Source: Constance Urdang, *Alternative Lives* (Pitts-
 burgh, PA: University of Pittsburgh Press, 1990),
 20

UROŠEVIĆ, Vlada, *Hieronymus Bosch*
Source: Martinovski (2K, above), 76

Urošević, Vlada, *Pieter Bruegel*
Source: Martinovski (2K, above), 76–7

Urošević, Vlada, *Vincent van Gogh*
Source: Martinovski (2K, above), 77

Urošević, Vlada, *Marc Chagall*
Source: Martinovski (2K, above), 78

Urošević, Vlada, *Hieronymus Bosch: "The Garden of
 Earthly Delights"*
Source: Martinovski (2K, above), 78–9

VAN DE KAMP, Alexandra, *Woman with Dancing
 Dress at the Entrance of a Theater Box*
Henri de Toulouse-Lautrec
Source: *Ekphrasis* 2, no. 6 (Fall–Winter 2002): 29–
 32

van de Kamp, Alexandra, *St. Francis in the Desert*
Giovanni Bellini, *St. Francis in the Desert*
Source: *Ekphrasis* 2, no. 6 (Fall–Winter 2002): 44–6

van de Kamp, Alexandra, *Winter Landscape*
Esaias Van de Velde, *Winter Landscape*
Source: *Ekphrasis* 1, no. 6 (Fall–Winter 1999): 19

van de Kamp, Alexandra, *Winter Landscape with a
 Cottage*
Pieter Santvoort, *Winter Landscape with a Cottage*
Source: *Ekphrasis* 2, no. 1 (Spring–Summer 2000):
 7–8

VAN DER BOS, Lambert. *Konst cabinet van Marten
 Kretzer = Art Cabinet of Martin Kretzer* (a poem
 of 120 four-line stanzas describing Marten Kret-
 zer's collection of paintings (Titian, del Sarto,
 Dürer, Rubens, Van Dyck, and many contem-
 porary Dutch painters)
Source: See Willem Frijhoff and Marijke Spies,
 "Poems on Paintings," in *Dutch Culture in a Eu-
 ropean Perspective*, vol. 1: *1650. Hard-Won Unity*
 (Assen: Uitgeverij Van Gorcum, 2004), 449 and
 n. 44.

VANDERMOLEN, Robert, *Diebenkorn's Ocean Park No. 52*
Source: Tillinghast (1F, above), 54–5

VANDO, Gloria, *Guernica*
Pablo Picasso, *Guernica*
Source: *Courtland Review* (Spring 2008). http://www.cortlandreview.com/features/08/spring/vando.html

VAN DOREN, Sally, *Sex at Noon Taxes*
Ed Ruscha, *Sex at Noon Taxes*
Source: Sally Van Doren, *Sex at Noon Taxes* (Baton Rouge: Louisiana State University Press, 2008), 3

VAN DUYN, Mona, *Goya's "Two Old People Eating Soup"*
Francisco Goya, *Old Men Eating Soup*
Source: Mona Van Duyn, *If It Be Not I: Collected Poems, 1959–1982* (New York: Knopf, 1982), 279

Van Duyn, Mona, *The Pietà, Rhenish, 14th c., The Cloisters*
Source: Mona Van Duyn, *If It Be Not I: Collected Poems, 1959–1982* (New York: Knopf, 1982), 103–5

Van Duyn, Mona, *Chagall's "Les Plumes en Fleur"*
Marc Chagall, *Les Plumes en Fleur*
Source: Mona Van Duyn, *Firefall* (New York: Knopf, 1993), 4

VAN TOORN, Willem, *Vermeer: Gezicht op Delft*
Johannes Vermeer, V*iew of Delft*
Source: Korteweg and Heijn (2F, above), 169

VAN VALIN, Joel, *To a Roman Lar*
Standing Deity Holding Horn and Bucket, Roman Mural, Pompeii
Source: http://www.northography.com/MIA/joel.php

VAN WALLEGHEN, Michael, *Vermeer*
Jan Vermeer
Source: Michael Van Walleghen, *The Last Neanderthal* (Pittsburgh, PA: University of Pittsburgh Press, 1999), 62–4

VARNOT, Susan, *Matisse: "Seated Pink Nude"*
Source: *Mississippi Review* 14, no. 4 (October 2008). http://www.mississippireview.com/2008/Vol14No4-Oct08/1404-100108-Varnot.html

VASILEVSKI, Risto, *The Sight, the Beginning*
Gligor Čemerski, *Waking of the Stone*
Source: Martinovski (2K, above), 118–19

VEENENDAAL, Cornelia, *Samson Bringing His Parents a Gift of Honeycomb*
Guercino (Giovanni Francesco Barbieri), *Samson Offering His Parents a Honeycomb*
Source: *Ekphrasis* 3, no. 5 (Spring–Summer 2005): 30

VEGA, Janine Pommy, *The Poppy of Georgia O'Keeffe*
Georgia O'Keeffe, *Poppy*
Source: Janine Pommy Vega, *The Green Piano* (Boston: David Godine, 2005), 64; and Greenberg, *Heart* (2J, above), 46–7

VEGLAHN, Sara, *Reading Lady*
Christopher Ruckhäberle, *Reading Lady*
Source: Geha and Nichols (1N, above), 87–90

VERCNOCKE, Ferdinand, *Bij Rembrandts "Man met de helm"*
Disciple of Rembrandt van Rijn, *Man with the Golden Helmet*
Source: Korteweg and Heijn (2F, above), 155

VERWEY, Albert, *Brueghels Ikarus*
Pieter Brueghel the Elder, *Landscape with the Fall of Icarus*
Source: Albert Verwey, *Oorspronkelijk Dichtwerk. Tweede Deel 1914–1937* (Amsterdam-Santpoort: E. Querido, 1938), 392; in Korteweg and Heijn (2F, above), 79; and in Achim Aurnhammer and Dieter Martin, eds., *Mythos Ikarus: Texte von Ovid bis Wolf Biermann* (Leipzig: Reclam, 2001), 188

Verwey, Albert, *Rembrandt*
Rembrandt van Rijn, *Portrait of a Family with Three Children*
Source: Korteweg and Heijn (2F, above), 153

Verwey, Albert, *Delfse Vermeer, ziende naar Delft zoals hij het zal schilderen*
Johannes Vermeer, V*iew of Delft*
Source: Korteweg and Heijn (2F, above), 168

Verwey, Albert, *Op een afbeelding van Vermeer's vrouweportret*
Johannes Vermeer, *Girl with a Pearl Earring*
Source: Korteweg and Heijn (2F, above), 172

VERY, Jones, *On Seeing the Portrait of Helen Ruthven Waterston*
Source: Jones Very, *Poems and Essays* (Boston: Houghton Mifflin, 1886), 473

Very, Jones, *To the Misses Williams, On Seeing Their Beautiful Paintings of Wild Flowers*
Source: Jones Very, *Poems and Essays* (Boston: Houghton Mifflin, 1886), 429

Very, Jones, *The Art Exhibition. On the Wild Flowers of the Art Exhibition*
Source: Jones Very, *Poems and Essays* (Boston: Houghton Mifflin, 1886), 474

VESTDIJK, Simon, *Vrouwenportret*
Maerten van Heemskerck, *Portrait of a Woman*
Source: Korteweg and Heijn (2F, above), 76

Vestdijk, Simon, *Blinden*
Pieter Brueghel the Elder, *The Parable of the Blind*
Source: Korteweg and Heijn (2F, above), 99

Vestdijk, Simon, *Laatste oordeel*
Peter Paul Rubens, *The Last Judgment*
Source: Korteweg and Heijn (2F, above), 102

Vestdijk, Simon, *De boer en de sater*
Jacob Jordaens, *Satyr and Peasant*
Source: Korteweg and Heijn (2F, above), 115

Vestdijk, Simon, *Rembrandt en Saskia*
Rembrandt van Rijn, *Rembrandt and Saskia*
Source: Korteweg and Heijn (2F, above), 123–4

Vestdijk, Simon, *De oprichting van het kruis*
Rembrandt van Rijn, *The Raising of the Cross*
Source: Korteweg and Heijn (2F, above), 127

Vestdijk, Simon, *Bathseba bij het toilet*
Rembrandt van Rijn, *Bathsheba Reading King David's Letter*
Source: Korteweg and Heijn (2F, above), 131

Vestdijk, Simon, *Lezende Titus*
Rembrandt van Rijn, *Titus Reading*
Source: Korteweg and Heijn (2F, above), 137

Vestdijk, Simon, *Saul en David*
Rembrandt van Rijn, *David Playing the Harp before Saul*
Source: Korteweg and Heijn (2F, above), 138–9

Vestdijk, Simon, *De miskende Phoenix*
Rembrandt van Rijn, *Phoenix*
Source: Korteweg and Heijn (2F, above), 141

Vestdijk, Simon, *Zelfportret*
Rembrandt van Rijn, *Self-Portrait* (1668)
Source: Korteweg and Heijn (2F, above), 146

Vestdijk, Simon, *Het Joodse bruidje*
Rembrandt van Rijn, *Portrait of Isaac and Rebecca* (*The Jewish Bride*)
Source: Korteweg and Heijn (2F, above), 148–9

VESTERGAARD, Bettina, *Untitled*
Edward Hopper, *Morning in a City*
Source: http://electricveneer.com/clients/inekphrasis/ekphrasis.html

VIERECK, Peter, *Nostalgia*
Esteban Vicente, engraving
Source: *Art News* 57 (November 1958): 26–7

VINCA, Nuhi, *Standing before the Painting "Cradle" by K.K.*
Source: Martinovski (2K, above), 92

Vinca, Nuhi, * * * [sic]
Leonardo Da Vinci, *Mona Lisa*
Source: Martinovski (2K, above), 100

VINOGRAD, Julia, *I Saw the Picture*
Hieronymus Bosch, *A Musical Hell*
Source: *The Young American Poets*, ed. Paul Carroll (Chicago: Follett, 1968), 460

VOGEL, Constance, *Nude before a Looking-glass*
Henri Toulouse-Lautrec, *Nude in Front of a Mirror*

Source: *Ekphrasis* 3, no. 5 (Spring–Summer 2005): 43

VOIGT, Ellen Bryant, *Two Trees*
Unidentified painting of the Garden of Eden
Source: Ellen Bryant Voigt, *Two Trees* (New York: Norton, 1992), 36–7

VONDEL, Joost van den. Two series of poems on the collection of the painter Joachim Sandrart
Source: See Willem Frijhoff and Marijke Spies, "Poems on Paintings," in *Dutch Culture in a European Perspective*, vol. 1: *1650. Hard-Won Unity* (Assen: Uitgeverij Van Gorcum, 2004), 449–51

VOS, Jan. Numerous poems on the masterpieces owned by Amsterdam burgomeisters
Source: See Willem Frijhoff and Marijke Spies, "Poems on Paintings," in *Dutch Culture in a European Perspective*, vol. 1: *1650. Hard-Won Unity* (Assen: Uitgeverij Van Gorcum, 2004), 451

VOSS, Sarah, *Woman Scrubbing*
Elizabeth Terrell, *Woman Scrubbing*
Source: Janovy (1O, above), 24–5

VRCHLICK, Jaroslaw, *Mona Lisa*
Leonardo da Vinci, *Mona Lisa*
Source: Kranz (2B, above), 128

VROEGINDEWEIJ, Rien, *Straat*
Meindert Hobbema, *The Avenue at Middelharnis*
Source: Korteweg and Heijn (2F, above), 177

WAALDIJK, Frank, *op n walrus*
Pieter Brueghel the Elder, *Landscape with the Fall of Icarus*
Source: http://home.hetnet.nl/~sufra/trijntjefop2.htm

Waaldijk, Frank. For more than one hundred other light verse poems by Waaldijk, see 4Ze, above.

WADE, Sidney, *Gas*
Edward Hopper, *Gas*
Source: Levin (3J, above), 66

WAGNER, Jeanne, "*The Dahlia*": Franz Kline
Source: *Ekphrasis* 2 (Fall–Winter 2000): 42

Wagner, Jeanne, *The Woman in the Red Cape*
Claude Monet, *Portrait of Madame Monet*
Source: *Ekphrasis* 3, no. 4 (Fall–Winter 2004): 19

Wagner, Jeanne, *Nude Descending the Stairs*
Marcel Duchamp, *Nude Descending a Staircase*
Source: *Ekphrasis* 4, no. 1 (Spring–Summer 2006): 26

Wagner, Jeanne, *Still Life of Kitchen*
Jeanne-Baptiste-Siméon Chardin, *Still Life of Kitchen Utensils*
Source: *Ekphrasis* 1, no. 2 (Winter 1997–98): 35

Wagner, Jeanne, *St. Christopher*
Ninth-century fresco, Brege, Cornwall

Source: *Ekphrasis* 1, no. 3 (Spring–Summer 1998): 38–9

Wagner, Jeanne, *Turner's "Norham Castle, Sunrise"*
Source: *Ekphrasis* 2, no. 1 (Spring–Summer 2000): 15

Wagner, Jeanne, *Impression: Sunrise, Le Havre 1872*
Claude Monet, *Impression: Sunrise, Le Havre 1872*
Source: *Ekphrasis* 4, no. 6 (Fall–Winter 2008): 24

Wagner, Jeanne, *Ontology*
Georgia O'Keeffe, *Green Apple on Black Plate*
Source: *Ekphrasis* 4, no. 6 (Fall–Winter 2008): 31–2

Wagner, Jeanne, *Lament*
Richard Diebenkorn, *Cityscape I*
Source: *Ekphrasis* 4, no. 6 (Fall–Winter 2008): 35–6

WAHLGREN, Jared Michael, *Shutters*
Brian Pike, *#1.9*
Source: *qarrtsiluni. online literary magazine.* http://q arrtsiluni.com/category/ekphrasis/

Wahlgren, Jared Michael,
Wilfedo Lam, *The Witnesses*
Source: *Beauty/Truth: A Journal of Ekphrastic Poetry* 1, no. 3 (Fall–Winter 2007): 8

WAIN, John, *The Shipwreck*
J.M.W. Turner, *The Shipwreck*
Source: Abse (2D, above), 79–81, and Adams (1B, above), 40–3

WAINWRIGHT, Jeffrey, *The Red-Headed Pupil: Part One: The Anatomy Lesson*
Rembrandt van Rijn, *The Anatomy Lesson of Dr. Nicholas Tulp*
Source: Jeffrey Wainwright, *The Red-Headed Pupil and Other Poems* (Manchester, UK: Carcanet, 1994), 7–30

WAKEFIELD, Kathleen, *Resting Rock*
Walter Murch, *Resting Rock*
Source: Holcomb (1I, above), 160–2

WAKOSKI, Diane, *After Looking at a Painting of the Crucifixion by an Unknown Master of the 14th Century*
Source: Diane Wakoski, *Trilogy* (Garden City, NY: Doubleday, 1974), 14–15

Wakoski, Diane, *Van Gogh: Blue Picture*
Source: Diane Wakoski, *Trilogy* (Garden City, NY: Doubleday, 1974), 20

Wakoski, Diane, *Night City*
Milton Avery, *Hammock Reader*
Source: Tillinghast (1F, above), 56–8

Wakowski, Diane, *Image as Narrative*
Francisco de Zurbarán, *Still Life: Lemons, Oranges and a Rose*
Source: Diane Wakoski, *Rings of Saturn* (Santa Rosa: Black Sparrow, 1986)

Wakoski, Diane, *Sitting at Hopper's Marbletop Table*
Edward Hopper, *Automat*
Source: Diane Wakowski, *Argonaut Rose* (Santa Rosa, CA: Black Sparrow Press, 1998), 37–9

Wakoski, Diane, *Seeing the World through Hopper's Glasses*
Edward Hopper
Source: Diane Wakowski, *The Emerald City of Las Vegas* (Santa Rosa, CA: Black Sparrow Press, 1995), 150–1

Wakoski, Diane, *Dogs: (A Meditation on Gertrude Stein in an Armchair Sitting Under Picasso's Portrait of Her in Paris)*
Pablo Picasso, *Portrait of Gertrude Stein*; John Singer Sargent, *Madame X*
Source: Diane Wakowski, *Jason the Sailor* (Santa Rosa, CA: Black Sparrow Press, 1993), 72–5

Wakoski, Diane, *Dawn Buds*
Georgia O'Keeffe
Source: Diane Wakowski, *Jason the Sailor* (Santa Rosa, CA: Black Sparrow Press, 1993), 168–9

Wakoski, Diane, *Zubaran*
Francisco de Zubarán, *St. Elizabeth of Portugal* and other paintings by Zubarán
Source: Diane Wakowski, *Jason the Sailor* (Santa Rosa, CA: Black Sparrow Press, 1993), 170–4

WALDMAN, Anne, *Gut Convinced*
Yvonne Jacquette, *Irving Place Intersection*, 1975–76
Source: Vanderlip (1A, above), 70

Waldman, Anne, *Love of His Art*
Joe Brainard, *Untitled*, 1978
Source: Vanderlip (1A, above), 72

Waldman, Anne, *Leonardo*
Leonardo da Vinci
Source: Anne Waldman, *Helping The Dreamer: New and Selected Poems 1966–1988* (Minneapolis, MN: Coffee House Press, 1989), 23

WALLACE, George, *sun in an empty room*
Edward Hopper, *Sun in an Empty Room*
Source: http://www.nycbigcitylit.com/may2002/co ntents/poetryasingles.html

WALCOTT, Derek, *Pissarro at Dusk*
Camille Pissarro
Source: Rita Dove, ed., *The Best American Poetry 2000* (New York: Scribner, 2000), 188–92

Walcott, Derek. For Walcott on Camille Pissarro, Paolo Veronese, and Giambattista Tiepolo, see 3Q, above.

WALD, Diane, *Improvisations on Titles of Works by Jean Dubuffet*
Source: *Mudlark* No. 10 (1998). http://www.unf. edu/mudlark/mudlark10/contents.html

WALLACE, Ronald, *The Hell Mural: Panel I* and *The Hell Mural: Panel II*
Iri and Toshi Maruki, *The Hiroshima Panels*
Source: Ronald Wallace, *The Makings of Happiness* (Pittsburgh, PA: University of Pittsburgh Press, 1991), 35–7

Wallace, Ronald, *After Monet*
Claude Monet
Source: Ronald Wallace, *Tunes for Bears to Dance To* (Pittsburgh, PA: University of Pittsburgh Press, 1983), 21–2

Wallace, Ronald, *Mermaids*
Carl Marr, *Mermaids*
Source: Ronald Wallace, *The Uses of Adversity* (Pittsburgh, PA: University of Pittsburgh Press, 1998), 76

WALLACE-CRABBE, Chris, *Near Arezzo*
Piero della Francesca, *The Flagellation of Christ*
Source: Chris Wallace-Crabb, *Whirling* (New York: Oxford University Press, 1998), 40

WALLIN, Derek, *A Hunter's Night*
Albert Pinkham Ryder, *Hunter's Rest*
Source: Janovy (1O, above), 41

WALLING, Mark, *On Rousseau's "The Snake Charmer"*
Henri Rousseau, *The Snake Charmer*
Source: http://www.nycbigcitylit.com/may2002/contents/poetryasingles.html

WALSH, Timothy, *Gramercy Park*
George Bellows, *Gramercy Park*
Source: *Beauty/Truth: A Journal of Ekphrastic Poetry* 1, no. 1 (Fall–Winter 2006): 8–9

WARD, Tom, *American Fragment*
Nancy S. Graves, *Fragment*
Source: Holcomb (1I, above), 164–6

WARDROP, Daneen, *Van Gogh's Room*
Vincent Van Gogh, *Room at Arles*
Source: *Ekphrasis* 1, no. 4 (Fall–Winter 1998): 13

WARREN, Amanda, *Murmuration*
Kate Baird, *Bird's Eye*
Source: *Broadsided: Switcheroo 2007*. http://www.broadsidedpress.org/switcheroo/nov07.shtml

WARREN, Deborah, *Noli Me Tangere*
Titian, *Noli Me Tangere*
Source: *Ekphrasis* 1, no. 5 (Spring–Summer 1999): 14

WARREN, Robert Penn, *The Sound of That Wind*
John James Audubon
Source: Robert Penn Warren, *Audubon: A Vision* (New York: Random House, 1969), 25–9

WARREN, Rosanna, *Renoir*
Pierre–Auguste Renoir, *Luncheon of the Boating Party*
Source: Rosanna Warren, *Each Leaf Shines Separate* (New York: Norton, 1984), 47–8; and Hollander (2I, above), 331

Warren, Rosanna, *Wreckers: Coast of Northumberland*
J.M.W. Turner, *Wreckers (Coast of Northumberland)*
Source: Rosanna Warren, *Each Leaf Shines Separate* (New York: Norton, 1984), 25

Warren, Rosanna, *Water Lily*
Claude Monet, *Waterlilies*
Source: Rosanna Warren, *Each Leaf Shines Separate* (New York: Norton, 1984), 49–50

Warren, Rosanna, *The Field*
Marc Chagall, *The Poet Reclining*
Source: Rosanna Warren, *Each Leaf Shines Separate* (New York: Norton, 1984), 26–7

Warren, Rosanna, *Through the East Door*
Theora Hamblett, various paintings
Source: Rosanna Warren, *Each Leaf Shines Separate* (New York: Norton, 1984), 28–32

Warren, Rosanna, *Interior at Petworth: From Turner*
J.M.W. Turner, paintings of interiors of Petworth, the house of Turner's patron Lord Egremont — *Interior at Petworth, The Burning of the House of Lords Commons, 16 October 1935*, et al.
Source: Rosanna Warren, *Each Leaf Shines Separate* (New York: Norton, 1984), 42–4.

Warren, Rosanna, *Virgin Pictured in Profile*
Egyptian fresco (Walters Art Gallery, Baltimore)
Source: Rosanna Warren, *Each Leaf Shines Separate* (New York: Norton, 1984), 58–9

Warren, Rosanna, *To Max Jacob*
Source: Rosanna Warren, *Each Leaf Shines Separate* (New York: Norton, 1984), 35

Warren, Rosanna, *Max Jacob at Saint Benoit*
Source: Rosanna Warren, *Each Leaf Shines Separate* (New York: Norton, 1984), 36

Warren, Rosanna, *"Departure"*
Max Beckman, *Departure*
Source: Rosanna Warren, *Departure: Poems* (New York: Norton, 2003), 30–2

Warren, Rosanna, *Siderium Exaltum*
Dorothea Tanning, *Siderium Exaltum (Starry Venus-weed)*
Source: Rosanna Warren, *Departure: Poems* (New York: Norton, 2003), 56, and *Another Language of Flowers* (New York: Braziller, 1998), plate 3.

Warren, Rosanna, *Bonnard*
Pierre Bonnard
Source: Rosanna Warren, *Departure: Poems* (New York: Norton, 2003), 107–8, and Hollander and Weber (1H, above), 50–2

WAS, Carol, *The Dance Class*
Edgar Degas, *The Dance Class*
Source: *Ekphrasis* 4, no. 3 (Spring–Summer 2007): 32

WATKINS, Amy, *First Dream*
Ian Jones, *The Big Blue Church*
Source: *qarrtsiluni. online literary magazine.* http://qarrtsiluni.com/category/ekphrasis

WATKINS, Vernon Phillips, *The Cave-Drawing*
Source: *The Collected Poems of Vernon Watkins* (Ipswich, UK: Golgonooza Press, 1986), 148–9

Watkins, Vernon Phillips, *Deposition: On the Painting by Ceri Richards*
Source: *The Collected Poems of Vernon Watkins* (Ipswich, UK: Golgonooza Press, 1986), 375–6

WATSON, Andrea L., *Inventing the Land*
Don Ward, *Distant Mountains*
Source: *Ekphrasis* 4, no. 2 (Fall–Winter 2006): 26

WATSON, Robert, *A Second Look at Veronese's "Mars and Venus United in Love"*
Source: Robert Watson, *Selected Poems* (New York: Atheneum, 1974), 69

Watson, Robert, *William Rimmer, M.D. (1816–1879)*
William Rimmer
Source: Robert Watson, *Selected Poems* (New York: Atheneum, 1974), 70–6

Watson, Robert, *Distances*
Pierre–Jacques Volaire, *The Eruption of Mt. Vesuvius*
Source: Paschal (1G, above), 38–9

WAX, Phyllis, *Southwest Pietà*
Luis Jiminez, *Southwest Pietà*
Source: *Wisconsin Poets* (1E, above), 64–5

WAYNE, Jane O., *Girl Writing*
Milton Avery, *Girl Writing*
Source: Greenberg, *Heart* (2J, above), 60–1

WAYSON, Kary, *Intimacy vs. Autonomy*
Angelina Gualdoni, *Reflecting Skin 2*
Source: Geha and Nichols (1N, above), 59–61

WEATHERFORD, Carol Boston, *The Brown Bomber*
William H. Johnson, *Joe Louis and Unidentified Boxer*
Source: Greenberg, *Heart* (2J, above), 12

WEAVER, Afaa M., *Taking Our Son to MOMA*
Frank Stella
Source: Afaa M. Weaver, *My Father's Geography* (Pittsburgh, PA: University of Pittsburgh Press, 1992)

WEBER, Kelly, *Cold Breath*
Robert Henri, *Woods Interior*
Source: Janovy (1O, above), 9

WEHLE, Ellen, *I Buy a Painting of an Unknown Street*
Source: *Ekphrasis* 3, no. 3 (Spring–Summer 2004): 36

WEINHEBER, Josef, *Die Blinden (Nach dem gleischnamigen Bilde von Pieter Brueghel d.Ä.)*
Pieter Brueghel the Elder, *The Parable of the Blind*
Source: Kranz (2B, above), 99–100

WEINSTEIN, Arnold, *From the Greek*
On pictures of Sappho and Medea
Source: *Art News* 56 (January 1958): 43–4

WEISS, David, *A Sin of Commission*
John Henry Twachtman, *The White Bridge*
Source: Holcomb (1I, above), 168–71

WEISS, Hilda, *Horses Skull with Pink Rose*
Georgia O'Keeffe, *Horse's Skull with Pink Rose*
Source: *Ekphrasis* 4, no. 2 (Fall–Winter 2006): 32

WEISS, Theodore, *Ten Little Rembrandts*
Rembrandt van Rijn, *Scholar in His Study*, et. al.
Source: Abse (2D, above), 56–7

WEITZMAN, Sarah Brown, *Ingres' "Le Bain Turc"*
Source: *Ekphrasis* 2 (Fall Winter 2000): 24

WELBORN, Braden, *Thornton Dial's "Blood and Meat: Survival for the World"*
Thornton Dial, *Blood and Meat: Survival for the World*
Source: *Prairie Schooner* 79, no. 4 (Winter 2005): 58–9

Welborn, Braden, *The Art of William Christenberry*
William Christenberry
Source: *Prairie Schooner* 79, no. 4 (Winter 2005): 59–61

Welborn, Braden, *Robert Motherwell's "Lyric Suite"*
Robert Motherwell, *Lyric Suite*
Source: *Prairie Schooner* 79, no. 4 (Winter 2005): 61–2

WELCH, Jane, *The Swimmer*
Yasuo Kuniyashi, *The Swimmer*
Source: *Elastic Ekphrastic: Poetry on Art/Poets on Tour through Galleries*, ed. Jennifer Bosveld (Johnstown, OH: Pudding House Publications, 2003), 45

WELLS, Robert, *Two Shepherd Boys with Dogs Fighting*
Thomas Gainsborough, *Two Shepherd Boys with Dogs Fighting*
Source: Robert Wells, *Selected Poems* (Manchester, UK: Carcanet, 1986), 64

Wells, Robert, *Richard Wilson in Wales*
Richard Wilson, landscapes
Source: Robert Wells, *Selected Poems* (Manchester, UK: Carcanet, 1986), 64

WENDT, Ingrid, *Remembering Brueghel's "Massacre of the Innocents"*
Source: Ingrid Wendt, *Moving the House* (Rochester, NY: Boa Editions, 1980)

WENGER, Renee, *After Chagall*
Marc Chagall
Source: Buchwald and Roston (2C, above), 62–3

WENTWORTH, Sarah, *To Mr. Stuart on His "Portrait of Mrs. M." and To Mrs. M——n*
Gilbert Stuart, *Portrait of Mrs. M*
Source: *Portfolio* 3 (June 1803): 193

WEST, Harriot, *Rain*
René Magritte, *Golconda*
Source: *Ekphrasis*, 3, no. 6 (Fall–Winter 2005): 22

WETZSTEON, Rachel, *Spring (The Procession)*
Joseph Stella, *Spring (The Procession)*, 1914–16
Source: Hollander and Weber (1H, above), 12–14

WEYANT, Karen J., *Advice for Woman on the Graveyard Shift*
Alesia F. Norling, Untitled painting
Source: *Broadsided.* http://www.broadsidedpress.org/bsides/2009/51-Graveyard.pdf

WHALEN, Philip, *The Fall of Icarus*
Pieter Brueghel the Elder, *Landscape with the Fall of Icarus*
Source: Philip Whalen, *On Bear's Head* (New York: Harcourt, Brace and World and Coyote, 1969), 113

Whalen, Philip, *Whistler's Mother*
James McNeill Whistler, *Arrangement in Gray and Black*
Source: Philip Whalen, *On Bear's Head* (New York: Harcourt, Brace and World and Coyote, 1969), 110

WHARTON, Edith, *Mona Lisa*
Michelangelo, *Mona Lisa*
Source: Hollander (2I, above), 233

WHEATLEY, David, *Gone*
James Arthur O'Connor, *Scene in Co. Wicklow*
Source: Reid and Rice (1J, above), 114–15

WHEATLEY, Phyllis, *To S.M., a Young African Painter, on Seeing His Works*
Scipio Moorhead
Source: *Great Poems by American Women*, ed. Susan L. Rattiner (Mineola, NY: Dover, 1998), 11–12

WHEELER, Susan, *The Debtor in the Convex Mirror*
Quentin Massys (Metsys), *The Moneylender and His Wife*
Source: *Boston Review* 28, no. 5 (October–November 2003), 54–5; also published as a chapbook by Wild Honey Press (Bray, Ireland, 2005); rpt. in Wheeler's *Ledger* (Iowa City: University of Iowa Press, 2005), and available at http://bostonreview.net/BR28.5/wheeler.html

WHEELWRIGHT, John Brooks, *A Twin Toilet after Rowlandson*
Thomas Rowlandson
Source: *The Collected Poems of John Wheelwright* (New York: New Directions, 1983), 246–7

WHITE, Gail, *Rossetti Considers Painting the Annunciation*
Dante Gabriel Rossetti, *Ecce Ancilla Domini (The Annunciation)*
Source: *Ekphrasis* 3, no. 2 (Fall–Winter 2003): 31

WHITE, Jon Manchip, *The Rout of San Romano*
Paolo Uccello, *Rout of San Romano*
Source: Abse (2D, above), 29–31

WHITE, Michael, *Camille Monet sur son lit de mort*
Claude Monet, *Camille Monet on Her Deathbed*
Source: Michael White, *Palma Cathedral* (Boulder: University Press of Colorado, 1998)

WHITEHILL, Karen, *Maternity*
Dorothea Tanning, *Maternity* (self–portrait)
Source: *Ekphrasis* 1, no. 3 (Spring–Summer 1998): 47

WHITMAN, Walt, *Death's Valley*
George Inness, *The Valley of the Shadow of Death*
Source: Hollander (2I, above), 223–4

Whitman, Walt, *Song of the Broad-Axe*
Albert Bierstadt, *The Wood Boat*
Source: Walt Whitman, *Leaves of Grass*, eds., Harold W. Blodgett and Sculley Bradley (New York: Norton, 1965), 184–95

WHITE, Patti, *The Robber of the Sparrow's Nest*
Antoine Watteau, *The Robber of the Sparrow's Nest*
Source: Patti White, *Yellow Jackets* (Tallahassee, FL: Anhinga Press, 2007), 12

White, Patti, *House with a Rain Barrel*
Edward Hopper, *House with a Rain Barrel*
Source: Patti White, *Yellow Jackets* (Tallahassee, FL: Anhinga Press, 2007), 13

WHITT, Laurelyn, *The Eyes of a Dark Horse*
Alex Colville, *Horse and Train*
Source: *Cadence of Hooves: A Celebration of Horses*, ed., Suzan Jantz (Igo, CA: Yarroway Mountain Press, 2008)

WHITTIER, John Greenleaf, *An Artist of the Beautiful: John Fuller*
Source: *The Complete Works of John Greenleaf Whittier* (Boston: Houghton Mifflin, 1894), 216

WICKS, Susan, *Monet: The Chicago Haystacks*
Claude Monet, *Haystacks*
Source: Susan Wicks, *The Clever Daughter* (London: Faber and Faber, 1996), 50

WIEMER, Rudolf Otto, *Pieter Brueghel: Jäger in Schnee*
Pieter Brueghel the Elder, *The Hunters in the Snow*
Source: Kranz (2B, above), 93–4

Wiemer, Rudolf Otto, *Pieter Brueghel: Heimkehr der Herde*
Pieter Brueghel the Elder, *The Return of the Herd*
Source: Kranz (2B, above), 89

WIENERS, John, *A poem for museum goers*
Edvard Munch
Source: John Wieners, *Selected Poems, 1958–1984* (Santa Rosa, CA: Black Sparrow Press, 1986); and in Donald Allen, ed., *The New American Poetry 1945–1960* (Berkeley: University of California Press, 1999), 371

Wieners, John, *Contradicting Picasso*
Pablo Picasso
Source: John Wieners, *Ace of Pentacles* (New York: James F. Carr & Robert A. Wilson, 1964), 42

WIENS, Paul, *Stoffwechsel: Hieronymus Bosch*
Source: Kranz (2B, above), 74

WILBUR, Richard, *Objects*
Pieter de Hooch, *A Dutch Courtyard*
Source: Richard Wilbur, *New and Collected Poems* (San Diego: Harcourt Brace Jovanovich, 1988), 362

Wilbur, Richard, *Museum Piece*
Edgar Degas, *Two Dancers on the Stage*
Source: Abse (2D, above), 94

Wilbur, Richard, *L'Etoile (Degas, 1876)*
Edgar Degas, *L'etoile (La danseuse sur la scene)*
Source: Richard Wilbur, *New and Collected Poems* (San Diego: Harcourt Brace Jovanovich, 1988), 373

Wilbur, Richard, *Ceremony*
Frédéric Bazille, *View of the Village of Castelnau-le-Lez*
Source: Richard Wilbur, *New and Collected Poems* (San Diego: Harcourt Brace Jovanovich, 1988), 334

Wilbur, Richard, *The Giaour and the Pacha (Eugène Delacroix, 1856)*
Eugène Delacroix, *Combat of the Giaour and the Pacha*
Source: Richard Wilbur, *New and Collected Poems* (San Diego: Harcourt Brace Jovanovich, 1988), 352

Wilbur, Richard, *A Hole in the Floor, for René Magritte*
Source: Richard Wilbur, *Advice to a Prophet and Other Poems* (New York: Harcourt, Brace and World, 1961), 21

Wilbur, Richard, *Wyeth's Milk Cans*
Andrew Wyeth, *Milk Cans* (dry-brush sketch)
Source: Richard Wilbur, *New and Collected Poems* (San Diego: Harcourt Brace Jovanovich, 1988), 25

WILCOX, Dan, *The Hopper Painting*
Edward Hopper, unidentified painting
Source: *Ekphrasis* 1, no. 3 (Spring–Summer 1998): 8

Wilcox, Dan, *Angels (from Jane Robbins drawing)*
Jane Robbins, untitled drawing
Source: *Tom Nattell, Charlie Rossiter, Dan Wilcox: 3 Guys from Albany* (Albany, NY: APD, n.d.), n.p.; and at http://www.poetrypoetry.com/PnG_2000.html#ANGELS

WILDERODE, Anton van, *Passie volgens Rubens*
 Boom en braamstruik, Peter Paul Rubens, *Tree and Blackberry Bush*
 Kroning Christi, Peter Paul Rubens, *The Derision of Christ*
 De Kruisdraging, Peter Paul Rubens, *The Bearing of the Cross*
 De oprichting van het kruis, Peter Paul Rubens, *The Elevation of the Cross*
 De Kruisiging, Peter Paul Rubens, *The Crucifixion*
 De lanssteek, Peter Paul Rubens, *Christ on the Cross* or *The Lance Cross*
 De kruisafneming, Peter Paul Rubens, *The Descent from the Cross*
 Bewening Chris, Peter Paul Rubens, *The Lamentation of Christ* (1601) and *The Lamentation of Christ by John the Evangelist and the Holy Women* (1614)
Source: Korteweg and Heijn (2F, above), 103–8

WILKINS, Paul, *The Avenue, Middleharnis*
Meindert Hobbema, *The Avenue at Middelharnis*
Source: Paul Wilkins, *Truths of the Unremembered Things* (Manchester, UK: Carcanet, 1999), 17–18

Wilkins, Paul, *The Drum-Bridge at Kameido*
Katsushika Hokusai, *The Drum-Bridge at Kameido Shrine*
Source: Paul Wilkins, *Truths of the Unremembered Things* (Manchester, UK: Carcanet, 1999), 11–12

Wilkins, Paul, *Jeune Homme Nu*
Hippolyte Flandrin, *Jeune homme nu assis sur le bord de la mer*
Source: Paul Wilkins, *Truths of the Unremembered Things* (Manchester, UK: Carcanet, 1999), 55–9

WILKINSON, Joshua Marie, *City, Phantom, Quays*
Sam Prekop, *Committees*
Source: Geha and Nichols (1N, above), 77–80

WILLIAMS, Alice Ahrens, *After "Sunrise, 1873" by Claude Monet*
Source: *Ekphrasis* 3, no. 4 (Fall–Winter 2004): 36

Williams, Alice Ahrtens, *Cleaning the Catch*
George Bellows, *Fishing Harbor, Monhegan Island*
Source: *Ekphrasis* 4, no. 1 (Spring–Summer 2006): 5

Williams, Alice Aherns, *Dance of the Eye*
Claude Monet, *Regatta at Argentruil*
Source: *Ekphrasis* 4, no. 2 (Fall–Winter 2006): 44

WILLIAMS, Alice Heard. For forty poems by Williams on paintings, see 4H, above.

WILLIAMS, C.K., *Self-portrait with Rembrandt Self-Portrait*
Source: C.K. Williams, *The Singing* (New York: Farrar, Straus and Giroux, 2003), 9

Williams, C.K., *Interrogation II: After the Painting by Leon Golub*
Source: Hirsch (1D, above), 94–7

Williams, C.K., *The World*
Fragonard, Jean-Honoré, *Les debuts du modele*
Source: Komunyakaa, Yusef, ed., *The Best American Poetry 2003* (New York: Scribner, 2003), 179, and at http://playsandpoems.com/favoritepoets links/ckwilliams.html

WILLIAMS, Donald, *At an Exhibit of Frank Reough Paintings*
Source: *South Dakota Review* 12 (Winter 1974–75): 74

WILLIAMS, Jonathan, *The Fourteen-Year-Old Samuel Palmer's Watercolor Notations for the Sketch, "A Lane at Thanet"*
Source: Jonathan Williams, *An Ear in Bartram's Tree* (Chapel Hill: University of North Carolina Press, 1969), unpaged

WILLIAMS, William Carlos, *Pictures from Brueghel*
Pieter Brueghel the Elder
 I *Self-Portrait*
 II *Landscape with the Fall of Icarus*
 III *The Hunters in the Snow*
 IV *The Adoration of the Kings*
 V *Peasant Wedding*
 VI *Haymaking*
 VII *The Corn Harvest*
 VIII *The Wedding Dance in the Open Air*
 IX *The Parable of the Blind*
 X *Children's Games*
Source: William Carlos Williams, *Pictures from Brueghel and Other Poems* (New York: New Directions, 1962), 3–14. II and X also in Benton and Benton, *Double Vision* (2E, above), 93, 83; III also in Benton and Benton, *Painting with Words* (2G, above), 76–7; II also in Achim Aurnhammer and Dieter Martin, eds., *Mythos Ikarus: Texte von Ovid bis Wolf Biermann* (Leipzig: Reclam, 2001), 202, German trans., 203

Williams, William Carlos, *Classic Scene*
Charles Sheeler, *Classic Landscape*
Source: *The Collected Poems of William Carlos Williams*, ed., Christopher MacGowan, 2 vols. (New York: New Directions, 1988), 1:444–5; *Landscape with the Fall of Icarus*, in Kehl (2A, above), 106–8

Williams, William Carlos, *The Dance*
Pieter Brueghel the Elder, *The Kermess*
Source: *The Collected Poems of William Carlos Williams*, ed., Christopher MacGowan, 2 vols. (New York: New Directions, 1988), 2:58–9; and in Abse (2D, above), 44; Benton and Benton, *Doubl;e Vision* (2E, above), 86; and Thomas R. Arp and Greg Johnson, eds., *Perrine's Sound and Sense: An Introduction to Poetry*, 12th ed. (Boston: Thomson Higher Education, 2008), 241

Williams, William Carlos, *Paterson*, book 5
The Unicorn Tapestries
Source: William Carlos Williams, *Paterson* (New York: New Directions Books, 1995), 126, 209–10, 213, 228–34. Painters and paintings appear through *Paterson*: Paul Signac (24), Henri de Toulouse-Lautrec (111, 204), Jackson Pollock (211), Paul Klee, Albrecht Dürer (*Melancholy*), Leonardo da Vinci (*Mona Lisa*), Hieronymus Bosch (*Hell*), Pablo Picasso, Juan Gris (219–20), and Pieter Brueghel the Elder (*The Adoration of the Magi*) (223–5).

Williams, William Carlos, *Portrait of a Lady*
Jean-Honoré Fragonard, *The Swing*
Source: *The Collected Poems of William Carlos Williams*, ed., Christopher MacGowan, 2 vols. (New York: New Directions, 1988), 2:129, and Kehl (2A, above), 84–5.

Williams, William Carlos, *The Botticellian Trees*
Sandro Botticelli
Source: *The Collected Poems of William Carlos Williams*, ed., Christopher MacGowan, 2 vols. (New York: New Directions, 1988), 1:348–9

Williams, William Carlos, *Tribute to the Painters*
Paul Klee; Albrecht Dürer, *Melancholy*; Leonardo da Vinci, *Mona Lisa*; Bosch; Picasso; Jan Gris
Source: *The Collected Poems of William Carlos Williams*, ed., Christopher MacGowan, 2 vols. (New York: New Directions, 1988), 2:296–8

Williams, William Carlos, *March*, part 4
Fra Angelico, *Annunciation*
Source: *The Collected Poems of William Carlos Williams*, ed., Christopher MacGowan, 2 vols. (New York: New Directions, 1988), 1:139–40

Williams, William Carlos, *From "The Birth of Venus" Song*
Sandro Botticelli, *The Birth of Venus*

Source: *The Collected Poems of William Carlos Williams*, ed., Christopher MacGowan, 2 vols. (New York: New Directions, 1988), 1:6

Williams, William Carlos, *Spring and All*, poem II
Charles Demuth, *Tube Roses*
Source: *The Collected Poems of William Carlos Williams*, ed., Christopher MacGowan, 2 vols. (New York: New Directions, 1988), 1:184

Williams, William Carlos, *The Crimson Cyclamen (To the Memory of Charles Demuth)*
Source: *The Collected Earlier Poems of William Carlos Williams* (New York: New Directions, 1951), 397–404

Williams, William Carlos, *Cézanne*
Source: *The Collected Poems of William Carlos Williams 1939–1962*, vol. 2 (New York: New Directions, 1986), 376–7

Williams, William Carlos, *The Painting*
Unidentified painting by Williams's mother
Source: *The Collected Poems of William Carlos Williams 1939–1962*, vol. 2 (New York: New Directions, 1986), 403–4

William Carlos Williams, *The Title*
Paul Gauguin, *The Loss of Virginity*
Source: *The Collected Poems of William Carlos Williams 1939–1962*, vol. 2 (New York: New Directions, 1986), 425

WILLIAMSON, Alan, *The Light's Reading: Meditations on Edward Hopper*
Edward Hopper, *Two Comedians*
Source: Levin (3J, above), 74–5

WILLIS, Jim, *Lei-Maker*
Theodore Wores, *The Lei-Maker*
Source: *Ekphrasis* 3, no. 2 (Fall–Winter 2003): 26–7

Willis, Jim, *A Painter's Light*
Henri Matisse, *Interior with Egyptian Curtain*
Source: *Ekphrasis* 4, no. 3 (Spring–Summer 2007): 5–7

WILLITTS, Martin, Jr., *Woman with Parasol*
Claude Monet, *Woman with Parasol*
Source: *Slow Trains* 7, no. 3. http://www.slowtrain s.com/vol7issue3/willittsvol7issue3.html

Willitts, Martin, Jr., *Harvest Time*
Eastman Johnson, *The Corn Husking*
Source: *Ekphrasis* 5, no. 1 (Spring–Summer 2009): 23–4

Willitts, Martin, Jr., *Monet's Greatest Painting Was His Garden*
Claude Monet
Source: *Slow Trains* 7, no. 3. http://www.slowtrain s.com/vol7issue3/willittsvol7issue3.html

Willitts, Martin, Jr., *Painting and Gardening*
Claude Monet, *Le Bassin aux nymphéas; Au Jardin, la famille de l'artiste*; and *Gondole à Venise*
Source: *Slow Trains* 7, no. 3. http://www.slowtrain s.com/vol7issue3/willittsvol7issue3.html

Willitts, Martin, Jr., *The Letter*
Jean-Baptiste-Camille Corot, *The Letter*
Source: *Bent Nail*. http://www.puzzleddragon.com/ Bent_Pin_Quarterly/Bent_Pin_Contents/Entr ies/2008/10/1_Condescension%E2%80%99s_chi ll__2.html

Willitts, Martin, Jr., *Bending into Light*
Georges Seurat, *Sunday Afternoon on the Island of La Grande Jatte*
Source: *Bent Nail*. http://www.puzzleddragon.com/ Bent_Pin_Quarterly/Bent_Pin_Contents/Entri es/2008/1/1_•_many-one,_the_blend.html

Willitts, Martin, Jr., *The Staircase of Good-byes*
Giacomo Balla, *The Staircase of Good-byes*
Source: *Bent Nail*. http://www.puzzleddragon.com/ BentPinQuarterly.net/Bent_Pin_Current_Issue/E ntries/2007/10/13_•_iteration_in_conflict:.html

Willitts, Martin, Jr., *Sadness Is Everywhere*
Vincent Van Gogh, *Olive Garden at St. Rémy*
Source: *Bent Nail*. http://www.puzzleddragon.com/ BentPinQuarterly.net/Bent_Pin_Current_Issue/E ntries/2007/10/13_•_on_Van_Gogh.html

Willitts, Martin, Jr., *Momentary*
Claude Monet
Source: *Bent Nail*. http://www.puzzleddragon.com/ Bent_Pin_Quarterly/Bent_Pin_Contents/Entri es/2008/4/1_•_replicating_reality.html

Willitts, Martin, Jr., *Grandma Moses*
Grandma Moses
Source: *Big City Lit*. http://www.bigcitylit.com/big citylit.php?inc=fall07/poetry/willitts

Willitts, Martin, Jr., *Perceptions of Light and Color*
John Frederick Kensett, *Eaton's Neck, Long Island*
Source: *Blue Fifth*. http://www.angelfire.com/zine/ bluefifth/Fall2008/poems4F08.html

Willitts, Martin, Jr., *The Banjo Lesson*
Henry Ossawa Tanner, *The Banjo Lesson*
Source: *Canadian Federation of Poets Anthology: The Poetry of Relationships*. http://www.federationof-poets.com

Willitts, Martin, Jr., *Three Ages of the Woman and the Death*
Hans Baldung Grien, *Three Ages of the Woman and the Death*
Source: *The Centrifugal Eye*. http://centrifugaleye. com/

Willitts, Martin, Jr., *Worship*
Florin Mihai, Twelve artworks

Source: *Hotmetalpress.net*. www.hotmetalpress.net/
Mihai-Willitts.html

Willitts, Martin, Jr., *Winter*
Ira Joel Haber, *Winter*
Source: *Hotmetalpress.net*. http://www.hotmetalpr
ess.net/Winter2006.html

Willitts, Martin, Jr., *Nighthawks*
Edward Hooper, *Nighthawks*
Source: *Hotmetalpress.net*. http://www.hotmetalpr
ess.net/martin08.html

Willitts, Martin, Jr., *How To Find Peace*
Edward Hicks, *Peaceable Kingdom*
Source: *New Verse News*. http://newversenews.blog
spot.com/2008/05/how-to-find-peace.html

Willitts, Martin, Jr., *1753—Washington Crossing the
Allegheny*
Carl Rakeman, *1753—Washington Crossing the Al-
legheny*
Source: *Allegheny River Anthology* (Kanona, NY:
Foothills Publishing, 2008)

Willitts, Martin, Jr., *Captive*
Florin Mihai, *Captive*
Source: *Alternatives to Surrender*, Martin Willitts, Jr.,
ed. (Austin, TX: Plain View Press, 2007), and at
http://www.hotmetalpress.net/Mihai-Willitts.html

Willitts, Martin, Jr., *Writer's World*
Florin Mihai, *Writer's World*
Source: http://www.hotmetalpress.net/Mihai-Wil
litts.html

Willitts, Martin, Jr., *Frieze-Like Composition*
Claude Monet, *The Ice Floes*
Source: *Autumn Sky Poetry* 11 (September 2008)

Willitts, Martin, Jr., *Mending More than Socks*
Archibald J. Motley, *Mending Socks*
Source: *Hot Metal Press*. http://www.hotmetalpress.
net/MartinWillitts.html

Willitts, Martin, Jr., *If You Ignore What Is Bothering
You*
Paul Cézanne, *The Artist's Father*
Source: *Hot Metal Press*. http://www.hotmetalpress.
net/MartinWillitts.html

Willitts, Martin, Jr., *Sunflowers*
Vincent Van Gogh, *Sunflowers*
Source: *Hot Metal Press*. http://www.hotmetalpress.
net/MartinWillits.html

Willitts, Martin, Jr., *Renoir on His Life*
Auguste Renoir
Source: Martin Willitts, Jr., *The Secret Language of
the Universe* (Greensboro, NC: March Street
Press, 2005), 1–2

Willitts, Martin, Jr., *Salvation*
William H. Johnson, *Swing Low, Sweet Chariot*
Source: *The Sylvan Echo*. http://sylvanecho.net

WILMER, Clive, *Three Brueghel Paintings*
Pieter Brueghel the Elder, *The Numbering at Beth-
lehem*; *The Parable of the Blind*; and *Hunters in
the Snow*
Source: Clive Wilmer, *Selected Poems: 1965–1993*
(Manchester, UK: Carcanet, 1995), 67–8

Wilmer, Clive, *The Disenchanted*
Atkinson Grimshaw, *Liverpool Quay by Moonlight*
Source: Clive Wilmer, *Selected Poems: 1965–1993*
(Manchester, UK: Carcanet, 1995), 32–3

Wilmer, Clive, *A Woodland Scene*
Maltby [John?]
Source: Clive Wilmer, *Selected Poems: 1965–1993*
(Manchester, UK: Carcanet, 1995), 57–8

WILNER, Eleanor, *Vermeer's Girl, A Restoration*
Jan Vermeer, *The Girl with the Pearl Earring*
Source: *Courtland Review* Spring 2008. http://ww
w.cortlandreview.com/features/08/spring/wilner.
html

WILSON, Keith, *The Two Horses*
Two paintings by Hsü Pei-hung
Source: *New American Poets*, ed. Ron Schreiber
(New York: Hill and Wang, 1969), 238

WILSON, Ralph Tejeda, *In Van Gogh's "Boats at
Sainte-Marie"*
Source: *Ekphrasis* 3, no. 3 (Spring–Summer 2004):
39

WINTER, Kathleen, *The McNay*
Kay Sage, *Le Passage*
Source: *Ekphrasis*, 3, no. 6 (Fall–Winter 2005): 15

WINTERS, Anne, *Works on Paper*
Rembrandt van Rijn, *St. Jerome Reading in a Land-
scape*, *Saskia* and other drawings and etchings
Source: *Poetry* 193, no. 4 (January 2009): 322–3

WISEMAN, Laura Madeline
Miwa Yanagi, *White Casket* (digital images)
Source: *Mississippi Review* 14, no. 4 (October 2008).
http://www.mississippireview.com/2008/Vol14No
4-Oct08/1404-100108-Wiseman.html

WISTER, Owen, Untitled poem accompanying
Frederic W. Remington's *The Cow Puncher*
Source: frontispiece in *Collier's* 14 September 1901

WITEK, Terri, *Venus Feeds Her Infant Son Cupid
with Tears*
Giorgione, *The Tempesta*
Source: http://www.nycbigcitylit.com/may2002/co
ntents/poetrybspecialists.html; rpt. as *The Tem-
pesta* in Witek's *Carnal World* (Ashland, OR:
Story Line Press, 2006), 63

Witek, Terri, *Portrait of a Man with a Palm and a
Paintbox*
Titian, *Portrait of Antonio Palma* or *Portrait of a Man
with a Palm*

Source: http://www.nycbigcitylit.com/may2002/contents/poetrybspecialists.html

Witek, Terri, *This Way Out*
Albrecht Dürer, *Adam and Eve*
Source: Terri Witek, *Fools and Crows* (Washington, DC: Orchises, 2002), 11–12

Witek, Terri, *Take a World*
Jan Van Eyck, *The Annunciation*
Source: Terri Witek, *Fools and Crows* (Washington, DC: Orchises, 2002), 13

Witek, Terri, *Bain-Marie* (St Mary's Bath)
Edgar Degas, *Woman Bathing in a Shallow Tub*
Source: Terri Witek, *Fools and Crows* (Washington, DC: Orchises, 2002), 14

Witek, Terri, *The Arnolfinis*
Jan Van Eyck, *Arnolfini Wedding Portrait*
Source: Terri Witek, *Fools and Crows* (Washington, DC: Orchises, 2002), 16–19

Witek, Terri, *Courting Couples*
Israhel Van Meckenem, engravings: *Banderoles, Ill-Sorted Couple, Church-Goers, Fight for the Pants, Juggler,* and *Couple Seated on a Bed*
Source: Terri Witek, *Fools and Crows* (Washington, DC: Orchises, 2002), 20–3

Witek, Terri, *Bosch's Birds*
Hieronymus Bosch, *Garden of Earthly Delights,* central panel
Source: Terri Witek, *Fools and Crows* (Washington, DC: Orchises, 2002), 24

Witek, Terri, *It Won't Hurt a Bit*
Albrecht Dürer, *St. Sebastian Christian Martyr*
Source: Terri Witek, *Fools and Crows* (Washington, DC: Orchises, 2002), 27

Witek, Terri, *The Dormition*
Hugo van der Goes, *Dormition of the Virgin Mary*
Source: Terri Witek, *Fools and Crows* (Washington, DC: Orchises, 2002), 33–4

Witek, Terri, *Holy Card, Holy Card II, Holy Card III*
Three poems on religious subjects by unidentified or anonymous artists: prayer for the dead, holy family, and an unnamed saint
Source: Terri Witek, *Fools and Crows* (Washington, DC: Orchises, 2002), 35–7

Witek, Terri, *The Docent Discusses "Massacre of the Innocents"*
Marcantonio Raimondi, engraving after Raphael, *The Massacre of the Innocents*
Source: Terri Witek, *Fools and Crows* (Washington, DC: Orchises, 2002), 38–9

Witek, Terri, *All Together Now*
Jan van Kissel I (attrib.), *A Concert of Birds*
Source: Terri Witek, *Fools and Crows* (Washington, DC: Orchises, 2002), 55

Witek, Terri, *Eustace and the Stag*
Albrecht Dürer, *St. Eustace*
Source: Terri Witek, *Fools and Crows* (Washington, DC: Orchises, 2002), 57–8

Witek, Terri, *The Fool's Arrival*
Illustrations to the Narrenschiff of Sebastian Brant
Source: Terri Witek, *Fools and Crows* (Washington, DC: Orchises, 2002), 59

Witek, Terri, *Fool the Eye (Trompe l'oeil)*
Quentin Massys, *Ill-Matched Lovers*
Source: Terri Witek, *Fools and Crows* (Washington, DC: Orchises, 2002), 67

Witek, Terri, *Apollo and Diana against a Plain Background*
Lucas Cranach the Elder, *Apollo and Diana*
Source: Terri Witek, *Fools and Crows* (Washington, DC: Orchises, 2002), 69

Witek, Terri, *Before the Night Goes*
Giovanni Bellini, Dosso Dossi, and Titian, *The Feast of the Gods*
Source: Terri Witek, *Fools and Crows* (Washington, DC: Orchises, 2002), 75–6

Witek, Terri, *Painting Madame Gautreau*
John Singer Sargent, *Madame X*
Source: Terri Witek, *Carnal World* (Ashland, OR: Story Line Press, 2006), 4–5

Witek, Terri, *Monsieur Degas*
Edgar Degas
Source: Terri Witek, *Carnal World* (Ashland, OR: Story Line Press, 2006), 6

Witek, Terri, *Women Combing Their Hair*
Edgar Degas
Source: Terri Witek, *Carnal World* (Ashland, OR: Story Line Press, 2006), 7–12

Witek, Terri, *Venus With*
Titian, various unnamed Venus paintings
Source: Terri Witek, *Carnal World* (Ashland, OR: Story Line Press, 2006), 13–14

Witek, Terri, *Bonnard on Painting Marthe Bathing*
Pierre Bonnard, various paintings of his wife, Marthe de Meligny, bathing
Source: Terri Witek, *Carnal World* (Ashland, OR: Story Line Press, 2006), 15

Witek, Terri, *The Source (Woman Bathing)*
Pierre Bonnard, *Woman Bathing*
Source: Terri Witek, *Carnal World* (Ashland, OR: Story Line Press, 2006), 16

Witek, Terri, *Stomacher*
Hieronymus Bosch, *The Temptation of St. Anthony*
Source: Terri Witek, *Carnal World* (Ashland, OR: Story Line Press, 2006), 18–19

Witek, Terri, *Edith Sitwell and the Carnal World,* part 4

John Singer Sargent, *The Sitwells*
Source: Terri Witek, *Carnal World* (Ashland, OR: Story Line Press, 2006), 45

Witek, Terri, *The Goldfinch (Het Puttertje)*
Carel Fabritius, *The Goldfinch*
Source: Terri Witek, *Carnal World* (Ashland, OR: Story Line Press, 2006), 55

Witek, Terri, *Still Life*
Juan Sanchez Cotán, *Quince, Melon, Cabbage and Cucumber*
Source: Terri Witek, *Carnal World* (Ashland, OR: Story Line Press, 2006), 57

Witek, Terri, *Incensing the Veil*
John Singer Sargent, *Fumée d'Ambre Gris*
Source: Terri Witek, *Carnal World* (Ashland, OR: Story Line Press, 2006), 58

Witek, Terri, *December (The Hunt)*
Bernaert van Orley, *The Killing of the Wild Boar* (tapestry)
Source: Terri Witek, *Carnal World* (Ashland, OR: Story Line Press, 2006), 60

Witek, Terri, *Portrait of a Woman Reading*
Giorgione, *Tempesta*
Source: Terri Witek, *Carnal World* (Ashland, OR: Story Line Press, 2006), 61

Witek, Terri, *The Yellow Curtain*
Edouard Vuillard, *The Yellow Curtain*
Source: Terri Witek, *Carnal World* (Ashland, OR: Story Line Press, 2006), 72

Witek, Terri, *Matisse's "L'Atelier Rouge" Reproduced in Black and White*
Henri Matisse, *L'Atelier Rouge*
Source: Terri Witek, *Carnal World* (Ashland, OR: Story Line Press, 2006), 78–9

Witek, Terri, *Landscape in the Blue and Green Manner*
Chen Hongshou
Source: Terri Witek, *Carnal World* (Ashland, OR: Story Line Press, 2006), 80

Witek, Terri, *Warm Night*
Pablo Picasso, *The Dream (Marie-Thérèse)*
Source: Terri Witek, *Carnal World* (Ashland, OR: Story Line Press, 2006), 82

WITHEFORD, Hubert, *A Blue Monkey for the Tomb*
The Saffron Gatherer (Blue Monkey fresco)
Source: Hubert Witheford, *A Blue Monkey for the Tomb* (London: Faber and Faber, 1944), 37

WITZ, Robert A., *Songs for Van Gogh's Ear, Allegro and Andante*
Vincent Van Gogh
Source: *Arts in Society* 2 (1963): 160–71

WOESSNER, Warren, *River Song*
Joseph Stella, *Brooklyn Bridge: Variation on an Old Theme*
Source: Greenberg, *Heart* (2J, above), 59

WOHLFELD, Valerie, *Sunflowers of Van Gogh*
Source: *Ekphrasis* 5, no. 2 (Fall–Winter 2009): 14

WOJAHN, David, *A Game of Croquet*
Thomas Eakins
Source: David Wojahn, *Glassworks* (Pittsburgh, PA: University of Pittsburgh Press, 1987), 25–6

Wojahn, David, *Tribute and Ash. I. A Landscape by Grant Wood*
Source: David Wojahn, *Late Empire* (Pittsburgh, PA: University of Pittsburgh Press, 1994), 71–2

Wojahn, David, *Patagonia Gorge*
John James Audubon
Source: David Wojan, *Icehouse Lights* (New Haven, CT: Yale University Press, 1982), 58–9

Wojahn, David, *Passenger Pigeon Migration Observed by Audubon, Illinois Territory, 1834*
John James Audubon
Source: David Wojahn, *Late Empire* (Pittsburgh: University of Pittsburgh Press, 1994), 6

Wojahn, David, *Hive Keepers*
Pieter Brueghel the Elder, *The Bee Keepers*
Source: David Wojahn, *Late Empire* (Pittsburgh: University of Pittsburgh Press, 1994), 11–13

Wojahn, David, *The World of Donald Evans*
Source: David Wojahn, *Glassworks* (Pittsburgh, PA: University of Pittsburgh Press, 1987), 63–4

Wojahn, David, *The Resurrection of the Dead: Port Glasgow, 1950*
Sir Stanley Spencer, *The Resurrection: Cookham-on-Thames*
Source: David Wojahn, *Mystery Train* (Pittsburgh, PA: University of Pittsburgh Press, 1990), 82–4

WONDRATSCHEK, Wolf, *Nighthawks: After Edward Hopper's Painting*
Source: Gerd Gemünden, *Framed Visions: Popular Culture, Americanization, and the Contemporary German and Austrian Imagination* (Ann Arbor: University of Michigan Press, 1998), 9–12. Trans. from the German by Gemünden; and http://alfielee.spaces.live.com/blog/cns!EC6A1EF3277D544A!1402.entry

WOOD, Allyn, *The Departure of St. Ursula*
Carpaccio, *The Legend of St. Ursula: The Meeting of the Betrothed and the Departure for the Pilgrimage*
Source: *College Art Journal* 18 (Spring 1959): 240

WOOD, Daniel, *The Women of Amphissa*
Sir Lawrence Alma-Tadema, *The Women of Amphissa*

Source: *Ekphrasis* 1, no. 5 (Spring–Summer 1999):
17

WOOD, Joseph P., *On Jasper Johns' Targets*
Jasper Johns, Various "target" paintings
Source: *Prairie Schooner* 79, no. 4 (Winter 2005): 34

Wood, Joseph P., *On Two Paintings by Thomas Eakins*
Thomas Eakins, *Biglin Brothers Racing* and *The Swimming Hole*
Source: *Prairie Schooner* 79, no. 4 (Winter 2005): 35

WOOD, Susan, *Analysis of the Rose as Sentimental Despair*
Cy Twombly, *Analysis of the Rose as Sentimental Despair* (series of paintings)
Source: Rita Dove, ed., *The Best American Poetry 2000* (New York: Scribner, 2000), 195–9

WOODS, Chris, *Gauguin's Tahiti*
Paul Gauguin
Source: Chris Woods, *Recovery* (London: Enitharmon, 1993), 43

WOODWORTH, Samuel, *The Bucket*
Jerome B. Thompson, *The Old Oaken Bucket*
Source: *The American Poets, 1800–1900*, ed. Edwin H. Cady (Glenview, IL: Scott, Foresman, 1966), 25–6

WORDSWORTH, William, *Elegiac Stanzas*
Sir George Beaumont, *Peele Castle in a Storm*
Source: Hollander (21, above), 129–31

Wordsworth, William, *To B.R. Haydon, On Seeing His Picture of Napoleon Buonaparte on the Island of St. Helena*
Source: *The Poetical Works of William Wordsworth*, vol. 3 (London: Edward Moxon, 1849), 103

Wordsworth, William, *Before the Picture of the Baptist, by Raphael, in the Gallery at Florence*
Source: *The Poems of William Wordsworth* (London: T. Nelson and Sons, 1849), 278

Wordsworth, William, *Upon the Sight of a Beautiful Picture, Painted by Sir G.H. Beaumont*
Source: *The Poems of William Wordsworth* (London: Methuen, 1901), 1:435

Wordsworth, William, *On a Portrait of the Duke of Wellington upon the Field of Waterloo, by Haydon*
Benjamin Robert Haydon
Source: *The Poems of William Wordsworth* (London: Methuen, 1901), 1:472

Wordsworth, William, *To the Author's Portrait*
Henry Pickersgill, Wordsworth's portrait, painted at Rydal Mount for St. John's College, Cambridge
Source: *The Poems of William Wordsworth* (London: Methuen, 1901), 1:470

Wordsworth, William, *Recollection of the Portrait of King Henry The Eighth, Trinity Lodge, Cambridge*
Source: *The Poems of William Wordsworth* (London: Methuen, 1901), 1:462

WRIGHT, Charles, *Portrait of the Poet in Abraham von Werdt's Dream*
von Werdt's wood engraving of a print shop, *Druckerwerkstatt*
Source: Charles Wright, *Country Music* (Middletown, CT: Wesleyan University Press, 1982), 18

Wright, Charles, *Tattoos*, poem 7
Piero della Francesca, *The Resurrection*
Source: Charles Wright, *Country Music* (Middletown, CT: Wesleyan University Press, 1982), 62

Wright, Charles, *Venetian Dog*
Titian, *The Martyrdom of St. Lawrence*
Source: Charles Wright, *Negative Blue: Selected Later Poems* (New York: Farrar, Straus and Giroux, 2000), 153

Wright, Charles, *Homage to Paul Cézanne*
Paul Cézanne
Source: Charles Wright, *The World of the Ten Thousand Things* (New York: Farrar, Straus and Giroux, 1990), 3–10

Wright, Charles, *Morandi*
Giorgio Morandi
Source: Charles Wright, *Country Music* (Middletown, CT: Wesleyan University Press, 1982), 114

Wright, Charles, *Morandi II*
Giorgio Morandi
Source: Charles Wright, *Chickamauga* (New York: Farrar, Straus and Giroux, 1995), 67

Wright, Charles, *Edvard Munch*
Source: Charles Wright, *Country Music* (Middletown, CT: Wesleyan University Press, 1982), 167

Wright, Charles, *Homage to Claude Lorrain*
Claude Lorrain, *Ship Foundering in Storm*
Source: Charles Wright, *The World of the Ten Thousand Things* (New York: Farrar, Straus and Giroux, 1990), 82

Wright, Charles, *Hard Dreams*
Caravaggio, *The Beheading of St. John*
Source: Charles Wright, *A Short History of the Shadow* (New York: Farrar, Straus and Giroux, 2002), 74–6

Wright, Charles, *Summer Storm*
Piet Mondrian, *Composition in Gray and Red*
Source: Charles Wright, *Negative Blue: Selected Later Poems* (New York: Farrar, Straus and Giroux, 2000), 61, and Hirsch (1D, above), 114–15

Wright, Charles, *A Journal of the Year of the Ox*
Francesco del Cossa, *Salon of the Months*
Source: Charles Wright, *The World of the Ten Thou-*

sand Things (New York: Farrar, Straus and Giroux, 1990), 170–2

Wright, Charles, *Still Life with Stick and Word*
Giorgio Morandi, *Natura Morta*
Source: Charles Wright, *Negative Blue: Selected Later Poems* (New York: Farrar, Straus and Giroux, 2000), 60

Wright, Charles, *Apologia Pro Vita Sua*, section 7
Giorgio Morandi, Mark Rothko, Paul Cézanne
Source: Charles Wright, *Negative Blue: Selected Later Poems* (New York: Farrar, Straus and Giroux, 2000), 74

Wright, Charles, *Giorgio Morandi and the Talking Eternity Blues*
Source: Charles Wright, *Negative Blue: Selected Later Poems* (New York: Farrar, Straus and Giroux, 2000), 67

Wright, Charles, *Back Yard Boogie Woogie*
Piet Mondrian, *Broadway Boogie-Woogie*
Source: Charles Wright, *Negative Blue: Selected Later Poems* (New York: Farrar, Straus and Giroux, 2000), 172

Wright, Charles, *Looking at Pictures*
Fra Angelico; Mark Rothko, *Red Ochre Black on Red*, Paul Cézanne, *Château Noir*,
Source: Charles Wright, *The World of the Ten Thousand Things* (New York: Farrar, Straus and Giroux, 1990), 113–14

WRIGHT, David, *By the Effigy of St. Cecilia*
Stefano Maderno, *St. Cecilia*
Source: Abse (2D, above), 50

Wright, David, *In Eckersberg's "The Cloisters, San Lorenzo fuori le mura"*
Wilhelm Eckersberg, *The Cloisters, San Lorenzo fuori le mura*
Source: *Ekphrasis* 3, no. 4 (Fall–Winter 2004): 15

Wright, David, *James Ward's "Gordale Scar"*
Source: Adams (1B, above), 54–5

Wright, David, *Before You Read the Plaque About Turner's "Slave Ship"*
J.M.W. Turner, *Slave Ship*
Source: http://www.dwpoet.com/turnerpoem.html

Wright, David, *Temptation*
Marc Chagall, *Temptation*
Source: http://ekphrastics.blogspot.com/

WRIGHT, Franz, *Van Gogh's "Undergrowth with Two Figures"*
Source: Franz Wright, *Earlier Poems* (New York: Knopf, 2007), 234–5

Wright, Franz, *Depiction of Childhood*
Pablo Picasso, *Minotauromachia*
Source: *The Best American Poetry 1992*, ed. Charles Simic (New York: Collier Books, 1992), 195

WRIGHT, Rob, *Bacon's "Triptych"*
Francis Bacon, *Triptych*
Source: http://www.nycbigcitylit.com/may2002/contents/poetryasingles.html

WYATT, Charles, *Crows in the Wheatfield*
Vincent Van Gogh, *Wheatfield with Crows*
Source: *Ekphrasis* 4, no. 6 (Fall–Winter 2008): 26

WYATT, Richard David, *The City*
Hans Hoffman, *The City*
Source: Janovy (1O, above), 45

WYLEY, Enda, *Painter at Work*
Roderic O'Conor, *View of Pont Aven*
Source: Reid and Rice (1J, above), 28–30

WYNNE, Robert, *Untitled Portrait by Kim Peterson*
Kim Peterson
Source: *Fort Worth Library Anthology* (Fort Worth, TX: Fort Worth Public Library, 2002), and at http://www.rwynne.com/poem12.html

Wynne, Robert. See also 4Zb, above.

XUE DI. For poems on Van Gogh, see 3Va, above.

YAU, John, *The Painter Asks*
Brice Marden
Source: Johan Tau, *Edificio Sayonara* (New York: Harper & Row, 1992), 137

Yau, John, *After a Painting by Jasper Johns*
Jasper Johns, *Corpse and Mirror*
Source: John Yau, *Forbidden Entries* (Santa Rosa, CA: Black Sparrow Press, 1996), 65–6

Yau, John, *The Sleepless Night of Eugene Delacroix*
Eugène Delacroix, *Jewish Wedding*
Source: John Yau, *Radiant Silhoutte: New & Selected Work: 1974–1988* (Santa Rosa, CA: Black Sparrow Press, 1994), 61–2

YEATS, William Butler, *On a Picture of a Black Centaur by Edmund Dulac*
Source: William Butler Yeats, *Collected Poems* (New York: Macmillan, 1959), 212

Yeats, William Butler, *The Municipal Gallery Revisited*
Antonio Mancini, *Lady Augusta Gregory*
Source: William Butler Yeats, *Collected Poems* (New York: Macmillan, 1959), 316–18; and in Abse (2D, above), 139–41

YEE, Debbie, *On Jasper Johns' Flag*
Jasper Johns, *Flag*
Source: *32 Poems* 6, no. 2 (Fall 2008): 22

YELLEN, Samuel, *Nighthawks*
Edward Hopper, *Nighthawks*
Source: Levin (3J, above), 32, and Kehl (2A, above), 196–8

YENSER, Stephen, *Pentimento*
Gustave Courbet, *L'Atelier*

Source: Stephen Yenser *The Fire in All Things* (Baton Rouge: Louisiana State University Press, 1993), 21.

Yenser, Stephen, *Flagrantis speculum veneris (Love-knot)*

Dorothea Tannin, *Flagrantis speculum veneris (Love-knot)*

Source: Dorothea Tanning, *Another Language of Flowers* (New York: Braziller, 1998), plate 11

YOLEN, Jane, *Grant Wood: American Gothic*

Grant Wood, *American Gothic*

Source: Greenberg, *Heart* (2J, above), 39

YOUMANS, Marly, *Botticelli*

Laura Frankstone, *Face 1* (after a sketch by Botticelli)

Source: *qarrtsiluni. online literary magazine.* http://qarrtsiluni.com/category/ekphrasis

YOUN, Monica, *After Franz Kline*

Franz Kline

Source: Monica Youn, *Barter* (St. Paul, MN: Graywolf Press, 2003), 10

Youn, Monica, *Titian's "Salome"*

Source: Monica Youn, *Barter* (St. Paul, MN: Graywolf Press, 2003), 15

Youn, Monica, *Fiona Rae*

Fiona Rae, *Untitled, 1995*

Source: Monica Youn, *Barter* (St. Paul, MN: Graywolf Press, 2003), 9

Youn, Monica, *Stealing "The Scream"*

Edvard Munch, *The Scream*

Source: Monica Youn, *Barter* (St. Paul, MN: Graywolf Press, 2003), 28

YOUNG, Andrew, *Winter Morning*

John Cotman

Source: Andrew Young, *Selected Poems* (Manchester, UK: Carcanet, 1998), 15

YOUNG, Mark. *Mark Young's Series Magritte: An On-going Series of Poems Inspired by the Great Belgian Painter.* Poems on each of the following paintings of René Magritte: *Titanic Days, The Use of Speech, The Treachery of Images, The Famous Man, The False Mirror, The Happy Donor, The Promenades of Euclid, Clear Ideas, The Ready-Made Bouquet,* and *The Discovery of Fire*

Source: http://seriesmagritte.blogspot.com/

YOUNG, Michael T., *At the Piano*

James McNeill Whistler, *At the Piano*

Source: http://www.nycbigcitylit.com/may2002/contents/poetryasingles.html

ZAGAJEWSKI, Adam, *Degas: "The Millinery Shop"*

Source: Adam Zagajewski, *Without End* (New York: Farrar, Straus and Giroux, 2002), 253; Hirsch (1D, above), 38–9; and http://the-exponent.com/2006/10/19/ekphrasis-the-sister-arts-of-painting-and-poetry/

Zagajewski, Adam, *Morandi*

Source: Adam Zagajewski, *Without End* (New York: Farrar, Straus and Giroux, 2002), 160

Zagajewski, Adam, *Georges Seurat: "Factory"*

Source: Adam Zagajewski, *Without End* (New York: Farrar, Straus and Giroux, 2002), 26

ZALLER, Robert, *Marsyas*

Titian, *Apollo and Marsyas*

Source: *Ekphrasis* 2, no. 1 (Spring–Summer 2000): 42

ZAYAS, Antonio de, *Carlos V*

Titian, *Carlos V*

Source: Antonio de Zayas, *Retratos antigues* (Madrid, 1902), 39

Zayas, Antonio de, *Carlos IV*

Francisco Goya, *Carlos IV*

Source: Antonio de Zayas, *Retratos antigues* (Madrid, 1902), 133

Zayas, Antonio de, *La reina María Luisa*

Francisco Goya, *La reina María Luisa*

Source: Antonio de Zayas, *Retratos antigues* (Madrid, 1902), 134

Zayas, Antonio de, *La Gioconda*

Leonardo da Vinci, *Mona Lisa*

Source: Antonio de Zayas, *Retratos antigues* (Madrid, 1902), 30

ZEALAND, Karen, *As a Winged Fish Swallows the Violinist: Chagall's Perspective*

Images from Chagall's *The Fiddler, The Promenade* and other works

Source: *Ekphrasis* 1, no. 6 (Fall–Winter 1999): 9

Zealand, Karen, *Habits of Mind, After Magritte*

René Magritte

Source: *Ekphrasis* 2, no. 1 (Spring–Summer 2000): 27

ZEIMER, Beverly, *Transformation in Gallery 10*

Peter Paul Rubens, *Christ Triumphant over Sin and Death*

Source: *Elastic Ekphrastic: Poetry on Art/Poets on Tour through Galleries,* ed. Jennifer Bosveld (Johnstown, OH: Pudding House Publications, 2003), 27

Zeimer, Beverly, *Dark Horse*

Walter King, *Lone Rider*

Source: *Elastic Ekphrastic: Poetry on Art/Poets on Tour through Galleries,* ed. Jennifer Bosveld (Johnstown, OH: Pudding House Publications, 2003), 29

ZELL, Josephine M., *Orpheus Greeting the Dawn*

Jean-Baptiste-Camille Corot, *Orpheus Greeting the Dawn*

Source: *Wisconsin Poets* (1E, above), 24–5

ZERBY, Chuck, _After Matisse's "Intérieur la boîte a violon"_
Henri Matisse, _Intérieur au violon_
Source: _Ekphrasis_ 3, no. 1 (Spring–Summer 2003): 26

ZIDE, Arlene, _The Village of the Mermaids_
Paul Delvaux, _The Village of the Mermaids_
Source: _Ekphrasis_ 1, no. 2 (Winter 1997–98): 40

ZOLLINGER, Albin, _Brueghel: Ikaros_
Pieter Brueghel the Elder, _Landscape with the Fall of Icarus_

Source: Albin Zollinger, _Werke_, ed. Silvia Weimar, vol. 4, _Gedichte_ (Zurich/München: Artemis, 1983), 179; in Werner Weber, ed., _Belege. Gedichte aus der deutsch-sprachigen Schweiz seit 1900_ (Zürich-München: Artemis Verlag, 1978), 108; and in Achim Aurnhammer and Dieter Martin, eds., _Mythos Ikarus: Texte von Ovid bis Wolf Biermann_ (Leipzig: Reclam, 2001), 189

PART TWO

Secondary Literature

Aarset, Hans Erik. "Ekphrasis Transposed. Adamas' Narration of Architecture, Sculpture and Painting in Urfé's 'L'Astrée' ('Histoire de Damon et de Fortune')." In Karin Gundersen and Solveig Schult Ulriksen, eds., *Représentations et figures baroques. Actes du colloque international d'Oslo, 13–17 Septembre 1995.* Oslo: Conseil Norvégien de la recherche scientifique, 1997. 251–68.

Acheson, Katherine O. "Hamlet, Synecdoche and History: Teaching the Tropes of 'New Remembrance.'" *College Literature* 3, no. 4 (2004): 111–34.

Accorrini, Linnio. *Antonia S. Byatt: Ritratti in letteratura.* Milan. Archinto, 2004.

Adam, Véronique. "La Poésie servante de la peinture au temps de Le Sueur: l'ekphrasis' de l'univers pictural." In Jean Serroy and Bernard Roukhomovsky, eds., *Littérature et peinture au temps de Le Sueur: actes du colloque organisé par le Musée de Grenoble et l'Université Stendhal à l'Auditorium du Musée de Grenoble les 12 et 13 Mais 2000.* Grenoble: Diffusion Ellug, 2003. 141–51.

Adams, Hazard. "Ekphrasis Revisited, or Antitheticality Reconstructed." In Michael P. Clark, ed., *Revenge of the Aesthetic: The Place of Literature in Theory Today.* Berkeley: University of California Press, 2000. 45–57.

Agosti, Gianfranco. "L'occhio noetico: Immagini e simboli nella poesia tardoantica e bizantina." *Semicerchio: Rivista di Poesia Comparata* 24–25 (2001): 29–42.

Ahern, Susan Whitcomb. *Chastity Embodied: Vision, Knowledge, and the Female Figure in Works by Spenser and Shakespeare.* Ph.D. dissertation, Yale University, 1999.

Aisenberg, Margaret Kate. *The Exploded Image: Ekphrasis in the Poetry and Prose of William Wordsworth, W.H. Auden, and Philip Larkin.* Ph.D. dissertation, Johns Hopkins University, 1991.

_____. *Ravishing Images: Ekphrasis in the Poetry and Prose of William Wordsworth, W.H. Auden and Philip Larkin.* New York: Peter Lang, 1995.

Albanese, Ralph. "Commentaire sur la communication de Dominique Bertrand, 'Entre mythe et analyse: Palimpsestes savants du rire de Vigenère à Cramail.'" In John D. Lyons and Cara Welch, eds., *Le Savoir au XVIIe siècle.* Biblio 17. 147. Tübingen, Germany: Narr, 2003. 403–4.

Albes, Claudia. "Porträt ohne Modell: Bildbeschreibung und autobiographische Reflexion in W.G. Sebalds 'Elementargedicht' Nach der Natur." In Michael Niehaus and Claudia Öhlschläger, eds., *W.G. Sebald: Politische Archäologie und melancholische Bastelei. Philologische Studien und Quellen.* 196. Berlin: Schmidt, 2006. 47–75.

Albrecht-Bott, Marianne. *Die bildende Kunst in der italienischen Lyrik der Renaissance und des Barock.* Wiesbaden: Steiner, 1976.

Alcobia-Murphy, Shane. "'If I Prolonged the Look to Rediscover Your Face': Medbh McGuckian's Ekphrastic Elegies." In Shane Alcobia-Murphy and Margaret Maxwell, eds., *The Enclave of My Nation: Cross-Currents in Irish and Scottish Studies.* Aberdeen, Scotland: AHRC Centre for Irish and Scottish Studies and Contributions, 2008. 1–17.

Alexander, George. "In So Many Words." *Art and Australia* 43, pt. 2 (Summer 2005): 198–9.

Alexiou, Maragret. "Ekphrasis: Between Time and Place." In Alexiou's *After Antiquity: Greek Language, Myth, and Metaphor.* Ithaca, NY: Cornell University Press, 2001. 296–309.

_____. "Writing against Silence: Antithesis and Ekphrasis in the Prose Fiction of Georgios Vizyenos." In *Dumbarton Oaks Papers. Number forty-seven. Dumbarton Oaks. Center for Byzantine Studies.* Washington, DC: Dumbarton Oaks Research Library and Collection, 1993.

Alfier, Thomas F. *At the Intersection: Visual Arts, Creative Writing, and Ekphrasis.* M.A.L.S. thesis, Dartmouth College, 1994.

Allbery, Debra. "'The Third Image': Constellations of Correspondence in Emily Dickinson, Joseph Cornell, and Charles Simic." *Courtland Review* (Spring 2008). http://www.cortlandreview.com/features/08/spring/index.html

Allen, Elizabeth. "The Ghost of Icarus." *Southerly: The Journal of the English Association,* Sydney 68, no. 1 (2008): 176–90.

Allison, Raphael C. "Muriel Rukeyser Goes to War: Pragmatism, Pluralism, and the Politics of Ekphrasis." *College Literature* 33, no. 2 (Spring 2006): 1–29.

Al-Nakib, Mai Basel. "Assia Djebar's Musical Ekphrasis." *Comparative Literature Studies* 42, no. 4 (2005): 253–76.

_____. *Transtemporal Modernism and Postcolonial Transmutations.* Ph.D. dissertation, Brown University, 2004.

Alonso, Jesús Cora. "Donne's Holy Sonnet I and Alciato's Emblem CXXI." *Sederi* 9 (1998): 91–121. 19184393.pdf

Alpers, Svetlana Leontief. "Ekphrasis and Aesthetic Attitudes in Varsari's *Lives.*" *Journal of the Warburg and Courtauld Institutes* 23 (July 1960): 190–215. German version in Boehm and Pfotenhauer, *Beschreibungskunst* (below), 217–52.

_____, and H.U. Davitt. "Ekphrasis und Kunstanschauung in Vasaris *Viten.*" In Boehm and Pfotenhauer, *Beschreibungskunst* (below), 217–58.

Alsa, S. Stephen. *Emphasizing Ekphrasis: Linking*

Visual Arts and Language Arts Curriculum Standards through Museum Pre- and Post-Visit Activities for Upper Elementary School Students. M.A. thesis, Seton Hall University, 2006.

Alvarez Borland, Isabel. "'A Reminiscent Memory': Lezama, Zoé Valdés, and Rilke's Island." *MLN* 119, no. 2 (March 2004): 344–62.

Ambrose, Timothy. "Lope de Vega and Titian: The Goddess as Emblem of Sacred and Profane Love." In de Armas, *Writing* (below), 169–84.

Ames-Lewis, Francis. "Ekphrasis." In Ames-Lewis's *The Intellectual Life of the Early Renaissance Artist*. New Haven: Yale University Press, 2000.

Amir, Ayala. "Sunt lacrimae rerum: Ekphrasis and Empathy in Three Encounters between a Text and a Picture. *Word & Image: A Journal of Verbal/Visual Enquiry* 25, no. 3 (2009): 232–42.

Amossy, Ruth. "Réflexions sur la 'critique d'art' surréaliste. *Donner à voir* de Paul Eluard." *Romanic Review* 93 (January–March 2002): 141–50.

Anderman, Elizabeth Quainton. *Visible Sensations: Ekphrasis and Illustration in Victorian Sensation Novels*. Ph.D. dissertation, University of Colorado, Boulder, 2006.

Andreas, Maria del Puig. *La poesía ekphrástica de Rafael Alberti y su arte de describir la pintura*. M.A. thesis, University of Georgia, 2002.

Andres, Sophia. "From Camelot to Hyde Park: The Lady of Shalott's Pre-Raphaelite Postmodernism in A.S. Byatt and Tracy Chevalier." *VIJ: Victorians Institute Journal* 34 (2006): 7–37.

_____. "Mary Elizabeth Braddon's Ambivalent Pre-Raphaelite Ekphrasis." *Victorian Newsletter* 108 (2005): 1–5.

Angehrn, Emil. "Beschreibung zwischen Abbild und Schöpfung." In Boehm and Pfotenhauer, *Beschreibungskunst* (below), 59–74.

Annegret, Heitmann. *Intermedialität im Durchbruch Bildkunstreferenzen in der skandinavischen Literatur der frühen Moderne*. Freiburg im Breisgau: Rombach, 2003.

Antonetti, Martin. "Typographic Ekphrasis: The Description of Typographic Forms in the Nineteenth Century." *Word & Image: A Journal of Verbal/Visual Enquiry* 15, no. 1 (January–March 1999): 41–53.

Antoniades, Eugenios Michael. *Ekphrasis tes Hagias Sophias: etoi melete synthetike kai analytike hypo epopsin architektoniken, archaiologiken kai historiken tu polythryletu temenus Konstantinupoleos*. 3 vols. Athens, Leipzig: Sakellariu, 1907–1909.

Arbasino, Alberto. "'Ekphrasis' e ironia ne 'Le Muse a Los Angeles.'" *Strumenti Critici* 2 (May 2008): 313–26.

Arbusow, Leonid. *Colores rhetorici*. 2nd ed. by Helmut Pete. Goettingen: Vandenhoeck & Ruprecht, 1963.

Ariani, Marco. "'Descriptio in somniis' racconto e 'ékphrasis' nella *Hypnerotomachia Poliphili*." In Vittorio Casale, ed., *Storia della lingua e storia dell'arte in Italia: dissimmetrie e intersezioni*. Firenze: Cesati, 2004. 153–60. **Review:** Pignatti, Franco. *Roma nel Rinascimento* (2004): 71–2.

Aristide, Dani. *"Ekfrasis" e storia: sul Santuario di Monte Berico ed altri scritti di storia dell'arte*. Padova: Le Edizioni Messaggero Padova, 2008.

Arkinstall, C. "Painting History: Ekphrasis, Aesthetics and Ethics in Rosa Chacel's 'Barrio de Maravillas' and 'Acropolis.'" *Revista de Estudios Hispanicos* 39, no. 3 (October 2005): 489–514.

Armendariz, Febe. *Écfrasis y exilio en El sueño de Úrsula*. M.A. thesis, Southwest Texas State University, 1999.

Armstrong, Jane. "Introduction to the Ekphrasis Issue." *Mississippi Review* 14, no. 4 (October 2008). http://www.mississippireview.com/2008/Vol14No4-Oct08/1404-100108-00introduction.html

Arnulf, Arwed. *Architektur- und Kunstbeschreibungen von der Antike bis zum 16. Jahrhundert*. München: Deutscher Kunstverlag, 2004.

_____. "Das Bild als Rätsel: zur Vorstellung der versteckten und mehrfachen Bildbedeutung von der Antike bis zum 17. Jahrhundert." *Münchner Jahrbuch der bildenden Kunst* 53 (2002): 103–62.

_____. *Mittelalterliche Beschreibungen der Grabeskirche in Jerusalem*. Stuttgart: Steiner, 1998.

Artigas, Irene. "Ecfrasis y naturaleza muerta: los 'Botines con lazos' de van Gogh y Olga Orozco." *Trans — Revue de literature générale et compare* No. 2, Littérature et Image (Juin 2006).

Ashton, Dore. "Vedere e Pensare (è Immaginare)." In Valtolina, *Annali* (below), 23–48.

Aspley, Keith, Elizabeth Cowling, and Peter Sharratt, eds. *From Rodin to Giacometti: Sculpture and Literature in France 1880–1950*. Amsterdam: Rodolpi, 2000.

Assmann, Aleida. *Erinnerungsräume. Formen und Wandlungen des kulturellen Gedächtnisses*. C.H. Beck: München, 1999.

Augusto, Petra Cristina. "Ekphrasis e ut pictura poesis: a linguagem comopintura ou a pintura como linguagem." *Gatilho: revista de estudos lingüísticos e literários* 2 (1999): 73–80.

Augustyn, Joanna. "Subjectivity in the Fictional Ruin: The Caprice Genre." *Romanic Review* 91, no. 4 (November 2000): 433–57.

Aune, David E. "Ekphrasis." *The Westminster Dictionary of New Testament and Early Christian Literature and Rhetoric*. Louisville: Westminster John Knox Press, 2003. 143–5.

Auraix-Jonchière, Pascale. "Ekphrasis et mythologie dans *La Toison d'or* de Théophile Gautier (1839): La Madeleine prétexte." In Pascale Auraix-Jonchière, ed., *Ecrire la peinture entre XVIIIe et XIXe siècles*. Révolutions et Romantismes. 4. Clermont-Ferrand, France: Presses Universitaires Blaise Pascal, 2003. 451–63. See also Auraix-Jonchière's "Avant-propos" to this vol., 11–19.

Aurenhammer, Hans H. "Phidias als Maler: Überlegungen zum Verhältnis von Maler und Skulptur in Leon Battista Albertis *De Pictura*." *Römische historische Mitteilungen* 43 (2001): 355–410.

Austin, C.F. "Mastering the Ineffable: Dante Gabriel Rossetti's 'The Vase of Life' and the Kantian Sublime." *Victorian Poetry* 45, no. 2 (Summer 2007): 159–73.

Autenrieth, Hans Peter. "Von der Ekphrasis zum restauratorischen Befund: Interpretationen der Farbigkeit mittelalterlicher Architektur." In *Il colore nel Medioevo: arte, simbolo, tecnica*. Lucca: Istituto storico lucchese, 1998. 1–15.

Avelar, Mário. *Ekphrasis: o poeta no atelier do artista*. Lisboa: Edições Cosmos, 2006.

Aygon, Jean-Pierre. "L'ecphrasis et la notion de description dans la rhétorique antique." *Pallas* 41 (1994): 41–56.

_____. "*Imagination* et description chez les rhéteurs du Ier s. ap. J.-C." *Latomus* 62 (2004): 108–123.

_____. *Pictor in fabula: La "descriptio-ecphrasis" dans les tragédies de Sénèque*. Bruxelles: Latomus, 2004. **Reviews:** Flaviana, Ficca. *Bollettino di Studi Latini* 35 (2005): 672–3. Mader, Gottfried. "Senecan Ekphrases." *Classical Review* 56, no. 2 (2006): 356–8.

Bäbler, Balbina, and Heinz-Günther Nesselrath. *Ars et Verba: die Kunstbeschreibungen des Kallistratos/Einführung, Text, Übersetzung, Anmerkungen, archäologischer Kommentar*. München: Saur, 2006.

Bacmeister, Anne. "Der Schild des Achilles—Zum klassischen Vorbild der Ekphrasis." Hauptseminar "Bild und Text—Ekphrastische Texte der spanischsprachigen Literatur." 26 pp. http://www.hausarbeiten.de/faecher/vorschau/67349.html

Bahti, Timothy. "A Minor Form and its Inversions: The Image, the Poem, the Book in Celan's *Unter ein Bild*." *MLN* 110 (April 1995): 565–78.

Bakker, Boudewijn. "Een goddelijk schilderij: Vondel over landschap en schilderkunst in zijn Bespiegelingen van 1662." In neerlandistiek.nl. Publicatiedatum 11 mei 2005, artikelnummer 05.02 at http://www.neerlandistiek.nl/publish/articles/000091/index.html.

Bal, Mieke. "Instantanés." In Bertho, *Proust* (below), 117–30.

_____. "Figuration." *PMLA* 119, no. 5 (October 2004): 1289–92.

Baldwin, Claire. "Speaking of Art: Ekphrastic Reflections in Postwar German Literature." In Robert Weninger and Brigitte Rossbacher, eds., *Wendezeiten, Zeitenwenden: Positionsbestimmungen zur deutschsprachigen Literatur 1945–1995. Studien zur Deutschsprachigen Gegenwartsliteratur/ Studies in Contemporary German Literature*. 7. Tübingen, Germany: Stauffenburg, 1997. 131–49.

Bailin, Miriam. "Seeing Is Believing in *Enoch Arden*." In Carol T. Christ and John O. Jordan, eds., *Victorian Literature and the Victorian Visual Imagination*. Berkeley: University of California Press, 1995. 313–25.

Baldwin, Thomas. "Proust, a Fountain and Some Pink Marble." *French Studies* 59, no. 4 (October 2005: 481–93.

Ball, Babette. "Beschreibung eines Sehvorgangs: John Constables Deadham Vale, von East Berholt gesehen." In Rebel, *Sehen* (below), 171–80.

Banks, Carol. "'You Are Pictures Out of Doore ... Saints in Your Iniuries': Picturing the Female Body in Shakespeare's Plays." *Women's Writing* 8, no. 2 (2001): 295–311.

Bann, Stephen. "Ekphrasis contemporain? Le Matisse de Greenberg et le Raphaël de Stokes." In Larys Frogier and Jean-Marie Poinsot, eds., *La description: actes du colloque: Archives de la critique d'art*. Châteaugiron: Archives de la critique d'art, 1997. 34–50

Barber, Charles. "A Sufficient Knowledge: Icon and Body in Ninth-Century Byzantium." In Heidi J. Hornik, ed., *Interpreting Christian Art: Reflections on Christian Art*. Macon, GA: Mercer University Press, 2003. 65–79.

Barbillon, Claire. "Que disent les descriptions des portraits sculptés au XIXe siècle?" In Bonfait, *La description* (below), 229–48.

Barchiesi, Alessandro. "Quel che resta dell'ecphrasis." In R. Ascarelli, ed., *Il classico violato. Per un museo letterario del '900*. Roma: Artemide, 2004. 11–19.

_____. "Virgilian Narrative: Ekphrasis." In Charles Martindale, ed., *The Cambridge Companion to Virgil*. Cambridge: Cambridge University Press, 1997. 271–81.

Barkan, Leonard. "Feast for the Eyes, Food for Thought." *Social Research* 66, no. 1 (Spring 1999: 225–52.

_____. "Making Pictures Speak: Renaissance Art, Elizabethan Literature, Modern Scholarship." *Renaissance Quarterly* 48 (Summer 1995): 326–51.

_____. "Picture This." *Parnassus: Poetry in Review* 30, nos. 1-2 (March 2008).

Barkhuizen, J.H. "Romanos Melodos, 'On the Massacre of the Innocents': A Perspective on Ekphra-

sis as a Method of Patristic Exegesis." *Acta Classica* 50 (2007): 29–50.

Bar-Nadav, Hadara. "Introduction" [to special section: A Prairie Schooner Portfolio: Ekphrastic Poems]. *Prairie Schooner* 79, no. 4 (Winter 2005): 22–3.

Barnaby, Edward Thomas. *Meta-Spectacle: The Politics of Realism and Visuality in the British Historical Novel*. Ph.D. dissertation, New York University, 2001.

Barnes, Michael Heath. *Inscribed Kleos: Aetiological Contexts in Apollonius of Rhodes*. Ph.D. dissertation, University of Missouri, Columbia, 2003.

Barr, Nancy Margot. *Artaud as Orator*. Ph.D. dissertation, University of California, Berkeley, 1997.

Barry, Peter. "Contemporary Poetry and Ekphrasis." *Cambridge Quarterly* 31, no. 2 (2002): 155–65.

Bartelink, G. "Constantin le Rhodien, ecphrasis sur l'église des Apôtres à Constantinople." *Byzantion* 46 (1976): 425 ff.

Bartsch, Shadi. "Ars and the Man: The Politics of Art in Virgil's *Aeneid*." *Classical Philology* 93, no. 4 (October 1998): 322–42.

_____. "'Wait a Moment, Phantasia': Ekphrastic Interference in Seneca and Epictetus." *Classical Philology* 102, no. 1 (January 2007): 83–95.

_____, and Jás Elsner. "Ekphrasis through the Ages — Introduction: Eight Ways of Looking at an Ekphrasis." *Classical Philology* 102, no. 1 (January 2007): i–vi. Also at http://209.85.165.104/search?q=cache:KKtNMkuI0-0J:humanities.uchicago.edu/depts/classics/people/PDF.Files/Ekphrasis.briefintro.final.pdf+ekphrasis&hl=en&ct=clnk&cd=16&gl=us&lr=lang_de

Baseu-Barabas, Theonie. *Zwischen Wort und Bild: Nikolaos Mesarites und seine Beschreibung des Mosaikschmucks der Apostelkirche in Konstantinopel (Ende 12. Jh.)*. Wien: Verband der wissenschaftlichen Gesellschaften Österreichs, 1992. **Review:** Albani, Jenny. *Byzantinische Zeitschrift* 86–87, no. 1 (1993): 119–21.

Basilío, Kelly. "Trilles et frétillements: L'Ecriture 'impressionniste' du désir dans Une partie de campagne de Maupassant." In Noëlle Benhamou, ed., *Guy de Maupassant*. CRIN: Cahiers de Recherche des Instituts Néerlandais de Langue et de Littérature Françaises. 48. Amsterdam: Rodopi, 2007. 33–44.

Bass, Laura A. "To Possess Her in Paint: (Pro)creative Failure and Crisis in *El pintor de su deshonra*." In de Armas, *Writing* (below), 185–211.

Bätschmann, Oskar. "Giovan Pietro Belloris Bildbeschreibungen." In Boehm and Pfotenhauer, *Beschreibungskunst* (below), 279–300.

Battaglia, Lucia. "'Come [...] le tombe terragne portan segnato': lettura del dodicesimo canto del *Purgatorio*." In Venturi, *Ecfrasi* (below), 33–63.

Baumann, Peter. "Gotter und Helden im Dienst der Repräsentation: Mythologische Themen auf spätantiken Mosaiken im Heiligen Land." *Antike Welt* 34, no. 2 (2003): 165–70.

Baumbach, Manuel. "Die Poetik der Schilde: Form und Funktion von Ekphrasis in den Posthomerica des Quintus Smyrnaeus." In Manuel Baumbach et al., eds., *Quintus Smyrnaeus: Transforming Homer in Second Sophistic Epic*. Berlin: Walter De Gruyter, 2007. 107–44.

Baxandal, Michael. *Words for Pictures: Seven Papers on Renaissance Art and Criticism*. New Haven: Yale University Press, 2003.

Baxter, John. "The Entrance to a World: Helen Pinkerton's 'Bright Fictions.'" *Renascence: Essays on Values in Literature* 59, no. 3 (Spring 2007): 159–77.

Bazin, Claire. "Approches littéraires et picturales de *Jane Eyre*." *Les Cahiers d'Inter-Textes*. Paris: Centre de recherche Inter-Textes Arts et Littératures modernes, 1985.

Bearden, Elizabeth B. *Repainting Romance: Ekphrasis and Otherness in Renaissance Imitations of Ancient Greek Romance*. Ph.D. dissertation, New York University, 2006.

Beaujou, Michel. "Some Paradoxes about Description." *Yale French Studies* 61 (1981): 27–59.

Beck, Deborah. "Ecphrasis, Interpretation, and Audience in 'Aeneid 1' and 'Odyssey 8.'" *American Journal of Philology* 128, no. 4 (Winter 2007): 533–49.

Becker, Andrew Sprague. *Rhetoric and Poetics of Early Greek Ekphrasis: Theory, Philology and the Shield of Achilles*. Lanham, MD: Rowman & Littlefield, 1995.

_____. "Contest or Concert? A Speculative Essay on Ecphrasis and Rivalry between the Arts" [with Bibliographical Appendix]. *Classical and Modern Literature* 23, no. 1 (Spring 2003): 1–14.

_____. *How to Read an Ecphrasis: The Poetics of the Homeric Shield of Achilles*. Ph.D. dissertation, University of North Carolina at Chapel Hill, 1988.

_____. "Reading Poetry through a Distant Lens: Ecphrasis, Ancient Greek Rhetoricians, and the Pseudo-Hesiodic Shield of Herakles." *American Journal of Philology* 113 (Spring 1992): 5–24.

_____. "Sculpture and Language in Early Greek Ekphrasis: Lessing's *Laokoon*, Burke's *Enquiry*, and the Hesiodic Descriptions of Pandora." *Arethusa* 26, no. 3 (Fall 1993): 277–93.

_____. *The Shield of Achilles and the Poetics of Ekphrasis*. Lanham, MD: Rowman & Littlefield, 1995. **Reviews:** de Jong, Irene J.F. *Mnemosyne* 52,

no. 3 (June 1999): 336–7. Ford, Andrew. *Journal of Hellenic Studies* 117 (1997): 213–14. Griffin, Jasper. *Classical Review* 47, no. 1 (1997): 1–2. Merrett, R.J. *Canadian Review of Comparative Literature* 27, nos. 1–2 (2000): 329–32. Webb, Ruth. *Bryn Mawr Classical Review* 11, no. 2 (Fall 1995).

_____. "The Shield of Achilles and the Poetics of Homeric Description." *American Journal of Philology* 111 (Summer 1990): 139–53.

Behrendt, Stephen C. "Community Relations: The Roles of Artist and Audience in William Carlos William's *Pictures from Brueghel*." *American Poetry* 2, no. 2 (1985): 30–52.

Belkin, Johanna. "Das mechanische Menschenbild in der Floredichtung von Konrad Fleck." *Zeitschrift für deutsches Altertum und deutsche Literatur* 100 (1971): 325–46.

Bellenger, Yvonne. "Ronsard, les peintres et la Peinture." In Luisa Secchi Tarugi, ed., *Lettere e arti nel Rinascimento: atti del X convegno internazionale, Chianciano-Pienza 20–23 luglio 1998*. Firenze: F. Cesati, 2000. 21–38

Belting, Hans. *Bild und Kult. Eine Geschichte des Bildes vor dem Zeitalter der Kunst.* München: C.H. Beck, 1990.

_____. "Exil in Arkadien: Giorgiones *Tempesta* in neuer Sicht." In Reinhard Brandt, ed., *Meisterwerke der Malerei: von Rogier van der Weyden bis Andy Warhol.* Leipzig: Reclam, 2001. 45–-68.

Belting, Hans, and Dietmar Kamper, eds. *Der zweite Blick. Bildgeschichte und Bildreflexion.* Wilhelm Fink Verlag: München, 2000.

Benazzi, Giordana. "Dalla reconquista dell'Albornoz alla renovatio di Nicolò V: le trasformazioni quattrocentesche della rocca di Spoleto." In Maria Grazia Nico Ottaviani, ed., *Rocche e fortificazioni nello stato della Chiesa.* Napoli: Edizioni Scientifiche Italiane, 2004. 235–53.

Benton, Michael. "Anyone for Ekphrasis?" *British Journal of Aesthetics* 37(October 1997): 367–76. Rpt. in Benton's *Studies in the Spectator Role: Literature, Painting and Pedagogy.* Abingdon, Oxon.: Taylor and Francis, 2000.

Benzel, Kathryn N. "Modern In(ter)vention: Reading the Visual." *Visual Resources*, 19, no. 4 (December 2003): 321–38.

Berar, Eva. "Ekfrasis v russkoi literature XX veka: Rossiia malëvannaia, Rossiia kamennaia." In Geller, *Ekfrasis* (below), 145–51.

Berghof, Oliver Gregor. *Psyche: Soul, Death, Spirit and Mind in Sterne and Diderot.* Ph.D. dissertation, University of California, Irvine, 1996.

Bergmann, Emilie. *Art Inscribed: Essays on Ekphrasis in Spanish Golden Age Poetry.* Cambridge, MA: Harvard University Press, 1979. **Review:** Terry, Arthur. *Comparative Literature* 34, no. 4 (Autumn 1982): 371–3.

_____. "Art Inscribed: El Greco's Epitaph as Ekphrasis in Góngora and Paravicino." *MLN* 90, no. 2 (March 1975): 154–66.

_____. "'Los sauces llorando a moco y baba': Ekphrasis in Galdós' *La de Bringas*." *Anales Galdosianos* 20, no. 1 (1985): 75–82. Also available at http://www.cevvantesvirtual.com/servlet/SirveObras/12383874243470495321435/p0000007.htm#I_20_

_____. "Painting in Poetry: Gongora's Ekphrasis." In Mary Ann Davis Beck et al., eds., *The Analysis of Hispanic Texts: Current Trends in Methodology.* Jamaica: Bilingual Press, York College, 1976. 242–55.

Berndt, Frauke. "Oder alles ist anders: Zur Gattungstradition der Ekphrasis in Heiner Müllers Bildbeschreibung." In Drügh and Moog-Grünewald, *Behext* (below), 287–312

Berns, Jörg Jochen. *Film vor dem Film. Bewegende und bewegliche Bilder als Mittel der Imaginationssteuerung in Mittelalter und Früher Neuzeit.* Marburg: Jonas Verlag, 2000.

Bernsdorff, Hans. *Kunstwerke und Verwandlungen: vier Studien zu ihrer Darstellung im Werk Ovids.* Frankfurt am Main: Lang, 2000.

_____. "Mythen, die unter die Haut gehen-zur literarischen Form der Tätowierelegie (PBrux. inv. e 8934 und PSorb. inv. 2254)." *Mnemosyne* 61 no. 1 (2008): 45–65.

Berr, Karsten. "Carus und Hegel über Landschaftsmalerei: Landschaftsästhetik nach dem 'Ende' der Landschaftsmalerei." In Annemarie Gethmann-Siefert, ed., *Zwischen Philosophie und Kunstgeschichte: Beiträge zur Begründung der Kunstgeschichtsforschung bei Hegel und im Hegelianismus.* Paderborn: Fink, 2008. 243–56.

Bertaud, Madeleine. "De l'allégorie à l'analyse: peinture ou dessin dans quelques romans du XVIIe siècle." In *La littérature et les arts figurés de l'Antiquité à nos jours: actes du XIVe Congrès de l'Association Guillaume Budé, Limoges 25–28 août 1998.* Paris: Les Belles Lettres, 2001. 589–97.

Berthier, Patrick. "Balzac portraitiste: position picturale du problème." In Pascale Auraix-Jonchière, ed., *Ecrire la peinture entre XVIIIe et XIXe siècles. Révolutions et Romantismes. 4.* Clermont-Ferrand, France: Presses Universitaires Blaise Pascal, 2003. 231–40.

Bertho, Sophie. "The Ancients and the Moderns: The Question of Ekphrasis in Goethe and Proust." *Revue de littérature comparée* 72, no. 1 (January–March 1998): 53–62.

_____. "Proust et Monet, la débacle de l'ekphrasis." In Uta Felten and Vokler Roloff, eds., *Proust und*

die Medien. München: Wilhelm Fink, 2005. 145–68.

_____, ed. *Proust contemporain*. *CRIN: Cahiers de Recherche des Instituts Neerlandais de Langue et de Litterature Francaises*. 28. Amsterdam: Rodopi, 1994.

Berthold, Dennis. "Ekphrastic Composites in 'At the Hostelry': Van de Veldes, Tromps, and Trompes l'Oeil." *Leviathan: A Journal of Melville Studies* 9, no. 3 (October 2007): 97–103.

Bertoli, Franco. "Mattoni e coppi per Busto Arsizio dalle fornaci del circondario (secoli XVII–XVIII)." *Almanacco della Famiglia Bustocca* (2005): 98–113.

Bertolini, J.A. "Ecphrasis and Dramaturgy: Leonardo's Leda in Rucellai's *Oreste*." In Joel H. Kaplan, ed., *Renaissance Drama: New Series VII: Drama and the Other Arts*. Evanston, IL: Northwestern University Press, 1977. 151–76.

Bertrand, Dominique. "Entre mythe et analyse: Palimpsestes savants du rire de Vigenère à Cramail." In John D. Lyons and Cara Welch, eds., *Le Savoir au XVIIe siècle*. Biblio 17. 147. Tübingen, Germany: Narr, 2003. 389–401.

Besslich, Barbara. "Napoleonic kaleidoscope: Interculturality, Early Realistic Romanticism Review and Intermediality in Wilhelm Hauff's Story 'Das Bild des Kaisers' (1827)." *Arcadia* 41, no. 1 (2006): 29–49.

Beurard-Valdoye, Patrick. "Ekphrasis." In Baptiste-Marrey et al., eds., *Les interdits de l'image*. Musées des Sens: Obsidiane, 2006. 63–8

Bezzerides, Ann Mitsakos. *Conversing with John Chrysostom as Christian Relgious Educator*. Ph.D. dissertation, Boston College, 2007.

Biagini, Enza. "Ecfrasi, dipintura: sguardo sulle teorie della descrizione nei trattati del Cinquecento." In Gianni Venturi, *Ecfrasi* (below), 405–19.

Bialostocki, Jan. *Mysilciele, kronikarze i drtysci o sztuce; od starozytnosci [Thinkers, Chroniclers and Artists on Art, from Antiquity to 1500]*. Warszawa: Naukowe, 1978.

Biaute, Marie-Hélène. "Vallès plasticien." *Revue d'Etudes Vallésiennes* 19 (December 1994): 5–15.

Bicket, Douglas, and Lori A. Packer. "An Early 'Denial of Ekphrasis': Controversy over the Breakout of the Visual in the Jazz Age Tabloids and the *New York Times*." *Visual Communication* 3, pt. 3 (October 2004) 360–79.

Biedermann, Gottfried. "Zur Orientmalerei Carl Leopold Müllers (1834–1892)." In *Von österreichischer Kunst*. Klagenfurt: Ritter, 1983. 185–90.

Bindman, David. "Text as Design in Gillray's Caricature." In Peter Wagner, *Icons* (below), 309–23.

Birss, Robert Craig. *"Imaginary Work": The Functions of Ekphrasis in Narrative Poetry*. Ph.D. dissertation, University of Iowa, 1977.

Bitel, Lisa M. "Ekphrasis at Kildare: The Imaginative Architecture of a Seventh-Century Hagiographer." *Speculum* 79, no. 3 (July 2004): 605–27; rpt. as a chapter in Bitel, *Landscape* (next entry).

_____. *Landscape with Two Saints: How Genovefa of Paris and Brigit of Kildare Built Christianity in Barbarian Europe*. New York: Oxford University Press, 2008.

Bizzotto, Elisa. "The Imaginary Portrait: Pater's Contribution to a Literary Genre." In Laurel Brake et al., eds., *Walter Pater: Transparencies of Desire. 1880–1920 British Authors*. 16. Greensboro, NC: ELT, 2002. 213–23.

Blackhawk, Terry. "Ekphrastic Poetry: Entering and Giving Voice to Works of Art." In *Third Mind: Creative Writing Through Visual Art*. Teachers and Writers Collaborative, New York, 2002. 1–14.

Blaison, Marie. "Suetonius and the Ekphrasis of the Domus-Aurea (Suetonius, *Nero* 31)." *Latomus* 57, no. 3 (July–September 1998): 617–24.

Blanc, Anne-Lise. "Une Image de l'Espagne dans *Histoire* de Claude Simon: Etude d'une ekphrasis." *Litteratures* 32 (Spring 1995): 177–89.

Blanchard, J.M. "The Eye of the Beholder: On the Semiotic Status of Paranarratives." *Semiotica* 22 (1978): 235–68.

Blanchard, Jean-Vincent. "Optique et rhétorique au XVIIe siècle: de l'ekphrasis jésuite au fragment pascalien." *Recherches des jeunes dix-septiémistes*. Tübingen: Gunter Narr Verlag, 2000. 149–60.

Blanco, María Elena. "Rapto sibilino: Hacia una mitopoética de la imagen." In Jesús J. Barquet at al., eds., *Haz de incitaciones: Poetas y artistas cubanos hablan*. Miami, FL: Baquiana, 2003. 26–36.

Blankman, Marijke. "Euterpe's Organ: Aspects of Spieghel's Hart-Spieghel in Interdisciplinary Perspective." In Theo Hermans and Reinier Salverda, eds., *From Revolt to Riches: Culture and History of the Low Countries, 1500–1700: International and Interdisciplinary Perspectives*. London, UCL, Centre for Low Countries Studies, 1993. 182–95

Blanning, Hannah Catherine. *Reanimating the Image: Verbal Triumphs in the Battle of the Sister Arts*. M.A. thesis, University of Colodaro, Boulder, 2007.

Blazina, John. "Szymborska's Two Monkeys: The Stammering Poet and the Chain of Signs." *Modern Language Review* 96, no. 1 (January 2001): 130–9.

Bleeker, Andrew. "Sheer, Crosshatching Pleasure: Art under the Influence of Poetry, and Vice

Versa." *The Stranger* [Seattle] 24 October 2006. http://www.thestranger.com/seattle/Content?oid= 93574

Bleisch, Pamela Rolanda. *The Aetiological Tradition in Vergil's "Aeneid": Books 1–6.* Ph.D. dissertation, University of California, Los Angeles, 1994.

_____. "The *Regia* of Picus: Ekphrasis, Italian Identity, and Artistic Definition in *Aeneid* 7.152–93." In Philip Thibodeau and Harry Haskell, eds. *Being There Together: Essays in Honor of Michael C.J. Putnam on the Occasion of His Seventieth Birthday.* Afton, Minnesota, 2003. 88–109.

Blumenfeld-Kosinski, Renate. "Ekphrasis and Memory in the Fourteenth-Century *Parfait du paon.*" In Donald Maddox and Sara Sturm-Maddox, eds., *The Medieval French Alexander.* Albany: State University of New York Press, 2002. 193–202.

Boam, Paul, and Hugo McCann. "The Painter and the Poet: An Aesthetic Duo in The Classroom." A paper presented at the 2001 AATE/ALEA Joint National Conference. http://wwwfp.education. tas.gov.au/English/hugopaul.htm

Bocchetti, Carla. *El espejo de las Musas: El arte de la descripción en la Ilíada y Odisea.* Santiago: Facultad de Filosofía y Humanidades. Universidad de Chile, 2006. **Review:** Hogel, Christian. *Bryn Mawr Classical Review* 15, no. 3 (2008).

Boeder, Maria. *Visa est vox: Sprache und Bild in der spätantiken Literatur.* Frankfurt am Main: Lang, 1996.

Boehm, Gottfried. "Anteil: Wilhelm Heinses 'Bildbeschreibung.'" In Helmut Pfotenhauer, ed., *Kunstliteratur als Italienerfahrung. Reihe der Villa Vigoni: Deutsch-Italienische Studien.* 5. Tübingen: Niemeyer, 1991. 21–39.

_____. "Bildbeschreibung: Über die Grenzen von Bild und Sprache." In Boehm and Pfotenhauer (next entry), *Beschreibungskunst,* 23–40.

Boehm, Gottfried, and Helmut Pfotenhauer, eds. *Beschreibungskunst, Kunstbeschreibung: Ekphrasis von der Antike bis zur Gegenwart.* München: W. Fink, 1995. **Review:** Harthun, Karoline. *Mittellateinisches Jahrbuch* 32, no. 2 (1997): 137–40.

Boggemann, M. "Ekphrasis: Musical Image Description between Convergence and Contrast." *Musiktheorie* 21, no. 2 (2006): 171–80.

Bognolo, Anna. "Il meraviglioso architettonico nel romanzo cavalleresco spagnolo." In Luisa Secchi Tarugi, ed., *Lettere e arti nel Rinascimento: atti del X convegno internazionale, Chianciano-Pienza 20–23 luglio 1998.* Firenze: F. Cesati, 2000. 207–19

Bohn, Willard. "Andre Breton: Where Dream Becomes Reality." *Esprit Createur* 36, no. 4 (Winter 1996): 43–51.

_____. *Apollinaire, Visual Poetry, and Art Criticism.* Lewisburg, PA: Bucknell University Press, 1993.

_____. "Apollinaire's 'Le Livre' and the Visual Imperative." *Modern Language Review* 83, no. 4 (October 1988): 852–60.

_____. "Giving Shape to Words: Apollinaire's 'Le Port.'" *Romanic Review* 79, no. 4 (November 1988): 611–20.

_____. "Louis Aragon and the Critical Muse." *Romanic Review* 89, no. 3 (May 1998): 367–79.

_____. "Marking Time with Apollinaire." In Theo d'Haen, ed., *Verbal/Visual Crossing 1880–1980.* Amsterdam: Rodopi, 1990. 114–32.

_____. "Mirroring Miro: J.V. Foix and the Surrealist Adventure." In C.B. Morris, ed., *The Surrealist Adventure in Spain.* Ottawa: Dovehouse, 1991. 40–61.

_____. "Poesie Critique and Poesie Visuelle: Apollinaire's 'Les Lunettes.'" *Neophilologus* 72 (1988): 34–43.

_____. "Semiosis and Intertextuality in Breton's 'Femme et oiseau.'" *Romantic Review* 76, no. 4 (November 1985): 415–28.

Boisclair, A.P. "Presence and Absence of the Portrait in the Literary School of Montreal: The Examples of Charles Gill and Emile Nelligan." *Études Françaises* 43, no. 2 (2007): 137.

Boland, Roy C. "Mario Vargas Llosa: Literature, Art, and Goya's Ghost." *Mester* 29 (2000): 93–115.

Bollard, Kathleen. "Ekphrasis and the Renaissance Student: Classical vs. Biblical Authority in Villalon's *El Scholástico.*" In de Armas, *Ekphrasis* (below), 59–77.

_____. "Ekphrasis and History: The Charles V Paintings in Villalón's El *Crótalon.*" *Cahiers Parisiens* 1 (2005): 149–60.

Bolognesi, Eugenia. "Ekphrasis, ou description rhétorique de cette église de Constantinople, d'après les déductions de l'A. (église de sainte Marie 'guide' du chrétien)." *Studi Medievali* 28, no. 1 (June 1987): 381–98.

_____. "La 'X Omelia' di Fozio: Quale ekphrasis della chiesa di S. Maria Hodegetria." *Studi Medievali* 28, no. 1 (June 1987): 381–98.

Bolter, Jay David. "Ekphrasis, Virtual Reality, and the Future of Writing." In Geoffrey Nunberg, ed., *The Future of the Book.* Berkeley: University of California Press, 1966. 253–72.

Bolzoni, Lina. "Descrizione come educazione dello sguardo nei predicatori e nei mistici fra il Duecento e il Quattrocento." In Bonfait, *La description* (below), 3–20.

Bona, Rodolfo, catalogue curator. *diSEGNI: grafica e pittura del Novecento nell'opera di Marino Parenti.* Mantova: Sometti, 2006.

Bonfait, Olivier, ed. *La description de l'oeuvre d'art: du modèle classique aux variations contemporaines.* Paris: Editions de la Réunion des musées nationaux, 2004.

_____. "Méthodes et enjeux de la description en France et en Italie au XVIIe siècle." In Bonfait (previous entry), *La description*, 21–44.

_____, ed. *Peinture et rhétorique*: 10–11 juin 1993. Actes du colloque de l'Académie de France à Rome. Paris: Réunion des Musées Nationaux, 1994.

Bongiorni, Kevin. "Balzac, Frenhofer, Le Chef-d'oeuvre inconnu: ut poesis pictura." *Mosaic* 33, no. 2 (June 2000): 87–99.

Borg, Barbara. "Bilder zum Hören — Bilder zum Sehen: Lukians Ekphraseis und die Rekonstruktion antiker Kunstwerke." *Millennium* 1 (2004): 25–57.

Borg, Camilla Brudin. "Ekfrasen som meta-bild i Lars Gyllenstens roman." In Harrits and Troelsen (below).

Borges, Cassandra. "(Re-)describing Odysseus: Homer and the Human Ecphrasis." http://www.camws.org/meeting/2007/program/abstracts/08F3%20Borges.htm

Borsi, Stephano. *Polifilo architetto: cultura architettonica e teoria artistica nell'Hypnerotomachia Poliphili di Francesco Colonna, (1499).* Roma: Officina Edizioni, 1995. **Review:** Furno, Martine. *Albertiana* (Firenze) 1 (1998): 218–20.

Bouillon, Jean-Paul. "Description de Gauguin 1888–1893. In Bonfait, *La description* (above), 251–72.

Bove, Alexander. "The 'Unbearable Realism of a Dream': On the Subject of Portraits in Austen and Dickens." *ELH* 74, no. 3 (Fall 2007): 655–79.

Bowen, K.A. "'Wounds of love': Dantean Pazienza and the Poetics of Mourning Dido in the Late Middle Ages." *Comitatus: A Journal of Medieval and Renaissance Studies* 39 (2008): 63–100.

Boyd, B.W. "Virgil's Camilla and the Traditions of Catalogue and Ecphrasis (*Aeneid* 7.803–17)." *American Journal of Philology* 113 (Summer 1992): 213–34.

_____. "Non enarrabile textum: Ecphrastic Trespass and Narrative Ambiguity in the Aeneid." *Vergilius* 41 (1995): 71–90.

Boyd, Norman Wingate. *Analogy in Vergil: An Examination of Simile and Ecphrasis in the "Aeneid."* B.A. honors thesis in Classics, Harvard University, 1996.

Boyde, Patrick. "'Ecfrasi ed ecceità' in Leopardi's *Canti.*" *Italian Studies* 43 (1988): 2–20.

Boylan, Rebecca Warburton. *The Moving Still: Ekphrasis in the Nineteenth-Century British Novel.*

Ph.D. dissertation, George Washington University, 2006.

Bradford, Eugene. *Dualities: Nine Poets Nine Images.* Ed. Jennifer Bosveld. Columbus, OH: Pudding House Publications, 2006.

Bram, Shahar. "Ekphrasis as a Shield: Ekphrasis and the Mimetic Tradition." *Word & Image: A Journal of Verbal/Visual Enquiry* 22, no. 4 (October–December 2006): 372–78.

Braschio, Jo. Baptista. *De tribus statuis in Romano Capitolio erectis anno MDCCXX: ecphrasis iconographica.* Romae: Ansovinus Urbanus, 1724.

Brattico L. "Per un indice tematico di ekphrasis greche (II–VI sec.)." *Ricerche sul mundo classico* 9 (1997): 57–74.

Braun–Jackson, Sally J. *Allusion in A.S. Byatt's Fiction.* Ph.D. dissertation, Memorial University of Newfoundland, 2006.

Breed, Brian W. "Portrait of a Lady: Propertius 1.3 and Ecphrasis." *Classical Journal* 99, no. 1 (October–November 2003): 35–56.

Breidbach, Olaf, and Karl Clausber, eds. *Video ergo sum. Repräsentation nach innen und außen zwischen Kunst- und Neurowissenschaften.* Hamburg: Hans Bredow Institut, 1999.

Brems, Hugo. "'Binnen of buiten. Of het iets uitmaakt': Over enkele beeldgedichten van Willem van Toorn." In Marc van Vaeck et al., eds., *De Steen van Alciato: Literatuur en visuele cultuur in de Nederlanden/The Stone of Alciato: Literature and Visual Culture in the Low Countries.* Louvain, Belgium: Peeters, 2003. 129–44.

Brenneman, Mina Todorova. *Beyond the Lessing Impasse: Intersemiotic Dialogue in Joseph Brodsky's Nativity Poems.* Ph.D. dissertation, Yale University, 2006.

Breslin, James. "William Carlos Williams and Charles Demuth: Cross-Fertilization in the Arts." *Journal of Modern Literature* 6 (1977): 248–63.

Bride, Jenny, and Kitty Maryatt. *Ekphrasis on the Writing of Poems about Works of Visual Art: A Suite of Six Broadsides.* Claremont, CA: Scripps College Press, 1990.

Bridges, Margaret. "The Picture in the Text: Ecphrasis as Self-Reflectivity in Chaucer's *Parliament of Fowles, Book of the Duchess* and *House of Fame.*" *Word & Image: A Journal of Verbal/Visual Enquiry* 5 (1989): 151–8.

Brînzeu, Pia. "Ekphrasis: A Definition. *B.A.S.: British and American Studies/Revista de Studii Britanice si Americane* 11 (2005): 247–58.

_____. "From Paintings to Poems: Stages in Ekphrastic Transposition." *B.A.S.: British and American Studies/Revista de Studii Britanice si Americane* 7 (2001): 9–15.

Brogniez, Laurence. "La transposition d'art en Bel-

gique: Le Massacre des Innocents vu par Maurice Maeterlinck et Eugène Demolder." In Pascale Auraix-Jonchière, ed., *Ecrire la peinture entre XVIIIe et XIXe siècles*. Révolutions et Romantismes. 4. Clermont-Ferrand, France: Presses Universitaires Blaise Pascal, 2003. 143–62.

Broome, Elisabeth Ellison. *Arachne's Politics: Tapestries and English National Identity*. Ph.D. dissertation, University of Kentucky, 2003.

Brown, Carl R.V. "Contemporary Poetry about Painting." *English Journal* 81, no. 1 (January 1992): 41–5.

_____. "Gemeistert dar mit worten: Ekphrasis und Visualisierungsstrategien in den illustrierten Wigalois-Handschriften." In Karthyn Starkey, ed., *Imagination und Deixis: Studien zur Wahrnehmung im Mittelalter*. Stuttgart: Hirzel, 2007. 33–49.

Brown, James Hamilton. *Imagining the Text: Ekphrasis and Envisioning Courtly Identity in Wirnt von Gravenbergs "Wigalois."* Ph.D. dissertation, University of North Carolina, Chapel Hill, 2006.

Brown, Laura. "Pope and the Other." In Pat Rogers, ed., *The Cambridge Companion to Alexander Pope*. Cambridge, England: Cambridge University Press, 2007. 222–36.

Brown, Shirley Ann, and Michael W. Herren. "The Adelae Comitissae of Baudri of Bourgueil and the Bayeux Tapestry." In Marjorie Chibnall, ed., *Proceedings of the Battle Conference, 1993*. Woodbridge: Boydell, 1994. 55–73

Brubaker, Leslie. "Life Imitates Arts: Writings on Byzantine Art History." *Byzantine and Modern Greek Studies* 17 (1993): 173–223.

Brückner, Wolfgang. "Der Blaue Reiter und die Entdeckung der Volkskunst als Suche nach dem inneren Klang." In Boehm and Pfotenhauer, *Beschreibungskunst* (above), 519–42.

Brumbaugh, Thomas B. "Concerning Marianne Moore's Museum." *Twentieth Century Literature: A Scholarly and Critical Journal* 1, no. 4 (January 1956): 191–5.

Bruhn, Siglind. *Musical Ekphrasis: Composers Responding to Poetry and Painting*. Hillsdale, NY: Pendragon Press, 2000. **Reviews:** Melo, James. *Notes* 58, no. 3 (March 2002): 604–6. Murka, Danuta. "Czy istnieje muzyczna ekphrasis?" ["Is There a Musical Ekphrasis?"]. *Ruch Muzyczny* 15 (2001): 21–2.

_____. *Musical Ekphrasis in Rilke's Marienleben*. Amsterdam/Atlanta: Rodopi, 2000. **Reviews:** Lichtenstein, S. *Arcadia* 36, no. 1 (2001): 219–23. Meyer, A. *Musikforschung* 56, no. 4 (October–December 2003): 450–2. Murka, Danuta. "Czy istnieje muzyczna ekphrasis?" ["Is There a Mu-

sical Ekphrasis?"]. *Ruch Muzyczny* 15 (2001): 21–2.

_____. "A Concert of Paintings: 'Musical Ekphrasis' in the Twentieth Century." *Poetics Today* 22, no. 3 (Fall 2001): 551–605.

_____. "Musikalisk ekfras." In Hans Lund, ed., *Intermedialitet: ord, bild och ton i samspel*. Lund: Studentlitteratur, 2002. 193–202.

_____. "New Perspectives in a Love Triangle: 'Ondine' in Musical Ekphrasis." In Ulla-Britta Lagerroth et al., eds., *Interart Poetics: Essays on the Interrelations of the Arts and Media. Internationale Forschungen zur Allgemeinen und Vergleichenden Literaturwissenschaft*. 24. Amsterdam: Rodopi, 1997. 47–60.

_____. "Some Thoughts Towards a Theory of Musical Ekphrasis." http://www-personal.umich.edu/~siglind/ekphr.htm

_____. *Sonic Transformations of Literary Texts: From Program Music to Musical Ekphrasis: Ten Essays*. Hillsdale, NY: Pendragon Press, 2008.

_____. *Das tönende Museum: Musik interpretiert Werke bildender Kunst*. Waldkirch: Gorz, 2004. See Siglind Bruhn's personal home page: http://www-personal.umich.edu/~siglind/ekphr.htm

_____. "Vers une méthodologie de l'ekphrasis musical.'" In Márta Grabócz and Danièle Piston, eds., *Sens et signification en musique*. Paris: Hermann, 2007. 155–76.

_____. "Vom Bild zum Text — vom Text zum Ton: Musikalische Ekphrastik in einem 'Klaviergedicht' Ravels." In Jörg Helbig, ed., *Intermedialität: Theorie und Praxis eines interdisziplinären Forschungsgebiets*. Berlin: Erich Schmidt Verlag, 1998. 161–76.

Brunel, Pierre. "Architectures en dialogue: La Gageure de Michel Butor." *Travaux de Littérature* 12 (1999): 197–204.

Bruner, Jeffrey. "'Illustrated' Fiction: Ekphrasis in Carlos Rojas's 'El Jardín de las Hespérides.'" *Modern Language Studies* 22, no. 2 (Spring 1992): 102–10.

_____. "The Lie That Reveals the Truth: Art as/and History in Carlos Rojas's *El Valle de los Caídos*." *Hispanofila* 110 (January 1994): 35–51.

_____. "A Picture Is Worth a Thousand Words: Ekphrasis in the Contemporary Spanish Novel." *Journal of Interdisciplinary Literary Studies* 3, no. 1 (1991): 71–90.

_____. *The Role of Painting in Two Novels by Carlos Rojas: 'El Valle de los Caídos' and 'El jardín de las Hespérides.'* Ph.D. dissertation, Rutgers University, 1990.

_____. "Visual Art as Narrative Discourse: The Ekphrastic Dimension of Carmen Laforet's

Nada." *Anales de la Literatura Española Contemporánea* 18, no. 2 (1993): 289–304.

Brunius, Teddy. "Ekfraser hos Vilhelm Ekelund." In Hakon Lund, ed., *En bog om kunst til Else Kai Sass.* København: Forum, 1978. 413–25.

Brunner, Michael. "Oberrheinische Hochgotik in Überlingen: die Verkündigung im Überlinger Münster." In Michael Brunner, ed., *1100 Jahre Kunst und Architektur in Überlingen (850–1950).* Petersberg: Imhof, 2005. 75–82.

Bruzzo, François, and S.C. Morris. "Textual Dominion: The Representative Text and Text Representation." *Word & Image: A Journal of Verbal/Visual Enquiry* 5, no. 3 (July-September 1989): 278–91.

Bryson, Norman. "Philostratus and the Imaginary Museum." In Simon Goldhill and Robin Osborne, eds., *Art and Text in Ancient Greek Culture* (Cambridge: Cambridge University Press, 1994). 255–83. Rpt. in Stephen Melville and Bill Readings, eds., *Vision and Textuality.* Basingstoke: Macmillan, 1995. 174–94.

Buch, Hans-Christoph. *Ut Pictora Poesis: Die Beschreibungsliteratur von Lessing bis Lukács.* München: Hanser, 1972.

Buch, Robert Caspar. "Laokoons ältester Sohn: Gewalt und Bildlichkeit bei Peter Weiss." *Arcadia: Internationale Zeitschrift für Literaturwissenschaft* 42, no. 1 (2007): 132–65.

_____. *Violent Images: Ekphrastic Writing in Claude Simon and Peter Weiss.* Ph.D. dissertation, Stanford University, 2003.

Bühler, Karl. *Sprachtheorie. Die Darstellungsfunktion der Sprache.* Stuttgart and New York: Gustav Fischer Verlag, 1982.

Bulst, Wolfger A. "Hercules Gallicus, der Gott der Beredsamkeit: Lukians Ekphrasis als künstlerische Aufgabe des 16. Jahrhunderts in Deutschland, Frankreich und Italien." In Ulrich Pfisterer, ed., *Visuelle Topoi: Erfindung und tradiertes Wissen in den Künsten der italienischen Renaissance.* München: Deutscher Kunstverlag, 2003. 61–121.

Bundy, Murray Wright. *The Theory of Imagination in Classical and Medieval Thought.* Urbana: University of Illinois Press, 1927.

Burwick, Frederick. "Ekphrasis and the Mimetic Crisis of Romanticism." In Wagner, *Icons* (below), 78–104.

_____. "Motion and Paralysis in the *English Mail-Coach.*" *Wordsworth Circle* 26, no. 2 (Spring 1995): 66–77.

_____, and Jürgen Klein, eds. *The Romantic Imagination: Literature and Art in England and Germany.* Amsterdam: Rodopi, 1997.

Buschendorf, Christa. "Ekphrasis und die Abkehr vom Mimesis-Prinzip: Bildgedichte Frank O'Ha-

ras auf Werke des Abstrakten Expressionismus." In Drügh and Moog-Grünewald, *Behext* (below), 249–70.

Butlin, Nina Hopkins. "Les Arbres musiciens de Jacques Stéphen Alexis: L' Ekphrasis comme acte de survie culturelle." *French Studies in Southern Africa* 27 (1998): 11–26.

Byatt, A.S. "Writers on Artists" [book excerpt]. *Modern Painters* 14, no. 3 (Autumn 2001): 46–7.

Byre, Calvin S. *Ekphraseis of Works of Art and Place in the Greek Epic from Homer to Nonnus.* Ph.D. dissertation, University of Chicago, 1976.

_____. "Narration, Description, and Theme in the Shield of Achilles." *Classical Journal* 88 (1992–93): 33–42.

Cage, Timothy S. *Frank O'Hara: Poetry, Painting and Performance.* M.A. thesis, University of North Carolina, Chapel Hill, 1988.

_____, and Lawrence B. Rosenfeld. "Ekphrastic Poetry in Performance: An Examination of Audience Perceptions of the Relationship between Poetry and Painting." *Text and Performance Quarterly* 9, no. 3 (July 1989): 199–206.

Cagnana, Aurora, and Silvana Gavagnin. "Indagini archeologiche nel borgo arroccato di Corvara (Beverino, La Spezia)." *Archeologia medievale* 31 (2005): 187–99.

Cahill, Suzanne. "Reflections, Disputes, and Warnings: Three Medieval Chinese Poems about Paintings of the Eight Horses of King Mu." *T'ang Studies* 5 (1987): 87–94.

Calabrese, Omar. *Ekfrasis: il cinema tradotto in poesia.* Modena: Franco Cosimo Panini, 1993.

Calhoun, K.S. "The Urn and the Lamp: Disinterest and the Aesthetic Object in Morike and Keats." *Studies in Romanticism* 26, no. 1 (1987): 3–25.

Caldwell, Ellen Cashwell. *The Breach of Time: History and Violence in the "Aeneid," "The Faerie Queene," and "2 Henry VI."* Ph.D. dissertation, University of North Carolina, Chapel Hill, 1986.

Calle, Román de la. "El espejo de la 'ekphrasis.' Más acá de la imagen. Más allá del texto." *XV Congrés Valencià de Filosofia*, ed. Enric Casaban Moya. Valencià: Societat de Filosofia del País Valencià, 2004. 475–94; rpt. in Calle's *Gusto, Bellezayarte: Doce ensayos de historia de la estética y teoría de las artes.* Zaragoza: Pórtico liberías, 2006; and in *Escritura e Imagen* 1 (2005): 59–81.

_____. *El espejo de la Ekphrasis: más acá de la imagen, más allá del texto: la crítica de arte como paideia = The ekphrastic mirror: the near side of pictures, the far side of words: art criticism as paideia = Der spiegel der ekphrasis: Diesseits des bildes, Jenseits des textes : die kunstkritik als paideia.* Lanzarote: Fundación César Manrique, 2005.

Calle-Gruber, Mireille. "Le Récit de la description ou de la nécessaire présence des demoiselles allemandes tenant chacune un oiseau dans les mains." In Sjef Houppermans, ed., *Claude Simon et Le Jardin des Plantes. CRIN: Cahiers de Recherche des Instituts Néerlandais de Langue et de Littérature Françaises.* 39. Amsterdam: Rodopi, 2001. 5–29.

Caluwé, Jean-Michel. *Poésie et description.* Paris: Presses Universitaires Franc-comtoises, 1999.

Cameron, Alan. "On the Date of John of Gaza." *Classical Quarterly* 43, n.s., no. 1 (1993): 348–51.

Cameron, Averil, and Alan Cameron. "Further Thoughts on the 'Cycle' of Agathias." *Journal of Hellenic Studies* 87 (1967): 131.

Camille, Michael. "Before the Gaze: The Internal Senses and Late Medieval Practices of Seeing." In R.S. Nelson, ed., *Visuality Before and Beyond the Renaissance: Seeing as Others Saw.* Cambridge: Cambridge University Press, 2000. 197–223.

Campo, Roberto E. "From Mirror to Memory: Uses of Ekphrasis in La 'Bergerie' by Remy Belleau." *Nouvelle Revue di Seizieme Siecle* 20, no. 2 (2002): 5–23.

———. *Pierre and the "Paragone": The Rivalry between Poetry and Painting in the Works of Pierre de Ronsard.* Ph.D. dissertation, University of Pennsylvania, 1989.

———. *Ronsard's Contentious Sisters: The Paragone between Poetry and Painting in the Works of Pierre de Ronsard.* Chapel Hill: University of North Carolina Press, 1998.

Canfield, Douglas W. "Purple Patches, Ars and Decorum, Hole and Overflow: Ekphrasis in Horace's *Ars Poetica.*" *Utah Foreign Language* Review (1994): 163–67.

Canovas, Frédéric. "De l'érotique à l'esthétique: Approche de lecture, lecture de l'approche." *Nottingham French Studies* 37, no. 1 (Spring 1998): 107–21.

Caracciolo, Maria Teresa. "Un'invenzione del Settecento neoclassico: lo scudo di Achille." *Neoclassico* (Venezia) 21 (2002): 4–24.

Caraion, Marta. *Pour fixer la trace: Photographie, littérature et voyage au milieu du XIXe siècle.* Geneva: Droz, 2003.

Carandell, Zoraida. "Ekphrasis et création. 'Luna y panorama de los insectos' de García Lorca et *El diàleg dels insectes* de Miró." In Paul-Henri Giraud and Nuria Rodríguez Lázaro, eds., *Poésie, peinture, photographie. Autour des poètes de 1927.* Paris: Indigo & Côté-femmes éditions, 2008.

Careri, Giovanni. "L'ecfrasi tra parola e pittura." In Venturi, *Ecfrasi* (below), 391–404.

Carlos, Luís F Adriano. *O arco-íris da poesia: ekphrasis em Albano Martins.* Oporto: Campo das Letras, 2002.

Carpo, Mario. "Descriptio urbis Romae: ekfrasis geografica e cultura visuale all'alba della rivoluzione tipografica." *Albertiana* (Firenze) 1 (1998): 121–42.

———. "Ecphrasis géographique et culture visuelle à l'aube de la révolution typographique." In Leon Battista Alberti, *Descriptio Urbis Romae*, eds. M. Furno et M. Carpo. Genève: Droz, 2000. 65–96. Italian translation: "Descriptio urbis Romae. Ekphrasis geografica e cultura visuale all'alba della rivoluzionetipografica." *Albertiana* 1 (1998): 111–32.

Carrier, David. "Ekphrasis and Interpretation: Two Modes of Art History Writing." *British Journal of Aesthetics* 27 (Winter 1987): 20–31.

Carroll, Khadija Z. "Re-membering the Figure: The Ekphrasis of J.J. Winckelmann." *Word & Image: A Journal of Verbal/Visual Enquiry* 21, no. 3 (July–September 2005): 261–9.

Carruthers, Mary. *The Book of Memory: A Study of Memory in Medieval Culture.* Cambridge: Cambridge University Press, 1990.

———. "The Poet as Master Builder: Composition and Locational Memory in the Middle Ages." *New Literary History* 24 (1993): 881–904.

———. *The Craft of Thought: Meditation, Rhetoric, and the Making of Images 400–1200.* Cambridge: Cambridge University Press, 1998.

Caruso, Carlo. "L'artista al bivio: Venere àntica e Venere pòstica nel Giudizio di Paride." *Italian Studies* 60, no. 2 (Fall 2005): 163–77.

Carvalho Homem, Rui. "Couplings: Agon and Composition in Paul Muldoon's Ekphrastic Poetry." *Estudios Irelandeses* No. 0 [sic] (2005): 58–66.

———. "Hallucination or Lucidity?: Vision and Time in Ciaran Carson's Ekphrastic Writing." *Etudes Britanniques Contemporaines: Revue de la Société d'Etudes Anglaises Contemporaines* 31 (November 2006): 127–41.

———. "Of Furies and Forgers: Ekphrasis, Re-vision, and Translation in Derek Mahon." *New Hibernia Review* 8, no. 4 (December 2004): 117–38.

Casali, Sergio. "Aeneas and the Doors of the Temple of Apollo." *Classical Journal* 91 (October–November 1995): 1–9.

Cast, David. "Sir Thomas Elyot's Description of 'Detraction' and a Lost Painting by Antonio Toto." In *In Memoriam Otto J. Brendel: Essays in Archaeology and the Humanities.* Mainz: P. von Zabern, 1976. 215–25.

Castelli, Anna. "Ekphrasis e montage dell'opera di Dürer in *Doktor Faustus* di Thomas Mann." http://72.14.205.104/search?q=cache:dISGxAT-eU8J:www.lerotte.net/download/article/articolo-9.pdf+ekphrasis+OR+ecphrasis+OR+ekfrase&hl=en&ct=clnk&cd=25&gl=us&lr=lang_it

Castelli, Patrizia, *L'estetica del Rinascimento*. Bologna: Il Mulino, 2005.

Castoldi, Alberto. "*L'ékphrasis* e il nulla." In Valtolina, *L'immagine rubata* (below), 54–61.

Castro, Elena. "Relaciones interartísticas en la poesía surrealista española: El ejemplo de Maruja Mallo y Rafael Alberti." *Letras Peninsulares* 16, no. 3 (Fall–Winter 2004): 871–97.

Castro Lee, Cecilia. "Ekphrasis y encantamiento en las trilogías de Carlos Rojas." *Anales de la Literatura Española Contemporánea* 22, no. 1 (1997): 4–5, 53–74.

Catalano, Gary. "The Picture in the Poem: David Campbell's Poems on Art." *Quadrant* 46, no. 3 (March 2002): 66–70.

Caws, Mary Ann. "Narrative Voice and Second Reading: Relation and Response." *Poetics Today* 10, no. 2 (Summer 1989): 243–53.

Ceserani, Remo. "Ekphrasis and Photography: A Story by Mario Praz and a Novel by Anita Brookner." *Arcadia: Zeitschrft für Allgemeine und Vergleichende Literaturwissenschaft* 35, no. 2 (2000): 211–24.

Chabanne, Marie-Pierre. "L'Histoire de la peinture en Italie: de l'ekphrasis à la satire anti-cléricale." *Stendhal et le comique: Textes réunis et présentés par Daniel Sangsue. Bibliothèque stendhalienne et romantique.* Grenoble: ELLUG, 1999. 61–74.

Chaffee, Diane. "Ekphrasis in Juan de Mena and the Marques de Santillana." *Romance Philology* 35, no. 4 (May 1982): 609–16.

_____. "Ekphrastic and Theatrical Interior Duplication: Irony and Verisimilitude in Don Quijote's Adventure with the Basque." *Romanische Forschungen* 101, nos. 2–3 (1989): 208–20.

_____. "Visual Art in Literature: The Role of Time and Space in Ekphrastic Creation." *Revista Canadiense de Estudios Hispanicos* 8, no. 3 (Spring 1984): 311–20.

Charney, Sara Beth. *Ariosto and the Visual Arts: An Iconographical Study of Avarice.* Ph.D. dissertation, University of Toronto, 1988.

Chastel, A. "Roberto Longhi: il genio dell' 'ekphrasis.'" In G. Previtali, ed., *L'arte di scrivere sull'arte. Roberto Longhi nella cultura del nostro tempo.* Roma: Editori Riuniti, 1982. 56–65.

Chatlos, Jon. "Automobility and Lyric Poetry: The Mobile Gaze in William Carlos Williams' 'The Right of Way.'" *Journal of Modern Literature* 30, no. 1 (Fall 2006): 140–54.

Chaves, Jonathan. "Some Relationships between Poetry and Painting in China." *Renditions* 6 (1976): 85–91.

Cheeke, Stephen. *Writing for Art: The Aesthetics of Ekphrasis.* Manchester: Manchester University Press, 2008.

Cheney, David Terrance Andrew. *The Garden Ekphrasis: Visual Aspects of the Ancient Novel.* M.A. thesis, University of Calgary, 1999.

Chew, Elaine. "The PPP Connection: Poems, Paintings, Pieces: An Essay on Wang Lisan's 'Impressions of Paintings by Higashiyama Kaii.'" *Proceedings of the 7th International Congress on Musical Signification,* Imatra, 7–10 June 2001. http://www-rcf.usc.edu/~echew/papers/ppp2/EC-7ICMS-Paper.doc

Chiarini, Gioachino. "Lo scudo di Achille e lo scudo di Enea: due sintesi cosmologiche a confronto." In Ugo Rozzi, ed., *Storia per parole e per immagini.* Udine: Forum, 2006. 9–16.

Chico, Tita. "The Arts of Beauty: Women's Cosmetics and Pope's Ekphrasis." *Eighteenth Century Life* 26, no. 1 (Winter 2002): 1–23.

_____. *Designing Women: The Dressing Room in Eighteenth-Century English Literature and Culture.* Lewisburg, PA: Bucknell University Press, 2005.

Childress, Cynthia. "Art from Art: Making a Picture's Thousand Words into Poetry." *Interdisciplinary Humanities* 23, no. 1 (Spring 2006): 73–8.

Chinn, Christopher M. "Before Your Very Eyes: Pliny 'Epistulae 5.6' and the Ancient Theory of Ekphrasis." *Classical Philology* 102, no. 3 (July 2007): 265–80.

_____. *Statius and the Discourse of Ekphrasis.* Ph.D. dissertation, University of Michigan, 2002.

_____. "Statius Silv. 4.6 and the Epigrammatic Origins of Ekphrasis." *Classical Journal* 100, no. 3 (February–March 2005): 247–63.

Christoforatou, Christina. *Visualizing Medieval Otherworlds in Greco–Byzantine Romances.* Ph.D. dissertation, City University of New York, 2003.

Churchward, Dale G.F. *Representing "Shakespearean" Discourse: "Hamlet," "Cymbeline," "Timon of Athens," and "Lucrece."* Ph.D. dissertation, University of Western Ontario, 1992.

Cibelli, Deborah. "Ekphrastic Treatments of Salviati's Paintings and *Imprese.*" In de Armas, *Ekphrasis* (below), 32–58.

Ciccuto, Marcello. "Spirantia signa: cultura ecfrastica di Agnolo Poliziano." In Venturi, *Ecfrasi* (below), 123–38.

Ciferri, Laura et al. *La Madonna di Citerna: terracotta inedita di Donatello [The Citerna Madonna: An Unpublished Terracotta by Donatello].* Morbio Inferiore: Selective Art, 2004.

Cirici-Pellicer, Alexandre. "El tema del vacío central en la plástica de Velázquez." In *Varia velázqueña: homenaje a Velázquez en el III centenario de su muerte, 1660–1960.* Madrid, 1960. 1. *Estudios sobre Velázquez y su obra* (1960): 134–46.

Cisneros, James. "Remains To Be Seen. Intermedi-

ality, Ekphrasis, and Institution." In Marion Froger and Jürgen E. Müller, eds., *Intermédialité et socialité. Histoire et géographie d'un concept.* Münster: Nodus Publikationen, 2007.

Cittadini, Rita. "L'immagine e il doppio: la Prassilla di Lisippo a Palazzo Farnese." In *Politiche scientifiche e strategie d'impresa nella ricostruzione: un confronto Francia—Italia.* Rome: École Française de Rome, 2003. 909–20.

Ciuffetti, Augusto. *Casa e lavoro: dal paternalismo aziendale alle 'comunità globali' villaggi e quartieri operai in Italia tra Otto e Novecento.* [Narni]: Giada, 2004.

Civil, Pierre. "Arts visuels et art du récit dans le Persiles." *Les Langues néo-latines* 97, no. 327 (December 2003): 73–91.

Clark, David Lang. "The Masturbating Venuses of Raphael, Giorgione, Titian, Ovid, Martial, and Poliziano." *Aurora: The Journal of the History of Art* 6 (2005): 1–14.

_____. "Poliziano's *Kupris Anadyomene* and Botticelli's *Birth of Venus.*" *Word & Image: A Journal of Verbal/Visual Enquiry* 22, no. 4 (October–December 2006): 390–7.

Clay, D. "The Archaeology of the Temple to Juno in Carthage (*Aen.* 1.446–93)." *Classical Philology* 83 (July 1988): 195–205.

Clemens, Will. *A Literary Life: Poems.* Ph.D. dissertation, University of Cincinnati, 2002.

Clément, Muriel Lucie. "Une ekphrasis paradoxale des statues du Belvédère dans les 'Vingt-quatre sonnets romains' de Jacques Grévin." *Studi Francesi* 145 (anno 49, no. 1) (2005): 49–60.

_____. *Présence de l'absence: une poétique de l'art (photographie, cinéma, musique).* Ph.D. thesis, Université d'Amsterdam, 2008.

Clemente, Linda Marie. *Literary Objets D'Art: Ekphrasis in Medieval French Literature, 1150–1210.* Ph.D. dissertation, University of Oregon, 1989.

_____. *Literary Objets D'Art: Ekphrasis in Medieval French Romance, 1150–1210* (American University Studies Series II, Romance Languages and Literature). Pieterien, Switzerland: Peter Lang, 1992.

Clements, W.M. "'Image and word cannot be divided': N. Scott Momaday and Kiowa Ekphrasis." *Western American Literature* 36, no. 2 (Summer 2001): 134–52.

Clüver, Claus. "Bilder warden Worte: Zu Bildgedichter auf gegenstandlose Kunst." In Ulrich Weisstein, ed., *Literatur und bildende Kunst: Ein Handbuch zur Theorie und Praxis eines komparatistischen Grenzgebiets.* Berlin: Eric Schmidt Verlag, 1992. 298–315.

_____. "Ekphrasis Reconsidered: On Verbal Representations of Non-Verbal Texts." In Ulla-Britta Lagerroth, Hans Lund, and Erik Hedling, eds., *Interart Poetics: Essays on the Interrelations of the Arts and Media.* Amsterdam: Rodopi, 1997. 19–34.

_____. "Klangfarbenmelodie in Polychromatic Poems: A. von Webern and A. de Campos." *Comparative Literature Studies* 18 (1981): 386–98.

_____. "Letteratura e arti figurative: sul metodo." In Pulvirenti, *Muse* (below), 17–26.

_____. *Literatura comparada: os novos paradigmas. Actas do II Congreso da Associação Portuguesa de Literatura Comparada.* Porto: Publicação da Associação Portuguesa de Literatura Comparada, 1996. 39–48.

_____. "The Musikgedicht: Notes on an Ekphrastic Genre." In Walter Bernhart et al., eds., *Word and Music Studies: Defining the Field. Word and Music Studies.* 1. Amsterdam: Rodopi, 1999. 187–204.

_____. "Painting into Poetry." *Yearbook of Comparative and General Literature* 27 (1978): 19–34.

_____. "On Intersemiotic Transposition." *Poetics Today* 10 (1989): 55–90.

_____. "On Representation in Concrete and Semiotic Poetry." In Martin Heusser, *Pictured* (below), 13–42.

_____. "Quotation, Enargeia, and the Function of Ekphrasis." In Robillard, *Pictures* (below), 35–52.

_____. "(Re)Writing Edward Hopper." In Manfred Schmeling and Monika Schmitz-Emans, eds., *Das visuelle Gedächtnis der Literatur.* Würzburg: Königshausen and Neumann, 1999. 141–65.

Cohen, Keith. 'Unweaving Puig's Spider Woman: Ecphrasis and Narration." *Narrative* 2, no. 1 (January 1994): 17–28.

Cometa, Michele. *Descrizione e desiderio: i quadri viventi di E.T.A. Hoffmann.* Roma: Meltemi, 2005.

_____. "Letteratura e arti figurative: Un catalogo." *Contemporanea* 3 (2005): 17.

_____. *Parole che dipingono: letteratura e cultura visuale tra Settecento e Novecento.* Roma: Meltemi, 2004.

Conan, Michael. "Éloge de la grenouille: le paysage dans les jardins à la française au XVIIème siècle." *Journal of Garden History* 11, no. 4 (December 1991): 191–8.

_____. "Poetry into Landscape: Evolving Views of the Pastoral in Painting and Poetry from Antiquity to the Nineteenth Century." *Journal of Garden History* 17 (July–September 1997): 165–70.

Connell, Penelope Lee. *Shifts of Distance in Five Plays by Edward Bond.* Ph.D. dissertation, University of British Columbia, 1989.

Connel-Ross, Brenda Kay. *Ekphrasis: Putting the Art into Language Arts: Drawing on Art and Visual*

Representation to Teach Writing. M.A.T. thesis, University of Texas at El Paso, 2006.

Connochie-Bourgne, Chantal. "Tour et détour dans Cligès de Chrétien de Troyes: le poète, le lecteur et loeuvre bâtie." In Marie-Madeleine Castellani, ed., *Architecture et discourse. Villeneuve d'Ascq: Conseil Scientifique de l'Université Charles-de-Gaulle Lille* 3 (2006): 31–9.

Conrado, Maria Fernanda. *Ekphrasis e Bildgedicht– Processos Ekphrásticos nas Metamorfoses de Jorge de Sena.* M.A. thesis, Universidade de Lisboa, 1996.

Conroy, Derval, "Ekphrasis, Edification and the Iconography of Women: The Case of Pierre Le Moyne's *Gallerie des femmes fortes* (1647)." In Michael Brophy, Phyllis Gaffney, and Mary Gallagher, eds., *Reverberations: Staging Relations in French Since 1500.* Dublin: UCD Press, 2008.

_____, and Johnnie Gratton, eds. *L'Œil écrit. Études sur des rapports entre texte et image, 1800–1940.* Geneva: Slatkine, 2005.

Consilio, Carmen. "Reading History through the Landscape: Ekphrasis in the Fiction of M. Ondaatje and R. Gunesekera." *SAVAL Conference Papers.* Johannesburg: University of Witwatersrand, 1998.

"Conventions of Ekphrasis." 2 July 2003. http://calamity.wordherders.net/archives/000422.html

Costantini, Michel. "Qu'est-ce qu'une transsémiose? Chénier, David et la peinture antique." In Rémy Poignault, ed., *Anniversaires 1994: Présence de l'antiquité chez Grégoire de Tours, François Rabelais, Voltaire, André Chénier, Anatole France, Jean Giraudoux. Collection Caesarodunum.* 29 1/2. Tours, France: Centre de Recherches André Piganiol, Université de Tours, 1996. 113–26.

Cooke, Peter. "Art Criticism and the Transposition of Art with Reference to 'Galatee' and 'Helene' by Gustave Moreau (1880 salon)." *Romantisme* 32, no. 118 (2002): 37–53.

Corbett, David Peters. "Ekphrasis, History and Value: Charles Ricketts's Art Criticism." *Word & Image: A Journal of Verbal/Visual Enquiry* 15, no. 2 (April–June 1999): 128–40.

_____. "Oedipus and the Sphinx: Visual Knowledge and Homosociality in the Ricketts Circle." *Visual Culture in Britain* 8, no. 1 (Summer 2007): 59–72.

Corbineau-Hoffmann, Angelika. "Architekturen der Vorstellung: Ansätze zu einer Geschichte architektonischer Motive in der Literatur." In Nerdinger, *Architektur* (below), 27–39

Corgnati, Martina. "Le immagini affamate: donne e cibo nell'arte; dalla natura morta ai disordini alimentary" ["Les images affamées: femmes et nourriture dans lart; de la nature morte aux désordres alimentaires"]. In Martina Corgnati, ed.,

Le immagini affamate: donne e cibo nell'arte. Aosta, 2005. 14–28.

Corn, Alfred. "Notes on Ekphrasis." *Academy of American Poets Newsletter* January 2008. http://www.poets.org/viewmedia.php/prmMID/19939

Cornell, Peter. "The Text in the Painting and the Painting in the Text: Some Reflections on Literary Interpretation." *Icon to Cartoon: A Tribute to Sixten Ringbom.* Helsinki: Society for Art History in Finland, 1995. 55–63.

Corrain, Lucia. "Scrivere con il pennello, dipingere con la penna. Lo sguardo di Perec e l'*ekphrasis.*" In Valtolina, *L'immagine rubata* (below), 37–53.

Corse, Taylor. "The Ekphrastic Tradition, Literary and Pictorial Narrative in the Epigrams of John Elsum, an Eighteenth-Century Connoisseur." *Word & Image: A Journal of Verbal/Visual Enquiry* 9, no. 4 (October–December 1993): 383–400.

Cosgrove, Brian. "Murray Krieger: Ekphrasis as Spatial Form, Ekphrasis as Mimesis." In Jeff Morrison and Florian Krobb, eds., *Proceedings of the Interdisciplinary Bicentenary Conference held at St. Patrick's College, Maynooth (The National University of Ireland) in September 1995.* Internationale Forschungen zur allgemeinen und verleichenden Literaturwissenschaft, 20. Amsterdam & Atlanta, GA: Rodopi, 1997. 25–31

Cosper, Dale. "Iconophilia and Iconophobia in Saint-Amant." In Rubin, *Word and Image* (below), 55–75.

Costantini, Michel, and Françoise Graziani. *Defi de l'art: L'Ekphrasis Selon Philostrate et Callistrate (Revue la Licorne).* Rennes: Presses Universitaires de Rennes, 2006.

Cots, Montserrat. "Figuras de la evidencia en *La Franciade.*" In Francisco Lafarga and Marta Segarra, eds., *Renaissance & Classicisme.* Barcelona: Promociones y Publicaciones Universitarias (PPU), 2004. 41–52.

Cottegnies, Line. "'Speechless Discourse': Image et discours dans un traité d'art du milieu du XVIIe siècle." *Bulletin de la Societe d'Etudes Anglo-Americaines des XVIIe et XVIIIe Siecles* 40 (June 1995): 7–25.

Cowling, David. *Building the Text: Architecture as Metaphor in Late Medieval and Early Modern France.* Oxford: Oxford University Press, 1998.

Coyrault, Sylviane. "Les Illuminations de Pierre Michon." In Ivan Farron and Karl Kürtös, eds., *Pierre Michon entre pinacothèque et bibliothèque.* Collection Variations. 4. Bern, Switzerland: Peter Lang, 2003. 35–55.

Crane, Susan Lynn. *Describing the World: Aldhelm's "Enigmata" and the Exeter "Riddles" as Examples of Early Medieval Ekphrasis.* Ph.D. dissertation,

State University of New York at Stony Brook, 2006.

Craven, Naomi Louise. *Behind the Gilded Edge: The Framing of Women in Nineteenth-Century Fiction.* M.A. thesis, University of Texas, San Antonio, 2008.

Crescenzo, Richard. *Peintures d'instruction: la postérité littéraire des Images de Philostrate en France de Blaise de Vignère à l'époque classique.* Genève: Librairie Droz, 1999.

Crichfield, G. Review of Marta Caraion, *Pour fixer la trace: photographie, littérature et voyage au milieu du XIXe siècle.* *Nineteenth-Century French Studies* 36 no. 1–2 (Fall 2007–Winter 2008): 150–1.

Criscuolo, Ugo. "Note all'*Ekphrasis* di Costantino Rodio." *Atti della Accademia Pontaniana,* n.s., 38 (1989): 141–9.

Croce, Erica. *Parole e imagine: ricerche sulla litteratura ecfrastica tra Rinascimento e Barocco.* Thesis, Universita degli Studi di Padova, 1997.

Csuros, Klára. "La Fonction de l'ekphrasis dans les longs poèmes: grande genre, grand œuvre, poème héroïque." *Nouvelle Revue du Seizieme Siecle* 15, no. 1 (1997): 169–83.

Cummins, Thomas. "From Lies to Truth: Colonial Ekphrasis and the Act of Crosscultural Translation." In Claire J. Farago, ed., *Reframing the Renaissance: Visual Culture in Europe and Latin America, 1450–1650.* New Haven: Yale University Press, 1995. 152–74.

_____. "El Lenguage del Arte Colonial: Imagen, Ekfrasis, y Idolatría." *I Encuentro Internacional de Peruanistas: Estado de Estudios Histórico–Sociales sobre el Perú a fines del Siglo XX.* Lima: Unversidad de Lima y Fondo de Cultura Económica. 23–45.

Cunci, Marie-Christine. "Sinclair Lewis et Edward Hopper: objets d'art et d'utilit é dans la chambre Claire." *Les Cahiers d'Inter-Textes.* Paris: Centre de recherche Inter-Textes Arts et Littératures modernes, 1985.

Cunningham, Valentine. "Why Ekphrasis?" *Classical Philology* 102, no. 1 (January 2007): 57–71.

Cupane, Carolina. "Künstliche Paradiese: Ortsbeschreibungen in der vulgärsprachlichen Dichtung des späten Byzanz." In Ratkowitsch, *Die poetische* (below), 221–45.

Cushman, Jennifer S. "Beyond Ekphrasis: Logos and Eikon in Rilke's Poetry." *College Literature* 29, no. 3 (Summer 2002): 83–108.

Cussinet, Marie-France. "A propos des peintures de M. Lenepveu au théâtre d'Angers." In Pascale Auraix-Jonchière, ed., *Ecrire la peinture entre XVIIIe et XIXe siècles.* Révolutions et Romantismes. 4. Clermont-Ferrand, France: Presses Universitaires Blaise Pascal, 2003. 119–25.

Cusatelli, Giorgio. "Il progetto della Kunstschreibung." In Maria Fancelli, ed., *J.J. Winckelmann tra letteratura e archeologia.* Venezia: Marsilio, 1993. 47–53.

Czerminska, Malgorzata. "Ekphrasis in Szymborska's Poetry." In Leonarda Neugera and Rikarda Wennerholma, eds., *Wisława Szymborska–a Stockholm Conference May 23–24, 2003.* Stockholm: The Royal Academy of Letters, History and Antiquities, 2006. 148–63.

_____. *Gotyk i pisarze: topika opisu katedry.* Gdansk: Slowo/obraz terytoria, 2005.

Da'An Pan. "Tracing the Traceless Antelope: Toward an Interartistic Semiotics of the Chinese Sister Arts." *College Literature* 23, no. 1 (February 1996): 36–66.

D'Agostini, Maria Enrica. "Il Genio di Rodi di Alexander von Humboldt: La descrizione come racconto." *Torre di Babele: Rivista di Letteratura e Linguistica* 1 (2003): 11–19.

Daley, Margaretmary. "The Gendered Eye of the Beholder: The Co-ed Art History of the Jena Romantics." In Evelyn K. Moore and Patricia Anne Simpson, eds., *The Enlightened Eye: Goethe and Visual Culture.* Amsterdamer Beiträge zur Neueren Germanistik. 62. Amsterdam: Rodopi, 2007. 93–110.

Dandrey, Patrick. "'Pictura loquens: l'ekphrasis' poétique et la naissance du discours esthétique en France au XVIIe siècle." In Bonfait, *La description* (above), 93–120.

Danek, Georg. "'Ein Bild von einem Helden': Ekphrasis im bosnisch-muslimischen Heldenlied; (Avdo Mededović, 'Die Hochzeit des Vlahinjić Alija')." In Ratkowitsch, *Die poetische* (below), 247–66.

D'Angelo, Frank J. "The Rhetoric of Ekphrasis." *JAC: A Journal of Composition Theory* 18, no. 3 (1998): 439–47.

Daniel, Lee A. "Ekphrasis en 'El impostor' de Rima de Vallbona." In Juana Alcira Arancibia et al., eds., *Protestas, interrogantes y agonías en la obra de rima de Vallbona, III: La mujer en la literatura hispánica. Colección La Mujer en la Literatura Hispánica.* 3. Westminster, CA: Instituto Literario y Cultural Hispánico, 1997. 183–9

Dara, Kathleen M. *Love Calls Us to Defenseless Things: How Ekphrasis Enriches the Arts.* D.Litt. dissertation, Drew University, 2005.

Davidson, Drew. "Ekphrastic Academia: Images, Sounds and Motions in Academic Discourse." http://waxebb.com/writings/ekphrasis.html

Davidson, Michael. "Ekphrasis and the Postmodern Painter Poem." *Journal of Aesthetics and Art Criticism* 42, no. 1 (Fall 1983): 69–79.

_____. "Ekphrasis a postmodernistyczne wiersze-

obrazy." In Marii Gołaszewskiej, ed., *Estetyka w świecie. Wybór tekstów*. Inst. Filozofii UJ, 1984.

———. "The Thematic Use of Ekphrasis in the Ancient Novel." In B.P. Reardon, ed., *Erotica Antiqua: Acta of the International Conference on the Ancient Novel*. Bangor: University of Wales, 1977. 32–3

Davis, William V. "'This Is What Art Could Do': An Exercise in Exegesis: R.S. Thomas's 'Souillac: Le Sacrifice d'Abraham.'" *Religion and the Arts* 4, no. 3 (2000): 374–87.

Dechery, Laurent. "Turning Words into Colors: Robbe-Grillet's Visual Language." *Mosaic* 32, no. 3 (September 1999): 59–74.

de Armas, Frederick Alfred. "Ekphrasis and Eros in Cervantes' *La Galatea*: The Case of the Blushing Nymphs." In Francisco La Rubia Pardo, ed., *Cervantes for the 21st Century: Essays in Honor of Edward Dudley*. Newark, DE: Juan de la Cuesta, 2000. 33–47

———, ed. *Ekphrasis in the Age of Cervantes*. Lewisburg, PA: Bucknell University Press, 2005. **Reviews:** Baena, Julio. *Revista de Estudios Hispanicos* 42, no. 2 (May 2008): 373–5. Barnard, M.E. *Hispanofila* 152 (January 2008): 159–161. Friedman, E.H. *Hispania* 89, no. 4 (December 2006): 873–5. Polchow, Shannon M. *Comparative Literature Studies* 43, no. 4 (2006): 537–44. Welles, Marcia A. *Cervantes* 25, no. 2 (22 September 2005: 147–59. Also available at http://www.h-net.org/~cervantes/csa/articf05/wellesf05.pdf

———. "The Eloquence of Mercury and the Enchantments of Venus: Humanitas in Botticelli and Cervantes's *Don Quixote*." *Laberinto. An Electronic Journal of Early Modern Hispanic Literatures* 2 (1998). 8 Oct. 2004. http://www.gc.maricopa.edu/laberinto/fall98/armas.htm. Rpt. in William S. Haney and Peter Malekin, eds., *Humanism and the Humanities in the Twenty-First Century*. Lewisburg: Bucknell University Press, 2001. 118–36.

———. "From Manuta to Madrid: The License of Desire in Giulio Romano, Correggio and Lope de Vega's *El Castigo Sin Venganza*." *Bulletin of the Comediantes* 59, no. 2 (2007): 233–65.

———. "The Hermetic Raphael: Ekphrasis in *Don Quixote* and John Crowley's *Aegypt*." *Central Institute of English and Foreign Languages Bulletin* 15–16, no. 1–2 (December 2005–June 2006): 133–54.

———. "(Mis)placing the Muse: Ekphrasis in Cervantes' *La Galatea*." In de Armas, *Writing* (below), 23–40.

———. "Painting Dulcinea: Italian Art and the Art of Memory in Cervantes' *Don Quijote*." *Yearbook of Comparative and General Literature* 49 (2001): 3–19.

———. "Painting with Blood and Dance: Titian's *Salome* and Cervantes's *El retablo de las maravillas*." In de Armas, *Ekphrasis* (above), 217–33.

———. *Quixotic Frescoes: Cervantes and Italian Renaissance Art*. Toronto: University of Toronto Press, 2006. **Reviews:** Cohen, Jaclyn. *MLN* 124, no. 1 (January 2009): 318–19. Conrod, Frédéric. *Revista de Estudios Hispánicos* 42, no. 1 (2008): 185–6. Scham, Michael. *Cervantes: Bulletin of the Cervantes Society of America* 26 (2006): 303–7. Wilson, Diana de Armas. *Comparative Literature Studies* 45, no. 3 (2008): 388–90.

———. "Simple Magic: Ekphrasis from Antiquity to the Age of Cervantes." In de Armas, *Ekphrasis* (above), 13–31.

———. "To See What Men Cannot: Teichoskopia in *Don Quijote* I." *Cervantes* 28, no. 1 (Spring 2008): 83–102.

———. "At War with Primavera: Botticelli and Calderón's *El Sitio de Breda*." *Hispania* 82, no. 3 (September 1999): 436–47.

———, ed. *Writing for the Eyes in the Spanish Golden Age*. Lewisburg, PA: Bucknell University Press, 2004.

Debby, Nirit Ben-Aryeh. "War and Peace: The Description of Ambrogio Lorenzetti's Frescoes in Saint Bernardino's 1425 Siena Sermons." *Renaissance Studies: Journal of the Society for Renaissance Studies* 15, no. 3 (September 2001): 272–86.

De Candia, Angelo. "Dalla descrizione verbale alla rappresentazione grafica dello spazio costruito." In Paola Clerici Maestosi, ed., *L'attività: le tesi dal 1990 al 1995*. Roma: Kappa, 2000. 79–90.

De Ciantis, Cheryl. *The Return of Hephaistos: Reconstructing the Fragmented Mythos of the Maker*. Ph.D. dissertation, Pacifica Graduate Institute, 2005.

Décultot, Elisabeth. "Peinture de paysage et description: quelques débats allemands autour de 1800." In Bonfait, *La description* (above), 201–14.

Dejbord-Sawan, Parizad. "Prácticas visuales revisionistas en 'Claroscuro,' 'La lección de guitarra' y 'El origen del mundo' de Cristina Peri Rossi." *Chasqui: Revista de Literatura Latinoamericana* 36, no. 1 (May 2007): 80–95.

de Jong, Irene J.F. "De novis libris iudicia." *Mnemosyne* 52, no. 3 (June 1999): 336–7.

de Jong, Jan L, ed. *Describing Depictions vs. Depicting Descriptions*. London: Routledge, 2003.

———. "1530: Getekend, gegraveerd en geschilderd. Een ekphrasis van Lucianus bij Rosso Fiorentino, Jacob Binck en Correggio." *Desipientia* 6, no. 1 (June 1999): 4–10.

———. "Il pittore a le volte è puro poeta: Cupid and Psyche in Italian Renaissance Painting." In M. Zimmerman et al., eds., *Aspects of Apuleius'*

Golden Ass, vol. 2: *Cupid and Psyche: A Collection of Original Papers*. Groningen: Egbert Forsten, 1998. 189–215.

_____. "Introduction." *Visual Resources* 19, no. 4 (December 2003): 253–7.

_____. "Word Processing in the Italian Renaissance: Action and Reaction with Pen and Paintbrush." *Visual Resources* 19, no. 4 (December 2003): 259–81.

Delbeke, Maarten. "A Poem, a Collection of Antiquities and a Saviour by Raphael: A Case-Study in the Visualization of Sacred History in Early Seventeenth-Century Rome." *Word & Image: A Journal of Verbal/Visual Enquiry* 20 (2004): 87–106.

Delinière, Jean. "Discours et peinture dans Les Années de voyage de Wilhelm Meister de Goethe." In Pascale Auraix-Jonchière, ed., *Ecrire la peinture entre XVIIIe et XIXe siècles*. Révolutions et Romantismes. 4. Clermont-Ferrand, France: Presses Universitaires Blaise Pascal, 2003. 435–50.

Della Torre, Stefano. "Dalla lettura della 'forma urbis' al restauro tipologico." In Claudio D'Amato, ed., *Gianfranco Caniggia: dalla lettura di Como all'interpretazione tipologica della città*. Bari: Adda, 2003. 81–8.

Del Val, Edward James. *The Allure of Ekphrasis*. M.A. thesis, San Francisco State University, 1999.

Demakopoulos, G. *Lexe kai ekfrase. Lexologikes askeseis me tis apanteseis*. Athene: Gregore, 2000.

Demeuse, Sarah. "'Ponte aquí al ledo': Ekphrasis and Deception in Anna Rossetti's and José Duarte's *Simparidades*." *Cultural Critique* 72 (Spring 2009): 203–24.

Demetrakopoulos, G. *E neoellenike mas glossa: sumbole sten ekfrase-ekthese: Gia ten ler gummasiou*. Athéna Ekdoseis Gutenberg, 1987.

Demetriou, Cynthia. "Lessons in Ekphrasis." *Academic Exchange Quarterly* 10, no. 2 (22 June 2006): 211–15.

Demus, Otto. "'The sleepless watcher': ein Erklärungsversuch." In Irmgard Hutter, ed., *Studies in Byzantium, Venice and the West*, 2 vols. London: Pindar, 1998. 150–4.

Denizot, Paul. "Ecriture et peinture dans Le Voyage sentimental." *Bulletin de la Societe d'Etudes Anglo-Americaines des XVIIe et XVIIIe Siecles* 40 (June 1995): 35–46.

Dennis, K. "The Image Made Flesh: A Photographic Re-reading of the Pygmalion Myth." *Analecta Husserliana* 81 (2004): 241–56.

Dennison, Julie. "'His Fundamental Passion': Hugh Selwyn Mauberley and the Ekphrastic Vortex of 'The Eyes.'" *Paideuma: A Journal Devoted to Ezra Pound Scholarship* 30, nos. 1–2 (Spring–Fall 2001): 185–200.

Deppman, Jed. "History in the Poetry of Prospero Saiz: A Reading of 'Document.'" *MELUS* 30 (2005): 205–33.

Deramaix, Marc. "Urna novis variata figuris. Ekphrasis métapoétique et manifeste littéraire dans le *De partu Virginis* de Sannazar." In Perrine Galand-Hallyn and Carlos Lévy, eds., *Vivre pour soi, vivre dans la cité. De l'antiquité à la Renaissance*. Presses de l'Université Paris-Sorbonne, 2006.

Deroux, Carl. "Some Remarks on the Handling of Ekphrasis in Catullus 64." *Studies in Latin Literature and Roman History*, ed. Carl Deroux. Brussels: Latomus, 1986. 247–58.

Derrida, Jacques. "Penser à ne pas voir." In Valtolina, *Annali* (below), 49–74.

Desiatov, Viacheslav. "Arnol'd Shvartsenegger-poslednii geroi russkoi literatury." In Geller, *Ekfrasis* (below), 190–8.

Desmas, Anne-Lise. *La description de l'oeuvre d'art: du modèle classique aux variations contemporaines /Academie de France à Rome. Actes du colloque organisé par Olivier Bonfait*. Paris: Somogy, Éditions d'Art, 2004.

Dessons, G. "The Poems of Henri Michaux as Readings of Paintings." *Litterature* 115 (September 1999): 48–54.

Deuling, Judy K. "Allusions to Structures and Works of Art in the *Aeneid*: A Revised Approach for Roman Epic." In Roald F. Docter and Eric M. Moorman, eds., *Proceedings of the XVth International Congress of Classical Archaeology*, Amsterdam, July 12–17, 1998. Classical Archaeology Towards the Third Millennium: Reflections and Perspectives (Amsterdam), 142–4.

de Vries, Lyckle. "Written Paintings: Real and Imaginary Works of Art in De Lairesse's *Schilderboek*." In de Jong, *Describing* (above), 307–20.

Diba, Layla S. "Invested with Life: Wall Painting and Imagery before the Qajars." *Iranian Studies: Journal of the Society for Iranian Studies* 34, nos. 1–4 (2001): 5–16.

Dickey, Frances. "Parrot's Eye: A Portrait by Manet and Two by T. S. Eliot." *Twentieth Century Literature* 52, no. 2 (Summer 2006): 111–44.

Diels, Hermann. *Über die von Prokop beschriebene Kunstuhr von Gaza, mit einem Anhang enthaltend Text und Übersetzung der Ekphrasis horologiou de Prokopius von Gaza*. Berlin: G. Reimer, 1917.

Diemer, Peter. "Abt Suger von Saint-Denis und die Kunstschätze seines Klosters." In Boehm and Pfotenhauer, *Beschreibungskunst* (above), 177–216.

Diers, Michael. "Ein Scherbengericht: zur politischen Ikonographie von Heinrich von Kleists Lustspiel *Der zerbrochne Krug*." In Pauline Helas et al., eds., *Bild/Geschichte: Festschrift für Horst*

Bredekamp. Berlin: Akademie Verlag, 2007. 461–79.

Dieterle, Bernard. *Erzählte Bilder. Zum narrativen Umgang mit Gemälden.* Marburg: Hitzeroth, 1988.

Di Piero, W.S. *Shooting the Works: On Poetry and Pictures.* Evanston, IL: Northwestern University Press, 1996.

Dillingham, T.F. "The Puritan of Words." *American Book Review* 25, no. 6 (September–October 2004): 22, 24.

Dolbec, Nathalie. "D'un tableau l'autre: Le parcours de l'ekphrasis dans 'Volkswagen Blues' de Jacques Poulin." *Canadian Literature* 184 (Spring 2005): 27–43.

Dolezal, Mary-Lyon, and Maria Mavroudi. "Theodore Hyrtakenos' 'Description of the Garden of St. Anna' and the Ekphrasis of Gardens." In Antony Robert Littlewood, ed., *Byzantine Garden Culture.* Washington, DC, 2002. 105–58.

Donaldson, Jeffery. "Ekphrastic Enlargements: The Daguerreotype and Richard Howard's 'Homage to Nadar.'" *Canadian Review of American Studies* 22, no. 3 (Winter 1991): 529–49.

Doody, Margaret Anne. "Chap. XVII. Ekphrasis: Looking at the Picture," and "Chap. XVIII. Ekphrasis: Dreams and Food." In Doody's *The True Story of the Novel.* New Brunswick, NJ: Rutgers University Press, 1995. 387–404, 405–31.

Donnelly, Brian. *Rebuilding "The House of Life": Dante Gabriel Rossetti, Ekphrasis, and Victorian Sexuality.* Ph.D. dissertation, University of York, 2005.

_____. "Sensational Bodies: Lady Audley and the Pre–Raphaelite Portrait." *Victorian Newsletter* 112 (Fall 2007): 69–90.

Dorangeon, Simone, ed. *La représentation des arts visuals.* Actes du colloque annuel du Centre de Recherche sur l'Imaginaire de l'UFR Lettres de Reims. Reims: Presses Universitaires de Reims, 1998.

Döring, Tobias. "Turning the Colonial Gaze: Carribean-English Ekphrasis" and "Writing Across the Meredian." Chapts. 5 and 6 of Döring's *Carribean-English Passages: Intertextuality in a Postcolonial Tradition.* London: Routledge, 2001. 137–202.

D'Ormea, Maria Pia. "Le miniature del messale Borgia nell'antica Biblioteca Capitolare di Chieti." In Raffaele Colapietra, ed., *Storia come presenza: saggi sul patrimonio artistico abruzzese. Rivista abruzzese* 38 (1985): 23–9, 67–80.

Downey. Glanville. "Description of the Church of the Holy Apostles at Constantinople by Nikolaos Mesarites." *Transactions of the American Philosophical Society,* new series 47, pt. 6 (1957). Review: Scranton, Robert. *Speculum* 33, no. 4 (October 1958): 557–8.

_____. "Ekphrasis." In *Reallexikon für Antike und Christentum* 4 (Stuttgart, 1959): cols. 921–44.

Downing, Crystal. "The Visual and the Verbal in *Middlemarch.*" *PMLA* 112, no. 3 (May 1997): 434–5.

Drewer, Lois. "Recent Approaches to Early Christian and Byzantine Iconography." *Studies in Iconography* 17 (1996): 1–65.

Driscoll, Eric. "Hellenistic Ekphraseis and Art." http://student-ww.uchicago.edu/~edris/pdfs/ekphrasis.pdf

Druce, Robert. "Information Control and Making: The Pragmatics of a Sestina." *Word & Image: A Journal of Verbal/Visual Enquiry* 5, no. 3 (September 1989): 292–99.

Drügh, Heinz J. *Ästhetik der Beschreibung: poetische und kulturelle Energie deskriptiver Texte (1700–2000).* Tübingen: Francke, 2006.

_____. "Kleists medienanalytische Ekphrasis." In Claudia Albes and Christiane Frey, eds., *Darstellbarkeit: zu einem ästhetisch-philosophischen Problem um 1800.* Würzburg: Königshausen & Neumann, 2003.

_____. "Präsenzen und Umwege-Kleists medienanalytische Ekphrasis." In Claudia Albes and Christiane Frye, eds., *Darstellbarkeit: Zu einem ästhetisch-philosophischen Problem um 1800.* Stiftung für Romantikforschung. 23. Wiesbaden, Germany: Königshausen & Neumann, 2003. 181–207.

_____. "Von der ästhetischen Illusion zur Zeichenmaterialität: Ekphrasis in Heinrich von Kleists Zerbrochenem Krug." In Joachim Knape and Elisabeth Gruner, eds., *Bildrhetorik.* Baden-Baden: Verlag Valentin Koerner, 2007. 377–402.

_____, and Maria Moog-Grünewald, eds. *Behext von Bildern? Ursachen, Funktionen und Perspektiven der textuellen Faszination durch Bilder. Neues Forum für allgemeine und vergleichende Literaturwissenschaft.* 12. Heidelberg: Carl Winter Universitätsverlag, 2001.

Drumm, Elizabeth. "Ekphrasis in Valle-Inclan's *Comedias barbaras.*" *Revista de Estudios Hispanicos* 34, no. 2 (May 2000): 391–410.

Drummond, Margaret Marina. *The Art of Failure in Carmen 64: "Nulla Domus," "Nullus Amor" in Catullus.* M.A. thesis, University of Alberta, 1990.

Dubel, Sandrine. "Ekphrasis et enargeia: la description antique comme parcours." In C. Lévy and L. Pernot, eds., *Dire l'évidence (philosophie et rhétorique antiques).* Paris, Montréal: l'Harmattan, 1997. 249–64.

_____. "Remarques sur l'ecphrasis antique: nature et statut de l'objet d'art dans la description littéraire." *Histoire de l'art* 25–26 (1994).

DuBois, Page Ann. *The Daedale Hand: Ekphrasis in Homer, Virgil, and Spenser.* Ph.D. dissertation, University of California, Berkeley, 1973.

_____. "'The Devil's Gateway': Women's Bodies and the Earthly Paradise." *Women's Studies* 7, no. 3 (1980): 43–58.

_____. *History, Rhetorical Description and the Epic: From Homer to Spenser.* Cambridge: Cambridge University Press, 1982. 28–51. **Reviews:** Desmond, Marilynn. *Comparative Literature* 38, no. 1 (Winter 1986): 96–8. Kellner, Hans. *MLN* 98, no. 5 (December 1983): 1339–41. Lea, K.M. *Review of English Studies* (new series) 36, no. 142 (May 1985): 254–6.

_____. "Reading the Writing on the Wall." *Classical Philology* 102, no. 1 (January 2007): 45–56.

Dubost, Jean-Pierre. "Iconolâtrie et iconoclastie de l'écriture libertine." In Wagner, *Icons* (below), 43–57.

Dufallo, Basil. "Ecphrasis and Cultural Identification in Petronius' Art Gallery." *Word & Image: A Journal of Verbal/Visual Enquiry* 23, no. 3 (July–September 2007): 290–304.

Dupras, Joseph A. "Browning's 'My Last Duchess': Paragon and Parergon." *Papers on Language & Literature* 32 (Winter 1996): 3–20.

Dziadek, A. "Problem ekphrasis — Dwa widoki Delf." *Teksty Drugie* 4 (2000) (Warszawa: IBL PAN).

Echenberg, Margo. "Self-Fashioning through Self-Portraiture in Sor Juana Inés de la Cruz." In Mary C. Carruth, ed., *Feminist Interventions in Early American Studies.* Tuscaloosa: University of Alabama Press, 2006. 27–41.

Eck, Virginie. "L'Ekphrasis au travers des textes de Cébès de Thèbes, Lucien de Samosate et Philostrate de Lemnos: traductions et interprétations aux XVè, XVIè et XVIIè siècles." DESS Ingénierie documentaire, Rapport de recherche bibliographique. 2003 http://www.enssib.fr/bibliotheque-numerique/document-729

Eckard, Gilles. "*Amplificatio* et *ekphrasis* dans la *Philomena* de Chrétien de Troyes. Observations sur l'adaptation en langue vulgaire des auteurs de l'antiquité classique au XIIe siècle." In Michel Erman and Philippe Monneret, eds., *Imaginaires et styles fin de siècle, Mélanges offerts à Jean Foyard.* Dijon: ABELL, 2006. 121–32.

Eckardt, Liselotte. *Exkurse und Ekphraseis bei Lucan.* Innaugural dissertation, Bottrop, 1936.

Ecrits sur l'art–2: Décrire l'oeuvre d'art/Describing the Artwork. Colloque international organisé par la S.A.I.T. Institut du Monde Anglophone, Paris III, Sorbonne Nouvelle 20 et 21 juin 2008. Abstracts of the papers in the list that follows are at http://74.125.45.104/search?q=cache:-65PCjJiufsJ:www.textesetsignes.org/Abstracts%2520SAIT%25202008.doc+ekphrasis+OR+ecphrasis&hl=en&ct=clnk&cd=107&gl=us&lr=lang_fr:

Yann Tholoniat, "Du Haggis et du whisky: poétique et politique de l'ekphrasis chez Robert Burns"

Caroline Bertonèche, "Décrire l'oeuvre d'art selon Keats: culture hellénique, *ekphrasis* féminine et modernité sexuelle dans les *Odes*"

Gilles Soubigou, "Walter Scott et le discours sur l'art: de l'oeil de l'antiquaire au regard du conteur"

Juliette Giraudeau, "Harmonies et discordances: l'ekphrasis musicale dans *The Mill on the Floss* et *Middlemarch* de George Eliot"

Carla Taban, "Samuel Beckett: du discours descriptif, fictif et critique sur la peinture à la contiguïté du discursif et du pictural"

Marie Bouchet, "L'ekphrasis nabokovienne, ou quand l'image enchante le langage"

Caroline Marie, "A Very Practical Utopia: *Alva & Irva* d'Edward Carey ou la transmodalité de l'art comme utopie"

Laurent Châtel, "William Beckford's *Biographical Memoirs of Extraordinary Painters* or the subversion of *Lives of the Artists*"

Dana Arnold, "It is not writing in the full sense of the word': Graphic Notations of Architecture as a Mode of Ekphrasis"

Paul Tucker, "The Changing Role of Description in Art Writing in English (1685–2007)"

Konstantinos Vassiliou, "Between Norm and Description: Art Writing and Postmodern Philosophy"

Robert Reay-Jones, "Performative Criticism : Logic, Ethics, Pragmatics"

Baldine Saint Girons, "L'Acte esthétique et la démangeaison de témoigner"

Isabelle Schwarz, "Propositions, Ideas and Concepts by Artists: Artists' Writing in Conceptual Art"

Jon Shaw, "*Untitled*—On Sculpture and Negation"

Laurence Corbel, "'Les mots pris dans les yeux': l'art de la critique chez Robert Smithson"

Robert Slifkin, "Philip Guston's 'Book' Paintings: Lateral Aesthetics and Literary Longing in 1960s Art"

Edgecombe, Rodney Stenning. "Dickens, Opie, and Poussin's *Deluge.*" *Explicator* 67, no. 1 (Fall 2008): 16–19.

_____. "Hood, Dickens, Auden and Churchyard Revels." *Notes and Queries* 253, no. 1 (March 2008): 43.

_____. "Trans-formal Translation: Plays into Bal-

lets, with Special Reference to Kenneth Macmillan's *Romeo and Juliet.*" *Yearbook of English Studies* 36, no. 1 (2006): 65–78.

_____. "A Typology of Ecphrases." *Classical and Modern Literature: A Quarterly* 13, no. 2 (Winter 1993): 103–16.

Egan, Ronald C. "Poems on Paintings: Su Shih and Huang T'ing-chien." *Harvard Journal of Asiatic Studies* 43, no. 2 (December 1983): 413–51.

Eglinger, Hanna and Annegret Heitmann, eds. *Bild-DurchSchrift: zum visuellen Diskurs in der skandinavischen Gegenwartsliteratur.* Freiburg im Breisgau: Rombach, 2002.

Eguchi, Osamu. "Image et rythme — L'ecphrasis et le blazon." *Review of Liberal Arts* 105 (2003): 23–36. [In Japanese]

Eidt, Laura M. Sager. *Writing and Filming the Painting: Ekphrasis in Literature and Film.* Amsterdam: Rodopi, 2008.

"Ekphrasis." *Oxford Classical Dictionary*, 3rd ed. (1996).

Ekphrasis: A Poetry Journal. Eds. Laverne Frith and Carol Frith. Available from Firth Press, P.O. Box 161236, Sacramento, CA 95816–1236 or www.hometown.aol.com/ekphrasis1

Elsner, Jaś. *Art and the Roman Viewer: The Transformation of Art from the Pagan World to Christianity.* Cambridge: Cambridge University Press, 1995.

_____, ed. *Art and Text in Roman Culture.* Cambridge: Cambridge University Press, 1996. **Review:** Brilliant, Richard. *Journal of Roman Archaeology* 11 (1998): 557–65.

_____. "From Empirical Evidence to the Big Picture: Some Reflections on Riegl's Concept of Kunstwollen." *Critical Inquiry* 32, no. 4 (Summer 2006): 741–66.

_____. "The Genres of Ekphrasis." *Ramus: Critical Studies in Greek and Roman Literature* 31 (2002): 1–18.

_____. "Preface" (Passmore–Edwards Symposium on Ekphrasis, Corpus Christi College, Oxford, September, 2002). *Ramus: Critical Studies in Greek and Roman Literature* 31 (2002): vii ff.

_____. *Roman Eyes: Visuality and Subjectivity in Art and Text.* Princeton, NJ: Princeton University Press, 2007.

_____. "Seeing and Saying: A Psycho-Analytic Account of Ekphrasis." *Helios* 31 (2004): 157–85. Trans. into Polish by W. Michera as "Patrzeć i mówić: ekfraza w ujęciu psychoanalitycznym." *Konteksty*, No.1 (2006).

_____. *The Verbal and the Visual: Cultures of Ekphrasis in Antiquity.* Bendigo North, Victoria: Aureal Publications, 2002.

_____. "Viewing Ariadne: From Ekphrasis to Wall Painting in the Roman World." *Classical Philology* 102, no. 1 (January 2007): 20–44.

Emden, Christian, Catherine Keen, and David Midgley, eds. *Imagining the City.* Oxford: Lang, 2006.

Emery, Mary Lou. "Ekphrasis/Diasporic Caribbean Imaginations 1960–2000." In Emery's *Modernism, the Visual, and Caribbean Literature.* Cambridge: Cambridge University Press, 2007. 180–234.

_____. "Refiguring the Postcolonial Imagination: Tropes of Visuality in Writing by Rhys, Kincaid, and Cliff." *Tulsa Studies in Women's Literature* 16, no. 2 (Fall 1997): 259–80.

_____. "'Spaces Sounds' in Wilson Harris's Recent Fiction." *Review of Contemporary Fiction* 17 (Summer 1997): 98–103.

Engelhardt, Dietrich von. "Beschreibung in der Medizin." In Boehm and Pfotenhauer, *Beschreibungskunst* (above), 607–16.

Epstein, Robert. "'With many a floryn he the hewes boghte': Ekphrasis and Symbolic Violence in the 'Knight's Tale.'" *Philological Quarterly* 85, nos. 1–2 (Winter–Spring 2006): 49–68.

Erickson, Christopher D. *The Shield of Achilles and the War on Terror: Ekphrasis as Critique.* Ph.D. dissertation, University of Massachusetts, Amherst, 2006

Eriksen, Roy T. "Princely Abodes: Fregoso, Milton, and the Ethics of Architecture." In Roy T. Eriksen, ed., *Basilike Eikon: Renaissance Representations of the Prince.* Roma: Kappa, 2001. 133–46.

Ernst, Ulrich. "'Nouveau Roman' im Mittelalter? Generistische Betrachtungen zum 'ekphrastischen Roman.'" *Das Mittelalter* 13, no. 1 (2008): 107–30.

Erwin, Timothy. "The Ecliptic of the Beautiful." *Studies in Eighteenth-Century Culture* 33 (2004): 339–67.

_____. "Text als Architektur — Architektur als Text." In Nerdinger, *Architektur* (below), 113–27.

Esaulov, Ivan. "Ekfrasis v russkoi literature novogo vremeni: Kartina i Ikona." In Geller, *Ekfrasis* (below), 167–79.

Escal, Françoise. "Stravinsky et son double modèle iconographique (Hogarth) et musical (la tradition italo-mozartienne de l'opéra) dans *The Rake's Progress.* *Les Cahiers d'Inter-Textes.* Paris: Centre de recherche Inter-Textes Arts et Littératures modernes, 1985.

Eskelinen, Helena. *L'ecfrasis nel Piacere di Gabriele D'Annunzio.* M.A. thesis, University of Helsinki, 2006.

Esposito, Elena. "Fiktion und Virtualität." In S. Kramer, ed., *Medien–Computer–Realität.* Frankfurt am Main: Suhrkamp, 1998. 269–96.

_____. "Die Wahrnehmung der Virtualität. Perzep-

tionsaspekte der interaktiven Kommuniktion." In Georg Stanitzek and Wilhelm Voßkamp, eds., *Schnittstelle. Medien und kulturelle Kommuni-kation.* Köln: DuMont Buchverlag, 2001. 116–31.

Essen, Gesa von. "Das 'durchstrichene' Wien: zu Robert Musils Stadtimaginationen." In Nerdinger, *Architektur* (below), 160–74.

Ette, Ottmar. "La Mise en scène de la table de travail: Poétologie et épistémologie immanenteschez Guillaume-Thomas Raynal et Alexander von Humboldt." In Peter Wagner, *Icons* (below), 175–209.

Evans, Michael. "Fictive Painting in Twelfth-Century Paris." In John Onians, ed., *Sight and Insight: Essays on Art and Culture in Honour of E.H. Gombrich at 85.* London: Phaidon, 1994. 73–87.

Ewalt, Margaret Russell. *A Colonial Cabinet of Curiosities: Joseph Gumilla's "Wunderkammer. El Orinoco ilustrado" and the Rhetoric of Wonder.* Ph.D. dissertation, University of Virginia, 2001.

Fabbri, Paolo. "La sfinge incompresa: *Sphinxartig* di P. Klee." In Lucia Corrain, ed., *Semiotiche Della Pittura: I Classici, Le Ricerche.* Roma: Meltemi editore, 2004. 91–106; rpt. in Valtolina, *Annali* (below), 75–99.

Faber, Reimer A. "The Description of Staphylos' Palace (*Dionysiaca* 18.69–86) and the Principle of Pi Oiki Lambda Ia." *Philologus* 148, no. 2 (2004): 245–54.

_____. "Callimachus Hecale Fr. 42 and the Language of Poetic Ekphrasis." In J. Bews et al., eds., *Celebratio. Thirtieth Anniversary Essays at Trent University.* Peterborough, ON: Trent University, 1998. 51–60.

_____. "The Description of the Palace in Seneca *Thyestes* 641–82 and the Literary Unity of the Play." *Mnemosyne* 60, no. 3 (2007): 427–42.

_____. *Ekphrasis in Hellenistic Poetry.* Ph.D. dissertation, University of Toronto, 1992.

_____. "The Literary Metaphor of the Chisel (Tornus) in Eclogue 3.38." *Hermes* 128, no. 3 (2000): 375–9.

_____. "Vergil *Eclogue* 3.37, Theocritus 1 and Hellenistic Ekphrasis." *American Journal of Philology* 116 (Fall 1995): 411–17.

_____. "Vergil's 'Shield of Aeneas' (*Aeneid* 8. 617–731) and the Shield of Heracles." *Mnemosyne* 53, fasc. 1 (February 2000): 49–57.

_____. "Vestis ... variata (Catullus 64. 50–51) and the Language of Poetic Description." *Mnemosyne* 51, fasc. 2 (April 1998): 210–15.

Fado, L. "L'impromta delle parole. Due momenti della pictura di reconstruzione." In Salvatore Settis, ed., *Memoria dell'antico nell'arte italiana.* 2 vols. Torino: Einaudi, 1985. 8–42.

Fairley, Irene R. "On Reading Poems: Visual and Verbal Icons in William Carlos Williams' 'Landscape with the Fall of Icarus.'" *Studies in Twentieth-Century Literature* 6 (1981–82): 6–97.

Fajardo, Salvador J. "Ekphrasis and Ideology in Cernuda's *Ninfa y pastor por Ticiano.*" *Anales de la Literatura Española Contemporanea* 22, no. 1–2 (1997): 29–51.

_____. "José Moreno Villa, the 'Residencia,' and Jacinta la pelirroja." *Anales de la Literatura Espanola Contemporanea* 19, nos. 1–2 (1994): 67–84.

Falaschi, Enid T. "Valvassori's 1553 Illustrations of *Orlando Furioso*: The Development of Multi-narrative Technique in Venice and Its Links with Cartography." *La bibliofilia* 77, no. 3 (1976): 227–51.

Falcão, Ana Maria. "A Voz do Olhar, ou a Ekphrasis Revisitada." In Maria Zina Gonçalves de Abreu and Marcelino de Castro, eds., *Estudos de Tradução — Actas de Congresso Internacional.* Cascais, Principia Editora, 2003.

Falcomatà, Gabriella, B. Polimeni, and G. Mazzacuva. "Il cosiddetto battistero di S. Severina o chiesetta di S. Giambattista (Crotone)." In Valentino Wolta, ed., *Rotonde d'Italia: analisi tipologica della pianta centrale.* Milano: Jaca Book, 2008. 184–90.

Falivene, Maria-Rosaria. "Esercizi di ekphrasis: delle opposte fortune di Posidippo e Callimaco." In Guido Bastianini and Angelo Casanova, eds., *Il Papiro di Posidippo un anno dopo. Atti del convegno internazionale di studi* (colloque, Florence, 2002). *Studi e Testi di Papirologia* n.s. 4, Florence (2002): 33–40.

Fan, Jinghua. "Sylvia Plath's Visual Poetics." In Kathleen Connors and Sally Bayley, eds., *Eye Rhymes: Sylvia Plath's Art of the Visual.* Oxford, England: Oxford University Press, 2007. 205–22.

Fanlo, Jean-Raymond. "'Si ... vous vous voulez representer un Sauvage': l'ekphrasis carnavalesque du pasteur Jean de Léry." In Jean-Pierre Landry and Pierre Servet, eds., *Le dialogue des arts: Littérature et peinture (du Moyen Age au XVIIIe siècle),* Université de Lyon III, *Centre d'étude des interactions culturelles* 18 (2001): 127–48.

Farnetti, Monica. "Teoria e forme dell'ecfrasi nella letteratura italiana dalle origini al Seicento: saggio bibliografico." In Venturi, *Ecfrasi* (below), 573–600.

_____. "Variazioni secentesche sul tema dell'ecfrasi." In Alice Di Stefano, ed., *Cyberletteratura: Tra mondi testuali e mondi virtuali.* Rome, Italy: Nuova Cultura, 2006. 157–61.

Faubel, Janet Reed. *Unveiling El Greco's Saint Francis in Meditation: Ekphrasis and Catholic Colo-*

nialism in Willa Cather's "Death Comes for the Archbishop." M.A. thesis, University of West Florida, 2005.

Fauser, Markus. "Bild und Text bei Martin Opitz: Beschreibung und mentale Bilder in den Liebesgedichten." In Thomas Borgstedt and Walter Schmitz, eds., *Martin Opitz (1597–1639): Nachahmungspoetik und Lebenswelt. Frühe Neuzeit: Studien und Dokumente zur Deutschen Literatur und Kultur im Europäischen Kontext.* 63. Tübingen: Niemeyer, 2002. 123–53.

Fay, Stephanie Wasielewsky. *American Pictorial Rhetoric: Describing Works of Art in Fiction and Art Criticism, 1820–1875.* Ph.D. dissertation, University of California, Berkeley, 1982.

Feal, Rosemary Geisdorfer. "The Painting of Desire: Representations of Eroticism in Mario Vargas Llosa's *Elogio de la madrastra.*" *Revista de Estudios Hispánicos* 24, no. 3 (October 1990): 87–106.

Fehl, Philipp P. "Iconography or Ekphrasis: The Case of the Neglected Cows in Titian's 'Rape of Europa.'" *Actas del XXIII. Congreso internacional de historia del arte: España entre el Mediterraneo y el Atlantico. Granada, 1976–1978* 2 (1977): 260–77.

_____. "Imitation as a Source of Greatness: Rubens, Titian, and the Painting of the Ancients." In *Bacchanals by Titian and Rubens: Papers Given at a Symposium in Nationalmuseum, Stockholm, March 18–19, 1987.* Stockholm, Nationalmuseum, 1987. 107–32.

_____. "Mantegnas 'Mutter der Tugenden.'" *Artibus et Historiae* 24, no. 48 (2003): 29–42.

Felber, Lynette. "The Literary Portrait as Centerfold: Fetishism in Mary Elizabeth Braddon's *Lady Audley's Secret.*" *Victorian Literature and Culture* 35, no. 2 (2007): 471–88.

Fellmann, Ferdinand. "Wovon sprechen die Bilder? Aspekte der Bild-Semantik." In Birgit Recki, ed., *Bild und Reflexion: Paradigmen und Perspektiven gegenwärtiger Ästhetik.* München: Fink, 1997. 147–59.

Ferguson, Suzanne. "Crossing the Delaware with Larry Rivers and Frank O'Hara: The Post-Modern Hero at the Battle of Signifiers." *Word & Image: A Journal of Verbal/Visual Enquiry* 2, no. 1 (January–March 1986): 27–32.

Fernandez-Zoïla, Adolfo. "Le Système écriture–peinture et le figural dans L'Oeuvre." *Les Cahiers Naturalistes* 38, no. 66 (1992): 91–103.

Ferrán, Ofelia. "Ekfrasis y exilio: Dos versiones de 'un amor interrumpido.'" *Barcarola: Revista de Creación Literaria* 44–45 (January 1994): 211–23.

Ferrari, Gloria. "Figures in the Text: Metaphors and Riddles in the *Agamemnon.*" *Classical Philology* 92 (January 1997): 1–45.

Ferrari, Oreste. "Poeti e scultori nella Roma seicentesca: i difficili rapporti tra due culture." *Storia dell'arte* 90 (1997): 151–61.

Ferraris, Maurizio. "L'occhio ragiona a modo suo." In Valtolina, *Annali* (below), 23–48.

Figueroa, Orlamdo. *Goya y la primera serie de Episodios nacionales de Benito Pérez Galdós: un ensayo sobre ékphrasis.* Ph.D. dissertation, Emory University, 1996.

Fimiani, Filippo. "Mondanità dell'antico." In Valtolina, *L'immagine rubata* (below), 62–87.

Findlay, F.M. "The Shield and the Horizon: Homeric Ekphrasis and History." In Anna-Teresa Tymieniecka, ed., *Existential Coordinates of the Human Condition: Poetic-Epic-Tragic: The Literary Genre.* Dordrecht, Holland: D. Reidel, 1984. 163–74.

Finn, Mary E. "The Ethics and Aesthetics of Shelley's *The Cenci.*" *Studies in Romanticism* 35 (Summer 1996): 177–97.

Fischer, Barbara K. *Museum Mediations: Reframing Ekphrasis in Contemporary American Poetry.* Ph.D. dissertation, New York University, 2004.

_____. *Museum Mediations: Reframing Ekphrasis in Contemporary American Poetry.* New York: Routledge, 2006.

Fischer, Hubertus. "The Art of Description: Park and Landscape in Pückler's 'Breife eines Verstorbenen.'" In Michael Rohde and Rainier Schomann, eds., *Historic Gardens Today.* Leipzig: Edition Leipzig, 2004, 140–5.

Fisher, Elizabeth A. "Image and Ekphrasis in Michael Psellos "Sermon on the Crucifixion." *Byzantinoslavica* 55, no. 1 (1994): 44–55.

Fjørtoft, Henning. "Allegory and Ekphrasis in Inger Christensen's *The Painted Room.*" Paper presented at the Norlit-konferenssi, August 2007.

Flaschenriem, Barbara Lynn. *Seeing Double: Amatory Rhetoric and Gender in Sappho, the "Anacreontea," and Propertius.* Ph.D. dissertation, University of California, Berkeley, 1992.

Fletcher, Jan, and D. S. Carne-Ross. "Ekphrasis: Lights in Santa Sophia from Paul the Silentiary." *Arion* 4, no. 4 (1965).

Fleury, Amy. "What Is Boundless: A Conversation with Edward Hirsch about Ekphrastic Writing." *Interdisciplinary Humanities* 20, no. 1 (Spring 2003): 47–53.

Flôrês, Panos. "Sonnet (W. Shakespeare), Ê ékfrasê tês psuhês (E. B. Browning), Ê méra teleíôse (H. W. Longfellow), Taedium vitae (Oscar Wilde)." In O. Mpekés and Giánnês Halkoúsê, eds., *O Lógos: mêniaío periodikó.* [Constantinople]: Polê, 1920.

Flusin, Bernard. "L'ekphrasis d'un baptistère byzantin." In *Mélanges en l'honneur de Jean-Pierre So-*

dini = *Travaux et Mémoires 15*. Paris, 2005. 163–82.

Fobelli, Maria Luigia. "L''ekphrasis' di Filagato da Cerami sulla Cappella Palatina e il suo modello." In Arturo Carlo Quintavalle, ed., *Medioevo: i modelli: atti del Convegno internazionale di studi Parma, 27 settembre–1 ottobre 1999*. Milano: Electa, 2002. 267–75.

_____. *Un tempio per Giustiniano: Santa Sofia di Costantinopoli e la "Descrizione" di Paolo Silenziario*. Roma: Viella, 2005. **Reviews:** Kovalchuk, Kateryna. *Byzantion* 77 (2007): 644–6. Ousterhout, Robert. *Journal of the Society of Architectural Historians* 65, no. 3 (September 2006): 435–7. Restel, Marcel. *Byzantinische Zeitschrift* 100, no. 2 (2008): 835–44.

Force, Pierre. "Peinture et poésie dans le Télémaque de Fénelon." *Op. Cit.: Revue de Littératures Française et Comparée* 3 (November 1994): 65–71.

Ford, Philip. *Ronsard's Hymnes: A Literary and Iconographical Study. Medieval & Renaissance Texts & Studies*. 157. Tempe, AZ: Arizona State University, 1997.

_____. "Ronsard the Painter: A Reading of 'Des Peintures contenues dedans un tableau.'" *French Studies: A Quarterly Review* 40, no. 1 (January 1986): 32–44.

Fort, Bernadette. "Ekphrasis as Art Criticism: Diderot and Fragonard's 'Coresus and Callirhoe.'" In Wagner, *Icons* (below), 58–77.

Foster, David William. "Playful Ecphrasis: María Elena Walsh and Children's Literature in Argentina." *Mester* 13, no. 1 (May 1984): 40–51.

Foucart, Claude. "La mort du Titien: Hugo von Hofmannsthal, 'l'écriture magique des images.'" In Pascale Auraix-Jonchière, ed., *Ecrire la peinture entre XVIIIe et XIXe siècles*. Révolutions et Romantismes. 4. Clermont-Ferrand, France: Presses Universitaires Blaise Pascal, 2003. 474–85.

Fowler, Don P. "Narrate and Describe: The Problem of Ekphrasis." *Journal of Roman Studies* 81 (1991): 25–35. Revised and reprinted as chapt. 3 of Fowler's *Roman Constructions: Readings in Postmodern Latin*. New York: Oxford University Press, 2000.

_____. "Virgilian Narrative: Ecphrasis." In Charles Martindale, ed., *The Cambridge Companion to Virgil*. New York: Cambridge University Press, 1977. 271–81.

Francis, James A. "Metal Maidens, Achilles' Shield, and Pandora: The Beginnings of 'Ekphrasis.'" *American Journal of Philology* 130, no. 1 (Spring 2009): 1–23.

Frank, Paul. *The Gothic: Literary Sources and Interpretations through Eight Centuries*. Princeton, NJ: Princeton University Press, 1960.

Frank, Suzi. "Zarazhenie strastiami ili tekstovaia 'nagliadnost'": Pathos i ekphrasis u Gogolia." In Geller, *Ekfrasis* (below), 31–41.

Freedberg, David. *The Power of Images: Studies in the History and Theory of Response*. Chicago: University of Chicago Press, 1989.

Freedman, Luba. "Titian's Portraits in the Letters and Sonnets of Pietro Aretino." In Golahny, *The Eye* (below), 102–130.

Frey-Sallmann, Alma. *Aus dem Nachleben antiker Göttergestalten: Die antiken Gottheiten in der Bildbeschreibung des Mittelalters und der italienischen Frührenaissance*. Leipzig: Dieterichsche Verlagsbuchhandlung, 1931.

Fridrich, Raimund, "Les Mystères de l'art : Wincklemanns Ekphrasis und die Begrifflichkeit der Schönhei." *Colloquium Helveticum* 30 (1999).

Friedländer, Paul. *Johannes von Gaza und Paulus Silentiarius. Kunstbeschreibungen justinianischer Zeit*. Leipzig und Berlin: Teubner, 1912.

_____, ed. *Spätantiker Gemäldezyklus in Gaza des Prokopios von Gaza Ekfrasis eikonos*. Roma: Multigrafica, 1972.

Friedman, Régine-Mihal. "Diffracted Reflectivity: Mise-en-abyme and the Beginning of Film." *Semiotica* 112, nos. 1–2 (1996): 51–65.

_____. "Génériques: entre ecphrasis et mise-en-abyme." In Christine B. Verzar, ed., *Pictorial Languages and Their Meanings: Liber Amicorum in Honor of Nurith Kenaan-Kedar*. Tel Aviv: Tel Aviv University, the Yolanda and David Katz Faculty of the Arts, 2006. 3–16.

Friese, Heidrun. "Literal Letters: On the Materiality of Words." *Paragraph: A Journal of Modern Critical Theory* 21, no. 2 (July 1998): 169–99.

Friis, Ron J. "'The fury and the mire of human veins': Frida Kahlo and Rosario Castellanos." *Hispania* 87, no. 1 (March 2004): 53–61.

_____. "'Recibir con ambas mejillas': Rosario Castellanos's Painterly Discourse." *South Carolina Modern Language Review* 1, no. 1 (Winter 2002), n.p.

Frijhoff, Willem, and Marijke Spies. "Poems on Paintings." *Dutch Culture in a European Perspective*, vol. 1: *1650. Hard-Won Unity*. Assen: Uitgeverij Van Gorcum, 2004. 449–51.

Frith, Carol. "Aesthetic Layering in Ekphrastic Verse." *Sulphur River Literary Review* 15, no. 2 (1999).

Fritoli, Luiz Arnani. *Do ideal e da obra: visualidade e conformação do. espaço literário em "Retábulo de Santa Joana Carolina."* M.A. thesis, Universidade de São Paulo, 2004. See chap. 4, "A écfrasis e a ilusão da dupla mimese," pp. 121–68.

Fritsch, Sylvia. "Ungegenständlich und unbeschreibbar? eine Annäherung an die Bilder Barnett Newmans." In Rebel, *Sehen* (below), 181–98.

Frogier, Larys, and Jean-Marie Poinsot, eds., *La description: actes du colloque Archives de la critique d'art*. Châteaugiron: Archives de la critique d'art, 1997.

Frojmovic, Eva. "Giotto's Circumspection." *Art Bulletin* 89, no. 2 (June 2007): 195–210.

Frommel, Sabine. "L'Italie de la Renaissance, du 'casino di caccia' à la résidence de chasse." In Claude d' Anthenaise, ed., *Chasses princières dans l'Europe de la Renaissance: actes du colloque de Chambord (1er et 2 octobre 2004)* Arles: Actes Sud, 2007. 289–326.

Frosh, Paul. "Industrial Ekphrasis: The Dialectic of Word and Image in Mass Cultural Production." *Semiotica: Journal of the International Association for Semiotic Studies/Revue de l'Association Internationale de Sémiotique* 147, no. 1–4 (2003): 241–64.

Fryd, Annette. "Ekfrasens grænser." In Harrits and Troelsen (below).

_____. *Ekfraser: Gunnar Ekelöfs billedbeskrivende digte.* Københavns Universitet, København: Museum Tusculanums Forlag, 1999. **Review:** Brostrøm, Torben. "Litterær ikonografi." http://www.information.dk/41416

_____. "Inde i stenen findes skulpturen allerede — om Morten Søndergaards ekfrase 'Nedtælling til en skulptur af Michelangelo.'" *Standart* 1 (February 2004): 30–2.

Fuchs, Anne. "W.G. Sebald's Painters: The Function of Fine Art in His Prose Works." *Modern Language Review* 101, no. 1 (January 2006): 167–83.

Fumaroli, Marc. *L'école du silence: le sentiment des images au XVIIè siècle.* Paris: Flammarion, 1998.

_____. "La Galeria de Marino et la Galerie Farnèse: épigrammes et oeuvres d'art profanes vers 1600." In *Carrache et les décors profanes: actes du colloque organisé par l'Ecole française de Rome, Rome, 2–4 octobre 1986.* Rome: Ecole française de Rome, 1988. 163–82.

Furst, Ulrich. "Die Wirkmacht der Säulenordnungen: eine beschreibende Bauanalyse des Mittelbaus von Schloss Weissenstein bei Pommersfelden." In Rebel, *Sehen* (below), 151–70.

Fussmann, Klaus. *Wahn der Malerei.* München: Siedler, 2005.

Gaisser, J.H. "Threads in the Labyrinth: Competing Views and Voices in Catullus 64." *American Journal of Philology* 116 (Winter 1995): 579–616.

Gabalas, Manuel, and Adriana Pignani. *Racconto di una festa populare: Ekphrasis per la festa di Pasqua.* Napoli: D'Auria, 1981.

Gabaude, Florent. "Les 'ekphrasis' de l'extase: la réception allemande de la 'Sainte Thérèse' du Bernin et l''éros' baroque." In Eduardo Ramos-Izquierdo, ed., *L'espace de l'Eros: représentations textuelles et iconiques.* Limoges: Pulim, 2007. 93–110.

Gabrieloni, Ana Lía. "Imágenes de la traducción y relaciones interartísticas" ["Images of translation and inter–artistic links"]. *Revista de Historia de la Traducción* 1 (2007). http://www.traduccionliteraria.org/1611/art/gabrieloni.htm

Gagliardi, Donato. "La poetica dell''ecphrasis' e Ausonio." In Gagliardi's *Aspetti della poesia latina tardoantica. Linee evolutive e culturali dell'ultima poesia pagana dai "novella" a Rutilio Namaziano.* Palermo: Palumbo, 1972. 65–89.

Gale, M.R. "The Shield of Turnus (*Aeneid* 7.783–92)." *Greece & Rome* 44 (October 1997): 176–96.

Galand-Hallyn, Perrine. "L'art de l''ekphrasis' en poesie: l''Elégie' III, 17 de Jean Second." In Jean Balsamo and Perrine Galand-Hallyn, eds., *La poétique de Jean Second et son influence au XVIe siècle: actes du colloque organisé à Paris les 6 et 7 février 1998.* Paris : Belles Lettres: Klincksieck, 2000.

_____. "Autour de Jean Second (l'ekphrasis de Saint-Denis: Elegie III, 17): fonctions et spécificité de la description dans la poésie humaniste néo-latine." In Jean-Michel Caluwé, ed., *Poésie et description.* Presses de l'Université de Besançon, 2000. 69–91.

_____. "Autour de la Vénus d'Amboise (1530): une refloraison de l'ekphrasis en France au XVIe siècle." *Bibliotheque de Humanisme et Renaissance* 61, no. 2 (1999): 345–74.

_____. "Les descriptions d'art dans la poésie néo-latine: du Quattrocento au début de la Renaissance française." In *La littérature et les arts figurés de l'Antiquité à nos jours: actes du XIVe Congrès de l'Association Guillaume Budé, Limoges 25–28 août 1998.* Paris: Les Belles Lettres, 2001. 539–53.

_____. "Génériques maniéristes dans les romans d'Achille Tatius et Claude Simon." *La Licorne* 35 (1995): 247–59.

_____. "Les fleurs de l'ecphrasis: autour du rapt de Proserpine (Ovide, Claudien, Politien)." *Latomus* 46 (1987): 87–122.

_____. "Jeux intertextuels de Du Bellay dans les poèmes romains: de l'emphase des Antiquitez à l'ekphrase des Elegiae." In *Du Bellay. Antiquité et nouveaux mondes dans les recueils romains,* Actes du Colloque de Nice (17–18 février 1995). J. Rieu, Publications de la faculté des Lettres de Nice, 1995. 73–98.

_____. "Lisible/visible. Ekphrasis et allégorie à la Renaissance." In F. Lestringant et M. Zink, eds., *Histoire de la France littéraire, tome I, Naissances, Renaissances (Moyen Âge, XVIe siècle).* Paris: P.U.F., 2006. 315–28.

_____. "Le portail du temple d'Apollon. Fonctions

de l'ekphrasis dans la narration épique (En., VI, 14–39)." *L'Ecole des lettres* 4 (1995–1996): 5–14.

_____. "Les portes de Vénus: tout un programme dans les Stanze d'Ange Politien." In Jean-Pierre Guillerm et al., eds., *Récits et tableaux*. Lille: Presses universitaires de Lille, 1994. 17–30.

_____. *Le reflet des fleurs, description et métalangage poétique d'Homère à la Renaissance*. Genève: Droz, 1994.

_____. *Les yeux de l'éloquence: poétiques humanistes de l'évidence*. Orléans: Paradigme, 1995.

Galavaris, George. "Stars of the Virgin: An Ekphrasis of an Ikon of the Mother of God." *Eastern Churches Review* 1, no. 4 (Winter 1967–1968) 364–69.

Galu, Cristina. "Ekphrasis and Multimediality: Destabilizing History and Subjectivity in Theresa Cha's *Dictee*." *Rhizomes* 9 (Fall 2004). http://www.rhizomes.net/issue9/galu.htm

Gamper, Michael. "Der Weg durchs Bild hindurch: Wackenroder und die Gemäldebeschreibung des 18. Jahrhunderts." *Aurora: Jahrbuch der Eichendorff Gesellschaft* 55 (1995): 43–66.

Gandelman, Claude. "Poetry as Ecphrasis: Rilke, Celan, Exner." In Ursula Mahlendorf und Lawrence Rickels, eds., *Poetry, Poetics, Translation. Festschrift in Honor of Richard Exner*. Würzburg: Königshausen & Neumann, 1994. 107–22.

_____. *Reading Pictures, Viewing Texts*. Bloomington: Indiana University Press, 1991.

_____. "Du visuel au textuel/ du textuel au visuel: formes de l'ecphrasis." *Etudes Art et Littérature, Université de Jérusalem* 19 (1992): 76–88.

Ganho, Ana Sofia. "Luiza Neto Jorge: Ekphrasis e Iconotexto." http://victorian.fortunecity.com/statue/44/zluizanetojorgeekphrasisiconotexto.htm

Garcia, Luis Francisco. *La ékfrasis en la poesía contemporánea española: De Angel González a Encarnación Pisonero*. Ph.D. dissertation, Temple University, 2005.

Garet, Nicole. *Le père Le Moyne ou les métamorphoses de l'ekphrasis*. Ph.D. dissertation, Université de Montréal, 1991.

Garza, Efrain. "Ecfrasis: El 'pintar con palabras' de Bécquer." In Santiago Juan-Navarro and Joan Torres-Pou, eds., *Memoria histórica, género e interdisciplinariedad: Los estudios culturales hispánicos en el siglo XXI*. Madrid, Spain: Biblioteca Nueva, 2008. 227–36.

Garzya, Antonio. "L'ekphrasis nella tragedia greca." *Atti dell'Accademia Pontaniana* 45 (1996): 87–95.

Gaston, Robert W. "Pictorial Representation and Ekphrasis in Elogio de la madrastra." *Antípodas: Journal of Hispanic and Galician Studies* 8–9 (1996–1997): 216–29.

Gätjens, Sigrid. "'El sueño de la razón produce monstruos'— Anmerkungen zu einem spanischen Bildbezug in Baudelaires 'Sur Le Tasse en Prison.'" In Kapp, *Bilderwelten* (below), 31–45.

Gatrall, Jefferson J.A. "Between Iconoclasm and Silence: Representing the Divine in Holbein and Dostoevskii." *Comparative Literature* 53, no. 3 (Summer 2001): 214–32.

_____. *Cult of Image: Literary Portraits of Jesus in European and American Prose, 1831–1895*. Ph.D. dissertation, Columbia University, 2005.

Gaultier, Veronique. *Ekphrasis in the Novels of Claude Simon*. Ph.D. dissertation, Columbia University, 2001.

Gavin, Kevin Matthew. *Toward a Theory of Epic Forms: Mimesis, Symbol, and Allegory*. Ph.D. dissertation, University of Michigan, 1994.

Geller, Leonid M., ed. *Ekfrasis v russkoj literature: trudy Lozanskogo simpoziuma*. Moskva: Izdat. MIK, 2002.

_____. "Voskreshenie poniatiia, ili Slovo ob ekfrasise." In Geller (previous entry), *Ekfrasis*, 5–22.

Gemert, Lia van. "Verreziende helden: visualiteit in het Nederlandse epos." In Marc Van Vaeck, ed., *De steen van Alciato: literatuur en visuele cultuur in de Nederlanden*. Leuven: Peeters, 2003. 387–403.

Gendrat-Claudel, A. "I paesaggi di 'Fede e bellezza,' ovvero un'ekphrasis inconfessata." *Rassegna della Letteratura Italiana* 110, no. 1 (January–June 2006): 43–71.

Georg, Held Heinz. "Ritualästhetik. Goethes Ekphrase der Frankfurter Kaiserkrönung von 1764." In M. Steinicke and S. Weinfurter, eds., *Investitur- und Krönungsrituale. Herrschaftseinsetzungen im kulturellen Vergleich*. Köln: Böhlau, 2005.

_____, ed. *E.T.A. Hoffmann: Ekphrasis als poetisches Prinzip in Winckelmann e i miti del classico*. Firenze, Olschki, 2006.

Georgi, K.L. "Making Nature Culture's Other: Nineteenth-Century American Landscape Painting and Critical Discourse." *Word & Image: A Journal of Verbal/Visual Enquiry* 19, no. 3 (July–September 2003): 198–213.

Gerdts, William H. "Ekphrasis: A Non-Critical Look at Early Nineteenth-Century Portraiture through Poetry." In David B. Dearinger and Avis Berman, eds., *Rave Reviews: American Art and Its Critics, 1826–1925*. New York: National Academy of Design, 2000. 145–58.

Gesalí, Esteban Pujals. "John Ashbery's Convex Mirror." In Nancy Bredendick, ed., *Mapping the Threshold: Essays in Liminal Analysis. Studies in Liminality and Literature*. 4. Madrid, Spain: Gateway, 2004. 91–8.

Geymonat, Mario. "Per un commento iconografico

all'*Eneide*." *Annali Accademia Mantova* 57 (1989): 95–133.

Giannandrea, Beatrice. *Ecfrasis: Escritura y pintura en el costumbrismo argentino*. Ph.D. dissertation, Florida International University, 2005.

Gibson, Craig A. "Alexander in the Tychaion: Ps.-Libanius on the Statues." *Greek, Roman & Byzantine Studies* 47, no. 4 (Winter 2007): 431–54.

Gilmore, Elsa M. "Marco Antonio de la Parra's *El padre muerto*: Ekphrasis and History." *Gestos: Teoria y Practica del Teatro Hispánico*, 13, no. 26 (November 1998): 99–108.

Gimbernat de González, Ester. "Apeles de la re-inscripción: A propósito del Poema heroico de Hernando Domínguez Camargo." *Revista Iberoamericana* 53, no. 140 (July–September 1987): 569–79.

Ginzburg, Carlo. "Ekphrasis and Quotation." *Tijdschrift voor Filosofie* 50, no. 1 (March 1988): 3–19.

_____. "Ekphrasis e citação." In Ginzburg's *A micro-história e outros ensaios*. Lisboa: Difel, 1991. 215–232.

Giorcelli, M. Christina. "'The Servant Girl at Emmaus (After a Painting by Velásquez)': Denise Levertov's Religious Ekphrasis." *Sources* 12 (2002): 69–92.

Giovio, Paolo. *Scritti d'arte: lessivo ed ecfrasi*. Pisa: Scuela Normale Superiore Stampa, 1999.

Giraud, Paul-Henri. "'Scriptor in tabula.' À propos du poème 'Retrato de poeta' de Luis Cernuda." In Paul-Henri Giraud and Nuria Rodríguez Lázaro, eds., *Poésie, peinture, photographie. Autour des poètes de 1927*. Paris: Indigo & Côté-femmes éditions, 2008.

Giraud, Paul-Henri, and Nuria Rodríguez Lázaro, eds., *Poésie, peinture, photographie. Autour des poètes de 1927*. Paris: Indigo & Côté-femmes éditions, 2008.

Giraud, Nadine. "Barrès et Le Sodoma dans 'Les beaux contrastes de Sienne.'" In Pascale Auraix-Jonchière, ed., *Ecrire la peinture entre XVIIIe et XIXe siècles*. Révolutions et Romantismes. 4. Clermont-Ferrand, France: Presses Universitaires Blaise Pascal, 2003. 465–74.

Giraud-Saugues, Sylviane. "Le Regard du peintre dans Clair de nuit." *Studies on Lucette Desvignes and the Twentieth Century* 5 (1995): 115–24.

Glad, Diana. "The Demons of Carlos Rojas." *World Literature Today* 71, no. 1 (1997): 77–8.

Glavey, Brian. "Frank O'Hara Nude with Boots: Queer Ekphrasis and the Statuesque Poet." *American Literature* 79, no. 4 (December 2007): 781–806.

_____. *Queer Ekphrasis, Modernism, and the Avant-garde*. Ph.D. dissertation, University of Virginia, 2008.

Gleizes, Delphine. "'Vanités': Codes picturaux et signes textuels." *Romantisme: Revue du Dix-Neuvième Siècle* 118 (2002): 75–91.

Gnilka, Christian. "Prudentius über die Statue der Victoria im Senat." *Frühmittelalterliche Studien* 25 (1991): 1–44.

Goebel, Gerhard. *Poeta faber. Erdichtete Architektur in der italienischen, spanischen und französischen Literatur der Renaissance und des Barock*. Heidelberg: Carl Winter, 1971.

_____. "Alberti als Traumarchitekt." In Nerdinger, *Architektur* (below), 70–4.

Goedde, Lawrence O. "A Little World Made Cunningly: Dutch Still Life Painting and Ekphrasis." *Still Lifes of the Golden Age* [exhibition catalogue]. Washington, DC: National Gallery, 1989. 39–44.

_____. *Tempest and Shipwreck in Dutch and Flemish Art*. University Park, PA: Pennsylvania State University Press, 1989.

_____. *Tempest and Shipwreck in the Art of the Sixteenth and Seventeenth Centuries: Dramas of Peril, Disaster, and Salvation*. Ph.D. dissertation, Columbia University, 1984.

Goffen, Rona. "Balancing Acts: Reading Sources and Weighing Evidence in Recent Italian Renaissance Art History." *Renaissance Quarterly* 52, no. 1 (Spring 1999): 207–20. Review of Anne Derbes, *Picturing the Passion in Late Medieval Italy: Narrative Painting, Franciscan Ideologies, and the Levant*, Martin Kemp, *Behind the Picture: Art and Evidence in the Italian Renaissance*, B.J. Maginnis, *Painting in the Age of Giotto: A Historical Reevaluation*, and Anabel Thomas, *The Painter's Practice in Renaissance Tuscany*.

Gohrbandt, Detlev. *Seeing and Saying: Self-Referentiality in British and American Literature*. Frankfurt am Main: Peter Lang, 1998.

Golahny, Amy, ed. *The Eye of the Poet: Studies in the Reciprocity of the Visual and the Literary Arts from the Renaissance to the Present*. Lewisburg, PA: Bucknell University Press; London: Associated University Presses, 1996. **Reviews:** Agoston, Laura Camille. *Renaissance Quarterly* 51, no. 2 (Summer 1998): 647–9. Even, Yael. *Sixteenth-Century Journal* 28 (Winter 1997): 1306–7.

_____. "Introduction: Ekphrasis in the Interarts Discourse." In Golahny (previous entry), *The Eye*, 11–18.

_____. "Paired Poems on Pendant Paintings: Vondel and Oudaan Interpret Lastman." In Golahny, *The Eye* (above), 154–78.

Goldhill, Simon. "The Naïve and Knowing Eye: Ekphrasis and the Culture of Viewing in the Ancient World." In Simon Goldhill and Robin Osborne, eds., *Art and Text in Ancient Greek Culture*.

Cambridge: Cambridge University Press, 1994. 197–223, 304–9.

_____. "What is Ekphrasis for?" *Classical Philology* 102, no. 1 (January 2007): 1–19.

Goldstein, Carl. "Writing History, Viewing Art: The Question of the Humanist's Eye." In Alina Payne et al., eds., *Antiquity and Its Interpreters.* Cambridge: Cambridge University Press, 2000. 285–96.

Goldt, Rainer. "Ekfrasis kak literaturnyi avtokommentarii u Leonida Andreeva i Borisa Poplavskogo." In Geller, *Ekfrasis* (above), 111–22.

Gombrich, E.H. "*Icones Symbolicae*: Philosophies of Symbolism and Their Bearing on Art," *Symbolic Images: Studies in the Art of the Renaissance.* London: Phaidon, 1972. 123–95.

Gómez, María Asunción. "Mirando de cerca 'Mujer, comedia y pintura' en las obras dramáticas de Lope de Vega y Calderón de la Barca." *Bulletin of the Comediantes* 49, no. 2 (Winter 1997): 273–93.

Gonzalez, Bernardo Antonio. "Ekphrasis and Autobiography: The Case of Rafael Alberti." In Anales de la Literatura Española Contemporánea. *Anales de la Literatura Española Contemporánea* 15, nos. 1–3 (1990): 29–49.

Gonzalez, Eduardo. "Odysseus' Bed and Cleopatra's Mattress." *MLN* 119, no. 5 (December 2004): 930–48.

González, Josefina. "From Ekphrasis to Short Story: Carme Riera's Dis(abling) of the Image in *Una primavera per a Domenico Guarini* and *Epitelis tendríssims.*" *Catalan Review: International Journal of Catalan Culture* 15, no. 2 (2001): 79–94.

Gores, Steven J. "The Miniature as Reduction and Talisman in Fielding's *Amelia.*" *SEL: Studies in English Literature, 1500–1900* 37, no. 3 (Summer 1997): 573–93.

Görner, Rüdiger. *Images of Words: Literary Representations of Pictorial Themes.* Munchen: Iudicium, 2004.

Gorrell, N. "Teaching Empathy through Ecphrastic Poetry: Entering a Curriculum of Peace" ["To the Little Polish Boy Standing with His Arms Up" by P.L. Fischl]. *English Journal* 89, no. 5 (May 2000): 32–41.

Gosetti-Ferencei, J.A. "The Aesthetic and the Poetic Image: Beyond the Ekphrasic Divide with Rilke and Cézanne." *Philosophy Today* 47, no. 5 (2003 supp.): 107–17.

Grady, C. Jill. "Huichol Yarn Painting Texts: Postcolonial Ekphrasis, Ethnic Art, and Exhibits." *Museum Anthropology* 27, pt. 1–2 (Spring–Fall 2004): 73–86.

Graf, Eric C. "Heliodorus, Cervantes, La Fayette: Ekphrasis and the Feminist Origins of the Modern Novel." In de Armas, *Ekphrasis* (above), 175–201.

Graf, Fritz. "Ekphrasis. Die Entstehung der Gattung in der Antike." In Boehm and Pfotenhauer, *Beschreibungskunst* (above), 143–55.

Grall, Catherine. "'Des tableaux se transformeraient en poèmes': à propos d'une référence picturale chez Hoffmann et Eichendorff." In Pascale Auraix-Jonchière, ed., *Ecrire la peinture entre XVIIIe et XIXe siècles.* Révolutions et Romantismes. 4. Clermont-Ferrand, France: Presses Universitaires Blaise Pascal, 2003. 173–86.

Grant, Lindy. "Naming of Parts: Describing Architecture in the High Middle Ages." In Georgia Clarke and Paul Crossley, eds., *Architecture and Language: Constructing Identity in European Architecture c. 1000–c. 1650.* Cambridge: Cambridge University Press, 2000. 46–181.

Grau, Oliver. *Virtuelle Kunst in Geschichte und Gegenwart. Visuelle Strategien.* Berlin: Reimer, 2001.

Gravely, Jessica. "The Primacy of Poetry: On Tita Chico's 'The Arts of Beauty: Women's Cosmetics and Pope's Ekphrasis.'" http://www4.ncsu.edu/unity/users/m/morillo/public/JGrev.htm

Graziani, Françoise, ed. and annotat. *Les images ou tableaux de platte-peinture/Philostrate.* Traduction et commentaire de Blaise de Vigenère (1578). Paris: Champion, 1995.

Greenway, William. "Poems and Paintings: Shades of the Prison House." *English Journal* 85, no. 3 (March 1996): 42–9.

Greger, Christoph. "Constructing the Aesthetic Gaze: *Salome* and the Submissive Art of Spectatorship." *Literature and Psychology* 47, no. 3 (2001): 38–54.

Gregory, Thomas West. "From Ekphrasis to Concrete Poetry: The Final Synthesis of Image and Word." In Karl Simms, ed., *Language and the Subject. Critical Studies.* 9. Amsterdam: Rodopi, 1997. 173–8.

Greif, Stefan. *Die Malerei kann ein sehr beredtes Schweigen haben: Beschreibungskunst und Bildästhetik der Dichter.* München: Fink, 1998.

Greimas, Teresa Keane. "Olga Orozco et la poésie picturale 'Botines con lazos,' de Vincent Van Gogh." In Milagros Ezquerro et Julien Rogereds., *Le texte et ses liens II*, Université Paris-Sorbonne, Les Ateliers du Séminaire Amérique Latine, 2007. http://www.crimic.paris-sorbonne.fr/actes/tl2/texte-liens2.htm

Gribben, Bryn Heather. *Bodies That Shatter: Ekphrasis, Beauty, and the Victorian Body as Art.* Ph.D. dissertation, University of Washington, 2005.

Grigg, R. "Byzantine Credulity as an Impediment to Antiquarianism." *Gesta* 26, no. 1 (1987): 3–9.

Grisé, Catherine M. "La Fontaine's 'Les Filles de Minée': Weaving a Poetic Narrative." In Anne L. Birberick and Russell Ganim, eds., *The Shape of Change. Faux Titre: Etudes de Langue et Littérature Françaises.* 223. Amsterdam: Rodopi, 2002. 239–63.

Grogan, Jane. "'So liuely and so like, that liuing sence it fayld': Enargeia and Ekphrasis in *The Faerie Queene.*" *Word & Image: A Journal of Verbal/Visual Enquiry* 25, no. 2 (2009): 166–77.

Gronau, Barbara. "Ereignis und Ekphrasis — Performative Schnittstellen von Text und Theater." In Edwigem et al., eds., *À la croisée des langages: Texte et arts dans les pays de langue allemande.* PIA: Publications de l'Institut d'Allemand. 38. Paris, France: Sorbonne Nouvelle, 2006. 229–41, 282.

Gross, Sabine. "Bild — Text — Zeit: Ekphrasis in Gert Hofmanns 'Der Blindensturz.'" In Ulla Fix and Hans Wellmann, eds., *Bild im Text—Text und Bild.* Heidelberg: C. Winter, 2000. 105–28.

_____. "Image and Text: Recent Research in Intermediality." *Monatshefte* 93, no. 3 (Fall 2001): 355–67.

_____. "A Look of Reading: Book, Painting, Text." *Poetics Today* 29, no. 3 (Fall 2008): 565–93.

Grosse, Max. "Die Ekphrasis im altfranzösischen Antikenroman: Magie und Darstellung statt Kunst und Beschreibung." In Ratkowitsch, *Die poetische* (below), 97–132.

Gruzelier, C.E. "Temporal and Timeless in Claudian's *De raptu Proserpinae.*" *Greece & Rome* 35 (April 1988): 56–72.

Gsoels-Lorenzen, Jutta. "Lê Thi Diem Thúy's 'The Gangster We Are All Looking For': The Ekphrastic Emigration of a Photograph." *Critique: Studies in Contemporary Fiction* 48, no. 1 (Fall 2006): 3–18.

Gualandri, Isabella. "Aspetti dell'Ekphrasis in età tardoantica." In *Testo e immagine nell'alto medioevo,* tomo 1. Spoleto, Italy: Centro Italiano di Studi sull'Alto Medioevo, 1994. 301–41.

Guardì, T. "L'ekphrasis di opere d'arte nella commedia romana." *Studi di filologia classica in onore di G. Monaco.* Palermo: Luxograph, 1991. 3:543–51.

Gueissaz, Anne. "Le logement: un aspect de l'oeuvre de Marc Camoletti (1857–1940), architecte." *Kunst und Architektur in der Schweiz* 56, no. 4 (2005): 66–7.

Guignery, Vanessa. "The Art of Vacillation: Photographs in Alain de Botton's Iconotexts." *Anglistik* 18, no. 2 (September 2007): 175–87.

Guilhendou, Evelyne. *Ekphraseis ou tableaux de belles lettres en France aux XVIè et XVIIè siècle.* Thesis, Université Paris, 1997.

Guillaume, Bordry. *L'ekphrasis musicale: la description littéraire de la musique dans les écrits spécialisés et dans la littérature autour de 1830.* Doctoral thesis, Université de Provence, 2000.

Guillén, Felisa. "Ekphrasis e imitación en la Jerusalén Conquistada." *Hispania* (American Association of Teachers of Spanish and Portuguese) 78 (May 1995): 231–9.

Guillerm, Jean-Pierre, ed. *Récits-tableaux.* Lille: Presses Universitaires de Lille, 1994.

Guillot, Isabelle. "Un champ abandonné et fécond, une grandissime cayonnade: l'ekphrasis chez le comte de Caylus: de la littérature artistique à la pratique artistiques des letters." In Nicholas Cronk and Kris Peeters, eds., *Le Comte de Caylus: les arts et les letters.* Amsterdam: Rodopi, 2004. 95–109.

_____. "L'*ekphrasis* dans les Tableaux de Philostrate de Goethe." In Pascale Auraix-Jonchière, ed., *Ecrire la peinture entre XVIIIe et XIXe siècles.* Révolutions et Romantismes. 4. Clermont-Ferrand, France: Presses Universitaires Blaise Pascal, 2003. 127–38

Gulliksen, Øyvind T. "'Renn over meg som regn.' Tekst og bilde. Meditasjonar over Georges de La Tour: Ekfrase og meditasjon." In *Paradoksal trøst: om Paal-Helge Haugens forfatterskap.* Oslo: Unipub forlag, 2007. 149–52

Gutzwiller, Kathryn J. "Art's Echo: The Tradition of Hellenistic Ecphrastic Epigram." In M.A. Harder et al., eds., *Hellenistic Epigrams* (Hellenistica Groningana 6). Leuven: Peeters, 2002. 85–112.

_____. "Seeing Thought: Timomachus' *Medea* and Ecphrastic Epigram." *American Journal of Philology* 125, no. 3 (Fall 2004): 339–86.

_____. "Visual Aesthetics in Meleager and Cavafy." *Classical and Modern Literature* 23, no. 2 (Fall 2003): 67–87.

Gysin, Fritz. "Paintings in the House of Fiction: The Example of Hawthorne." *Word & Image: A Journal of Verbal/Visual Enquiry* 5, no. 2 (April–June 1989): 159–72.

Haan, Estelle. "Vergilius Redivivus: Studies in Joseph Addison's Latin Poetry." *Transactions of the American Philosophical Society* 95, pt. 2. Philadelphia: American Philosophical Society, 2005.

Habra, Hedy. "Revelación anamorfótica en Elogio de la madrastra." In Claire J. Paolini, ed., *La Chispa '97: Selected Proceedings.* New Orleans, LA: Tulane University, 1997. 175–85.

Hachmann, Gundela. "Ein Moment der Unvorhersehbarkeit: Bruch mit der Notwendigkeit in E.T.A. Hoffmanns *Die Fermate.*" *E.T.A. Hoffmann-Jahrbuch* 15 (2007): 86–99.

Hägg, Tomas. "Konstverksekfrasen som litterär

genre och konstvetenskaplig källa." In Elisabeth Piltz, ed., *Bysans och Norden: akta för Nordiska forskarkursen i bysantinsk konstvetenskap*. Stockholm: Almqvist & Wiksell International, 1989. 37–50.

Haferland, Harald, and Michael Mecklenburg, eds. *Erzählungen in Erzählungen. Phänomene der Narration in Mittelalter und Früher Neuzeit.* München: Fink Wilhelm GmbH and Co, 1996.

Hagstrum, Jean H. *The Sister Arts: The Tradition of Literary Pictorialism and English Poetry from Dryden to Gray.* Chicago: University of Chicago Press, 1958.

Haley, Margaret B. *Student Ekphrasis; Creative, Original and Unique*. M.A. thesis, Pennsylvania State University, Harrisburg, 2005.

Hallberg, Andrea Heinzelmann von. "Anmut und Mass: Raffaels Bildnis des Baldassare Castiglione." In Rebel, *Sehen* (below), 118–28.

Hamer, Mary. "Black and White? Viewing Cleopatra in 1862." In Shearer West, ed., *Victorians and Race*. Brookfield, VT: Ashgate, 1996. 53–67

Hamilton, Craig. "Ekphrasis, Repetition, and Ezra Pound's 'Yeux Glauques.'" *Imaginaires* 9 (2003): 215–24.

Hamner, Robert D. "Ekphrasis and V.S. Naipaul's *The Enigma of Arrival*." *Comparatist: Journal of the Southern Comparative Literature Association* 30 (May 2006): 37–51.

Hamon, Philippe. "Images parlantes, paroles imageantes et images parlées (étude d'un sonnet de Rimbaud, L'Eclatante victoire de Sarrebrück ... ekphrasis pop-art et parodique). In Hamon's *Imageries, littérature et image au XIXème siècle*. Paris: José Corti, 2007. 309–26.

Hamrick, Cassandra. "Au-dela de la traduction: Baudelaire, Gautier et le dictionnaire du poete-artiste-critique." In Falconer, et al, eds., *Langues du XIXe siecle*. Centre d'Etudes romantiques. Universite de Toronto, 1998. 215–32.

_____. "Gautier et l'anarchie de l'art." In Freeman Henry, ed., *Retire Gautier*. Amsterdam: Rodopi, 1998. 91–117.

Hannah, Robert. "Imaging the Cosmos: Ekphraseis in Euripides." *Ramus: Critical Studies in Greek and Roman Literature* 31 (2002): 19–32.

Hansen, João Adolfo. "Categorias epidíticas da ekphrasis." *Revista Universidade de São Paulo* 71 (September–November 2006): 85–105.

Hardie, Philip Russell. "Pygmalion: Art and Illusion," chapt. 6 of Hardie's *Ovid's Poetics of Illusion*. Cambridge: Cambridge University Press, 2002.

_____. *Virgil. Greece & Rome.* New Surveys in the Classics 28 (Oxford: Oxford University Press, 1998. 75–7.

Hardy, Clara Shaw. "Ecphrasis and the Male Narrator in Ovid's Arachne." *Helios* 22 (1995): 140–48.

Harloe, K. "Allusion and Ekphrasis in Winckelmann's Paris Description of the Apollo Belvedere." *Cambridge Classical Journal* 53 (2006): 229–52.

Hārmā, Juhani. "Le Portrait d'une dame: Description et ekphrasis." *Neuphilologische Mitteilungen: Bulletin de la Société Néophilologique/Bulletin of the Modern Language Society* 101, no. 2 (2000): 177–84.

Harms, Wolfgang, ed. *Text und Bild. Bild und Text. DFG-Symposion 1988.* Stuttgart: Metzler, 1990.

Harrison, Stephen J. "Picturing the Future: The Proleptic Ekphrasis from Homer to Vergil." In Stephen J. Harrison, ed., *Texts, Ideas, and the Classics: Scholarship, Theory, and Classical Literature*. Oxford: Oxford University Press, 2001. 70–92.

Harrits, Cecilie. "Modernismens eksfrase." In Harrits and Troelsen (next entry).

Harrits, Cecilie, and Anders Troelsen, eds., *Ekfrasens former: billeder i tekst*. Århus: Åarhus Universitetsforlag, 2007. **Review:** Christiansen, Steen. http://www.kulturkapellet.dk/faglitteraturanmeldelse.php?id=17

Haslam, Richard. "Wilde's *The Picture of Dorian Gray*." *Explicator* 61, no. 2 (Winter 2003): 96–8.

Hattaway, Michael. "Ekphrasis in Tudor Drama: The Representation of Representations." *Theta VII: Théâtre Tudor* (2007): 39–50. http://umr6576.cesr.univ-tours.fr/publications/Theta7/fichiers/pdf/hattaway.pdf

Haug, Walter. "Gebet und Hieroglyphe. Zur Bild- und Architekturbeschreibung in der mittelalterlichen Dichtung." *Zeitschrift für deutsches Altertum und deutsche Literatur* 106 (1977): 163–83.

Hauck, Evan William. *Vergil's Contribution to Ekphrasis.* Ph.D. dissertation, Ohio State University, 1985.

_____. "Literaturgeschichtsschreibung im höfischen Roman. Die Beschreibung von Enites Pferd und Sattelzeug im 'Erec' Hartmanns von Aue." In Klaus Matzel and Hans-gert Roloff, eds., *Festschrift Herbert Kolb*. Bern: Lang, 1989. 202–19.

_____. "Literarische Bildbeschreibung im Artusroman — Tradition und Aktualisierung. Zu Chrestiens Beschreibung von Erecs Krönungsmantel und Zepter." *Zeitschrift für Germanistik* N.F. 9 (1999): 557–85.

Hauser, Rex Brian. *Parnassianism in the Theory and Literature of Spanish-American and Spanish Poets*. Ph.D. dissertation, University of Michigan, 1988.

Haverkamp, Anselm, and Renate Lachmann, eds. *Gedächtniskunst. Raum–Bild–Schrift. Studien zur*

Mnemotechnik. Frankfurt am Main: Suhrkamp, 1991.

Haxell, N.A. "The Image of the Republic in 1848: An Exercise in 'Imaginary ekphrasis.'" *Nottingham French Studies* 25, no. 1 (May 1986): 1–11.

Hayase, Hironori, ed. *Amerika bungaku to kaiga: Bungaku ni okeru pikutoriarizumu.* Hiroshima, Japan: Keisui-sha, 2000.

Hayashi, Chihiro. "L'ekphrasis dans les Odes (1550) de Pierre de Ronsard." *Études de Langue et Littérature Française* 84 (2004): 17–30.

He, Weiling. *Flatness Transformed and Otherness Embodied: A Study of John Hejduk's Diamond Museum and Wall House 2 across the Media of Painting, Poetry, Architectural Drawing and Architectural Space.* Ph.D. dissertation, Georgia Institute of Technology, 2005.

Hebert, Bernhard D. *Schriftquellen zur hellenistischen Kunst: Plastik, Malerei und Kunsthandwerk der Griechen vom vierten bis zum zweiten Jahrhundert.* Horn: F. Berger, 1989.

Heckscher, W.S, .and F. Baron, eds., *Melancholia (1541). An Essay in the Rhetoric of Description by Joachim Camerarius. Edition, Translation with Commentaries and Notes.* München: Fink, 1978.

Hedley, J. "Sylvia Plath's Ekphrastic Poetry." *Raritan* 20, no. 4 (Spring 2001): 37–73.

Heffernan, James A.W. "Alberti on Apelles: Word and Image in De Pictura." *International Journal of the Classical Tradition* 2, no. 3 (Winter 1996): 345–59.

_____. "Byron and Sculpture." In Frederick Burwick and Jurgen Klein, eds., *The Romantic Imagination: Literature and Art in England and Germany.* Amsterdam: Rodopi, 1996. 289–300.

_____. "Ekphrasis and Representation." *New Literary History* 22 (1991): 297–316.

_____. "Ekphrasis, Art Criticism, and the Poetry of Art." In Ole Karlsen, ed., *Krysninger. Om moderne nordisk lyrikk.* Unipub/ekspedition: Scanvik, Nordisk afdeling. Udgivet, 2008.

_____. "Entering the Museum of Words: Ashbery's *Self-Portrait in a Convex Mirror.*" In Robillard, *Pictures* (below), rpt. from Heffernan, *Museum* (below), 169–90.

_____. "Entering the Museum of Words: Browning's 'My Last Duchess' and Twentieth-Century Ekphrasis." In Wagner, *Icons* (below), 262–80.

_____. "Literacy and Picturacy: How Do We Learn to Read Pictures?" In Eril Hedling and Ulla-Britta Laggeroth, eds., *Cultural Functions of Intermedial Exploration. Internationale Forschungen zur Allgemeinen und Vergleichenden Literaturwissenschaft.* 62. Amsterdam: Rodopi, 2002. 35–66.

_____. "Lusting for the Natural Sign." *Semiotica: Journal of the International Association for Semiotic Studies/Revue de l'Association Internationale de Sémiotique* 98, nos. 1–2 (1994): 219–28.

_____. *Museum of Words: The Poetics of Ekphrasis from Homer to Ashbery.* Chicago: University of Chicago Press, 1993. **Reviews:** Bredin, Hugh. *British Journal of Aesthetics* 35, no. 3 (July 1995): 306–8. Burwick, Frederick. *Wordsworth Circle* 26, no. 4 (Fall 1995): 216–23. Ford, Mark. "Pen and Ink Sketch." *TLS* no. 4787 (30 December 1994): 36. Goslee, Nancy Moore. *Studies in Romanticism* 34, no. 4 (Winter 1995): 648–52. Hurley, Ann. *European Romantic Review* 5, no. 2 (1995): 273–81. Latane, David E., Jr. *South Atlantic Review* 59, no. 4 (1994): 115–17. Macksey, Richard. *Modern Language Notes* 110, no. 4 (September 1995): 1010–15.

_____. "Painting against Poetry: Reynolds' Discourses and the Discourse of Turner's Art." In Martin Heusser et al., eds., *Word & Image Interactions: A Selection of Papers Given at the Second International Conference on Word and Image, Universität Zürich, August 27–31,1990.* Basel: Wiese Verlag Basel, 1993. 135–41.

_____. "Speaking for Pictures: The Rhetoric of Art Criticism (Poetics of Ekphrasis)." *Word & Image: A Journal of Verbal/Visual Enquiry* 15, no. 1 (January–March 1999): 19–33.

Heinze, Richard. *Virgils epische Technik.* Leipzig/Berlin, 1915; rpt. Stuttgart/Leipzig, 1995. 396–403.

Heitmann, Annegret. *Intermedialität im Durchbruch: Bildkunstreferenzen in der skandinavischen Literatur der frühen Moderne.* Freiburg im Breisgau: Rombach, 2003.

Helle, Anita. "A Plath Photograph, Annotated: Point Shirley, 1936." *Virginia Woolf Miscellany* 71 (Spring–Summer 2007): 10–12.

Heller, Léonid. *Ekfrasis v russkoi literature: trudy Lozannskogo simpoziuma.* Moskva: MIK, 2002.

Hellerstein, Nina S. "Phenomenology and Ekphrasis in Claudel's *Connaissance de l'Est.*" *Nottingham French Studies* 36, no. 2 (Fall 1997): 34–44.

Henin, Emmanuelle. "L'enfant Jesus au milieu des docteurs: une image de la parole au XVIIe siecle. A propos d'une ekphrasis jesuite d'un tableau de Stella." *Gazette des Beaux-Arts* 136, nos. 1578–79 (July–August 2000): 31–48.

Henriksen, Line. "'Big Poems Burn Women': Fredy Neptune's Democratic Sailor and Walcott's Epic *Omeros.*" *Australian Literary Studies* 20, no. 2 (2001): 87–109.

Henry, Anne C. "Blank Emblems: The Vacant Page, the Interleaved Book and the Eighteenth-Century Novel." *Word & Image: A Journal of Verbal/Visual Enquiry* 22, no. 4 (2006): 363–71.

Herbert, Bernhard. "Philosophenbildnisse bei Sido-

nius Apollinaris. Eine Ekphrasis zwischen Kunstbeschreibung und Philosophiekritik." *Klio* 70, no. 2 (1988): 519–38.

Hermange, Emmanuel. "Aspects and Uses of Ekphrasis in Relation to Photography, 1816–1860." *Journal of European Studies* 30, pt. 1 (March 2000): 5–18; rpt. in Stephen Bann and Emmanuel Hermange, eds., *Photography and Literature: An Anglo-French Symposium.* Chalfont St. Giles, Bucks, England, 2000.

_____. "L'invention de la critique photographique: un plaisir exalté de l'ekphrasis (1851–1860)." In Pierre–Henry and Jean-Marc Poinsot, eds., *L'invention de la critique d'art: actes du colloque international tenu à l'Université Rennes 2 les 24 et 25 juin 1999.* Rennes: Presses Universitaires de Rennes, 2002. 169–82.

_____. "Langage et genèse de l'image: ou Niépce en 1816." *Romantisme. Revue du dix-neuvième siècle* 29, no. 105 (1999): 17–22.

_____. "The Link between Language and Fixing the Image Permanently: Nicéphore Niépce's Early Attempt at Photography (1816)." *Romantisme* 29, no. 105 (1999): 17–22.

Herrnbrodt, Adolf. "Der Husterknupp, eine niederrheinische Burganlage des frühen Mittelalters." In *Neue Ausgrabungen in Deutschland.* Berlin: Mann, 1958. 542–63.

Hersant, Yves. "Ekphrasis." *Le Grand Dictionnaire de la philosophie.* Paris, Larousse/CNRS, 2003. 324.

Hersey, George. "Rossetti's Jenny." *Yale Review* 69 (Autumn 1079): 17–32.

Hess, Günter. "Die Bilder des Grünen Heinrich: Gottfried Kellers poetische Malerei." In Boehm and Pfotenhauer, *Beschreibungskunst* (above), 373–95.

Heusser, Martin et al., eds. *The Pictured Word: Interactions II.* A Selection of Papers Given at the Third International Conference on Word and Image, University of Ottawa, August 16–21, 1993. Amsterdam, Atlanta: Rodopi, 1998.

Heynders, O. "Regarding Paintings: Works of El Greco in Simon Vestdijk's 'Het Vijfde Zegel.'" *Arcadia* 41, no. 2 (2006): 419–435.

Hibbard, G.R. "The Country House Poem of the 17th Century." *Journal of the Warburg and Courtauld Institutes* 19 (1956): 159–74.

Hilmer, Brigitte. "Kunstphilosophische Überlegungen zu einer Kritik der Beschreibung." In Boehm and Pfotenhauer, *Beschreibungskunst* (above), 75–97

Hinds, Michael. "Randall Jarrell's 'The Bronze David of Donatello': Exhibiting Himself, In and Out." *Letterature d'America: Rivista Trimestrale* 23, no. 96 (2003): 29–49.

Hines, John. "Ekphrasis as Speech-Act: *Ragnarsdrápa* 1–7." *Viking and Medieval Scandinavia* 3 (2007): 225–44.

Hinnant, Charles H. "Marvell's Gallery of Art." *Renaissance Quarterly* 24, no. 1 (Spring 1971): 26–37.

Hiroshi, Motoe. *Ekphrasis and the Relationship of the Self and the Other.* Doctoral thesis, University of Tokyo, 2002. [In Japanese]

Hirschberger, Elisabeth. *Dichtung und Malerei im Dialog. Von Baudelaire bis Eluard, von Delacroix bis Max Ernst.* Tübingen: Narr, 1993.

Hirst, Wolf Z. "How Dreams Become Poems: Keats's Imagined Sculpture and Re-Vision of Epic." In Frederick Burwick and Jürgen Klein, eds., *The Romantic Imagination: Literature and Art in England and Germany. Studies in Comparative Literature.* 6. Amsterdam: Rodopi, 1996. 301–14.

Hochman, Michele. "L'ekphrasis efficace: l'influence des programmes iconographiques sur les peintures et les décors italiens au XVIe siècle." In Olivier Bonfait, ed., *La description de l'oeuvre d'art: du modèle classique aux variations contemporaines.* Paris: Editions de la Réunion des musées nationaux, 2004. 43–76.

Hock, Ronald F. et al., eds. *Ancient Fiction and Early Christian Narrative.* Atlanta, GA: Scholars Press, 1998.

Hoek, Leo H. "Les 'Minutes profondes' de Marcel Proust." In Sophie Berto, ed., *Proust contemporain. CRIN: Cahiers de Recherche des Instituts Neerlandais de Langue et de Litterature Francaises.* 28. Amsterdam: Rodopi, 1994. 103–16.

Hodson, W.L. Review of *Marcel Proust 5: Proust au tournant des siecles,* ed. Bernard Brun and Juliette Hassine. *Modern Language Review* (2007).

Hofmann, Klaus. "Keats's 'Ode to a Grecian Urn.'" *Studies in Romanticism* 45, no. 2 (2006): 251–84.

Holladay, Kandace K. "La imagen fílmica en El beso de la mujer araña de Manuel Puig como inversión del proceso ecfrástico." *Alba de América: Revista Literaria* 21, nos. 39–40 (July 2002): 309–15.

Holländer, Hans. "Phantastische Architektur: Texte und Bilder." In Nerdinger, *Architektur* (below), 40–56.

Hollander, Elizabeth. *Fiction's Likeness: Portraits in English and American Novels from "Frankenstein" to "Middlemarch."* Ph.D. dissertation, Graduate Center, City University of New York, 1999.

Hollander, John. "A Circle of Representations." In Golahny, *The Eye* (above), 224–37.

_____. *The Gazer's Spirit: Poems Speaking to Silent Works of Art.* Chicago: University of Chicago Press, 1995. Part 2 of this seminal study, "The Gallery," contains eighteen poems in conversa-

tions with paintings, along with Hollander's commentary. **Reviews:** Birmelin, Blair T. *Women Artists News Book Review* 23 (1998): 39–40. Bloom, Harold. *Artforum International* 34 (Summer 1996): bookforum 9. Kirby, D. *Library Journal* 120 (15 September 1995): 66. Lloyd, Christopher. *Review of English Studies* n.s. 49, no. 193 (February 1998): 121–3. Vendler, Helen. On the Laws of Poetic Art." *New York Review of Books* 43 (9 May 1996): 39.

_____. "The Figure on the Page: Words and Images in Wright Morris's *The Home Place*." *Yale Journal of Criticism* 9 (Spring 1996): 93–108.

_____. "The Gazer's Spirit: Romantic and Later Poetry on Painting and Sculpture." In Gene W. Ruoff, ed., *The Romantics and Us: Essays on Literature and Culture*. New Brunswick: Rutgers UP, 1990. 130–67.

_____. "The Poetics of Ekphrasis." *Word & Image: A Journal of Verbal/Visual Enquiry* 4 (1988): 209–19.

_____. "Three Dazzlers." *Yale Review* 80 (July 1992): 101–26.

_____. "Words on Pictures." *Art and Antiques* (March 1984): 80–91.

Hollenberg, Donna K. "'History as I desired it': Ekphrasis as Postmodern Witness in Denise Levertov's Late Poetry." *Modernism—Modernity* 10, no. 3 (September 2003): 519–37.

Hollsten, Anna Charlotta. *Ei kattoa, ei seinia. Nakokulmia Bo Carpelanin kirjallisuuskasitykseen.* Ph.D. dissertation, Helsingin Yliopisto, 2004.

Holsinger, Bruce. "Lollard Ekphrasis: Situated Aesthetics and Literary History." *Journal of Medieval and Early Modern Studies* 35, no. 1 (Winter 2005): 67–89.

Holt, Timothy James. *Setting as a Poetic Device to Enhance Character in the Apologos of Homer's "Odyssey."* M.A. thesis, Queen's University (Hamilton, ON), 2008.

Hohlweg, A. "Ekphrasis." In *Reallexikon zu byzantinischer Kunst* 2 (Stuttgart 1971): cols. 33–75.

Hooker, Richard. "Lycidas and the Ecphrasis of Poetry." *Milton Studies* 27 (1991): 59–77.

Hoover, Polly Ruth. *Boundaries and Transgression in Lucan's "Bellum Civile."* Ph.D. dissertation, University of Wisconsin, Madison, 1995.

Hoppin, M.C. "New Perspectives on Horace, *Odes* 1.5." *American Journal of Philology* 105 (Spring 1984): 54–68.

Hörandner, Wolfram. "Zur Beschreibung von Kunstwerken in der byzantinischen Dichtung— am Beispiel des Gedichts auf das Pantokratorkloster in Konstantinopel." In Ratkowitsch, *Die poetische* (below), 203–19.

Horn Fuglesang, Signe. "Billedbeskrivende dikt."

In Else Mundal and Anne Ågotnes, eds., *Ting og tekst*. Bergen: Bryggens Museum, 2002. 119–42.

_____. "Ekphrasis and Surviving Imagery in Viking Scandinavia." *Viking and Medieval Scandinavia* 3 (2007): 193–224.

Horstkotte, Silke. "Visual Memory and Ekphrasis in W.G. Sebald's *The Rings of Saturn*." *English Language Notes* 44, no. 2 (Fall–Winter 2006): 117–29.

Horstkotte, Silke, and N. Pedri. "Introduction: Photographic Interventions." *Poetics Today* 29, no. 1 (2008): 1–29.

Howard, Richard. "Poems on Pictures and Other Ekphrases." *Word & Image: A Journal of Verbal/Visual Enquiry* 4, no. 1 (January–March 1988): 37–42.

Howard, William Guild. "*Ut Pictura Poesis*." *PMLA* 24, no. 1 (1909): 40–123.

Howe, Sarah. "'Pregnant images of life': Visual Art and Representation in *Arcadia* and *The Faerie Queene*." *Cambridge Quarterly* 34, no. 1 (2005): 33–53.

Howell, Jennifer. "Reconstituting Cultural Memory through Image and Text in Leïla Sebbar's *Le Chinois vert d'Afrique*." *French Cultural Studies* 19, no. 1 (February 2008): 57–70.

Hsu, Hsuan. "Auden's 'Musée des Beaux Arts.'" *Explicator* 57, no. 3 (Spring 1999): 166–7.

_____. "War, Ekphrasis, and Elliptical Form in Melville's Battle-Pieces." *Nineteenth Century Studies* 16 (2002): 51–71.

Huber-Rebenich, Gerlinde. "Zur Wahrnehmung der Bildenden Kunst durch Literaten im Umfeld Dürers: Eobanus Hessus im Vergleich mit Joachim Camerarius." In Bodo Guthmüller, ed., *Künstler und Literat: Schrift- und Buchkultur in der europäischen Renaissance*. Wiesbaden: Harrassowitz, 2006. 75–96.

Hübner, Wolfgang. "'Corpore semifero': Ekphrasis oder Metamorphose des Steinbocks?" *Hermes: Zeitschrift für Klassische Philologie* 108, no. 1 (1980): 73–83.

Huddleston, Eugene L., and Douglas A. Noverr. *The Relationship of Painting and Literature: A Guide to Information Sources*. Detroit: Gale Research, 1978.

Hufstader, Jonathan. "Derek Mahon." In Hufstader's *Tongue of Water, Teeth of Stones* (Frankfort: University Press of Kentucky, 1999).

Hühn, Peter. "Double Transgenerity: Narrating Pictures in Poems." *Anglistik* 18, no. 2 (September 2007): 43–61.

Hülse, S. Clarke. "'A Piece of Skilful Painting' in Shakespeare's *Lucrece*." *Shakespeare Survey* 31 (1978): 13–22.

Hultsberg, Peter. *Därför berör oss fåglarnas liv:*

Lennart Sjögrens poetiska livsförståelse. Doctoral thesis, Växjö University, 2008.

Hunt, John Dixon. "Ekphrasis of Gardens." *Interfaces* (Dijon) 5 (1994): 61–74.

_____. "Putting You in the Picture: Visual Image and Ekphrasis in Publications of the Picturesque Garden." In *Internationaler Kongress "Garten Kunst im Bild": am 24./25. Mai 2002 im Wiener Gartenbaukino.* Worms: Werner, 2003. 290–7.

_____. *Self-Portrait in a Convex Mirror of Poems on Paintings: An Inaugural Lecture.* London: Bedford College, University of London, 1982.

Hutchings, Stephen C. *Russian Literary Culture in the Camera Age: The Word as Image.* London: New York: Routledge Curzon, 2004.

Hyde, Monique. "The Functions of Pictorial Art in Marie-claire Blais's *Le Sourd dans la Ville.*" *West Virginia University Philological Papers* 41 (1995): 132–42.

Ibrišimović-Šabić, Adijata. "Ekfrazis 'Kamenog spavaća' ili 'Kameni spavać' kao ekfrazis" = "Ekphrasis of 'The Stone Sleeper' or 'The Stone Sleeper' as Ekphrasis." *New Expression* 37–38 (2007): 155–71.

_____. "Ekfrazis Kamenog spavaca Mehmedalije Maka Dizdara (ili Kameni spavac kao ekfrazis)." *Pismo: Journal for Linguistics and Literary Studies* 4, no. 1 (2006): 171–92.

Il'ichev, A.V. "Skul'ptura i tekst: 'Tsarskosel'skaia statuia' A.S. Pushkina." *Russkaia Literatura: Istoriko-Literaturnyi Zhurnal* 1 (2004): 95–102.

Insolia, Riccardo. "Come acqua nell'acqua": a proposito di *Ekphrasis* di Luciano Berio." In Valtolina, *L'immagine rubata* (below), 116–28.

Ioannidake-Ntostoglou, Euaggelia. "Efraim o Súros kaí Márkos Eugenikós" [Ephrem le Syrien et Marc Eugénikos]. *Deltion tes Hristianikes arhaiologikes etaireias* 15 (1989): 279–82.

_____. "Parastáseis koimeseos osíon kai asketon 14ou–15ou aiona [Iconographie de la dormition des saints et des ascètes au 14e–15e siècle]. *Arhaiologikon deltion* 42, no. 1 (1987): 99–151.

Irmscher, Johannes. "Die poetische Ekphrasis als Zeugnis justinianischer Kulturpolitik." *Wischenschaftliche Zeitschrift der Friedrich-Schiller-Universität Jena,* 1965. 79–87.

Iversen, Gunnar. "Pike med perleøredobb som filmatisk ekfrase." In Gunnar Iversen, ed., *Estetiske teknologier 1700–2000,* vol. 3. Oslo: Scandinavian Academic Press, 2006.

Iversen, Stefan. "Billedet om igen — kunstsyn og ekfrase i Johannes V. Jensens forfatterskab." In Stefan Iversen, ed., *Kraftlinjer — om Johannes V. Jensens forfatterskab* (Johannes V. Jensen-Centrets skriftserie, 3, 2004). Syddansk Universitetsforlag. 81–109.

Ivić, Nenad. "Historian's Shield and the Politics of Ekphrasis." *Semiotische Berichte* 1, no. 4 (2000): 95–105.

Jackson, John L., Jr. "Abandoning Advertisements over Edificial Ekphrases." *Journal of Visual Culture* 2, no. 3 (December 2003): 341–52.

Jackson, Noel B. "Orpheus to Narcissus: The Observer as Other in John Ashbery's *Self-Portrait in a Convex Mirror.*" *Chicago Art Journal* 7, no. 1 (Spring 1997): 34–42.

Jacob, Marie. "L'Ekphrasis en images: Métamorphoses de la description dans l'Histoire de la destruction de Troye la Grant enluminée par l'atelier des Colombe à la fin du XVe siècle (BnF. Nv.Acq.Fr. 24920)." In Laurence Harf-Lancner et al., eds., *Conter de Troie et d'Alexandre.* Paris, France: Sorbonne Nouvelle, 2006. 291–308.

Jacobs, Frederika H. "Woman's Capacity to Create: The Unusual Case of Sofonisba Anguissola." *Renaissance Quarterly* 47, no. 1 (Spring 1994): 74–101.

Jacobs, Helmut C. "Aspectos de la relación entre imagen y texto en las novelas españolas de los años 80 y 90." *Iberoamericana: Lateinamerika Spanien Portugal* 23, nos. 3–4 [75–76] (1999): 122–54.

Jäger, Ludwig. "Sprache als Medium. Über die Sprache als audio-visuelles Dispositiv des Medialen." In Wenzel, Seipel, and Wunberg (below), 19–42.

_____. "Transkriptivität. Zur medialen Logik der kulturellen Semantik." In Ludwig Jäger and Georg Stanitzek, eds., *Transkribieren. Medien/Lektüre.* München: Wilhelm Fink Verlag, 2002. 19–41.

_____. "Zeichen/Spuren. Skizze zum Problem der Sprachzeichenmedialität." In Georg Stanitzek and Wilhelm Voßkamp, eds., *Schnittstelle. Medien und kulturelle Kommunikation.* Köln 2001. 17–31.

Jakobi-Mirwald, Christine. "Karl der Grosse und seine Aachener Marienkirche." In Gottfried Kerscher, ed., *Hagiographie und Kunst: der Heiligenkult in Schrift, Bild und Architektur.* Berlin: D. Reimer, 1993. 179–94.

James, Clive. "The Simple Excellence of Peter Porter." *Critical Survey* 18, no. 1 (2006): 78–92.

James, Liz, and Ruth Webb. "'To understand ultimate things and enter secret places': Ekphrasis and Art in Byzantium." *Art History* 14 (March 1991): 1–17.

Jamieson, Sara. "'Now That I Am Dead': P.K. Page and the Self-Elegy." *Canadian Literature* 166 (Autumn 2000): 63–82.

Jansson, Mats. "Ekfras som estetisk hermeneutic." In Harrits and Troelsen (above), 143–64.

_____. *Den siste barden. Ord och bild hos Sven Alfons.* Stockholm/Stehag: Symposion, 2005. **Review:** Bäckström, Per. "Mystik och ekfras i svensk modernism." *Edda* 1 (2005): 4.

Jarniewicz, Jerzy. "To Be or to Be? Facts and Interpretations in W.C. Williams' Reading of Breughel's Icarus." In Jadwiga Maszewska and Zbigniew Maszewski, eds., *Walking on a Trail of Words: Essays in Honor of Professor Agnieszka Salska.* Lódz, Poland: Wydawnictwo Uniwersytetu Lodzkiego, 2007. 177–82.

Jessar, Kevin L. "Angels by Way of and in the Laundry: Richard Wilbur's Sacramental Ekphrasis." *Mosaic* 32, no. 4 (December 1999): 91–110.

Johansson, Birgitta. "Iconographic Metafiction: A Converging Aspect of Michael Ondaatje's *The English Patient* and John Berger's *To the Wedding.*" *Textual Studies in Canada* 13–14 (2001): 81–90.

Johnson, Christopher., eds., "Appropriating Troy: Ekphrasis in Shakespeare's *The Rape of Lucrece.*" In Alan Shepherd and Stephen D. Powell, eds., *Fantasies of Troy: Classical Tales and the Social Imaginary in Medieval and Early Modern Europe.* Publications of the Centre for Reformation and Renaissance Studies: Essays and Studies. 5. Toronto, ON: Centre for Reformation and Renaissance Studies, 2004. 193–212.

Johnson, L. W. "Amorum Emblemata: Tristan l'Hermite and the Emblematic Tradition." *Renaissance Quarterly* 21, no. 4 (Winter 1968): 429–41.

Joly, R. *Le tableau de Cébès et la philosophie religeuse.* Collection Latomus 61. Brussells-Berchem: Latomus, 1963.

Jonckheere, Wilfred. "Blurring the Roles of Viewer-Poet-Critic: Mooij's Sonnet Cycle (1991) on Rembrandt's Staalmeesters (1662)." In Golahny, *The Eye* (above), 196–213.

_____. "Two Bosch Paintings and Two Poems: Saint Jerome in the Mirror of Simon Vestdijk's and W.E.G. Louw's Painter Poems." In Martinus A. Bakker and Beverly H. Morrison, eds., *Studies in Netherlandic Culture and Literature.* Lanham, MD: University Press of America, 1994. 45–54.

Jones, Kendra. "The Ekphrasis Effect: An Analysis of Goya's Black Paintings within Antonio Buero Vallejo's Play the *Sleep of Reason.*" *Ciberletras: Revista de crítica literaria y de cultura* 19 (2008). http://www.lehman.edu/faculty/guinazu/ciberletras/v19/jones.html

Jones, Lynn, and Henry Maguire. "A Description of the Jousts of Manuel I Komnenos." *Byzantine and Modern Greek Studies* 26 (2002): 104–48.

Jongeneel, Els. "Rilke's Speaking Gods." In Robillard, *Pictures* (below).

_____. "'Un de ces tableaux impressionnistes': L'Im-age comme fixatif de l'histoire dans *L'Herbe* de Claude Simon." In Suzan van Dijk and Christa Stevens, eds., *(En)jeux de la communication romanesque. Faux Titre: Etudes de Langue et Litterature Francaises.* 86. Amsterdam: Rodopi, 1994. 257–69.

_____. "Vision lectorale et effets d'image (La Bataille de Pharsale)." In Christian Doumet et al., eds., *Art, regard, écoute: La Perception à l'Oeuvre.* Saint-Denis, France: Presses Universitaires de Vincennes, 2000. 93–107.

Jørgensen, Hans Henrik Lohfert. "Fra tyste til rungende ord." In Harrits and Troelsen (above).

Joron, Andrew. "Flowing Uphill." http://www.poetryfoundation.org/journal/feature.html?id=182364

Jouanno, Corinne. *L'ekphrasis dans la littérature byzantine d'imagination.* Doctoral thesis, Université de Paris IV: Paris-Sorbonne, 1987.

Joycee, O.J. "The Smile that Launched a Thousand Lines: The *Mona Lisa* and the Poetics of Ekphrasis." *Icfai Journal of English Studies* 1, no. 4 (December 2006): 50–62.

Jukic, Tatjana. "The Optics of the Pre–Raphaelite Keats." *Studia Romanica et Anglica Zagrabiensia* 47–48 (2002–2003): 127–46.

Jungmann, Alfred. "Städtisches Museum Abteiberg, Mönchengladbach: ein Besuch: Eindrücke und Gedanken." In Michael Berens, ed., *Florilegium artis: Beiträge zur Kunstwissenschaft und Denkmalpflege.* Saarbrücken: Verlag "Die Mitte," 1984. 72–5.

Jurkevich, Gayana. "Azorín's Painted Lady: María Fontán and the Economics of Ekphrasis." In Claire J. Paolini, ed., *La Chispa '97: Selected Proceedings.* New Orleans, LA: Tulane University, 1997. 211–20.

_____. *In Pursuit of the Natural Sign: Azorín and the Poetics of Ekphrasis.* Lewisburg, PA: Bucknell University Press, 1999. **Reviews:** Johnson, Roberta. *Hispanic Review* 70, no. 4 (Fall 2002): 650–2. Landeira, R., *Revista de canadiense de estudios hispanicos* 26, no. 3 (2002): 563–4. Parker, M.R. *Hispania* 83, no. 4 (December 2000): 797–9. Torrecilla, J. *Revista de Estudios Hispanicos* 35, no. 3 (October 2001): 676–7.

_____. "A Poetics of Time and Space: Ekphrasis and the Modern Vision in Azorin and Velázquez." *MLN* 110 (March 1995): 284–301.

Jurt, Joseph. "Ekphrasis." In Eva Kimminich and Claudia Krülls-Hepermann, eds., *Zunge und Zeichen.* Frankfurt am Main and New York: Peter Lang, 2000.

_____. "Les arts rivaux: La description littéraire — le temps pictural (Homère, Poussin, Le Brun)." *Neophilologus* 72, no. 2 (April 1988): 168–79.

_____. "Die Debatte um die Zeitlichkeit in der Académie Royale de Peinture am Beispiel von Poussins Mannalese." In Franziska Sick and Christof Schoch, eds., *Zeitlichkeit in Text und Bild*. Heidelberg: Universitätsverlag (Winter, 2007): 337–47.

Juszczak, W. "Ekfraza imaginacyjna: eidolon Heleny." http://www.gnosis.art.pl/e_gnosis/aurea_catena_gnosis/juszczak_eidolon_heleny01.htm

Kaes, E. "Un exemple de l'ekphrasis claudélienne: sur la Présentation au Temple de Rembrandt." *Champs du Signe: Sémantique, Poétique, Rhétorique*, no. 6. (1995): 315–26.

Kafalenos, Emma. "Effects of Sequence, Embedding, and Ekphrasis in Poe's 'The Oval Portrait.'" In James Phelan and Peter Rabinowitz, eds., *A Companion to Narrative Theory*. Oxford: Blackwell, 2005. 253–68.

Kahng, Eik. "L'Affaire Greuze and the Sublime of History Painting." *Art Bulletin* 86, no. 1 (March 2004): 96–113.

Kaldellis, Anthony. "Christodoros on the Statues of the Zeuxippos Baths: A New Reading of the 'Ekphrasis.'" *Greek, Roman and Byzantine Studies* 47, no. 3 (Fall 2007): 361–83.

Kalleres, Dayna S. "Cultivating True Sight at the Center of the World: Cyril of Jerusalem and the Lenten Catechumenate." *Church History* 74, no. 3 (September 2005): 431–59.

Kane, Siobhan. *Reevaluating the Boundaries of Visual and Verbal Aesthetics: A Critical Inquiry into the Significance of Ekphrasis in John Keats' Odes*. [St. Bonaventure, N.Y.]: St. Bonaventure University, 2006.

Kanekar, Aarati. *The Geometry of Love and the Topography of Fear: On Translation and Metamorphosis from Poem to Building*. Ph.D. dissertation, Georgia Institute of Technology, 2000.

Kaplan, Carol L. "Gide et Poussin: Une Lecture-ekphrasis des Faux-Monnayeurs." *Bulletin des Amis d'André Gide* 35, no. 154 (April 2007): 237–46.

Kapp, Volker et al., eds., *Bilderwelten als Vergegenwärtigung und Verrätselung der Welt: Literatur und Kunst um die Jahrhundertwende. Schriften zur Literaturwissenschaft*. 12. Berlin, Germany: Duncker & Humblot, 1997.

_____. "Vom Bild als Vergegenwärtigung zum Bild als Simulation und Verrätselung der Welt." In Kapp (previous entry), *Bilderwelten*, 9–29.

Karbyshev, A.A. "Ekphrasis and Narration in the Novel by S. Sokolov, *Between a Dog and a Wolf*." *World of Science, Culture, Education: Science Journal* 1, no. 8 (January–March 2008). [in Russian].

Kardokas, Laima. "The Twilight Zone of Experience Uncannily Shared by Mark Strand and Edward Hopper." *Mosaic* 38, no. 2 (June 2005): 111–28.

Karlsen, Ole. *Ord og bilete. Ekfrasen i moderne norsk lyrikk*. Oslo: Det Norske Samlaget, 2003. For table of contents, see http://www.bokklubben.no/SamboWeb/side.do?dokId=10420089

_____. "Å synleggjere det usynlege." In Harrits and Troelsen (above).

Kässer, Christian. "The Body is Not Painted on: Ekphrasis and Exegesis in Prudentius *Peristephanon* 9." *Ramus: Critical Studies in Greek and Roman Literature* 31, no. 1–2 (2002): 158–74.

Kasten, Ingrid. "Der Pokal in "Flore und Blanschelflur." In Haferland and Mecklenburg (above), 189–98.

Kaufmann, Thomas Dacosta. "Dazwischen: Kulturwissenschaft auf Warburgs Spuren (Saecula Spiritalia, 29)." *Art Bulletin* 80, no. 3 (September 1998): 580–5. Review of Dieter Wuttke's *Renaissance-Humanismus und Naturwissenschaft in Deutschland*, Jeffrey Morrison's *Winckelmann and the Notion of Aesthetic Education*, Catherine M. Soussloff's *The Absolute Artist: The Historiography of a Concept*, and Michael Ann Holly's *Past Looking: Historical Imagination and the Rhetoric of the Image*.

Kay, Richard. "Vitruvius and Dante's 'Imago dei.'" *Word & Image: A Journal of Verbal/Visual Enquiry* 21, no. 3 (2005): 252–60.

Keane-Geimas, Teresa. *L'ecphrasis dans la poésie espagnole (1898–1985) ou le plaisir des formes*. Centre de Recherches Interdisciplinaires sur les Mondes Ibériques Contemporains. Université de Paris-Sorbonne, 2007.

Keller, Lynn. "Poems Living with Paintings: Cole Swensen's Ekphrastic 'Try.'" *Contemporary Literature* 46, no. 2 (Summer 2005): 176–212.

Kelley, Theresa M. "Keats, Ekphrasis, and History." In Nicholas Roe, ed., *Keats and History*. Cambridge: Cambridge University Press, 1995. 212–37.

_____. "Keats and 'Ekphrasis': Poetry and the Description of Art." In Susan J. Wolfson, ed., *The Cambridge Companion to Keats*. Cambridge, England: Cambridge University Press, 2001. 170–85.

Kemp, Wolfgang. "Praktische Bildbeschreibung: über Bilder in Bildern, besonders bei Van Eyck und Mantegna." In Boehm and Pfotenhauer, *Beschreibungskunst* (above), 99–109.

Kern, Robert. "Mountains and Rivers Are Us: Gary Snyder and the Nature of the Nature of Nature." *College Literature* 27 (2000): 119–38.

Kenaan-Kedar, Nurith. "The Ekphrastic Components of Victor Hugo's *Notre-Dame de Paris*." In Robillard, *Pictures* (below), 145–55.

Kennedy, Brian. "Crazy about Women: Poems about Paintings." In Colm Tóibín, ed., *The Kilfenora Teaboy: A Study of Paul Durcan*. Dublin: New Island, 1996. 155–62.

Kenny, John. "Well Said Well Seen: The Pictorial Paradigm in John Banville's Fiction." *Irish University Review: A Journal of Irish Studies* 36, no. 1 (Spring-Summer 2006): 52–67.

Kepetzi, Victoria. "Empereur, pitié et rémission des péchés dans deux ekphraseis byzantines: image et rhétorique." *Deltion tes Hristianikes arhaiologikes etaireias* 20 (1998): 231–44.

Kersh, Sarah Erin. "*Mine Eye Hath Play'd the Painter*": Desire and Ekphrasis in Shakespeare's "*Venus and Adonis*," and "*The Sonnets*." M.A. thesis, Vanderbilt University, 2006.

Kestner, Joseph. "Ekphrasis as Frame in Longus' *Daphnis and Chloe*." *Classical World* 67 (1974): 166–71.

Keuls, Eva. "Rhetoric and Visual Aids in Greece and Rome." In Eric A. Havelock and Jackson P. Hershbell, eds., *Communication Arts in the Ancient World*. New York: Hastings House, 1978, 121–34.

Kheteni, Zhuzha. "Ekfrasis o dvukh kontsakhteoreticheskom i prakticheskom: Tezis nesostoiavshegosia doklada." In Geller, *Ekfrasis* (above), 162–6.

Khodel, Robert. "Ekfrasis i 'demodalizatsiia' vyskazyvaniia." In Geller, *Ekfrasis* (above), 23–30.

Kibédé Varga, Áron. "Mediality and Forms of Interpretation of Artworks." *Neohelicon* 30, no. 2 (December 2003): 183–91.

_____. "La rhétorique et la peinture dans les essais d'Yves Bonnefoy. In Partick Nee, ed., *Yves Bonnefoy: poésie, recherche et saviors*. Paris: Herman, 2007. 93–111.

Kietrys, Kyra A. *Visión hecha verbo: Palabra frente a imagen en la novela española de 1878 a 1925*. Ph.D. dissertation, University of Pennsylvania, 2001.

Kimberley, Emma. "Textual Implications of Ekphrasis in Contemporary Poetry." In Rebecca Styler and Joseph Pridmore, eds., *Textual Variations: The Impact of Textual Issues on Literary Studies*. Leicester: Department of English, University of Leicester, 2006. 89–99.

Kitzinger, Ernst. "The Date of Philagathos' Homily for the Feast of Sts. Peter and Paul." *Byzantinosicula II* (Mél. G. Rossi-Taibbi) (1975): 301–6.

_____. "The Pantokrator Bust: Two Medieval Interpretations." In Ernst Dassmann and Klaus Thraede, eds., *Tesserae Festschrift für Josef Engemann*. Münster: Aschendorff, 1991. 161–3

Kjeldsen, Jette. "What Can the Aesthetic Movement Tell Us about Aesthetic Education?" *Journal of Aesthetic Education* 35, no. 1 (Spring 2001): 85–97.

Kjørup, Søren. *Ekfrase og meditation: om Paal-Helge Haugens meditasjonar over Georges de la Tour*. Oslo: Det norske Samlaget, 1997.

Klarer, Mario. *Ekphrasis: Bildbeschreibung als Repräsentationstheorie bei Spenser, Sidney, Lyly und Shakespeare*. Tübingen: Niemeyer, 2001.

_____. *Ekphrasis*. London: Taylor & Francis, 1999.

_____. "Ekphrasis, or the Archeology of Historical Theories of Representation: Medieval Brain Anatomy in Wernher der Gartenaeres *Helmbrecht*." *Word & Image: A Journal of Verbal/Visual Enquiry* , no. 1 (January–March 1999): 34–40.

_____. "Ekphrasis: Introduction (Literary Descriptions of Paintings)." *Word & Image: A Journal of Verbal/Visual Enquiry* 15, no. 1 (January–March 1999): 1–4.

_____. "Ekphrasis und der Chronotopos der Simultaneität in Virginia Woolfs *Mrs. Dalloway* und *Orlando*." In Gudrun M. Grabher, ed., *Geburt und Tod im Kunstvergleich*. Trier: Wissenschaftlicher Verlag Trier, 1995.

_____. "Die mentale imago im Mittelalter: Geoffrey Chaucers Ekphrasen." In Ratkowitsch, *Die poetische* (below), 77–96.

_____. "Selected Bibliography of Book-length Studies and Collections of Essays on Ekphrasis (Verbal Renderings of Pieces of Visual Art)." *Word & Image: A Journal of Verbal/Visual Enquiry* 15, no. 1 (January–March 1999): 4–6.

_____. "Spiegelbilder und Ekphrasen. Spekulative Fiktionspoetik im 'Pfaffen Amis' des Strickers." *Das Mittelalter* 13, no. 1 (2008): 80–106.

Klecker, Elisabeth. "Tapisserien Kaiser Maximilians: zu Ekphrasen in der neulateinischen Habsburg-Panegyrik." In Ratkowitsch, *Die poetische* (below), 181–202.

Klettke, Cornelia. "Zeitlichkeit im Spannungsverhältnis von Malerei und Poesie bei Victor Hugo und Jean-François Millet." In Franziska Sick and Christof, eds., *Zeitlichkeit in Text und Bild*. Heidelberg: Universitätsverlag (Winter, 2007): 253–70.

Kleinhans, Martha. "Ekphrastische Bilder: Schreiben und Malerei." Chapter 3 of Kleinhans's *Satura und pasticcio: Formen und Funktionen der Bildlichkeit im Werk Carlo Emilio Gaddas*. Tübingen: Niemeyer, 2002. 147–230.

Kling, Oleg. "Topoekfrasis: Mesto deistviia kak geroi literaturnogo proizvedeniia: Vozmozhnosti termina." In Geller, *Ekfrasis* (above), 97–110.

Klohe, Carmen Fernández. *Descripción y ékfrasis en la prosa de Ramón Gómez de la Serna*. Ph.D. dissertation, The Gradute Center, City University of New York, 1999.

Knapp, Thyra E. "*Ja, ihr seid gemalt*": Ekphrasis and the Outsider in Three Postmodern German Novels.

Ph.D. dissertation, University of Wisconsin, Madison, 2008.

Knocny, Lubomir. "Tiziano, Lodovico Dolce e i topoi dell'imaginazione erotica." *Umeni* 40, no. 1 (1992): 1–5.

Koelb, Janice Hewlett. *Figures in the Carpet: Classical Ecphrasis and Romantic Description.* Ph.D. dissertation, University of North Carolina, 2004.

_____. *The Poetics of Description: Imagined Places in European Literature.* New York: Palgrave Macmillan, 2007.

Koering, Jeremie. "La Sala di Troia de Jules Romains: l'histoire et ses complications." *Studiolo* 3 (2005): 191–218.

Kofler, P., ed. *Ekstatische Kunst—Besonnenes Wort: Denkräume der Ekphrasis in Deutschland von Wilhelm Heinse bis Aby Warburg.* Innsbruck-Wien-München-Bozen: Sturzflüge-Studienverlag, 2008.

Kokole, Stanko. "Cognitio Formarum and Agostino di Duccio's Reliefs for the Chapel of the Planets in the Tempio Malatestiano." In Charles Dempsey, ed., *Quattrocento Adriatico: Fifteenth-Century Art of the Adriatic Rim: Papers from a Colloquium Held at the Villa Spelman, Florence, 1994.* Bologna: Nuova Alfa, 1996. 177–206.

_____. "The Tomb of the Ancestors in the Tempio Malatestiano and the Temple of Fame in the Poetry of Basinio da Parma.'" In Giancarla Periti and Charles Dempsey, eds., *Drawing Relationships in Northern Italian Renaissance Art: Patronage and Theories of Invention.* Aldershot, Burlington, VT: Ashgate, 2004. 11–34.

Kolstrup, Inger-Lise. "Kunsten i Rosens navn" [The Art in *The Name of the Rose*]. In Andre Wang Hansen, ed., *Synsvinkler på kunsthistorien.* Århus: Aarhus universitetsforlag, 1991. 30–53.

Kolve, V.A. *Chaucer and the Imagery of Narrative. The First Five Canterbury Tales.* Stanford, CA: Stanford University Press, 1984.

Könczöl-Kiss, Erzsébet. "Ekphrasis és illúzió Philostratos Eikones ében." *Antik Tanulmányok* 52, no. 1 (June 2008): 103–7.

Konečný, Lubomír. "Hra o jablko: Karel Škréta a Filostratos" = "Playing for the Apple: Karel Škréta and Philostratus." *Opuscula historiae atrium* 51 (2002): 7–23.

König, Eberhard. "Buchmalerei—eine narrative Kunst?" In Nigel F. Palmer, ed., *Mittelalterliche Literatur und Kunst im Spannungsfeld von Hof und Kloster.* Tübingen: Niemeyer, 1999. 141–48.

Konstantinova, Ralitza Hristova. *Emotions and Their Functions in Achilles Tatius' "Leucippe."* Ph.D. dissertation, University of California, Berkeley, 2000.

Kontoglou, Photios. *Ekphrasis tes orthodoxu eikono-*

graphias: meta pollon schedion kai eikonon. 2 vols. Athenai: Papademetrios, 1960.

Koopps, Bert-Jaap. "De Boer Staat nu Voorop: Beeldgedichten op Bruegels 'De val van Icarus.'" http://rechten.uvt.nl/koops/HERZICAR.HTM

Kooy, Michael John. "Word and Image in the Later Work of Geoffrey Hill." *Word & Image: A Journal of Verbal/Visual Enquiry* 20, no. 3 (July–September 2004): 191–205.

Korey, Alexandra. *Putti, Pleasure, and Pedagogy in Sixteenth-century Italian Prints and Decorative Arts.* Ph.D. dissertation, University of Chicago, 2007.

Körner, Hans. "Der imaginäre Fremde als Bildbetrachter: Zur Krise der Bildbeschreibung im französischen 19. Jahrhundert." In Boehm and Pfotenhauer, *Beschreibungskunst* (above), 397–424.

Kortenaar, Neil ten. "Postcolonial Ekphrasis: Salman Rushdie Gives the Finger Back to the Empire." *Contemporary Literature* 38 (Summer 1997): 232–59.

Kostyuk, Victoria V. "Экфрасис в творчестве Елены Гуро" = "Ekphrasis in the Works of Elena Guro." *ВЕСТНИК МОЛОДЫХ УЧЕНЫХ* [*Journal of Young Scientists*] 5 (2004): 69–87.

Kotopoule, Marika, and Eua Georgousopoulou. *Ekphrasis.* Athena: Ekdoseis Kastaniote, 2001.

Kowalski, Jacek. "Tour, pilier, escaboucle littérature et architecture en France au XIIe siècle." In *Tours et clochers à l'époque préromane et romane.* Codalet: Association Culturelle de Cuixà, 1996. 139–54.

Kozak, Romy. *Sounding Out: Musical Ekphrasis, Sexuality, and the Writings of Willa Cather.* Ph.D. dissertation, Stanford University, 2003.

Kranz, Gisbert. *Das Architekturgedicht.* Köln: Böhlau, 1988.

_____. *Das Bildgedicht in Europa: Zur Theorie und Geschichte einer literarischen Gattung.* Paderborn: Schöningh, 1973.

_____. "Das Bildgedicht: Geschichtliche und poetologische Betrachtungen." In Ulrich Weisstein, ed., *Literatur und Bildende Kunst: Ein Handbuch zur Theorie und Praxis eines komparatistischen Grenzgebietes.* Berlin: Schmidt, 1992. 152–7.

_____. *Das Bildgedicht: Theorie, Lexikon, Bibliographie.* 3 vols. Köln: Böhlau, 1981–87.

_____. *Meisterwerke in Bildgedichten: Rezeption von Kunst in der Poesie.* Frankfurt: Peter Lang, 1986.

_____, ed. *Gedichte auf Bilder: Anthologie und Galerie* (Munich: Deutscher Taschenbuch Verlag, 1975.

Krau, Ingrid. "Utopie und Ideal—in Stadtutopie und Idealstadt." In Nerdinger, *Architektur* (below), 75–82.

Krieger, Murray. *Ekphrasis: The Illusion of the Nat-*

ural Sign. Baltimore: Johns Hopkins University Press, 1991. **Reviews:** Gilman, Ernest B. *Modern Language Quarterly* 54, no. 4 (December 1993): 572–5. Golden, L. *Choice* (September 1992), 30, no. 1:108–9. Heffernan, James A.W. *Semiotica* 98, nos. 1–2 (1994): 219–28. MacDonald, Raymond A. *Word & Image: A Journal of Verbal/Visual Enquiry* 9, no. 1 (January–March 1993): 81–6. Russell, Daniel. *Canadian Review of Comparative Literarure/Revue Canadienne de Littérature Comparée* 20, nos. 1–2 (March–June 1993): 223–5. Scott, Grant. F. *European Romantic Review* 3, no. 2 (Winter 1993): 215–23. Steiner, Wendy. "Speaking Pictures." *TLS,* no. 4665 (28 August 1992): 20. *University Press Book News* 4 (June 1992): 34. Vickery, John B. "Theory." *Modern Fiction Studies* 39, no. 2 (Summer 1993): 433–5. *Virginia Quarterly Review* 68 (Autumn 1992): 120.

———. "Ekphrasis and the Still Movement of Poetry; or, *Laokoon* Revisited." In F.P.W. MacDowell, ed., *The Poet as Critic.* Evanston, IL: Northwestern University Press, 1967. 3–26; also in Frank Lentricchia and Andrew DuBois, eds., *Close Reading: The Reader.* Durham, NC: Duke University Press, 2003. 88–110; rpt. as an appendix in Krieger, *Ekphrasis* (previous entry).

———, and Andrea Antor. "Das Problem der Ekphrasis: Wort und Bild, Raum und Zeit–und das literarische Werk." In Boehm and Pfotenhauer, *Beschreibungskunst* (above), 41–57; rpt. as "The Problem of Ekphrasis, Image and Works, Space and Time, and the Literary Work," in Robillard, *Pictures* (below).

Kruse, Christiane. "Dialoge über Natur, Künste und Medien: zu Aretinos Briefen und Gedichten auf Tizians Porträts." In Bodo Guthmüller, ed. *Künstler und Litera: Schrift- und Buchkultur in der europäischen Renaissance.* Wiesbaden: Harrassowitz, 2006. 97–120.

Kšicová, Danuše. "Mifopoetika russkogo simvolizma i avantgarda–problémy ekfrazii" = "Poetics of Russian Symbolism and the Avant-Garde–the Problems of Ekphrasis (Aleksandr Blok, Velemir Chlebnikov–Grigorij Musatov)." *Litteraria Humanitas XIV. Problémy poetiky.* Brno: Masaryk University, 2006, 113–22.

———. "Tři typy ekhphrase" = "Three Types of Ekphrasis." In *Text a kontext.* Ostrava: Ostravská univerzita, 2003. 31–7.

Ku, Tim-hung . "A Semiotic Approach to 'Ekphrastic' Poetry in the English-Chinese Comparative Context." *Semiotica: Journal of the International Association for Semiotic Studies/Revue de l'Association Internationale de Sémiotique* 118, nos. 3–4 (1998): 261–80.

Kudonopoulos, Basileios. "Paratereseis sten taútise tou naoú tes Theotókou tes 10es Omilías tou patriárhou Fotíou me to naó tes Theotókou tou Fárou: néa stoiheía upér autes tes taútise" [Remarques sur l'identification de l'église de la Vierge de la 10e Homélie du patriarche Photius avec l'église de la Vierge du Phare: nouveaux éléments pour son identification]. *Buzantina* (Thessalonike) 23 (2002): 143–53.

Kuliapin, Aleksandr. "'Intermedial'nost' Mikhaila Zoshchenko: Ot zvuka k tsvety." In Geller, *Ekfrasis* (above), 135–44.

Kumbier, William A. "Besonnenheit, Ekphrasis and the Disappearing Subject in E.T.A. Hoffmann's 'Die Fermate.'" *Criticism* 43, no. 3 (Summer 2001): 325–39.

Kummer, Stefan. "Kunstbeschreibungen Jacob Burckhardts in Cicerone und in der Baukunst der Renaissance in Italien." In Boehm and Pfotenhauer, *Beschreibungskunst* (above), 357–67.

Kurman, George. "Ecphrasis in Epic Poetry." *Comparative Literature* 26 (1974): 1–13.

Kyriakides, Gregores G., and Michael Euthymiou. *Theia ekphrasis: technike tes Vyzantines hagiographies.* Leukosia: G.G. Kyriakides, 2001.

Labarthe-Postel, Judith. "The Figure in the Novel: Literary, Pictorial and Mythical Patterns in the Fiction of Henry James." *Romantisme* 32, no. 118 (2002): 55–73.

———. "L'Image dans le roman: Modèles littéraires, pictural et mythique dans la fiction de Henry James." *Romantisme: Revue du Dix-Neuvième Siècle* 118 (2002): 55–73.

———. *Littérature et peinture dans le roman moderne: une rhétorique de la vision.* Paris: L'Harmattan, 2002.

Lachman, L. "Time, Space, and Illusion: Between Keats and Poussin." *Comparative Literature* 55, no. 4 (Fall 2003): 293–319.

Lacoue-Labarthe, Judith. *La description de peinture dans les romans de 1795 à 1927: in rhetorique de la vision: thèse de doctorat nouveau régime.* Villeneuve d'Ascq: Presses de Universitaires du Septentrion, 2002.

———. "To Transplant Rather Than Translate: Narrative Embassies in *The Ambassadors* by Henry James, the *Alexandria Quartet,* by Lawrence Durrell, and *Under the Volcano* by Malcolm Lowry." *Revue de littérature comparée* 74, no. 1 (January–March 2000): 55–74.

Lada-Richards, Ismene. "'Cum Femina Primum ...': Venus, Vulcan, and the Politics of Male Mollitia in *Aeneid* 8." *Helios* 33, no. 1 (2006): 27–72.

Laferl, Christopher F. "Erzählende Urnen und webende Nymphen: Ekphrasis bei Garcilaso de la Vega." In Ratkowitsch, *Die poetische* (below), 153–79.

Laguna, Ana María. "Ekphrasis in the Prologue to *Don Quijote* I: Urganda "the unknowable" and the Mirrors of Fiction." In de Armas, *Ekphrasis* (above), 127–43.

Lahusen, Götz. *Schriftquellen zum römischen Bildnis*. Bremen: B.C. Heye, 1984.

Laird, Andrew. "Sounding Out Ecphrasis: Art and Text in Catullus 64." *Journal of Roman Studies* 83 (1993): 18–30.

Lamberini, Daniela. *Il Sanmarino: Giovan Battista Belluzzi, architetto militare e trattatista del Cinquecento*. Firenze: Olschki, 2007.

Lambert-Charbonnier, Martine. "Poetics of Ekphrasis in Pater's 'Imaginary Portraits.'" In Laurel Brake et al., eds., *Walter Pater: Transparencies of Desire. 1880–1920 British Authors*. 16. Greensboro, NC: ELT, 2002. 202–12.

Lamothe, Alison F. *Color My Words: Ekphrastic Tradition and the Spanish American Modernista Narrative*. Ph.D. dissertation, University of Massachusetts, Amherst, 1995.

_____. "Color My Words: Ekphrasis in Turn-of-the-Century Spanish American Narrative." *RLA: Romance Languages Annual* 6 (1994): 499–504.

Lampsidis, Odysseus. "Der vollständige Text der Ecphrasis ges des Konstantino Manasses." *Jahrbuch der Osterreichischen Byzantinistik* 41 (1991): 189–205.

Lancaster, Patricia. "Tardieu's *Rythme à trois temps*: An Exercise in Ekphrasis." *West Virginia University Philological Papers* 41 (1995): 102–7.

Land, Norman E. "Ekphrasis and Imagination: Some Observations on Pietro Aretino's Art Criticism." *Art Bulletin* 68, no. 2 (1986): 207–17.

_____. "Titian's *Martyrdom of St. Peter Martyr* and the 'Limitations" of Ekphrastic Art Criticism." *Art History* 13 (September 1990): 293–317.

_____. *The Viewer as Poet: The Renaissance Response to Art*. University Park, PA: Pennsylvania State University Press, 1994. **Reviews:** Agoston, Laura Camille. *Renaissance Quarterly* 50, no. 3 (Fall 1997): 940–1. Baumlin, James S. *Sixteenth-Century Journal* 27, no. 1 (Spring 1996): 249–50. Bent, George R. *Southeastern College Art Conference Review* 13, no. 1 (1996): 61–3. Whitaker, Elaine E. *South Atlantic Review* 60, no. 3 (September 1995): 159–61.

Landwehr, Margarete. "Literature and the Visual Arts: Questions of Influence and Intertextuality." *College Literature* 29, no. 3 (2002): 2–16.

Langlands, Rebecca. "'Can You Tell What It Is Yet?': Descriptions of Sex Change in Ancient Literature." *Ramus: Critical Studies in Greek and Roman Literature* 31 (2002): 91–110.

Lann, Zhan-Klod. "O raznykh aspektakh ekfrasisa u Velimira Khlebnikova." In Geller, *Ekfrasis* (above), 71–86.

Lanone, Catherine. "Pain, Paint and Popular Fiction: *The Passion of Artemisia* by Susan Vreeland." *Etudes Britanniques Contemporaines: Revue de la Société d'Etudes Anglaises Contemporaines* 31 (November 2006): 191–209.

Laoureux, Denis. *Contribution à l'étude des interactions entre les arts plastiques et les lettres belges de langue française. Analyse d'un cas: Maurice Maeterlinck et l'image*. Doctoral dissertation, Université de Libre Bruxelles, 2005.

LaPlace, Marie Marcelle Jeanine. "L'ecphrasis de la parole d'apparat dans l'Electrum et le De domo de Lucien, et la representation des deux styles d'une esthetique inspirée de Pindare et de Platon." *Journal of Hellenic Studies* 116 (1996): 158–65.

La Porta, Cristina. "Confronting the Artifact: Interrogative Ekphrasis in Keats and Leopardi." *Rivista di Studi Italiani* 14, no. 1 (June 1996): 36–47.

_____. *The Realms of Reverie: A Rhetorical Investigation of the Romantic Daydream*. Ph.D. dissertation, Columbia University, 1995.

Lara Garrido, José. "Poética del género bucólico y ekphrasis en la Egloga de Pilas y Damón." In José Lara Garrido, ed., *De saber poético y verso peregrino: La invención manierista en Luis Barahona de Soto. Analecta Malacitana: Anejo de la Revista de la Sección de Filología de la Facultad de Filosofía y Letras*. 43. Málaga, Spain: Universidad de Málaga, 2002. 297–428.

Larson, Victoria T. *The Role of Description in Senecan Tragedy*. Frankfurt am Main: Peter Lang, 1994.

Larue, Anne. "La Mélancolie de Dürer dans la poésie du XIXe siècle: Ekphrasis, allégorie, logotype?" *Imaginaires: Revue du Centre de Recherche sur l'Imaginaire dans les Littératures de Langue Anglaise* 3 (1998): 245–72; and in Dorangeon, *La representation* (above).

Lascar, Alex. "Eugène Sue romancier: la tentation picturale." In Pascale Auraix-Jonchière, ed., *Ecrire la peinture entre XVIIIe et XIXe siècles. Révolutions et Romantismes*. 4. Clermont-Ferrand, France: Presses Universitaires Blaise Pascal, 2003. 187–202.

Latimer, Quinn. "Carl Andre: Andrea Rosen." *Modern Painters* 19, no. 5 (June 2007): 111.

Latane, David E., Jr. Review of Frederick Burwick's *Mimesis and Its Romantic Reflections*. *South Atlantic Review* 66, no. 4 (Autumn 2001): 199–201.

Latorre, Yolanda. "La presencia de las artes en literatura: La transposición artística en Emilia Pardo Bazán." *Exemplaria: Revista de Literatura Comparada/Journal of Comparative Literature* 3 (1999): 93–109.

Laureillard, Marie. "The Poetry of Chen Li and its Visual Effects: Landscapes, Ekphrasis, Visual Poetry." Paper presented at The Second International Workshop on Literature, Borders and Limits/Deuxième Colloque International sur "Littératures, Limites et Frontierès." Abstract available at http://hakka.nctu.edu.tw/hs/literature2008/abstracts/abstract-13.html

Lauter, Estella. "Feminist Interart Criticism: A Contradiction in Terms?" *College Literature* 19, no. 2 (1992): 98–105.

Lavocat, Françoise. "Ut saltatio poiesis? Danse et Ekphrasis à la fin de la Renaissance et à l'âge baroque." In Alain Montandon, ed., *Ecrire la Danse*. Clermont-Ferrand: Presses Universitaires Blaise Pascal, 1999. 55–96.

Lawlor, William T. "When He Looks at Pictures: Lawrence Ferlinghetti and the Literary Tradition of Ekphrasis." In Cornelis A. van Minnen et al., eds., *Beat Culture: The 1950s and Beyond*. Amsterdam: VU University Press, 1999.

Leach, Eleanor Winsor. "Ekphrasis and the Theme of Artistic Failure in Ovid's *Metamorphoses*." *Ramus* 3, no. 1 (1974): 102–35.

Lebedev, Andrei. "Ekfrasis kak element propovedi: Na primere propovedei Filareta (Drozdova)." In Geller, *Ekfrasis* (above), 42–52.

Le Bozec, Yves. "Ekphrasis of My Heart, or Argumentation through Pathetic Description." *Littérature* (October 1998): 111–124.

Lee, C.C. "Ekphrasis and Enchantment in the Trilogies of Carlos Rojas." *Anales de la Literatura Española Contemporanea* 22, nos. 1–2 (1997): 53–74.

Lee, Hai-soon. "A Study of Li Saek's Poems on Paintings: A Comparative Approach." *Tamkang Review* 18, nos. 1–4 (1988): 207–17.

Lee, Mary Alice. "Love and la suprema istoria: Pietro da Cortona's *Divina providenza* and the Codex Barberini Latino 4335, Il Pellegrino, o vero la dichiaratione delle pitture della Sala Barberina." *Word & Image: A Journal of Verbal/Visual Enquiry* 18 (2002). 315–31.

Lee, R.W. *Ut Pictura Poesis: The Humanistic Theory of Painting*. Paris: Macula, 1991.

Lees-Jeffries, Hester. "Sacred and Profane Love: Four Fountains in the *Hypnerotomachia* (1499) and the *Roman de la Rose*." *Word & Image: A Journal of Verbal/Visual Enquiry* 22, no. 1 (2006): 1–13.

Legler, Tim, Chris Tiedeman, Erik Piazza. "Ekphrasis." http://www.facli.unibo.it/NR/rdonlyres/E7DB0CA5–6734–4ED5–ADDA–E64BB65D0F23/16824/Ekphrasis1.doc.

Legros, Philippe. *François de Sales, une poétique de l'imaginaire: étude des représentations visuelles dans*

l'Introduction à la vie dévote et le Traité de l'amour de Dieu. Tübingen: Gunter Narr Verlag, 2004.

Lemay, Shawna. "A Selection of Links to Ekphrasis." *Capacious Hold-All*. 14 January 2009. http://capacioushold-all.blogspot.com/search?q=ekphrasis

Lenz, Christian. "Goethes Kunstbeschreibung — erläutert an dem Aufsatz 'über Laokoon.'" In Boehm and Pfotenhauer, *Beschreibungskunst* (above), 234–51.

Lerner, Laurence. "Browning's Painters." *Yearbook of English Studies* 36, no. 2 (2006): 96–108.

Leslie, Michael. "Edmund Spenser: Art and *The Faerie Queene*." *Proceedings of the British Academy* 76 (1990): 73–107.

Lessing, Gotthold Ephraim. *Laocoön: An Essay on the Limits of Painting and Poetry*. Baltimore: Johns Hopkins University Press, 1962; orig. pub. 1766.

Lestrigant, Frank. "La Chorégraphie des Indiens ou le ravissement de Jean de Léry." *Op. Cit.: Revue de Littératures Française et Comparée* 13 (November 1999): 49–58.

_____. "La voie des îles." *Médiévales* 47 (automne 2004): 113–22.

Létoublon, F. "L'oeuvre d'art et le jugement esthétique en Grèce. Réalité et représentation à l'époque archaïque." *Diotima* 15 (1987): 51–9.

Levin, Gail, and John B. Van Sickle. "Paris No Paradise for Pissarro in New Epic Poem." *Art Journal* 60, 1 (Spring 2001): 107–9. Review of Derek Walcott, *Tiepolo's Hound*.

Lewin, Jennifer. "Audible Ecphrasis: Songs in Nineteenth-Century Fiction." In Jennifer Lewin, ed., *Never Again Would Birds' Song Be the Same: Essays on Early Modern and Modern Poetry in Honor of John Hollander*. New Haven, CT: Beinecke Library, Yale University, 2002. 122–46.

Liardet, Tim. "Ekphrasis and Ekphrasis." *New Welsh Review* 72 (Summer 2006). http://www.poetrymagazines.org.uk/magazine/record.asp?id=19323

Lichtenberg, Heinrich. *Die Architekturdarstellungen in der mittelhochdeutschen Dichtung*. Münster: Verlag der Aschendorfschen Verlagsbuchhandlung, 1931.

Lichtenstein, Jacqueline. *La couleur éloquente. Rhétorique et peinture à l'âge classique*. Paris: Flammarion, 1999.

_____. "La description de tableaux: énoncé de quelques problèmes." In Bonfait, *La description* (above), 295–302.

Lie, Hallvard. "Billedbeskrivende dik." In J. Danstrup et al., eds. *Kulturhistorisk leksikon for nordisk middelalder fra vikingetid til reformationstid*. Copenhagen: Rosenkilde og Bagger, 1956. 1: cols. 342–5.

Lieberman, Hilary. "Art and Power(lessness): Ekphrasis in Campanella's *The City of the Sun*,

Virgil's *Aeneid*, and Dante's *Purgatorio* X." *RLA: Romance Languages Annual 1997* 9 (1998): 224–231, and at http://tell.fll.purdue.edu/RLA-Archive/1997/Italian-html/Lieberman,Hilary.htm

_____. *Poetry, Painting and Politics: Epic Ekphrasis in Virgil, Dante, Boiardo, Ariosto, Tasso and Campanella*. Ph.D. dissertation, Yale University, 2000.

Ligorio, Pirro. *Libri delle Antichità, Torino: Archivio di Stato di Torino, codici ligoriani 19—30 bis*. Roma: De Luca, 2005.

Lindhé, Cecelia. "Digital Ekphrasis: The Intersection of Literature, Visual Art, and Technology." http://digitalekphrasis.wordpress.com/2008/10/16/digital-ekphrasis-the-intersection-of-literature-visual-art-and-technology/?referer=sphere_related_content/

_____. *Visuella vändningar: Bild och estetik i Kerstin Ekmans romankonst* [*Visual Variations. Image and Aesthetics in Kerstin Ekman's Novels*]. Ph.D. dissertation, Uppsala University, 2008.

Lingo, Estelle. "The Greek Manner and a Christian Canon: François Duquesnoy's Saint Susanna." *The Art Bulletin* 84, no. 1 (2002): 65–93.

Lisible Visible Collective. *L'image génératrice de texte de fiction*. Poitiers: La Licorne, 1996.

Liu, Joyce Chi-hui. "Palace Museum vs. the Surrealist Collage: Two Modes of Construction in Modern Taiwanese Ekphrasis Poetry." *Canadian Review of Comparative Literature/Revue Canadienne de Littérature Comparée* 24, no. 4 (December 1997): 933–46.

Livingston, Paisley. "Nested Art." *Journal of Aesthetics and Art Criticism* 61, no. 3 (Summer 2003): 233–45.

Lizcano Rejano, Susana. "La educación de Aquiles: Estructura compositiva y modelo educativo de una ekfrasiV del siglo II d.C." *Cuadernos de Filología Clásica* 13 (2003): 195–211.

Lloyd, Rosemary. *Shimmering in a Transformed Light: Writing the Still Life*. Ithaca, NY: Cornell University Press, 2005.

Lock, Charles. "Those Lips: On Cowper (Ekphrasis in Parentheses)." In Lene Østermark-Johansen, ed., *Angles on the English-Speaking World, vol. 3. Romantic Generations. Text, Authority and Posterity in British Romanticism*. Københavns Universitet, København: Museum Tusculanums Forlag, 2003.

Loizeaux, Elizabeth Bergmann. "Ekphrasis and Textual Consciousness (Verbal/Visual Relation in Contemporary Poetry)." *Word & Image: A Journal of Verbal/Visual Enquiry* 15, no. 1 (January–March 1999): 76–96.

_____. "Reading Word, Image, and the Body of the Book: Ted Hughes and Leonard Baskin's *Cave Birds*." *Twentieth-Century Literature* 50, no. 1

(Spring 2004): 18–58; also published in Loizeaux, *Twentieth-Century Poetry* (next entry).

_____. *Twentieth-Century Poetry and the Visual Arts*. New York: Cambridge University Press, 2008. Contains these chapters: 1. Private Lives in Public Places: Yeats and Durcan in Dublin's Galleries; 2. Bystanding in Auden's "Musee"; 3. Women Looking: The Feminist Ekphrasis of Marianne Moore and Adrienne Rich; 4. Ekphrasis in Conversation: Anne Sexton and W. D. Snodgrass on Van Gogh; 5. Ekphrasis in Collaboration: Ted Hughes and Leonard Baskin's *Cave Birds*: An Alchemical Cave Drama; 6. Ekphrasis in the Book: Rita Dove's African American museum.

Lojkine, Stéphane. "L'héritage de l'ekphrasis." *Utpictura18*. http://galatea.univ-tlse2.fr/pictura/UtpicturaServeur/Salons/SalonsEkphrasis2.php

Long, Beverly Whitaker, and Timothy Scott Cage. "Contemporary American Ekphrastic Poetry: A Selected Bibliography." *Text and Performance Quarterly* 9 (1989): 286–96.

Longley, Edna. "No More Poems about Paintings?" In Longley's *The Living Stream: Literature and Revisionism in Ireland*. Newcastle-Upon-Tyne: Bloodaxe 1994. 227–51.

Lonsdale, Steven. "Simile and Ecphrasis in Homer and Vergil: The Poet as Craftsman and Choreographer." *Vergilius* 36 (1990): 7–30.

López Alemani, Ignacio. "A Portrait of a Lady: Representations of Sigismunda-Auristela in Cervantes's *Persiles*." In de Armas, *Ekphrasis* (above), 202–15.

Lord, Michel. "L'Ekphrasis fantastique: Descriptif d'étrangeté et modalités du savoir dans 'La Bouquinerie d'Outre–Temps' d'André Carpentier." *Voix et Images: Litterature Quebecoise* 21, no. 1 [61] (Autumn 1995): 124–37.

Lorenz, Helmutt. "Dichtung und Wahrheit—das Bild Johann Bernhard Fischers von Erlach in der Kunstgeschichte." In Friedrich B. Polleroß, ed., *Fischer von Erlach und die Wiener Barocktradition* Wien: Böhlau, 1995. 129–46.

Losano, Antonia Jacqueline. "Ekphrasis and the Art of Courtship in *Jane Eyre*." In Losano's *The Woman Painter in Victorian Literature*. Columbus: Ohio State University Press, 2008. 96–118.

_____. "'A Great Passion for Taking Likenesses': The Woman Painter in *Emma*." *Persuasions: The Jane Austen Journal* 27 (2005): 185–94.

_____. *The Woman Painter in Victorian Literature*. Columbus: Ohio State University Press, 2008. **Review:** Novak, Daniel A. *Victorian Studies* 51, no. 1 (Autumn 2008): 186–8.

Lottes, Wolfgang. "Appropriating Botticelli: English Approaches 1860–1890." In Wagner, *Icons* (below), 236–61.

Louvel, Liliane. "Introduction: The Eye in the Text or the Infinite Relation." *European Journal of English Studies* 4, no. 1 (2000): 1–9.

_____. "Last Orders de Graham Swift: 'Ode on a Cockney Urn.'" *Etudes Britanniques Contemporaines: Revue de la Société d'Etudes Anglaises Contemporaines* 14 (June 1998): 133–52, 159–60.

_____. "Nuances du pictural." *Poétique: Revue de Théorie et d'Analyse Littéraires* 126 (April 2001): 175–89.

Lovasz, Laura Elizabeth. *Literate Gentlemen and the Viewing Masses: The Antagonism between Seeing and Reading in the Romantic Period.* Ph.D. dissertation, Indiana University, 2002.

Lovatt, Helen V. "Statius on Parade: Performing Argive Identity in *Thebaid* 6.268–95." *Classical Journal* 53 (2006): 72–95.

_____. "Statius' Ekphrastic Games: *Thebaid* 6.531–47." *Ramus: Critical Studies in Greek and Roman Literature* 31 (2002):

Lowrie, Joyce O. "Barbey D'Aurevilly's *Une page d'histoire*: A Poetics of Incest." *Romantic Review* 90, no. 3 (1999): 379–5.

Lowrie, Michèle. "Telling Pictures: Ecphrasis in the *Aeneid*." *Vergilius* 45 (1999): 111–20.

Lund, Hans. "Ekphrastic Linkage and Contextual Ekphrasis." In Robillard, *Pictures* (below), 173–88.

_____. *Text as Picture: Studies in the Literary Transformation of Pictures.* Lewiston, NY: Edwin Mellen Press, 1992 (originally published in Swedish as *Texten som tavla*, Lund, 1982).

Lundquist, Sara. "Reverence and Resistance: Barbara Guest, Ekphrasis, and the Female Gaze." *Contemporary Literature* 38 (Summer 1997): 260–86.

_____. "Another Poet among Painters: Barbara Guest with Grace Hartigan and Mary Abbott." In Terence Diggory and Stephen Paul Miller, eds., *The Scene of Myselves: New Work on the New York School Poets.* Orono, ME: National Poetry Foundation, 2001. 245–64.

Lusin, Bernard F. "L'ekphrasis d'un baptistère byzantin." In *Mélanges Jean-Pierre Sodini dans: Travaux et mémoires.* Paris, 2005. 163–82.

Lutz, Eckart Conrad. "Verschwiegene Bilder–geordnete Texte. Mediävistische Überlegungen." *Deutsche Vierteljahrschrift für Literaturwissenschaft und Geistesgeschichte* 70 (1996): 3–47.

Lützeler, Paul Michael. *Kulturbruch und Glaubenskrise: Hermann Brochs "Schlafwandler" und Matthias Grünewalds "Isenheimer Altar."* Tübingen and Basel: Francke, 2001. **Review:** Horrocks, David. *Modern Language Review* 98, no. 3 (July 2003): 776–8.

Lyons, Deborah, and Adam D. Weinberg. *Edward Hopper and the American Imagination.* New York: Norton, 1995.

Lythgoe, Michael. "Night of Painted Iron." In Lythgoe's *A Gradual Twilight.* Ft. Lee, NJ: CavanKerry Press 2003.

McCaffrey, Phillip. "Painting the Shadow: (Self-) Portraits in Seventeenth Century English Poetry." In Golahny, *The Eye* (above), 179–95.

McClatchy, J.D. *Poets on Painters: Essays on the Art of Painting by Twentieth-Century Poets.* Berkeley: University of California Press, 1988.

McCombie, Duncan. "Philostratus, *Histoi, Imagines* 2.28: Ekphrasis and the Web of Illusion." *Ramus: Critical Studies in Greek and Roman Literature* 31, no. 1–2 (2002): 146–57.

McCooey, David. "'Looking into the Landscape': The Elegiac Art of Rosemary Dobson." *Westerly* 40, no. 2 (1995): 15–25.

McCorkle, James. "The Demands of Reading: Mapping, Travel and Ekphrasis in the Poetry from the 1950s of John Ashbery and Elizabeth Bishop." In Terence Diggory and Stephen Paul Miller, eds., *The Scene of My Selves: New Work on New York School Poets.* Orono, ME: National Poetry Foundation; Hanover, NH: Distributed by University Press of New England, 2000. 67–92.

Macdonald, Raymond. "*Ekphrasis*, Paradigm Shift, and Revisionism in Art History." *Res: Journal of Anthropology and Aesthetics* 24 (Fall 1993): 112–23.

McGuiness, Daniel Matthew. *Some Measures of Contemporary Poetry.* Ph.D. dissertation, University of Iowa, 1986.

Maciver, Calum A. "Returning to the Mountain of Arete: Reading Ecphrasis, Constructing Ethics in Quintus Smyrnaeus' *Posthomerica*." In Manuel Baumbach et al., eds., *Quintus Smyrnaeus: Transforming Homer in Second Sophistic Epic.* Berlin: Walter De Gruyter, 2007.

McKeown, Adam. "Looking at Britomart Looking at Pictures." *Studies in English Literature 1500–1900* 45, no. 1 (Winter 2005): 43–63.

McKinley, Kathryn. "Kingship and the Body Politic: Classical Ecphrasis and *Confessio Amantis* VII." *Mediaevalia: An Interdisciplinary Journal of Medieval Studies Worldwide* 21 (Fall 1996): 161–87.

McKinney, Collin S. *Word and Image in Gustavo Adolfo Bécquer's "Historia de los templos de España."* M.A. thesis, Brigham Young University, 2003.

Macleod, Catriona. "Sculpture and the Wounds of Language in Clemens Brentano's *Godwi*." *Germanic Review* 74, no. 3 (1999): 178–94.

McMinn, Joseph. "Ekphrasis and the Novel: The Presence of Paintings in John Banville's Fiction." *Word & Image: A Journal of Verbal/Visual Enquiry* 18, no. 2 (April–May 2002): 137–46.

MacPhail, Eric. "Rich Rhyme: Acoustic Allusions in

Ronsard's Amours." *French Forum* 27, no. 2 (Spring 2002): 1–12.

McSweeney, Kerry. "J. Stanyan Bigg's 'An Irish Picture'" [with appendix]. *Victorian Poetry* 39, no. 3 (Fall 2001): 407–11.

_____. "The Light in the Heart." *Boston Review* 31, no. 2 (March–April 2006): 46–7.

Macrides, Ruth, and Paul Magdalino. "The Architecture of Ekphrasis: Construction and Context of Paul the Silentiary's Poem on Hagia Sophia." *Byzantine and Modern Greek Studies* 12 (1988): 47–82.

Maffei, Sonia. "L'ecfrasi gioviana tra generi e 'imitatio.'" In Elena Vaiani, ed., *Dell'antiquaria e dei suoi metodi*. Pisa: Scuola Normale Superiore, 2001. 15–30.

Magdalino, Paul. "Cosmological Confectionary and Equal Opportunity in the Eleventh Century: An Ekphrasis by Christopher of Mitylene (Poem 42)." In John W. Nesbitt, ed., *Byzantine Authors: Literary Activities and Preoccupations: Texts and Translations Dedicated to the Memory of Nicolas Oikonomides*. Leiden: Brill, 2003. 1–8.

_____. "The Evergetis Fountain in the Early Thirteenth Century: An Ekphrasis of the Paintings in the Cupola." In Magdalino's *Studies on the History and Topography of Byzantine Constantinople*. Aldershot and Burlington, VT: Ashgate, 2007.

_____, and Lyn Rodley. "The Evergetis Fountain in the Early Thirteenth Century: An Ekphrasis of the Paintings in the Cupola." In Margaret Mullett and Anthony Kirby, eds., *Work and Worship at the Theotokos Evergetis 1050–1200*. Belfast: Belfast Byzantine Enterprises, 1997.

Maderuelo, Javier, ed. *El jardín como arte: arte y naturaleza*. Huesca: Diputación de Huesca, 1997.

Magnien, Aline. "Callistrate et le discours sur la sculpture à l'âge moderne." In Philippe Hoffmann, ed., *Antiquités imaginaires: la référence antique dans l'art moderne de la Renaissance à nos jours*. Paris: Presses de l'École Normale Supérieure, 1996. 21–41.

Maguire, Henry. "The Beauty of Castles: A Tenth-Century Description of a Tower at Constantinople." *Deltion tes Christianikes Archaiologikes Etaireias* 17 (1993): 421–4.

_____. "Byzantine Rhetoric, Latin Drama and the Portrayal of the New Testament." In Elizabeth Jeffreys, ed., *Rhetoric in Byzantium: Papers from the Thirty-fifth Spring Symposium of Byzantine Studies, Exeter College, University of Oxford, March 2001*. Aldershot: Ashgate, 2003. 215–33.

_____. "The Classical Tradition in the Byzantine Ekphrasis." In *Byzantium and the Classical Tradition: University of Birmingham Thirteenth Spring Symposium of Byzantine Studies 1979: in Conjunction with the Seventy-fifth Anniversary of the Classical Association*. [Birmingham], Centre for Byzantine Studies, University of Birmingham, 1981. 94–102.

_____. "A Description of the Aretai Palace and Its Garden." *Journal of Garden History* 10, no. 4 (December 1990): 209–13.

_____. "The Ekphrasis of Spring in Byzantine Art." *Byzantine Studies Conference Abstracts of Papers, Madison, 1978*. 25–6.

_____. "Gardens and Parks in Constantinople." In Alice-Mary Talbot, ed., *Dumbarton Oaks Papers, No. 54*. Washington, DC: Dumbarton Oaks Research Library and Collection, 2000.

_____. "Originality in Byzantine Art Criticism." In Antony Robert Littlewood, ed., *Originality in Byzantine Literature, Art and Music*. Oxford: Oxbow Books, 1995. 101–14.

_____. "Truth and Convention in Byzantine Descriptions of Works of Art." *Dumbarton Oaks Papers* 28 (1974): 113–40.

Maguire, Robert A. "Ekphrasis in Isaak Babel." In William Edward Harkins and Douglas M. Greenfield, eds., *Depictions: Slavic Studies in the Narrative and Visual Arts in Honor of William E. Harkins*. Dana Point, CA: Ardis, 2000. 14–23.

Maiorino, Giancarlo. "Titian's *Concert Champetre* and Sannazaro's *Arcadia*: Titology and the Invention of the Renaissance Pastoral." In Golahny, *The Eye* (above), 53–78.

Majewski, Henry F. "Art, Ekphrasis, and the Museum." In Majewski's *Transposing Art into Texts in French Romantic Literature*. Chapel Hill, NC: North Carolina Studies in the Romance Languages and Literatures, 2002.

Makris, Mary. "Collage as Metapoetry in Angel González's 'Palabras desprendidas de pinturas de José Hernández.'" *Anales de la Literatura Espanola Contemporanea* 18, no. 1 (1993): 157–72.

_____. "Intertextualidad, discurso y ekfrasis en 'El Cristo de Velázquez' de Angel González." In Andrew P. Debicki and Sharon Keefw Ugalde, eds., *En homenaje a Angel González: Ensayos, entrevista y poemas*. Boulder: Society of Spanish & Spanish-American Studies, 1991. 73–83.

_____. "Mass Media and the 'New' Ekphrasis: Ana Rossetti's 'Chico Wrangler' and 'Calvin Klein, Underdrawers.'" *Journal of Interdisciplinary Literary Studies* 5, no. 2 (1993): 237–49.

Maloney, Ian S. *Melville's Monumental Imagination*. Ph.D. dissertation, City University of New York, 2004.

_____. "Peeping into Polynesian Memorials: Ekphrastic Indifference in Travel and *Typee*." In Maloney's *Melville's Monumental Imagination*. New York: Routledge, 2006. 15–38.

Malpezzi, Frances R. "'Clear Geometric Praise': Two Ekphrastic Poems of May Sarton." *Cithara: Essays in the Judaeo-Christian Tradition* 35, no. 2 (May 1996): 18–26.

Manakidou, Flora. *Beschreibung von Kunstwerken in der hellenistischen Dichtung. Ein Beitrag zur hellenistischen Poetik.* Stuttgart: Vieweg and Teubner, 1993.

Manasses, Konstantinos. "Ekphrasis eikonismaton en marmare kykoterei." In Panagiotes Agapetos et al., eds., *Eikon kai logos: hexi vyzantines perigraphes ergon technes.* Athena: Ekdoseis Agra, 2006.

Mandelker, Amy. "A Painted Lady: Ekphrasis in *Anna Karenina.*" *Comparative Literature* 43 (Winter 1991): 1–19; rpt. in Harold Bloom, ed. *Leo Tolstoy.* Philadelphia: Chelsea House, 2003.

Mann, Jill. "Allegorical Buildings in Mediaeval Literature." *Medium Aevum* 63 (1994): 191–210.

Mansuelli, Guido Achille. "La Ekphrasis sulla S. Sofia nel Perì Ktismáton di Procopio di Cesarea, I, 1–78." In *Studi in memoria di Giuseppe Bovini,* 2 vols. Ravenna, M. Lapucci, Girasole, 1989. 345–54.

Marco, Alessandri. *Ekphrasis.* Roma: Libri editore Fermenti, 2001.

Marek, Michaela J. *Ekphrasis und Herrscherallegorie: Antike Bildbeschreibungen im Werk Tizians und Leonardos* [*Ekphrasis and Allegories of Rulers: Antique Descriptions of Paintings in the Work of Titian and Leonardo*]. Worms: Werner Verlagsgesellschaft, 1985. **Review:** Holberton, Paul. *The Burlington Magazine* 128 (1986): 294.

_____. *Ut pictura ekphrasis: Studien zur Bedeutung antiker Ekphrases für die Bildersprache der Herrscherpanegyrik in der Hochrenaissance.* Dissertation, Universität Köln, 1981.

Marias, Fernando. "El Greco y los usos de la antigüedad clásica." In *Visión del mundo clásico en el arte español.* Madrid: Alpuerto, 1993. 173–82.

Maridakis, Georgios S. "He Helleniki Epanastasis hos ekphrasis tou Europaikou pneumatos." *Nea Hestia* 89 (1971): 354–65.

Marincic, Marko. "Ecphrastic Creation and Rhetorics of Silence in Achilles Tatius' *Leucippe and Clitophon.*"http://www.ican2008.ul.pt/ICAN2008_pt/Programa/23_July/MN_121_Marko_Marincic.pdf

Markham, Malinda. Review of Mary Jo Bang's *Eye Like a Strange Balloon. Antioch Review* 63, no. 3 (June 2005).

Marling, William. *William Carlos Williams and the Painters.* Athens: Ohio University Press, 1982.

Marsh, David. "Lucian's Slander in the Early Renaissance: The Court as Locus Invidiae." *Allegorica: A Journal of Medieval and Renaissance Literature* 21 (2000): 62–70.

Marshall, Adam Richard. *Statius, "Siluae" I: A Commentary on the Ecphrastic Poems.* Ph.D. dissertation, Queen's University of Belfast, 2004.

Marsico, Lynn. "Ekphrastic Poetry: Exploring the Visual Arts with a Poets Eye." http://www.google.com/search?q=cache:4wtG0M1wd0oJ:www.chatham.edu/Pti/2005%2520Units/Play%2520It%2520Again,%2520Sam/Marsico%2520UNIT.pdf+%22ekphrastic+excursions%22&cd=1&hl=en&ct=clnk

Martinez, Michele. "Women Poets and the Sister Arts in Nineteenth-Century England." *Victorian Poetry* 41, no. 3 (Winter 2003): 621–8.

Martinho, Fernando J. B. "Ver e depois: a poesia ecfrástica em Pedro Tamen." *Revista Colóquio/Letras. Notas e Comentários,* Nos. 140–141 (Abr. 1996): 258–63.

Martinovski, Vladimir. "L'ekphrasis en tant que phénomené herméneutique dans la littérature antique." *Mirage* 10 (December 2004). See http://www.mirage.com.mk/tekst.asp?lang=eng&tekst=86

_____. "In the Beginning Was the Picture." In Vladimir Martinovski, ed., *Poetry in Dialogue with the Plastic Arts: A Thematic Selection of Contemporary Macedonian Poetry.* Trans. Zoran Ancíevski. [Struga, Macedonia]: Struga Poetry Evenings, 2006. 11–14.

Marty, Philippe. "Weit sur les pèlerins d'Emmaüs et la femme dans Lenz de Büchner." *Romantisme: Revue du Dix-Neuvième Siècle* 118 (2002): 23–36.

Marzola, Alessandra. "L'urna fatale: John Keats e il museo dell'indicibile." In Giovanna Silvani and Bruno Zucchelli, eds., *Poesia e memoria poetica: Scritti in onore di Grazia Caliumi. Civiltà delle Scritture.* 15. Parma, Italy: Facoltà di Lettere e Filosofia, Università degli Studi di Parma, 1999. 239–51.

Masaru, Aoki. "Daiga bungaku no hatten." *Aoki Masaru Senshū* (Shunchōsha) 2 (1970):491–504.

Masoliver Ródenas, Juan Antonio. "Las pesadillas de la memoria." *Letras Libres* 1, no. 5 (May 1999): 92–3.

Mason, Travis. "Placing Ekphrasis — Paintings and Place in 'Stanley Park'" [Timothy Taylor]. *Canadian Literature* 194 (Fall 2007): 12–32.

Massing, Jean Michel. *Du texte à l'image: la Calomnie d'Apelle et son iconographie.* Strasbourg: Presses Universitaires de Strasbourg, 1990. **Review:** Dempsey, Charles. *Burlington Magazine* 134, no. 1068 (March 1992): 185–6.

Masson, Jacqueline. *Elene Tagkalake, e E poietike ekfrase mias pneumatikotetas = L'expression poétique d'une spiritualité.* Athena: Ekd. Armos, 2002.

Masuga, Kathy. "Henry Miller's Painterly Eye." *Journal of the Humanities* (National Central University, Taiwan) 34 (April 2008): 173–212.

Matevosian, E.R. "M. Gor'kii i Ieronim Boskh: Po materialam romana 'Zhizn' Klima Samgina.'" In V.S. Barakhov et al., eds., *Novyi vzgliad na Gor'kogo: M. Gor'kii i ego epokha: Materialy i issledovaniia, Vypusk* 4. Moscow, Russia: Nasledie, 1995. 215–27.

Mathieu-Castellani, Gisele. "Michael Riffaterre pour lire les poetes du XVIe siecle." *Romantic Review* 93, nos. 1–2 (2002).

Mathis, Sean. *Visions of Grandeur: Hannibal's Gaze and Ekphrasis in the Punica of Silius Italicus*. M.A. thesis, University of Georgia, 2004.

Mattessich, Stefan. "Ekphrasis, Escape, and Thomas Pynchon's *The Crying of Lot 49.*" *Postmodern Culture* 8, no. 3 (May 1998): 73–98; rpt. in Massessich's *Lines of Flight: Discursive Time and Countercultural Desire in the Work of Thomas Pynchon*. Durham, NC: Duke University Press, 2002.

Mattos, Claudia Valladão de. "Ekphrasis e Crítica nas Vidas de Giorgio Vasari." *Alea* 4, no. 2 (2002): 161–77.

Matussek, Peter. "Computer als Gedächtnistheater." In G.-L. Darsow, ed., *Metamorphosen. Gedächtnismedien im Computerzeitalter*. Stuttgart and Bad Cannstatt: Frommann Holzboog, 2000. 81–100.

_____. "Performing Memory. Kriterien für einen Vergleich analoger und digitaler Gedächtnistheater." *Paragrana* 10 (2001): 303–34.

Maurisson, Charlotte and Agnès Verlet. *Ecrire sur la peinture: anthologie*. Dossier et notes réalisés par Charlotte Maurisson; lecture d'image par Agnès Verlet. Paris: Gallimard, 2006. Maurisson's *dossier*, "Du tableau au texte," 167–75; Verlet's *lecture*, "Le texte en perspective," 179–240.

Maxwell, Catherine. "From Dionysus to 'Dionea': Vernon Lee's Portraits." *Word & Image: A Journal of Verbal/Visual Enquiry* 13, no. 3 (September 1997): 253–69.

Mayers, Kathryn Marie. "Between 'allá' and 'acá': The Politics of Subject Positioning in Three Ekphrastic Poems by Sor Juana Inés de la Cruz." *Calíope: Journal of the Society for Renaissance & Baroque Hispanic Poetry* 11, no. 1 (2005): 5–20.

_____. *Imag(in)ing Differently: The Politics and Aesthetics of Ekphrasis in Luis de Góngora, Hernando Domínguez Camaro, and Sor Juana Inés de la Cruz*. Ph.D. dissertation, University of Wisconsin, Madison, 2003.

Mayr, Monika. "Beschreibung zwischen Referenz und Metapher: Wilhelm Kalfs Stilleben mit Nautilusbecher." In Rebel, *Sehen* (below), 91–117.

Mazzara, Federica. "Il dibattito anglo-americano del Novecento sull'*ekphrasis*." In *Intermedialità ed Ekphrasis nel Prerffaellitismo: Il caso Rossetti*. Naples, Italy: University of Naples, 2007. 1–70. http://eprints.ucl.ac.uk/4712/

Méchoulan, Eric. "Le Bouclier de Télémaque: Immédiateté de la représentation et représentation de l'immédiateté." *French Studies in Southern Africa* 26 (1997): 60–9.

Medici, Maria Teresa Guerra. "La rocca di Camerino." In Maria Grazia Nico Ottaviani, ed., *Rocche e fortificazioni nello stato della Chiesa*. Napoli: Edizioni Scientifiche Italiane, 2004. 285–94.

Medina Barco, Inmaculada. "'Estos que...': Ecfrasis satírico–burlesca en cinco poemas quevedianos de sociedad. *Perinola: Revista de Investigación Quevediana* 8 (2004): 279–304, 591–2.

_____. "Retratismo alegórico/emblemático en la obra de Quevedo." *Perinola: Revista de Investigación Quevediana* 9 (2005): 125–50.

Medoff, Richard Brad. *The Dramatization of Paintings: Methods and Processes*. Ph.D. dissertation, City University of New York, 1993.

Meek, Richard. "Ekphrasis in *The Rape of Lucrece* and *The Winter's Tale*." *Studies in English Literature 1500–1900* 46, no. 2 (Spring 2006): 389–414.

Megged, Matti. "The Language of Visibility." In Valtolina, *Annali* (below), 126–34.

Mehta, Arti. *How Do Fables Teach? Reading the World of the Fable in Greek, Latin and Sanskrit Narratives*. Ph.D. dissertation, Indiana University, 2007.

Meltzer, Françoise. *Salomé and the Dance of Writing: Portraits of Mimesis in Literature*. Chicago: University of Chicago Press, 1987.

Melville, Stephen. Review of *Salome and the Dance of Writing* by Francoise Meltzer and *Pictures of Romance: Form against Context in Painting and Literature* by Wendy Steiner. *Journal of Aesthetics and Art Criticism* 47, no. 1 (Winter 1989): 91.

Méndez-Ramírez, Hugo. *Neruda's Ekphrastic Experience: Mural Art and "Canto general."* Lewisburg, PA: Bucknell University Press, 1999. **Reviews:** Aldarondo, Hiram. *Modern Philology* 101, no. 1 (August 2003): 151–4. Boyer, Agustin, *Studies in 20th Century Literature* 27, no. 1 (Winter 2003): 202–5. Kuhnheim, Jill S. *Latin American Research Review* 38, no. 3 (2003): 200–9.

Mengaldo, Vincenzo. *Tra due linguaggi, arti figurative e critica*. Torino: Bollati Boringhieri, 2005. **Review:** De Seta, Cesare. "Maniere e artifici per narrare l'arte." *Op-cit: rivista quadrimestrale di selezione della critica d'arte* 125 (2006): 15–21.

Meredith-Goymour, Hallie. *Texts as Contexts for Viewing: Ekphrasis, Inscribed Decoration and Glass Open-Work Vessels in Late Antiquity*. D.Phil. thesis, Oxford University, 2006.

Messenger, Cynthia. "'But How Do You Write a Chagall?' Ekphrasis and the Brazilian Poetry of P.K. Page and Elizabeth Bishop." *Canadian Literature* 142–143 (Fall–Winter 1994): 102–17.

_____. "'Their small-toothed interlock': Biomorphism and Mystical Quest in the Visual Art of P.K. Page and John Vanderpant." *Journal of Canadian Studies* 38, no. 1 (2004): 76–96.

Meyer, A. "Time, Space, and Illusion: Between Keats and Poussin." *Comparative Literature* 55, no. 4 (Fall 2003): 293–319.

Meyer, Daniel. "A propos d'une *ekphrasis* dédaléenne: *Der grüne Heinrich* de Gottfried Keller entre encyclopédie et teleology." *Creliana*, 6 (2006): 105–16.

Meyer, Kinereth. "Ekphrasis and the Hermeneutics of Landscape." *American Poetry* 8 (Fall 1990): 23–36.

Meyers, Jeffrey. "Robert Lowell: The Paintings in the Poems." *Papers on Language & Literature* 23, no. 2 (Spring 1987): 218–40

Michel, Christian. "Comment plier le tableau à la description? Scènes de la vie quotidienne et verbalisations dans la France du XVIIIe siècle." In Bonfait, *La description de l'oeuvre* (above), 187–200.

_____. De l'Ekphrasis à la description analytique: histoire et surface du tableau chez les théoriciens de la France de Louis XIV." In Roland Recht, ed., *Le texte de l'oeuvre d'art: la description*. Strasbourg: Presses Universitaires, 1998. 45–55.

Miedema, H. "The Shaping of Early Frisian History." *Oud Holland* 118, no. 1–2 (2005): 1–27.

Miko, Arpad. "Ekphraseis: a budapesti Philostratoskódex és a Biblioteca Corvina" ["Ekphrasis: le Codex de Philostrate de Budapest et la Biblioteca Corvina"]. In *Muvézettörténeti tanulmányok Mojzer Miklós hatvanadik születésnapjár*. Budapest, 1991. 69–77.

Milinari, Carla. "Sullecfrasi epica tassiana." In Venturi, *Ecfrasi* (below), 311–54.

Milkova, Stiliana Vladimirovna. *Sightseeing: Writing Vision in Slavic Travel Narratives (Russia, Bulgaria)*. Ph.D. dissertation, University of California, Berkeley, 2007.

Miller, Andrew. "Looking Hard At Things: The Chronotope of the Photograph." http://www.aber.ac.uk/contempo/Contempo%20(A%20Miller%20-%20paper).pdf

Miller, J. Hillis. *Illustration*. Cambridge: Harvard University Press, 1992. See part 2, "Word and Image."

Miller, Patricia Cox. "'The little blue flower is red': Relics and the Poetizing of the Body (An Exploration of the Culture and Spirituality of Christian Religio-Aesthetic Ritual Devotion)." *Journal of Early Christian Studies* 8, no. 2 (Summer 2000): 213–36.

Miller, Sanda. "Paciureas Chimeras." *Apollo* (October 2003).

Millesoli, Gianluca M. "Frammenti di cultura grafica ad Arezzo nei secoli XI e XII." In Caterina Tristano, ed., *Arezzo il Pionta*. Arezzo: Letizia Editore, 2005. 71–3.

Millichap, Joseph R. "William Faulkner: Genealogy and Stewardship, Ekphrasis and Appellation in *Go Down, Moses*." In Millichap's *A Backward Glance: The Southern Renascence, the Autobiographical Epic, and the Classical Legacy*. Knoxville: University of Tennessee Press, 2009.

Miltner, Robert. "Where the Visual Meets the Verbal: Collaboration as Conversation." *Enculturation: A Journal for Rhetoric, Writing, and Culture* 3, no. 2 (Fall 2001), n.p.

Mirabile, Andrea. *Parola e immagine nel novecento italiano l'ekphrasis in Longhi, Banti, Pasolini e Testori*. Ph.D. dissertation, University of North Carolina, Chapel Hill, 2005.

Miranda-Wolff, Galia N. *Characterization and Ekphrasis in the XIXth and XXth Centuries French Novel*. Ph.D. dissertation, Stanford University, 2001.

Merieux, Veronique. "I Ragionamenti de Giorgio Vasari 1567: hasard et sens dessus dessous au Palais de la Seigneurie." *Italies: Littérature, civilisation, société* 9 (2005): 71–94.

Mirollo, James V. "Bruegel's *Fall of Icarus* and the Poets." In Golahny, *The Eye of the Poet* (above), 131–53.

Mitchell, Margaret M. "Ekphrasis." In Mitchell's *Heavenly Trumpet*. Louisville, KY: Westminster/John Knox, 2002. 101–4.

Mitchell, W.J.T. "Ekphrasis and the Other." *South Atlantic Quarterly* 91 (Summer 1992): 695–719; rpt. in Mitchell's *Picture Theory* (below), 151–81.

_____. *Iconology: Image, Text, Ideology*. Chicago: University of Chicago Press, 1986.

_____. *Picture Theory*. Chicago: University of Chicago Press, 1994. Chapter 5: "Ekphrasis and the Other." **Review:** Holman, Valerie. *Art History* 18, no. 4 (December 1995): 595–8. Ray, K., *Essays in Criticism* 45 (July 1995): 279–83.

_____. *What Do Pictures Want?* Chicago: University of Chicago Press, 2005.

Mitchell, Sally E. "Speculations on Language in the Arts." *Journal of Aesthetic Education* 35, no. 2 (Summer 2001): 87–96.

Mitsi, Efterpi. "Veiling Medusa: Arthur's Shield in *The Faerie Queene*." In Mike Pincombe, ed., *The Anatomy of Tudor Literature: Proceedings of the First International Conference of the Tudor Sym-*

posium (1998). Aldershot, England: Ashgate, 2001. 130–41

_____. *"Writing against Pictures": A Study of Ekphrasis in Epics of Homer, Virgil, Ariosto, Tasso and Spenser.* Ph.D. dissertation, New York, 1991.

Miziolek, Jerzy. "'Rodzina Centaurów' Louis de Silvestre'a w Pałacach Prezydenckim i w Wilanowie: o recepcji ekphrasis Lukiana w polskiej kulturze artystycznej" ["The Family of Centaurs" by Louis de Silvestre: On the Reception of Lucian's 'Ekphrasis' in Polish Artistic Culture"]. *Biuletyn historii sztuki* 65, no. 1 (2003): 41–56.

Mnikh, Roman. "Sakral'naia simvolika v situatsii ekfrasisa: Stikhotvorenie Anny Akhmatovoi 'Tsarskosel'skaia statuia.'" In Geller, *Ekfrasis* (above), 87–96.

Moench, Esther. "Lontano dall'Italia: Giuliano ad Avignone." In Giovanna Rotondi Terminiello, ed., *Giulio II: papa, politico, mecenat.* Genova: De Ferrari, 2005. 130–40.

Moffitt, John F. "An Exemplary Humanist Hybrid: Vasari's 'Fraude' with reference to Bronzinos 'Sphinx.'" *Renaissance Quarterly* 49, no. 2 (Summer 1996): 303–33.

_____. "Another Look at Michelangelo's 'Centauromachia.'" *Source* 25, no. 4 (Summer 2006): 16–26.

_____. "Michelangelo, Pliny, and Ekphrasis." In Moffitt's *Inspiration: Bacchus and the Cultural History of a Creation Myth.* Leiden: Brill, 2005. 44–50.

_____. "The Palestrina Mosaic with a Nile Scene: Philostratus and Ekphrasis; Ptolemy and Chorographia" [Hellenistic semi-cartographic landscape paintings]. *Zeitschrift fur Kunstgeschichte* 60, no. 2 (1997): 227–47.

_____. "Ptolemy's *Chorographia* in the New World: Revelations from the *Relaciones Geograficas de la Nueva Espana* of 1579–1581" (Colonial cartography). *Art History* 21, no. 3 (September 1998): 367–92.

Molinari, Carla. "Sull'ecfrasi epica tassiana." In Venturi, *Ecfrasi* (below), 311–54.

Molnar, Istvan. "'One's Faith Could Be Smashed by Such a Picture': Interrelation of Word and Image (Icon) in Dostoevsky's Fiction: Holbein's 'Christ in the Tomb' in the Ideological and Compositional Structure of the Novel 'The Idiot.'" *Acta Litteraria Academiae Scientiarum Hungaricae* 32, nos. 3–4 (1990): 245–58.

Monacchia, Paola. "Nuovi e vecchi documenti intorno alla Rocca Maggiore di Assisi." In Maria Grazia Nico Ottaviani, ed., *Rocche e fortificazioni nello stato della Chiesa.* Napoli: Edizioni Scientifiche Italiane, 2004. 183–212.

Montaclair, Florent, ed. *La littérature et les arts.* Vol.

1. Besançon: Centre Unesco d'Etudes pour l'Education et l'Interculturalité, Paris: Didier érudition, 1997.

Montagu, Jennifer. "Interpretations of Timanthes's *Sacrifice of Iphigenia.*" In John Onians, ed., *Sight and Insight: Essays on Art and Culture in Honour of E.H. Gombrich at 85.* London: Phaidon, 1994. 305–25.

Montalbano, Kathryn. *Ecstasis of Ekphrasis: Dialectically (De)framing Self in John Banville's The Book of Evidence.* B.A. thesis, Haverford College, 2009.

Montanari, Franco. "Ekphrasis e verità storica nella critica di Luciano." *Ricerche di filologia classica II: Filologia e critica letteraria della grecità.* Pisa, 1984. 111–23.

Montanari, Tomaso. "Contributo ad una sociologia dell''ecfrasis': la 'Dichiarazione morale' sul bassorilievo di Théodon al Monte di Pietà in Roma." In Bonfait, *La description* (above), 45–54.

Montandon, Alain. "Ecritures de l'image chez Théophile Gautier." In Wagner, *Icons* (below), 105–19.

Montefalcone, Barbara. "'An Active and Defining Presence': The Visual and the Verbal in Robert Creeley's Collaborations." *La Revue LISA/LISA e-journal* 5, no. 2 (2007): 39–61.

Moog-Grünewald, Maria. "Der Sänger im Schildoder: Über den Grund ekphrastischen Schreibens." In Drügh and Moog-Grünewald, *Behext* (above), 1–19.

Mooney, Susan. "Two Hundred Years of Pushkin." *Canadian Slavonic Papers* 47, nos. 3–4 (September–December): 475–8. Review of three volumes about Pushkin.

Moore, Thomas, and Joseph Reynolds. "Poems and Paintings: The Writer's View." *School Arts* 85, no. 2 (October 1985): 25–6.

Moorman, Honor. "Backing into Ekphrasis: Reading and Writing Poetry about Visual Art." *English Journal* 96, no. 1 (September 2006): 46–53.

Mora, Francine. "Des romans d'antiquité aux premiers romans 'réalistes': évolution des formes et des fonctions de l'ecphrasis, du milieu du XIIe s. au début du XIIIe s." In *La littérature et les arts figurés de l'Antiquité à nos jours: actes du XIVe Congrès de l'Association Guillaume Budé, Limoges 25–28 août 1998.* Paris: Les Belles Lettres, 2001. 501–14.

Moretti, Lara. "L'iconografia della Calunnia nel XVI secolo." *Grafica d'arte* 9, no. 33 (March 1998): 2–7.

Morganti, Bianca Fanelli. "A morte de Laocoonte e o Gigante Adamastor: a écfrase em Virgílio e Camões." *Nuntius Antiquus* (Belo Horizonte, Universidade Federal de Minas Gerais) 1 (2008): 1–14.

Morrison, Jeff. "The Discreet Charm of the Belvedere: Submerged Homosexuality in the Eighteenth-Century Writing on Art." *German Life & Letters* 52, no. 2 (April 1999): 123–36.

_____, and Florian Krobb, eds. *Text into Image: Image into Text: Proceedings of the Interdisciplinary Bicentenary Conference Held at St. Patrick's College Maynooth (The National University of Ireland) in September 1995*. Amsterdam: Rodopi, 1997.

Mortensen, Camilla H. "(Eco)Mimesis and the Ethics of the Ethnographic Presentation." *Journal of American Folklore* 118, no. 467 (Winter 2005): 105–20.

Morwood, J. "Catullus 64, *Medea*, and the François Vase." *Greece & Rome* 46, no. 2 (October 1999: 221–31.

Mosebach, Martin. "Das epische Haus." In Nerdinger, *Architektur* (below), 20–6.

Moser-Verrey, Monique. "Chorégraphies narrées ou la question de l'ekphrasis." In Claude Duchet and Stéphane Vachon, eds., *La Recherche littéraire: Objets et méthodes*. Montreal: XYZ, 1993. 193–204

Motoyoshi, Akiko. *Wasf and Ekphrasis in the Arabic Qasidah Tradition*. Ph.D. dissertation, Indiana University, 2001.

_____. "Reality and Reverie: Wine and Ekphrasis in the ʿAbbāsid Poetry of Abū Nuwās and al-Buhturī." *Annals of Japan Association for Middle East Studies*, No. 14: 85–120. Rpt. as chapter 3 of Motoyoshi's *Description in Classical Arabic Poetry*. Leiden: Brill, 2004. 92–121.

Mottet, P. "From the Ekphrasis to the New: Poetic Genesis by Roland Bourneuf." *Litteratures* 52 (2005): 161–75.

Moulinat, Francis. "Gautier et l'ekphrasis." *Bulletin de la Société Théophile Gautier* 21 (1999): 133–47.

Mrozewicz Anna. "Towards an Understanding of Ekphrasis: Morten Søndergaard's Nedtælling til en skulptur af Michelangelo (Pietà di Rondanini i Milano)." *Folia Scandinavica Posnaniensia* 9 (2006): 137–56.

Mrugalski M. "Prolegomena to the Rósewicz's Body and the End of Ekphrasis." *Przeglad Humanistyczny [Humanistic Review]* 49, no. 4 (2005): 25–43.

Mudrovic, W. Michael. "Ekphrasis, Intertextuality and the Reader in Poems by Francisco Brines and Claudio Rodríguez." *Studies in Twentieth Century Literature* 14, no. 2 (Summer 1990): 279–300.

Mukai, Kumiko. "Hoson no 'Dairiseki no bokushin' ni okeru nimai no kaiga wo megutte." In Hironori, ed., *Amerika bungaku to kaiga: Bungaku ni okeru pikutoriarizumu*. Hiroshima, Japan: Keisui-sha, 2000. 25–51.

Müller, Cristina. "Individuation, Ekphrasis, and Death in *Don Quixote*." In de Armas, *Ekphrasis* (above), 156–73.

Müller-Muth, Anja. "'You Have Been Framed': The Function of Ekphrasis for the Representation of Women in John Banville's Trilogy (*The Book of Evidence, Ghosts, Athena*)." *Studies in the Novel* 36, no. 2 (Summer 2004): 185–205.

_____. "Re-presenting Representations: The Landscape Garden as a Sight/Site of Difference in Tom Stoppard's *Arcadia*." *Word & Image: A Journal of Verbal/Visual Enquiry* 15, no. 1 (January–March 1999): 97–106.

Munsterberg, Marjorie. "Ekphrasis." *Writing about Art*. http://www.writingaboutart.org/pages/ekphrasis.html

Murck, Alfreda. "Eight Views of the Hsiao and Hsiang Rivers by Wang Hung." In Wen C. Fong et al., eds., *Images of the Mind* (Princeton, NJ: The Art Museum, Princeton University, 1984), 214–35.

Murdoch, Jim. "Responsorial Poetry." *The Truth about Lies*. 27 July 2009. http://jim-murdoch.blogspot.com/

_____. "Poetry and Art." *The Truth about Lies*. 4 August 2008. http://jim-murdoch.blogspot.com/

Murgatroyd, Paul. "Apuleian Ecphrasis: Cupid's Palace at *Met*. 5.2.2." *Hermes* 125 (1997): 357–66.

Murphy, James R., ed. *Three Medieval Rhetorical Arts*. Berkeley: University of California Press, 1971.

Myer, Valerie Grosvenor. "Martha as Magdalen: An Illustration in *David Copperfield*." *Notes and Queries* 43, no. 241 (December 1996): 430.

Myslinski, Michal. "Michala Psellosa analiza dziel sztuki: bizantynskie antecedencje metody ikonograficznej [L'analyse des oeuvres d'art par Michel Psellos: les antécédents byzantins de la méthode iconographique]. In Maria Poprzecka, ed., *Ars longa: prace dedykowane pamieci profesora Jana Bialostockiego: materialy sesji Stowarzyszenia historyków sztuki Warszawa, listopad 1998*. Kraków: Arx regia, 1999. 179–86.

Nannicini, Chiara. "Perec et le renouveau de l'ekphrasis." *Le cabinet d'amateur*. http://www.cabinetperec.org/articles/nannicini-ekphrasis/nannicini-article.html

Nash, Jerry C. "'Fantastiquant mille monstres bossus': Poetic Incongruities, Poetic Epiphanies, and the Writerly Semiosis of Pierre de Ronsard." *Romanic Review* 84 (March 1993): 143–62.

Nassaar, Christopher S. "Wilde's *The Picture of Dorian Gray*." *Explicator* 57, no. 4 (Summer 1999): 216–17.

Naugrette, Jean-Pierre. "Les métamorphoses du Musée: art et voyage dans la fiction de R.L.

Stevenson." *Les Cahiers d'Inter-Textes*. Paris: Centre de recherche Inter-Textes Arts et Littératures modernes, 1985.

Nativel, Colette. "La Comparaison entre la peinture et la poesie dans le *De Pictura Veterum* (1,4) de Franciscus Junius (1589–1677)." *Word & Image: A Journal of Verbal/Visual Enquiry* 4, no. 1 (January–March 1988): 323–30.

Ndiaye, Emilia. "Retour sur l'épisode d'Ariane dans le Carmen 64 de Catulle: une ekphrasis vocale?" *Rursus*, No. 3. http://revel.unice.fr/rursus/document.html?id=216

Neel, Alexandra Hayward. *The Writing of Ice: The Literature and Photography of Polar Regions*. Ph.D. dissertation, Princeton University, 2007.

Nelson, Robert S. "To Say and to See: Ekphrasis and Vision in Byzantium." In Robert S. Nelson, ed., *Visuality Before and Beyond the Renaissance: Seeing as Others Saw*. Cambridge: Cambridge University Press, 2000. 141–68.

Nemerov, Howard. "On Poetry and Painting, with a Thought on Music." *Figures of Thought*. Boston: David Godine, 1978. 95–9; rpt. in J.D. McClatchy, ed., *Poets on Painters: Essays on the Art of Painting by Twentieth-Century Poets*. Berkeley: University of California Press, 1988. 177–84.

Nerdinger, Winfried, ed. *Architektur wie sie im Buche steht: fiktive Bauten und Städte in der Literatur/Architekturmuseum der Technischen Universität München*. Salzburg: Pustet, 2006.

_____. "Architektur wie sie im Buche steht." In Nerdinger, *Architektur* (previous entry), 9–19.

Nervaux, Laure de. *De l'ekphrasis à la scène: intensité, énergie et représentation chez Sylvia Plath*. Doctoral thesis, Université de Paris–Sorbonne, 2004.

Netto, Jeffrey A. "Intertextuality and the Chess Motif: Shakespeare, Middleton, Greenaway." In Michele Marrapodi and Keir Elam, eds., *Shakespeare, Italy, and Intertextuality*. Manchester, England: Manchester University Press, 2004. 216–26.

Neumann, Gerhard. "'Eine Maske, ... eine durchdachte Maske': Ekphrasis als Medium realistischer Schreibart in Conrad Ferdinand Meyers Novelle *Die Versuchung des Pescara*." In Boehm and Pfotenhauer, *Beschreibungskunst* (above), 445–91.

Neundorfer, German. "Ekphrasis in Carl Einsteins Negerplastik." In Roland Baubaum and Hubert Roland, eds., *Carl-Einstein-Kolloquium 1998*. Frankfort am Main: Peter Lang, 2001.

_____. "*Kritik an Anschauung*": Bildbeschreibung im kunstkritischen Werk Carl Einsteins. Epistemata: Würzburger Wissenschaftliche Schriften. Reihe

Philosophie. 453. Würzburg, Germany: Königshausen & Neumann, 2003.

Newby, Zahra. "Testing the Boundaries of Ekphrasis: Lucian *On the Hall*." *Ramus: Critical Studies in Greek and Roman Literature* 31, no. 1–2 (2002): 126–35.

Newlands, Carol E. "Ecphrasis: An Introduction." Paper presented at a panel on ecphrasis at a meeting of the Classical Association of the Middle West and South, Knoxville, TN, April 2000.

Newton, Candelas. "Representación del sujeto y escritura femenina en los poemas ecfrásticos de María Victoria Atencia." *Revista de Estudios Hispanicos* 29, no. 2 (May 1995): 213–29.

Niefanger, Dirk. "Narrative Verwandlungen: Ein intermediales Verfahren in Bildbeschreibungen Wilhelm Heinses, Heinrich von Kleists und Johann Wolfgang von Goethes." *Jahrbuch der Deutschen Schillergesellschaft: Internationales Organ für Neuere Deutsche Literatur* 45 (2001): 224–49.

Nichols, Stephen G. "Ekphrasis, Iconoclasm, and Desire." In Kevin Brownlee and Sylvia Huot, eds., *Rethinking "The Romance of the Rose": Text, Image, Reception*. Philadelphia: University of Pennsylvania Press, 1992. 133–60.

_____. "Pictures of Poetry in Marot's *Epigrammes*. In Michael P. Clark, ed., *Revenge of the Aesthetic: The Place of Literature in Theory Today*. Berkeley, CA: University of California Press, 2000. 93–100.

_____. "Seeing Food: An Anthropology of Ekphrasis, and Still Life in Classical and Medieval Examples." *MLN* 106 (September 1991): 818–51.

Nicosia, Salvatore. *Teocrito e l'arte figurate*. Palmero: Università di Palermo, 1968. **Review**: Berg, William. *American Journal of Philology* 92, no. 2 (April 1971: 383–4.

Nike, Mishel.' "Tipologiia ekfrasisa v 'Zhizni Klima Samgina' M. Gor'kogo." In Geller, *Ekfrasis* (above), 123–34.

_____. "Ekfrasis v 'Zhizni Klima Samgina' M. Gor'kogo." In G.S. Zaitseva et al., eds., *Maksim Gor'kii-khudozhnik: Problemy, itogi i perspektivy izucheniia: Gor'kovskie chteniia 2000 god*. Nizhniy Novgorod, Russia: Nizhegorodskii gosudarstvennyi universitet im. N. I. Lobachevskogo, 2002. 21–5.

_____. "'Venetsianka' Nabokova, ili Chary iskusstva." *Zvezda* 10 (2000): 201–05.

Nilsson, Ingela. *Erotic Pathos, Rhetorical Pleasure: Narrative Technique and Mimesis in Eumathios Makrembolites' "Hysmine & Hysminias."* Uppsala: Acta Universitatis Upsaliensis, 2001.

_____. "Narrating Images in Byzantine Literature: The Ekphrasis of Konstantinos Manasses."

Jahrbuch der österreichischen Byzantinistik 55 (2005): 121–46.

_____. "Phantasia: A Wise and Subtle Artist. Visualizing a Twelfth-Century Ekphrasis." In Elizabeth Piltz and Paul Åström, eds., *Kairos: Studies in Art History and Literature in Honour of Professor Gunilla Åkerström-Hougen.* Jonsered: Paul Åströms Förlag, 1998. 50–65.

Nimis, Stephen A. "Memory and Description in the Ancient Novel." *Arethusa* 31, no. 1 (Winter 1998): 99–122.

Niolle-Clauzade, Christine. "La figure de la description dans la théorie rhétorique classique: histoire de la description scolaire." *Pratiques* (Université de Nantes, Metz), Nos. 109–10 (2001): 5–14.

Niqueux, Michel. "Ekphrasis et fantastique dans *la Vénitienne* de Nabokov ou l'Art comme envoûtement." *Revue des études slaves* 72 (2000), fasc. 3 and 4.

Noe, Alfred. "Die Visionen von Kunstwerken bei Dante und Boccaccio: Ekphrasis in der italienischen Großepik des 14. Jahrhunderts." In Ratkowitsch, *Die poetische* (below), 133–52.

Noll, Thomas. "Zur 'Idee' von Joseph Anton Kochs 'Schmadribachfall.'" *Jahrbuch der Berliner Museen* 46 (2004): 171–96.

Norris, Nélida. "La visibilidad pictórica en la obra de Enrique Anderson Imbert." In Juana Alcira, ed., *La lógica del crítico en la creación lúdico-poética: Homenaje a Enrique Anderson Imbert. Colección La Mujer en la Literatura Hispánica.* 8. Westminster, CA: Instituto Literario y Cultural Hispánico, 2001. 265–75.

Norton-Smith, John. "Ekphrasis as a Stylistic Element in Douglas's *Palis of Honoure.*" *Medium Aevum* 48 (1979): 240–53.

Nys, Philippe. "El arte de los jardines: una hermenéutica del lugar y la cuestión de la ekphrasis." In Javier Maderuelo, ed., *El jardín como arte: arte y naturaleza.* Huesca: Diputación de Huesca, 1997. 175–93.

Ogee, Frederic. "Sterne and Fragonard: 'the escapades of death.'" In Wagner, *Icons* (below), 136–48.

Olmedo, Rebeca Rosell. *Ekphrasis and Spatial Form in Selected Works of Severo Sarduy.* Ph.D. dissertation, University of North Carolina, Chapel Hill, 2005.

Olson, Rebecca. *Behind the Arras: Tapestry Ekphrasis in Spenser and Shakespeare.* Ph.D. dissertation, Brandeis University, 2008.

Olson, Todd P. "'Long live the knife': Andrea Sacchi's Portrait of Marcantonio Pasqualini." *Art History* 27, no. 5 (November 2004): 697–722.

Olubas, Brigitta. "Anachronism, Ekphrasis and the 'Shape of Time' in 'The Great Fire.'" *Australian Literary Studies* 23, no. 3 (2008): 279–89.

Omlin, Sibylle. "In the Conceptual World of the Image: Ekphrasis and Palimpsest." In Klaus Honnef and Lukas Hammerstein, eds., *Andreas Horlitz: Arbeiten = Works.* Nürnberg: Verlag für Moderne Kunst; Bonn: VG Bild-Kunst, 2005.

Ophaug, Marianne Soon. *Envy and Ecphrasis in Augustan Poetry.* Doctoral thesis, University of Oslo, 2006.

Opitz, Christian Nikolaus. "'Lur fayt, lur vida, lur ventura, tot so divisav'en pintura.' Zum Gebrauch der Ekphrasis bei Guillem de Torroella. Mit einem Ausblick auf Anselm Turmeda und Joanot Martorell." *Zeitschrift für Katalanistik/Revista d'Estudis Catalans* 20 (2007): 123–48.

Orduna, Ferrario de, and Lilia Elda. "Función de la ékphrasis en los relatos caballerescos." *Letras* 40–41 (July 1999–June 2000): 107–14.

Orgel, Stephen. "'Counterfeit presentments': Shakespeare's Ekphrasis." In Stephen Orgel and Sean Keilen, eds., *Shakespeare and the Arts.* New York: Garland, 1999. 253–60; and in Edward Chaney and Peter Mack, eds., *England and the Continental Renaissance: Essays in Honour of J.B. Trapp.* Rochester, NY: Boydell Press, 1990. 177–84.

Ormond, Leonée. "Framing the Painting: The Victorian 'Picture Sonnet.'" *Moveable Type.* http://www.ucl.ac.uk/english/graduate/issue/2/leonee.htm

_____. "Thackeray and the 'Old Masters.'" In Shirley Chew and Alistair Stead, eds., *Translating Life: Studies in Transpositional Aesthetics.* Liverpool, England: Liverpool University Press, 1999. 233–52.

Orth, Ernst Wolfgang. "Beschreibung als Symbolismus." In Boehm and Pfotenhauer, *Beschreibungskunst* (above), 595–605.

Ossola, Carlo, Lina Bolzoni, and Giorgio Petrocchi. "Figurazione retorica e interni letterari: 'salons' e 'tableaux' (secoli XVI-XVIII)." In Antonio Franceschetti, ed., *Letteratura italiana e arti figurative: atti del XII convegno dell'Associazione internazionale per gli studi di lingua e letteratura italiana, Toronto, Hamilton, Montreal, 6–10 maggio 1985.* Firenze: L.S. Olschki, 1988. 117–40.

Osterkamp, Ernst. *Im Buchstabenbilde: Studien zum Verfahren Goethescher Bildbeschreibungen.* Stuttgart: J.B. Metzlersche Verlagsbuchhandlung, 1991.

_____. "Däubler oder die Farbe-Einstein oder die Form: Bildbeschreibung zwischen Expressionismus und Kubismus." In Boehm and Pfotenhauer, eds., *Beschreibungskunst* (above), 543–68.

Oudot, Estelle. "Regarder Rome, percevoir Athènes: remarques sur le vocabularie de la vision dans les éloges de villes chez Aelius Aristide." In Laurence Villard, ed., *Couleurs et vision dans l'antiquité clas-*

sique. Rouen: Publications de l'Université de Rouen, 2002.

Ovlsen, Steen Klitgård. "Ekfrasens aktualitet: Om Caravaggio i ny litteratur." In Harrits and Troelsen (above), 197–212.

Oxenstierna, Elena. "'Ikonmålare har målat dig svart': Ortodoxa Gudsmodersikonografier i Gunnar Ekelöfs tolkning." *Tidskrift för Litteraturvetenskap* 1 (2002): 62–81.

Oxfeldt, Elizabeth. "Orientalism, Decadence and Ekphrasis in Hamsun's *Dronningen av Saba.*" *Edda* 2 (2003): 181–93.

Pace, Claire. "'Semplice traduttore': Bellori and the Parallel between Poetry and Painting." *Word & Image: A Journal of Verbal/Visual Enquiry* 17, no. 3 (July–September 2001): 233–42.

Padgett, Jacqueline Olson. "Ekphrasis, Lorenzo Lotto's *Annunciation,* and the Hermeneutics of Suspicion." *Religion & the Arts* 10, no. 2 (June 2006): 191–218.

Pagano, Tullio. "Metamorfosi dell'immagine nell'-opera di Vincenzo Consolo." *Anello Che Non Tiene: Journal of Modern Italian Literature* 11–12, nos. 1–2 (Spring–Fall 1999–2000): 83–97.

Paldam, Camilla Skovbjerg. "Surrealistiske ekfraser: en indkredsning af et operationelt ekfrasebegreb." In Harrits and Troelsen (above), 101–16.

Pallas, Demetrios I. "Les 'ekphrasis' de Marc et de Jean Eugénikos: le dualisme culturel vers la fin de Byzance." In L. Hadermann Misguich et al., eds., *Rayonnement grec. Hommages à Charles Delvoye.* 505–11; and in *Byzantion* 52 (1982): 357–74.

Panszczyk, Anna M. *The Elasticity of Ekphrasis in the Poetry of Elizabeth Bishop and Wislawa Szymborska.* M.A. thesis, University of North Carolina at Chapel Hill, 2004.

Pao, Maria T. "Ekphrasis in Bousoño: duro jarro, jarro que dura." *Revista Canadiense de Estudios Hispanicos* 28, no. 1 (Fall 2003): 241–62.

_____. "Still(ed) Life: The Ekphastic Prose Poems of Ernesto Giménez Caballero." *Revista Canadiense de Estudios Hispánicos* 25, no. 3 (Spring 2001): 469–92.

Pamela [no surname given]. "Ekphrasis in Elizabeth Bishop's *Filling Station.*" http://chisenbop.blogspot.com/2009/03/ekphrasis-in-elizabeth-bishops-filling.html

Pap, Jennifer. "Apollinaire's Ekphrastic 'Poésie-Critique' and Cubism." *Word & Image: A Journal of Verbal/Visual Enquiry* 8, no. 3 (July–September 1992): 206–14.

_____. "The Cubist Image and the Image of Cubism." In Dudley Andrew, ed., *The Image in Dispute: Art and Cinema in the Age of Photography.* Austin, TX: University of Texas Press, 1997. 155–80.

_____. "From Ekphrasis to 'Moviment': Ponge's 'Nuage ... informe.'" *Dalhousie French Studies* 55 (Summer 2001): 95–119.

Papaioannou, Sophia. "Wedding Bells or Death Knells: Cross-Textual Doom and Poetics in 'Depicting' Famous Epic Banquets." *Ordia Prima* 5 (2006): 73–90.

Pape, Walter. "Ecritures de l'image chez Théophile Gautier." In Wagner, *Icons* (below), 324–45.

Papini, M. "Lo scudo di Achilleus. Appunti per una nuova interpretazione." *Annali della Facolta di Lettere e Filosofia dell' Universita di Siena* 4 (1983): 261–73.

Pappas, Sara. "Reading for Detail: On Zola's Abandonment of Impressionism." *Word & Image: A Journal of Verbal/Visual Enquiry* 23, no. 4 (October–December 2007): 474–84.

Park, Elaine Virginia. *The Rhetoric of Antecedence: Latin in Middle English Poetry.* Ph.D. dissertation, University of Calgary, 1993.

Parker, Sarah. *Techniques of Description in Apuleius' "Cupid and Psyche."* Ph.D. dissertation, McMaster University, 1999.

Pasch, Sandra. *Intermediale Aspekte der Picasso-Rezeption in der spanischen und hispanoamerikanischen Lyrik des 20. Jahrhunderts.* Frankfurt am Main; New York: Peter Lang, 2006.

Paschalis, Michael. "Reading Space: A Re-examination of Apuleian Ecphrasis." In Paschalis's *Space in the Ancient Novel,* Ancient Narrative Supplementum 1. Groningen: Barkhuis, 2002. 132–42.

Pas de Sécheval, Anne. "Réflexions sur des textes méconnus. Quels enjeux pour l'histoire de l'art?" *XVIIe siècle* 230 (2006): 7–22.

Passarelli, Gaetano. "L'*Ekphrasis* per la festa di Pasqua." *Orientalia christiana periodica* 48, no. 1 (1982): 2445.

Pataki, Zita Ágota. *Anhänge und Abbildungen.* Stuttgart: Ibidem-Verlag, 2005.

_____. "Beobachtungen zu einem Brunnengedicht Giulio Roscios." In Sebastian Schütze, ed., *Kunst und ihre Betrachter in der Frühen Neuzeit: Ansichten, Standpunkte, Perspektiven.* Berlin: Reimer, 2005. 15–33.

_____. *"nympha ad amoenum fontem dormiens" (CIL VI/5, 3*e), Herrscherallegorese?: Studien zu einem Nymphenbrunnen sowie zur Antikenrezeption und zur politischen Ikonographie am Hof des ungarischen Königs Matthias Corvinus.* Dissertation, Jena University, 2003. Published Stuttgart: Ibidem-Verlag, 2005.

Paterson, A.K.G. "Ecphrasis in Garcilaso's *Egloga tercera.*" *Modern Language Review* 72 (1977): 73–92.

Patke, Rajeev S. "Painting into Poetry: The Case of Derek Mahon." *Word & Image: A Journal of Verbal/Visual Enquiry* 22, no. 2 (April–June 2006):

118–27. Also available at http://courses.nus.edu. sg/course/ellpatke/Miscellany/Painting/Painting %20into%20Poetry.htm

Patten, Janice E. *Dark Imagination: Poetic Painting in Romantic Drama*. Ph.D. dissertation, University of California, Santa Cruz, 1992.

Paterson, Alan K.G. "Ecphrasis in Garcilaso's 'Egloga tercera.'" *Modern Language Review* 72 (1977): 73–92.

Paul the Silentiary. *Descriptio S. Sophiae*. Medieval Sourcebook: http://www.fordham.edu/halsall/ source/paulsilent-hagsophl.html

Paulicelli, Eugenia. "Parola e spazi visivi nella Galeria." In Francesco Guardiani, ed., *The Sense of Marino: Literature, Fine Arts and Music of the Italian Baroque. Literary Criticism Series*. 5. New York: EGAS, 1994. 255–65.

Paulson, Ronald. "The Harlot, Her Father, and the Parson: Representing and Interpreting Hogarth in the Eighteenth Century." In Wagner, *Icons* (below), 149–74.

Pavlov Evgeny. "Puteshestvie v ekfrasis. 'Shestoe chuvstvo' v armianskoi proze Mandel'shtama." ["Journey to Ekphrasis: 'The Sixth Sense' in Mandelstam's Armenian Prose"]. *Izobrazhenie i slovo: formy ekrfrasisa v literature. [Picture and Word: Forms of Ekphrasis in Literature]*. Moscow: Nauka, 2009.

Paxson, James J. "The Anachronism of Imagining Film in the Middle Ages: Wegener's *Der Golem* and Chaucer's *Knight's Tale*." *Exemplaria* 19, no. 2 (Summer 2007): 290–309.

Payne, Mark. "Ecphrasis and Song in Theocritus *Idyll* 1." *Greek, Roman and Byzantine Studies* 42, no. 3 (Autumn 2001): 263–87.

Pederson, Elizabeth. "*What can six apples not be?:* Ekphrasis in *To the Lighthouse* and *Spending*: A Utopian Divertimento." *Alphaeus* (online postgraduate journal) 3 (November 2005). http://w ww.uow.edu.au/arts/research/ejournal/archives/ nov05/pederson-article.pdf

Pedri, Nancy. "From Photographic Product to Photographic Text: Lalla Romano's Movement Away from Ekphrasis." *Rivista di Studi Italiani* 19, no. 2 (December 2001): 141–61.

Peek, Wendy Chapman. *Vision, Language, Spectacle: Ekphrasis in the "Aeneid" and Medieval Romance*. Ph.D. dissertation, Cornell University, 1992.

Peers, Glenn. "Manuel II Paleologos's Ekphrasis on a Tapestry in the Louvre: Word over Image." *Revue des études byzantines* 61 (2003): 201–14.

Peeters, Benoît. "Reisen in die geheimnisvollen Städte." In Nerdinger, *Architektur* (above), 137–45.

Pellini, Pierluigi. *La descrizione*. Roma: Editore Laterza, 1998.

Penna, Baso. *To buzantino nomisma: meso sunallages kai ekfrase autokratorikes propagandas*. Leukosia: Politistiko Idruma Trapezes Kuprou, 2002.

Pentcheva, Bissera. "The Performative Icon." *Art Bulletin* 88, no. 4 (2006): 631–55.

_____. "Visual Textuality: The Logos as Pregnant Body and Building." *Res: Journal of Anthropology and Aesthetics* 45 (2004): 225–38.

Pérez, Janet. "Ekphrasis and Memory: Delibes's *Portrait of a Lady*." *Revista Hispanica Moderna* 47, no. 1 (June 1994): 123–33.

Perini, Giovanna. "L'arte di descrive: la tecnica dell'ecfrasi in Malvasia e Bellori." In *I Tatti Studies, Essay on the Renaissance*, vol. 3. Firenze: L.S. Olschki, 1989. 175–206.

Perloff, Marjorie. "The Pleasures of Déja Dit: Citation, Intertext and Ekphrasis in Recent Experimental Poetry." In Kornelia Freitag and and Katharina Vester, eds. *Another Language: Poetic Experiments in Britain and North America*. Berlin/ Hamburg/Münster: LIT Verlag. 125–48.

Persin, Margaret Helen. *Getting the Picture: The Ekphrastic Principle in Twentieth-Century Spanish Poetry*. Lewisburg, PA: Bucknell University Press, 1997. Contents: "Get the Picture?," "How Manuel Machado Did (Not) Get the Picture," "The Writerly/Painterly Text: Rafael Alberti and Pablo Picasso," "Shot Out of the Can(n)on: Gloria Fuertes, Carmen Martín Gaite, and the Problem of Liminality," "(Self-)Portraits, (Dis)guises, and Frames: The Disfiguring Gaze of Jaime Gil Biedma, and José Angel Valente," "Pop Goes the (W)easel: Portraits by and of Maria Victoria Atencia and Ana Rossetti," "Pere Gimferrer and Jenaro Talens on (the) Camera, or The Lens and The I's/Eye's Obscure Object of Desire"

_____. "The Ekphrastic Principle in the Poetry of Manuel Machado." *Hispania* 72, no. 4 (December 1989): 919–26.

_____. "L'inversione speculare. Per una retorica dell'ecphrasis." *Materiali e discussioni* 1 (1978): 87–98.

_____. "La mirada femenina de Rosario Castellanos." In Kirsten F. Nigro and Sandra M. Cypess, eds., *Essays in Honor of Frank Dauster. Homenajes*. 9. Newark, DE: Cuesta, 1995. 51–63.

_____. "The Passionate Vision of Ana Rossetti." In Jill Robbins, ed., *P/herversions: Critical Studies of Ana Rossetti*. Lewisburg, PA: Bucknell UP, 2004. 240–57.

_____. "El principio exfrástico en tres poemas de Rosario Castellanos." In Juana Alcira et al., eds., *Literatura como intertextualidad: IX Simposio International de Literatura*. Buenos Aires: Inst. Lit. y Cultural Hispánico, 1993. 488–500.

_____. "Rafael Alberti's Los 8 nombres de Picasso:

Visual and Verbal Collage." *Siglo XX/20th Century* 3, nos. 1–2 (1985–86): 11–15.

_____. "Reading Goya's Gaze with Concha Zardoya and María Victoria Valencia. *Anales de la Literatura Española Contemporánea* 22, no. 1 (1997): 5, 75–90.

Perutelli, Alessandro. *La narrazione commentata. Studi sull'epillio latino.* Pisa: Giardini, 1979.

Pescarmona, K. Denee. "Et[urn]al Existence: Keats and Dialogic Ekphrasis in 'Ode on a Grecian Urn.'" http://prometheus.cc.emory.edu/panels/5C/Pescarmona.html

Pestalozzi, Karl. "Das Bildgedicht." In Boehm and Pfotenhauer, *Beschreibungskunst* (above), 569–91.

Petit, Laurence. "Inscribing Colors and Coloring Words: A.S. Byatt's 'Art Work' as a 'Verbal Still Life." *Critique* 49, no. 4 (Summer 2008): 395–412.

Petrain, David. "Moschus' *Europa* and the Narratology of Ecphrasis." *Beyond the Canon: Hellenistica Groningana* 7 (2006): 249–69.

Petrosky, Barbara. *L'Activité imageante chez Pierre Loti et Emile Zola: Deux écrivains photographes.* Ph.D. dissertation, University of Florida, 2006.

Peyré, Yves. "Le livre de dialogue." In Marie-Hélène Popelard, ed., *Le même et l'autre: poésie, musique, peinture.* [Mont-de-Marsan]: Atelier des Brisants, 2003. 153–8.

Pfau, O. "The Double Doubled: Ekphrasis as a Mirror (Statius, *Thebaid* 1,544–551)." *Societe Études Classiques* 70, no. 3 (2002): 277–89.

Pfeiffer, Bogusław. "Galerie i pałace: kategoria 'ekphrasis' w utworach staropolskich." *Pamiętnik Literacki* 2 (2001): 61–78.

Pfister, M. *The Dialogue of Text and Image, Antoni Tapies and Anselm Kiefer.* In Klaus Dirscherl, ed., *Bild und Text in Dialog.* Passau: Wissenschaftsverlag Rothe, 1993. 321–43.

Pfotenhauer, Helmut. "Winckelmann und Heinse: Die Typen der Beschreibungskunst im 18. Jahrhundert oder die Geburt der neueren Kunstgeschichte." In Boehm and Pfotenhauer, *Beschreibungskunst* (above), 313–40.

Philipp, Klaus Jan. "'Non e vero, ma ben trovato': Rekonstruktionen literarisch überlieferter Bauwerke." In Nerdinger, *Architektur* (above), 89–112.

Phillips, Helen. "Scott and Chaucer: Ekphrasis, Politics, and the Past in *The Antiquary*." *Poetica* 61 (2000).

Phillips, James M., and Jean-Jacques Thomas. *Representational Strategies in Les Misérables and Selected Drawings by Victor Hugo: An Intermedial Comparison. Currents in Comparative Romance Languages and Literatures.* 86. New York: Peter Lang, 1999.

Phillips, Rowan Ricardo. "Derek Walcott: Imagi-nation, Nation and the Poetics of Memory." *Small Axe: A Caribbean Journal of Criticism* 11 (March 2002): 112–32.

Phillips, Tom. *Works and Texts.* London: Thames and Hudson, 1992.

Photography and Literature: An Anglo-French Symposium [special issue]. *Journal of European Studies* 30, pt. 1 (March 2000): 5–110.

Piagnani, Francesco, and Mirko Santanicchia. *Storie di pittori tra Perugia e il suo lago.* Morbio Inferiore, Switzerland: Selective Art Edizioni, 2008.

Pierazzo, Elena. "Iconografia della 'Zucca' dell Doni: emblematica, ekphrasis e variantistica." *Italianistica* 27 (1998): 403–25.

Pigeaud, Jackie. "Le bouclier d'Achille (Homère, *Iliade* xviii, 478–608)." *Revue des Etudes Grecques* 101 (1988): 54–63.

_____. "La naissance de la critique d'art." In Pierre–Henry and Jean-Marc Poinsot, eds., *L'invention de la critique d'art: actes du colloque international tenu à l'Université Rennes 2 les 24 et 25 juin 1999.* Rennes: Presses universitaires de Rennes, 2002. 61–80.

Pignani, Adriana. *Racconto di una festa popolare: ekphrasis per la festa di Pasqua.* Napoli: M. D'Auria, 1984.

_____. *L'ekphrasis per la festa Pasquia: testo critico, introduzione e traduzione.* Napoli: M. D'Auria, 1981.

Pimentel, L.A. "Ekphrasis and Cultural Discourse: Coatlicue in Descriptive and Analytic Texts (Representations of the Aztec earth mother goddess)." *Neohelicon* 30, no. 1 (2003): 61–75.

Piña Rosales, Gerardo. "El 98 y el descubrimiento del paisaje español." *Círculo: Revista de Cultura* 28 (1999): 25–37.

Pincombe, Michael. "Classical and Contemporary Sources of the 'Gloomy Woods' of *Titus Andronicus*: Ovid, Seneca, Spenser." In John Batchelor et al., eds., *Shakespearean Continuities: Essays in Honour of E.A.J. Honigmann.* Basingstoke, England; New York: Macmillan: St. Martin's, 1997. 40–55.

Pineda, Victoria. "La invención de la écfrasis." In José Luis Sánchez Abal, ed., *Homenaje a la Profesora Carmen Pérez Romero.* Cáceres, Spain: Facultad de Filosofía y Letras, Universidad de Extremadura, 2000. 251–62.

Pinelli, Antonio. "Neoclassicismo in scultura: circolarità e apoteosi dell'ékphrasis.'" In Bonfait, *La description* (above), 75–90.

Pintacuda, Paola. "'L'ekphrasis' nella poesia castigliana del secolo XV." In *Lettere ed arti nel Rinascimento* (Atti del X Convegno internazionale, Chianciano-Pienza, 20–23 luglio 1998). Firenze: Franco Cesati, 2000. 261–78.

Piot, Henry. *L'Ecphrasis.* Rennes: Simon, 1914.

_____. *Les procédés littéraire de la seconde sophistique*

chez Lucien: L'ecphrasis. Dissertation, Th. Lett. Rennes, 1914.

Pipher, Karen Lynn. *Visual Representation as Used in Compositional Processes.* M.A. thesis, York University, 2001.

Pires, Alessandra Maria. *Ekphrasis le cas du Lancelot-Graal.* Ph.D. dissertation, University of Georgia, 2004.

Piwowarska, D. "Ekphrasis w poezii Afanasija Feta." In Jerzego Kapuścika, ed., *Dialog sztuk w kulturze Słowian wschodnich.* Kraków: Tertium Krakowskie Towarzystwo Popularyzowania Wiedzy, 2002.

Pizzorusso, Claudio. "Mirone e Dafne: su Bartolomeo Ammannati scultore e Laura Battiferri." *Artista* (2003): 72–87.

Platt, Verity. "Evasive Epiphanies in Ekphrastic Epigram." *Ramus: Critical Studies in Greek and Roman Literature* 31 (2002): 33–50.

Polacco, Marina. "'Terre di mezzo': novellizzazione, *ekphrasis* e altre visioni." *Contemporanea: rivista di studi sulla letteratura e sulla comunicazione* 5 (2007).

Pollini, John. "The Warren Cup: Homoerotic Love and Symposial Rhetoric in Silver." *Art Bulletin* 81, no. 1 (March 1999): 21–52.

Pommier, Édouard. "L'ekphrasis dans la littérature artistique du classicisme français." In Venturi, *Ecfrasi* (below), 541–72.

Poole, Russell. "Ekphrasis: Its 'Prolonged Echoes' in Scandinavia." *Viking and Medieval Scandinavia* 3 (2007): 245–67.

Pop, Doru Aurel. "For an Ekphrastic Poetics of Visual Arts and Representations." *Studia Universitatis Babes-Bolyai: Studia Dramatica* 2 (2008): 3–10.

Porter, Yves. "La Forme et le sens: A propos du portrait dans la littérature persane classique." In Christophe Balaÿ et al., eds., *Pand-o Sokhan: Mélanges offerts à Charles-Henri de Fouchécour.* *Bibliothèque Iranienne.* 44. Tehran, Iran: Institut Français de Recherche en Iran, 1995. 219–31.

Poseq, Avigdor W. "On Creative Interpretation: Igael Tumarkin's Homage to Velasquez's *Las Meninas.*" *Konsthistorisk tidskrift* 69, no. 1 (2000): 33–40.

Post, Jonathan F.S. "Ekphrasis and the Fabric of the Familiar in Mary Jo Salter's Poetry." http://www.maryjosalter.com/Ekphrasis.htm

Potts, Alex. "Sans tête, ni bras, ni jambes: la description du Torse du Belvédère de Winckelmann." In Larys Frogier and Jean-Marie Poinsot, eds., *La description: actes du colloque Archives de la critique d'art.* Châteaugiron: Archives de la critique d'art, 1997. 18–33

Pound, Francis. "James K. Baxter's 'The Book of

Hours,' and the *Très Riches Heures du Duc de Berry.*" *New Zealand Journal of French Studies* 20, no. 2 (November 1999): 17–34.

Povlsen, Steen Klitgård. *Willumsens smil: En omvendt ekfrase.* Århus: Aarhus Universitetsforlag, 2006. 189–98.

Pozner, Valerie. "Kino-èkfrasis. Po povodu kinokommentarija v Rossii." In Geller, *Ekphrasis* (above), 152–61.

Pralon, D. "Homère *Odyssée* xi. Ce que disent les Ombres." *Connaissance hellénique* No. 25 (1985): 53–61.

Prandi, Stefano. "L'ecfrasi pastorale." In Venturi, *Ecfrasi* (below), 203–25.

Prauscello, L. "Sculpted Meanings, Talking Statues: Some Observations on Posidippus 142.12 a-b (= xix g-p) Kai En Prothuois Theke Didaskalien." *American Journal of Philology* 127, no. 4 (Winter 2006): 511–23.

Prendergast, Monica. "Ekphrasis and Inquiry: Artful Writing on Arts-Based Topics in Educational Research." http://209.85.173.104/search?q=cache:_UkLVzBcPLAJ:www.ierg.net/confs/2004/Proceedings/Prendergast_Monica.pdf+ekphrasis&hl=en&ct=clnk&cd=120&gl=us

_____. "Inquiry and Poetry: Haiku on Audience and Performance in Education." *Language and Literacy: A Canadian Educational E-Journal* 6, no. 1 (Spring 2004). http://www.langandlit.ualberta.ca/Spring2004/Prendergast.html

Preston, Claire. Review of Alison Saunders and Peter Davidson, *Visual Words and Verbal Pictures: Essays in Honour of Michael Bath. Modern Language Review* 102, no. 1 (January 2007): 185–86.

Price, Leah. Review of Garrett Stewart, *The Look of Reading. Victorian Studies* 49, no. 3 (Spring 2007): 531–2.

Prince, Nathalie. "Le chef-d'oeuvre inconnu de Dorian Gray." In Pascale Auraix-Jonchière, ed., *Ecrire la peinture entre XVIIIe et XIXe siècles.* Révolutions et Romantismes. 4. Clermont-Ferrand, France: Presses Universitaires Blaise Pascal, 2003. 393–404.

Prinz, Wolfram. *Die Storia oder die Kunst des Erzählens in der italienischen Malerei und Plastik des späten Mittelalters und der Frührenaissance 1260–1460.* Mainz: von Zabern, 2000.

Puchner, H. Martin. "Textual Cinema and Cinematic Text: The Ekphrasis of Movement in Adam Thorpe and Samuel Beckett." *Erfurt Electronic Studies in English* 4 [misnumbered 1]) (1999). http://webdoc.gwdg.de/edoc/ia/eese/artic99/puchner/4_99.html

Pugh, Christina. *Revising the Pictorial: Ekphrasis and the Nature of Modern Lyric.* Ph.D. dissertation, Harvard University, 1998.

Pulvirenti, Grazia. "Altre scritture: il 'Gesamtkunst-werk' nel primo Novecento." In Pulvirenti, *Le muse* (below), 39–58.

———. "*Ekphrasis* dell'invisibile." In Valtolina, *L'immagine rubata* (below), 88–103.

———, ed. *Le muse inquiete: sinergie artistiche nel Novecento Tedesco.* Firenze: Olschki, 2003.

Pursglove, Glyn. "'The Story Talks Louder Than the Paint': From Canvas to Page in Some Contemporary Poems." In Holger Klein et al., eds., *Poetry Now: Contemporary British and Irish Poetry in the Making. Studies in English and Comparative Literature.* 13. Tübingen, Germany: Stauffenburg, 1999. 113–22.

Putnam, Michael C.J. "Dido's Murals and Virgilian Ekphrasis (*Aeneid*, Book 1, 453–493)." *Harvard Studies in Classical Philology* 98 (1998): 243–75.

———. "Ganymede and Virgilian Ekphrasis." *American Journal of Philology* 116 (Fall 1995): 419–40.

———. "Silvia's Stag and Virgilian Ekphrasis." *Materiali e discussioni per l'analisi dei testi classici* 34 (1995): 107–33.

———. "Two Ways of Looking at the *Aeneid*." *The Classical World* 96, no. 2 (Winter 2003): 177–84.

———. "Virgil's Danaid Ekphrasis." *Illinois Classical Studies* 19 (1994): 171–89.

———. *Virgil's Epic Designs: Ekphrasis in the "Aeneid."* New Haven: Yale University Press, 1998. **Reviews:** Bartsch, Shadi. *Classical Review* 50, no. 1 (2000): 47–8. Becker, Andrew Sprague. *American Journal of Philology* 121, no. 2 (Summer 2000): 324–28. Callatay, G.D. *Latomus* 60, no. 3 (July–September 2001): 732–3. Casali, Sergio. *Classical Journal* 96, no. 1 (October–November 2000): 99–101. *Choice.* January 1999: 882. Hardie, Philip Russell. *Journal of Roman Studies* 90 (2000): 239–40. Knox, Bernard M. "Virgil the Great." *New York Review of Books* 46, no. 18 (18 November 1999): 60–5. Maleuvre, J.Y. *Études Classiques* 68, no. 2–3 (2000): 260. Starnes, Colin. *Dalhousie Review* 77, no. 3 (Fall 1997): 429–31.

Pyle, Forest. "Kindling and Ash: Radical Aestheticism in Keats and Shelley." *Studies in Romanticism* 42, no. 4 (Winter, 2003): 427–59.

Pypeć, Magdalena. "Browning's The *Statue and the Bust* as an Example of Ekphrasis." In Władysław Witalisz and Peter Leese, eds., *Papers in Culture and Literature.* Instytut Filologii Angielskiej Uniwersytet Jagieloński, 2002. 131–38 .

———. "Watching the Speaker Watching: The Poetic Persona in Browning's Ekphrastic Poems." In Grażyna Bystydzieńska and Paddy Lyons, eds., *Papers in Literature and Culture.* Uniwersytet Warszawski, 2005. 274–80.

Qian, Zhaoming. *The Modernist Response to Chinese Art: Pound, Moore, Stevens.* Charlottesville: University of Virginia Press, 2003.

Quinn, Kelly A. "Ekphrasis and Reading Practices in Elizabethan Narrative Verse." *Studies in English Literature 1500–1900* 44, no. 1 (Winter 2004): 19–35.

Quintero, María Cristina. "Mirroring Desire in Early Modern Spanish Poetry: Some Lessons from Painting." In de Armas, *Writing* (above), 87–108.

Raaberg, Gwen. "Ekphrasis and the Temporal/Spatial Metaphor in Murray Krieger's Critical Theory." *New Orleans Review* 12, no. 4 (Winter 1985): 34–43.

Rabel, R.J. "The Shield of Achilles and the Death of Hector." *Eranos* 87 (1989): 81–90.

Rabin, Lisa. "The 'Voz' and the 'Vocerio': José Asunción Silva Faces Culture at the Foot of Bolívar's Statue." *Revista de Estudios Hispánicos* 34, no. 3 (October 2000): 607–24.

Rabitti, Giovanna. "Un arabesco per nome: l'ecfrasi nei Rabisch di Giovan Paolo Lomazzo." In Venturi, *Ecfrasi* (below), 433–76.

Race, William H. *Classical Genres and English Poetry.* London: Croom Helm, 1988.

———. "Ekphrasis." In Alex Preminger et al., eds., *Princeton Encyclopedia of Poetry and Poetics.* Princeton, NJ: Princeton University Press, 1993. 320–21

———. "Some Visual Priamels from Sappho to Richard Wilbur and Raymond Carver." *Classical and Modern Literature* 20, no. 4 (Fall 2000): 3–17.

Raithel, Jutta Christine. *In a Mirror, Brightly: The Didactic Value of Visual Imagery in an Early Icon and an Ekphrastic Sermon (the Enthroned Virgin of Mount Sinai and Pseudo-Gregory of Nazianzus, "oration 35").* M.A. thesis, York University, 1999.

Raitt, George. "Ekphrasis and Illumination of Painting: The End of the Road?" *Word & Image: A Journal of Verbal/Visual Enquiry* 22, no. 1 (January–March 2006): 14–26.

———. "Waiting for a Sign from Home: Fay Zwicky and Gerhard Marcks' *der Rufer*." *Westerly* 52 (November 2007): 131–8.

Ramos, Manuel João. "Drawing the Lines: The Limitations of Intercultural Ekphrasis." In Sarah Pink et al., eds., *Working Images: Visual Research and Representation in Ethnography.* London: Routledge, 2004. 147–56.

Rannoux, Catherine. "Claude Simon: La Confusion créative." *La Licorne* 35 (1995): 283–90.

Rapaport, Herman. "The Phenomenology of Spenserian Ekphrasis." In Bruce Henricksen, ed., *Murray Krieger and Contemporary Critical The-*

ory. Irvine Studies in the Humanities. New York: Columbia University Press, 1986. 157–75.

Ratkowitsch, Christine, "Die Gewebe in Claudians Epos De raptu Proserpinae — ein Bindeglied zwischen Antike und Mittelalter." In Ratkowitsch, *Die poetische* (below), 17–42.

_____. *Descriptio picturae: die literarische Funktion der Beschreibung von Kunstwerken in der lateinischen Großdichtung des 12. Jahrhunderts*. Wien: Verlag der Österreichischen Akademie der Wissenschaften, 1991. **Review:** Smith, Christine. *Speculum* 69, no. 2 (April 1994): 555–7.

_____, ed. *Die poetische Ekphrasis von Kunstwerken: eine literarische Tradition der Grossdichtung in Antike, Mittelalter und früher Neuzeit*. Wien: Verlag der Österreichischen Akademie der Wissenschaften, 2006.

Rauth, Eric. *The Work of Memory: Ekphrasis, Museums, and Memorialism in Keats, Quatremère de Quincey, Balzac, and Flaubert*. Ph.D. dissertation, Princeton University, 1990.

Ravenna, Giovani. "Ekphrasis." *Enciclopedia virgiliana*. Istituto Della Roma, 1996.

_____. "L'ekphrasis poetica di opere d'arte in latino. Temi i problemi." *Quaderni dell'Istituto di Filologia Latina di Padova* 3 (1974): 1–54.

_____. "Giasone e l'enargheia: ekphrasis ed economia narrativa (Val. Fl. 2, 629–fine)." *Orpheus*, n.s., 2 (1981): 340–56.

_____. "Per l'identità di ekphrasis." In Lucio Cristante, ed., *Incontri Triestini di Filologia Classica IV — 2004–2005*. Atti del convegno internazionale. Phantasia. Il pensiero per immagini degli antichi edei moderni. Trieste, 28–30 aprile 2005. Trieste: Edizioni Università di Trieste, 2005. 21–30.

Read, Richard. *Art and Its Discontents: The Early Life of Adrian Stokes*. University Park, PA: Pennsylvania State University Press, 2002.

Rebel, Ernst, ed., "Bis Winckelmann: Etappen auf dem Weg zur modernen Bildbeschreibung." In Rebel, *Sehen* (below), 13–39.

_____. "Darf Bildbeschreibung 'Erlebnis' bieten? Tendenzen und Diskussionen seit Burckhardt." In Rebel, *Sehen* (below), 40–73.

_____. "Die gute Beschreibung: nachträgliche Stichworte vor pädagogischem Horizont." In Rebel, *Sehen* (below), 213–30.

_____. *Sehen und Sagen: das Öffnen der Augen beim Beschreiben der Kunst*. Ostfildern: Edition Tertium, 1996.

Recht, Roland. "Buren sur Ryman, Moritz sur Winckelmann: la critique constitutive de l'histoire de l'art." In Bonfait, *La description* (above), 285–94.

_____, ed. *Le texte de l'oeuvre d'art: la description*. Strasbourg: Presses Universitaires de Strasbourg, 1998.

Redekop, Magdalene. "Alice Munro's Tilting Fields." In Martin Kuester et al., eds., *New Worlds: Discovering and Constructing the Unknown in Anglophone Literature. Schriften der Philosophischen Fakultäten der Universität Augsburg*. 59. München: Vögel, 2000. 343–62.

Rees, Roger. "Common Sense in Catullus 64." *American Journal of Philology* 115 (Spring 1994): 75–88.

Reeves, Bridget T. *The Rape of Europa in Ancient Literature*. Ph.D. dissertation, McMaster University, 2004.

_____. "The Role of the Ekphrasis in Plot Development: The Painting of Europa and the Bull in Achilles Tatius' *Leucippe and Clitophon*." *Mnemosyne* 60, no. 1 (2007): 87–101.

Reggiani, Christelle. "Des livres d'images: Statuts textuels de l'image roussellienne." In Ann-Marie Amiot and Christelle Reggiani, eds., *Formes, images et figures du texte roussellien. Revue des Lettres Modernes: Histoire des Idées et des Littératures*. 2. Paris: Minard, 2004. 23–46.

Regoliosi, Mariangela. "Le 'virtutes loquentes' di Lorenzo Valla: ovvero, intorno all'idea valliana di poesia." In Venturi, *Ecfrasi* (below), 101–21.

Regopoulos, Ioannes K. *Ut pictura, poesis: to 'ekphrastiko' systema tes poieses kai poietikes tou K. Kavaphe*. Athena: Smile, 1991.

Rehder, Robert. "R.S. Thomas's Poems about Paintings." *Renascence: Essays on Values in Literature* 60, no. 2 (January 2008): 83–102.

Reinitzer, Heimo. *Text — Bild — Musik: zur Orgelspielerin im Maler Nolten; für Dietrich Gerhardt zum 11. Februar 2001; mit einer Würdigung und Schriftenverzeichnis; vorgelegt in der Sitzung vom 13. Juli 2001*. Göttingen: Vandenhoeck & Ruprecht, 2002.

Renaut, Luc. "La description d'une croix cosmique par Jean de Gaza, poète palestinien du VIe siècle." In Robert Favreau and Marie-Helene Debies, eds., *Iconographica: mélanges offerts à Piotr Skubiszewski*. Poitiers, Université de Poitiers, centre d'études supérieures de civilisation médiévale, 1999. 211–20

Rengakos, Antonios. "'Du würdest dich in deinem Sinn täuschen lassen': zur Ekphrasis in der hellenistischen Poesie." In Ratkowitsch, *Die poetische* (above), 7–16.

Renner, Ursula. *Die Zauberschrift der Bilder. Bildende Kunst in Hofmannsthals Texten*. Freiburg: Rombach Verlag, 1999.

Restle, Marcell. "Neuere Wege zum Verständnis der Hagia Sophia in Istanbul" ["More Recent Ways of Understanding Hagia Sophia in Istan-

bul"]. *Pantheon* 39, no. 2 (April–June 1981): 156–60.

Reulecke, Anne-Kathrin. *Geschriebene Bilder. Zum Kunst- und Mediendiskurs in der Gegenwartsliteratur*. München: Wilhelm Fink, 2002.

Reveles, Patricia. "Para una lectura iconotextual de 'Farabeuf' de Salvador Elizondo." *Trans— Revue de literature générale et compare* 6 (2007). http://trans.univ-paris3.fr/article.php3?id_article=189

Revermann, M. "The Text of *Iliad* 18.603–6 and the Presence of an Aoidos on the Shield of Achilles." *Classical Quarterly* 48, n.s., no. 1 (1998): 29–38.

Rhoby, Andreas. "Bemerkungen zur Komez ecphrasis des Johannes Eugenikos." *Jahrbuch der österreichischen Byzantinistik* 51 (2001): 321–36.

Ribbat, Christoph. "Literaten der Kamera." *Fotogeschichte* 24, no. 94 (2004): 75–6.

Ribeyrol, Charlotte. "Swinburne–Whistler: Correspondance(s)." *Études Anglaises* 57, no. 1 (January–March 2004): 63–78.

Ricci, Battaglia. "'Come [...] le tombe terragne portan segnato': lettura del dodicesimo canto del Purgatorio." In Venturi, *Ecfrasi* (below), 33–63.

Ricci, Franco. *Painting with Words, Writing with Pictures: Word and Image Relations in the Work of Italo Calvino*. Toronto: University of Toronto Press, 2001.

Ricciardi, Caterina. "Piero della Francesca nella poesia di Ezra Pound." In Attilio Brilli, ed., *Piero della Francesca nella cultura europea e Americana*. Città di Castello: Edimond, 1993. 41–59.

Richards, Sylvie L.F. "Texts, Eyes, and Double Takes: The Work of Art in Zola and Huysmans." *West Virginia University Philological Papers* 41 (1995): 50–8.

Riches, Harriet. "Addressing Ekphrasis." *Classical Philology* 102, no. 1 (2007): 72–82.

Rico, Gabriele. "Daedalus and Icarus Within: The Literature/Art/Writing Connection." *English Journal* 78, no. 3 (March 1989): 14–23.

Ridder, Klaus. "Ästhetisierte Erinnerung-erzählte Kunstwerke. Tristans Lieder, Blanscheflurs Scheingrab, Lancelots Wandgemälde." *Zeitschrift für Literaturwissenschaft und Linguistik* 27 (1997): 62–84.

Rieu, Josiane. "L'Ecphrasis dans la poésie religieuse maniériste." Claude Faisant, ed., *Hommage à Claude Digeon. Pubs. de la Fac. des Lettres & Sciences Humaines de Nice*. 36. Paris: Belles Lettres, 1987. 27–39.

Riffaterre, Michael. "Ekphrasis Lyrique." *Pleine Marge: Cahiers de Litterature, d'arts plastiques et de critique*, No. 13 (1991): 133–49. Rpt. in *Romanic Review* 93, nos. 1–2 (January–March 2002): 201–16.

_____. "L'Illusion d'ekphrasis." In Gisele Mathieu-Castellani, ed., *La Pensee de l'Image: Signification et figuration dans le texte et dans la peinture*. Paris: Presses Universitaires de Vincennes, 1994. 211–29.

_____. *The Poetics of Ekphrasis*. Baltimore, MD: Johns Hopkins University Press, 1990.

Rifkin, Adrian. "Addressing Ekphrasis: A Prolegomenon to the Next." *Classical Philology* 102, no. 1 (January 2007): 72–82.

Riggs, Sarah Brenda. *Word Sightings: Visual Apparatus and Verbal Reality in Stevens, Bishop and O'Hara*. Ph.D. dissertation, University of Michigan, 1999.

Rigolot, François. "Ekphrasis and the Fantastic: Genesis of an Aberration." *Comparative Literature* 49 (Spring 1997): 97–112.

Rijser, David. *Raphael's Poetics: Ekphrasis, Interaction and Typology in Art and Poetry of High Renaissance Rome*. Ph.D. thesis, Universiteit van Amsterdam, 2006.

Rippol, F. "Variations épiques sur un motif d'ecphrasis: l'enlèvement de Ganymède." *Revue des Études Anciennes* 102 (2000): 479–500.

Rippl, Gabriele. *Beschreibungs-Kunst: zur intermedialen Poetik angloamerikanischer Ikontexte (1880–2000)*. München: Fink, 2005.

_____. "Ekphrasis: Pictorial Description as Representational Theory in Spenser, Sidney, Lyly, and Shakespeare." *Zeitschrift für Anglistik und Amerikanistik* 50, no. 4 (2002): 425–27.

Rischin, Abigail S. "Beside the Reclining Statue: Ekphrasis, Narrative, and Desire in *Middlemarch*." *PMLA* 111 (October 1996): 1121–32.

_____. "Ekphrasis and the Art of Rescue: Rossetti's Sonnets 'For Ruggiero and Angelica by Ingres.'" In Golahny, *The Eye* (above), 214–23.

_____. *Speaking Looks: Varieties of Ekphrastic Experience in Nineteenth-Century Literature*. Ph.D. dissertation, Yale University, 1995.

_____. "Visuality and Ekphrasis in A.S. Byatt's *Still Life* and 'Art Work.'" In Bernhard Reitz et al., eds., *Anglistentag 1999 Mainz: Proceedings. Proceedings of the Conference of the German Association of University Teachers of English*. 21. Trier, Germany: Wissenschaftlicher, 2000. 519–34.

Rizzarelli, Giovanna. "Descrizioni di descrizioni: Preliminari per una ricerca sull'ékphrasis in Giovan Battista Marino." In Alice Di Stefano, ed., *Cyberletteratura: Tra mondi testuali e mondi virtuali*. Rome: Nuova Cultura, 2006. 173–90.

_____, ed. "On Description: the Ekphrasis in Giovan Battista Marino's Work." An online textual project. See http://www.ctl.sns.it/apps/center/index.php?lang=en&area=02.10

Roberts, Sasha. "Historicizing Ekphrasis, Gender, Textiles, and Shakespeare's Lucrece." In Robillard, *Pictures* (below).

Robertson, Calire. Review of Julian Kliemann and Michael Rohlmann, *Wandmalerei in Italien: Hochrenaissance und Manierismus, 1510–1600 = Italian Frescoes: High Renaissance and Mannerism, 1510–1600* (München: Hirmer, 2004). *Kunstchronik* 59, no. 1 (2006): 20–2.

Robillard, Douglas. *Melville and the Visual Arts: Ionian Form, Venetian Tint.* Kent, OH: Kent State University Press, 1997.

Robillard, Valerie. *The Ekphrastic Moment in the Poetry of William Carlos Williams.* Groningen: Rijksuniversiteit Groningen, 1999.

———. "In Pursuit of Ekphrasis, an Intertextual Approach." In Robillard, *Pictures* (next entry), 53–72.

Robillard, Valerie, and Els Jongeneel, eds. *Pictures into Words: Theoretical and Descriptive Approaches to Ekphrasis.* Amsterdam: VU University Press, 1998.

Rochat, Denise. "Corps dérobé: handicap et condition postmoderne dans Homme invisible a la fenêtre de Monique Proulx." *Quebec Studies* 31 (Spring–Summer 2001): 112–15.

Rochester, Joanne Marie. *Inset Forms of Art in the Plays of Philip Massinger.* Ph.D. dissertation, University of Toronto, 2000.

Rodrigues, Nuno Manuel Simões. "Ut pictura poesis: A Guerra de Tróia numa ekphrasis vergiliana (Aeneidos liber I, 453–493)." *Artis* 3 (2004): 13–34.

Rogers, Jane Susan. *Ekphrasis in Robert Browning's Men and Women.* Ph.D. dissertation, University of Alabama, 1998.

Rogers, Pat. "'How I Want Thee, Humorous Hogart': The Motif of the Absent Artist in Swift, Fielding and Others." *Papers on Language and Literature: A Journal for Scholars and Critics of Language and Literature* 42, no. 1 (Winter 2006): 25–45.

Rogerson, Anne. "Dazzling Likeness: Seeing Ekphrasis in *Aeneid* 10." *Ramus: Critical Studies in Greek and Roman Literature* 31 (2002): 51–72.

Rombach, Ursula. "Alexander der Grenzgänger: ein Herrscherbild zwischen Forscherdrang und Hybris." In Arwed Arnulf, ed., *Mittelalterliche Beschreibungen der Grabeskirche in Jerusalem.* Stuttgart: Steiner, 1998. 45–70.

Rommel, Thomas. "Ekphrasis." In Rommel's *Literatursplaten: Bücher lesen und verstehen.* Hamburg: Merus, 2006.

Rondeau, Corrine. "L'impossible ekphrasis." *La Revue de Belles Lettres, Revue de poésie.* Lausanne, Suisse, 2005.

Ronk, Martha C. "A Foreign Substance." *Chicago Review* 53, no. 4, and 54, nos. 1–2 (Summer 2008): 109–12.

———. "Locating the Visual in *As You Like It.*" *Shakespeare Quarterly* 52, no. 2 (Summer 2001): 255–76.

———. "Representations of Ophelia." *Criticism* 36 (Winter 1994): 21–43.

———. "Viola's (Lack of) Patience." *The Centennial Review* 37, no. 2 (Spring 1993): 385–99.

Rooney, Monique. "'Recoil' or 'Seize'?: Passing, Ekphrasis and 'Exact Expression' in Nella Larsen's *Passing.*" *Enculturation* 2, no. 1 (Fall 2001), n.p. http://enculturation.gmu.edu/3_2/rooney/index.html

———. "Representations of Ophelia." *Criticism* 36 (Winter 1994): 21–43.

Rosand, David. "An Arc of Flame: On the Transmission of Pictorial Knowledge." In *Bacchanals by Titian and Rubens: Papers Given at a Symposium in Nationalmuseum, Stockholm, March 18–19, 1987.* Stockholm, Nationalmuseum, 1987. 81–92.

———. "Ekphrasis and the Generation of Images." *Arion,* third series 1 (1990): 61–105.

———. "Ekphrasis and the Renaissance of Painting: Observations on Alberti's Third Book." In Karl-Ludwig Selig, ed., *Florilegium Columbianum: Essays in Honor of Paul Oskar Kristeller.* New York: Italica Press, 1987. 147–65. Also available at http://www.diesel-ebooks.com/cgi-bin/item/1599100223

———. "Ut Pictor Poeta: Meaning in Titian's Poesie." *New Literary History: A Journal of Theory and Interpretation* 3, no. 3 (Spring 1972): 527–46.

Rose, Jonathan S. *Parthenius of Nicaea and the Rise of Alexandrianism in Rome.* Ph.D. dissertation, Bryn Mawr College, 1994.

Rosenberg, Raphael. *Beschreibungen und Nachzeichnungen der Skulpturen Michelangelos: eine Geschichte der Kunstbetrachtung.* München: Deutscher Kunstverlag, 2000.

———. "Inwiefern Ekphrasis keine Bildbeschreibung ist: zur Geschichte eines missbrauchten Begriffs." In Joachim Knape and Elisabeth Gruner, eds., *Bildrhetorik.* Baden-Baden: Verlag Valentin Koerner, 2007. 271–82

———. "'Une ligne horizontale interrompue par une ligne diagonale': de la géométrie dans la description d'oeuvres d'art." In Bonfait, *La description* (above), 55–74.

———. "Von der Ekphrasis zur wissenschaftlichen Bildbeschreibung: Vasari, Agucchi, Félibien, Burckhardt." *Zeitschrift für Kunstgeschichte* 58, no. 3 (1995): 297–318.

Roske, Thomas. "'Eine Bewegung von übermenschlicher Wucht': Ausnahmeerfahrungen in expressionistischer Kunstgeschichtsschreibung." In

Ulrich Pfisterer and Anja Zimmermann, eds., *Animationen/Transgressionen: das Kunstwerk als Lebewesen*, VIII. Hamburg, Kunstgeschichtliches Seminar der Universität Hamburg. 229–45.

Ross, Margaret Clunies. "The Cultural Politics of the Skaldic Ekphrasis Poem in Medieval Norway and Iceland." In Helen Fulton et al., eds., *Medieval Cultural Studies: Essays in Honour of Stephen Knight*. Cardiff: University of Wales Press, 2006. 227–40.

_____. "Stylistic and Generic Definers of the Old Norse Skaldic Ekphrasis." *Viking and Medieval Scandinavia* 3 (2007): 161–85.

Rossi, Massimiliano. "La peinture guerrière: artistes et paladins à Venise au XVIIIe siècle." In Giovanni Careri, ed., *La Jérusalem délivrée du Tasse: poésie, peinture, musique, ballet*. Paris: Klincksieck, 1999. 67–108.

Rosso, Adélaïde. "L'ekphrasis dans Les Collages de Louis Aragon: *ekplexis, enargeia, escamotage*." In Jean Arrouye, ed., *Écrire et voir. Aragon, Elsa Triolet et les arts visuels*. Aix-en-Provence: Publications de l'Université de Provence, 1991. 211–227

_____. "Operatività dell'ecfrasi." In Venturi, *Ecfrasi* (below), 355–66.

Roth, Roman. "Varro's 'picta Italia' (RR I. ii. 1) and the Odology of Roman Italy" [Varro]. *Hermes: Zeitschrift für Klassische Philologie* 135, no. 3 (2007): 286–300.

Royston, Pamela L. "Unraveling the Ecphrasis in Chapman's Hero and Leander." *South Atlantic Review* 49, no. 4 (November 1984): 43–53.

Ruberg, Uwe. "'Lancelot malt sein Gefängnis aus.' Bildkunstwerke als kollektive und individuelle Memorialzeichen in den Aeneas-, Lancelot- und Tristanromanen." In Dietmar Peil et al., eds., *Erkennen und Erinnern in Kunst und Literatur*. Tübingen: Niemeyer, 1998. 181–94.

Rubin, David Lee, ed. *Word and Image. EMF: Studies in Early Modern France*. 1. Charlottesville: Rookwood, 1994.

Rubins, Maria. *Crossroad of Arts, Crossroad of Cultures: Ekphrasis in Russian and French Poetry*. New York: Palgrave, 2000. **Reviews:** Knighton, Mark. *Canadian Slavonic Papers* 44, nos. 3–4 (September–December 2002): 317. Kruger, Carole, *Nineteenth Century Studies* 18 (2004): 175–81. Morley, Rachel. *Slavonic & East European Review* 80, no. 3 (July 2002): 498–500. *Russian Review* 61, no. 1 (January 2002): 139. Wanner, Adrian. *Slavic Review: Interdisciplinary Quarterly of Russian, Eurasian, & East European Studies* 61, no. 1 (Spring 2002): 187–8. Zieliński, Jan. *Slavic & East European Journal* 46, no. 2 (Summer 2002): 376–7.

_____. *Ecphrasis in Parnasse and Acmeism: Comparative Visions of Poetry and Poetics*. Ph.D. dissertation, Brown University, 1998.

_____. "The 'Telling' Image: Ecphrasis in Russian Acmeist Verse." *Mosaic* 31, no. 2 (June 1998): 57–76.

_____. "Ekfrasis v rannem tvorchestve Georgiia Ivanova" ["Ecphrasis in Georgy Ivanov's Early Verse"]. *Russkaia Literatura: Istoriko-Literaturnyi Zhurnal* 1 (2003): 68–85.

_____. "'Plasticeskaja radost' krasoty': ekfrasis v tvorcestve akmeistov i evropejskaja tradicija" ["*The Plastic Joy of Beauty*": Ecphrasis in Acmeist Poetry and the European Tradition']. Saint Petersburg: Academic Project Publishers, 2003.

Ruckhäberle, Hans-Joachim. "Theatertexte — Theaterbilder." In Nerdinger, *Architektur* (above), 175–86.

Rudolph, Conrad. "*First, I Find the Center Point*": *Reading the Text of Hugh of Saint Victor's "The Mystic Ark*." Philadelphia, American Philosophical Society, 2004.

Rudy, Elizabeth Mathieu. *Pierre–Paul Prud'hon (1758–1823) and the Problem of Allegory (France)*. Ph.D. dissertation, Harvard University, 2007.

Ruiz, Pedro Guerrero. "Ekphrasis en 'tablas,' de Federico García Lorca." In Rafael T. Corbalán et al., eds., *Confabulaciones: ensayos sobre artes y letras hispánicas*. New York: Graduate School and University Center, The City University of New York, 2001.

Ruotolo, Renato. "Turisti ed illustrazioni per turisti: l'immagine di Napoli dal Grand Tour al turismo borghese." In Clara Gelao, ed., *Scene di vita popolare napoletana nei disegni, acquerelli, gouaches e litografie dell'archivio Congedo*. Galatina: Congedo, 2006. 11–16.

Rupp, Michael. "Ekphrasis, Verbal Representations of Art and Virtual Spaces through Different Media, an International Conference Held in Berlin, May 2003." *Zeitschrift für Germanistik* 14, no. 1 (2004): 186–8.

Rusche, Harry. "The Poet Speaks of Art." http://homepage.mac.com/mseffie/assignments/paintings&poems/titlepage.html

Rusk, Lauren. "Poems That Respond to Works of Visual Art." *Proceedings of the Hawaii International Conference on Arts and Humanities* (2007).

_____. "The Possibilities and Perils of Writing Poems about Visual Art." *Writer's Chronicle* 39, no. 5 (March–April 2007): 75

_____. "When Ekphrasis Opens Out." *Proceedings of the Hawaii International Conference on Arts and Humanities* 11–14 January 2006.

Russek, Dan. "Ekphrasis and the Contest of Representations in Tomás Martínez's *La novela de Perón*." In Marcy E. Schwartz and Mary Beth

Tierney-Tello, eds., *Photography and Writing in Latin America: Double Exposures*. Albuquerque: University of New Mexico Press, 2006. 173–91.

Ryden, Lennart. "The Date of the Life of Andreas Salos." *Dumbarton Oaks Papers* 32 (1978): 127–55.

Sabbatino, Pasquale. "'La guerra e la pace tra 'l celeste e 'l vulgare amore': il poema pittorico di Annibale Carracci e l'ecfrasi di Bellori (1657, 1672)." In Venturi, *Ecfrasi* (below), 471–511.

Sabor, Peter. "'Staring in Astonishment': Portraits and Prints in *Persuasion*." In Juliet McMaster and Bruce Stovel, eds., *Jane Austen's Business: Her World and Her Profession*. Hampshire, Eng.; New York: Macmillan-St. Martin's, 1996. 17–29.

_____. "The Strategic Withdrawal from Ekphrasis in Jane Austen's Novels." In Wagner, *Icons* (below), 213–35.

Sachs-Hombach, Klaus. *Bilder im Geiste: Zur kognitiven und erkenntnistheoretischen Funktion piktorialer Repräsentationen*. Amsterdam und Atlanta: Editions Rodopi, 1995. 40–61.

Sadoulet, Pierre. "L'Emotion esthétique et sa représentation verbale dans [Rabelais's] *Le Songe de Poliphile* (Livre I). pp. 57–79." In Françoise Parouty-David and Claude Zilberberg, eds., *Sémiotique et esthétique*. Limoges, France: Presses Universitaires de Limoges, 2003.

Safit, Ilan. "Animating Vision: Visual Adaptation in [Vermeer's] *Girl with a Pearl Earring*." *Comparatist* 30 (May 2006): 52–67.

Safran, Linda. "A Medieval Ekphrasis from Otranto." *Byzantinische Zeitschrift* 83, no. 2 (1990): 425–7.

Sage, Michel. "Introduction: 'Literature and the Arts: A French Perspective on Visual Poetics, Language, and Artistic Representation." *College Literature* 30, no. 2. (2003): 73–81.

Sager, Laura Mareike. *Writing and Filming the Painting: Ekphrasis in Literature and Film*. Ph.D. dissertation, University of Texas, Austin, 2006. http://66.102.1.104/scholar?q=cache:sYwiM3QQ7oAJ:scholar.google.com/+ekphrasis&hl=en

Sager Eidt, Laura M. *Writing and Filming the Painting: Ekphrasis in Literature and Film*. Amsterdam: Rodopi, 2008.

Saglia, Diego. "The Hybrid Sign: Depicting the Margin in David Dabydeen's *Turner*." In Diego Saglia and Giovanna Silvani, eds., *Narrare Rappresentare: Incroci di segni fra immagine e parola*. Heuresis: Strumenti. 40. Bologna, Italy: CLUEB, 2003. 241–64.

Sakamoto, Hiroya. "Revisiter l'atelier d'Elstir: l'image du cheval dans l'ekphrasis du 'Port de Carquethuit.'" In Bernard Brun and Juliette Hassine, eds., *Marcel Proust Tome 5: Proust au tournant du siècle*, 2. Paris and Caen: Lettres Modernes Minard, 2005.

Salazar, Philippe-Joseph. "La Ruse du pli: Parole et nudité au XVIIe siècle." *French Studies in Southern Africa* 22 (1993): 20–9.

_____. "De Poussin à Fénelon: La Corruption classique." *French Studies in Southern Africa* 18 (1989): 29–37.

Saltzman, A.M. "Beholding Paul West and *The Women of Whitechapel*." *Twentieth Century Literature* 40 (Summer 1994): 256–71.

Samosata, Luciano di. *Descrizioni di opere d'arte*. Ed. Sonia Maffei. Torino: Einaudi, 1994.

Sandbank, Shimon. "Poetic Speech and the Silence of Art." *Comparative Literature* 46 (Summer 1994): 225–39.

Sanders, Karin. "Fanget mellem ord og billede. Betragtninger over ekfraseteorier og køn." *Kultur og Klasse* 88, no. 2 (1999): 169–84.

Sanni, Amidu. Review of Akiko Motoyoshi Sumi, *Description in Classical Arabic Poetry: Wasf, Ekphrasis, and Interarts Theory* (below). *Welt des Islams* 45, n.s., no. 2 (2005): 304–6.

Santos, Ariane Souza. *Ekphrasis in Shawna Lemay: To Make Something Mythical of My Life*. M.A. thesis, Universidade Federal de Minas Gerais, UFMG, Brasil, 2005.

_____. "Ekphrasis on Vermeer: The Letter as a Sign in Lemay and Alves." In II SEMINECAL, 2004, Assunção, Paraguay. Los Retos frente a la internacionalizacion, lo publico, lo privado y la identidad en America Latina y Canadá. La Habana: Felix Varela, 2004. 312–25.

_____. "Canadá/Brasil: Ekphrasis sobre Vermeer." In *VII Congresso Internacional da ABECAN, 2003, Belo Horizonte*. Caderno de Resumos, 2003.

Saradi-Mendelovici, Helen. "Beholding the City and the Church: The Early Byzantine Ekphraseis and Corresponding Archaeological Evidence." *Deltion tis Christianikis Archaiologikis Hetaireias* 24 (2003): 31–6.

_____. "The Ekphrasis of Trebizond of Bessarion, Antiquity and the Historical Message" [in Greek]: *Proceedings of the Conference of the Graduate Program of Philosophy, University of Athens, and the School of Humanities, University of Peloponnese, Katerini, 10–11 March 2007*.

Sargent, Stuart. "Colophons in Countermotion: Poems by Su Shi and Huang T'ing-chien on Paintings." *Harvard Journal of Asiatic Studies* 52, no. 1 (1992): 263–302.

Saslow, James M. "The Unconsummated Portrait: Michelangelo's Poems about Art." In Golahny, *The Eye* (above), 79–101.

Sauder, Gerhard. "Die Sexualisierung des Ästhetischen bei Heinse." In Gert Theile, ed., *Das Maß des Bacchanten: Wilhelm Heinses Über-Lebenskunst*. Munich: Fink, 1998. 77–90.

_____. "Fiktive Renaissance : Kunstbeschreibungen in Wilhelm Heinses Roman *Ardinghello*." In Silvio Vietta, ed., *Romantik und Renaissance: die Rezeption der italienischen Renaissance in der deutschen Romantik*. Stuttgart: J.B. Metzler, 1994. 61–73.

Sauer, Christine. "Theoderichs Libellus de locis sanctis, ca. 1169–1174: Architekturbeschreibung eines Pilgers." In Gottfried Kerscher, ed., *Hagiographie und Kunst: der Heiligenkult in Schrift, Bild und Architektur*. Berlin: D. Reimer, 1993. 213–39.

Saunders, Alison, and Peter Davidson, eds. *Visual Words and Verbal Pictures: Essays in Honour of Michael Bath*. Glasgow Emblem Studies, special volume. Glasgow: Glasgow Emblem Studies, 2005.

Sayre, Frank Connell. *Ekphrasis in Ancient Poetry*. M.A. thesis, University of Texas, Austin, 1976.

Schaefer, Christina, and Stefanie Rentsch. "Ekphrasis. Anmerkungen zur Begriffsbestimmung in der neueren Forschung." *Zetischrift für Franzosische Sprache und Literatur* 114, no. 2 (2004): 132–65.

Scheidegger, Jean R. "Le Sexe du Crucifix: Littérarité, art et théologie dans Le Prêtre teint et Le Prêtre crucifié." *Reinardus: Yearbook of the International Reynard Society/Annuaire de la Société Internationale Renardienne* 7 (1994): 143–59.

Schenck, Ernst-Peter. "Pictorial Desires and Textual Anxieties: Modes of Ekphrastic Discourse in Nineteenth-Century American Culture." *Word & Image: A Journal of Verbal/Visual Enquiry* 15, no. 1 (January–March 1999): 54–62.

Schenka, Astrid. *Ekphrasis und Theatralität*. Saarbrücken: VDM Verlag, 2008.

Schick, C.G. "A Case Study of Descriptive Perversion: Theophile Gautier's Travel Literature." *Romanic Review* 78 (May 1987): 359–67.

Schiedermair, Joachim. "Bildets begjær etter teksten." In Harrits and Troelsen (above).

_____. "Sublime ekfraser: Det upphøyede som semiotisk proses i Henrik Wergelands Jan van Huysums Blomsterstykke." *Edda: Nordisk Tidsskrift for Litteraturforskning/Scandinavian Journal of Literary Research* 2 (2006): 118–30.

_____. "Blinde Ekphrasen: Gustaf Lundbergs Bild *Badin* (1775) in Ola Larsmos Roman *Maroonbeget* (1996)." In Eglinger, *BildDurchSchrift* (above), 103–26.

Schipper-Hönicke, Gerold. *Im klaren Rausch der Sinne: Wahrnehmung und Lebensphilosophie in den Schriften und Aufzeichnungen Wilhelm Heinses*. Epistemata: Würzburger Wissenschaftliche Schriften. Reihe Literaturwissenschaft. 379. Würzburg, Germany: Königshausen & Neumann, 2003.

Schissel von Fleschenberg, O. "Die Technik des Bildeinsatzes." *Philologus* 76, no. 26 (1913): 83–114.

Schlegelmilch, Ultich. *Descriptio templi: Architektur und Fest in der lateinischen Dichtung des konfessionellen Zeitalters*. Regensburg: Schnell & Steiner, 2003.

Schlosser, Julius von. "Die höfische Kunst des Abendlandes in byzantinischer Beleuchtung." *Mitteilungen des Instituts für Österreichische Geschichtsforschung* 17 (1896): 441–56.

Schluter, Lucia Luna Elisabeth. *Niet alleen: een kunsthistorisch-ethische plaatsbepaling van tuin en woning in het "Conuiuium religiosum" van Erasmus* [*Not Alone: An Art-historical-ethical Location of Garden and House in Erasmus's "Conuiuium religiosum"*]. Amsterdam: Amsterdam University Press, 1995. **Review:** Ebels-Hoving, Bunna. *Bijdragen en mededelingen betreffende de geschiedenis der Nederlanden* 112, no. 4 (1997): 541–43.

Schmeling, Manfred, and Monika Schmitz-Emans, eds. *Das visuelle Gedächtnis der Literatur*. Würzburg: Königshausen and Neumann, 1999.

Schmiddunser, Agathe. "Barocke Körpersprache: Gregorio Fernández' 'passión animada.'" In Rebel, *Sehen* (above), 129–50

Schmidt, Elisabeth. "Wirkliche und unwirkliche Bilder in Prousts *A la recherche du temps perdu*." In Boehm and Pfotenhauer, *Beschreibungskunst* (above), 493–518.

Schmidt, Gisela. "I see, I see, said the blind man..." *Journal of Visual Art Practice* 4, nos. 2–3 (2005): 151–65.

Schmitt, Lothar. "'Mentem non potuit pingere docta manus': die heikle Allianz von Künstlern und Gelehrten in der frühen Neuzeit." In Bodo Guthmüller, ed., *Künstler und Literat: Schrift- und Buchkultur in der europäischen Renaissance*. Wiesbaden: Harrassowitz, 2006. 195–230.

Schmitzer, Ulrich. "Praesaga ars. Zur literarischen Technik der Ekphrasis bei Valerius Flaccus." *Würzburger Jahrbücher für die Altertumswissenschaft*, Neue Folge 23 (1999): 143–60.

Schneck, Ernst-Peter. "Pictorial Desires and Textual Anxieties: Modes of Ekphrastic Discourse in Nineteenth-Century American Culture." *Word & Image: A Journal of Verbal/Visual Enquiry* 15, no. 1 (January–March 1999): 54–62.

_____. "'To See Things before Other People See Them': Don DeLillo's Visual Poetics." *Amerikastudien/American Studies* 52, no. 1 (2007): 103–20.

Schneider, Manfred. "Das Kino und die Architekturen des Wissens." In Georg Chr. Tholen et al., eds., *Zeit-Zeichen. Aufschübe und Interferenzen zwischen Endzeit und Echtzeit*. Weinheim: Wiley-VCH, 1990. 281–95.

Schneider, Steven P. "Crossing Borders With Poetry and Art." *Chronicle of Higher Education* 52, no. 29 (24 March 2006): B9.

Schöch, Christof. "L'ekphrasis comme description de lieux: de l'antiquité aux romantiques anglais." *Acta Fabula* 8, no. 6 (Novembre–Décembre 2007). http://www.fabula.org/revue/document3 691.php. Review of Koelb, *Poetics*.

Scholz, Bernhard F. "Ekphrasis and Enargeia in Quintilian's *Institutionis oratoriae* libri xii." In Peter Lothar Oesterreich and Thomas O. Sloane, eds., *Rhetorica movet: Studies in Historical and Modern Rhetoric in Honor of Heinrich F. Plett*. Leiden: Brill, 1999.

_____. "'Sehen lehren, Sehen lernen': Zum Verhaltnis von Bild und Wort in Johannes Itten's Analysen alter Meister (1921)." *Compass: Mainzer Hefte fur Allgemeine und Vergleichende Literaturwissenschaft* 3 (1998): 1–25.

_____. "Sub oculus subiectio: Quintilianus on 'Ekphrasis' and 'Enargeia.'" In Robillard, *Pictures* (above), 73–99.

Schönbeck, Gerhard Hans-Joachim. *Der Locus Amoenus von Homer bis Horaz*. Dissertation, University of Heidelberg, 1962.

Schönberger, Otto. "Die 'Bilder' des Philostratos." In Boehm and Pfotenhauer, *Beschreibungskuns* (above), 157–75.

Schonhorn, Manuel. "Fielding's Ecphrastic Moment: Tom Jones and his Egyptian Majesty." *Studies in Philology* 78, no. 3 (Summer 1981): 305–24.

Schörle, Eckart. "Die Verhöflichung des Lachens: Anmerkungen zu Norbert Elias' *Essay on Laughter*." In Claudia Opitz, ed., *Höfische Gesellschaft und Zivilisationsprozess: Norbert Elias' Werk in kulturwissenschaftlicher Perspektive*. Köln: Böhlau, 2005. 225–44.

Schotter, Anne Howland. "The Poetic Function of Alliterative Formulas of Clothing in the Portrait of the Pearl Maiden." *Studia Neophilologica: A Journal of Germanic and Romance Languages and Literature* 51 (1979): 189–95.

Schröter, Jens. "Intermedialität. Facetten und Probleme eines aktuellen medienwissenschaftlichen Begriffs." *montage/av* 7 (1998): 129–54.

Schuhmacher, Klaus. "'Brüder der Schmerzen': Zur Krise des geschriebenen Bildes um 1900." In Kapp, *Bilderwelten* (above), 195–216.

Schulte, Raphael J. "Re-Imaging the 'Beautiful History': Frank O'Hara and Larry Rivers." *Fu Jen Studies: Literature & Linguistics* 32 (1999): 45–57.

Schuster, Meinhard. "Probleme des Beschreibens fremder Kulturen." In Boehm and Pfotenhauer, *Beschreibungskunst* (above), 617–31.

Schwartz, S.L., and J.P. Mendes. "The Shield of Achilles and the Temple of Venus [port. Zus.], *Classica* (Brazil) 3 (1990): 125–34.

Schweinfurth, Dagmar. *Ekphrasis topôn und ekphrasis tropôn. Aspekte der topographischen Ekphraseis in der griechischen Prosa der Kaiserzeit und Spätantike*. Heidelberg: University Magisterarbeit, 2005. http://archiv.ub.uni-heidelberg.de/propy laeumdok/frontdoor.php?source_opus=88&la= de

Scolnicov, Hanna. "Making Ears Serve for Eyes: Stoppard's Visual Radio Play." *Word & Image: A Journal of Verbal/Visual Enquiry* 20, no. 1 (January–March 2004): 63–83.

Scott, D. *Pictorialist Poetics: Poetry and the Visual Arts in Nineteenth-Century France*. Cambridge: Cambridge University Press, 1988.

Scott, Grant F. "Beautiful Ruins: The Elgin Marbles Sonnet in its Historical and Generic Contexts." *Keats-Shelley Journal* 39 (1990): 123–50.

_____. "Copied with a Difference: Ekphrasis in William Carlos Williams' *Pictures from Brueghel*." *Word & Image: A Journal of Verbal/Visual Enquiry* 15, no. 1 (January–March 1999): 63–75.

_____. "Ekphrasis and the Picture Gallery." In Thomas A. Sebeok et al., eds., *Advances in Visual Semiotics: The Semiotic Web 1992–93. Approaches to Semiotics*. 118. Berlin: Mouton de Gruyter, 1995. 403–21.

_____. "The Fragile Image: Felicia Hemans and Romantic Ekphrasis." In Nanora Sweet and Julie Melnyk, eds., *Felicia Hemans: Reimagining Poetry in the Nineteenth Century*. Basingstoke, England: Palgrave, 2001. 36–54.

_____. "Review Essay: Ekphrasis." *European Romantic Review* 3, no. 2 (Winter 1993): 215–23.

_____. "The Rhetoric of Dilation: Ekphrasis and Ideology." *Word & Image: A Journal of Verbal/Visual Enquiry* 7, no. 4 (October–December 1991): 301–10.

_____. *The Sculpted Word: Keats, Ekphrasis, and the Visual Arts*. Hanover, NH: University Press of New England, 1994. **Reviews:** Baker, William, and Kenneth Womack. "Recent Work in Critical Theory." *Style* 30, no. 4 (Winter 1996): 584 ff. Bennett, Andrew. *Romanticism* 2, no. 1 (1996): 110–13. Burwick, Frederick. *Wordsworth Circle* 26, no. 4 (Fall 1995): 217–23. Cevasco, G.A. *Choice* 32 (March 1995): 1120. Gidal, Eric. *Keats-Shelley Journal* 46 (1997): 194–6. Goslee, Nancy Moore. *European Romantic Review* 6, no. 2 (1996): 277–81. Marsland, Clive. *Keats-Shelley Review* 10 (Spring 1996): 107–10. Ryan, Robert M. *Journal of English and Germanic Philology* 95, no. 3 (July 1996): 456–8. Shaffer, E.S. *Modern Language Review* 92 (October 1997): 954–55. Spiegelman, Willard. *Studies in Romanticism* 36, no. 1 (Spring

1997): 133–6. Spivey, Nigel. "Realms of Gold." *TLS*, no. 4841 (January 12 1996): 24.

_____. *Seduced by Stone: Keats, Ekphrasis, and Gender*. Ph.D. dissertation, University of California, Los Angeles, 1989.

_____. "Shelley, Medusa, and the Perils of Ekphrasis." In Frederick Burwick and Jürgen Klein, eds. *Romantic Imagination: Literature and Art in England and Germany*. Amsterdam: Rodopi, 1997. 315–32.

Scott, R.T. "The Shield of Aeneas and the Problem of Ecphrasis." In B. Magnusson et al., eds., *Ultra terminum vagary: Scritti in onore di Carl Nylander*. Roma: Edizioni Quasar, 1997.

Scuderi, Vincenza. "Modi *ékphrasis*. Un'introduzione." In Valtolina, *L'immagine rubata* (below), 9–17.

Seabra Ferreira, Marie-Aline. "The Passion of the Brides: Angela Carter, Marcel Duchamp and Max Ernst." *Etudes Britanniques Contemporaines: Revue de la Société d'Etudes Anglaises Contemporaines* 31 (November 2006): 83–103.

Secatore, Megan. "Fighting Words: Text, Image, and the New Ekphrasis." University of Massachusetts at Dartmouth, May 19, 1997. www.enl.umassd.edu/InteractiveCourse/msecatore/fightingwords.html

Seelig, Adam. "On Saba's Painting of Moses Seeing the Promised Land." *Midstream* 1 January 2002.

Segeberg, Harro, ed. *Die Mobilisierung des Sehens. Zur Vor- und Frühgeschichte des Films in Literatur und Kunst*. München: Fink Verlag, 1996.

Sejersen, Peter. "Det ekfrasiske håb hos William Blake og Charles Baudelaire — en opgave om forholdet mellem de verbale og de visuelle repræsentationsmåder." 2004. http://www.petersejersen.dk/projekter/opgaver/det-ekfrasiske-haab-hos-blake-og-baudelaire/

Selig, Karl-Ludwig. "Góngora's Fábula de Polifemo y Galatea: Ekphrasis and the Interaction and Competition of the Senses." In Titus Heydenreich et al., eds., *Romanische Lyrik: Dichtung und Poetik-Walter Pabst zu Ehren*. Tübingen: Stauffenburg, 1993. 215–19

Selmeci, Barbara. "Les romans scudériens: *ut pictura narratio*?" *Acta Fabula* 5, no. 2 (Printemps 2004). http://www.fabula.org/revue/document226.php. Review of Spica, *Savoir* (below).

Semanoff, Matthew. "Astronomical Ecphrasis." In Christophe Cusset, ed., *Musa docta. Recherches sur la poésie scientifique dans l'Antiquité*. Saint-Étienne: Publications de l'Université de Saint-Étienne, 2006 (Mémoires du Centre Jean Palerne 30). 157–78.

Seyfarth, Jutta. "Ein Schatzhaus des Apelles, Iconophylacium: Beschreibung der Bildersammlung des Kölner Ratsherrn Franz von Imstenraedt, 1667." In Werner Schafke, ed., *Coellen eyn Croyn: Renaissance und Barock in Köln*. Köln: DuMont, 1999. 157–254.

Sens, Alexander. "An Ecphrastic Pair: Asclepiades AP 12.75 and Asclepiades or Posidippus AP168." *Classical Journal* 97, no. 3 (February–March 2002): 249–62.

Senn, Werner. "Speaking the Silence: Contemporary Poems on Paintings." *Word & Image: A Journal of Verbal/Visual Enquiry* 5, no. 2 (April–June 1989): 181–97.

Severi, Carlo. "Un'immagine della voce." In Valtolina, *Annali* (below), 111–25.

Shaffer, Diana. "Ekphrasis and the Rhetoric of Viewing in Philostratus's Imaginary Museum." *Philosophy and Rhetoric* 31, no. 4 (1998): 303–16.

_____. *The Poetics of Ekphrasis in Walter Pater's Painted Prose*. Ph.D. dissertation, Texas Christian University, 1995.

Shaffer, E.S. "Coleridge's Ekphrasis: Visionary Word-Painting." In Tim Fulford and Morton D. Paley, eds., *Coleridge's Visionary Languages: Essays in Honour of J.B. Beer*. Rochester, NY: Brewer, 1993. 111–21.

Shapiro, David. "Poets and Painters: Lines of Color, Theory, and Some Important Precursors." In Dianne Perry Vanderlip, ed., *Poets & Painters*. Denver, CO: Denver Art Museum, 1979. 7–27.

Shapiro, Gary. "The Absent Image: Ekphrasis and the 'Infinite Relation' of Translation." *Journal of Visual Culture* 6, no. 1 (April 2007): 13–24.

_____. "Pipe Dreams: Eternal Recurrence and Simulacrum in Foucault's Ekphrasis of Magritte." *Word & Image: A Journal of Verbal/Visual Enquiry* 13, no. 1 (January–March 1997): 69–76.

_____. "Seeing and Saying: Foucault's Ekphrasis of *Las Meninas*." In Shapiro's *Archaeologies of Vision*. Chicago: University of Chicago Press, 2005. 245–64.

Shapiro, Marianne. "Ecphrasis in Virgil and Dante." *Comparative Literature* 42 (Spring 1990): 97–115.

Sharratt, P. "The Image of the Temple: Bernard Salomon, Rhetoric and the Visual Arts." In Jelle Koopmans et al., eds., *Rhetoric — rhétoriqueurs — rederijkers*. Amsterdam: Netherlands Academy of Arts and Sciences, 1995. 247–67.

Shaw, Brent D. "Judicial Nightmares and Christian Memory." *Journal of Early Christian Studies* 11, no. 4 (Winter 2003): 533–63.

Shaw, Mary. "Semiosis and Hunger: Riffaterre on Mallarmé." *Romantic Review* 93, nos. 1–2 (2002): 111–121.

Shea, Chris. "Setting the Stage for Romances:

Xenophon of Ephesus and the Ecphrasis." In Hock, *Ancient* (above), 61–76.

Shedd, Meredith. "'Ut sculptura descriptio': Ekphrasis in Emeric-David's *Recherches sur l'art statuaire.*" *Gazette des Beaux-Arts*, ser. 6, 135, part 1576-7 (May–June 2000): 315–24.

Shepherd, Rupert. "Art and Life in Renaissance Italy: A Blurring of Identities?" In Mary Rogers, ed., *Fashioning Identities in Renaissance Art.* Aldershot, Brookfield, Ashgate, 2000. 63–77.

_____. *An Examination of Giovanni Sabadino degli Arienti's Writings on Art and Architecture.* Ph.D. dissertation, Courtauld Institute of Art, 1997.

Shi, Lijun, ed. *Zhongguo gu jin tihua shici quanbi* (*A Complete Collection of Chinese Ancient and Modern Poems and Ci Poems about Paintings*), vol. 2. Shijiazhuang, China: Hebei jiaoyu chubanshe, 1994.

Shirley, Phillips. *Bellori's Ekphraseis of Poussin's Paintings.* Thesis, University of Essex, 2001.

Short, Bryan C. "Multitudinous, God-omnipresent, Coral Insects: Pip, Isabel, and Melville's Miltonic Sublime." *Leviathan: A Journal of Melville Studies* 39, no. 1 (March 2005): 49–53.

Sideli, Kathleen Ann. *Imitation as "Ars Consolatoria" in the Poetry of Garcilasco de la Vega.* Ph.D. dissertation, Indiana University, 1983.

Signorini, Rodolfo. "In margine ad Alberti lucianista: il 'Peri tou oikou' di Luciano e la 'Camera dipinta' del Mantegna e altra fortuna di Luciano a Mantova fra Quattro e Cinquecento." In *Leon Battista Alberti: architettura e cultura.* Firenze: L.S. Olschki, 1999. 295–315.

Simon, Erika. "Der Schild des Achilleus." In Boehm and Pfotenhauer, *Beschreibungskunst* (above), 123–41.

_____. "Vergil und die Bildkunst." *Maia* 34 (1982): 203–17.

Simonsen, Peter. "Late Romantic Ekphrasis: Felicia Hemans, Leigh Hunt and the Return of the Visible." *Orbis Litterarum*, no. 5 (2005): 317–43.

_____. "Meter, Writing, Ekphrasis: Permanent Pleasures in Wordsworth's Poetics." *PEO* 110 (October 2000): 1–16.

_____. "Tiltalende portrætter: Letitia Elizabeth Landon og romantikkens kvindelige ekfrase." In Harrits and Troelsen (above).

_____. *Word-Preserving Arts: Material Inscription, Ekphrasis, and Spatial Form in the Later Work of William Wordsworth.* Ph.D. dissertation, Københavns Universitet, 2002.

_____. *Wordsworth and Word-Preserving Arts: Typographic Inscription, Ekphrasis and Posterity in the Later Work.* Basingstroke, Hampshire, UK: Palgrave/Macmillan, 2007. **Review:** Hale, R.C. *Wordsworth Circle* 38, no. 4 (Fall 2007): 162–4.

_____. "Wordsworth og det visuelle. Sonderinger i europæisk romantik." In Mads Nygaard Folkmann, ed., *Orfeus, imagination, det visuelle. Litteraturkritik & Romantikstudier–Skriftrække* 34. København, 2004. 31–43.

Simopoulos, Theophilos N. *He hiera Mone Zermpitses: anekdota peri autes engrapha-keimelia.* Athenai: Kassandra M. Gregore, 1966.

Singley, Paulette "Devouring Architecture: Ruskin's Insatiable Grotesque." *Assemblage* 32 (April 1997): 108–25.

Sirios, Martin. *L'ekphrasis du bouclier d'Achille (Iliade 18.478–617): étude pour une nouvelle analyse esthétique de la description littéraire.* M.A. thesis, Université de Montréal, 2001.

Slater, John. "Eucharistic Conjunction: Emblems, Illustrations, and Calderóns *Autos.*" In de Armas, *Ekphrasis* (above), 78–100.

_____. "History as an Ekphrastic Genre in Early Modern Spain." *Modern Language Notes* 122, no. 2 (March 2007): 217–32.

Slater, Niall W. "From Harena to Cena: Trimalchio's Capis (Sat. 52.1–3)." *Classical Quarterly* 44, n.s., no. 2 (1994): 549–51.

Smick-McIntire, Rebekah Jane. "Evoking Michelangelo's Vatican Pieta: Transformation in the Topos of Living Stone." In Golahny, *The Eye* (above), 23–52.

_____. "Vivid Thinking: Word and Image in Descriptive Techniques of the Renaissance." In Alina Payne et al., eds., *Antiquity and Its Interpreters.* Cambridge: Cambridge University Press, 2000. 159–173.

Smith, Alden. *The Primacy of Vision in Vergil's "Aeneid."* Austin: University of Texas Press, 2005. **Reviews:** Rogerson, Anne. *Classical Review* 57, no. 2 (October 2007): 389–91. Elsner, Jas. *Journal of Roman Studies* 97 (2007): 315–16.

Smith, Mack. *Literary Realism and the Ekphrastic Tradition.* University Park: Pennsylvania State University Press, 1995. **Reviews:** Henricksen, Bruce. *Criticism* 39 (Spring 1997). Oxford, Jeffrey. *Sourth Central Review* 14, no. 2 (Summer 1997): 91–2.

_____. *Figures in the Carpet: The Ekphrastic Tradition in the Realistic Novel.* Ph.D. dissertation, Rice University, 1981.

Smith, Paul J. "Remy Belleau et la peinture: aspects du métadiscours poétique de la Pléiade." In John Dixon Hunt et al., eds. *First International Conference on Word & Image = Premier Congres international de texte et image.* 331–37.

Smoliarova, Tatiana. "*The Bronze Horseman* and the Tradition of Ekphrasis." In Robert Reid and Joe Andrew, eds., *Two Hundred Years of Pushkin*, vol. 2. Amsterdam: Rodopi, 2003. 103–16.

Smorąg-Różycka, M. "O pięknie i sztuce w najstarszych przekazach pisanych Rusi Kijowskiej w świetle bizantyjskich ekphrasis." *Ars Graeca. Ars Latina. Studia dedykowane A. Różyckiej-Bryzek.* Kraków 2001. 99–114.

Smonpias, Kostas. *Diakoinotikes scheseis kai sumbolike ekfrase sten proanaktorike Krete.* Mainz: Verlag des Römisch-Germanischen Zentralmuseums, 1999.

Snodgrass, W.D. "Poems about Paintings." In Snodgrass's *In Radical Pursuit: Critical Essays and Lectures.* New York: Harper & Row, 1975. 63–97.

Snook, Jean M. "A Tale of Two Monuments: Social Criticism in Brentano's *Geschichte vom braven Kasperl und dem schönen Annerl.*" *Seminar: A Journal of Germanic Studies* 39, no. 3 (September 2003): 187–203.

Soares, Nair de Nazaré Castro. "Rhetorics and Ekphrasis in António Ferreira's *Castro.*" http://7 4.125.113.132/search?q=cache:VmwHtRp4hOEJ: www.ican2008.ul.pt/ICAN2008_en/Program me/25_July/OO_344_Nair_Soares.pdf+ekphras is+OR+ecphrasis+OR+ekfrasis&hl=en&ct=clnk& cd=194&gl=us

Sobral, Luís de Moura. "Ekphrasis, oubli et mémoire: restitution du cycle pictural de la Chapelle Royale de Lisbonne." In Wessel Reinink, ed., *Memory & Oblivion: Proceedings of the XXIXth International Congress of the History of Art held in Amsterdam, 1–7 September 1996.* Dordrecht: Kluwer, 1999. 295–300.

_____. *Pintura e poesia na époce barroca: a homenagem da Academia dos Singulares a Bento Coelho da Silveira* [*Painting and Poetry in the Baroque Era: The Tribute of the Academia dos Singulares to Bento Coelho da Silveira*]. Lisboa: Estampa, 1994.

Söhring, Otto. "Werke bildender Kunst in altfranzösischen Epen." *Romanische Forschungen* 12 (1900): 493–640; also published in book form: Erlangen: Fr. Junge, 1900.

Solana Díez, Guillermo. "La figura y el eco. Tres écfrasis en la poesía de Cernuda." In Angel Gallardo, ed., *Estudios de literatura española de los siglos XIX y XX: Homenaje a Juan María Díez Taboada. Anejos de Revista de Literatura.* 47. Madrid, Spain: Consejo Superior de Investigaciones Científicas, 1998. 731–40.

Sole, Davide. *Poetische Ekphrasis am Beispiel der "Zwei Gemäldeschilderungen" in Wilhelm Heinrich Wackenroders und Ludwig Tiecks Herzensergießungen eines kunstliebenden Klosterbruders.* München and Ravensburg: Grin Verlag, 2008.

Sonnenfeld, Albert. "L'ekphrasis proustienne." *Bulletin de la Société des Amis de Marcel Proust et des Amis de Combray* 41 (1991): 91–103.

Sørensen, Bent. "Ekphrasis in Reverse: The Use and Abuse of Poetry in Popular Films." http://www. hum.aau.dk/~il2bent/poetryfilm.ppt.

Souchier, Emmanuël. "Le texte du dit de l'image." In Baptiste-Marrey et al., eds., *Les interdits de l'image.* Musées des Sens: Obsidiane, 2006. 7–16.

Soufas, C. Christopher. "'Et in Arcadia ego': Luis Cernuda, Ekphrasis, and the Reader." *Anales de la literatura española contemporánea* 7, no. 1 (1982): 97–108.

Souriau, Etienne. *La poésie française et la Peinture.* London: Athlone, 1966.

Spaccini, Jacqueline. "Le peintre dans l'univers du roman: les antécédents ou de l'archéologie." *Studia Romanica et Anglica Zagrabiensia* 49 (Siječanj 2006): 78–111.

Spandonis, Sophie. "De 'paraphrase' en 'hallucination': Réflexions sur l'ekphrasis chez Jean Lorrain." In Pascale Auraix-Jonchière, ed., *Ecrire la peinture entre XVIIIe et XIXe siècles. Révolutions et Romantismes.* 4. Clermont-Ferrand, France: Presses Universitaires Blaise Pascal, 2003. 203–12.

Spengler, Dietmar. "Invenit, pinxit, sculpsit: Cristoforo Roncallis Auferstehung Christi." *Das Münster* 57 (2004): 50–4.

Spica, Anne-Élisabeth. "L'ecphrasis comme genre littéraire: les descriptions dans les romans en France au XVIIe siècle." In Bonfait, *La description* (above), 121–40.

_____. "Postérité et influences des Images de platte peinture de Philostrate sur la fiction narrative en prose au XVIIe siècle." In *La littérature et les arts figurés de l'Antiquité à nos jours: actes du XIVe Congrès de l'Association Guillaume Budé, Limoges 25–28 août 1998.* Paris: Les Belles Lettres, 2001. 599–608.

_____. *Savoir peindre en littérature. La description dans le roman au XVII e siècle: Georges et Madeleine de Scudéry.* Paris: Honoré Champion, 2002.

_____. *Symbolique humaniste et emblématique: l'évolution et les genres (1580–1700).* Paris: Champion, 1996.

Spiegelman, Willard. *How Poets See the World: The Art of Description in Contemporary Poetry.* New York: Oxford University Press, 2005.

Spiller, Elizabeth A. "Speaking for the Dead: King Charles, Anna Weamys, and the Commemorations of Sir Philip Sidney's *Arcadia.*" *Criticism* 42, no. 2 (2000): 229–51.

Spinozzi, Paola. "As Yet Untitled. A Sonnet by Walter Crane for a Painting by G.F. Watts: Ekphrasis as Nomination." *Textus* 12, no. 1 (1999): 113–34.

_____. "Ekphrasis as Portrait: A.S. Byatt's Fictional and Visual Doppelgänger." In Rui Carvalho and Maria de Fátima Lambert, eds., *Writing and Seeing: Essays on Word and Image. Internationale Forschungen zur Allgemeinen und Vergleichenden*

Literaturwissenschaft. 95. Amsterdam: Rodopi, 2006. 223–31.

Spitzer, Leo. "The 'Ode on a Grecian Urn,' or Content vs. Metagrammar." *Comparative Literature* 7 (1955): 203–225.

Sprout, Frances Mary. *Pictures of Mourning: The Family Photograph in Canadian Elegiac Novels*. Ph.D. dissertation, University of Victoria, 2005.

Stamatakis, Matina L. *ek-ae: A Journey into Ekphrastic Aesthetics*. Dusie, 2007.

Stamelman, R. "Critical Reflections: Poetry and Art Criticism in Ashbery's *Self-portrait in a Convex Mirror*." *New Literary History* 15 (Spring 1984): 607–30.

Stanton, Joseph. "Fra Angelico and Richard Howard on the Last Judgment." *Yearbook of Interdisciplinary Studies in the Fine Arts*, 1994.

_____. "Hopper Stories in an Imaginary Museum." *Proceedings for the School of Visual Arts. Eighteenth Annual National Conference on Liberal Arts and the Education of Artists: Art and Story*, 59–61. http://media.schoolofvisualarts.edu/sva/media/1403/medium/Proceedings2004.pdf

_____. "'I'm Not from Here Either': Some Contexts for Quagliano." *Literary Arts Hawai'i*, 1982.

_____. "A Langerian Comparison of a Starnina Painting and a Richard Howard Poem." *Art Criticism*, 1993.

_____. "Moving Image, Moving Words: Performing Films as Poems." In F. Tillman, ed., *A Cinema of Ideas*. Honolulu: Hawai'i Committee for the Humanities, 1996.

_____. "Painter Envy: The Poet's Desire for the Picture." *Yearbook of Interdisciplinary Studies in the Fine Arts*, 1992.

_____. *A Langerian Analysis of the Iconic Poems of Richard Howard and Their Referents*. Ph.D. dissertation, New York University, 1989.

_____. "Winslow Homer, Helena de Kay, and Richard Watson Gilder: A Rivalry of Forms." *Harvard Library Bulletin*, 1994.

_____. "Wintering in a Picture." *The Paper*, 1982.

Starzyk, Lawrence J. "Browning and the Ekphrastic Encounter." *Studies in English Literature 1500–1900* 38, no. 4 (Autumn 1998): 689–706.

_____. "Browning's 'Childe Roland': The Visionary Poetic." *Victorian Newsletter* 107 (2005): 11–17.

_____. "Elizabeth Siddal and the 'Soulless Self-Reflections of Man's Skill.'" *Journal of Pre-Raphaelite Studies* 16 (Fall 2007): 9–25.

_____. "'The Gallery of Memory': The Pictorial in Jane Eyre." *Papers on Language & Literature* 33 (Summer 1997): 288–309.

_____. "Rossetti's 'Jenny': Aestheticizing the Whore." *Papers on Language & Literature* 36, no. 3 (Summer 2000): 227–45.

_____. "Swinburne's 'Notes on Designs of the Old Masters at Florence': The Exegesis of Icons." *Victorian Newsletter* 96 (Fall 1999): 15–21.

_____. "Tennyson's 'The Gardener's Daughter': The Exegesis of an Icon." *Mosaic: A Journal for the Interdisciplinary Study of Literature* 32, no. 3 (September 1999): 41–58.

_____. "'Tristram and Iseult': Arnold's Ekphrastic Experiment." *Victorian Review: The Journal of the Victorian Studies Association of Western Canada and the Victorian Studies Association of Ontario* 28, no. 1 (2002): 25–46.

_____. "'Ut pictura poesis': The Nineteenth-Century Perspective." *Victorian Newsletter* 102 (Fall 2002): 1–8.

_____. "The Victorian Esthetic Dialogue of the Mind with Itself." *Mosaic: A Journal for the Interdisciplinary Study of Literature* 21, no. 4 (1988): 1–17.

Stead, Evanghélia. "Gravures textuelles: un genre littéraire." *Romantisme: Revue du Dix-Neuvième Siècle* 32, no. 118 (2002): 113–32.

Stearns, Thaine. "The 'Woman of No Appearance': James Joyce, Dora Marsden, and Competitive Pilfering." *Twentieth-Century Literature* 48, no. 4 (2002): 461–86.

Stephanski, Margaret K. *Retrato, espejo, teatralidad: Reflejos de la estetica finisecular en la narrative de Filipe Trigo*. Ph.D. dissertation, State University of New York at Buffalo, 1999.

Steiner, Wendy. "The Causes of Effect: Edith Wharton and the Economics of Ekphrasis." *Poetics Today* 10, no. 2 (Summer 1989): 279–97.

_____. *The Colors of Rhetoric: Problems in the Relation between Modern Literature and Painting*. Chicago: University of Chicago Press, 1982.

_____. "Literature and Painting." In Jean-Pierre Barricelli, Joseph Gibaldi, eds., *Teaching Literature and Other Arts*. New York: Modern Language Association, 1990. 40–5.

_____. *Pictures of Romance: Form against Context in Painting and Literature*. Chicago: University of Chicago Press, 1988.

_____. "Speaking Pictures." *TLS* 4665 (28 August 1992): 20.

Stelmach, Kathryn. "From Text to Tableau: Ekphrastic Enchantment in *Mrs. Dalloway* and *To the Lighthouse*." *Studies in the Novel* 38, no. 3 (Fall 2006): 304–26.

Stenström, Johan. "Bilden och betraktandet i Carl Michael Bellmans diktning." In Harrits and Troelsen (above).

_____. "The Representation of Orthodox Icons in the Poetry of Ingemar Leckius." In Erik Hedling and Ulla-Britta Laggeroth, eds., *Cultural Functions of Intermedial Exploration. Internationale*

Forschungen zur Allgemeinen und Vergleichenden Literaturwissenschaft. 62. Amsterdam: Rodopi, 2002. 203–14.

Stephenson, Paul. "Nicholas Mesarites, Ekphrasis on the Church of the Holy Apostles." http://homepage.mac.com/paulstephenson/trans/mesarites.html

Sternberg, Meir. "The Laokoon Today: Interart Relations, Modern Projects and Projections." *Poetics Today* 20, no. 2 (Summer 1999): 291–379.

Stevens, S.T. *Image and Insight: Ekphrastic Epigrams in the Latin Anthology.* Ph.D. dissertation, University of Wisconsin, Madison, 1983.

Stevens, Wallace. "The Relations between Poetry and Painting." In Stevens's *The Necessary Angel.* New York: Random House, 1951. 159–76.

Stevenson, Lesley. "Sister Arts or Sibling Rivalry? Cézanne and the Logic of the Senses." *Word & Image* 24, no. 2 (April–June 2008): 152–61.

Stevenson, Sarah Lansdale. "The Violence of the Visible: The Refusal of Representation in Lisa Kron's 2.5 Minute Ride." *New England Theatre Journal* 14 (2003): 25–38.

Stewart, D.J. "Ekphrasis: A Friendly Communication." *Arion* 5, no. 4 (Winter 1966): 554–6.

Stewart, Garrett. *The Look of Reading: Book, Painting, Text.* Chicago: University of Chicago Press, 2006.

_____. "The Mind's Sigh: Pictured Reading in Nineteenth-Century Painting." *Victorian Studies* (online) 46, no. 2 (Winter 2004).

_____. "Reading Figures: The Legible Image of Victorian Textuality." In Carol T. Christ and John O. Jordan, eds. *Victorian Literature and the Victorian Visual Imagination.* Berkeley: University of California Press, 1995. 345–65.

Stewering, Roswitha. "Architectural Representations in the Hypnerotomachia Poliphili (Aldus Manutius, 1499)." *Journal of the Society of Architectural Historians* 59 (2000): 6–25.

Stichel, Rudolf U.W. "Ein byzantinischer Kaiser als Sensenmann: Kaiser Andronikos I. Komnenos und die Kirche der 40 Märtyrer in Konstantinopel." *Byzantinische Zeitschrift* 93, no. 2 (2000): 586–608.

Stillers, Ranier. "Bilder einer Ausstellung: Kunstwahrnehmung in Giovan Battista Marinos 'Galeria.'" In Bodo Guthmüller, ed., *Künstler und Literat: Schrift- und Buchkultur in der europäischen Renaissance.* Wiesbaden: Harrassowitz, 2006. 231–51.

Stimato, Gerarda. "L'ekphrasis' da Vasari a Pontormo: tra narrazione letteraria e rinuncia alla letteratura. In Gigliola Fragnito, ed., *Quinta settimana di Alti Studi Rinascimentali: l'età di Alfonso I.* Ferrara: Panini, 2004. 245–52.

_____. "Teoria dell'ecfrasi e prassi letteraria: Riflessioni sul rapporto tra poesia e arti figurative nella Galeria del Marino." In Alice Di Stefano, ed., *Cyberletteratura: Tra mondi testuali e mondi virtuali.* Rome, Italy: Nuova Cultura, 2006. 163–71.

Stock, Lorraine Kochanske. "Peynted ... text and [visual] glose': Primitivism, Ekphrasis, and Pictorial Intertextuality in the Dreamers' Bedrooms of *Roman de la Rose* and *Book of the Duchess.*" In T.L. Burton and John F. Plummer, eds., '*Seyd in forme and reverence': Essays on Chaucer and Chaucerians in Memory of Emerson Brown, Jr.* Provo, UT: Chaucer Studio Press, 2005. 97–114.

Stoichita, Victor I. "Ein Idiot in der Schweiz: Bildbeschreibung bei Dostojewski." In Boehm and Pfotenhauer, *Beschreibungskunst* (above), 425–44.

Storey, Christina. "The Philosopher, the Poet, and the Fragment: Ficino, Poliziano, and 'Le Stanze per la Giostra.'" *Modern Language Review* 98, no. 3 (July 2003): 602–19.

Storm, Mel. "The Wife of Bath's Portrait." *Studies in Philology* 96, no. 2 (Spring 1999): 109–26.

Stougaard-Nielsen, Jakob. "Frontispieces and Other Ruins: Portraits of the Author in Henry James's New York Edition." *The Henry James Review* 28, no. 2 (Spring 2007): 140–58.

Strier, Richard. "George Herbert and Ironic Ekphrasis." *Classical Philology* 102, no. 1 (January 2007): 96–109.

Strobl, Hilda. "Die Planung des Raumes in der Zeichnung des Dichters." In Nerdinger, *Architektur* (above), 146–59.

Subel, S. "Ekphrasis et enargeia: la description antique comme parcours." In Carlos Lévy and Laurent Pernot, eds., *Dire l'évidence (philosophie et rhétorique antiques).* Paris, Montréal: l'Harmattan, 1997. 249–64.

Sullivan, Rachael. *Scenic America: This Is a Test. Poems.* M.F.A. thesis, University of Nevada, Las Vegas, 2007.

Sumi, Akiko Motoyoshi. *Description in Classical Arabic Poetry: Waṣf, Ekphrasis, and Interarts Theory.* Leiden: Brill, 2003.

Surel, Jeannine. "William Hogarth, les images, les mots." *Les Cahiers d'Inter-Textes.* Paris: Centre de recherche Inter-Textes Arts et Littératures modernes, 1985.

Suzuki, Masashi. "Roman shugi jidai no ekufurashisu: Ferishia Hemanzu no baai." *Eigo Seinen/Rising Generation* 153, no. 4 (July 2007): 200–2.

Svorinich, Victor. "Lenny White's "Guernica": A Study in Ekphrasis and the Creative Process." http://www.guitaracademynj.com/docs/1.html

Swartz, Dorothy Dilts. *Stylistic Parallels between the*

Middle Irish Epic "Tain Bo Cualnge" in the Book of Leinster and Twelfth-Century Neo-Classical Rhetoric with an Excursus upon the Personality of the Redactor. Ph.D. dissertation, Harvard University, 1983.

Swensen, Cole. "Drowning in a Sea of Love." http://www.poetryfoundation.org/journal/feature.html?id=182364

_____. "Presentation: Ekphrasis That Ignores the Subject." http://poetrycenter.arizona.edu/conceptualpoetry/cp_media/papers/cp_papers_swensen.shtml

_____. "What To Do Besides Describe It: Ekphrasis that Ignores the Subject." *University of Arizona Poetry Center.* May 2008. http://poetrycenter.arizona.edu/conceptualpoetry/cp_media/papers/cp_papers_swensen.shtml

Swiderska, Malgorzata. "Ekfraza w powiesci Idiot Fiodor M. Dostojewskiego jaka sposób konstruowania kulturowej obcosci." *Slavia Orientalis* 52, no. 2 (2003): 179–91.

Sze, Arthur. "On Poetry and Water." http://www.poetryfoundation.org/journal/feature.html?id=182367

Szantyr, A. "Bemerkungen zum Aufbau der vergilischen Ekphrasis." *Museum Helveticum* 27 (1970): 28–40.

Szarmach, Paul E. "The Dream of the Rood as Ekphrasis." In Alastair Minnis et al., eds., *Text, Image, Interpretation: Studies in Anglo-Saxon Literature and Its Insular Context in Honour of Éamonn Ó Carragáin.* Studies in the Early Middle Ages. 18. Turnhout, Belgium: Brepols, 2007. 267–88

Szczepanek, Anna. "Cubistic Techniques in William Carlos Williams' Ekphrastic Poetry." http://209.85.173.104/search?q=cache:UVkiMnPgnQQJ:filologija.vukhf.lt/7–12/9_4%2520Szczepanek.doc+ekphrasis&hl=en&ct=clnk&cd=218&gl=us

Szépe, Helena Katalin. "Artistic Identity in the Poliphilo." *Papers of the Bibliographical Society of Canada* 35, no. 1 (Spring 1997): 39–73.

_____. "Desire in the Printed Dream of Poliphilo." *Art History* 19 (1996): 370–92.

Tabios, Eileen. "Redeeming My Faith in Ekphrasis" [review of Sharon Dolin's *Serious Pink*]. *Jacket Magazine* 23 (August 2003). http://jacketmagazine.com/23/tabi-dolin.html

Tadini, Faustino. *Le sculture e le pitture di Antonio Canova pubblicate fino a quest'anno 1795.* Venezia: Dalla Stamperia Palese, 1796; Bassano del Grappa: Istituto di Ricerca per gli Studi su Canova e il Neoclassicismo, 1998.

_____. "Qui." In Valtolina, *Annali* (below), 105–10.

Takayama, Hiroshi, Yoichi Komori, and Chiaki Ishihara. "Kiso tengai: Gubijinso kogi." *Soseki Kenkyu* 16 (2003): 161–85.

Talgam, Rina. "The *Ekphrasis Eikonos* of Procopius of Gaza: The Depiction of Mythological Themes in Palestine and Arabia During the Fifth and Sixth Centuries." In Brouria Bitton-Ashkelony and Aryeh Kofsky, eds., *Christian Gaza in Late Antiquity.* Leiden: Brill Academic Publishers, 2004. 209–34.

Taljaard-Gilson, Gerda Hendrika. *The Interaction between Literature and Art: An Exploration of Ekphrastic Literature Inspired by the Paintings of Bruegel.* Ph.D. dissertation, University of Pretoria, 2003.

Talon-Hugon, Carole. "Dire la peinture." In Fabrice Parisot, ed., *Littérature et représentations artistiques.* Paris: L'Harmattan, 2005. 35–55.

Tane, Benoit. "Discours, peinture, gravure dans l'édition illustrée du Paysan perverti de Rétif de la Bretonne, 1782: de l'exposition à l'impression." In Pascale Auraix-Jonchière, ed., *Ecrire la peinture entre XVIIIe et XIXe siècles.* Révolutions et Romantismes. 4. Clermont-Ferrand, France: Presses Universitaires Blaise Pascal, 2003. 93–115.

Taplin, Oliver. "The Shield of Achilles within the *Iliad.*" *Greece & Rome* 27 (1980): 1–21.

Tarasova, M. S. "'Etot dvorec pol'nyj cudes': rezidencija renessansnogo nobilja v vosprijatii sovremennikov ["Ce palais est plein de merveilles": la résidence du noble de la Renaissance dans la réception des contemporains]. In L.M. Bragina et al., eds., *Kul'tura Vozrozdenija i vlast.'* Moskva: Nauka, 1999. 99–107.

Tassi, Marguerite A. "The Player's Passions and the Elizabethan Painting Trope: A Study of the Painter Addition to Kyd's *The Spanish Tragedy.*" *Explorations in Renaissance Culture* 26, no. 1 (Summer 2000): 73–100.

Tavernier, L. "Ekphrasis and the Allegory of the Ruler." *Literature, Music, Fine Arts* 20, no. 2 (1987): 194.

Taylor, James O. "Art Imagery and Destiny in Alistair MacLeod's Fiction: 'Winter Dog' as Paradigm." *Journal of Commonwealth Literature* 29, no. 2 (1994): 61–9.

Telesko, Werner. "Probleme der hochmittelalterlichen Ekphrasis am Beispiel des 'Teppichs von Bayeux.'" In Ratkowitsch, *Die poetische* (above), 43–54.

Terpening, Ronnie H. "Poliziano's Treatment of a Classical Topos: Ekphrasis, Portal to the Stanze." *Italian Quarterly* 65 (1973): 39–71.

Tham, Hilary. "Poetic Justice: Ekphrasis, Now." *Potomac Review* 5, no. 4 [20] (Fall 1998): 59–60.

Thein, Karel. "Filostratos Starší a zrození dějin umění z ducha ekphrasis" ["Philostratus the Elder and the Birth of Art History from the Spirit of Ekphrasis"]. In B. Bukovinská, B. and L. Slaví-

ček, eds., *Picta Verba Cupit. Sborník příspěvků pro Lubomíra Konečného*. Praha: Artefactum, 2006. 23–9.

_____. "Gods and Painters: Philostratus the Elder, Stoic *Phantasia* and the Strategy of Describing." *Ramus: Critical Studies in Greek and Roman Literature* 31 (2002): 136–45.

Thibau, R. "Le bouclier d'Achille, Hommages à Jozef Veremans." F. Decreus and C. Deroux, eds., *Collection Latomus*, No. 193. Bruxelles: Latomus, 1986. 299–307.

Thibault, Louis-Jean. "Poésie, peinture: Abstraction et approche de l'immédiat chez Yves Bonnefoy." *Études Littéraires* 31, no. 1 (Autumn 1998): 45–58.

Thijs, Boukje. "'Ghevoestert uyt een borst': woord en beeld in *Den Nederduytschen helicon* (1610) ["Fed from one breast": Word and Image in *Den Nederduytschen helicon* (1610)]. In Karel Bostoen et al., eds., *"Tweelinge eener dragt": woord en beeld in de Nederlanden (1500–1700)*. Hilversum: Verloren, 2001. 263–74

Thom, Lisa Harwell Fleissner. *Proust's Layers of Art: The Framed Description in the Structure of "A la recherche du temp perdu."* Ph.D. dissertation, Columbia University, 2006.

Thomas, Paula Lawson. *Spenser's Ecphraseis: Double Vision*. Ph.D. dissertation. Indiana University, 1991.

Thomas, Thelma K. "The Medium Matters: Reading the Remains of a Late Antique Textile." In Elizabeth Sears and Thelma K. Thomas, eds., *Reading Medieval Images: The Art Historian and the Object*. Ann Arbor: University of Michigan Press, 2002. 38–49

Thomasy, Molly. "Writing the Plastic Arts: Ekphrasis in the Poetry of A.A. Fet." Paper presented at the AATSEEL-WI Conference, October 2006 and National AATSEEL Conference, Philadelphia, PA, December, 2006. Abstract at http://aatseel.org/100111/pdf/program/2006/abstracts/28C_1.htm

Thürlemann, Felix. "Die narrative Allegorie in der Neuzeit: Über Ursprung und Ende einer textgenerierten Bildgattung." In Drügh and Moog-Grünewald, *Behext* (above), 21–36.

Tilburg, L.E. "Regarding Paintings — Works of El Greco in Simon Vestdijk's *Het Vijfde Zegel*." *Arcadia* 41, no. 2 (2006): 419–35.

Tilg, Stefan. "Eine christliche Spur in Petarcas heidnischem Götterkosmos? Zur Reihung der Planeten in der Ekphrasis des Syphax-Palastes (Africa, 3, 95–110)." *Humanistica Lovaniensia* 54 (2005).

Timmermann, Achim. "Architectural Vision in Albrecht von Scharfenberg's *Jüngerer Titurel*: A Vision of Architecture?" In Georgia Clarke and Paul Crossley, eds., *Architecture and Language: Constructing Identity in European Architecture c. 1000–c. 1650*. Cambridge: Cambridge University Press, 2000. 158–84

Ting, Zheng. "On Poems on Paintings of Gu Kuang." *Journal of Jinggangshan University* 27, no. 5 (2006). In Chinese.

Tison-Braun, Micheline. *Poétique du paysage: essai sur le genre descriptif*. Paris: Gallimard, 1980.

Tissoni, Francesco. *Cristodoro: un'introduzione e un commento*. Alessandria: Edizioni dell'Orso, 2000.

Tomadakis, Nikolaos V. "He logotechnia mas hos ekphrasis tis ethnikis mas zois." *Nea Hestia* 83 (1968): 458–60.

Tomlinson, Robert. "Langue littéraire/langue visuelle: l'ekphrasis des Salomé de Moreau dans *À Rebours*." In Graham Falconer et al., eds., *Langues du XIXe siècle*. Toronto: Centre d'études du XIXe siècle français, 1998. 271–80.

Tönnesmann, Andreas. "Erzählte Idealstädte von Filarete bis Ledoux." In Nerdinger, *Architektur* (above), 57–69.

Trautwein, Robert. "Bildbeschreibung in der Krise: oder einige Anmerkungen zur Wechselwirkung von Rationalität und Sinnlichkeit in der Kunstbetrachtung." In Rebel, *Sehen* (above), 40–76

Treherne, Matthew. "Ekphrasis and Eucharist: The Poetics of Seeing God's Art in *Purgatorio* X." *Italianist* 26, no. 2 (2006) 177–96.

_____. "Pictorial Space and Sacred Time: Tasso's Le lagrime della Beata Vergine and the Experience of Religious Art in the Counter-Reformation." *Italian Studies* 62, no. 1 (Spring 2007): 5–25.

Trenc, Elesio. "Autour d'un crâne et de la flamme d'une bougie. Luis Fernández et ses poètes." In Paul-Henri Giraud and Nuria Rodríguez Lázaro, eds., *Poésie, peinture, photographie. Autour des poètes de 1927*. Paris: Indigo & Côté-femmes éditions, 2008.

Trier, Jost. "Architekturphantasien in der mittelalterlichen Dichtung." *Germanish-Romanische Monatsschrift* 17 (1929): 11–24.

Trimble, J., and J. Elsner. "Introduction: 'If you need an actual statue...'" *Art History* 29, no. 2 (April 2006): 201–12.

Trinquier, Jean. "Le motif du repaire des brigands et le topos du locus horridus: Apulée, Metamorphoses, IV, 6 ("The Bandits Hideout as Locushorridus: Apuleius' *Metamorphoses* IV, 6"). *Revue de philosophie, de Littérature et d'Histoire Anciennes* 73, no. 2 (1999): 257–77.

Troelsen, Anders. "At få billeder i tale: Om kunsthistorisk ekfrase." In Harrits and Troelsen (above), 233–64.

Trono, Mario Thomas J. *Salvaging the Subject: Mediant Fiction contra the Mass Media*. Ph.D. dissertation, University of Alberta, 2000.

Trussler, Michael. "Literary Artifacts: Ekphrasis in the Short Fiction of Donald Barthelme, Salman Rushdie, and John Edgar Wideman." *Contemporary Literature* 41, no. 2 (Summer 2000): 252–90.

Tsimborska-Leboda, Mariia. "Ekfrasis v tvorchestve Viacheslava Ivanova: Soobshchenie-Pamiat'-Inobytie. In Geller, *Ekfrasis* (above), 53–70.

Tsolakes, Christos, and Kuriake Adaloglou. *Ekfrase, ekthese gia to lukeio*. Athena: Organismos Ekdoseos Didaktikon Biblion, 1990.

Tucker, George Hugo. "Neo-Latin Literary Monuments to Renaissance Rome and the Papacy 1553–1557: Janus Vitalis, Joachim Du Bellay & Lelio Capilupi — from Ekphrasis to Prosopopoeia." In Perrine Galand-Hallyn et al., eds., *Acta Conventus Neo-Latini Bonnensis. Proceedings of the Twelfth International Congress of Neo-Latin Studies*, Bonn, 6–9 August 2003. Medieval & Renaissance Texts & Studies 315 (Tempe, AZ: M.R.T.S., 2006): 81–120.

_____. "*Roma instaurata* en dialogue avec *Roma Prisca*. La représentation néo-latine de Rome sous Jules III chez Vitalis, Du Bellay et Capilupi–de l'*ekphrasis* à la prosopopée." In C. Lévy and Perrine Galand-Hallyn, eds., *Roma aeterna: voir, dire et penser Rome dans l'Antiquité et à la Renaissance* [journée d'études de l'équipe Traditions Romaines / Rome et ses renaissances, EPHE, Ve section, ParisIV-Sorbonne, 28 janv. 2006]. *Camenae* No. 2 (juin 2007).

Turnbull, Sue. "Moments of Inspiration." *European Journal of Cultural Studies* 8, no. 3 (August 2005): 367–73.

Twedt, Carlin. "Flaubert, Manet, and Ekphrasis in the 19th Century and Today." Dennison University, Young Scholars Program, 2007.

Ugalde, Sharon Keefe. "Time and Ekphrasis in the Poetry of Maria Victoria Atencia." *Confluencia: Revista Hispanica de Cultura y Literatura* 3, no. 1 (Fall 1987): 7–12.

Ushirokawa, Tomomi. "Sutoreza no miru e: 'Shishatachi' ni okeru Jeimuzu no kaiga-teki shuho. In Hayase, *Amerika* (above), 53–78.

Utnes, Astrid. "Meditasjoner over ensomheten: Ekfrasiske dikt som Gunvor Hofmos epilog." *Nordlit: Arbeidstidsskrift i litteratur* 3 (Spring 1998): 59–78.

Uzundemir, Özlem. "Challenging Gender Roles through Narrative Techniques: Virginia Woolf's *To the Lighthouse*." *Virginia Woolf Miscellany* 70 (Fall 2006): 8–10.

Valdivia Baselli, Alberto. "Ekphrasis como traducción visual y correspondencias literarias en el lenguaje pictórico desde 'Museo interior' de José Watanabe." *Revista de Literatura Ajos & Zafiros* 7 (2005): 57–68.

Valtolina, Amelia, ed. *Annali 2005/I. Fondazione europea del disegno (Fondation Adami)*. Milano: Bruno Mondadori, 2005. See the seven essays in part 2, "Ékphrasis," 23–134.

_____. "Premessa" and "Sull'orlo della notte." In Valtolina, *L'immagine rubata* (next entry), 7–8, 104–15.

_____, ed. *L'immagine rubata: Seduzioni e astuzie dell'ekphrasis*. Milano: Bruno Mondadori, 2007.

Vance, G. Warlock. "Hanging Paintings on Literary Walls: Ekphrasis in J. K. Huysmans's *A rebours*." *Essays in Arts and Sciences* 31 (October 2002): 65–82.

Vandewaetere, S. "The Force of the Image in the Literature of Testimony: Dantesque 'Ekphrasis' in *Se questo e un uomo* by Primo Levi." *Studi Piemontesi* 34, no. 1 (2005): 89–96.

Van Gelder, G.J. Review of Akiko Motoyoshi Sumi, *Description in Classical Arabic Poetry: Waṣf, Ekphrasis, and Interarts Theory* (above). *Bulletin of the School of Oriental and African Studies, University of London* 67 (2004): 393–5.

Van Laar, Daren. "Ekphrasis in Colour Categorisation: Time for Research, or Time for Revolution?" *Behavioral & Brain Sciences* 20, no. 2 (June 1997): 210.

Varga, A. Kibédi. "Criteria for Describing Word-and-Image Relations." *Poetics Today* 10, no. 1 (Spring 1989): 31–53.

Varga, Tünde. "Image and Imagination in the Ekphrastic Tradition." *The Anachronist*, ed. Péter Ágnes. Budapest: ELTE English Department, 2002. 190–216.

Veigl, Christa. *Literarische Gemäldebeschreibungen: Untersuchungen zu einem unbestimmten Genre zwischen 1770 und 1830*. Dissertation, Universität Wien, 1987.

Ventura, Héliane. "An Instance of Ekphrasis in Contemporary Canadian Poetry." *Rivista di Studi Canadesi* 11 (1998): 113–20.

_____. "L'implicite dans l'ekphrasis ou le cryptogramme pictural chez Alice Munro." In Laurent Lepaludier, ed., *L'implicite dans la nouvelle de langue anglaise*. Rennes: Presses Universitaires de Rennes, 2005. 157–67.

Venturi, Gianni, ed., *Ecfrasi: modelli ed esempi fra Medioevo e Rinascimento*. Roma: Bulzoni, 2004.

_____. "Una lectura Dantis e l'uso dell'ecfrasi: *Purgatorio* X." In Venturi, *Ecfrasi* (previous entry), 15–31.

Verdonk, Peter. "Painting, Poetry, Parallelism: Ekphrasis, Stylistics and Cognitive Poetics." *Language & Literature* 14, no. 3 (August 2005): 231–44.

Veres, Luis. "La configuración de lo fantástico en un cuento de Cristina Peri Rossi." *Espéculo: Re-*

vista de Estudios Literarios 6 (July–October 1997): n.p.

Versini, Laurent. "Littérature et arts figurés au XVIIe et au XVIIIe siècles." In *La littérature et les arts figurés de l'Antiquité à nos jours: actes du XIVe Congrès de l'Association Guillaume Budé, Limoges 25–28 août 1998.* Paris: Les Belles Lettres, 2001. 568–88.

Vescovo, Piermario. "Ecfrasi con spettatore (Dante, *Purgatorio*, X–XVII)." *Lettere Italiane* 45, no. 3 (July–September 1993): 335–60.

Vieira, Miriam de Paiva. "Ekphrasis em Moça com Brinco de Pérola. *X congresso internacional ABRALIC, 2006, Rio de Janeiro. Lugares dos discursos.* Rio de Janeiro: ABRALIC, 2006. vol. 10; rpt. in *IX Semana de Letras — As Letras e seu ensino, 2006, Mariana. Caderno de Resumos.* Mariana: DELET-ICHS-UFOP, 2006. vol. 9. 6–185.

Vilatte, Sylvie. "Art et polis. Le bouclier d'Achille." *Dialogues d'Histoire Ancienne* 14 (1988): 89–107.

Villaça, Cristina Ribeiro. "Ekphrasis e ut pictura poesis: a linguagem comopintura ou a pintura como linguagem." *Gatilho: revista de estudos lingüísticos e literários* 2 (1999): 73–80.

Vincent, Michael. "Between Ovid and Barthes: Ekphrasis, Orality, Textuality in Ovid's *Arachne*." *Arethusa* 27, no. 3 (Fall 1994): 361–86.

_____. "Ekphrasis and the Poetics of the Veil: Le Moyne's 'Actéon' and La Fontaine's 'Le Tableau.' In Rubin, *Word and Image* (above), 90–112.

_____. "Figures of the Text: Reading and Writing (in) La Fontaine." *PUMRL* 39. Amsterdam and Philadelphia: John Benjamins, 1992.

_____. "From Ekphrasis to the Ekphrastic." In David Lee Rubin, ed., *Signs of the Early Modern 2: 17th Century and Beyond. EMF: Studies in Early Modern France.* 3. Charlottesville, VA: Rookwood, 1997. 187–91.

Voci, Paola. "From the Center to the Periphery: Chinese Documentary's Visual Conjectures." *Modern Chinese Literature and Culture* 16, no. 1 (Spring 2004): 65–113.

Vogel, H. "'Durch-Bilder-gehn': Rose Auslander's Painter Poems. A Workshop Report from the Estate." *Etudes Germaniques* 58, no. 2 (April–June 2003): 247–64.

Voigt, Lisa. "Visual and Oral Art(ifice) in Maria de Zayas's *desenganos amorosos*." In de Armas, *Writing* (above), 212–24.

Volpiano, Mauro. "Consigliata anche ai piromani della Reggia di Caserta: Luigi Vanvitelli." *Il giornale dell'arte* 17, no. 176 (1999): 70. Review of Cesare de Seta, *Luigi Vanvitelli* (Napoli: Electa: 1999).

von Samsonow, Elisabeth. *Fenster im Papier. Die imaginäre Kollision der Architektur mit der Schrift oder die Gedächtnisrevolution der Renaissance.* München: Fink, 2001.

Vos, Alvin. "Christopher Fry's Christian Dialectic in *A Phoenix Too Frequent*." *Renascence: Essays on Values in Literature* 36, no. 4 (Summer 1984): 230–42.

Vosters, Simon A. "Das Reiterbild Philipps IV. von Spanien als Allegorie der höfischen Affektregulierung." In Ulrich Heinen and Andreas Thielemann, eds., *Rubens Passioni: Kultur der Leidenschaften im Barock. Rekonstruktion der Künste.* 3. Göttingen, Germany: Vandenhoeck & Ruprecht, 2001. 180–91

Vouilloux, Bernard. "La description des oeuvres d'art dans le roman français au XIXe siècle." In Bonfait, *La description* (above), 153–84.

_____. "L'Evidence descriptive." *Licorne* 23 (1992): 3–15

_____. *La peinture dans le texte: XVIIIe-XXe siècles.* Paris: CNRS, 1995.

_____. "Pour introduire à une poétique de l'informe." *Poétique* 98 (1994): 213–33.

Vrânceanu, Alexandra. "Le Voyage ekphrastique: Interférences entre le verbal et le visuel dans Le Journal indien." *Studies on Lucette Desvignes and Contemporary French Literature* 17 (2007): 81–91.

Vries, Lyckle de. "Written Paintings: Real and Imaginary Works of Art in De Lairesse's *Schilderboek*." *Visual Resources* 19, no. 1 (2003): 307–20.

Wachtel, Andrew. "Dostoevsky's *The Idiot*: The Novel as Photograph." *History of Photography* 26, no. 3 (Autumn 2002): 205–15.

Waddington, Raymond B. "Pisanello's Paragoni." In Stephen K. Sher, ed., *Perspectives on the Renaissance Medal.* New York: American Numismatic Society, 2000. 27–45.

Wærp, Henning Howlid. "'Ekfrase,' en innledning til et begrep." *Kuiper* 1 (2005): 34–7.

Wagner, Kirsten. "Architektonika in *Erewhon*: Zur Konjunktur architekturaler und urbaner Metaphern." *Wolkenkuckucksheim* 3 (1998): H 1. http://www.theo.tu-cottbus.de/Wolke/deu/Themen/981/Wagner/wagner_t.html

_____. "Städte auf dem Bildschirm. Orientierung und Ordnung an der Oberfläche." In *Parapluie. Elektronische Zeitschrift für Kulturen–Künste–Literaturen.* http://parapluie.de/archiv/stadt/ordnung/index.html

Wagner, Peter, ed. *Icons, Texts, Iconotexts: Essays on Ekphrasis and Intermediality.* Berlin and New York: W. de Gruyter, 1996. **Reviews:** Helbig, Jörg. *Arbeiten aus Anglistik und Amerikanistik* 23, no. 1 (1998): 130–4. Schnackertz, H.J. *Anglia: Zeitschrift fur Englische Philologie* 116, no. 4 (1998): 554–60; Welz, Stefan. *Zeitschrift für An-*

glistik und Amerikanistik 46, no. 3 (1998): 265–67.

_____. "Learning to Read the Female Body: On the Function of Manet's *Olympia* in John Braine's *Room at the Top.*" *Zeitschrift fur Anglistik und Amerikanistik: A Quarterly of Language, Literature and Culture* 42, no. 1 (1994): 38–53.

_____. "Satirical Functions of the Bible in Hogarth's Graphic Art." *Études Anglais* 46, no. 2 (April–June 1993): 141–66.

_____. "How to (Mis)Read Hogarth — or Ekphrasis Galore." *1650–1850. Ideas, Aesthetics, and Inquiries in the Early Modern Era* 2 (1996): 203–40.

_____. "Introduction: Ekphrasis, Iconotexts and Intermediality: The State(s) of the Art(s)," in Wagner, *Icons* (above), 1–40.

Wagschal, Steven. "Digging up the Past: The Archeology of Emotion in Cervantes' 'Romance de los cellos.'" *Cervantes: Bulletin of the Cervantes Society of America* 27, no. 2 (2007): 213–28.

_____. "From Parmigianino to Pereda: Luis de Góngora on Beautiful Women and Vanitas." In de Armas, *Ekphrasis* (above), 102–23.

Wagstaff, Emma. "Francis Ponge and Andre Du Bouchet on Giacometti: Art Criticism as Testimony." *Modern Language Review* 101, no. 1 (2006): 75–89.

Walker, Julia M. "Medusa: Ekphrasis and Iconography in *The Faerie Queene.*" *European Studies Conference, Selected Proceedings.* University of Nebraska at Omaha, 2006. http://www.unomaha.edu/esc/2006Proceedings/KellerbySpenser.pdf

Wall, Kathleen. "Significant Form in *Jacob's Room*: Ekphrasis and the Elegy." *Texas Studies in Literature and Language* 44, no. 3 (Fall 2002): 302–23.

Wallace, Nathaniel. "Cultural Process in the Iliad 18: 478–608, 19:373–80 ("Shield of Achilles") and Exodus 25:1–40:38 ("Ark of the Covenant"). *College Literature* 35, no. 4 (Fall 2008): 55–74.

Walthaus, Rina. "En el Principio Era el Lienzo: In the Beginning Was the Canvas. Painting in the Poetic Universe of Calderonian Drama." In Robillard, *Pictures* (above), 125–43.

Wandhoff, Haiko. "Bilder der Liebe — Bilder des Todes: Konrad Flecks Flore–Roman und die Kunstbeschreibungen in der höfischen Epik des deutschen Mittelalters." In Ratkowitsch, *Die poetische* (above), 55–76.

_____. "Ekphrasis. Bildbeschreibungen von der Antike bis in die Gegenwart." In Wenzel, Seipel, and Wunberg (below), 175–184, and in *Ekphrasis: Kunstbeschreibungen und virtuelle Räume in der Literatur des Mittelalters.* Trends in Medieval Philology. 3. Berlin: de Gruyter, 2003.

_____. *Ekphrasis: Kunstbeschreibungen und virtuelle Räume in der Literatur des Mittelalters.* Berlin, New York: De Gruyter, 2003. **Reviews:** Brown, James. *The German Quarterly* 78, no. 1 (Winter 2005): 106–7. Haupt, Barbara. *Zeitschrift für Deutsche Philologie* 125, no. 1 (2006): 120–3. Köbele, Susanne. *Zeitschrift für Germanistik* 15, no. 2 (2005): 404–5. Puff, Helmut. *Journal of English and Germanic Philology* 105, no. 2 (April 2006): 353–5. Schmitz, S. *Zeitschrift für Deutsches Altertum und Deutsche Literatur* 133, no. 3 (2004): 385–92.

_____. "Found(ed) in a Picture: Ekphrastic Framing in Ancient, Medieval, and Contemporary Literature." In Walter Bernhart and Werner Wolf, eds., *Framing Borders in Literature and Other Media. Studies in Intermediality.* Amsterdam: Rodopi 2006. 207–27.

_____. "Gemalte Erinnerung. Vergils *Aeneis* und die Troja-Bilddenkmäler in der deutschen Artusepik." *Poetica* 28 (1996): 66–96.

_____. "Das geordnete Welt-Bild im Text: Enites Pferd und die Funktionen der Ekphrasis im 'Erec' Hartmanns von Aue." In Wolfgang Harms, C. Stephen Jaeger und Horst Wenze, eds., *Ordnung und Unordnung in der Literatur des Mittelalters.* Stuttgart: Hirzel 2003. 45–60.

_____. "Im virtuellen Raum des Textes: Bild, Schrift und Zahl in Chrétiens de Troyes 'Erec et Enide.'" In Ulrich Schmitz und Horst Wenzel, eds., *Wissen und neue Medien: Bilder und Zeichen von 800 bis 2000.* Philologische Studien und Quellen. 177. Berlin, Germany: Schmidt, 2003. 39–56.

Wang, Orrin N.C. "Coming Attractions: Lamia and Cinematic Sensation." *Studies in Romanticism* 42, no. 4 (2003): 461–500.

Wanlin, Nicholas. "L'ekphrasis: problématiques majeures de la notion." *Acta Fabula* (2007). http://www.fabula.org/atelier.php?Ekphrasis%3A_probl%26eacute%3Bmatiques_majeures_de_la_notion

Wannagat, Detlev. *Der Blick des Dichters: antike Kunst in der Weltliteratur.* Darmstadt Wissenschaftliche Buchgesellschaft, 1997.

Ward, James Olney. *Giambattista Marino and the Greek Literary and Rhetorical Tradition.* Ph.D. dissertation, University of California, Berkeley, 1992.

Ward, Judith Stallings. *The Ultraist Poetry of Gerardo Diego: A Study of "Manual de espumas."* Ph.D. dissertation, Yale University, 1993.

Ware, Karen Marie. *Frank O'Hara's Oranges: Poetry, Painters and Painting.* M.A. thesis, University of Louisville, 2001.

Warne, Vanessa K. *"Purport and Design": Print Culture and Gender Politics in Early Victorian Liter-*

ary Annuals. Ph.D. dissertation, Queen's University (Kingston, ON), 2001.

Wat, Pierre. "Décrire le rien?: 'Le Paysage Anglais' de John Constable." In Bonfait, *La description* (above), 215–28.

Watkins, John. "'Neither of idle shewes, nor of false charmes aghast': Transformations of Virgilian Ekphrasis in Chaucer and Spenser." *Journal of Medieval & Renaissance Studies* 23 (Fall 1993): 345–63.

Watson, Patricia A. "Martial's Snake in Amber: Ekphrasis or Poetic Fantasy." *Latomus* 60, no. 4 (October–December 2001): 938–43.

Webb, Ruth. "Accomplishing the Picture: Ekphrasis, Mimesis and Martyrdom in Asterios of Amaseia." In Liz James, ed., *Art and Text in Byzantine Culture*. Cambridge: Cambridge University Press, 2007. 13–32.

_____. "The Aesthetics of Sacred Space: Narrative, Metaphor, and Motion in Ekphraseis of Church Buildings." *Dumbarton Oaks Papers* 53 (1999): 59–74.

_____. "Ekphrasis." *Dictionary of Art*, ed. Jane Turner, vol. 10 (London: Macmillan, 1996), 128–31.

_____. "*Ekphrasis*, Amplification and Persuasion in Procopius' *Buildings*." *Antiquité tardive* 8 (2000): 67–71.

_____. "Ekphrasis Ancient and Modern: The Invention of a Genre." *Word & Image: A Journal of Verbal/Visual Enquiry* 15 (1999): 7–18.

_____. *Ekphrasis, Imagination and Persuasion in Ancient Rhetorical Theory and Practice*. Aldershot, Hampshire, UK: Ashgate, 2009.

_____. "The *Imagines* as a Fictional Text: Ekphrasis, Apatê and Illusion." *La Licorne* 75 (2006): 113–36 .

_____. "Picturing the Past: Uses of Ekphrasis in the Deipnosophistae and other Works of the Second Sophistic." In David Braund and John Wilkins, eds., *Athenaeus and his World: Reading Greek Culture in the Roman Empire*. Exeter, Devon: Exeter University Press, 2000. 218–26.

_____. *The Transmission of the Eikones of Philostratos and the Development of Ekphrasis from Late Antiquity to the Renaissance*. Ph.D. dissertation, University of London, 1992.

Weber, Thomas. "Die Statuengruppe Jesu und der Haimorrhousa in Caesarea-Philippi." *Damaszener Mitteilungen* 9 (1996): 209–16.

Weddigen, Tristan. "Italienreise als Tugendweg: Hendrick Goltzius 'Tabula Cebetis.'" *Nederlands Kunsthistorisch Jaarboek* 54 (2003): 90–139.

Weilandt, Gerhard. "Heiligen-Konjunktur: Reliquienpräsentation, Reliquienverehrung und wirtschaftliche Situation an der Nürnberger Lorenzkirche im Spätmittelalter." In Markus Mayr, ed., *Von goldenen Gebeinen: Wirtschaft und Reliquie im Mittelalter*. Innsbruck: Studien-Verlag, 2001. 186–220.

Weimer, Christopher B. "The Quixotic Art: Cervantes, Vasari, and Michelangelo." In de Armas, *Writing* (above), 63–83.

Welish, Marjorie. "The How and the Why: John Taggart's 'Slow Song for Mark Rothko.'" In Tonya Foster and Kristin Prevallet, eds. *Third Mind: Creative Writing Through Visual Art*. New York: Teachers and Writers Collaborative, 2002. 122–30.

Wells, Marion A. "'To find a face where all distress is stell'd': Enargeia, Ekphrasis, and Mourning in *The Rape of Lucrece* and the *Aeneid*." *Comparative Literature* 54, no. 2 (Spring 2002): 97–126.

Welsh, Ryan. "Exphrasis." *Keywords Glossary: University of Chicago: Theories of Media*. http://humanities.uchicago.edu/faculty/mitchell/glossary2004/ekphrasis.htm

Weltzien, Friedrich. "Virtuosen der Ekphrasis: die Sprache der Musik bei Kandinsky und Nay." In Cordula Heymann-Wentzel et al., eds., *Musik und Biographie: Festschrift für Rainer Cadenbach*. Würzburg: Königshausen & Neumann, 2004.

Wenzel, Horst. *Hören und Sehen, Schrift und Bild. Kultur und Gedächtnis im Mittelalter*. München, 1995.

_____, ed. "Visualität. Sichtbarkeit und Imagination im Medienwandel." *Zeitschrift für Germanistik* 9 (1999): 549–690.

Wenzel, Horst, Wilfried Seipel, and Gotthart Wunberg, eds. *Audiovisualität vor und nach Gutenberg. Zur Kulturgeschichte der medialen Umbrüche*. Wien und Mailand: Ginko, 2001.

Werckmeister, Otto Karl. *Linke Ikonen: Benjamin, Eisenstein, Picasso — nach dem Fall des Kommunismus*. München: C. Hanser, 1997.

_____. "Walter Benjamin's Angel of History, or, The Transfiguration of the Revolutionary into the Historian." *Critical Inquiry* 22, no. 2 (Winter 1996): 239–67.

Wertheim, Margaret. *Die Himmelstür zum Cyberspace. Eine Geschichte des Raumes von Dante zum Internet*. Zürich: Piper, 2002.

West, Timothy Lee. *Re-presenting the "Aeneid": Ekphrasis and the Dreamed Book in Chaucer's "House of Fame."* M.A. thesis, Wake Forest University, 2000.

Wettlaufer, Alexandra K. *In the Mind's Eye: The Visual Impulse in Diderot, Baudelaire and Ruskin*. Amsterdam: Rodopi, 2003.

Whalen, Logan E. "A Medieval Book-Burning: Objet d'art as Narrative Device in the Lai of Guigemar." *Neophilologus* 80, no. 2 (April 1996): 205–11.

Wharton, David Bradford. *Ambiguity in the "Aeneid."* Ph.D. dissertation, University of North Carolina, Chapel Hill, 1992.

Wheeler, Stephen M. "Imago Mundi: Another View of the Creation in Ovid's *Metamorphoses.*" *American Journal of Philology* 116 (Spring 1995): 95–121.

Whitby, Mary. "The Occasion of Paul the Silentiary's Ekphrasis of S. Sophia." *Classical Quarterly* 35, n.s., no. 1 (1985): 215–28.

_____. "Paul the Silentiary and Claudian." *Classical Quarterly* 35, no. 2 (1985): 507–16.

_____. "Procopius' Buildings, Book I: A Panegyrical Perspective." In Charlotte Roueche et al., eds., *Le De Aedificiis de Procope: le texte et les réalités documentaires.* 45–57.

Whitmarsh, Tim. "Written on the Body: Ekphrasis, Perception and Deception in Heliodorus' *Aethiopica.*" *Ramus: Critical Studies in Greek and Roman Literature* 31, no. 1–2 (2002): 111–25.

Whittingham, Georgina. "Transgresiones ecfrásticas: El texto y la imagen en Los herederos de Segismundo de Schmidhuber de la Mora." *Latin American Theatre Review* 39, no. 2 (Spring 2006): 117–33.

Wieser D. "Les ekphrasis de la mort." *Année Baudelaire* 1 (1995): 107–32.

Wiesenthal, Christine. "Taking Pictures with Stephanie Bolster." *Canadian Literature* 166 (Autumn 2000): 44–60.

Wiesmann, Karc-Andre. "Intertextual Labyrinths: Ariadne's Lament in Montaigne's 'Sur des vers de Virgile.'" *Renaissance Quarterly* 53, no. 3 (Autumn 2000): 792–820.

Wilcox, Helen. "Afterword: Poets, Painters, and Portraits." In Robillard, *Pictures* (above), 213–17.

Wild, Christopher. "'Weder mit worten noch rutten': The Force of Gryphius's Examples." *Germanic Review* 76, no. 2 (Spring 2001): 99–118.

Williams, Adelia V. "Jean Tardieu: 'Saurai-je peindre avec des mots?'" *French Literature Series* 18 (1991): 114–25.

_____. "Poésie critique as 'Poetics of Space': Edward Hopper and Claude Esteban." *Mosaic: A Journal for the Interdisciplinary Study of Literature* 31, no. 4 (December 1998): 123–34.

Williams, Allyson Burgess. "*Le donne, i cavalier, l'arme, gli amori*": Artistic Patronage at the Court of Alfonso I d'Este, Duke of Ferrara.* Ph.D. dissertation, University of California, Los Angeles, 2005.

Williams, Tamara R. "Re-Imaging Nation: Memory and Desire in Antonio Cisneros's *Comentarios reales.*" *Revista de Estudios Hispánicos* 36, no. 2 (May 2002): 291–309.

Williams, Wesley C. "For Your Eyes Only": Corneille's View of *Andromeda.*" *Classical Philology* 102, no. 1 (January 2007): 110–23.

Wilson, Anna. "Reflections on Ekphrasis in Ausonius and Prudentius." In Doreen Innis et al., eds., *Ethics and Rhetoric Classical Essays for Donald Russell on his Seventy-Fifth Birthday.* Oxford: Clarendon Press, 1995. 149–60.

Wilson, D.B. *Descriptive Poetry in France from Blason to Baroque.* Manchester, UK: Manchester University Press, 1967.

Wilson, D. Harlan. "Wells's Cinematic Ekphrasis." *Science Fiction Studies* 35, no. 3 (Noverber 2008): 519–21.

Wilson, Robert R. "Shakespeare's Narrative: The Craft of Bemazing Ears." *Shakespeare–Jahrbuch* 125 (Winter 1989): 85–102.

Winkler, Hartmut. *Docuverse. Zur Medientheorie der Computer.* München: Klaus Boer Verlag, 1997.

Winner, Matthais. "Ekphrasis bei Vasari." In Boehm and Pfotenhauer, *Beschreibungskunst* (above), 259–73.

Witosz, Bozena. *Opis w prozie narracyjnej na tle innych odmian deskrypcji: zagadnienia struktury tekstu.* Uniwersytetu Śląskiego (Katowice): Wydawn, 1997.

Witt, Mary Ann Frese. "Reconfiguring Borders." *Comparatist* 30 (May 2006): 1–4.

Witthinrich, Jochen. "Stadtutopien und Planstädte: eine Strukturanalyse. In Nerdinger, *Architektur* (above), 83–8.

Wolf, Bryan. "Confessions of a Closet Ekphrastic." *Yale Journal of Criticism* 3 (1990): 181–204.

Wolf, Werner. "The Role of Music in Gabriel Josipovici's *Goldberg: Variations.*" *Style* 37, no. 3 (2003): 294–317.

Wood, Nigel, and Alison Yarrington. "Ut sculptura poesis: British Romantic Poetry and Sculptural Form." In Thomas Frangenberg, ed., *Poetry on Art: Renaissance to Romanticism.* Donington: S. Tyas, 2003. 215–35

Woodland, Malcolm. "'Pursuit of Unsayables': Repetition in Kristeva's *Black Sun* and Strand's 'Two de Chiricos.'" *Mosaic* 37, no. 3 (2004): 121–38.

Worden, William. "The First Illustrator of *Don Quixote*: Miguel de Cervantes." In de Armas (above), *Ekphrasis,* 144–54.

Wrigley, Richard. "'Au Salon' ou les ennuis de la description." In Bonfait, *La description* (above), 141–52.

Wu, Sophie Schaller. *L'Ekphrasis dans la littérature française du Moyen Âge. Recherches sur les représentations littéraires de l'oeuvre d'art dans les textes français des origines à la fin du XIIIe s.* Doctoral thesis, Université de Neuchâtel, 2007.

Wulff, O. "Das Raumerlebnis des Naos im Spiegel der Ekphrasis." *Byzantinische Zeitschrift* 30 (1929–30): 531–9.

Wunderlich, Werner. "Apelles' Tomb Paintings in the Alexander Epic of Ulrich von Etzenbach." *Jahrbuch der Oswald von Wolkenstein-Gesellschaft* 11 (1999): 1–8.

_____. "Ekphrasis und Narratio: Die Grabmalerei des Apelles und ihre 'Weiberlisten' in Walters von Châtillon und Ulrichs von Etzenbach Alexanderepen." In Haferland and Mecklenburg (above), 259–71.

Wylie, Alex. "Ekphrasis." *Stand* 7, no. 3 (2007): 15.

Wynne, Robert. *Imaginary Ekphrasis.* Columbus, OH: Pudding House Publications, 2005.

Yacobi, Tamar. "Ashbery's 'Description of a Masque': Radical Interart Transfer Across History." *Poetics Today* 20, no. 4 (Winter 1999): 673–707.

_____. "Ekphrasis in the Service of Time: The Case of Dan Pagis." *Interfaces* 2, nos. 19–20 (2002): 3–25.

_____. "Ekphrasis and Perspectival Structure." In Erik Hedling and Ulla-Britta Laggeroth, eds., *Cultural Functions of Intermedial Exploration. Internationale Forschungen zur Allgemeinen und Vergleichenden Literaturwissenschaft.* 62. Amsterdam: Rodopi, 2002. 189–202

_____. "Ekphrastic Double Exposure: Blake Morrison, Francis Bacon, Robert Browning and Fra Pandolf as Four-in-One." In Martin Heusser et al., eds., *On Verbal/Visual Representation. Word & Image: Interactions 4.* Amsterdam/New York: Editions Rodopi, 2005. 219–27.

_____. "The Ekphrastic Figure of Speech." In Martin Heusser et al., eds., *Text and Visuality: Word & Image Interactions III.* Amsterdam/Atlanta: Editions Rodopi, 1999. 93–101.

_____. "The Ekphrastic Model, Forms and Functions." In Robillard (above), *Pictures*, 21–34.

_____. "Interart Narrative: (Un)Reliability and Ekphrasis" [With appendix: Blake Morrison, *Teeth* (Poem)]. *Poetics Today* 21, no. 4 (Winter 2000): 711–49.

_____. "Pictorial Models and Narrative Ekphrasis." *Poetics Today* 16 (Winter 1995): 599–649.

_____. "Verbal Frames and Ekphrastic Figuration." In Ulla-Britta Lagerroth, Hans Lund and Erik Hedling, eds., *Interart Poetics. Essays in the Interrelations of the Arts and Media.* Amsterdam, Atlanta: Rodopi, 1997. 35–46.

Yamamoto, Hideko. *Ekphrasis as an Authorial Mirror: A Reading of John Keats' Odes.* B.A. thesis, Keio University, 2004.

Yngborn, Katarina. "Die Erzählung als erweiterte Ekphrasis: Kunst und Kunstdiskurs in Torgny Lindgrens Erzählung I brokiga blads vatten." In Eglinger, *BildDurchSchrift* (above), 231–49.

Yoch, James J. "Architecture as Virtue: The Luminous Palace from Homeric Dream to Stuart Propaganda." *Studies in Philology* 75 (1978): 403–29.

Yu, Christina. *Embedded Mirrors: Ekphrasis as a Mirror of Art, and Art as the Embryonic Impulse of History.* Senior honor thesis, Dartmouth College, 2005.

Zacharopoulos, Nikolaou Gr. *Gregorios E': saphes ekphrasis tes ekklesiastikes politikes epi Tourkokratias.* Thessalonike, 1974.

Zachmann, Gayle. "The Photographic Intertext: Invisible Adventures in the Work of Claude Cahun." *Contemporary French and Francophone Studies* 10, no. 3 (September 2006): 301–10.

Zanker, G. "New Light on the Literary Category 'Ekphrasis Epigram' in Antiquity: The New Posidippus (col. X 7–XI 19 P. Mil. Vogl. VIII 309)." *Zeitschrift für Papyrologie und Epigraphik* 143 (2003).

Zieliński, Jan. "Ekphrasis in der Lyrik von Aleksander Wat." In Matthias Freise and Andreas Lawaty, eds., *Aleksander Wat und "sein" Jahrhundert.* Wiesbaden: Harrassowitz Verlag, 2002. 218–34.

Zimmerman, Clayton Lawrence. *The Pastoral Narcissus: Daphnis in the First "Idyll of Theocritus."* Ph.D. dissertation, University of North Carolina, Chapel Hill, 1989.

Zivley, Sherry Lutz. "Sylvia Plath's Transformations of Modernist Paintings." *College Literature* 29, no. 3 (Summer 2002) 35–57.

Zoltán, Simon. "Non vulgare genus. Ekphrasis, literarisches Gedächtnis und gattungsspezifische Innovation in der sechsten Ekloge des T. Calpurnius Siculus." *Acta Classica Universitatis Scientiarum Debreceniensa* 43 (2007): 57–70.

Zumbo, Antonino. "L'Ekphrasis d'opera d'arte: esercitazione letteraria o strumento di comunicazione?" In E.A. Arslan et al., eds., *La "Parola" delle immagini e delle forme di scrittura. Modi e techne della comunicazione nel mondo antico.* Messina: Dipartimento di scienze dell'antichita degli studi di Messina, 1998. 19–40.

Index